THE JACK AND BELLE LINSKY COLLECTION
IN THE METROPOLITAN MUSEUM OF ART

THE JACK AND BELLE LINSKY COLLECTION

IN THE METROPOLITAN MUSEUM OF ART

The Metropolitan Museum of Art, New York

PUBLISHED BY

The Metropolitan Museum of Art, New York

Bradford D. Kelleher, *Publisher*

John P. O'Neill, *Editor in Chief*

Polly Cone, *Project Manager*

Kathleen Howard, Ellen Shultz, Emily Walter, *Editors*

Peter Oldenburg, *Designer*

PHOTOGRAPHY

Photograph Studio, The Metropolitan Museum of Art

LIBRARY OF CONGRESS CATALOGING IN PUBLICATION DATA

Metropolitan Museum of Art (New York, N.Y.)
 The Jack and Belle Linsky Collection in the Metropolitan
Museum of Art.

 Includes bibliographies and index.
 1. Art—New York (N.Y.)—Catalogs. 2. Linsky, Jack—Art
collections—Catalogs. 3. Linsky, Belle—Art collections—
Catalogs. 4. Art—Private collections—New York (N.Y.)—
Catalogs. 5. Metropolitan Museum of Art (New York, N.Y.)—
Catalogs. I. Title.
N611.L55A58 1984 709'.4'07401471 84-4551
ISBN 0-87099-370-4

Type set by Graphic Composition, Inc., Athens, Georgia
Printed by Rae Publishing Co., Inc., Cedar Grove, New Jersey
Bound by A. Horowitz & Sons, Fairfield, New Jersey

Contents

Foreword

THIS PUBLICATION celebrates the permanent installation of the Jack and Belle Linsky Collection at The Metropolitan Museum of Art. It is inevitable, I suppose, that as a museum professional I qualify my delight at describing the Linskys' art with just a touch of envy at the Linskys' ability to indulge their collectors' instinct in the grand manner, forming a superlative collection without institutional constraints. They had the freedom to be bold, willful, and even capricious, and they exercised it unsparingly. Unfettered by the restraints placed on those of us who care for public collections—where a need for balance and comprehensiveness must often outweigh individual taste—the Linskys bought for themselves only, submitting totally to the pleasure principle. Now, through their munificent gift, that pleasure may be shared by all who visit the Metropolitan.

It is testimony to the Linskys' keen eye that their collection should be at the same time outstanding and so very personal. Much of its character is due to the Linskys having made choices based on an innate sense of quality, undulled by too much bookish knowledge. It is also worth noting that to an uncommon degree the collection is free from the encumbrance of too many "expert" opinions and from the anonymity that devolves from a passionless, unengaged consensus.

The Linskys' sensibility drew them to precious and luxurious objects—to the elegance of eighteenth-century French furniture as well as to French and German porcelains. Their proclivity for things meticulously executed and carefully finished led them to concentrate, when they bought pictures, on "primitives"—that inapt traditional term for the works of the early Netherlandish and Italian schools that produced Gerard David, Juan de Flandes, Carlo Crivelli, and Giovanni di Paolo. These artists, whose works are represented by gemlike examples in the Linsky Collection, made what we now know to be among the most sophisticated and refined works imaginable. The Linsky *Adoration of the Magi* by Giovanni di Paolo joins twenty-one other paintings by that master already at the Museum. These range from a large polyptych to small narrative scenes from the predellas of altarpieces and individual devotional pictures. Ours is the most comprehensive collection outside the artist's hometown of Siena, but, even in such distinguished company, the Linsky picture holds a special place, both because of its immaculate condition and the magical landscape that fills its background.

Belle and Jack Linsky's preferences in furniture were not for highly ornate pieces; a certain purity of taste led them to the more chaste—and commendable—*ébénisterie*, in which overall quality, unobscured by cascades or ormolu, remains a function of design, proportion, refinement of execution, and, most of all, *mesure*. The degree to which sobriety of line and surface treatment in French and

7

French-inspired eighteenth-century furniture marks a masterpiece is gloriously demonstrated in Roentgen's commode, on which comedy scenes continue in marquetry a pictorial tradition that goes back to Pater or Boucher, two artists also well represented in the collection.

Although the sustained level of quality in the Linsky Collection is in the *grand goût*, the scale of the works of art themselves is intimate and private. No picture—not even the large and imposing Meléndez (an artist heretofore not represented in the Metropolitan)—calls for *recul*, or distance. In its installation of the Linsky Galleries, the Museum has striven to create the atmosphere of intimacy the works of art demand and thus to preserve what Kenneth Clark called the "touching quality" that "in some mysterious way" private collections often "lose in a public gallery." In addition, the Linsky Galleries are ideally located—retaining the integrity of the collection as a whole, yet allied to the Museum's holdings in European sculpture and decorative arts, through the disposition of the rooms, which lead logically into areas where cognate material is displayed.

The Linskys now join the constellation of preeminent collectors whose gifts and bequests invest the Museum with so splendid and multifaceted an identity. In the Linsky rooms the visitor is surrounded by the palpable aura of passion, daring, and discernment. In the visitor's enjoyment of these beautiful works of art he bears witness to the extraordinary public spirit that is the foundation block of America's great museums.

The substantial grant from The Dillon Fund, which has made this exemplary installation possible, is no less in this spirit, and our deepest thanks are extended to Douglas Dillon.

PHILIPPE DE MONTEBELLO
Director
The Metropolitan Museum of Art

List of Contributors

Katharine Baetjer

Guy C. Bauman

Keith Christiansen

James David Draper

Carmen Gómez-Moreno

Clare Le Corbeiller

Walter Liedtke

Charles T. Little

Jessie McNab

William Rieder

Clare Vincent

William D. Wixom

Alice Zrebiec

Introduction: Paintings

T HE PAINTINGS in the Linsky Collection are the fruit of forty years of wide-ranging but discriminating purchases. From the first, the focus of Jack and Belle Linsky's interest was small paintings of excellent quality, and the tone of the collection was set in 1924 when the Linskys acquired one of the most beautiful and intimate portrait groups by Gerard ter Borch of three members of the van Moerkerken family (no. 30). It was soon joined by a first-rate small Metsu (no. 32) and by a jewel-like *Virgin and Child* by or from the workshop of Dieric Bouts (no. 16), of which an inferior version is in the Staatliche Museen in Berlin. In 1949 these were followed by two small Italian paintings from the Bondy collection in Vienna: a well-known panel of *The Adoration of the Magi* by Giovanni di Paolo—part of a predella of which a number of other panels are known (no. 4)—and the Bacchiacca *Leda and the Swan* (no. 11).

One of the peculiarities of the Linsky Collection is that so many of its major paintings were bought directly in the auction room. In London in 1965 at the Spencer-Churchill sale, Mr. and Mrs. Linsky secured the Gerard David *Adoration of the Magi* (no. 17), which till then had formed the centerpiece of the picture gallery at Northwick, as well as an Italian predella panel of *The Presentation in the Temple* traditionally given to Lorenzo Monaco, but actually painted in Pisa (no. 3). When in 1967 two panels by Juan de Flandes appeared at the sale of pictures from the Watney collection at Cornbury, one of them was purchased by the National Gallery of Art in Washington, but the other, arguably the finer, was secured for the Linsky Collection (no. 20). An auction in New York in 1949 yielded one of the undoubted masterpieces of the collection, the earliest dated portrait by Rubens (no. 24), and at the 1961 sale of the Erickson paintings, a *Madonna and Child* by Carlo Crivelli (no. 5) was acquired. The Crivelli was, after Rembrandt's *Aristotle with a Bust of Homer*, the best-known picture in the collection, being from a polyptych of which two panels are in the Metropolitan Museum, another in the Brooklyn Museum, and a fourth in the Cleveland Museum of Art. On someone like myself, who first met the Linskys in the auction room in London, their security of judgment and catholicity of taste made an indelible impression.

Slowly through the nineteen-fifties and sixties the collection assumed its present form. The Erickson Crivelli was joined by what is perhaps the most beautiful of Vittore Crivelli's half-length Madonnas (no. 6), and the Bacchiacca *Leda* was joined by a fine *Madonna and Child* by the same artist (no. 10). To these were added in 1955 a beautiful early portrait by Fra Bartolomeo (no. 8) and a little-known male portrait by Andrea del Sarto (no. 9). The Linskys' Northern primitives were enriched with the addition of a delicate *Crucifixion* by Jan Provost (no. 21), a remarkable *Nativity* from the

workshop of Jan Joest of Calcar (no. 22), and paintings by Conrad Faber and Cranach (nos. 36–38). A great Jan Steen, *The Dissolute Household* (no. 31), which shows the artist at the height of his incomparable powers, was purchased in 1964. The French eighteenth-century paintings in the Linsky Collection are one and all exceptional. They include a superlative Nattier portrait (no. 43), two admirable mythological Bouchers of 1763, *Jupiter in the Guise of Diana, and Callisto* and *Angelica and Medoro* (nos. 46, 47), and—rarest and most appealing of all—an early Boucher landscape of the Campo Vaccino painted in 1734 (no. 45). Of even greater importance is the single Spanish painting included in the Linsky gift, an exceptionally large still life, Luis Egidio Meléndez's *La Merienda* (no. 40), which is generally regarded on grounds not only of size but of sheer sensibility as the painter's masterpiece.

JOHN POPE-HENNESSY
Consultative Chairman
Department of European Paintings

Introduction: Decorative Arts

BY 1952, WHEN Jack and Belle Linsky moved to a new apartment on Fifth Avenue, they had already attracted attention as serious collectors of European porcelains. It was, however, after their move that the Linskys' collecting interests expanded profoundly. In little more than twenty years, with bold and single-minded determination, they were able to assemble one of the most remarkable New York collections of French eighteenth-century furniture, Renaissance and Baroque bronzes, goldsmiths' work, and jewelry.

The French furniture came almost entirely from the auction houses of London and Paris, where, between 1952 and 1971, each piece was obtained after fierce competition with other important collectors. Often without hesitation, the Linskys established record prices in those years. Some twenty-five pieces of Louis XV and Louis XVI furniture thus acquired strike us today as an anthology of the very best creations of Paris *menuisiers* and *ébénistes*. From the architectural vigor and opulent ornamentation of a famous commode the model of which was made in 1710 by André-Charles Boulle for Louis XIV's bedroom at the Grand Trianon (no. 126), to the severe outlines and exquisite proportions of a mahogany commode designed by Jean-Henri Riesener on the eve of the French Revolution (no. 139), the stylistic evolution of eighteenth-century Paris furniture is dazzlingly represented. The best qualities of Louis XV's style at mid-century can be admired in the sculptured perfection of a sofa signed *Tilliard* (no. 140), in the fantasy and sensuous grace of a commode created by Charles Cressent and embellished with superb gilt-bronze mounts (no. 127), and in the sophistication of a mechanical writing table, a well-known masterpiece of about 1760, commissioned by Mme de Pompadour and signed by Jean-François Oeben (no. 128).

A subsequent moment in taste and patronage is represented by two small desks (nos. 133, 134) and a candlestand (no. 135), decorated with plaques of Sèvres porcelain, designed between 1769 and 1780 by Martin Carlin, one of the masters of the Louis XVI style. No European *ébéniste* of the 1770s achieved greater international fame than the German David Roentgen, whose furniture, veneered with pictorial marquetry and fitted with gilt bronzes and intricate mechanical devices, was eagerly sought by European courts from Saint Petersburg to Paris. An extraordinary commode veneered with three marquetry panels depicting Italian Comedy scenes and musical vignettes, probably after designs by Januarius Zick , carries the château mark of Versailles (no. 136). It can, in fact, be identified with a *commode à vantaux* described in the 1792 furniture inventory of the private apartments of Louis XVI. A few exquisite accessories were also acquired to accompany these pieces of furniture. Among them we must note a rare *cartel clock* surrounded by a frame in Chantilly porcelain mounted in gilt

bronze by Etienne Le Noir (no. 147) and an imposing longcase regulator whose neoclassical design may well be the work of Philippe Caffiéri (no. 150).

The Linsky collection of eighteenth-century European porcelains, continually enriched during the 1950s and 1960s, must surely be among the most important collections of its kind assembled after World War II. Numbering over two hundred figures, it is remarkable for the exacting quality of the examples represented as well as for their variety and originality. Broadly speaking, the porcelains fall into three groups. The largest, as one would expect, is represented by some thirty-nine Meissen models and fifty-two more from other German factories as well as from Vienna. Among the Meissen pieces, a sizable number of Italian Comedy figures, most of them models created by J. J. Kändler in 1736–43, represent this artist's talent at its best. It was the Commedia dell'Arte subjects, so popular for their humorous tone and vivid plasticity, that were most frequently imitated throughout the second part of the century by the proliferating German factories. From Höchst, Fürstenberg, Nymphenburg, Frankenthal, Ludwigsburg, and Fulda, the collection has spirited variations on the Italian Comedy and other themes, often varying in mood and palette, yet always reflecting the pervasive influences of the stage, the ballet, and social satire, and the ever-present fashion for chinoiserie.

In the second group, comprising twenty-nine French and twelve Italian soft-paste porcelain figures, are even rarer examples of eighteenth-century ceramic art. The French pieces, acquired by the Linskys very early, quite ahead of fashionable trends, include delightful figures of Orientals directly inspired by Chinese and Japanese models, all modeled before the middle of the eighteenth century at the early factories of Saint-Cloud, Chantilly, and Mennecy. In the range of their styles and hues, some of them recall the traditional elegance of French faience; others evoke the quality and mood of the works of Watteau or Boucher, while all convey the playful eloquence of Régence and Louis XV rocaille and chinoiserie interiors.

Quite different in mood are the Italian porcelains, produced at the factory of Capodimonte between 1750 and 1759. They are informal or humorous subjects, like the Washerwoman (no. 313) and Rabbit Catchers (no. 315), modeled with great suavity and painted in pastel colors, and they charm us like vignettes from Neapolitan life.

Again different in character are the fifty figures that make up the third group of porcelains. These are unusual examples of late eighteenth-century Danish and Russian porcelains that evoke entirely different social contexts and esthetic sensibilities. The Copenhagen group combines humble subjects with neoclassical concerns and shows a certain dryness of color and modeling that reveals the influence of nearby Prussia on local Scandinavian traditions. The Linsky Russian porcelains, a truly unusual group (many of the pieces secured from the Russian emigré collector Popov), number about twenty-five. Many of them, created at the Imperial Porcelain Factory at Saint Petersburg, make up the astonishing series of *Peoples of Russia* and *Craftsmen and Tradesmen*. These figures are notable for their popular rather than courtly flavor, quite evocative of the traits perceived in other Russian arts as well.

Jack and Belle Linsky's sense of quality and independence of taste did not stop them at the arts of

the eighteenth century. Always attracted by the rare, the personal, the strong, they did not hesitate to venture into the difficult fields of medieval and Renaissance objets d'art, Renaissance and Baroque bronzes, goldsmiths' work of the Renaissance and later, and jewelry, three groups of objects among which the visitor to the Linsky Galleries will discover many a masterpiece.

One of the most striking works in the collection is also one of the earliest: a brass *Monk-Scribe Astride a Dragon* (no. 49), made by a Rhenish artist active in the third quarter of the twelfth century. Filled with vitality and grace, this object recalls some of the most compelling motifs of Romanesque art as we know them from illuminated manuscripts and sculptures in stone and wood. The wealth and refinement of the Franco-Burgundian court at the beginning of the fifteenth century are demonstrated by an enameled gold relief of the *Entombment of Christ* (no. 52), rendered in the exacting technique of *émail-en-ronde-bosse*.

Two fine medieval bronze corpuses, one a Romanesque work of Mosan-Rhenish origin, dating from about 1150–75 (no. 48), the other modeled by a Gothic sculptor from northern Italy in about 1350–1400 (no. 51), introduce a collection of thirty-six Renaissance and Baroque bronzes, from both Italian and northern European centers of casting. The earliest and by far the most extraordinary of these is the statuette of a standing satyr (no. 56), a little-known treasure acquired by the Linskys from the collection of Prince Nicolas of Rumania. In the satyr's suavely lyrical pose and exquisitely chased details we easily recognize the hand of Antico, the great goldsmith-sculptor of the Gonzaga family at Mantua. The figure's pose seems to be best understood when imagined in combination with a lighting device, and, if it was once equipped with a candlestick, this fine statuette may well have been one of a pair made for Isabella d'Este's Palace at Mantua. By far the best of an interesting group of Paduan bronzes and utensils is the statuette of another satyr, this time a seated figure, the model of which was created by Andrea Riccio (no. 57). The sensitive modeling and unusually crisp chasing of this bronze date it to the 1520s, the decade when Riccio's workshop produced its finest statuettes. A model known in several versions, the Linsky example is clearly the most accomplished of these.

No serious collection of bronzes can do without works associated with the name of Giovanni Bologna, whose complex and refined sculptures were repeated and varied for many decades after the artist's death in 1608. In the Linsky Collection, there are three such bronzes, all fine seventeenth-century Florentine casts. Among them, a *Hercules and the Erymanthian Boar* (no. 69), based on a composition created by Giovanni Bologna for his famous series of the *Labors of Hercules*, will be admired for its fresh, vigorous modeling and chasing and its impeccable lacquered patina.

In spite of the presence of fine bronzes by the great Italian Renaissance masters, as one studies the Linskys' collection, one is struck by the predominance of atypical and strongly expressive statuettes over the better-known classical models so often encountered in continental collections formed before World War II. The Linskys' personal taste and their willingness to depart from popular trends in collecting allowed them to venture in the 1960s into the less-familiar field of Baroque bronzes, and especially of northern European ones. It is here that some of the most interesting objects in the collection are found.

A miniature portrait bust of Paolo Giordano II Orsini, duke of Bracciano (no. 73), long believed to have been cast after a model by Gian Lorenzo Bernini, appears now to be the work of Johann Jakob Kornmann, a German medalist who produced several portrait medals of the duke while working in Rome at the papal mint, about 1625–35. It is an appealing little masterpiece, whose pictorial warmth and courtly tone typify the Rome of Urban VIII.

The earliest of the Northern bronzes is a south German Venus (no. 80), which, in the stark simplicity of its outlines and the primitive vigor of its gouged details, will especially please devotees of modern sculpture. This statuette and two others, portraying boisterous landsknechts (nos. 82, 83), may seem almost naïve. But nothing of the sort can be said of the Linskys' Late Mannerist groups, which reflect the wealth of classical allusion that so delighted German princely patrons. One of these groups is the well-known model of Tarquin and Lucretia by Hubert Gerhard (no. 85). It is represented by a late seventeenth-century cast, quite appealing in its variations. The base, with spouting masks, suggests that it was used as a table fountain. Another bronze represents the Ovidian story of Neptune and Caenis (no. 84); its complex interlocking forms are based on a drawing by Bartholomaeus Spranger.

A fascination with strongly expressive forms and virtuoso techniques is revealed in two seventeenth-century groups that we can easily imagine forming part of a German Baroque *Kunstkammer*. One is a bronze presenting the spectacle of two *Nude Women Wrestling* (no. 91), an especially fine cast based on a composition by Leonhard Kern. The other is an arresting ivory group, *Hercules and Antaeus* (no. 93), carved with the exaggerated realism of a mid-seventeenth-century Austrian master. The vigor of this ivory sculpture, which seems to express a yearning to capture nature's power, is paralleled in the energy-charged forms of a Baroque masterpiece in another medium altogether: a superb smoky rock-crystal ewer (no. 95)—once known as the Beckford Vase—whose exuberant volutes and masks in turn echo the forms of the crystal vessels carved around 1680 by Ferdinand Eusebio Miseroni for the imperial court at Prague.

Yet another object in the Linsky Collection illustrates the variety of ways semiprecious stones could be treated by seventeenth-century goldsmiths: a small covered cup of reddish brown carnelian, whose disciplined outlines are underscored by its delicate carving and the restrained design of its finely enameled mounts (no. 94). Probably made for Cardinal Mazarin, the cup belonged to Louis XIV and remained in the French royal collections until the Revolution. In a small group of late sixteenth- and seventeenth-century pendent jewels, the most interesting are a south German *Charity and Her Children* (no. 97), inspired by designs by Daniel Mignot, and a Netherlandish *Neptune and a Sea Monster* (no. 104). Very different works indeed are the collection's two masterpieces of eighteenth-century goldsmiths' work. These are an elegant German nécessaire (no. 110), of 1745–50, in mother-of-pearl and gold, decorated with lively chinoiserie motifs very close to the style of François Cuvilliés, and an automaton by James Cox (no. 111), commissioned in London in 1766 by the English East India Company for presentation to the emperor of China. A mechanical fantasy, half Rococo, half chinoi-

serie, the Cox automaton reminds us of the eighteenth-century's love for mechanical toys and the proliferation of commercial contacts with the East.

Finally, nothing could tell us more about the European veneration for the works of goldsmith's art and jewelry created in the Renaissance than the revival of the designs and techniques of the sixteenth century carried out by goldsmiths working in the second half of the nineteenth century. A reappraisal of the activities of a few virtuoso craftsmen working in the period between 1850 and 1900 has only just begun, with the recent discovery of a number of works by the German goldsmith Reinhold Vasters (1827–1909). Among these, four works in the Linsky Collection—a miniature ebonized fruit-wood cabinet, set with enameled gold and designed in the late-Renaissance Munich style (no. 113), and three pendants (nos. 114–116), also designed in the Renaissance style, stand out for the quality of their workmanship. These and other remarkable works, such as a large decorative pendant with the Sacrifice of Isaac (no. 119) and an impressive gold cup (no. 125), theatrical in its flamboyant eclecticism, remind us that the exploration and reassessment of the arts of the nineteenth century and their social context promise to yield rich rewards.

<div style="text-align:right">

OLGA RAGGIO

Chairman
Department of European Sculpture and Decorative Arts

</div>

PAINTINGS

Catalogue entries by

KEITH CHRISTIANSEN

GUY C. BAUMAN

WALTER LIEDTKE

KATHARINE BAETJER

Italian Paintings

GUIDO OR GUIDUCCIO PALMERUCCIO
(also called Palmerucci)

Active 1315–49, Gubbio

THERE ARE NO documented works by Palmerucci, though he is known to have worked in the Church of Santa Maria de' Laici in Gubbio, on the façade of which is a ruined fresco of Saint Anthony. He also worked in the Palazzo de' Consoli in Gubbio, where there is a fresco of the Madonna and Child with saints. He has traditionally been credited with a fairly extensive group of paintings. The cleaning of one of these, the *Madonna and Child with Angels* formerly in the Pieve di Agnano and now in the Diocesan Museum in Gubbio, has, however, revealed the signature *Melli de Eugubio* (Mello or Nello da Gubbio).[1] It is unlikely that the heterogeneous paintings associated with Palmerucci's name are the work of a single artist; Mello, to whom may be attributed a number of other works recognized by Giampiero Donnini[2] and Enrica Lusanna[3] as not by Palmerucci and whose career falls in the middle years of the fourteenth century, would appear to be one of his followers. Judging from documents, Palmerucci was active as early as 1315 and must have been the most prominent painter in Gubbio in the first half of the century. The present picture and some cognate works show a close dependence on the early Pietro Lorenzetti, probably the work at Assisi, and are very probably by Palmerucci.

1. Saint Romuald

Tempera on wood, gold ground. Overall, with engaged frame, 18⅛ × 10¾ in. (46 × 27.3 cm.)
1982.60.1

A vertical strip 1½ inches in width at the right is modern, as is an irregular strip that varies from ½ to 1 inch in width along the left. Only the upper third of the molded arch is original. The picture has lost its surface glazing, which has deprived the white habit of most of its modeling, and much of the book's cover has been repainted. The gold is on a white ground, and the linen between the wood and the gesso layer is visible along the bottom edge.

THE SAINT wears the white habit of the Camaldolese, Cistercian, or Olivetan order, and he holds a pale green book in his right hand. He has been persuasively identified as Saint Romuald, the founder of the Camaldolese order, by Enrica Lusanna (1977), who notes that the order had a number of establishments in and around Gubbio.

Of the paintings attributed to Palmerucci, this is one of the finest. The figure type shows a pronounced dependence on the early work of Pietro Lorenzetti, as does the type of halo with its beautifully incised leaves against a stippled ground. Lusanna has plausibly suggested a date in the 1320s, in the vicinity of that of the *Madonna and Child* now cut down to form a tondo and the *Annunciation*, both in the Pinacoteca at Gubbio. Indeed, the similarities between the present panel and the *Madonna and Child* are so close—they have the same pronounced crackle pattern and the same type of linen beneath the gesso layer— that the two might well be supposed to have formed part of the same polyptych, were it not for the fact that the *Madonna and Child* seems originally to have had a triangular, not a rounded, top.

NOTES:
1. F. Santi, "Due Restauri ed un ignoto maestro del Trecento: Mello da Gubbio," *Bollettino d'Arte* LXIV (no. 4, 1979), pp. 63–68.
2. G. Donnini, "Gli Affreschi di Montemartello," *Antichità Viva* XIII (no. 6, 1974), pp. 7–8.
3. Lusanna (1977), pp. 20, 38 n. 52.

EX COLL.: Mr. and Mrs. Jack Linsky, New York (before 1980); Mrs. Belle Linsky, New York (1980–82).

BIBLIOGRAPHY: E. Lusanna, "Percorso di Guiduccio Palmerucci," *Paragone Arte* XXVIII (no. 325, 1977), pp. 18, 34 n. 25.

KC

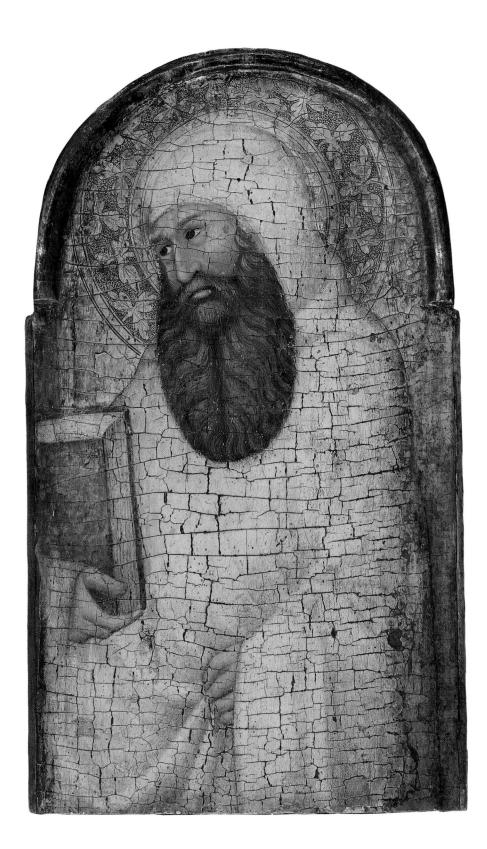

21

ITALIAN (PISAN) PAINTER, UNKNOWN

Active second quarter of 14th century, Pisa

2. Madonna and Child with Saints Michael and John the Baptist; The Noli Me Tangere; The Conversion of Saint Paul

Tempera on wood, gold ground. Overall, with additions, 18 × 11⅝ in. (45.7 × 29.5 cm.); without additions, 17½ × 11 in. (44.5 × 27.9 cm.); painted surface 17¼ × 10⅞ in. (43.8 × 27.6 cm.)

Inscribed (upper right, on Saint John's scroll): Ec[c]e ag[nu]s dei. Ecce / qui tollit pecc[atum mundi] ("Behold the Lamb of God, which taketh away the sin of the world," John 1:29); (lower right, on Christ's scroll, barely legible): [Sau]le qu[i]d me / persequeris [?]"Saul, why persecutest thou me?" Acts 9:4); (bottom right): . . . (illegible) . . . / . . . / . . . girenus qu . . . / . . . (illegible) . . . / . . . et . . . / ingre . . . / quid . . .

1982.60.2

The surface of the painting has been rubbed throughout so that the flesh has been largely reduced to the green underpainting and the gold to the bole preparation. The best-preserved figures are the Saint John the Baptist and the Christ Child. The larger tree and the flora in the Noli Me Tangere also give some impression of the original delicacy of the painting. There is a raised edge or lip all around. The back shows what appears to be a bole preparation, but there is no trace of tooling or gilding. Traces of two metal attachments along the back left border at 3 inches and 9¼ inches from the bottom of the panel confirm that the picture is the left side of a portable diptych.

IN THE UPPER, gabled portion of the picture are shown the Madonna and Child before a gray-green wall flanked by half-length diminutive figures of Saints Michael and John the Baptist. The Christ Child wears an orange tunic that buttons down the front and is elaborately embroidered. Over his right shoulder and his legs is draped a red mantle with a pink-to-green *changeant* lining. He holds a goldfinch, symbol of Christ's Passion, in his left hand, and gathers up the Virgin's veil in his right. Saint Michael is shown winged and holding his attributes, a gilt globe and a staff. He wears a bluish tunic with a red mantle lined in orange that is fastened with a brooch. Saint John the Baptist is shown in his traditional camel skin over which he wears a pink mantle. In his left hand he holds a scroll and a staff surmounted by a red cross. In the scene at the lower left Saint Mary Magdalen, who wears a dark dress with a vermilion mantle lined in yellow, is shown kneeling, her arms outstretched to Christ. Christ, clad in a pale mantle decorated with small dots and crosses and holding a red banner with a white cross, moves away from Mary Magdalen while he turns to address her. Two trees punctuate the scene at the left; the larger one seems to be a cherry tree and may be intended to symbolize Christ's blood. In the scene at the lower right Saint Paul is shown kneeling on a two-toned pink pavement before a half-length figure of Christ, who appears in a large, nimbed circle in the upper right corner. Saint Paul wears a deep wine-colored coat belted at the waist, and he holds in his crossed arms a sword in a belted scabbard, the symbol of his martyrdom.

The inscription on the scroll held by Christ in the lower right scene leaves no doubt that the subject is the conversion of Saint Paul; other representations of his conversion in which he similarly kneels before an apparition of Christ are known.

Though badly damaged, this small panel is of considerable importance in that it is one of the few works from the following of Francesco Traini, the most important Pisan painter of the fourteenth century. The combination of pale pinks, oranges, and reds is typical of Pisan painting, as are the delicate patterns on the garments. Given the picture's poor condition, any attribution must be tentative. However, there are a number of affinities with some paintings that Luciano Bellosi has convincingly grouped together under the sobriquet of the Master of the Carità, who was apparently active in the second quarter of the fourteenth century and whose works must have influenced Giovanni di Nicola da Pisa (active in the third quarter of the fourteenth century).[1] Because of the picture's poor condition, special importance attaches to the tooling of the gold ground. A number of decorative motifs—the

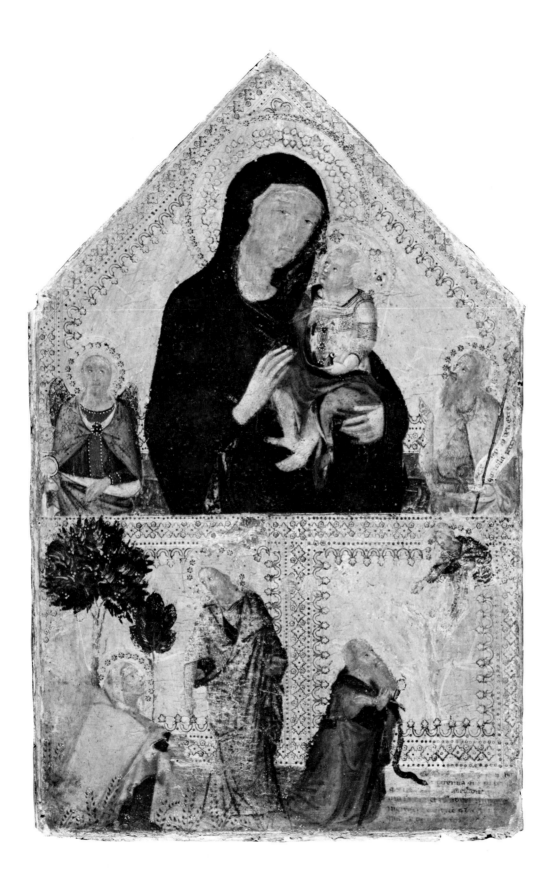

23

trefoil inscribed within a rounded arch and the squat fleurs-de-lys that are combined on the inner edge of the border; and the large, pointed floral punch and small, rounded five-petal floral punch in the border proper—recur in Traini's Saint Dominic Altarpiece in the Museo Nazionale, Pisa, as well as in various works by the Master of the Carità.[2] However, it would be difficult to find a parallel for the manner in which a small circular punch has been used to decorate the outer edge of the Madonna's and the Christ Child's haloes.

NOTES:

1. L. Bellosi, *Buffalmacco e il trionfo della morte*, Turin, 1974, pp. 95–96.

2. E. Skaug, in a letter, Sept. 2, 1983, has confirmed that the tooling is characteristic of Pisan practice, and he too views the work as early (i.e., pre-Giovanni di Nicola).

EX COLL.: Roland Robert, Toulouse (before 1954); Mr. and Mrs. Jack Linsky, New York (by 1954–1980); Mrs. Belle Linsky, New York (1980–82).

KC

MASTER OF THE LINSKY PRESENTATION IN THE TEMPLE

Active first third of 15th century, Pisa

3. Presentation in the Temple

Tempera and gold on wood. 13⅜ × 15⅞ in.
(34 × 40.3 cm.)
1982.60.3

The panel has been cut all around, thinned, and cradled. On the whole the condition is extremely good. There are two major losses of circular shape: one on the Virgin's shoulder (about 1¼ inches in diameter) and the other on the hem of the Virgin's dress (about 1½ inches in diameter). A similar damage occurs at the top center of the picture. The remaining, scattered losses are insignificant. The picture was cleaned in 1983, at which time a layer of modern gold was removed from the haloes of the figures, revealing the present, crisp tooling.

THE CENTER of the composition is dominated by the Virgin, who wears a blue cloak lined in yellow and extends her arms to receive the Christ Child from the bearded figure of Simeon. Behind Simeon and before the Temple, the interior of which is visible, stand two acolytes; one holds an incense boat, perhaps originally silvered. Behind the Virgin stand the aged prophetess Anna, clad in a pale green cloak over a gray-pink dress and holding a scroll inscribed with pseudo-Hebrew script; Saint Joseph, who raises his right hand in deference to Anna's words; a turbaned man; and a woman. Beyond the pink wall that closes off the foreground space is a grove of trees above which is the sky.

The painting entered the Northwick collection as a work by Giotto. It was subsequently attributed to Lorenzo Monaco both in the *Arundel Club* (1913) and by Tancred Borenius (1921), and it was exhibited under this name in 1930 and 1960. On the occasion of the 1960 exhibition Roberto Longhi (1960) proposed an alternative attribution to the young Paolo Schiavo. It has now been demonstrated by Federico Zeri (1973) that the picture is from the predella of an altarpiece of which five other elements are known. These include two pinnacles showing the Annunciation (Gemäldegalerie, Berlin-Dahlem, inv. 1111, each 33 × 23 cm.) and three figures of standing saints from the pilasters: a Saint Jerome in the Louvre, Paris (inv. 839; 35 × 15 cm.), a figure of a Blessed (Beato Lucchese?) in the Museo Nazionale, Pisa (40 × 22 cm.), and Saint Raynerius (formerly Gentner collection, Florence, 37 × 11 cm.). The panels in the Louvre and at Pisa still have their original frames, and there can be no serious doubt that all six panels are from the same altarpiece. Zeri's grouping has been accepted by Arnauld Brejon de Lavergnée and Dominique Thiébault (1981). As noted by Zeri, the presence of Saint Raynerius, patron of Pisa, suggests that the altarpiece was painted for that city.

Zeri has characterized the author of these panels as "close but superior in quality to Alvaro Pirez . . . ; influenced by Lorenzo Monaco and, to a degree, by Paolo Schiavo . . . ; singularly similar to the Master of the Bambino Vispo."[1] Indeed, the Berlin *Annunciation* has at one time or another been attributed to each of these artists,[2] while the saints have received attributions of an astonishing inconsistency.[3] As Zeri has noted, the connection with Alvaro Pirez is extremely close, and a direct attribution to him has been sustained by M. Boskovits (1983). An artist of Portuguese origin, Pirez is documented in Pisa in 1411 and in Volterra in 1423, and was presumably active in Tuscany until 1434, the date of his portable triptych in Brunswick.[4] Pirez's work is uneven in quality. In the main panels of his altarpieces he was often a careless draftsman

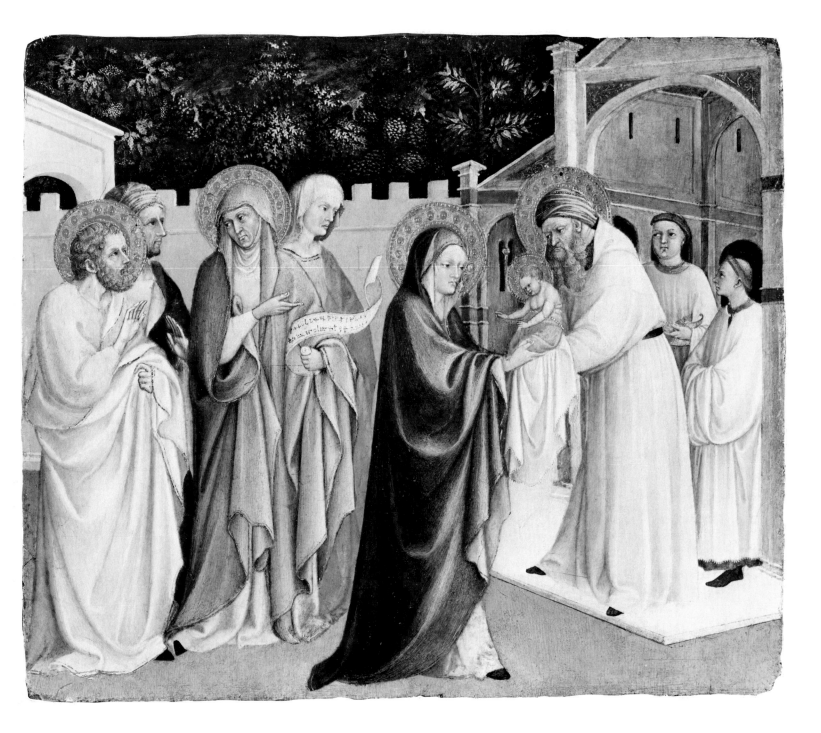

25

and uninventive, but he was also capable of producing small-scale work of great refinement, the Brunswick triptych being a prime example. Although the Linsky panel and those pieces related to it show a greater attention to descriptive detail and volume than normally encountered in the work of Pirez, an attribution to him cannot be excluded. The most probable date for the *Presentation* would be about 1430, when the use of a naturalistically rendered sky in a predella panel was still something of a novelty.

NOTES:

1. Zeri (1973), p. 370.

2. It is catalogued as school of Lorenzo Monaco in Staatliche Museen Berlin, *Die Gemäldegalerie, Die italienischen Meister, 13. bis 15. Jahrhundert*, Berlin, 1930, p. 82; as Paolo Schiavo when close to Alvaro Pirez by R. Longhi, "Fatti di Masolino e di Masaccio," *Critica d'Arte* V (1940), p. 188 n. 25 (reprinted in R. Longhi, *Opere complete*, Florence, VIII, 1 [1975], p. 59 n. 25); as the Master of the Bambino Vispo by B. Berenson, *Italian Pictures of the Renaissance: Florentine School*, London, 1963, I, p. 139; and as Alvaro Pirez by F. Zeri, unpublished opinion, 1965, at the Frick Art Reference Library, New York.

3. W. Suida made an attribution of the Louvre panel to Ambrogio Lorenzetti, recorded by L. Hautecoeur, *École italienne et école espagnole*, vol. II of Musée du Louvre, *Catalogue des peintures exposées dans les galeries*, Paris, 1926, p. 150, no. 1624; B. Degenhart, "Di una pubblicazione su Pisanello e di altri fatti," *Arte Veneta* VIII (1954), pp. 116–17, attributed the Pisa saint to Pisanello (on this see also K. Christiansen, *Gentile da Fabriano*, London, 1982, p. 91); and B. Berenson, *Italian Pictures of the Renaissance: Central Italian and North Italian Schools*, London, 1968, I, p. 109, attributed the Louvre and Pisa saints to Domenico di Bartolo.

4. See K. Steinweg, "Opere sconosciute di Alvaro di Pietro," *Rivista d'Arte* XXXII (1957), pp. 39–55.

EX COLL.: John Rushout, 2nd Lord Northwick, Thirlestane House, Cheltenham (until 1859; Cat. 1859, no. 841, as Giotto); George Rushout, 3rd Lord Northwick (1859–87; Cat. 1864, no. 90, as Giotto); Elizabeth Augusta, Lady Northwick (1887–1912); Captain Edward George Spencer-Churchill, Northwick Park (1912–64; Cat. 1921, no. 48, as Lorenzo Monaco; sale, Christie's, London, May 28, 1965, no. 11); Mr. and Mrs. Jack Linsky, New York (1965–80); Mrs. Belle Linsky, New York (1980–82).

EXHIBITED: Worcester, 1882, no. 81 (as Giotto, lent by Lord Northwick); Royal Academy, London, *Italian Art 1200–1900*, 1930, no. 65 (as Lorenzo Monaco, lent by Captain E. G. Spencer-Churchill); Royal Academy, London, *Italian Art and Britain*, 1960, no. 272 (as Lorenzo Monaco, lent by Captain E. G. Spencer-Churchill).

BIBLIOGRAPHY: *Arundel Club* (1913), no. 1, ill. // T. Borenius, comp., *A Catalogue of the Collection of Pictures at Northwick Park*, London, 1921, no. 48 // R. Longhi, "Appunti: Uno squardo alle fotografie della Mostra: 'Italian Art and Britain,'" *Paragone Arte* XI (no. 125, 1960), p. 60, fig. 42 // P. Lindsay, in *Great Private Collections*, ed. D. Cooper, New York, 1963, pp. 42, 44, ill. p. 49 // F. Zeri, "Qualche appunto su Alvaro Pirez," *Mitteilungen des Kunsthistorischen Institutes in Florenz* XVII (1973), pp. 361–70, fig. 6 // A. Brejon de Lavergnée and D. Thiébault, *Catalogue sommaire illustré des peintures du Musée du Louvre*, vol. II: *Italie, Espagne, Allemagne, Grand-Bretagne et divers*, Paris, 1981, p. 255 // M. Boskovits, letter, Mar. 19, 1983.

KC

GIOVANNI DI PAOLO
(Giovanni di Paolo di Grazia)

Active by 1420, Siena; died 1482, Siena

THE ARTIST is sometimes identified with a Giovanni di Paolo born in 1403, but in the event that he was already active by 1420, the identification is not certain. Giovanni di Paolo may have been trained by Taddeo di Bartolo, but the major influences on his work were Gentile da Fabriano, who painted in Siena in 1425 and 1426, and Sassetta. In addition to panel paintings and altarpieces, the earliest of which dates from 1426, he also painted frescoes and miniatures. He was one of the most prolific as well as individual artists of the fifteenth century.

4. The Adoration of the Magi

Tempera and gold on wood. 10⅝ × 9⅛ in.
(27 × 23.2 cm.)
1982.60.4

The picture is in exceptionally fine state. A thin horizontal crack runs through the panel below the Virgin's face, and there are a few scattered losses, all inconsequential. Traces of the original raised, lipped edge remain on all four sides, and there are remnants of a gilt molded border at the upper left.

THE VIRGIN is seated on a wooden box between the two thatched roofs of a stable. Behind her is a gray, wattled manger from which an ox and ass feed. In front of the Virgin kneels the eldest, gray-bearded magus, whose gold crown lies at her feet and who kisses the foot of the Christ Child seated on her lap. The head of the magus is aligned with the central vertical axis of the picture, and to the

right of this axis are shown the aged Saint Joseph, who supports himself with a rough-hewn staff; the youngest magus, who places his right arm around Joseph's shoulder while with his left he clasps the saint's hand; the middle-aged magus, who, kneeling, holds his gold gift in his left hand while he removes his gold crown with his right; a groom; and three horses. Each of the magi wears brocaded garments, the patterns of which have been created by scratching through the surface pigment to reveal a layer of gold. In the middle ground, composed of a pale green and buff hillock framed by a hedge of bushes and three rocky peaks, is shown a shepherd and six sheep, while in the distance are bluish geometric fields that recede to an area in the upper right, and three small rocky mountains. The remnants of a gold star are visible above the head of the Virgin. Incised lines have been employed to fix the features of the stable and the distant fields; originally they established the three mountains and the horizon higher than they now appear.

The picture, universally ascribed to Giovanni di Paolo since it was first exhibited in 1930, was recognized as part of a predella to an altarpiece and related to *The Infant Christ Disputing in the Temple* in the Isabella Stewart Gardner Museum, Boston, by Philip Hendy (1931), and to a *Nativity* formerly in the Winthrop collection, New York, and now in the Fogg Art Museum, Cambridge, by John Pope-Hennessy (1937). All three panels are extremely close in size and style and employ the same figure types and haloes. The settings in both the Fogg picture and the present one are, moreover, in all essentials the same.[1] Pope-Hennessy has further proposed that a *Baptism of Christ* in the Ashmolean Museum, Oxford, may have formed the center of the predella, with the three scenes from the Infancy of Christ on the left and three scenes conjecturally devoted to Christ's divine mission on the right. To this Cesare Brandi (1941; 1947) has objected that the Ashmolean *Baptism* is earlier in date and belongs to a different series, but his proposal has been shown to be incorrect.[2] The relation of the *Baptism* to the other three pictures is very close, and though its association with the predella cannot be demonstrated, the hypothesis has been tentatively accepted by Rollin Hadley (1967) and Bernard Berenson (1968). The fragmentary molding along the upper left edge of the *Adoration of the Magi* suggests that originally the scenes were separated by decorated gilt strips similar to those in the series of the *Life of Saint John the Baptist* in the National Gallery, London. Pope-Hennessy dates the present panels about 1460, Brandi about 1460 or after 1463. The series is likely to precede Giovanni di

Paolo's altarpiece in the cathedral of Pienza, which is dated 1463.

Giovanni di Paolo treated the subject of the Adoration of the Magi on at least three other occasions. The earliest surviving depiction is the predella panel in the Rijksmuseum Kröller-Müller, Otterlo, which follows the Sienese convention of showing the Journey of the Magi in the upper half of the composition and the Adoration of the Magi in the lower half. Shortly after this picture was painted, probably in the mid-1430s, Giovanni made a trip to Florence, and his subsequent depictions of the Adoration all depend to a greater or lesser degree from Gentile da Fabriano's altarpiece in the Uffizi, Florence, of 1423. In a panel in the Cleveland Museum of Art, which is part of a predella dating from about 1440, the principal features in the foreground of Gentile's altarpiece are repeated, while in a panel in the National Gallery of Art, Washington, D.C., of about 1450–55, the composition has been reversed and the relation to Gentile is less close. In both the Cleveland and the Washington pictures Gentile's narrative background has been suppressed in favor of landscapes of markedly individual character. In the Cleveland picture are shown travelers on a road and a man and dog hunting in a field, with rounded hills defining the horizon. In the Washington picture there appears a flat landscape of scored geometric fields punctuated by little hills and fortified towns. It is this type of landscape that is introduced into the present picture, which, however, far from showing the simple combination of elements from these pictures posited by Henry Sayles Francis (1942), marks a departure from the theme.

The poses of the Virgin and Child and of the first and second magi still derive from Gentile's altarpiece, but the youngest magus now embraces Saint Joseph, endowing the scene with a new intimacy. The only precedent for this action is in the work of Fra Angelico, where, however, it is invariably the eldest magus who greets Joseph, by clasping his two hands. There is no evidence of Fra Angelico's influence on Giovanni's scene, but it is probable that both artists used a common literary source. The setting of the present picture departs from all earlier treatments of the subject in Siena by discarding the traditional cave and masonry structure in favor of a simple thatched-roof stable more common to depictions of the Nativity. There can be no doubt that this has been done to give greater narrative unity to the predella to which this scene belonged, since the stable and indeed the landscape background have been adapted with only minimal changes from the companion Fogg *Nativity*. The most novel ele-

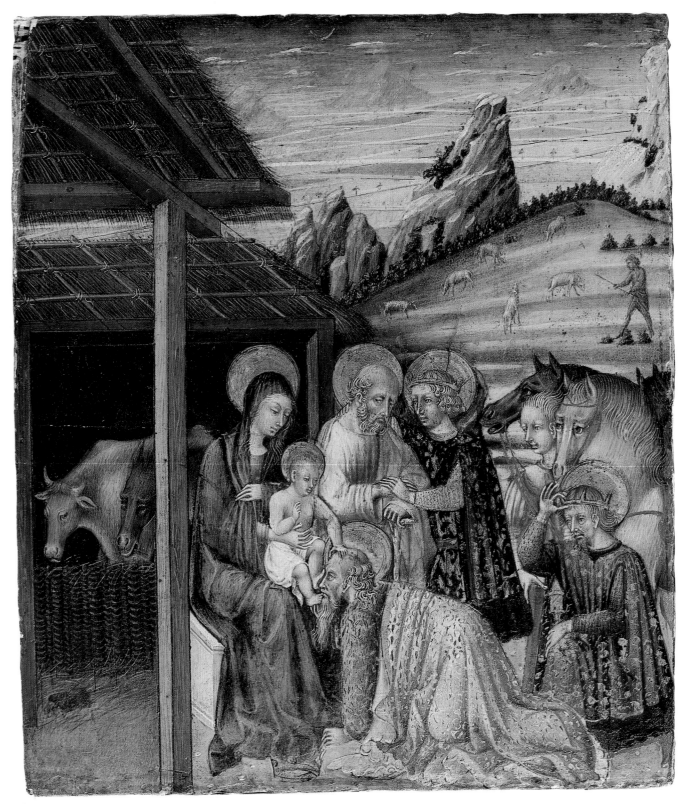

28

ments of the Fogg *Nativity*—the thatched roof viewed from below; the wattle manger; and the motif of the naked, blessing Christ Child seated on a part of the Virgin's cloak that has been swept in front of her—depend from Paolo Uccello's fresco of the Nativity from San Martino alla Scala in Florence and now in the Uffizi, and it is from this same source that the geometric landscapes in the background of the *Nativity* and the *Adoration of the Magi* also derive. In the Fogg picture an Annunciation to the Shepherds appears on the hillock in the middle ground. In the present picture, which shows a subsequent event, a shepherd has returned to his flock. This detail again underscores the remarkable unity and inventiveness of the series.

NOTES:
1. Hendy (1974) has subsequently, without basis, doubted the association of the Gardner picture with the other two.
2. See J. B. Shaw, *Paintings by Old Masters at Christ Church Oxford*, London, 1967, p. 46; and Lloyd (1977).

EX COLL.: Stefan von Auspitz, Vienna (until 1932); [Kurt Walter Bachstitz, The Hague, 1932]; Oscar Bondy, Vienna (about 1932–1949; sale, Kende Galleries, New York, Mar. 3, 1949, no. 84, as Giovanni di Paolo); Mr. and Mrs. Jack Linsky, New York (1949–80); Mrs. Belle Linsky, New York (1980–82).

EXHIBITED: Royal Academy, London, *Italian Art 1200–1900*, 1930, no. 78 (as Giovanni di Paolo, lent by Stefan Auspitz); Wildenstein, New York, *The Italian Heritage*, 1967, no. 4 (as Giovanni di Paolo, lent by Mr. and Mrs. Jack Linsky); Metropolitan Museum of Art, New York, *Giovanni di Paolo: Paintings*, 1973, no. 13.

BIBLIOGRAPHY: P. Hendy, in Isabella Stewart Gardner Museum, *Catalogue of the Exhibited Paintings and Drawings*, Boston, 1931, p. 174 // A. L. Mayer, "Die Sammlung Auspitz-Wien," *Pantheon* X (1932), p. 400 // B. Berenson, *Italian Pictures of the Renaissance*, Oxford, 1932, p. 249 // J. Pope-Hennessy, *Giovanni di Paolo*, London, 1937, pp. 90–91, III nn. 79, 80, 82, 177 // C. Brandi, "Giovanni di Paolo," *Le Arti* XIX (1941), pp. 321 n. 58, 337 n. 82 // H. S. Francis, "A New Giovanni di Paolo," *Art Quarterly* V (1942), p. 322 // C. Brandi, *Giovanni di Paolo*, Rome, 1947, pp. 79 n. 58, 91 n. 82 // R. Hadley, "Giovanni di Paolo," *Fenway Court* I (Oct. 1967), pp. 49–56, ill. p. 51 // B. Berenson, *Italian Pictures of the Renaissance: Central Italian and North Italian Schools*, London, I, 1968, pp. 175–76, 179 // M. Reinders, in *Sienese Paintings in Holland* (exhib. cat.), Groningen, Groninger Museum voor Stad en Lande, 1969, no. II // P. Hendy, *European and American Paintings in the Isabella Stewart Gardner Museum*, Boston, 1974, p. 107 // C. Lloyd, *A Catalogue of the Earlier Italian Paintings in the Ashmolean Museum*, Oxford, 1977, p. 85.

KC

CARLO CRIVELLI

Active by 1457, Venice; died 1495, Ascoli Piceno

CARLO CRIVELLI is first mentioned as a painter in Venice in 1457, when he was imprisoned for having committed adultery. By 1465 he is recorded as a citizen of Zara in Dalmatia, but three years later he returned to Italy, living first in Fermo and then at Ascoli Piceno. His activity after 1468 was confined to the Marches, and this inevitably affected the kinds of commissions he received—primarily for elaborate Gothic polyptychs with a gold ground. There are dated works from 1468 to 1493. Although Crivelli probably received his first training from his father, the critical factor in his development was contact with Paduan painting. He may have worked with Francesco Squarcione in Padua, and certainly he was familiar with works by Squarcione's pupil Giorgio Schiavone, probably both in Padua and in Dalmatia, where Schiavone returned by 1462. From his contact with Paduan painting Crivelli derived his peculiar form of hyperrealism, which, in the provincial environment of the Marches, he was able to develop so richly—apparently with few restraints.

5. Madonna and Child

Tempera on wood, gold ground. Overall, with added strips, 40⅜ × 17⅝ in. (102.6 × 44.8 cm.); painted surface 38¾ × 17¼ in. (98.4 × 43.8 cm.)
Signed and dated (bottom left): + CAROLVS + CRIVELLVS + VENETVS + / 1472 PINSIT +
1982.60.5

The panel has been thinned and cradled. Only along the bottom is the original edge preserved. The picture surface has been cropped at the top, where there is a triangular addition. The picture was cleaned and restored in 1983. The state is not good; the surface is abraded throughout, affecting particularly the darks. What was perhaps originally a red madder glaze on the dress of the Virgin is now reduced to preparation and underdrawing, and the green lining of her cloak has lost most of its modeling. The right side of the Virgin's face and the right side of her veil are almost completely lost. The gold brocade on her left arm, the right side of her halo, and the right side of the gold background—excepting an area in the lower right—are modern. By contrast, the Christ Child is relatively well preserved, except for the left hand and a damage in the forehead and left eye. The dais and left side

of the throne are also well preserved. It is worth recording that these damages occurred prior to 1845: the modern tooling of the background matches exactly that found in the filled-out spandrels of the companion panels (see below), which were separated from the Linsky panel at the sale of the Fesch collection. It is probable that the worst damage occurred while the altarpiece was still intact and in situ, possibly as a result of water leakage. The damages are, moreover, apparent in the illustration in the Benson catalogue.

THE VIRGIN, her head turned three-quarters to the left, is seated on a polychrome marble throne with an arched top before which hangs a cloth of honor. A white veil covers her forehead, and an elaborately patterned gold brocade cloak with a green lining falls over both her shoulders and sweeps across her lap. With her hands she delicately steadies the infant Christ, who is turned toward the right, his legs straddling her lap and his arms outstretched. In front of the throne is a broken marble dais, the front edge of which marks the picture plane. On this, to the right, are two small pears and a fly. The pears may be symbols of the Virgin and Christ or of the Fall of Man.[1] The fly has been explained by André Pigler (1964) as a device to protect the picture from flyspecks rather than as a symbol of evil or sin. The gold background is elaborately tooled.

There is a curious pentiment in the date, which Crivelli originally inscribed as 1473 and then changed to 1472. The explanation for this back-dating may have to do with a confusion on Crivelli's part as to which regional calendar pertained. The Venetian calendar officially began March 1, while the papal states observed the *stile fiorentino*, which began the new year with the Annunciation on March 25. Other coastal towns, such as Rimini, observed December 25 as the beginning of the new year. It therefore seems likely that Crivelli completed the altarpiece after December 25, 1472 (modern style); possibly after March 1, 1473; and in any event before March 25, 1473.

The composition, one of Crivelli's most inventive, has received much comment. Pietro Zampetti (1961) has suggested that some of its innovations may be due to Crivelli's knowledge of paintings by Girolamo di Giovanni. However, it would be difficult to find a parallel to the Child's dynamic movement, so perfectly held in check by the turn of the Virgin's head in the opposite direction and by the rumpled mass of drapery that cascades over the left-hand portion of the marble dais, in any of Girolamo di Giovanni's works. These motifs, like the promi-

nently cracked marble at the right, are Paduan in origin and reflect Crivelli's training in Padua. The action of the Child, usually interpreted as a visual link to the lateral figure of a saint, was probably directed at a flying bird, the symbol of Christ's Passion. The composition is intimately tied to that of the central panel of the Montefiore Altarpiece in the Musées Royaux des Beaux-Arts, Brussels. The Brussels picture is not dated, but its conception would seem logically to precede that of the Linsky picture.[2] It also provides the best visual evidence for mentally reconstructing the arched top of the Linsky panel.

The picture was correctly recognized by Bernard Berenson (1895) as the center panel of a polyptych, but only in 1933 were three of the lateral panels, a Saint Dominic and a Saint George in the Metropolitan Museum (05.41.1,2; 97.2 × 32.4 cm. and 96.5 × 33.7 cm., respectively) and a Saint James formerly in the Babbott collection, Brooklyn, New York, and now in the Brooklyn Museum (97.3 × 32 cm.), identified by Lionello Venturi (1933) on the basis of style, tooling, and dimensions. Harry B. Wehle (1940) further noted that the three panels of saints were in the collections of Cardinal Fesch and the Reverend Davenport Bromley, along with a fourth panel showing Saint Nicholas; this panel was subsequently identified by Henry Sayles Francis (1952) with a picture in the Cleveland Museum of Art (52.111; 97.3 × 33 cm.). There can be no doubt that the five panels belong to the same altarpiece. Beyond their agreement in style and dimensions, all five are listed in the Fesch catalogue, and the modern tooling on the background of the Madonna and Child matches exactly that on the filled-out spandrels of the companion pictures.

P. Zampetti (1961) has further suggested that a *Pietà* in the John G. Johnson Collection, Philadelphia, formed the central element of a second tier of panels, while five small panels that show, respectively, Christ Blessing (Philbrook Art Center, Tulsa), Saint Peter (Yale University Art Gallery, New Haven), Saints John the Evangelist and Bartholomew (Museo del Castello Sforzesco, Milan), and Saint Andrew (Proehl collection, Amsterdam) belonged to a predella. Federico Zeri (1961), who first grouped the predella panels together, correctly noted that they were contemporary with the ex-Fesch polyptych. Although Zampetti's reconstruction has been accepted by a number of critics,[3] Zampetti himself (1971) seems later to have rejected the association of the Johnson *Pietà* and, inexplicably, to have regrouped the predella panels.

Neither the *Pietà* nor the set of predella panels is likely

to have belonged to the altarpiece. The five ex-Fesch panels have a combined width of 174.9 centimeters, while the probable number of predella panels of the size of those under consideration (the predella would logically have included Christ, the apostles minus Saint James, who appears above, and possibly another figure) would measure over 300 centimeters. The Johnson panel must originally have had a plain gold ground—the tooled hanging behind Christ is a later addition—whereas the gold ground of the five main panels is elaborately tooled; such disparity of treatment is not encountered in other altarpieces by Crivelli. No appropriate subsidiary panels are cited in the Fesch catalogue. The most convincing arrangement of the extant panels is that of Berenson (1957), who places Saints Nicholas and Dominic at the two extremities, and Saints James and George flanking the Virgin.

On the basis of the presence of Saint Dominic, Anna Bovero (1961) has suggested that the altarpiece may be identical with one in San Domenico, Fermo, described by Amico Ricci as a "Madonna in mezzo a due Santi . . . di recente venduta."[4] Ricci's description does not correspond to the present altarpiece. He was, moreover, familiar with the Fesch collection[5] and would surely have known if the San Domenico altarpiece had been sold to Fesch.

NOTES:
1. See M. Levi d'Ancona, *The Garden of the Renaissance*, Florence, 1977, p. 296.
2. This was the opinion of Rushforth (1900); Venturi (1914); Testi (1915); Berenson (1916); Drey (1927); van Marle (1936, pp. 13–14); Zeri (1961); Bovero (1961). The contrary position, that the Brussels picture postdates the Linsky panel, is maintained by Zampetti (1952, pp. 26, 68; 1961), and Pallucchini (1961).
3. See Sweeny (1966); Shapley (1968); Seymour (1970); and Fernandez-Gimenez (1974).
4. A. Ricci, *Memorie storiche della arti e degli artisti della Marca di Ancona* . . . , Macerata, 1834, I, p. 214.
5. Ibid., p. 213.

EX COLL.: Cardinal Fesch, Palazzo Falconieri, Rome (until 1839; his estate 1839–45; Cat. 1841, no. 2303; sale, Rome, Mar. 24ff., 1845, no. 1777; to Baseggio); G. H. Morland, London (until 1863; sale, Christie's, London, May 9, 1863, no. 76, to Parker); William Graham, London (by 1875–1885; his estate 1885–86; unpublished cat. 1882, no. 363; sale, Christie's, London, Apr. 2–3, 1886, no. 331); [Colnaghi, London]; Robert and Evelyn Benson, London (1887–1927; Cat. 1914, no. 70, ill.); [Duveen Brothers, New York, 1927–28]; Mr. and Mrs. A. W. Erickson, New York (1928–61; sale, Parke-Bernet, New York, Nov. 15, 1961, no. 9); Mr. and Mrs. Jack Linsky, New York (1961–80); Mrs. Belle Linsky, New York (1980–82).

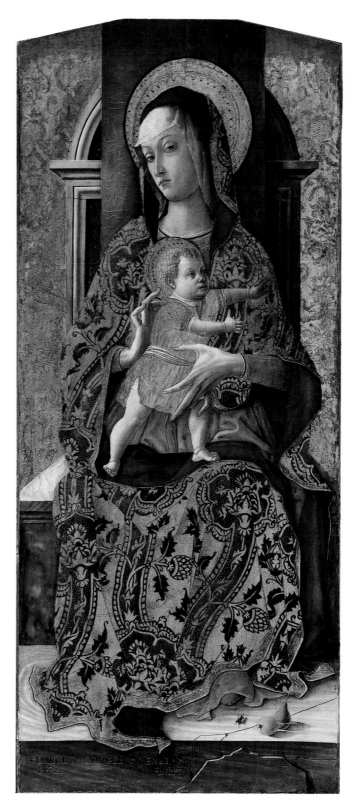

EXHIBITED: Royal Academy, London, *Old Masters*, 1875, no. 182 (lent by W. Graham); Royal Academy, London, *Old Masters*, 1887, no. 180 (lent by R. H. Benson); The New Gallery, London, *Exhibition of Venetian Art*, 1894–95, no. 32 (lent by Mrs. R. H. Benson); Grafton Galleries, London, *National Loan Exhibition*, 1909–10, no. 71 (lent by R. H. Benson); Burlington Fine Arts Club, London, *The Early Venetian School*, 1912, no. 4 (lent by R. H. Benson); Wildenstein, New York, *The Italian Heritage*, 1967, no. 6a (lent by Mr. and Mrs. Jack Linsky).

BIBLIOGRAPHY: J. A. Crowe and G. B. Cavalcaselle, *A History of Painting in North Italy*, London, 1871, I, p. 86 n. 1 // B. Berenson, *Venetian Painting, Chiefly before Titian* (exhib. cat.), London, New Gallery, 1895 (reprinted in *The Study and Criticism of Italian Art*, London, 1901, pp. 102–3) // *The Venetian Painters of the Renaissance*, London, 1895, p. 99 // G. Gronau, "L'Art vénetien à Londres," *Gazette des Beaux-Arts* ser. 3, XIII (1895), p. 165 // G. McN. Rushforth, *Carlo Crivelli*, London, 1900, pp. 46, 93–94, 119, ill. frontispiece // L. Cust, "La Collection de M. R–H Benson," *Les Arts* no. 70 (1907), p. 3, ill. // L. Venturi, *Le origini della pittura veneziana*, Venice, 1907, pp. 195–97 // R. Fry, "La mostra di antichi dipinti alle 'Grafton Galleries' di Londra," *Rassegna d'Arte* X (1910), p. 36 // T. Borenius, "La mostra di dipinti veneziani primitivi," *Rassegna d'Arte* XII (1912), p. 88, ill. p. 89; T. Borenius, ed., J. A. Crowe and G. B. Cavalcaselle, *A History of Painting in North Italy*, 2nd ed., New York, 1912, I, p. 85 note // A. Venturi, *La pittura del Quattrocento*, Milan, VII, 3 (1914), pp. 362, 364, fig. 279 // B. Berenson, "Nicola di Maestro Antonio di Ancona," *Rassegna d'Arte* XV (1915), p. 168 // L. Testi, *La storia della pittura veneziana*, Bergamo, II (1915), pp. 557, 611–12, 616–17, 673, ill. p. 617 // "Duveen Buys the Famous Benson Collection," *Art News* XXV (no. 38, 1927), pp. 5, 8 // B. Berenson, *Venetian Painting in America*, New York, 1916, p. 20 // F. Drey, *Carlo Crivelli und seine Schule*, Munich, 1927, pp. 54–55, 57, 63, 127, 150, fig. XXI // B. Berenson, *Italian Pictures of the Renaissance*, Oxford, 1932, p. 162 // L. Venturi, *Italian Paintings in America*, trans. M. Heuvel and C. Marriott, New York, 1933, II, pls. 364–66 // L. Serra, *L'Arte nelle Marche*, Rome, II (1934), p. 389 // R. van Marle, *The Development of the Italian Schools of Painting*, The Hague, XVIII (1936), pp. 7–10, fig. 4 // B. Berenson, *Pitture italiane del rinascimento*, Milan, 1936, p. 140 // H. Wehle, Metropolitan Museum of Art, *A Catalogue of Italian, Spanish and Byzantine Paintings*, New York, 1940, I, p. 178 // H. S. Francis, "'St. Nicholas' by Carlo Crivelli," *Bulletin of the Cleveland Museum of Art* XXXIX (1952), pp. 187–89 // P. Zampetti, *Carlo Crivelli nelle Marche*, Urbino, 1952, pp. 22, 69 no. 82 // F. Zeri, "Il Maestro della Annunciazione Gardner," *Bollettino d'Arte* XXXVIII (1953), p. 241 // B. Berenson, *Italian Pictures of the Renaissance: Venetian School*, London, 1957, I, pp. 69–70, fig. 137 // A. Bovero, *Tutta la pittura del Crivelli*, Milan, 1961, pp. 23–24, 51, 59–60, fig. 27 // F. Zeri, "Cinque schede per Carlo Crivelli," *Arte Antica e Moderna* (no. 13/16, 1961), p. 162 // R. Pallucchini, "Carlo Crivelli in Palazzo Ducale," *Pantheon* XIX (1961), p. 274 // P. Zampetti, *Carlo Crivelli*, Milan, 1961, pp. 16, 24, 75–77, 103, figs. 24–25 // A. Pigler, "La Mouche peinte: Un talisman," *Bulletin du Musée Hongrois des Beaux-Arts* (no. 24, 1964), pp.

47–64, fig. 37 // B. Sweeny, *Catalogue of Italian Paintings*, John G. Johnson Collection, Philadelphia, 1966, p. 25 // F. R. Shapley, *Paintings from the Samuel H. Kress Collection, Italian Schools XV–XVI Century*, London, 1968, pp. 35–36 // G. Reitlinger, *The Economics of Taste*, London, 1970, III, p. 85 // C. Seymour, *Early Italian Paintings in the Yale University Art Gallery*, New Haven, 1970, p. 240 // P. Zampetti, *La pittura marchigiana da Gentile a Raffaelo*, [Milan], [1971], pp. 180–82 // F. Zeri and E. E. Gardner, *Venetian School*, vol. II of *Italian Paintings: A Catalogue of the Collection of the Metropolitan Museum of Art*, [New York], 1973, pp. 21–22. // E. de Fernandez-Gimenez, in Cleveland Museum of Art, *European Paintings Before 1500*, Cleveland, 1974, pp. 68–69, fig. 26a // A. Bovero, *L'Opera completa del Crivelli*, Milan, 1975, pp. 83, 87–89, 95, fig. 48 // E. Fahy, "Babbott's Choices," *Apollo*, n.s. CXV (1982), p. 240.

KC

VITTORE CRIVELLI

Active by 1465, Zara (Dalmatia); died 1501/1502, Fermo

VITTORE CRIVELLI was the (younger?) brother of Carlo, with whom his career is closely bound. By 1465 he had, like Carlo, moved from his native Venice to Zara in Dalmatia. He remained there after Carlo's return to Italy three years later and is first documented in the Marches in 1481, when he took up lifelong residence in Fermo. The earliest securely dated work is from 1489 (but see below). Antonio Vivarini was of some importance to Vittore's formation as an artist, but after Vittore's transfer to the Marches he fell completely under the spell of his more brilliant brother.

6. Madonna and Child with Two Angels

Tempera and gold on wood. Overall, with added strips, 22½ × 16⅝ in. (57.2 × 42.4 cm.); painted surface 21⅞ × 16 in. (55.6 × 40.6 cm.)
Signed (on ledge): OPVS VICTORIS · CRIVELLV · VENETI
1982.60.6

The panel has been thinned and cradled. The picture surface may be slightly cropped along the vertical edges. It has suffered from overrigorous cleaning in the past, which has affected especially the flesh areas. However, much of the original glazing on the gold is still intact, as is the fine gilt decoration on the bodice of the Virgin's dress. The lower left corner, including the carnation, has suffered local damage.

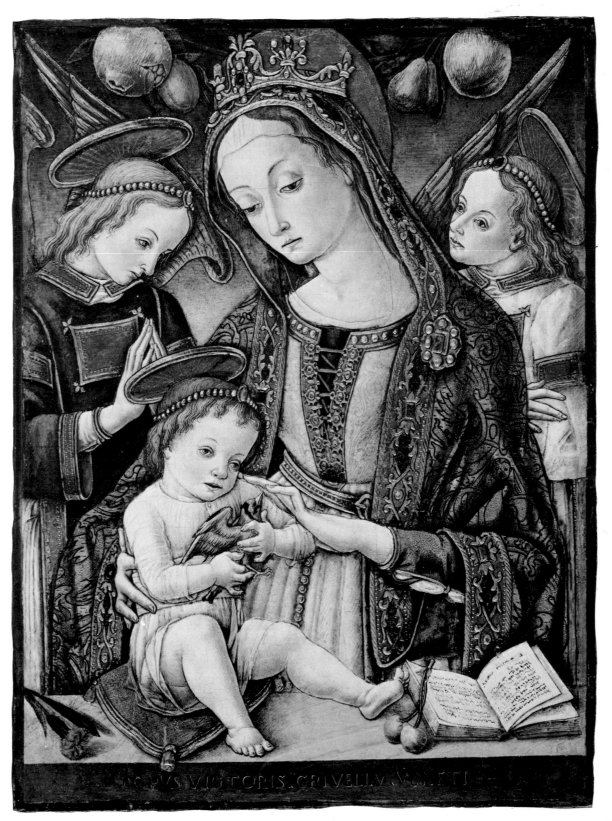

THE VIRGIN, who wears a pink dress over a green blouse and an elaborate gold brocaded mantle over a transparent white veil, is viewed half-length behind a marble parapet. The crown on her head, the brooch on her left shoulder decorated with pearls and gold beads around a ruby, the gallooning of the veil, the belt, and the buttons and trimming of her dress are of gilt modeled plaster (*pastiglia*). With her right hand she supports the Christ Child, who is seated on a gilt pillow, his attention directed toward the viewer while he holds a goldfinch, explained by Herbert Friedmann (1946) as a symbol of Christ's Passion. He wears a transparent tunic, and on his head is a pearl diadem in raised relief. Behind the Madonna and Child stand two angels dressed in dalmatics, blue on the left and white on the right, the decorative portions of which are, again, in gilt relief. They, too, have pearl diadems on their heads and, like the Christ Child, wear haloes with raised borders. The angel at the left clasps his hands in prayer, while the angel at the right has folded arms. At the top of the picture is shown a swag composed of a pomegranate, symbol of the Church and of the Resurrection; a plum, possibly an allusion to fidelity or to Christ's Passion; and two pears and an apple, which probably symbolize Original Sin. On the parapet are a carnation, whose Greek name means "the flower of God"; two cherries, symbolic of Christ's blood; and what is probably an open breviary.[1]

The picture is one of Vittore's finest works and the only one of this format by either Vittore or Carlo Crivelli in which large figures of adoring angels fill the area at the sides. Both Federico Zeri (1961) and Sandra di Provvido (1972) have noted the very close relation the picture bears to Vittore's altarpiece for the Church of San Francesco at Fermo, the main panels of which are in the Philadelphia Museum of Art, and it is from the central panel of this, Vittore's most ambitious work, that the motif of the two angels surely derives. There is evidence that the San Francesco altarpiece was painted in 1481, but in any event it was painted prior to 1485.[2] Luigi Dania (1968) has argued that the present picture postdates this work. The two are more likely contemporary.

The Linsky *Madonna and Child* has been confused with a painting formerly in the collection of Michelangelo Gualandi in Bologna that was described by Crowe and Cavalcaselle in 1871.[3] Borenius later stated that the Gualandi picture appeared in the sale of the collection of F. Mylius of Genoa on November 5, 1879, but no picture answering to the description appears in the sale cata-

logue.[4] According to Crowe and Cavalcaselle the Gualandi picture showed, behind the Virgin and Child, a red cloth of honor with a landscape to either side, and there can be no reasonable doubt that that picture is the one now in the Szépmüvészeti Múzeum in Budapest.

NOTES:

1. On the symbolism of the fruits and flower see M. Levi d'Ancona, *The Garden of the Renaissance*, Florence, 1977, pp. 46–50, 79–81, 89–90, 311–17.

2. See di Provvido (1972), pp. 60–68; and S. Legoux, "Vittore Crivelli's Altar-piece from the Vinci Collection," *Burlington Magazine* CXVII (1975), pp. 98–102.

3. J. A. Crowe and G. B. Cavalcaselle, *A History of Painting in North Italy*, London, 1871, I, p. 97 n. 2.

4. Borenius (1912), p. 7 n. 2; Geiger (1913); and Testi (1915).

EX COLL.: Private collection, Rome (before 1902); Robert H. and Evelyn Benson, London (by 1902–1927; Cat. 1914, no. 72, ill.); [Duveen Brothers, New York, 1927–29]; [Kleinberger Galleries, New York, 1929–33]; [Duveen Brothers, New York, 1933–about 1962]; Mr. and Mrs. Jack Linsky, New York (about 1962–1980); The Jack and Belle Linsky Foundation, New York (1980–82).

EXHIBITED: Burlington Fine Arts Club, London, 1902–3, no. 22 (lent by R. H. Benson); Royal Academy, London, *Old Masters*, 1908, no. 22 (lent by R. H. Benson); Burlington Fine Arts Club, London, *Early Venetian Pictures*, 1912, no. 6 (lent by R. H. Benson); Palazzo Strozzi, Florence, *2a Biennale*, 1961 (lent by Duveen Brothers).

BIBLIOGRAPHY: L. Cust, "La Collection de M. R. H. Benson," *Les Arts*, no. 70 (1907), p. 3, ill. p. 2 // T. Borenius, ed., *A History of Painting in North Italy*, by J. A. Crowe and G. B. Cavalcaselle, 2nd ed., New York, 1912, I, p. 98 n. 4 // B. Geiger, in *Allgemeines Lexikon* . . . , ed. U. Thieme and F. Becker, Leipzig, VIII (1913), p. 137 // A. Venturi, *Storia dell'arte italiana*, Milan, VII, 3, 1914, p. 396, fig. 307 // L. Testi, *La storia della pittura veneziana*, Bergamo, II (1915), p. 698 // L. Serra, *L'Arte nelle Marche*, Rome, II (1934), p. 392 // R. van Marle, *The Development of the Italian Schools of Painting*, The Hague, XVIII (1936), pp. 73–74, fig. 47 // R. L. Douglas, unpublished ms., 1942; "A Madonna by Vittorio Crivelli," *Art in America* XXXI (1943), p. 31, ill. // H. Friedmann, *The Symbolic Goldfinch*, New York, 1946, pp. XXV, 157, fig. 97 // B. Berenson, *Italian Pictures of the Renaissance: Venetian School*, London, 1957, I, p. 71, fig. 163 // F. Zeri, "Appunti nell'Ermitage e nel museo Pusckin," *Bollettino d'Arte* XLVI (1961), p. 235 // L. Dania, *La pittura a Fermo e nel suo circondario*, Fermo, 1968, p. 16 // S. di Provvido, *La pittura di Vittore Crivelli*, Aquila, 1972, pp. 79–80, 82–83, 150, 283, fig. 13.

KC

ITALIAN (MILANESE) PAINTER, UNKNOWN

Active early 16th century, Milan

7. Madonna and Child

Oil on wood. Overall, with additions, 15⅞ × 12 in. (40.3 × 30.5 cm.); painted surface 15⅝ × 11⅝ in. (39.7 × 29.5 cm.)

1982.60.7

The panel, which has a slight concave warp, is backed with Masonite. It has probably been thinned and cut down. There are a number of minor losses, and the drawing has been reinforced in places. However, the most serious factor is the general lack of crispness and the loss of such details as the veil over the Virgin's right hand, which is attributable to a combination of abrasion and solvent action.

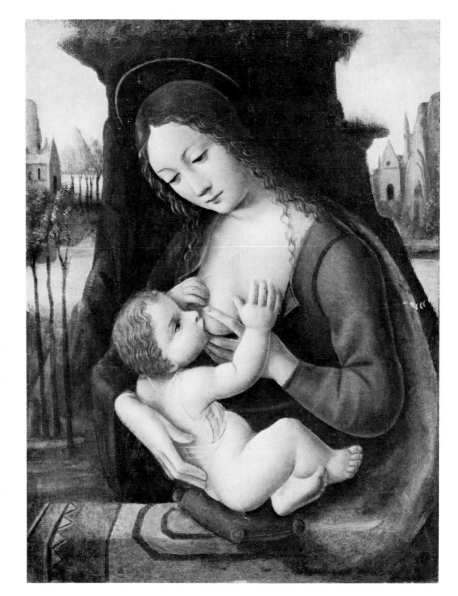

THE VIRGIN, turned three-quarters to the left, stands behind a parapet covered with a patterned carpet. With her right hand she supports the Christ Child, who wears a transparent tunic with a striped, transparent sash, and with her left she offers him her breast. The softly lighted figures are viewed against the mass of a dark cliff, to either side of which there is a distant landscape of mountains and water with church buildings.

Features of this composition, which conforms to the Madonna del Latte type, recur in other Leonardesque paintings, but given the manner in which Leonardo's followers isolated and recombined motifs from the master's pictures, it is doubtful that there was ever a prototype by Leonardo himself. It is, however, worth noting that in 1543 Michiel described a *Madonna del latte* by Leonardo in the collection of Michiel Contarini in Venice,[1] and that the so-called *Madonna Litta* in the Hermitage, Leningrad, which shares some features with the present picture, was at the very least designed by Leonardo.

William Suida (1949) ascribes the present painting to a Milanese artist of the early sixteenth century and goes on to group with it two other pictures, neither of which can now be identified with certainty.[2] He also notes similarities with a painting formerly in the New-York Historical Society[3] and another formerly in the H. Morison collection, Boston, and now in the Fogg Art Museum, Cambridge (1923.37). The attribution of the New-York Historical Society painting is problematic,[4] but there can

be no reasonable doubt that the Fogg picture and the Linsky painting are by the same artist. With these two works may be grouped a *Madonna and Child* formerly with Georges Brauer and now in the Rijksmuseum, Amsterdam (inv. A 3399), and another in the Pinacoteca Malaspina, Pavia (inv. 130). Of these the Pavia painting is of special interest in that the dark mass of a cliff is again used as a foil for the softly lighted Madonna and Child, and the landscape view to either side is closely analogous to those in the Linsky panel. In both cases the model was

35

obviously Leonardo's composition for *The Virgin of the Rocks.*

The Fogg, Rijksmuseum, and Malaspina pictures have all been ascribed to the Leonardo imitator Francesco Napolitano, and have been considered early works, made when his contact with Leonardo was still superficial.[5] It is, however, difficult to believe that the author of the two highly individual and accomplished Leonardesque paintings in the Kunsthaus, Zurich—both of which are signed—and of a very few other pictures[6] is the same artist responsible for the group in question, where Leonardo's influence is secondary to a local, Milanese training.

NOTES:

1. See T. Frimmel, "Der Anonimo Morelliano," *Quellenschriften für Kunstgeschichte und Kunsttechnik des Mittelalters und der Neuzeit* I (1888), p. 110.

2. Suida (1949) mentions a painting of the Madonna and Child in the Worcester Art Museum and another in Karlsruhe. The Karlsruhe picture cannot be traced, and the only two Lombard pictures at Worcester which may answer his description are nos. 1924.13 and 1940.41. The former is attributed to Foppa, the latter to Martino Piazza (see M. Davies, in *European Paintings in the Collection of the Worcester Art Museum,* Worcester, Mass., 1974, I, pp. 360–61, 434–35).

3. Sale, Parke-Bernet, New York, Dec. 2, 1971, no. 148.

4. It was published by G. Cagnola, "Intorno a Francesco Napolitano," *Rassegna d'Arte* V (1905), p. 83, ill., with an attribution to Francesco Napolitano. With the exception of Suida (1949) this attribution has been accepted by all subsequent critics (see note 4 below and B. Berenson, *Italian Pictures of the Renaissance: Central Italian and North Italian Schools,* London, 1968, p. 144) but is difficult to credit.

5. For the Fogg picture see F. M. Perkins, "Alcuni dipinti italiani in America," *Rassegna d'Arte* IX (1909), pp. 146–47, ill. p. 148, who also accepts the attribution to Francesco Napolitano of the New-York Historical Society painting. For the Rijksmuseum picture see S. de Ricci, "New Pictures by Francesco Napolitano," *Burlington Magazine* XVIII (1910), p. 27, fig. A, who, again, accepts the New-York Historical Society painting as by Francesco Napolitano, and *All the Paintings of the Rijksmuseum in Amsterdam,* trans. M. Buikstra-de Boer, Amsterdam, 1976, p. 408. The Malaspina picture is tentatively attributed to Francesco by G. G. Vedovello, in *Pavia, Pinacoteca Malaspina* (coll. cat.), Pavia, 1981, pp. 193–94, on the basis of its resemblance to the Fogg, Rijksmuseum, and New York paintings. The thesis that the last three are early works of Francesco is argued by F. Bock, "Leonardofragen," *Repertorium für Kunstwissenschaft* XXXIX (1916), pp. 159–60.

6. Of the number of pictures sometimes attributed to Francesco Napolitano (for which see B. Berenson, *Italian Pictures* . . . , 1968, I, pp. 143–44) only three seem to me unquestionably by him: the *Madonna and Child* in the Brera, Milan (inv. 278), the *Madonna and Child* in the Cleveland Museum of Art (inv.

16.779; see N. C. Wixom, in *European Paintings of the 16th, 17th, and 18th Centuries,* vol. III of Cleveland Museum of Art, *Catalogue of Paintings,* Cleveland, 1982, p. 380), and the *Madonna and Child Enthroned* in the National Museum, Stockholm (inv. 2636; reproduced in Berenson, *Italian Pictures* . . . , 1968, III, fig. 1518).

EX COLL.: Mr. and Mrs. Jack Linsky, New York (by 1949–until 1980); Mrs. Belle Linsky, New York (1980–82).

EXHIBITED: Los Angeles County Museum of Art, *Leonardo da Vinci,* 1949, no. 47, ill. (lent by Mr. and Mrs. Jack Linsky).

BIBLIOGRAPHY: W. Suida, in *Leonardo da Vinci Loan Exhibition* (exhib. cat.), Los Angeles County Museum of Art, Los Angeles, 1949, p. 94, ill.

KC

FRA BARTOLOMEO
(Bartolomeo di Paolo del Fattorino, also called Baccio della Porta)

Born 1472, Soffignano (Prato); died 1517, Pian di Mugnone (Florence)

FRA BARTOLOMEO was a pupil of Cosimo Rosselli, with whom he was working in 1485. During the 1490s he is known to have collaborated with his friend Mariotto Albertinelli. At this time he came under the influence of Savonarola, and in 1500 he entered the monastery of San Domenico at Prato as a novice. He took his vows the following year and transferred to the Florentine monastery of San Marco. From 1500 to 1504 Fra Bartolomeo ceased to paint. While there are dated works after this period, his activity prior to 1497—the date of the *Annunciation* in the cathedral of Volterra that appears to have been painted in collaboration with Albertinelli—has only recently been convincingly established (see below). In the 1490s Fra Bartolomeo was, aside from Leonardo, the most innovative painter in Florence.

8. Portrait of a Man

Oil on wood. Overall 15⅝ × 12⅛ in. (39.7 × 30.8 cm.); painted surface 15½ × 11¾ in. (39.4 × 29.8 cm.)
Inscribed (at top): MATTHAEVS · SASS T[HA]NVS · OBIIT · 1506 (Matteo Sass . . . [?] died 1506)
1982.60.8

The picture has suffered from past overcleaning and abrasion, affecting especially the head and hair, where the surface is broken and much of the original glazing has been lost. There are losses along a vertical split, the most important of which is in the sitter's left cheek and adjoining hair and extending into the jaw, neck, and scarf. Little remains of the collar and black neckline. By contrast, the lower left area of the right tree and passages of the distant landscape at the left, as well as the hat, the scarf, and the sitter's left sleeve, still preserve much of the original delicacy. There are remnants on the reverse of a painted porphyry decoration.

THE SITTER, a man perhaps in his thirties, is shown bust-length in a three-quarter view against a landscape. He wears a red cap, or *beretto*, and around the neck of his black robe is draped a pink scarf. In the left distance are a group of buildings with pitched roofs and the diminutive figure of a man.

The inscription at the top of the picture is early but certainly not original. It was first transcribed as MATTHAEUS SASS. THANUS[1] and later, by Lionello Venturi (1929), as MATTHAEUS SASS[E]TTIANUS. Venturi's reading has been accepted by all subsequent critics, though careful examination suggests that the *Sass* was always followed by a space, the second letter of the third word was probably an *H*, the third letter was almost certainly an *A*, and the first letter should be interpreted as an *I* with an abbreviation line above. The resultant transcription is puzzling, but at least no less odd than Venturi's interpretation of Sassettiano as a diminutive for Sassetti, the well-known Florentine family whose most illustrious member, Francesco Sassetti, was a head of the Medici bank and a patron of Domenico Ghirlandaio.[2] There is no mention of a Matteo Sassetti in the "Notizie . . . " of Francesco di Giovambattista Sassetti.[3]

The portrait was attributed by Venturi, Alfred M. Frankfurter (1931), and W. R. Valentiner (1933) to Ghirlandaio's pupil and son-in-law Sebastiano Mainardi. This attribution was based on the supposed identity of the sitter and the notion that a Sassetti commission would logically have been given to Ghirlandaio but was in this case carried out by a pupil. Bernard Berenson (1936; 1963) lists the work as by Cosimo Rosselli.

What is certainly the correct attribution to Rosselli's pupil, Fra Bartolomeo, was advanced by Everett Fahy (1969) in a carefully reasoned article reconstructing the artist's career prior to 1500. As Fahy noted, the landscape is thoroughly characteristic of Fra Bartolomeo, and the

picture is executed with a delicacy and refinement consonant with an attribution to him. The format of the picture is not uncommon in late fifteenth-century Florentine portraiture, but Fahy is surely correct in suggesting that the motif of the trees to either side of the face and the placid, almost vacant expression of the figure derive from a prototype by Memling very like the *Portrait of a Man* in the Uffizi, Florence (inv. 1102). This Flemish influence extends to the technique and to the detailed physiognomic description, as is abundantly clear if the portrait

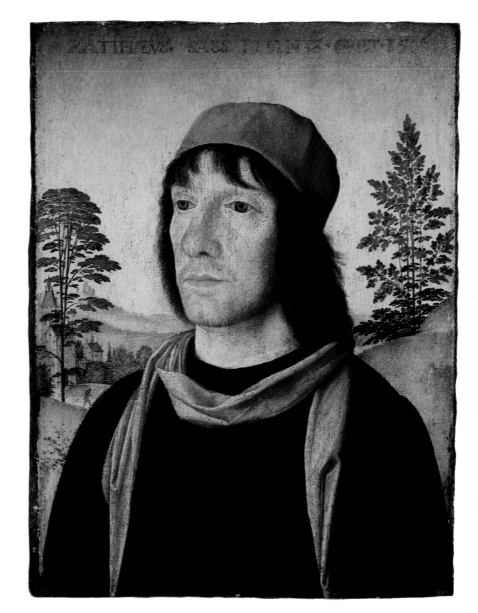

is compared to Fra Bartolomeo's earlier portrayal of members of the Malatesta family in the Saint Vincent Altarpiece in the Pinacoteca Comunale at Rimini.[4] Fahy has related the portrait to a drawing in the National Gallery of Scotland, Edinburgh (D 681 v), which, however, seems to show a younger, fuller-faced man.[5] His dating of the picture shortly after 1497 is convincing.

NOTES:

1. Sale, Christie's, London, Dec. 22, 1919, no. 140.

2. See E. Borsook and J. Offerhaus, *Francesco Sassetti and Ghirlandaio at Santa Trinita, Florence*, Doornspijk, 1981, with earlier bibliography.

3. This information has kindly been checked for me by Dr. E. Borsook, who tentatively suggests reading the "Sass" as an abbreviation for "Sassoni" (i.e., from Saxony). The seventeenth-century "Notizie dell'origine e nobiltà della famiglia de' Sassetti, raccolte da Francesco di Giambatista Sassetti. MDC" were published in 1855, in *Lettere edite e inedite di Filippo Sassetti*, edited by Ettore Marucci: see A. Warburg, "Francesco Sassettis letztiwillige Verfügung," in *Gesammelte Schriften*, ed. G. Bing, Leipzig, 1932, I, p. 29 n. 1.

4. E. Fahy, "The Beginnings of Fra Bartolommeo," *Burlington Magazine* CVIII (1966), pp. 456–60.

5. See K. Andrews, *Catalogue of Italian Drawings*, National Gallery of Scotland, Cambridge, 1968, I, pp. 13–14, fig. 120.

EX COLL.: R. Fleming, London (until 1919; sale, Christie's, London, Dec. 22, 1919, no. 140, as Bellini); A. J. Hugh Smith, London (1919–28; sale, Christie's, London, July 13, 1928, no. 67, as Bellini); [Norman Fischmann, Munich, 1928–after 1929]; Edwin D. Levinson, New York (by 1931–1933); [John Levy Galleries, New York, 1933]; [Julius Weitzner, New York, before 1955]; Mr. and Mrs. Jack Linsky, New York (1955–80); Mrs. Belle Linsky, New York (1980–82).

EXHIBITED: Detroit Institute of Arts, *The Sixteenth Loan Exhibition of Old Masters: Italian Paintings of the XIV to XVI Century*, Mar. 8–30, 1933, no. 31 (as Bastiano Mainardi, lent by Mr. E. D. Levinson); William Rockhill Nelson Gallery of Art, Kansas City, 1933 (as Sebastiano Mainardi, lent by the John Levy Galleries, New York).

BIBLIOGRAPHY: L. Venturi, "Ein Porträt des Bastiano Mainardi," *Pantheon* III (1929), pp. 280–81, ill. in color // A. M. Frankfurter, "Ghirlandaio and Mainardi: A Study in Portraiture," *Antiquarian* XVII (1931), p. 58, ill. in color // W. R. Valentiner, in *The Sixteenth Loan Exhibition of Old Masters: Italian Paintings of the XIV to XVI Century* (exhib. cat.), Detroit, Detroit Institute of Arts, 1933, no. 31, ill. // B. Berenson, *Pitture italiane del rinascimento*, Milan, 1936, p. 423; *Italian Pictures of the Renaissance: Florentine School*, London, 1963, I, p. 191; II, fig. 1009 // E. Fahy "The Earliest Works of Fra Bartolomeo," *Art Bulletin* LI (1969), p. 148, fig. 16; *Some Followers of Domenico Ghirlandaio*, New York, 1976, pp. 61–62, 93–94, no. 98, fig. 44.

KC

38

ANDREA DEL SARTO
(Andrea d'Agnolo)

Born 1486, Florence; died 1530, Florence

ANDREA'S FATHER was a tailor, whence the name "del Sarto." According to Vasari, Sarto was trained, in part, by Piero di Cosimo, whose shop he abandoned in order to establish a partnership with Franciabigio. He was admitted to the painters' guild in 1508, and within five years had become one of the major figures of the High Renaissance in Florence, taking on a number of pupils that included Pontormo and, possibly, Rosso. He worked for Francis I in 1518–19, but otherwise spent almost his entire career in Florence.

9. Portrait of a Man

Oil on canvas, transferred from wood. 26¼ × 19⅞ in. (66.7 × 50.5 cm.)
1982.60.9

The surface texture has been altered by an old transfer from the original wood support, and the green background is thin and riddled with losses. By contrast, cleaning in 1983 has revealed the figure to be in generally good condition, though somewhat less sharply defined than was intended. The shaded areas (especially on the nose and hat) are thin, and there are scattered small losses, the most important of which is on the chin.

THE SITTER, fair haired and gray eyed, is shown with his torso in profile and his head turned three-quarters to the left. He wears a *beretto* and a plain, blue-gray robe over a white shirt, the collar and one cuff of which are visible. In his right hand he holds a small book bound in red with yellow-edged pages. The simplicity of the sitter's costume as well as his mien suggest a scholarly occupation.

The attribution to Sarto goes back to F. Mason Perkins (1915) and Bernard Berenson (1915; 1932; 1936). It has, however, been questioned—first by Berenson (1963), who classifies the picture as a work from Sarto's studio, and then by S. J. Freedberg (1963) and John Shearman (1965). Freedberg tentatively attributes the picture to Santi di Tito, while Shearman, who correctly underscores the painting's close relation to Sarto's work of about 1528, attributes it to Francesco Salviati and dates it about 1530–

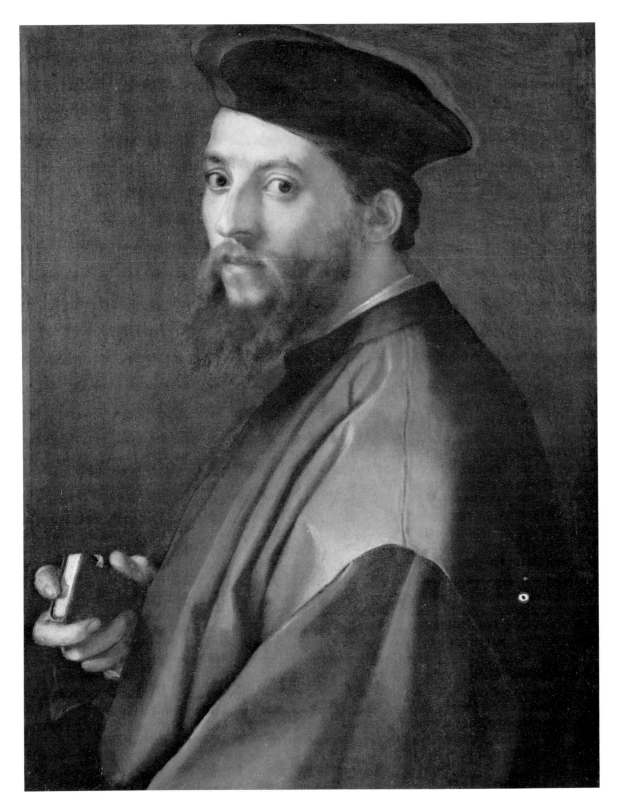

32.[1] Though the figure in the Linsky picture is less sharply described and the silhouette simpler than in other portraits by Sarto of the late 1520s—most notably the *Portrait of a Girl* and the *Self-Portrait*, both in the Uffizi, Florence—the balance of probability is that the picture is a late work by Sarto, an opinion expressed by Freedberg (1983) after an examination of the painting during cleaning.

NOTES:
1. For Santi di Tito see J. Spalding, *Santi di Tito*, New York, 1982, pp. 517–18. I. H. Cheney, *Francesco Salviati*, Ph.D. diss., New York University, 1963 (Ann Arbor, Mich., 1976, microfiche), pp. 416–33, reviews the literature on Salviati's portraits.

EX COLL.: [D. Costantini ?, Florence, 1905]; [Wildenstein, New York, 1915]; Mrs. Morton F. Plant, later Mrs. William Hayward, later Mrs. John E. Rovensky, New York (by 1932–1957; sale, Parke-Bernet, New York, Jan. 16, 1957, no. 454, as Andrea del Sarto); Mr. and Mrs. Jack Linsky, New York (1957–80); The Jack and Belle Linsky Foundation, New York (1980–82).

BIBLIOGRAPHY: F. M. Perkins, "Miscellanea," *Rassegna d'Arte* XV (1915), p. 122, ill. // B. Berenson, *Italian Pictures of the Renaissance*, Oxford, 1932, p. 19; *Pitture italiane del rinascimento*, Milan, 1936, p. 16; *Italian Pictures of the Renaissance: Florentine School*, London, 1963, I, p. 10 // S. J. Freedberg, *Andrea del Sarto*, Cambridge, Mass., 1963, II, p. 229, fig. 169 // J. Shearman, *Andrea del Sarto*, Oxford, 1965, pp. 105 n. 2, 169 // S. J. Freedberg, letter, May 27, 1983.

KC

BACCHIACCA
(Francesco d'Ubertino)

Born 1495, Borgo San Lorenzo (Florence); died 1557, Florence

BACCHIACCA WAS a pupil of Perugino's. According to Vasari he also studied with Franciabigio and was a close friend of Andrea del Sarto, "by whom he was greatly aided and favored in artistic matters." Vasari singles out for praise Bacchiacca's small-scaled work and his depiction of animals. It was as a painter of furniture and panels for the decoration of private apartments of wealthy Florentines that he excelled. His most famous works in this genre are six scenes of the story of Joseph for a marriage chamber in the Palazzo Borgherini, apparently begun in or shortly after 1515 in collaboration with Sarto, Pontormo, and Francesco Granacci. Until about 1525 the pre-

dominant influences on his work were Perugino and Sarto; thereafter he fell increasingly under the spell of Michelangelo, though only in a superficial manner. There is only one dated work, a portrait of 1533. His compositions derive both from those of his compatriots and from northern prints.

10. Madonna and Child

Oil and gold on wood. 34¼ × 26½ in. (87 × 67.3 cm.)
Inscribed (on Virgin's collar): AVE MARIA
1982.60.10

The panel support has been thinned and cradled. It has possibly been slightly cropped along the vertical edges but not, apparently, at the top or bottom. On the whole the condition is excellent; there is, however, a loss on the Virgin's breast. The picture was cleaned in 1983.

THE VIRGIN, seated with her head in profile, wears a red dress over which is draped a blue cloak lined in green. The collar is embroidered with rectangular cartouches alternating with winged cherub heads, and hanging from its center is an inscribed cartouche with, below, a seraph highlighted in gold. Her hair is elaborately braided, and over it she wears what appears to be an embroidered net. The Child, seated on her lap, holds in his left hand a nosegay of jasmine and a cornflower. Behind the figures and in front of the rocky background are, at right, a rose bush and, at left, another rose bush, a cornflower, and sweetbriar. These flowers are common to Renaissance paintings of the Madonna and Child, and the rose, jasmine, and sweetbriar are traditional symbols of the Virgin. Sweetbriar may, additionally, allude to the five wounds of Christ; the cornflower, too, is associated with Christ.[1]

The authorship of the picture, one of Bacchiacca's most beautiful portrayals of the Madonna and Child, is not open to doubt, though Christian von Holst (1974), who knew only photographs of it, suggested that workshop assistants were also involved. The composition was repeated by Bacchiacca on three other occasions: on a diminutive scale in *The Vision of Saint Bernard*, in the Palazzo Venezia, Rome; in a picture of dimensions identical to the present one in the Baltimore Museum of Art; and in a considerably larger picture formerly with Colnaghi's.[2] In the ex-Colnaghi picture the Virgin is shown full-length, seated on a rock, with a figure of the infant Saint John the Baptist gathering hazelnuts, a symbol of salvation, at the left. It has been argued that this is the first version,

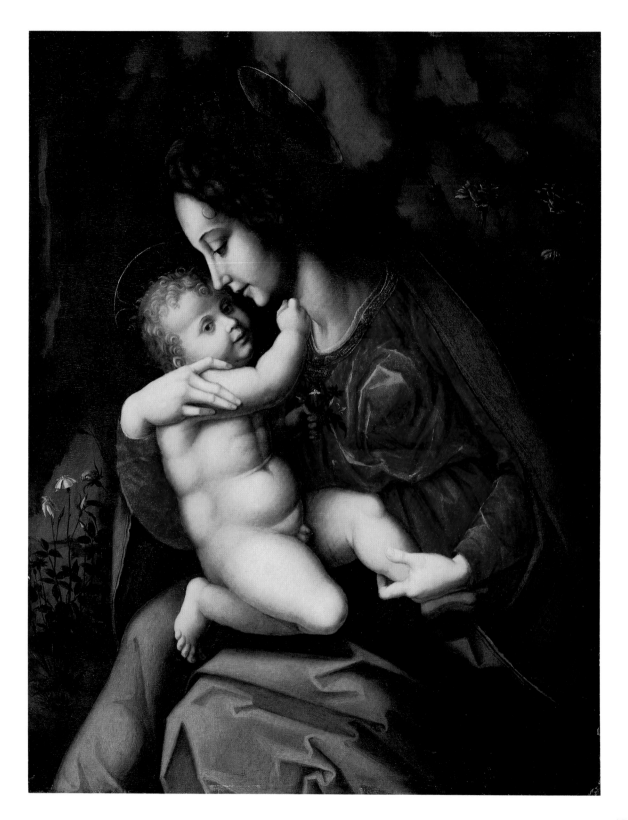

41

the assumption being that a full-scale Madonna necessarily preceded the "truncated" ones.[3] John Russell Sale (1981), however, has convincingly demonstrated that the ex-Colnaghi picture depends from the present one, and is somewhat later in date. In the Baltimore picture the composition has been further revised, and the Virgin's legs are placed at an oblique angle rather than parallel to the picture plane, while her head has been given a Michelangelesque cast. That picture was recognized as a late work by Arthur McComb in 1926,[4] and is dated to 1530–35 by H. Merritt,[5] and, more convincingly, to 1540–57 by Lada Nikolenko (1966) and about 1540 by Sale. It is, without question, the latest of the four versions. The present picture depends from Sarto for its treatment of light and is, consequently, more likely to date to the early 1520s, as Sale has argued, than about 1533–40, as proposed by Nikolenko. It is probably the earliest of the four.

There exist two pictures by Francesco Granacci, one in the Fine Arts Museums of San Francisco and the other formerly in the Hardy collection, London, that employ the same composition (a third picture by Granacci, *The Flight into Egypt* in the Musée d'Art et d'Archéologie, Toulon, also derives from the composition). The earlier of these is the San Francisco picture, which dates about 1515 and shows the Virgin and Child seated on a bench in front of a wall with a window to either side. The Virgin's legs are placed at an oblique angle, as in the Baltimore picture by Bacchiacca, but her head is viewed three-quarters rather than in profile. The underdrawing, however, establishes that her face was originally conceived in profile, with her nose overlapping the Child's forehead, as in Bacchiacca's pictures, and it is to this original conception that Granacci returned in the ex-Hardy picture of about 1520.[6] In all other respects, however, Bacchiacca's pictures are closer to the composition of the San Francisco picture than to the ex-Hardy one, where the Child is draped and his right hand is open rather than closed. Given the differences, there can be no doubt that both Granacci's and Bacchiacca's pictures derive from a common, lost prototype. Several opinions have been advanced on the authorship of this prototype: S. J. Freedberg traces it to Donatello;[7] Von Holst considers the likely source to have been a design by Michelangelo;[8] Sale has tentatively proposed either Raphael or Leonardo. The question is a complicated one and, in the present state of knowledge, cannot be satisfactorily answered. One may, nonetheless, note that the composition as first drawn by Granacci and as treated by Bacchiacca is decidedly planar and would seem more appropriate to a sculpture in low relief than to a painting. Indeed, the modifications made by Granacci in the San Francisco picture are best understood as accommodating features of a relief to the demands of a painting by reducing the planarity of the composition. Furthermore, although there are Donatellesque aspects to the composition—the most frequent comparison is with Donatello's *Madonna of the Clouds* in the Museum of Fine Arts, Boston—it is unlikely that Donatello was the author of the prototype. Granacci's friendship with Michelangelo, on the other hand, is well documented, and it would not be surprising if Granacci had access to a drawing or cartoon by him. Bacchiacca worked with Granacci on the decorations for the Palazzo Borgherini from 1515.

NOTES:

1. See M. Levi d'Ancona, *The Garden of the Renaissance*, Florence, 1977, pp. 113–14, 193–95, 330–37, 342–43, 368–70.

2. Sale, Christie's, London, Apr. 23, 1982, no. 72.

3. *Paintings by Old Masters* (1978), p. 13.

4. A. McComb, "Francesco Ubertini," *Art Bulletin* VIII (1926), p. 158.

5. H. Merritt, in *Bacchiacca and His Friends: Florentine Paintings and Drawings of the Sixteenth Century* (exhib. cat.), Baltimore Museum of Art, Baltimore, 1961, p. 30.

6. For both the San Francisco and the ex-Hardy pictures, see Holst (1974), pp. 27–28, 31, 141–42, 157.

7. S. J. Freedberg, *Painting of the High Renaissance in Rome and Florence*, Cambridge, 1961, I, p. 491. He was followed by Merritt (see note 4 above), p. 26.

8. On Michelangelo's relation to earlier, Donatellesque reliefs, see C. de Tolnay, *The Youth of Michelangelo*, Princeton, 1943, pp. 129–31 n. 8; and on the attribution of the relief in the Victoria and Albert Museum discussed by Tolnay see J. Pope-Hennessy, *Catalogue of Italian Sculpture in the Victoria and Albert Museum*, London, 1964, pp. 138–41.

EX COLL.: Sir H. Michelis; Viscountess H. de Kernavanois; private collection, Germany (until 1955; sale, Lempertz, Cologne, Nov. 23, 1955, no. 1, fig. 4); Mr. and Mrs. Jack Linsky, New York (1955–80); Mrs. Belle Linsky, New York (1980–82).

EXHIBITED: Baltimore Museum of Art, *Bacchiacca and His Friends: Florentine Paintings and Drawings of the Sixteenth Century*, 1961, no. 13, ill. (lent by Mr. Jack Linsky).

BIBLIOGRAPHY: L. Nikolenko, *Francesco Ubertini called Il Bacchiacca*, New York, 1966, pp. 26, 45, 57–58, fig. 67 // C. von Holst, *Francesco Granacci*, Munich, 1974, pp. 27, 141, 142 n. 3 // *Paintings by Old Masters* (exhib. cat.), London, Colnaghi, 1978, p. 13 // J. R. Sale, in *Italian Paintings, XIV–XVIIIth Centuries from the Collection of The Baltimore Museum of Art*, Baltimore, 1981, pp. 94–95, 98 nn. 29, 30, fig. 5.

KC

11. Leda and the Swan

Oil on wood. Overall 16⅞ × 12½ in. (42.9 × 31.8 cm.);
painted surface 16½ × 12½ in. (41.9 × 31.8 cm.)
1982.60.11

The picture is painted on a panel with an intentionally convex surface. The vertical edges have been cut, though probably not very much. On the whole the condition is good. There are scattered minor losses and a few larger ones in the foreground and on the left wing of the swan. The picture was cleaned in 1983.

THE COMPOSITION is dominated by the figure of the nude Leda seated with legs crossed on the back of the swan, whose wings are outstretched. Her left arm is placed around the swan's neck, while with her right hand she offers the bird her breast. To the left are two children, one astride a rock formation and leaning on the broken shell of an egg, the other seated on the ground with the other half of the eggshell on his head. To the right two children play on another broken egg, from which a fifth child emerges. Behind the figures is a dense copse of trees masking two-thirds of the background, to the left of which are two buildings with a seated figure approached by two standing figures.

Leda was the wife of Tyndareus, king of Sparta. Most commonly she is said to have conceived on the same night two children by her husband and two by Zeus, who came to her in the form of a swan. The children, hatched from two eggs, are generally stated to be the twins Castor and Pollux and Helen and Clytemnestra, but who was the child of whom varies from author to author. Moreover, while Helen is said by Apollodorus to have been the daughter not of Zeus and Leda but of Zeus and Nemesis, whose egg was entrusted to Leda, Euripedes, in *Iphigenia at Aulis*, adds to Leda's two daughters a third, Phoebe. The medieval text known as the First Vatican Mythographer states that Castor, Pollux, and Helen all emerged from a single egg, and this was also the view expressed by the fourteenth-century Benedictine Pierre Bersuire in the popular *Ovide moralisé*. That Bacchiacca was familiar with the *Ovide moralisé* there can be no doubt. Whereas in all other contemporary Florentine paintings of the subject either two or four children are shown, in a picture in the Musée des Beaux-Arts at Troyes, another in the Museum Boymans-van Beuningen in Rotterdam, and a third formerly with Böhler in Lucerne,[1] Bacchiacca shows a standing figure of Leda with the swan and three infants. In both the Troyes and ex-Böhler pictures there is only one egg. In the present picture the three children at the right also hatch from one egg and can consequently be identified as Castor and Pollux—the only infants shown with male genitals—and Helen, who is but partially hatched. The two children at the left must logically be Clytemnestra and Phoebe, though William Suida (1949) gives alternative identifications.

The picture was first published as a work of Bacchiacca by Suida (1929), who later noted (1949) that the pose of Leda derives from Dürer's print of *The Penance of Saint John Chrysostom*, where a seated nude woman suckles a child. John Shearman (1965) correctly identifies the source of the buildings in the left background in a print of *The Prodigal Son* by Lucas van Leyden of 1510. The same buildings recur in a painting of Leda and the swan that is probably by Andrea del Sarto,[2] and in no fewer than six paintings by Bacchiacca, including a *Leda and the Swan* in the Berenson Collection at the Harvard Center for Renaissance Studies in Florence.[3] Neither print can be used to establish a precise date for the pictures in which they have been used. According to Shearman the posture of the swan depends from Sarto's painting, but in fact the closest parallel occurs in a small panel in the Uffizi, Florence, that bears a tentative attribution to the young Pontormo.[4] Bacchiacca, of course, worked with both Sarto and Pontormo on the decoration of the marriage chamber of the Palazzo Borgherini in Florence from 1515, and he may well have known these two paintings. However, the peculiar iconography of his picture argues for a good deal of independence.

Of Bacchiacca's five known pictures of Leda and the swan, the present one is by far the most individual and accomplished. Lada Nikolenko (1966) has dated it about 1525 and considers the Troyes picture somewhat earlier and the remaining three somewhat later. There can be no reasonable doubt that, excepting the Berenson picture, the other four paintings are relatively close in date. However, the present picture is most likely to have been the earliest. The playfully lascivious detail of the swan nibbling Leda's breast, for example, must have been introduced via the seated figure in Dürer's print and then adapted for the standing Leda of the other three pictures. The closest analogies of style with the present painting occur in Bacchiacca's *Legend of the Dead King* in the Gemäldegalerie, Dresden, which was probably painted in or about 1523.[5] The Berenson painting, which combines the *Rape of Leda* with the hatching of two of her children and

has a more distinctly Michelangelesque quality, must be considerably later in date.

Judging from the intentionally curved surface of the picture, it must have been conceived as part of a piece of furniture.

NOTES:

1. Illustrated in P. Schubring, "New Cassone Panels," *Apollo* VIII (Oct. 1928), p. 183.

2. An attribution to Sarto has been argued by J. Shearman (1965), pp. 30, 215–17; S. McKillop, *Franciabigio*, Berkeley, 1974, pp. 190–91; and, most recently, S. Meloni Trkulja (1980).

3. For the paintings, see Nikolenko (1966), figs. 28, 34, 35, 40, 46, 69.

4. See L. Berti, "Precisazioni sul Pontormo," *Bollettino d'Arte*

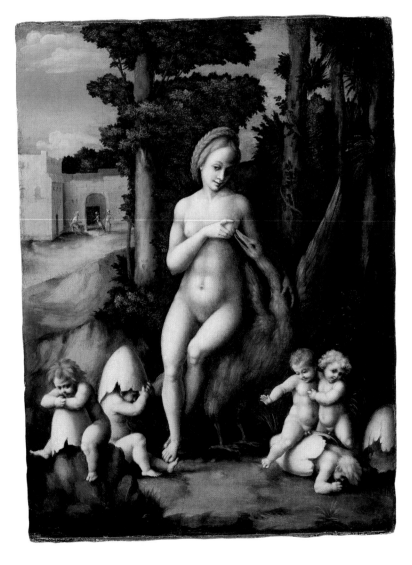

LI (1966), pp. 50, 54–55 n. 5, where the picture is attributed to Puligo, and in *Gli Uffizi, Catalogo Generale*, Florence, 1979, p. 428, where a tentative attribution to Pontormo is maintained.

5. The picture formed part of the series painted for Giovanni Maria Benintendi. Another picture from the same series, by Franciabigio, is dated 1523: see S. McKillop (see note 2 above), p. 168.

EX COLL.: Oscar Bondy, Vienna (by 1929–before 1949); Mr. and Mrs. Jack Linsky, New York (1949–80); Mrs. Jack Linsky, New York (1980–82).

EXHIBITED: Los Angeles County Museum, *Leonardo da Vinci*, 1949, no. 7 (lent by Mr. and Mrs. Jack Linsky); Baltimore Museum of Art, *Bacchiacca and His Friends*, 1961, no. 8 (lent by Mr. Jack Linsky).

BIBLIOGRAPHY: W. Suida, *Leonardo und sein Kreis*, Munich, 1929, p. 245 // B. Berenson, *Italian Pictures of the Renaissance*, Oxford, 1932, p. 36; *Pitture italiane del rinascimento*, Milan, 1936, p. 31 // R. Salvini, *Allgemeines Lexikon . . .*, ed. U. Thieme and F. Becker, Leipzig, XXXIII (1939), p. 523 // W. Suida, in *Leonardo da Vinci Loan Exhibition* (exhib. cat.), Los Angeles, Los Angeles County Museum of Art, 1949, pp. 75–76, no. 7, ill. // G. Rosenthal, in *Bacchiacca and His Friends* (exhib. cat.), Baltimore, Baltimore Museum of Art, 1961, p. 8, fig. 8; "Il Bacchiacca at Baltimore," *Connoisseur* 149 (1962), p. 61, fig. 8 // B. Berenson, *Italian Pictures of the Renaissance: Florentine School*, London, 1963, I, p. 20; II, fig. 1247 // J. Shearman, *Andrea del Sarto*, Oxford, 1965, p. 216 // L. Nikolenko, *Francesco Ubertini, called Il Bacchiacca*, New York, 1966, pp. 18, 50, fig. 45 // S. Meloni Trkulja, in *Firenze e la Toscana dei Medici nell'Europa del Cinquecento: Il primato del disegno* (exhib. cat.), Florence, Palazzo Strozzi, 1980, p. 60; in *Leonardo e il Leonardismo a Napoli e a Roma* (exhib. cat.), Naples, Museo Nazionale di Capodimonte, 1983–84, p. 111, fig. 201.

KC

THE MASTER OF THE ANNUNCIATIONS TO THE SHEPHERDS

Active second quarter of 17th century, Naples

THE NAME of the artist derives from the subject he most frequently represented. It was first used by Fernando Bologna in 1955[1] to distinguish a number of paintings that had previously been attributed to Bartolomeo Bassante (or Passante),[2] an artist described by both Carlo Celano[3] and Bernardo de' Dominici[4] as Ribera's most faithful and

gifted pupil and the author of a *Nativity* (no longer traceable) in San Giacomo de' Spagnuoli, Naples. There is a signed work by Bassante in the Prado, Madrid, showing the Adoration of the Shepherds, but it is only generically in the style of Ribera, and most critics now agree with Bologna that the Master of the Annunciations to the Shepherds is a distinct personality.[5] He may have been of Spanish origin, but was certainly active in Naples in the 1630s, when he would have worked with Ribera. His activity seems to parallel that of Francesco Fracanzano, and there is a relation with the early work of Bernardo Cavallino that has not been satisfactorily defined. The Master of the Annunciations to the Shepherds has been tentatively but inconclusively identified with Giovanni Do, of Spanish origin and active in Naples by 1626.[6] He was obviously a gifted painter, though his importance has perhaps been exaggerated by Longhi and Bologna, who considered his pictures greater than those by Ribera himself.

12. The Sense of Sight

Oil on canvas. Overall, with additions, 29⅞ × 24⅞ in. (75.9 × 63.2 cm.); without additions, 27¾ × 21¾ in. (70.5 × 55.2 cm.)
1982.60.12

The original picture surface has been enlarged 1⅞ inches at the left, 1¼ inches at the right, 1⅜ inches at the top, and ¾ inch at the bottom. These additions are masked by the frame. In general the condition is excellent, though the contours have been strengthened somewhat and there is an old tear through the bust and left arm.

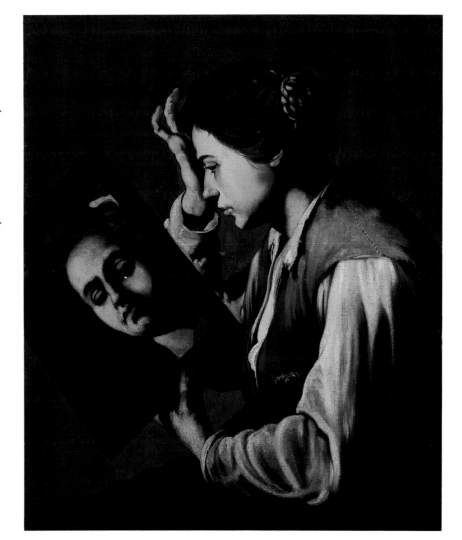

A YOUNG WOMAN in peasant clothes is shown seated in profile. With her right hand she arranges her hair, while with her left she holds a mirror at an angle that allows her face to be reflected frontally to the viewer.

The attribution of the picture to the Master of the Annunciations to the Shepherds was first suggested by Jesús Perera (1957) and has not been questioned. When it was exhibited in 1920, the picture was described simply as a girl with a mirror. Perera is almost certainly correct in interpreting it as an allegory of Sight. A mirror usually figures among the most prominent attributes of Sight,[7] and is specifically mentioned by Ripa.[8] The genrelike treatment of the present picture derives from Ribera, who first conceived of illustrating the five senses with half-length, unidealized figures involved in an activity that

would convey the essence of each sense. In Ribera's earliest treatment of the theme, in 1615, Hearing is represented by a man playing a lute, Taste by a man eating, Touch by a blind man feeling a marble bust, Smell by a man holding a sliced onion, and Sight by a man who holds a telescope while on a ledge in front of him are displayed a pair of glasses and a rectangular mirror.[9] Possibly in 1632 and again in 1637 Ribera repeated the theme, and it is probable that in one of the two series he represented Sight by a man or woman looking into a mirror.[10] It is, in any event, clear that the present picture depends from a prototype by Ribera.

Perera (1957) has suggested that a painting of a man

playing a mandolin formerly in the Mont collection, New York,[11] is a companion to the Linsky picture. However, its dimensions differ considerably from the Linsky picture, and De Vito is almost certainly correct in associating it with a second, earlier series of the senses by the Master of the Annunciations to the Shepherds, with which two other pictures can be associated: a girl with a rose (Smell) in the De Vito collection, and a man looking into a mirror (Sight) formerly on the art market, Paris.[12] The later series is, at present, known only through the Linsky picture and may date from as late as 1640, when the anonymous master's work shows an increasingly fluid handling and refinement.

NOTES:

1. F. Bologna, *Opere d'arte nel Salernitano dal XII al XVIII secolo* (exhib. cat.), Salerno, San Matteo Cathedral, 1955, p. 55 n.; and *Francesco Solimena*, Naples, 1958, pp. 18, 30–32 n. 7.

2. The first to attribute these pictures to Bassante was A. Mayer, *Jusepe de Ribera (lo Spagnoletto)*, 2nd ed., Leipzig, 1923, pp. 176–77. R. Longhi, "I pittori della realtà in Francia," *L'Italia Letteraria*, Jan. 19, 1935 (reprinted in *Paragone Arte* XXIII, no. 269, 1972, p. 17) further enlarges the catalogue and in "G. B. Spinelli e i naturalisti napoletani del Seicento," *Paragone Arte* XX (no. 227, 1969), pp. 50–52, maintains that the Master of the Annunciations to the Shepherds is a misnomer for Bassante.

3. C. Celano, *Notizie del bello dell'Antico e del curioso della Città di Napoli*, Naples, 1692, ed. G. B. Chiarini, IV (1859), p. 379.

4. B. de' Dominici, *Vite de'pittori, scultori, ed architetti napoletani*, Naples, 1742, III, pp. 23–24.

5. See, in particular, Perera (1957); A. E. Pérez Sanchez "Una nueva obra del 'Maestro del Anuncio a los Pastores,'" *Archivo Español de Arte* XXXIV (1961), pp. 325–27; R. Causa, "La pittura del Seicento a Napoli dal naturalismo al Barocco" (reprint from *Storia di Napoli*), Naples, 1972, pp. 928–31, 973–74 nn. 51–54; G. De Vito, in *Painting in Naples 1606–1705 from Caravaggio to Giordano* (exhib. cat.), Washington, D.C., National Gallery of Art, 1982, pp. 190–95.

6. M. Marini, *Pittori a Napoli, 1610–1656: Contributi e Schede*, Rome, 1974, pp. 103–7.

7. See, for example, the engraved series after Hendrick Goltzius by Jan Saenredam, dating from about 1595, where Sight is illustrated by a pair of figures in fancy dress, one of whom holds a mirror, or Jacob Backer's engraved series of about 1630 with a nude, full-length, reclining female admiring herself in a mirror.

8. C. Ripa, *Iconologia . . .*, Rome, 1603, p. 447.

9. See R. Longhi, "I cinque sensi del Ribera," *Paragone Arte* XVII (no. 193, 1966), pp. 74–78; and, most recently, C. Felton, in *Jusepe de Ribera: lo Spagnoletto, 1591–1652*, (exhib. cat.), Fort Worth, Kimball Art Museum, 1982, pp. 92–101.

10. Felton (see note 9 above), pp. 95 n. 7, 161, argues that a picture of a man holding a mirror, known in a number of versions, may belong to a series of the senses painted in 1632. The picture has also been identified as showing Socrates by D. F. Darby, "The Wise Man with a Looking-Glass," *Art in America*

36 (1948), pp. 113–26. See also N. Spinosa, *L'Opera completa del Ribera*, Milan, 1978, p. 127, no. 238. Whether or not this particular composition formed part of a series of the senses, one very like it must have.

11. Sale, Christie's, London, Dec. 2, 1983, no. 96.

12. De Vito (see note 5 above), pp. 194–95, no. 84.

EX COLL.: Sir Herbert Cook, Doughty House, Richmond (1919–39; Cat. 1932, p. 59, no. 553, as Ribera); Sir Francis F. M. Cook, Doughty House, Richmond (1939–about 1950); Mr. and Mrs. Jack Linsky, New York (about 1950–1980); The Jack and Belle Linsky Foundation, New York (1980–82).

EXHIBITED: Royal Academy, London, *Exhibition of Spanish Paintings*, 1920–21, no. 52 (as Ribera, lent by Sir Herbert Cook).

BIBLIOGRAPHY: J. H. Perera, "Bartolome Bassante y el 'Maestro del Anuncio a los Pastores,'" *Archivo Español de Arte* XXX (1957), pp. 220–21, pl. V // G. De Vito, letter, June 7, 1983.

KC

ALESSANDRO MAGNASCO

Born 1667, Genoa; died 1749, Genoa

MAGNASCO, who was also known as Lissandrino because of his small stature, received his training in Milan with Filippo Abbiati. He remained in Milan until 1703, and was there again from about 1711 to 1735, after which he established himself in his native Genoa. His principal biographer, Carlo Giuseppe Ratti, reports that Magnasco did not enjoy the celebrity in Genoa that he had had in Milan and in Florence, where he also worked. Magnasco specialized in paintings of genre or fanciful subjects with small, mannered figures; he sometimes collaborated with other artists. Few of his works are dated, and his chronology remains largely hypothetical. According to Ratti, he was widely imitated.

13. Nuns at Work

Oil on canvas. 20⅛ × 28⅜ in. (51.1 × 72.1 cm.)
1982.60.13

The picture is in a good state of preservation.

SEVEN NUNS dressed in the habit of Poor Clares of the Franciscan order are shown in a simple room performing

a variety of tasks. One, with her back to the viewer, reads. Another, at the left, embroiders. A third, in the center, makes lace, while another, farther back, embroiders or mends a piece of blue cloth. A fifth is shown spinning, while a nun behind her holding a small tray with a cup looks on. A seventh nun is shown below a large, grilled window, carrying a carafe of water.

In his biography of Magnasco, Ratti lists among the artist's typical subjects women at work and monks in a variety of occupations. Recently, F. Franchini Guelfi has related the subject of the present picture, as well as that of similar works, to ideas of monastic reform current in Milan in the late seventeenth and early eighteenth centuries.[1] The composition of the present picture is closely related to that of a painting in the collection of Count Giacomo Carrara in Bergamo in 1796 described as a "workroom of nuns."[2] The picture is now in the Hessisches Landesmuseum, Darmstadt. The poses of each of the nuns recur in that picture. Although Benno Geiger (1953) and Giuseppe Fiocco (1953) both attribute the present picture to Magnasco and date it to his second Milanese period, it is decidedly inferior to the ex-Carrara picture and may be by one of the several followers Magnasco had in Milan.

NOTES:
1. F. Franchini Guelfi, *Alessandro Magnasco*, Compomorone, 1977, pp. 205, 208–10, 212.
2. See B. Geiger, *Magnasco*, Bergamo, 1949, pp. 76–77, fig. 428.

EX COLL.: Private collection, Rome (1953); Mr. and Mrs Jack Linsky, New York (until 1980); Mrs. Belle Linsky, New York (1980–82).

BIBLIOGRAPHY: B. Geiger, unpublished opinion, 1953 // G. Fiocco, unpublished opinion, 1953.

KC

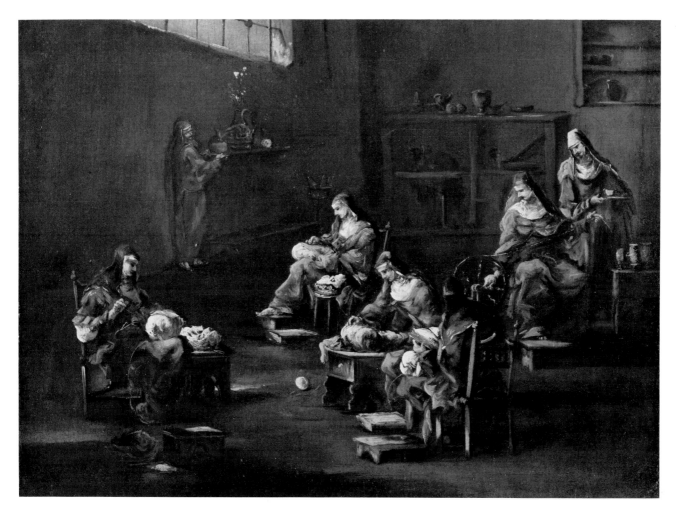

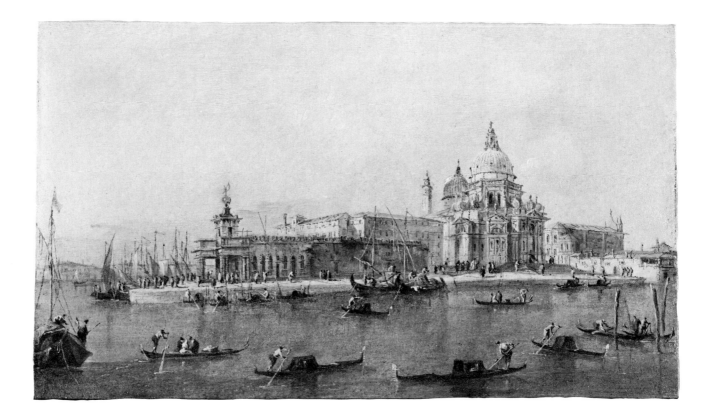

FRANCESCO GUARDI

Born 1712, Venice; died 1793, Venice

FRANCESCO GUARDI was trained by and later collaborated with his brother Gian Antonio, who was primarily a figurative painter. However, in 1764 Francesco exhibited two views of Venice, and it is as a *veduta* painter that he is principally known. He was admitted to the Accademia di Belle Arti as a perspective painter in 1784, when he was seventy-two years old and had long enjoyed success and popularity, especially in England. There is little documentary evidence for the chronology of his work, and the situation is complicated by the large number of replicas and pastiches.

14. Venice: The Dogana and Santa Maria della Salute

Oil on wood. 7⅛ × 12⅝ in. (18.1 × 32.1 cm.)
1982.60.14

On the whole, the condition is very good, although abrasion has broken up some of the glazes and black lines.

THE DOGANA and the churches of Santa Maria della Salute and San Gregorio are shown as though viewed across the Grand Canal from a point on or near the Capitaneria di Porto. The light comes from the east.

The picture is a pendant to *Venice: The Rialto* (no. 15). A closely related version is in the collection of M. Bissey, Paris.[1]

NOTE:
1. See Morassi (1973), I, p. 402, no. 486; II, fig. 490.

EX COLL.: Sir Charles Long, later Baron Farnborough, Bromley Hill Place, Kent (until 1838?); Norah Dawson, Little Bidlake, Bridestowe, North Devon (until 1942; sale, Christie's,

London, Oct. 2, 1942, no. 97); [Koester Gallery, New York, 1942–43]; Mr. and Mrs. Jack Linsky, New York (1943–80); Mrs. Belle Linsky, New York (1980–82).

BIBLIOGRAPHY: A. Morassi, *Guardi: Antonio e Francesco Guardi*, Venice, [1973], I, pp. 401–2, no. 485; II, fig. 489 // L. Rossi Bortolatto, *L'Opera completa di Francesco Guardi*, Milan [1974], p. 107, no. 301, 114.

KC

15. Venice: The Rialto

Oil on wood. 7⅛ × 12⅝ in. (18.1 × 32.1 cm.)
1982.60.15

The condition is slightly less good than that of the companion picture (no. 14).

THE RIALTO BRIDGE is shown from the south with the Riva del Vin and the Palazzo dei Dieci Savi at the left. Beyond the bridge is the Palazzo dei Camerlenghi, across from which is the receding façade of the Fondaco dei Tedeschi. The light comes from the east.

The picture is a pendant to *Venice: The Dogana and Santa Maria della Salute* (no. 14). The Guardi workshop treated both views a number of times with variations in the details of buildings, differences in viewpoint, and differences of scale. There are, however, two pictures that are intimately related to the present painting in scale, viewpoint, and lighting, and in the relative positions of the gondolas and sailing vessels: one in a private collection, Geneva, the other formerly with Silvano Lodi in Munich.[1] All three clearly derive from a drawing very like the one in the Musée Départemental des Vosges, Epinal. The Epinal drawing, however, was employed rather for a closely related group of pictures, one of which has dimensions almost identical to it.[2] Several of the gondolas in the present picture and in the two related pictures are repeated in a drawing attributed to Guardi in the Musée du Petit Palais, Paris.[3] The picture in Munich is on paper attached to a panel and may be the prime version.

49

The role played by Guardi's workshop (which by this time included his son Giacomo) in the production of such minor paintings is difficult to determine. Both Morassi (1973) and Bortolatto (1974) consider the present picture and its pendant characteristic late works by Francesco.

NOTES:

1. See Morassi (1973), I, p. 408, no. 526, II, fig. 518; I, p. 409, no. 532, II, fig. 517.

2. See A. Morassi, *Guardi: Tutti i disegni di Antonio, Francesco e Giacomo Guardi*, Venice, 1975, p. 143, no. 366, fig. 366. Morassi attributes the drawing to Francesco assisted by Giacomo and relates it generically to a group of pictures. There can be little doubt that it was the point of departure for Morassi (1973), nos. 527, 530, 531, 535; no. 530 is of almost identical dimensions.

3. See A. Morassi (see note 2 above), p. 144, no. 368, fig. 367, who notes the weak quality of the drawing.

EX COLL.: Sir Charles Long, later Baron Farnborough, Bromley Hill Place, Kent (until 1838?); Norah Dawson, Little Bidlake, Bridestowe, North Devon (until 1942; sale, Christie's, London, Oct. 2, 1942, no. 97); [Koester Gallery, New York, 1942–43]; Mr. and Mrs. Jack Linsky, New York (1943–80); Mrs. Belle Linsky, New York (1980–82).

BIBLIOGRAPHY: A. Morassi, *Guardi: Antonio e Francesco Guardi*, Venice, [1973], I, p. 410, no. 536 // L. Rossi Bortolatto, *L'Opera completa di Francesco Guardi*, Milan [1974], pp. 107, 114, no. 414.

KC

Flemish Paintings

Workshop of
DIERIC BOUTS

DIERIC BOUTS is first documented as a painter in Louvain in 1457, though he must have been active before this date. His birth date is estimated about 1410–20, and his marriage in Louvain to Katharina van der Brugghen, called Metten Gelde ("with the money"), probably occurred at the latest about 1447–48. Karel van Mander's report of an early inscription that gives Bouts's birthplace as Haarlem is supported by a Louvain document that says Bouts was born outside that town. Also, the *Raising of Lazarus* in the Staatliche Museen, Berlin-Dahlem, attributed to Aelbert van Ouwater, a Haarlem painter, displays a style that appears to have had a formative influence on Bouts.

Because Bouts's name recurs regularly in the Louvain archives after 1457 but not before, some surmise that between 1448 and 1457 he returned to Haarlem; van Mander calls attention to a house there that he claims Bouts lived in. The close relationship between Dieric's style and that of Rogier van der Weyden is reason to suppose that he spent time in Brussels before settling in Louvain. A *Crucifixion* in the Staatliche Museen, Berlin-Dahlem, attributed to Bouts shows in its background the skyline of Brussels.

Bouts was named official painter of the city of Louvain about 1468–69. Shortly before the end of January 1473, after the death of his first wife, he married the widow of the mayor of Louvain. Of the four children by his first marriage, the two sons became painters: Dieric the Younger (died 1491) and Aelbert (died 1549).

Three securely documented works form the basis for a number of firm attributions: the Altarpiece of the Holy Sacrament in the Church of Saint-Pierre, Louvain, commissioned in 1464 and completed by 1468; the Martyrdom of Saint Erasmus Triptych, also in Saint-Pierre, datable before 1466; and the *Justice of Emperor Otho*, two large panels in the Musées Royaux des Beaux-Arts, Brussels. The panels were commissioned about 1470 for the town hall of Louvain, but only one, *The Ordeal by Fire*, was finished by 1475, the year of the artist's death.

16. Virgin and Child

Oil on wood. Overall 11½ × 8¼ in. (29.2 × 21 cm.); painted surface 11¼ × 7¾ in. (28.6 × 19.7 cm.)
1982.60.16

The picture is in an excellent state of preservation. There are very minute paint losses along one crack three-quarters across from the left that runs vertically just to the inside of the Child's left eye, and a second crack that runs through his left ear. The painted surface appears to have been expanded at an early date by a quarter of an inch along the right edge. When the painting was cleaned at the Metropolitan Museum in 1982, a crude later addition bolstering the left shoulder of the Virgin was removed, revealing the original landscape beneath it.

IN A HALF-LENGTH composition, the Christ Child, loosely draped in a white cloth, is held in both arms by the Virgin. She wears a dark blue, nearly black, dress with short sleeves trimmed in fur over a garment of black and gold brocade of which one long sleeve is visible; a red mantle is draped over her head and shoulders and gathered in her lap, and a diadem with clusters of pearls adorns her forehead. She looks down to the Child, who is presented frontally and looks directly outward, smiling. In his left hand he holds a pink,[1] and with his right thumb and forefinger he holds the big toe of his right foot. The figures are set before a stone parapet beyond which is seen a sunny landscape with, to the right, a tranquil pond and part of a castle, a church steeple, bushy trees, and gently sloping hills and, to the left, a winding road, trees, and in the distance mountainous peaks.

The picture comes from the collection of the princes of Hohenzollern-Sigmaringen.[2] In the 1871 catalogue of the collection it is attributed to Rogier van der Weyden. However, J. A. Crowe and G. B. Cavalcaselle (1872), who erroneously refer to the picture as "full-length," consider the attribution an arbitrary one. In the 1883 edition of the Sigmaringen catalogue, the van der Weyden attribution is questioned, and it is noted that Ludwig Scheibler regarded the picture as more in the style of Bouts.

The present picture is almost always mentioned along

with a version of the composition that was acquired by the Kaiser-Friedrich Museum, Berlin (today the Staatliche Museen, Berlin-Dahlem), in 1896 (inv. 545c). The 1898 catalogue of the Berlin museum attributes both pictures to Bouts, but describes the Sigmaringen version as a "much weaker repetition with variant landscape and precisely corresponding figures."

Paul Heiland (1902) considers both pictures the work of an unknown follower of Bouts, whereas Pol de Mont (1909) defends the Berlin picture and considers the Sigmaringen version a replica of less merit.

Max Friedländer (1925), who, it should be remembered, was a curator at the Kaiser-Friedrich Museum, observes that the Berlin picture is "entirely in Dieric's style," but thinks that it falls just short of being autograph. He lists the present picture as "a weaker replica," along with a number of copies of markedly inferior quality (see below). In a certificate, Friedländer (1951) rates the picture "of about the same quality as the replica in the museum in Berlin." W. R. Valentiner (1945) certifies it as a "beautiful original work" by Dieric Bouts.

In his authoritative monograph, Wolfgang Schöne (1938) lists both pictures as works by a follower of Bouts, but he correctly designates as the finest surviving copy of a lost Bouts composition the Sigmaringen panel, not the Berlin work. Noting, as others had before, the rigid linearity of the Berlin landscape, Schöne considers the painting much weaker than the one from Sigmaringen. He also draws attention to a drawing of about 1480 after Bouts of a three-quarter-length Virgin and Child formerly in the Rodrigues collection, Amsterdam,[3] that he suggests reflects the lost Bouts painting from which the present picture depends. However, the connection is tenuous.

Schöne lists eight variants of the Berlin/Sigmaringen composition, including Friedländer's. His list, in turn, is emended and expanded by Hélène Adhémar (1962), who compiles thirteen pictures in all.[4] In some, a rosary or an apple has been substituted for the pink in the Christ Child's hand, and the figures are most often set against a dark or gold ground, or in an interior space rather than in a landscape. Of widely varying quality, five of these can be attributed to the Master of the Saint Lucy Legend, an anonymous late fifteenth-century Bruges artist. Nicole Veronee-Verhaegen expresses the opinion that the Linsky *Virgin and Child* is closer to the Master of the Saint Lucy Legend than is one of the pictures attributed to him by Friedländer.[5] An attribution to this master, however, is not tenable.[6]

The rather unusual motif of the Child playing with his toe may be an invention of Rogier van der Weyden's.[7] After Bouts, it was taken up not only by the Master of the Saint Lucy Legend but also by Hans Memling.[8]

The recent cleaning of the Linsky *Virgin and Child* has confirmed Schöne's opinion that it is superior to the painting in Berlin. In particular, the less dry landscape and the better integration of figure and landscape mark it as the finest surviving workshop copy of a lost Bouts from his late years 1470–75. A later date than this, however, is indicated by the style of the landscape, which was current in Flemish panel painting during the last quarter of the fifteenth century.

NOTES:

1. The pink, called *nagelbloem* in medieval Flemish because of its spikelike petals, alludes to Christ's nailing to and death on the cross. See R. A. Koch, "Flower Symbolism in the Portinari Altar," *Art Bulletin* XLVI (1964), p. 73.

2. A similar Bouts workshop *Virgin and Child* at the Metropolitan Museum (49.7.18) was also in the Sigmaringen collection.

3. Reproduced in Schöne (1938), pl. 51b.

4. Adhémar's list, to which the reader is referred, can be updated as follows: no. 3, from the V. J. Mayring collection, sold at the Galerie Fischer, Lucerne, Nov. 20, 1973, no. 252; no. 5, from a Ghent private collection, sold at Christie's, London, June 23, 1967, no. 87 (bought by Pritchard); no. 10 has a replica, not listed by Adhémar, which is attributed by M. Friedländer, *Early Netherlandish Painting*, New York, IV (1969), p. 86, Supp. 128, pl. 82, to the Master of the Embroidered Foliage. Of a number of other copies not cited by Adhémar, only one is of a quality to merit attention here: a copy of about 1500 with a gold ground and spurious Dürer monogram that, in 1971, belonged to Col. Joseph Weld, Lulworth Manor (uncatalogued photograph, "Bouts supply," in the Frick Art Reference Library, New York).

5. N. Veronee-Verhaegen in M. Friedländer, *Early Netherlandish Painting*, New York, VIb (1971), p. 131, no. 92.

6. Roberts (1982) identifies the artist of the Berlin picture as the Master of the Saint Lucy Legend, and catalogues the Linsky picture with it on Veronee-Verhaegen's authority, though with reservations. After seeing the present picture, she excluded it from the Lucy Master's oeuvre (verbal communication, June 12, 1983).

7. See the *Virgin and Child* by a follower of Rogier van der Weyden, Jamar collection, Brussels, reproduced in M. Friedländer, *Early Netherlandish Painting*, New York, II (1967), p. 86, no. 117, pl. 123.

8. See the *Virgin and Child*, Metropolitan Museum of Art, New York (49.7.22), reproduced in M. Friedländer, *Early Netherlandish Painting*, New York, VIb (1971), pp. 52–53, no. 53, pl. 100.

EX COLL.: [Bricken, Cologne, bought by A. Müller for the prince of Hohenzollern-Sigmaringen]; Prince Karl Anton von Hohenzollern-Sigmaringen (by 1868–1885); the princes of Hohenzollern, Fürstlich Hohenzollern'sches Museum, Sigmaringen (from 1885); [A. S. Drey, Munich and New York, by 1928–1929]; Ernst Rosenfeld, New York (1929–37; his estate 1937–43); Mr. and Mrs. Jack Linsky, New York (1943–80); The Jack and Belle Linsky Foundation, New York (1980–82).

EXHIBITED: Kunstausstellungsgebäude, Munich, *Ausstellung, Gemälde älterer Meister*, 1869, no. 54 (as Rogier van der Weyden, lent by the Prince of Hohenzollern); Alte Pinakothek, Munich, 1928; A. S. Drey Galleries, New York, *Exhibition of Flemish Primitives from the Collection of the Prince Hohenzollern-Sigmaringen*, 1928, no. 4 (as Dierik Bouts?); F. Kleinberger Galleries, New York, *Loan Exhibition of Flemish Primitives*, Oct. 26–Nov. 16, 1929, no. 16 (as Dirk Bouts, lent by Ernst Rosenfeld); Nelson Gallery and Atkins Museum, Kansas City, *Seventh Anniversary Exhibition of German, Flemish, and Dutch Painting*, Dec. 1940–Jan. 1941, no. 6 (as Dirk Bouts, lent by the Ernst Rosenfeld collection).

BIBLIOGRAPHY: *Fünfzig der bedeutenderen Gemälde zu Sigmaringen*, ed. F. A. von Lehner, Stuttgart, 1868, no. 34 // F. A. von Lehner, comp., *Verzeichniss der Gemälde*, Fürstlich Hohenzollern'sches Museum zu Sigmaringen, Sigmaringen, 1871, p. 12, no. 38 // J. A. Crowe and G. B. Cavalcaselle, *The Early Flemish Painters*, 2nd ed., London, 1872, pp. 225–26 // F. A. von Lehner, comp., *Verzeichniss der Gemälde*, Fürstlich Hohenzollern'sches Museum zu Sigmaringen, 2nd ed., Sigmaringen, 1883, p. 13, no. 38 // *Beschreibendes Verzeichnis der Gemälde*, Königlich Museen zu Berlin, 4th ed., Berlin, 1898, p. 38 (and subsequent editions) // P. Heiland, *Dirk Bouts und die Hauptwerke seiner Schule: Ein stilkritischer Versuch*, Potsdam [1902], p. 166 // P. de Mont, *Early Painters of the Netherlands*, trans. E. Hawke, Berlin, 1909, p. 38 // F. Winkler, *Die Altniederländische Malerei*, Berlin, 1924, p. 97 // M. Friedländer, *Die Altniederländische Malerei*, Berlin, III (1925), pp. 47–48, 126, no. 93a; *Early Netherlandish Painting*, New York, III (1968), pp. 29, 72, no. 93a, pl. 97 // "Die Fürstlich-Hohenzollernschen Sammlungen in Sigmaringen," *Pantheon* I (1928), p. 64, ill. // W. Schöne, *Dieric Bouts und seine Schule*, Berlin, 1938, pp. 136, 214–15, no. 145 // W. R. Valentiner, unpublished opinion, Feb. 26, 1951 // H. Adhémar, *Le Musée National du Louvre, Paris*, Brussels, I (1962), pp. 63–64, no. 2 (Fasc. of *Les Primitifs flamands. I, Corpus de la peinture des anciens Pays-Bas méridionaux aux quinzième siècle*) // A. Roberts, *The Master of the Legend of Saint Lucy: A Catalogue and Critical Essay*, Ph.D. diss., University of Pennsylvania, 1982, pp. 34, 238–39, no. 22a.

GCB

Attributed to
GERARD DAVID

Active by 1484, Bruges; died 1523, Bruges

ACCORDING TO the eighteenth-century chronicler Sanderus, who records Ambrosius Benson as a pupil of "Gerardi Davidis Veteraquensis," Gerard David was born in Oudewater, near Gouda, in South Holland. He is first documented in 1484, when he became a freemaster in the Bruges painters' guild. He held various official positions in the guild between 1487 and 1502, and was eventually elected *voorzitter*. Soon after 1496 he married Cornelia Cnoop, a miniaturist and the daughter of a goldsmith. An indication of his comfortable social standing is his acceptance, in 1508, as a member of the Confraternity of Our Lady of the Dry Tree, to which Hans Memling had also belonged. The "Meester Gheraet van Brugghe, scildere" who registered in the Antwerp painters' guild in 1515 may be our painter.

The only work authenticated by documents as by David is the *Virgin Enthroned with Female Saints* in the Musée des Beaux-Arts, Rouen, an altarpiece given by the artist to the Church of the Carmelite Convent of Sion in Bruges in 1509, which includes portraits of himself and his wife. Two large panels unquestionably by David in the Groeningemuseum, Bruges, *Cambyses Arresting the Judge Sisamnes* and *The Flaying of Sisamnes*, painted for the town hall of Bruges, are dated 1498.

Gerard David was the most important artist of his day in Bruges. His style reveals the influence of his predecessor Hans Memling, and especially of the Ghent painter Hugo van der Goes, whose compositions he often copied. The work of David had a profound effect on the next generation of Bruges artists—in particular, Ambrosius Benson, who appears to have worked in his shop, and Adriaen Isenbrant.

17. The Adoration of the Magi

Oil on wood. Overall 27¾ × 28⅞ in. (70.5 × 73.3 cm.); painted surface 27½ × 28⅜ in. (69.2 × 72.1 cm.)
1982.60.17

The picture is in an excellent state of preservation.

THE NAKED Christ Child, with a halo of gold rays, is the center of attention at the left. Mary holds the baby on a cloth in her lap with her right hand, and rests her left hand on the lid of a gold jar on her knee. Joseph stands behind her. The eldest magus is on both knees before her, hands clasped. The second magus, in front of him to the right, bends on one knee and opens a gold jar filled with coins. His hat lies at his feet.

The black magus is at the head of a second group of figures at the right. He strides forward, holding a gold vessel before him in the left hand and a hat by his side in the right. A dog at his feet sniffs the ground, and five of the kings' attendants stand behind him. The two at the left hold, respectively, a lance and a halberd. The attendant at the far right carries a sword and scabbard on a shoulder chain.

The two groups of figures are situated beneath a barrel vault supported by an entablature and pilasters of Renaissance design. The frieze of the entablature features putti and a monster among acanthus leaves. The end wall, in ruins, is open, giving a framed view onto the landscape. At the other side of the wall, three men stand together in conversation. Beyond them, two mounted riders water their horses at a pond beside a tall, slender tree. And in the distance, nestled at the foot of wooded hills, is a Romanesque town in front of which men, on foot and on horseback, are seen with several dogs and a camel.

In all probability, this picture is the one seen by Gustav Waagen at the 2nd Lord Northwick's Thirlestane House. Waagen suggested that although the picture was attributed there to Hubert and Jan van Eyck, it was, compared to their achievement, "a moderate work of art, painted at the earliest in 1500."[1] The picture seen by Waagen is listed as "Van Eyck, no. 172, *The Adoration of the Magi*," in the 1859 Thirlestane House sale catalogue, where its exceptional state of preservation is noted; the fairly detailed description agrees with the present picture with one exception: the architecture is described as Gothic. Number 172 was not purchased by the 3rd Lord Northwick, but rather by John Watkins Brett. In the 1864 sale of the Brett collection, the picture was attributed to

Memling. This attribution, Waagen's according to an erroneous citation in Crowe and Cavalcaselle (1872), is rejected by them. They consider the picture to be of the sixteenth century. If the present picture is the one in these references, then it must have reentered the Northwick collection after 1864.[2] It is not in the 1864 catalogue of the 3rd Lord Northwick's collection, but, according to Tancred Borenius (1921), it is the unnumbered, unattributed *Adoration of the Magi* on page twenty-eight of the 1908 reprint of the 1864 catalogue. The earliest sure documentation of the present picture is its reproduction in the 1913 portfolio of the Arundel Club, where it is listed as by Gerard David for the first time. Presumably Borenius was the source for this attribution.

Max Friedländer (1929) attributes the Linsky painting to the Master of Hoogstraeten, an anonymous early sixteenth-century Antwerp painter.[3] He suggests that the composition is a free copy after David.

When the picture was first exhibited, it drew the attention of Ellis Waterhouse (1937), who did not object to its attribution to David. However, when it was exhibited in 1956, Fritz Grossmann (1957) regarded its composition, though partly derived from works by David, as alien to the artist in its conception of space. He suggests that the picture is closer to Ambrosius Benson.

Leo van Puyvelde (1962) returns to the Master of Hoogstraeten attribution. He associates the present picture with an *Adoration of the Magi* in the Museum Mayer van den Bergh, Antwerp,[4] a triptych he saw exhibited alongside the Linsky painting in London in 1954. However, he separates these two works from the panels in the Musée Royal des Beaux-Arts, Antwerp, that came from the church of Hoogstraeten and from which the artist's name derives—paintings that Puyvelde finds of a *retardataire* style. For him, the painter of the Linsky and van den Bergh Adorations has a greater talent and must be considered an accomplished, independent follower of Gerard David.

Friedländer's attribution to the Master of Hoogstraeten is unsatisfactory. If it were correct, the picture would be by far that artist's finest achievement. Moreover, the style is totally unrelated to his eponymous work. Puyvelde's proposal of isolating the Linsky and van den Bergh Adorations is also wanting. Although these works share a similar spatial conception, the figural types—particularly the Virgins—are of divergent styles. The van den Bergh picture displays a type characteristic of the so-called Antwerp mannerists of the 1520s. The conception of the Linsky Virgin and Child, on the other hand, is totally Davidian. Micheline Comblen-Sonkes (1983) suggests the possibility that the heads of the Virgin and Child and of the two kneeling magi were repainted by Gerard David over the work of one of his followers.

The present picture is very close to two other Adorations by David—one in the National Gallery, London (inv. 1079),[5] the other in the Musées Royaux des Beaux-Arts, Brussels[6]—enough to warrant attribution of the Linsky picture to this artist. However, the depth of space here, and the style of architecture, which reveals an advanced awareness of recent architectural developments in Italy, surpass anything in David's oeuvre and argue for as late a date as possible.

A picture attributed to Ambrosius Benson that sold at Sotheby's, London, in 1964[7] copies in half-length format the five figures at the left in the Linsky painting. Benson often used Davidian models, and both pictures may reflect a lost prototype by David. Evidence for this supposition is provided by an *Adoration of the Magi* in the Groeningemuseum, Bruges.[8] Its composition corresponds precisely to that of the present picture, yet it also clearly depends from Hugo van der Goes's Monforte Altarpiece in Berlin, since it repeats exactly the left segment of the Monforte landscape. The Bruges picture seems to be an intermediary between the present picture and Hugo's, yet it is inferior in quality. A possible inference is that both the Bruges and Linsky pictures depend from a lost composition by Gerard David, perhaps a free copy after Hugo.[9]

NOTES:

1. Waagen (1854), p. 206.

2. Such was the case with other Thirlestane House pictures not bought by the 3rd Lord Northwick. See no. 25, note 5.

3. However, in a certificate dated Sept. 16, 1957, M. Friedländer termed the present picture "ein makellos erhaltenes, glückliches Werk von Gerard David."

4. See Museum Mayer van den Bergh, *Catalogus 1, Schilderijen, Verluchte Handschriften, Tekeningen*, 3rd ed., ed. J. de Coo, Antwerp, 1978, p. 97, no. 365, pl. 25.

5. Reproduced in M. Friedländer, *Early Netherlandish Painting*, New York, VIb (1971), p. 103, no 182, pl. 193.

6. Ibid., p. 103, no. 180, pl. 191.

7. Sale, Sotheby's, London, June 24, 1964, no. 6; see G. Marlier, *Ambrosius Benson et la peinture à Bruges au temps de Charles-Quint*, Damme, 1957, p. 289, no. 28.

8. By an anonymous Bruges artist from the first quarter of the sixteenth century. See D. de Vos, *Catalogus Schilderijen 15de en 16de Eeuw*, Stedelijke Musea Brugge, Bruges, 1979, pp. 39–41, inv. O.213.

56

9. An *Adoration of the Magi* by David in the Alte Pinakothek, Munich (inv. 118), is a copy after another lost Hugo composition. For another instance of David copying Hugo see no. 22, note 4.

EX COLL.: Probably John Rushout, 2nd Lord Northwick, Thirlestane House, Cheltenham (by 1854–1859; sale, Phillips', London, July 27, 1859, no. 172, as Van Eyck, to John W. Brett, Esq); probably John Watkins Brett, London (1859–64; sale, Christie's, London, Apr. 9, 1864, no. 858, as J. Hemmelinck); George Rushout Bowles, 3rd Lord Northwick, Northwick Park, Gloucestershire (until 1887); his widow, Elizabeth Augusta Bowles, Lady Northwick, Northwick Park (1887–1912); her grandson, Capt. E. G. Spencer-Churchill, Northwick Park (1912–64; sale, Christie's, London, May 28, 1965, no. 41, as Gerard David); [Julius Weitzner, New York, 1965]; Mr. and Mrs. Jack Linsky, New York (1965–80); The Jack and Belle Linsky Foundation, New York (1980–82).

EXHIBITED: Burlington Fine Arts Club, London, *Winter Exhibition*, 1936–37, no. 14 (as Gerard David, lent by Capt. E. G. Spencer Churchill); Royal Academy of Arts, London, *Flemish Art 1300–1700*, Dec. 5, 1953–Mar. 6, 1954, no. 39 (as Gerard David, lent by Capt. E. G. Spencer Churchill); Groeningemuseum, Bruges, *L'Art flamand dans les collections britanniques et la Galerie Nationale de Victoria*, Aug.–Sept. 1956, no. 26 (as Gerard David, lent by Capt. E. G. Spencer Churchill).

BIBLIOGRAPHY: G. Waagen, *Treasures of Art in Great Britain*, London, 1854, III, p. 206 // J. A. Crowe and G. B. Cavalcaselle, *The Early Flemish Painters*, 2nd ed., London, 1872, p. 298 // *A Catalogue of the Pictures, Works of Art, &c. at Northwick Park*, 1908 reprint with additions of 1864 edition, p. 28 // *Arundel Club* (1913), no. 9 // T. Borenius, comp., *Catalogue of the Pictures at Northwick Park*, London, 1921, p. 58, no. 121 // M. Friedländer, *Die Altniederländische Malerei*, Berlin, VII (1929), p. 134, no. 111; *Early Netherlandish Painting*, New York, VII (1971), p. 73, no. 111, pl. 86 // E. Waterhouse, "The Winter Exhibition at the Burlington Fine Arts Club," *Burlington Magazine* LXX (1937), p. 45 // F. Grossman, "Flemish Paintings at Bruges," *Burlington Magazine* IC (1957), p. 4 // M. Friedländer, unpublished opinion, Sept. 16, 1957 // L. van Puyvelde, *La Peinture flamand au siècle de Bosch et Breughel*, Paris, 1962, p. 365 // P. Lindsay, in *Great Private Collections*, ed. D. Cooper, New York, 1963, p. 43 // M. Comblen-Sonkes, unpublished opinion, Oct. 11, 1983.

GCB

FLEMISH PAINTER, UNKNOWN

About 1490

18. Saint Donatian

Oil on wood. 9½ × 3⅞ in. (24.1 × 9.8 cm.)
1982.60.18

19. A Warrior Saint, probably Maurice, Presenting a Donor

Oil on wood. 9½ × 4 in. (24.1 × 10.2 cm.)
1982.60.19

These panels are in an excellent state of preservation despite the fact that each has been cut down on all four sides.

IN ONE panel Saint Donatian, bishop of Rheims, who was martyred in 309, is represented facing to the right before an open window. He wears a jewel-encrusted miter and an embroidered cope, and holds a cruciform crosier with a crystal rod in one hand and a wheel set with candles around its rim in the other. According to legend, Saint Donatian's drowned body was found in the Tiber when a wheel studded with candles that had been set afloat downstream miraculously came to a halt over the corpse.

In the other panel a warrior saint presents a tonsured ecclesiastic, who kneels before him. The saint wears a woolen cap, and an embroidered cloak with ermine lapels draped over his armor. He holds a lance from which is suspended a blue pennon bearing an emblem in yellow composed of six fleurs-de-lys radiating from a circle. The emblem indicates that the saint represented is probably Maurice. Similar emblems are found in at least two contemporary works of art.[1] In a panel by the Master of Moulins in the Glasgow Art Gallery and Museum, Kelvingrove, a donor is presented by a warrior saint, identified as Victor or Maurice, who carries a red shield bearing a similar emblem, a gold escarbuncle with eight fleurs-de-lys.[2] One of three saints presenting King René of Anjou in Nicolas Froment's Burning Bush Triptych in the Cathedral of Saint-Sauveur, Aix-en-Provence, is a knight carrying a red banner with an emblem in gold also terminating in eight fleurs-de-lys.[3] He is certainly Maurice, patron saint of the chivalric order founded by René and commander of the Theban Legion, who was martyred with his troops in 287 in Gaul, hence the fleurs-de-lys.

The present panels may have been cut down from the wings of a small devotional triptych, or they may be fragments from a single panel. In either case the saints surely flanked a seated Virgin and Child, to whom the donor is presented by his patron saint. The cropped wooden ledge in the lower right corner of the *Donatian* fragment, probably the arm of a seat, argues for a single panel, as does the fact that such a composition would certainly appear to have been inspired by Jan van Eyck's *Madonna with Canon van der Paele*, in the Groeningemuseum, Bruges (inv. 0.161), where an enthroned Virgin and Child are flanked by Saint Donatian on the left and a warrior saint presenting a kneeling ecclesiastic on the right.[4]

Although a former attribution to Simon Marmion of these panels is untenable, it points to the problem they pose. A number of works exhibiting a strong influence of the Ghent/Bruges school of painting have been attributed to Marmion, a painter documented as active in northern France. The clear, bright colors and the simplified conception of composition in the present panels are characteristic of late fifteenth-century northern French painting. The possibility of a French origin is supported by the inclusion of a figure thought to be Maurice, a saint venerated primarily in France. However, these same qualities are not uncommon in works by anonymous minor masters of the Ghent/Bruges school. The voluminous modeling of the faces indicates a Flemish painter, and the influence of the van Eyck *Madonna* suggests a painter in Bruges, where the cathedral was dedicated to that town's patron saint, Donatian.

NOTES:
1. Kindly brought to the author's attention by Micheline Comblen-Sonkes.
2. For the identification of the Glasgow saint and donor, see *Paintings from Glasgow Art Gallery* (exhib. cat.), London, Wildenstein and Co., 1980, pp. 13–14, no. 20.
3. See G. Ring, *A Century of French Painting 1400–1500*, London, 1949, p. 238, no. 301, pl. opp. p. 236. The same emblem, though dark and on a light field, appears on the banner and breast of a warrior saint, identified as Maurice (?), on the left wing of a triptych by the fifteenth-century German Master of the Holy Kinship in the Staatliche Museen, Berlin (DDR), *Beschreibendes Verzeichnis der Gemälde im Kaiser-Friedrich-Museum und deutschen Museum*, 9th ed., Berlin, 1931, p. 301, inv. 578B, ill. p. 88 of plate volume.
4. See D. de Vos, *Catalogus Schilderijen 15e en 16e Eeuw*, Stedelijke Musea Brugge, Bruges, 1979, pp. 220–25.

EX COLL.: Mr. and Mrs. Jack Linsky, New York (until 1980); The Jack and Belle Linsky Foundation, New York (1980–82).

GCB

JUAN DE FLANDES

Active by 1496, Toro; died 1519, Palencia

A JUAN DE FLANDES was employed by Isabella the Catholic, queen of Castile, in 1496 and from 1498 until her death in 1504. This artist is identifiable with the Juan de Flandes who undertook to paint pictures for altarpieces for the chapel of Salamanca University in 1505 and for Palencia cathedral in 1509. The latter, thoroughly documented, is secure basis for attribution of a body of work to Juan de Flandes. Juan de Flandes is not identical with Juan Flamenco, documented at the charterhouse of Miraflores from 1496 to 1499.

The name for this artist is less specific than it would appear. His family name is not known, but in Spain he was called John of Flanders. The implication that he came from the Lowlands is validated by the thoroughly Flemish style of the few works that have been identified as his. He appears to have been trained in Bruges or Ghent. Gerard David seems to have exerted the greatest influence, though an early work, the *Adoration of the Magi* in the parish church of Cervera de Pisuerga, is markedly influenced by Hugo van der Goes and, possibly, by the Master of Moulins.

20. The Marriage Feast at Cana

Oil on wood. 8¼ × 6¼ in. (21 × 15.9 cm.)
1982.60.20

The painting is in a near excellent state of preservation. There are minor paint losses and inpainting along a crack that runs the length of the oak panel 1¾ inches from the left along the right edge of the second pilaster, and a second crack that extends downward about 1¾ inches from top center. What appears to be a highlight in the center of the mirror's reflection is a missing chip of paint. The two foreground pilasters are abraded. Some streaks of paint in the coffered ceiling are overpainting. The right eye of the bride is repainted over a small wormhole. A few irregular spots on the picture's surface, as on the table at the wine steward's elbow, seem to be the result of minor heat damage such as a candle burn. The gilded border of about ⅛ inch is a later addition. Remains of eight small holes drilled after the picture was painted are found at the four corners and at the middle of each side.

Examination by infrared reflectograph reveals lively underdrawing, with numerous changes in the

composition: Instead of the potted plant at the lower left corner there was originally a floppy-eared dog, and on the table were a loaf of bread before Christ, a charger in place of the jar, and a knife on the napkin that hangs over the table's edge. The back wall was ornamented by an arch supported by two squat attached pilasters surmounted by statues of two nude youths holding between them what appears to be a banner or swag. The changes introduced in the final picture have the effect of reducing the genrelike aspects of the scene.

THE MARRIAGE FEAST is set at a sparsely laid table in a loggia open at the left through five classicizing pilasters. Christ, seated on a bench at the table, blesses the water being poured from a pitcher into one of four large pots by the wine steward at the right, thereby enacting the first of his miracles, the changing of the water into wine. The Virgin, who has called attention to the lack of wine, is seated beside him and looks in his direction, her hands in prayer. At the far side of the table, the groom and bride face each other, a cloth of honor and a bull's-eye mirror hanging on the stone wall behind them. The groom gestures with his right hand, and the bride, like Mary, holds her hands in prayer. The bearded man at the picture's right edge, carrying a large covered cup, is probably the master of the feast, who, upon tasting the wine, complimented the groom for having saved the best until last. The man at the far left, partly visible behind a column outside the loggia, engages the viewer's glance directly as he pulls his mantle across his shoulder, and is thought to be a self-portrait. The asymmetry and cropping of the composition suggest that the feast extends beyond the pictorial frame; and indeed, the two other water pots and the disciples described in the Gospel are not visible.

The miracle at Cana was the first manifestation of Christ's divine powers, and the story of it in the Gospel (John 2:1–11) became at an early date a part of the liturgy for the feast of Epiphany. The event is also important as a prefiguration of the institution of the Eucharist at the Last Supper. The marriage at Cana was popularly believed in the late Middle Ages to be that of John the Evangelist to Mary Magdalen, and judging by the apostle-like groom depicted here, this tradition was apparently followed by the artist. Indeed, in an inventory of the estate of Isabella the Catholic, dated February 25, 1505, the picture is described as "the nuptials of Saint John in the house of the master of the feast" ("las bodas de sant Juan en casa de archit[r]iclino").[1]

The *Marriage Feast at Cana* is one of forty-seven small panel paintings—with scenes from the life of Christ and of the Virgin, and depictions of saints—listed in the 1505 inventory.[2] According to contemporary marginal annotations made by a notary, ten of the panels were purchased by the Marquesa de Denya. On March 13, 1505, thirty-two of these, including the present picture, were bought by Diego Flores, who served in various capacities, including treasurer, for Margaret of Austria, regent of the Netherlands.[3] According to these two records of sale, five of the forty-seven panels were not purchased.[4] Thirty-two panels, presumably those bought by Flores, are mentioned though not itemized in an inventory of the contents of the palace of Margaret of Austria in Malines dated July 17, 1516. Thirty of these were "in a deal coffer, where there had been thirty-two, but the two that were made by the hand of Michel [Michiel Sittow] were removed in order to make a diptych."[5]

On June 7, 1521, Albrecht Dürer saw the panels in Malines. He wrote of them in his journal, "On Friday Lady Margaret showed me all her beautiful things. Among them I saw about forty small panels painted in oil, the likes of which I have never seen for purity [*reinigkeith*] and quality [*güth*]."[6]

A second inventory of the palace in Malines, dated July 9, 1523, mentions only twenty-two panels in the deal coffer, but here they are itemized and the *Marriage Feast* is one of them.[7] Evidently, eight of the panels in addition to the two taken for the Sittow diptych had been dispersed by this date. At Margaret's death in 1530, the panels must have passed to her residuary and legatee, Charles V. He sent twenty of them to Spain, including the *Marriage Feast*, incorporated in a lavishly framed portable altarpiece as a gift for his empress, Isabella of Portugal. It comprised eighteen panels in a silver-gilt frame, surmounted by two others, not specified, similarly framed.[8]

The altarpiece is described in more detail in an inventory made at the Palacio Real, Madrid, in 1598, at the death of Philip II, heir of Charles V.[9] The eighteen pictures were arranged in a diptych format, nine on each panel, and the frame is said to have included the coat of arms of Margaret of Austria. Their subjects are specified (although the *Mocking of Christ* is omitted by error), and the two pictures surmounting the diptych are identified. They are the *Marriage Feast at Cana* (described as "las bodas del architiclino") and the *Temptation of Christ*. These last two next appeared in the sale of the Prince of Fondi's collection in 1895, having been separated from the fifteen

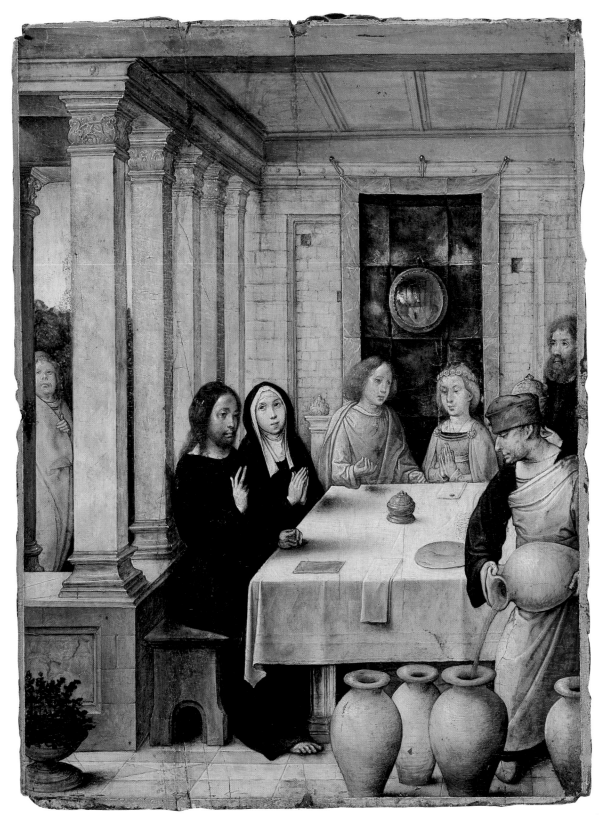

61

now in the Museo del Palacio Real, Madrid, by 1857 at the latest. It has been suggested that they may have entered the collection of the first Prince of Fondi in 1759.[10]

In the records of the panels bought by the Marquesa de Denya and by Diego Flores, there are various conflicts, confusions, and omissions. The pictures bought by Diego Flores are listed in almost exactly the same order that they appear in the 1505 inventory; there are two minor inversions and perhaps one exception, the *Feeding of the Five Thousand.* The *Christ Crowned with Thorns (La coronaçion despinas)* appears to be another glaring displacement. It is the thirty-first item on the list of pictures bought by Flores, but in the 1505 inventory, where it appears seventeenth, a marginal annotation records it as a purchase by the marquesa.[11] The three preceding items on Flores's list must correspond to the forty-fourth to forty-sixth items in the 1505 inventory. Is it possible that the forty-seventh item in the 1505 inventory, the *Coronation of the Virgin (La coronaçion de nuestra Señora),* corresponds to the thirty-first item on Flores's list, *La coronaçion despinas,* and that the notary made an error?[12] If *Christ Crowned with Thorns* was not purchased by Flores, it would explain how it is possible that it surfaced at the beginning of this century in Berlin together with *Christ Alone Appearing to the Virgin,* a panel not recorded as bought by Flores.[13] It is not possible to trace the so-called *Coronaçion despinas* (the *Coronation of the Virgin?*) after its purchase by Flores, since it is one of the eight panels not mentioned in the next specific inventory, that of 1523.

The 1516 inventory documents that two of the panels from this series, the *Assumption of the Virgin* and the *Ascension,* are by Michiel Sittow, a painter trained in Bruges who entered Isabella's service in 1492. A third panel, the *Coronation of the Virgin,* has been attributed to him on stylistic grounds. No other artist's name is found in the documents for the majority of the panels that survive.[14] The fifteen panels in Madrid were first attributed to Juan de Flandes by J. A. Crowe and G. B. Cavalcaselle.[15] Carl Justi convincingly supports the attribution by comparison with the altarpiece in Palencia, and this attribution has been extended to all the related panels discovered subsequently.[16] Sánchez Cantón, however, notes that some of the panels are inferior in quality, which he views as evidence that more than one artist was responsible for their execution.[17] MacLaren suggests that possibly as many as five different hands are distinguishable among the surviving panels.[18] The general consensus is to isolate as by an inferior artist the following panels: *Christ Calming the Storm, Christ in the House of Simon,* the *Last Supper,* the

Agony in the Garden, the *Betrayal,* the *Mocking of Christ, Christ Before Pilate,* and *Christ Alone Appearing to the Virgin.* MacLaren assigns *Christ and the Redeemed Appearing to the Virgin* to the workshop of Juan de Flandes because its style seems to him distinct from that of the group most closely related to the Palencia altarpiece. The *Marriage Feast at Cana* undoubtedly belongs to the superior group; that it is one of the finest of the surviving panels has never been questioned.

The original arrangement of the forty-seven panels commissioned by Isabella is not known. In the 1505 inventory they are said to be "en un armario," which is probably best translated as "in a cupboard." Because it would be difficult to put forty-seven panels in a harmonious arrangement, it seems likely that they were stored in the cupboard rather than mounted on its doors. The awkward number also leads one to suspect that the series was not completed at the queen's death, a suspicion that is all but verified by the fact that the 1505 inventory does not include a Resurrection, certainly a requisite subject for such an extensive cycle of the life of Christ.[19] A further indication that the project may have been cut short is the fact that Juan de Flandes was actively employed by Isabella until she died, in November 1504; he received his last payment on February 25, 1505. That no final arrangement for the panels was realized is supported by the dispersal of the panels by sale shortly after the queen's death.

H. Isherwood Kay (1931), later cited by E. Bermejo (1962), suggests that a dispersed series with scenes from the life of Christ by Bernardo Butinone, a Milanese artist active between 1484 and 1507, may have served as a model for the Juan de Flandes cycle. However, though similar in format, of the fourteen or fifteen panels identified from the Butinone series, only two agree in subject with known panels from the series by Juan de Flandes: the *Marriage Feast at Cana,* in the Borromeo collection, Milan, and *Christ in the House of Simon,* in the Manning collection, New York.[20] The Cana scenes are not compositionally related, and the similarity of the two depictions of *Christ in the House of Simon,* though striking, is insufficient to establish a connection between the two artists.

C. M. Kauffman observes that there are close compositional similarities between many of the panels by Juan de Flandes and miniatures in the Breviary of Queen Isabella (British Library, Add. ms. 18851), particularly the scenes of the *Temptation of Christ* and of the *Entry into Jerusalem,* which are nearly identical.[21] The breviary, produced in Bruges, was given to Isabella, probably in 1497, by Francisco de Rojas, Spanish ambassador to Flanders.

If the manuscript served as a partial model for Juan de Flandes, it would elucidate the relationship, often noted, between the style of the panels and that of book illumination.

Juan de Flandes's connection to the school of Bruges, as opposed to the school of Ghent, is also underscored by the apparent influence of Gerard David. All the salient compositional features of the *Marriage Feast*—the asymmetric arrangement with colonnade at the left; the positioning of Christ and the Virgin, the groom and bride, and the wine steward and master of the feast; even the inclusion of a portraitlike figure outside the loggia—are found in Gerard David's *Marriage Feast at Cana* in the Louvre, Paris. The present picture appears to be a stripped-down redaction of the one by David. Perhaps the same model inspired both artists, but the connection may be more direct. The Louvre picture was most probably commissioned by Jan de Sedano, a member of the Spanish community in Bruges. The latest possible date for the present picture is 1504, and the earliest possible date for the Louvre picture is 1501, though there is evidence that an earlier treatment of the subject by David, today lost, was made before 1499.[22] It is therefore conceivable that Juan de Flandes, during his apprenticeship in Flanders, was familiar with David's work, which then served as a model for the *Marriage Feast at Cana*.

NOTES:

1. For the best transcription of this document, see Davies (1970), pp. 14–15. The *Marriage Feast at Cana* is twenty-fifth on the list.

2. Twenty-eight of the forty-seven panels have been identified. They are, approximately in the chronological order in which they were recognized, *Christ Calming the Storm on the Sea of Galilee, Christ in the House of Simon,* the *Feeding of the Five Thousand, Christ and the Woman of Canaan,* the *Transfiguration,* the *Raising of Lazarus,* the *Entry into Jerusalem,* the *Betrayal, Christ Before Pilate,* the *Mocking of Christ,* the *Descent into Limbo,* the *Three Marys at the Sepulchre, Christ Appearing to the Magdalen,* the *Supper at Emmaus,* and the *Descent of the Holy Spirit,* all Museo del Palacio Real, Madrid; the *Last Supper,* Wellington Museum, Apsley House, London; *Christ and the Redeemed Appearing to the Virgin,* National Gallery, London; the *Temptation of Christ,* National Gallery of Art, Washington, D.C.; the *Marriage Feast at Cana,* Metropolitan Museum of Art, New York; *Christ Alone Appearing to the Virgin,* Staatliche Museen, Berlin (DDR); *Christ Crowned with Thorns,* Detroit Institute of Arts; *Christ Carrying the Cross* and *Christ Nailed to the Cross,* Kunsthistorisches Museum, Vienna; the *Assumption of the Virgin,* National Gallery of Art, Washington, D.C.; *Christ and the Woman of Samaria,* Louvre, Paris; the *Agony in the Garden,* M. Lindenmeyer-Christ collection, Basel; the *Ascension,* Earl of Yarborough, Brocklesby Park, Habrough, Lincolnshire; and the *Coronation of the Virgin,* Louvre, Paris. No further panels have

been identified since 1931. The *Baptism,* in the monastery of Guadalupe, and the *Circumcision,* in the Hirsch collection, Buenos Aires, both cited by Winkler (1926), have been excluded by all recent scholars.

3. For the best transcription of the document that records this sale, see Davies (1970), pp. 16–17. The *Marriage Feast at Cana* is the third item on fol. 4ro. Diego Flores should not be confused, as he sometimes is, with Diego de Guevara.

4. Sánchez Cantón (1930), p. 103, mistakenly counts three. Mac Laren (1952), p. 25, presumably accepting Sánchez Cantón's proposal of purchase by the marquesa of *Christ Carrying the Cross* (see note 11 below), counts four.

5. J. Finot, *Inventaire sommaire des Archives départementales antérieures à 1790, Nord. Archives civiles. Série B: Chambre des comptes de Lille,* Lille, VIII (1895), p. 211.

6. J. Veth and S. Muller, *Albrecht Dürers niederländische Reise,* I: *Die Urkunde über die Reise,* Berlin, 1918, p. 84.

7. H. Michelant, "Inventaire des vaisselles, joyaux, tapisseries, peintures, manuscrits, etc., de Marguerite d'Autriche, régente et gouvernante des Pays-Bas, dressé en son palais de Malines, le 9 juillet, 1523," *Académie Royal des Sciences des Lettres et des Beaux-Arts de Belgique. Commission Royale d'Histoire. Bulletin* ser. 3, XII (1870), pp. 89–90. The *Marriage Feast at Cana* is no. 6, as "comme N^re S^gr transmua l'eau en vin en une nopces."

8. For a transcription of this undated document, see Sánchez Cantón (1930), pp. 107–8. The twenty panels comprising this diptych are listed in the same order as in the 1523 inventory; the *Marriage Feast at Cana* is no. 6. The two panels excluded are the only non-narrative ones, i.e., *Saints Michael and Gabriel* and *Saints John, James, Peter, and Paul.* It is tempting to suppose that the gilded border added to the *Marriage Feast at Cana* dates from this arrangement. However, other panels from the series, known not to have been part of the diptych or even to have been purchased by Diego Flores, have similar borders; for example; *Christ Alone Appearing to the Virgin, Christ and the Woman of Samaria,* and *Christ Carrying the Cross.* Is it possible that the gilded borders antedate the panels' dispersal in 1505? It is likely, however, that the eight holes around the perimeter of the present panel date from this arrangement. At least two of the other panels from the diptych, the *Last Supper* and the *Temptation of Christ,* have similar holes. A detailed comparative study of the physical aspects of the surviving panels remains to be done.

9. Sánchez Cantón (1930), p. 108.

10. Sale catalogue, Christie's, London, June 23, 1967, no. 33.

11. Sánchez Cantón (1930), p. 100, presumes that the notary erred when annotating *Christ Crowned with Thorns* as a purchase of the Marquesa de Denya. He suggests the following item, *Christ Carrying the Cross,* should have been marked. There is no recorded buyer for this picture, yet it surfaced in Vienna at the beginning of this century together with *Christ Nailed to the Cross,* a recorded purchase of the marquesa. It is possible, however, that both *Christ Crowned with Thorns* and *Christ Carrying the Cross* were bought by her.

12. It appears that other titles are confused on the list of Flores's purchases. To judge again by the order, but also by respective evaluations, the twenty-sixth item, *Como subio a los çielos,* given a higher value than the thirtieth, *La Asençion,* does not

correspond to the *Assumption of the Virgin* (*La asumpción de nuestro* [sic] *Señora*) in the 1505 inventory, as is usually thought, but rather to the *Ascension* (*Como subió a los çielos Christo*), which is given a higher value than the *Assumption of the Virgin*. The thirtieth item, *La Asençión*, would then correspond to *La asumpción de nuestro Señora*.

13. It seems, then, that *Christ Alone Appearing to the Virgin* was a purchase by the marquesa that the notary, apparently not a completely reliable authority, failed to annotate. The *Ascension* is listed as one of Flores's purchases, and this must be correct since it passed to Margaret of Austria. Yet it is recorded, evidently erroneously, as bought by the marquesa.

14. MacLaren (1952), p. 43, records that the backs of two of the panels in Madrid are inscribed, apparently in a sixteenth-century hand, "Juan Astrat," and "Juᵒ Astrat." He infers that these may be Spanish renderings of the Netherlandish name Jan Straat or Straten, although no artist with this name has been found in contemporary archival sources.

15. J. A. Crowe and G. B. Cavalcaselle, *The Early Flemish Painters*, London, 1857, pp. 284–85.

16. C. Justi, "Juan de Flandes: Ein Niederländischer Hofmaler Isabella der Katholischen," *Jahrbuch der Königlich Preussischen Kunstsammlungen* XVIII (1887), pp. 157–69. For the Palencia altarpiece, see I. Vandevivere, *La Cathédrale de Palencia et l'église paroissiale de Cervera de Pisuerga*, Brussels, 1967, pp. 1–81, pls. I–CXCa (Fasc. of *Les Primitifs flamands. I, Corpus de la peinture des anciens Pays-Bas méridionaux au quinzième siècle*).

17. Sánchez Cantón (1930), pp. 117–18, 127.

18. MacLaren (1952), p. 23.

19. The fact that *Christ with the Redeemed Appearing to the Virgin* and *Christ Alone Appearing to the Virgin* nearly duplicate each other has caused some speculation that all the panels were not intended for a single series. A. Braham, in MacLaren (1970), p. 43, suggests that the latter may have been intended as a replacement for the former, which was perhaps deemed compositionally unsatisfactory.

20. The panels are reproduced in M. Salmi, "Bernardo Butinone: I," *Dedalo: Rassegna d'Arte* X (1929–30), pp. 349 and 348, respectively.

21. C. M. Kauffman, *Catalogue of Paintings in the Wellington Museum*, London, 1982, p. 79. For the breviary see T. Kren, ed. *Renaissance Painting in Manuscripts: Treasures from the British Library* (exhib. cat.), Malibu, J. Paul Getty Museum, 1983–84, no. 5, pp. 40–48.

22. For the problems surrounding the donor and dating of the Louvre *Marriage Feast at Cana*, see H. Adhémar, *Le Musée National du Louvre, Paris*, Brussels, 1962, pp. 109–10, 125–27 (Fasc. of *Les Primitifs flamands. I, Corpus de la peinture des anciens Pays-Bas méridionaux au quinzième siècle*).

EX COLL.: Isabella, queen of Castile, Castle of Toro, province of Zamora (until 1504); Diego Flores, probably as agent for Margaret of Austria (1505); Margaret of Austria, regent of the Netherlands, Malines (by 1516–1530); her nephew Charles V, Holy Roman Emperor and (as Charles I) king of Spain (1530–58); his son Philip II, king of Spain, Palacio Real, Madrid (1558–98); Oderisio di Sangro, prince of Fondi, Naples (until 1895; sale, Galerie Sangiorgi, Palazzo Borghese, Rome, May 1, 1895, no. 738bis, as "école Bolonaise du XVIIe siècle"); [Stefano Bardini, Florence, until 1899]; Vernon J. Watney, Corn-

bury Park, Charlbury, Oxfordshire (1899–1928); his son Oliver Vernon Watney, Cornbury Park (1928–67; sale, Christie's, London, June 23, 1967, no. 33, as Juan de Flandes, to Linsky); Mr. and Mrs. Jack Linsky, New York (1967–80); The Jack and Belle Linsky Foundation, New York (1980–82).

EXHIBITED: Royal Academy, London, *Winter Exhibition*, 1908, no. 9 (as Gerard David, lent by Vernon Watney, Esq.).

BIBLIOGRAPHY: C. Justi, *Miscellaneen aus drei Jahrhunderten Spanischen Kunstlebens*, Berlin, 1908, I, pp. 318–19 // E. Bertaux, in Commission royale du centenaire des sièges de 1808–1809, *L'Exposition rétrospective d'art, 1908*, Saragossa, 1910, p. 80 // A. L. Mayer, *Geschichte der Spanischen Malerei*, Leipzig, 1913, I, p. 149 (rev. ed., 1922, p. 148) // V. J. Watney, *A Catalogue of Pictures and Miniatures at Cornbury Park and 11 Berkeley Square*, Oxford, 1915, no. 56 // J. Veth and S. Muller, *Albrecht Dürer's Niederländische Reise*, II: *Geschichte der Reise*, Berlin, 1918, pp. 81–83, ill. p. 82 // G. Glück, ed., *Die Gemäldegalerie des Kunsthistorischen Museums in Wien*, Vienna, 1925, p. 171 (Eng. ed., p. 170; 3rd enl. ed., 1931, p. 207; 3rd enl. ed., in English p. 206) // F. Winkler, in *Allgemeines Lexikon . . .*, ed. U. Thieme and F. Becker, Leipzig, XIX (1926), p.279 // Kunsthistorisches Museum, *Katalog der Gemäldegalerie*, Vienna, 1928, I, p. 111 (2nd ed., 1938, I, p. 85; 3rd ed., 1963, I, p. 79) // M. Friedländer, "Juan de Flandes," *Der Cicerone* XXII (1930), pp. 2–3 // F. J. Sánchez Cantón, "El retablo de la Reina Católica," *Archivo Español de Arte y Arqueología* VI (1930), pp. 109, 120, pl. I [rev. *Gazette des Beaux-Arts* ser. 6, VI (1931), p. 319] // H. I. Kay, "Two Paintings by Juan de Flandes," *Burlington Magazine* LVIII (1931), pp. 197–201 // *Beschreibendes Verzeichnis der Gemälde im Kaiser-Friedrich-Museum und Deutschen Museum*, 9th ed., Berlin, 1931, p. 232 // F. J. Sánchez Cantón, "El retablo de la Reina Católica (Addenda et corrigenda)," *Archivo Español de Arte y Arqueología* VII (1931), pp. 149–50, pl. I [rev. *Gazette des Beaux-Arts* ser. 6, VII (1932), pp. 167–68] // G. Hulin de Loo, "Juan de Flandes," in *Trésor de l'art flamand du Moyen Age au XVIIIᵉ siècle: Mémorial de l'exposition d'art flamand ancien à Anvers 1930*, Paris, 1932, I, p. 51 // C. R. Post, *A History of Spanish Painting*, Cambridge, Mass., IV, I (1933), p. 38 n. I // F. J. Sánchez Cantón, *Libros, tapices y cuadros que coleccionó Isabel la Católica*, Madrid, 1950, p. 186 // N. MacLaren, *The Spanish School, National Gallery Catalogues*, London, 1952, pp. 24–25 (2nd ed., rev. by A. Braham, 1970, pp. 45, 46) // A. Gaya Nuño, *La pintura española fuera de España*, Madrid, 1958, p. 147, no. 751 // E. Bermejo, *Juan de Flandes*, Madrid, 1962, pp. 12–13, 41, pl. 2 // C. Eisler "The Sittow Assumption," *Art News* 64 (Sept. 1965), p. 53 // "The Sale Room," *Apollo* n.s. LXXXVI (Sept. 1967), pp. 245–46, fig. 5 // "Les Cours des Ventes," *Connaissance des Arts* no. 190 (1967), p. 133, fig. 5 // N. Reynaud, "Le Couronnement de la Vièrge de Michel Sittow," *La Révue de Louvre* XVII (1967), p. 346 n. 6 // M. Davies, *The National Gallery London*, Brussels, III (1970), p. 9 (Fasc. of *Les Primitifs flamands. I, Corpus de la peinture des anciens Pays-Bas mèridionaux au quinzième siècle*) // A. Tzeutschler Lurie, "Birth and Naming of St. John the Baptist Attributed to Juan de Flandes: A Newly Discovered Panel from a Hypothetical Altarpiece," *Bulletin of the Cleveland Museum of Art* LXIII (1976), p. 123.

GCB

Attributed to
JAN PROVOST

Active by 1491, Valenciennes; died 1529, Bruges

PROVOST MAY have received his earliest training from Jacquemart Pilavaine, a manuscript illuminator whose workshop was in the town of Provost's birth, Mons. It is likely that he moved to Valenciennes before 1489, the year of Simon Marmion's death, since two years later he married Marmion's elderly widow. This was not an uncommon way of assuming professional control of an artist's workshop. The Jan Provost who was admitted as a free-master in the Antwerp painters' guild in 1493 may be our artist. Provost became a citizen of Bruges in 1494 and remained there until his death. He married a second time in 1506. In 1520 he met Albrecht Dürer in Antwerp during the German artist's travels through the Lowlands, and in April 1521 he accompanied Dürer to Bruges and lodged him in his house.

The only extant documented work by Jan Provost is the Last Judgment Altarpiece in the Groeningemuseum, Bruges (inv. 0.117). The artist's entire oeuvre has been reconstructed on the basis of stylistic comparison with this altarpiece, one of his latest works if not the last, which has given rise to many problems of attribution and dating.

21. The Crucifixion

> Oil on wood. Overall 13⅛ × 10¾ in. (33.3 × 27.3 cm.); painted surface 12⅝ × 10¼ in. (32.1 × 26 cm.)
> Inscribed (top center, on cross): INRI
> 1982.60.21

The state is exceptionally fine. A pentiment is visible at the lower left in Saint John's white mantle, which originally billowed out and back inward in a smooth curve rather than, as here, folding back to display a right-angled corner. The picture has been cradled and backed since 1930, and wooden strips were added along all four sides, entirely concealing the original support. It appears that at the same time, the painted surface was expanded about a ¼ inch at the top and bottom to mask the unpainted edges of the original support. The dimensions of the original painted surface are 12⅛ × 10 in. (30.8 × 25.4 cm.). The diagonal striated craquelure and the thick impasto are not characteristic of panel painting. It is possible that the picture is on a canvas or parchment support laid down on wood.

CHRIST, HALOED and wearing the crown of thorns and a loincloth, is seen on the cross in the center foreground under a dark gray clouded sky. At the left Saint John supports the swooning Virgin, and at the right Mary Magdalen embraces the cross. Behind her one of the Marys, shrouded in a red mantle, sits weeping, her back to the scene. A human jawbone, a rib, and a third bone are strewn about on the ground. In the middle ground, beyond a hill, a procession of soldiers with lances winds around a second hill. The background is filled by a walled Gothic city. At the right a large arched opening permits a view of the Annunciation in an interior chamber.[1]

When this painting appeared in the 1883 Nieuwenhuys sale, it was catalogued as by "Gerard vander Meire." Two falsely signed works provided the basis in the nineteenth century for attributing any number of works to this artist, documented as active in Brussels and Ghent in the second half of the fifteenth century, but to whom no works can be plausibly assigned.[2] Otto Pächt first called the picture an early work by Jan Provost when it was exhibited in Vienna in 1930.[3] The attribution is accepted by Ludwig Baldass (1930) and, with some hesitation, by Hans Tietze (1930), who agrees that the picture has the characteristics of a youthful work, but notes that knowledge of Provost's oeuvre is derived almost entirely from works of his maturity.

Max Friedländer (1931) fully endorses Pächt's opinion and recognizes in the painting Provost's earliest identifiable work, giving it a date of 1490–1500. He associates it with a *Crucifixion*, one of three panels now in the Saint Louis Art Museum (74:1950), that he dates about 1505.[4]

Recent scholarly opinion tends to question Friedländer's reconstruction of Provost's early period.[5] Nicole Reynaud singles out the Saint Louis *Crucifixion* as a work characterized by a "tormented and dolorous expressionism" alien to Provost's origins and later development.[6] The Linsky *Crucifixion*, however, fits logically into Provost's stylistic development culminating in the 1524–25 Bruges *Last Judgment*, and offers, in embryonic form, numerous formal qualities analogous to those in later works. The doll-like conception of the figures and the clear, bright tonality are evidence of the artist's recent association with the northern French workshop of Simon Marmion. Yet the squat figures and the common-featured

65

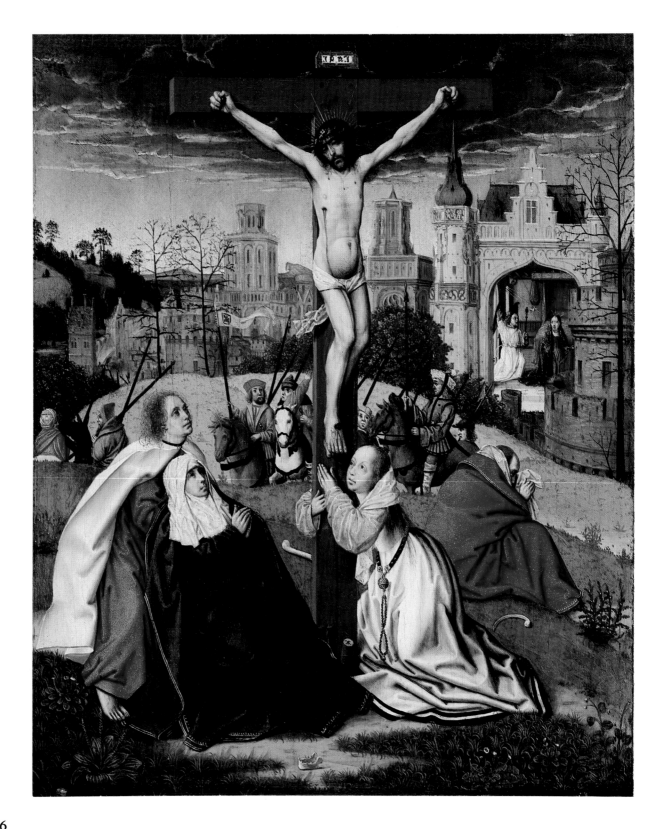

66

female type anticipate Provost's more monumental Bruges style. The relationship is demonstrated persuasively by comparing the present picture with the *Crucifixion* in the Groeningemuseum, Bruges (inv. 0.1661), which can be dated to the early 1520s.[7] Considering the facts of Provost's career, a date of about 1495 seems most appropriate for the Linsky painting.

NOTES:

1. The pairing of the Crucifixion with the Annunciation is unusual, as is often the case with the iconography of Provost's paintings. The two events encompass Christ's mortal life, from the moment of his incarnation to his expiration on the cross, indicated here by the darkened sky.

2. The Linsky *Crucifixion* bears a superficial resemblance to one of these two works: an altarpiece in the Cathedral of Saint-Sauveur, Bruges, now assigned to the Master of the Bruges Passion Retable, previously called the Bruges Master of 1500; see *Anonieme Vlaamse Primitieven* (exhib. cat.), Bruges, Groeningemuseum, 1969, no. 26. The second work once thought to be signed by vander Meire is Joos van Ghent's Crucifixion Triptych in the Cathedral of Saint Bavo, Ghent.

3. O. Pächt, in *Drei Jahrhunderte Vlämische Kunst: 1400–1700* (exhib. cat.), Vienna, Künstler Wiener Secession, 1930, no. 22.

4. See L. Silver, "Early Northern European Paintings," *Saint Louis Art Museum Bulletin* 16 (no. 3, 1982), pp. 12–13.

5. See M. Davies, *Early Netherlandish School*, National Gallery Catalogues, 3rd ed. rev., London, 1968, p. 173; E. W. Hoffman, "Simon Marmion or 'The Master of the Altarpiece of Saint-Bertin': A Problem of Attribution," *Scriptorium* XXVII (1973), pp. 270–71.

6. N. Reynaud, "Une Allégorie sacrée de Jan Provost," *Revue du Louvre* XXV (1975), p. 9 and n. 5.

7. See D. de Vos, *Catalogus Schilderijen 15de en 16de Eeuw*, Stedelijke Musea Brugge, Bruges, 1979, pp. 201–3.

EX COLL.: Col. Hugh Duncan Baillie; [sale, M. C.-J. Nieuwenhuys, Brussels, May 4, 1883, no. 13, as Gerard vander Meire, to Koffermans]; Eugen Felix, Leipzig; [Agnew and Sons, London]; Oscar Bondy, Vienna, (by 1930–1951); [Newhouse Galleries, New York, 1951]; John Myers, Ohio (1951–55); [Newhouse Galleries, New York, 1955]; Mr. and Mrs. Jack Linsky, New York (1955–80); Mrs. Belle Linsky, New York (1980–82).

EXHIBITED: Künstler Wiener Secession, Vienna, *Drei Jahrhunderte Vlämische Kunst: 1400–1700*, Jan. 11–Feb. 23, 1930, no. 22 (as Jan Provost, lent by Oscar Bondy).

BIBLIOGRAPHY: L. Baldass, "Drei Jahrhunderte Flämische Malerei," *Pantheon* v (1930), p. 132 // H. Tietze, "Exhibition of Flemish Art at Vienna," *Formes* no. 4 (1930), p. 15 // M. Friedländer, *Die Altniederländische Malerei*, Berlin, IX (1931), pp. 83–84, 148, no. 148; *Early Netherlandish Painting*, New York, IX (1973), pp. 89–90, 113, no. 148, pl. 167; in *Allgemeines Lexikon . . .* , ed. U. Thieme and F. Becker, Leipzig, XXVII (1933), p. 429.

GCB

Follower of
JAN JOEST OF CALCAR
(also called Jan Joest of Haarlem)

THE EARLIEST documentary reference to Jan Joest has him serving as a guard in the civic militia of Calcar in 1474, which suggests that he was born about 1455–60. Later he may have spent time in the workshop of his uncle, the painter Derick Baegert, in Wesel, which is known to have been Jan's birthplace. The earliest pictures attributable to Jan Joest date from the 1490s. Jan Joest's reputation suffers for the fact that he was not active in either Bruges or Antwerp, the principal Flemish art centers around 1500. Wesel and Calcar are near Cleves, in the lower Rhine region.

Jan Joest's principal work is the polyptych for the high altar of the Church of Saint Nicholas, Calcar, which occupied him from 1506 until 1509. That work, however, cannot be regarded as representative of him solely, since it is known that he was engaged to complete the wings begun but left unfinished by another artist. In 1509 Jan Joest is documented in Haarlem, where in 1510 he bought a house and evidently maintained residence until his death in 1519. The influence of the Haarlem school apparent in the wings of the Calcar altarpiece is evidence that Jan probably spent time in Haarlem before 1505.

Jan Joest appears to have exerted a strong influence on Joos van Cleve, the Master of Frankfurt, and Barthel Bruyn, his son-in-law. Joos and the Master of Frankfurt, whose eponymous work is the Saint Anne Altarpiece from the Dominican church in Frankfurt, subsequently set up shop in Antwerp, where each became a significant artistic force, while Barthel Bruyn established himself in Cologne.

22. Nativity with the Annunciation to the Shepherds

Oil on wood. Overall 41 × 28¼ in. (104.1 × 71.8 cm.); painted surface 41 × 27⅝ in. (104.1 × 70.2 cm.)
1982.60.22

The paint surface has suffered from heat damage, but the picture is otherwise in a fair state of preservation. There is some restoration along vertical joins in the panel. It has been trimmed slightly at the top and bottom; the painted surface extends to the very edge of the support here, and its barbs survive only at the left and right sides.

THE NAKED Christ Child, himself the principal source of illumination, lies in a wooden crib in the center of a dark, ruinous structure. Mary kneels at the left, and a somber-faced Joseph stands behind her, shielding with one hand the candle he holds in the other. Six adolescent angels in various liturgical vestments kneel in adoration at the right around the crib. The central angel wears a dalmatic encrusted with pearls and precious stones. The foreground angel in profile wears a light blue alb, and behind him is seen the back of an angel in a red and gold brocade cope. Two other angels hover along the right edge of the composition, just above the partly visible head of the ox. Six infant angels cavort in the rafters overhead, singing from music on the arabesque banderole that they hold. Two shepherds look into the interior through a double-arched window divided by a porphyry column surmounted by a gilded pagan idol. Their dimly lighted faces are ruddy orange in contrast to the bright flesh tones of the foreground figures. One shepherd holds a bagpipe, the other a horn and a crook. In the landscape beyond, the Annunciation to the Shepherds is seen beneath a dusky sky.

The problems presented by this panel are complex, since a number of versions of the composition survive. When it was in the Richard von Kaufmann collection, it was published by Max Friedländer (1916; 1917). Subsequently Friedländer (1931) drew attention to the existence of five other paintings with similar compositions. Two he attributed to the Master of Frankfurt: one in the Musée des Beaux-Arts, Valenciennes,[1] and one in the Lehman Collection in the Metropolitan Museum (1975.1.116). Another, signed by Barthel Bruyn and dated 1516, is in the Städelsches Kunstinstitut, Frankfurt (inv. 1652).[2] Friedländer inferred that all six paintings must depend from a lost original by Jan Joest. Analogies for the present picture are found in the *Nativity* on the exterior of Jan Joest's Calcar polyptych, and in another *Nativity* by the same artist formerly in the Bissing collection, Munich.[3] Friedländer believed the Linsky picture to be the most faithful surviving version of Jan's lost prototype.

Friedrich Winkler (1964), expanding on an observation first made by Friedländer and developed by Baldass (1920–21), provides the fullest exposition of the notion that the present picture derives originally from a lost nocturnal *Nativity* by Hugo van der Goes.[4] He also draws attention to at least one other version of the Linsky composition.[5] A link between the present picture and Hugo's lost model is offered by Geertgen tot Sint Jans's *Nativity*, National

Gallery, London (inv. 408), also dependent from Hugo's. Geertgen, a Haarlem painter, appears to have influenced Jan Joest, as is noted by G. J. Hoogewerff (1937), who dates the Linsky panel after 1510.

Alfred Stange (1954) assigns the Linsky picture, which he describes as an Adoration of the Shepherds, to Jan Joest without qualification. He believes it to be later than the Calcar altarpiece and implies a date of about 1515.

Friedländer (1940) relates the painting to a drawing in the Hermitage, Leningrad, that had previously been ascribed to Barthel Bruyn,[6] but which he observes is closer to pictures attributable to Jan Joest, among them the present work.

S. Goddard (1983) questions the validity of isolating specific hands when dealing with large, prolific workshops, many of whose productions were collaborative.[7] He proposes such a workshop for the Master of Frankfurt, and groups the Linsky *Nativity* with the one in the Lehman Collection, associating both with a Deposition Triptych in the Church of Our Lady, Watervliet. In handling, the Linsky panel differs notably from the Lehman picture. Examination by infrared reflectograph reveals animated underdrawing and pentimenti in the paint surface that cannot be detected in the Lehman panel because of its markedly different technique. Variations in the treatment of the faces of the shepherds and the angels also mark it clearly as by a hand different from that responsible for the version in Valenciennes.

If associated with Jan Joest, this picture is the strongest connection between him and the Master of Frankfurt, who is therefore thought to have emerged from his workshop. The currency of its composition in Jan Joest's shop has been established by its use by Barthel Bruyn. Although Comblen-Sonkes (1983), like Goddard, would assign the picture to the workshop of the Master of Frankfurt, she notes that there is no parallel for the lively chorus of six angels with a banderole seen here. Of the eight known versions of the composition, the Linsky *Nativity* is unique for the inclusion of this group, evidently an invention of the artist. The only admissible inference is that the panel is the work of an independent artist from the orbit of Jan Joest active about 1515, probably in Antwerp.

NOTES:
1. *Catalogue illustré et annoté des oeuvres exposées au Palais des Beaux-Arts de la Ville de Valenciennes*, Valenciennes, 1931, p. 82, no. 172.

68

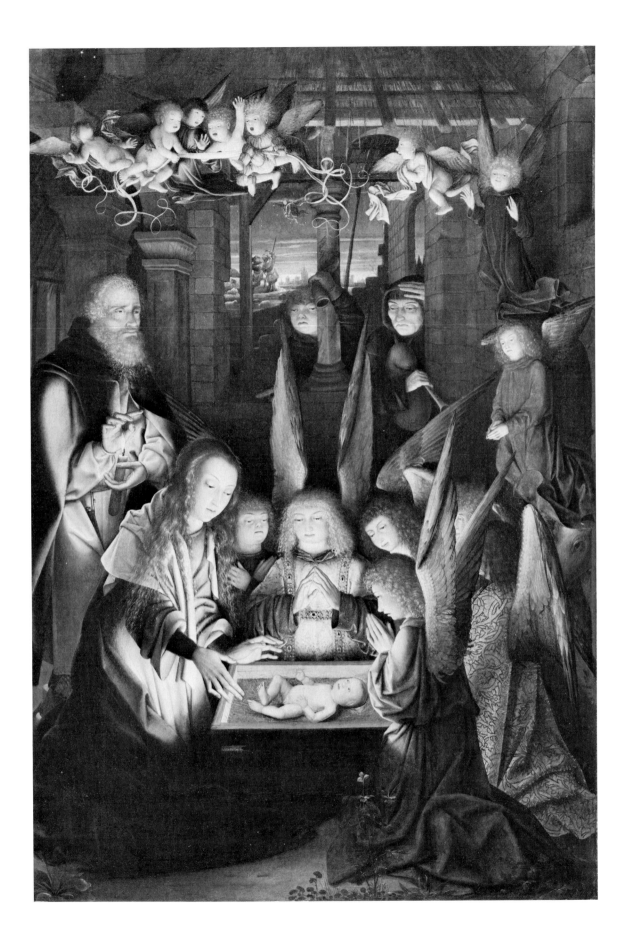

2. The two other versions cited by Friedländer (1931) are inferior copies. One is in the Dunedin Public Art Gallery, New Zealand; the other was with the dealer Shatzker in Vienna in 1933 and in the Cox collection, London, in 1946. A version very similar to the present picture not known to Friedländer was sold at Christie's, London, Nov. 20, 1925, no. 100, as Geertgen tot Sint Jans (photograph in Frick Art Reference Library, New York, "Joest van Calcar," 303–4b).

3. For recent literature concerning the Calcar altarpiece, see F. Gorissen, "Meister Matheus und die Flügel des Kalkarer Hochaltars. Ein Schlüsselproblem der niederrheinländischen Malerei," *Wallraf-Richartz Jahrbuch* XXXV (1973), pp. 149–206.

4. The most faithful copy of Hugo's lost *Nativity* is by Gerard David in the Kunsthistorisches Museum, Vienna (inv. 904).

5. At the Galerie Koti, Paris, in 1962. Winkler (1964) also cites a picture said to be in Kiev, but it is not listed in the 1961 catalogue of the State Museum of Western and Oriental Art, Kiev. It appears from Winkler's reproduction that it is the same as the Lehman version, which is said to have come from the Hermitage, Leningrad, before 1930.

6. See M. Dobroklonsky, "Bartholomäus Bruyn," *Old Master Drawings* XI (1936–37), pp. 53–54, pl. 49.

7. S. Goddard, letter, July 30, 1983.

EX COLL.: Richard von Kaufmann, Berlin (until 1917; sale, Paul Cassirer, Berlin, Dec. 4 and following days, 1917, no. 110, as Jan Joest van Calcar?, to Haniel); F. Haniel, Düsseldorf (1917–after 1964); Herbert Ritter, Munich, apparently acting as agent for Mrs. Lieven (until 1967; sale, Christie's, London, June 23, 1967, no. 73, as the Master of Frankfurt, to Linsky); Mr. and Mrs. Jack Linsky, New York (1967–80); The Jack and Belle Linsky Foundation, New York (1980–82).

BIBLIOGRAPHY: M. Friedländer, *Von Eyck bis Bruegel*, Berlin, 1916, pp. 139–40; *From van Eyck to Bruegel*, trans. M. Kay, New York, 1956, pp. 108–9; *Die niederländischen, französischen und deutschen Gemälde*, vol. II of *Die Sammlung Richard von Kaufmann, Berlin*, Berlin, 1917, pp. 215–17, no. 110; "Der Meister von Frankfurt," *Jahrbuch der Königlich Preuszischen Kunstsammlungen* XXXVIII (1917), p. 142 // L. von Baldass, "Mabuses 'Heilige Nacht,' eine freie Kopie nach Hugo van der Goes," *Jahrbuch der Kunsthistorischen Sammlungen in Wien* XXXV (1920–21), p. 46 // J. Rosenberg in *Allgemeines Lexikon . . .* , ed. U. Thieme and F. Becker, Leipzig, XVIII (1925), p. 377 // M. Friedländer, *Die Altniederländische Malerei*, Berlin, IX (1931), pp. 17–18; 126, no. 4a; *Early Netherlandish Painting*, New York, IXa (1972), pp. 15, 52, no. 4a, pl. 11 // G. J. Hoogewerff, *De Noord-Nederlandsche Schilderkunst*, The Hague, II (1937), pp. 447–48 // M. Friedländer, "Eine Zeichnung von Jan Joest von Kalkar," *Oud Holland* LVII (1940), p. 162, fig. 5 // A. Stange, *Nordwestdeutschland in der Zeit von 1450 bis 1515*, vol. VI of *Deutsche Malerei der Gotik*, Munich, 1954, p. 67, pl. 126 // F. Winkler, *Das Werk des Hugo van der Goes*, Berlin, 1964, p. 153 // S. Goddard, *The Master of Frankfurt and his Shop*, Ph.D. diss., University of Iowa (Ann Arbor, 1983, microfiche), 1983, pp. 146–47, 343 // M. Comblen-Sonkes, unpublished opinion, Oct. 11, 1983.

GCB

AMBROSIUS BENSON

Active by 1519, Bruges; died 1550, Bruges

THE EARLIEST documentary mention of Ambrosius Benson records his entry in 1519 as a freemaster in the Bruges painters' guild, and reports that he came from Lombardy, in northern Italy. He held various official positions in the guild from 1521 to 1546, including *voorzitter*. It is known from legal archives that he was associated with Gerard David, against whom he brought legal action in 1519 over two coffers containing pictures and a pattern book David had taken from him. The association is corroborated by Benson's style, which is much indebted to David. The style of his early works is also very similar to that of another close follower of David's, Adriaen Isenbrant. Benson belongs to the post-Davidian generation of Bruges artists, who often must have been rivals, which includes Isenbrant, Jan Provost, and Aelbert Cornelisz. From 1526 to 1530 he exhibited paintings for sale regularly at the January and May fairs.

Many of Benson's productions were destined for the Spanish market. Three important altarpieces are from Segovia, for which reason many of his works were, before the artist's identity was known, grouped under the rubric "Master of Segovia." Another group, clustered around a painting in Antwerp, was labeled "Master of the Antwerp *Deipara Virgo*." Two stylistically related works, each with the monogram *AB*—the *Holy Family with Saint John the Baptist*, dated 1527, in a private collection, New York, and the *Saint Anthony of Padua Triptych* in the Musées Royaux des Beaux-Arts de Belgique, Brussels—make possible the attribution of both groups to Benson. Ambrosius Benson was one of the earliest practitioners in Bruges of a new style that reveals the influence of High Renaissance art in Italy.

23. The Lamentation

Oil on canvas. 36 × 22⅛ in. (91.4 × 56.2 cm.)
Inscribed (top center, on cross): INRI
1982.60.23

The picture is quite well preserved although it has been transferred from panel to canvas. There are repairs along what was a vertical crack in the original support that runs vertically the length of the picture 1½ inches to the right of the cross. Minor paint losses, most notably in the fingers of the Virgin's right hand, Christ's right

cheek, and all around the perimeter, have been inpainted. An abrupt transition in the tonality of the sky running horizontally about 2½ inches below the cross bar may be a pentiment—perhaps the bar was originally lower—though examination by infrared reflectograph failed to elucidate this curious appearance.

CHRIST'S BODY, draped in a loincloth, is held in a three-quarter upright position on a shroud. The Magdalen, kneeling at the right, lifts Christ's left arm in both hands to kiss his wounds. His limp right arm hangs vertically. Behind Christ, the Virgin leans over to support his head with her right hand, while with her left she holds her mantle to her cheek. Saint John, kneeling at the left, gently touches the wounds on Christ's forehead. The crown of thorns lies on the ground together with three spikes from the cross and the Magdalen's ointment jar. The cross is visible on the central axis directly behind the Virgin. An empty rock-cut tomb, a rectangular stone slab leaning beside the opening, is seen in the middle distance, while in the background, under a clear sky, is a city with verdant hills beyond.

When this *Lamentation* entered the Charles Sedelmeyer collection in 1905, it was described as Flemish school, sixteenth century. In the 1907 Sedelmeyer sale it was attributed to the school of Gerard David. By 1920, when it was exhibited at the Ehrich Galleries, New York, it was recognized as a work by Benson. Max Friedländer (1933), to whom, presumably, the attribution is due, calls attention to the landscape painted in the archaic style of David, and notes the stylistic similarity between this *Lamentation* and the one from the center panel of a triptych by Benson from the C. J. Wawra collection, Vienna.[1] The Benson attribution is endorsed by W. R. Valentiner (1944).

Martin Davies (1953) cites the present picture among other works whose compositions are similar to that of a *Deposition* by David in the National Gallery, London; and Georges Marlier (1959) notes the stylistic closeness between Benson's works, particularly this one, and David's. He finds the Linsky painting distinguished especially by its sobriety, which borders on classical reserve when compared to the complex fabrications of Benson's Antwerp and Leiden contemporaries. Marlier suggests as a model for this composition the *Lamentation* by David in the John G. Johnson Collection, Philadelphia, and marks what he considers Benson's improvements.[2] For one of these, the positioning of the Magdalen, Marlier proposes other models by David: the *Deposition* in the National Gallery,

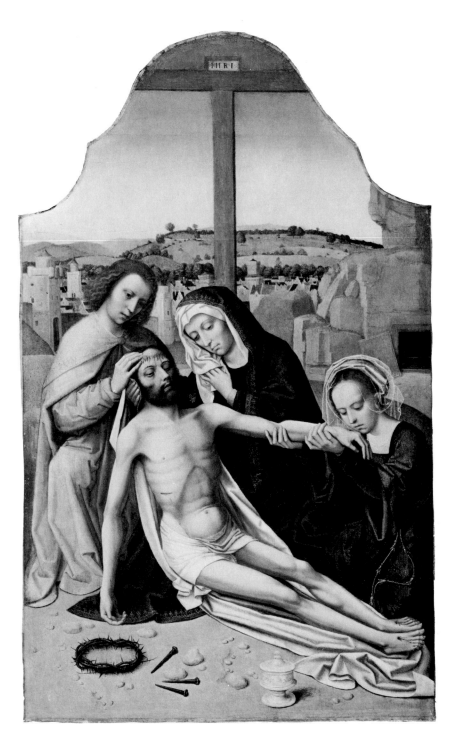

London, and a *Lamentation* in the P. and N. de Boer Foundation collection, Amsterdam.[3] Marlier further praises the present picture by contrasting it with one by Adriaen Isenbrant in the Ashmolean Museum, Oxford,[4] that is modeled after the same David composition. Marlier dates the Linsky *Lamentation* about 1520–25.

The four figures in the present picture are repeated in a somewhat later half-length composition by Benson in Bilbao.[5] Another *Lamentation*, attributed to Isenbrant and with the same composition as the Linsky picture, sold recently at auction,[6] further evidence of a popular model by David that inspired both Isenbrant and Benson.

NOTES:
1. Reproduced in Friedländer (1974), p. 94, no. 234, pl. 158.
2. See *Catalogue of Flemish and Dutch Paintings* (John G. Johnson Collection), Philadelphia, 1972, p. 28, no. 328, ill. p. 134.
3. Reproduced in M. Friedländer, *Early Netherlandish Painting*, New York, VIB (1971), p. 112, Supp. 251, pl. 250.
4. Reproduced in Friedländer (1974), p. 86, no. 170, pl. 131.
5. Reproduced in Marlier (1959), no. 41, pl. XI.
6. Sale, Sotheby's, Amsterdam, Mar. 14, 1983, no. 63.

EX COLL.: Delassue, Paris (until 1905); [Charles Sedelmeyer, Paris, 1905–7; sale, Galerie Sedelmeyer, Paris, June 3–5, 1907, no. 214, as school of Gerard David]; Paul Mersch, Paris (1907–8; sale, Hôtel Drouot, Paris, May 8, 1908, no. 21, as Gerard David, to Rothschild); possibly Bolton, London; Victor Hahn, Berlin (by 1926–1932; sale, Ball and Graupe, Berlin, June 27, 1932, no. 12, as Ambrosius Benson); Ernst Schwarz, New York (by 1957–1959; sale, Christie's, London, June 26, 1959, no. 30, as Ambrosius Benson, to Linsky); Mr. and Mrs. Jack Linsky, New York (1959–80); The Jack and Belle Linsky Foundation, New York (1980–82).

EXHIBITED: Bruges, *Exposition de la Toison d'Or*, 1907, no. 208 (as G. David, lent by Paul Mersch); Ehrich Galleries, New York, *Exhibition of Flemish Primitives*, Jan. 5–21, 1920, no. 4 (as Ambrosius Benson).

BIBLIOGRAPHY: Sedelmeyer Gallery, *Illustrated Catalogue of the Ninth Series of 100 Paintings by Old Masters*, Paris, 1905, p. 18, no. 11 // A. Donath, "Sammlung Victor Hahn," *Der Kunstwanderer* (Jan. 1927), p. 192 // "Die Sammlung Victor Hahn," *Der Kunstwanderer* (May 1932), pp. 248–49 // M. Friedländer, *Die Altniederländische Malerei*, Berlin, XI (1933), p. 143, no. 253; *Early Netherlandish Painting*, New York, XI (1974), p. 96, no. 253, pl. 168 // W. R. Valentiner, unpublished opinion, Oct. 4, 1944 // M. Davies, *The National Gallery London*, Antwerp, I (1953), p. 90 (Fasc. of *Les Primitifs flamands. I, Corpus de la peinture des anciens Pays-Bas méridionaux aux quinzieme siècle*) // G. Marlier, *Ambrosius Benson et la peinture à Bruges au temps de Charles-Quint*, Damme, 1959, pp. 90–91, 292, no. 38.

GCB

72

PETER PAUL RUBENS

Born Siegen, 1577; died Antwerp, 1640

PEETER PAUWEL RUBENS was born June 28, 1577, at Siegen in Westphalia, the son of an Antwerp lawyer in the service of Anna of Saxony. The family moved to Cologne the following year. After his father's death in 1587, his mother moved back to Antwerp (about 1588). Rubens did not develop quickly as an artist, but during the next ten years gained a good education, the experience of serving as a page in a noble house, and training in the studios of Tobias Verhaecht, Adam van Noort, and Otto van Veen. Rubens became a master in the painters' guild of Antwerp in 1598. In May 1600 he left for Italy. He served the duke of Mantua for nearly eight years, but studied and worked in Genoa, and for long periods in Rome as well as other cities. In 1603 Rubens was in Spain as the duke's goodwill ambassador; at the court of Philip III he was introduced to royalty, diplomacy, and a great art collection. Rubens spent most of 1606–8 in Rome, where he worked on the most prestigious commission of the period—the high altar of the Chiesa Nuova. News that his mother was seriously ill forced him to leave Rome suddenly at the end of 1608. He never returned to Italy.

There was much to keep Rubens in Antwerp. He was appointed court painter to Archduke Albert and Archduchess Isabella, who governed the Netherlands from the court at Brussels but allowed Rubens to establish his studio in Antwerp. Always a good businessman, Rubens realized that with the Twelve Years' Truce and the need to redecorate the desecrated Flemish churches came the promise of a flourishing trade. He married Isabella Brant on October 3, 1609, and in the next year bought the land for his now famous house and studio. From 1609 to 1621 Rubens and his growing number of assistants were swamped with orders from the city, the court, and, above all, the churches (the orders were often placed, however, by distinguished laymen with a discerning knowledge of the arts). This period culminates with the completion of two major altarpieces and thirty-nine ceiling paintings for the Jesuit church in Antwerp.

Aware of his own debt to prints by and after other artists, Rubens supervised the engraving of many of his Antwerp designs. This played a large part in establishing his influence and reputation both at home and abroad, in addition to the fact that some of his major works were

already being seen in other European countries. These factors led to Rubens's role in the 1620s as the foremost painter of decorative projects outside Italy. From 1622 to 1625 he painted the *Life of Marie de' Medici* cycle for the Palais du Luxembourg in Paris. During the next five years the death of his wife (in 1626), his important role in peace negotiations between England and Spain, and the demands of his international clientele made Rubens what he described as the most harassed man in the world. He spent seven months in Madrid in 1628–29, and nine months in London in 1629–30. The first visit was by far the more important for his art: he painted a number of portraits of the royal family and made copies of works by Titian in the royal collections. In England, Rubens was knighted and secured the peace with Spain.

On his return to Antwerp, Rubens attempted to live a more settled life. He asked for leave from political affairs, although he served as the archduchess's agent until 1633. In 1630 he married Helena Fourment; their fifth child was born more than eight months after Rubens's death. Rubens organized his busy studio in Antwerp to work efficiently in his absence, and in May 1635 bought the country estate of Steen. Three great projects occupied Rubens during the 1630s: the ceiling paintings (1630–34) for the Banqueting House at Whitehall in London; the Triumphal Entry into Antwerp of the new governor, Cardinal Infante Ferdinand; and the designs for paintings made to decorate Philip IV's hunting lodge, the Torre de la Parada, near Madrid. Rubens often suffered from gout in his later years. He died in Antwerp on May 30, 1640.

Rubens has long been admired both as an artist and as a man. He was perhaps the most educated artist who ever lived—a great linguist, a diplomat equal to any contemporary figure, and a scholar regarded as a peer by some of the most eminent minds of the century. If the appeal of Rubens's art is sometimes less immediate now than that of a few contemporary artists, the reason lies partly in the nature of the patrons he served, and partly in the sophistication of his subjects and style. Before and during his years in Italy he absorbed something from almost every great master of the Renaissance and the early Baroque, and became an accomplished student of classical art. The most important sources of his style are found in Michelangelo, Raphael, Tintoretto, Caravaggio, and (effecting a synthesis among these diverse influences) Annibale Carracci. At the same time Rubens found moments of greatness in many minor masters (such as Elsheimer), while his love of the art of Titian grew as he matured. However

eclectic, Rubens was one of the most original and regenerating inventors of the Baroque, and possibly the most influential proponent of the style for artists of the next two centuries.

24. Portrait of a Man, Possibly an Architect or Geographer

Oil on copper. 8½ × 5¾ in. (21.6 × 14.6 cm.)
Inscribed (upper left): [MDLXXX]XVII; (upper right): AETAT. XXVI.; engraved on the back of the copper plate: PETRVS PAVLVS RVBENS / PI.
1982.60.24

The picture is in excellent condition.

THIS SMALL portrait on copper, of 1597, is the earliest known dated work by Rubens. The twenty-six-year-old sitter has not been identified but has been variously described, on the basis of the objects he holds, as a geographer, an architect, an astronomer, a goldsmith, and a watchmaker. In the sitter's right hand are a square and dividers. The object in his left hand is closed inside a gold oval case, which is chased and decorated in enamel. Small scientific instruments of the period are often elaborately worked, but none of them bears a close resemblance to this object. It was suggested by Julius Held (1947) that the object might be an astrolabe, but astrolabes are almost always round or octagonal and much thinner, and are generally not less than fifteen centimeters in diameter, which is at least twice the width of the present object. While it may be questioned whether a specialized instrument meant to identify the sitter's profession would be presented, as it is here, in a closed case—which even a contemporary viewer would be unable to distinguish from that of a watch—there can be little doubt that the object is, in fact, a watch: the size, shape, and decoration of the case are very typical of Netherlandish and German watches of the late sixteenth century.

The square and dividers would be appropriate implements for an architect, a geographer, a cartographer, a navigator, or possibly an engineer. The hesitation of scholars to identify the other object as a watch depends—as does Rudolf Oldenbourg's (1919) conclusion that the sitter is probably a watchmaker—on the assumption that it must also have something to do with the sitter's profession. Watches commonly appear next to, and sometimes in the hands of, sitters in sixteenth-century portraits. In

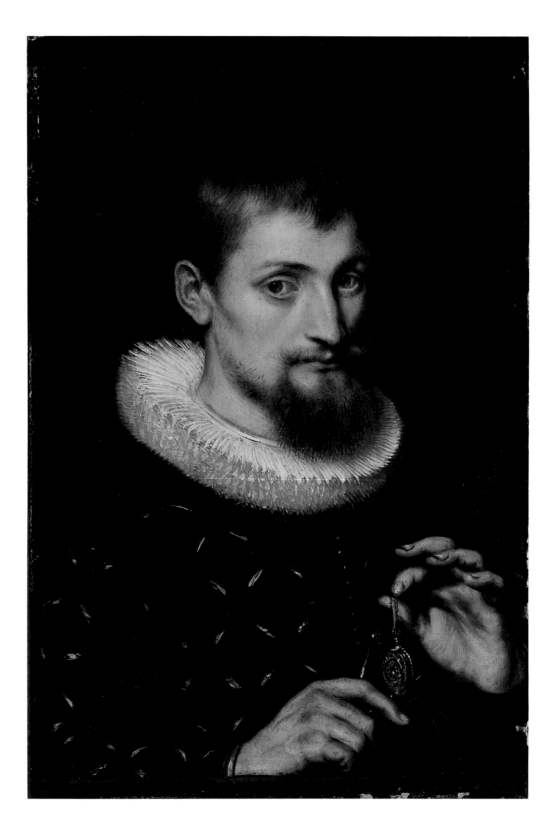

74

the present picture the watch must be independently significant as a *vanitas* motif, a reminder of the brevity of life and of the relative unimportance of worldly affairs.[1]

This reading accounts for the action of holding the watch toward the viewer, which is more strongly sensed in the original than in a reproduction both because of the illusionistic effect of the ledge supporting the right hand and because of the corresponding form overhead. The watch presented as a *vanitas* motif adds meaning to the reflective glance, the serious expression, and the inscription of the sitter's age: his physical appearance and his everyday activities are but temporal concerns, of no importance compared to that of his spiritual being. Such a comment on the "vanity" of life was recognized at the time as especially appropriate to portraiture. In the seventeenth century portraits of men with this meaning tend to convey it less obliquely; they frequently include a skull and a significant gesture. The watch becomes a familiar motif in the foreground of seventeenth-century *vanitas* still lifes. Its place in the present portrait recalls such common subjects of sixteenth- and early seventeenth-century prints as the young man, or young couple, encountering death, and parallels the engraved inscriptions on contemporary watches: *Time, and thou too, envious Old Age, devour all things* (Horace).

The attribution of the present picture to Rubens has never been questioned. The engraving of the artist's name on the back of the copper plate is probably contemporary with the painting and is possibly Rubens's work.[2] The portrait is described by Christopher Norris as "remarkable for the sensitive quality of the modelling in the hands and head," and as already revealing "traces of [Rubens's] fully developed style."[3] Most writers concur, and employ the picture as a standard by which other paintings may be assigned to Rubens's pre-Italian period. Frans Baudouin, for example, compares the modeling of Adam's upraised hand in *Adam and Eve in Paradise* in the Rubenshuis in Antwerp.[4] Of works dating from this period, among the most convincing attributions to Rubens is the *Portrait of the Emperor Commodus*, recently discussed by Held.[5] It has often been observed that the style of these early pictures derives from that of Rubens's teacher Otto van Veen. The composition follows that of portraits by Anthonis Mor and his followers. As emphasized by Justus Müller Hofstede, however, the portrait departs from the current Flemish manner in its strong modeling and in the spatial effect of the ledge and the hands. In this Rubens follows earlier Netherlandish portraits of the type found in, for

example, Adriaen Isenbrant's *Man Weighing Gold*, in the Metropolitan Museum.[6]

NOTES:

1. Müller Hofstede (1962), p. 280: "presented not as an attribute but as a *vanitas* symbol." No later writer has cited this remark.

2. W. von Bode in Oldenbourg (1922, p. 137) published a facsimile of the inscription, which is not professionally engraved. A signature on the paint surface would not be expected in a picture of this scale bearing two inscriptions already. Valentiner (1953, p. 69 n. 2) points out that Rubens had not yet joined the guild in 1597 and therefore should not have been signing works of his own.

3. Norris (1940), p. 193.

4. Baudouin (1977), p. 55.

5. J. S. Held, "Thoughts on Rubens' Beginnings," *Ringling Museum of Art Journal* 1983, pp. 14–35 (paper presented at the International Rubens Symposium, John and Mable Ringling Museum of Art, Sarasota, Apr. 14–16, 1982). See pp. 20, 29, fig. 3 for the *Portrait of the Emperor Commodus*.

6. Cited by Müller Hofstede (1962), p. 282.

EX COLL.: Johann Focke, Bremen (in 1904); [K. Haberstock, Berlin]; Henry Blank, Newark; the estate of Henry Blank (until 1949; sale, Parke-Bernet, New York, Nov. 16, 1949, no. 8, as *Portrait of a Goldsmith*); Mr. and Mrs. Jack Linsky, New York (1949–80); The Jack and Belle Linsky Foundation, New York (1980–82).

EXHIBITED: Kunsthalle, Bremen, *Gemälde alter Meister im Bremischen Privatbesitz*, 1904 (lent by Dr. Focke); Detroit Institute of Arts, *Sixty Paintings and Some Drawings by Peter Paul Rubens*, 1936, no. 16 (lent by Henry Blank, Newark); Wildenstein, New York, *A Loan Exhibition of Rubens*, 1951, no. 1 (lent by Mr. and Mrs. Jack Linsky); Musées Royaux des Beaux-Arts, Brussels, *Le Siècle de Rubens*, 1965, no. 205 (lent by Mr. and Mrs. Jack Linsky); Wildenstein, New York, *The Italian Heritage*, 1967, no. 58 (lent by Mr. and Mrs. Jack Linsky).

BIBLIOGRAPHY: R. Oldenbourg, "Beiträge zur Rubens als Bildnismaler," *Münchner Jahrbuch* XI (no. 1–2, 1919), pp. 55–56, fig. 1, as a "portrait of a mechanic, probably a watchmaker"; *Die Flämische Malerei des XVII. Jahrhunderts*, Berlin 1918 (2nd ed., 1922), p. 32, as "the so-called Mechanic"; *Peter Paul Rubens*, ed. W. von Bode, Munich, 1922, pp. 136–38, fig. 78, reprinting the article of 1919, and publishing facsimiles of the inscriptions and the engraved signature on the back // K. Bauch, "Beiträge zur Rubensforschung," *Jahrbuch der Preussischen Kunstsammlungen* XLV (1924), p. 187, as *Portrait of a Watchmaker* // L. Burchard, "Genuesische Frauenbildnisse von Rubens," *Jahrbuch der Preussischen Kunstsammlungen* L (1929), p. 319 n. 1, as a portrait of a mechanic // G. Glück, "Einige Frauenbildnisse aus Rubens' Anfängen," *Jahrbuch der Kunsthistorischen Sammlungen in Wien* n.s. VI (1932), p. 157, as a portrait of a watchmaker or mechanic // W. R. Valentiner,

Sixty Paintings and Some Drawings by Peter Paul Rubens (exhib. cat.), Detroit, Detroit Institute of Arts, 1936, no. 16, ill., as *Portrait of a Goldsmith*, "painted about 1598" // *Parnassus* VIII (Mar. 1936), p. 18, ill. // W. R. Valentiner, "The Art and Personality of Rubens in a Loan Exhibition of Sixty Paintings at Detroit" (excerpt from exhib. cat.), *Art News* XXXIV (1936), p. 6 // C. Norris, "Rubens before Italy," *Burlington Magazine* LXXVI (1940), pp. 190, 193, pl. IIa, as signed and dated 1597, "the first true sign of this period" // H. G. Evers, *Peter Paul Rubens*, Munich, 1942, pp. 26, 484 n. 31 // W. R. Valentiner, "Rubens' Paintings in America," *Art Quarterly* IX (1946), p. 155, no. 1, as *Portrait of a Goldsmith* // J. S. Held in J.-A. Goris and J. S. Held, *Rubens in America*, New York, 1947, p. 29, no. 19, pl. 1, as *Portrait of a Geographer (?)*, and stating, "Since the objects . . . seem to be a compass, a square, and an astrolab, he might have been a geographer, or possibly an astronomer" // H. Robels, "Die niederländische Tradition in der Kunst des Rubens," Ph.D. diss., Cologne, 1950, pp. 85ff., comparing the pose of the hands to that in fifteenth-century Netherlandish portraits // L. Burchard, in *A Loan Exhibition of Rubens*, New York, Wildenstein, 1951, p. 11, no. 1, ill. p. 30, as *Portrait of a Twenty-Six-Year-Old Man*, "standing behind a parapet . . . from his left [hand] a circular instrument, not yet identified, is suspended" // P. Bird, "Rubens Presented in First New York Show," *Art Digest* 25 (Mar. 1, 1951), pp. 7, 24 // L. van Puyvelde, *Rubens*, Paris, 1952, p. 88, on the style // E. Larsen, *P. P. Rubens*, Antwerp, 1952, p. 214, no. 1, as *Portrait of a Mechanic*, identifying the object in the left hand as "a watch of the type called 'Nuremberg Egg'" // W. R. Valentiner, "An Early Portrait by Rubens," *Art Quarterly* XVI (1953), pp. 68–69, fig. 2, comparing the *Man with a Sword* attributed to Rubens and now in the Chrysler Museum, Norfolk // H. Konnerth, "Ein neuentdeckter früher Rubens," *Zeitschrift für Kunstwissenschaft* IX (1955), pp. 81–82, fig. 1, as *Portrait of a "Geographer"* // H. Gerson and E. H. ter Kuile, *Art and Architecture in Belgium 1600–1800*, Baltimore, 1960, p. 72 // J. Müller Hofstede, "Zur frühen Bildnismalerei von Peter Paul Rubens," *Pantheon* XX (1962), pp. 279–84, 289–90 n. 4, 10–15, fig. 5, as an architect, identifies the object in the left hand as a watch serving as a *vanitas* symbol, and thoroughly discusses the picture's style in relation to sixteenth-century Netherlandish portraits and to works by Otto van Veen // L. van Puyvelde, in *Le Siècle de Rubens* (exhib. cat.), Brussels, Musées Royaux des Beaux–Arts, 1965, pp. 195–96, no.205, ill., as *Portrait of a Young Scholar*, the object in the left hand not yet identified // F. Baudouin, *Pietro Pauolo Rubens*, trans. E. Callander, Antwerp, 1977, pp. 55, 366 n. 22, comparing the *Adam and Eve in Paradise* in the Rubenshuis // M. Jaffé, *Rubens and Italy*, Oxford, 1977, pp. 16, 105 n. 37, as "the so-called 'Geographer' or 'Architect,'" and wrongly as inscribed on the reverse "P. P. Rubens / 1597" // *Peter Paul Rubens 1577–1640* (exhib. cat.), Cologne, Wallraf-Richartz-Museum, 1977, I, p. 137 under no. 3, *Portrait of a Man* in the Chrysler Museum.

WL

Dutch Paintings

JAN MOSTAERT

Active by 1498, Haarlem; died 1555/56, Haarlem

MOST OF what is known about Mostaert's life, including the date of his death, must be taken on faith from Karel van Mander's account, written in 1604. Van Mander interviewed an elderly painter who said that around 1544 Mostaert claimed to be about seventy. His birth date is thus estimated to be 1473.[1] The earliest documentary mention of the artist has him working in Haarlem in 1498. In 1500 he painted wings for an altarpiece there in the Cathedral of Saint Bavo. He is listed intermittently from 1507 until 1543 as an officer of the Haarlem painters' guild. In 1449–50 he painted the high altarpiece for the church in Hoorn.

According to van Mander, Mostaert was a student of Jacob Jansz. van Haarlem, who, in turn, was a student of Geertgen tot Sint Jans.[2] Thus a connection is made to Geertgen, who died too early for Mostaert to have known him personally, yet whose works had the greatest influence on his early style. Van Mander also reports that Mostaert was in service for eighteen years to Margaret of Austria, regent of the Netherlands, who held court in Malines and Brussels. Presumably his source for this information was the artist's grandson, whom he interviewed. It is to be suspected that family chauvinism led the descendants to exaggerate the extent of Mostaert's association with the regent, since the artist is rarely recorded in the accounts of the court, and he seems, from data in the Haarlem archives, never to have left that town for any great length of time.

There are no surviving works securely documented as by Jan Mostaert.[3] However, among the stylistically coherent body of work assigned to him, there are a number of paintings that agree so closely with descriptions of lost works as to make their attribution to him all but certain. Of special interest here is the "Ecce Homo" seen by van Mander in the house of Mostaert's grandson and described by him.

25. Christ Shown to the People

Oil on wood. Overall 12 × 8⅞ in. (30.5 × 22.5 cm.);
 painted surface 11½ × 8¼ in. (29.2 × 21 cm.)
1982.60.25

The state of preservation is very fine, and there is no evidence that the panel has been cut down. The picture has been cleaned since 1965, when one of the Marys that had been painted out and the grassy hill with trees that had been painted over with a mountainous landscape were uncovered.

CHRIST, HIS WRISTS roped together, is presented at the left by Pontius Pilate. He wears the crown of thorns, a gray-white cloak knotted around the shoulders, and a loincloth. Pilate, in a fur-trimmed red robe, gold chain, and large hat with upturned brim, lifts a corner of Christ's cloak with his left hand and gestures with his right to a group of three men. Presumably represented here is the moment he spoke the words *ecce homo* ("Behold the man"). The artist's conflation of different moments from the Passion, though not uncommon for this period, is of iconographic interest. Christ is depicted wearing the white raiment he received from Herod's soldiers according to Luke (23:11). But in the Gospel of John (19:1–5), the only account to quote Pilate's words, Christ is specifically described as wearing the crown of thorns and a purple robe. Christ and Pilate stand at a somewhat higher level than the group at the right, in what appears to be a vaulted porch, judging by the column behind them and the corner of a parapet at the lower left in front of them. Of the richly dressed individuals at the right, most prominent is the portly balding man who rests his right hand on a cane and extends his left hand open before him; a purse and dagger are attached to his belt. It is not clear whether the two spiraling feathers are attached to his cap or to that of the man at his right. The latter points upward with his right index finger. Of the third man, who cranes his neck for a view, only the eyes and nose are visible. In the cobblestoned city square, with turreted gatehouse at the back, is a group of figures that consists of the swooning Virgin

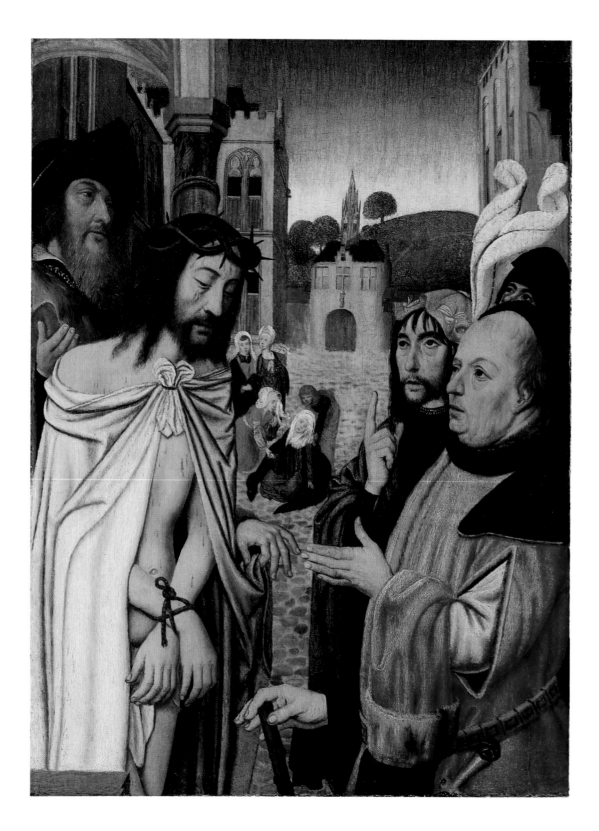

supported by Saint John and the Magdalen and attended by the two other Marys.

According to the compilers of the 1965 Christie's sale catalogue, the picture was bought by John, 2nd Lord Northwick, in 1832. The picture bought in 1832, a *Christ Mocked* that was attributed to Cornelis Engelbrechtsz., does not appear in the catalogue of the 1859 sale of Lord Northwick's collection, unless it is listed as "Quentin Matsys, no. 1466, *Christ Mocked*."[4] However, no. 1466 was not one of the pictures purchased by the 3rd Lord Northwick at the 1859 sale. If that picture is the present one, it would have to have been bought back at a later date,[5] but before 1864, when, according to Tancred Borenius (1921), it was listed as "C. Enghelbrechtsen, no. 163, *Christ Mocked*" in the catalogue of pictures at Northwick Park.

The earliest sure reference to the picture is that of Max Friedländer (1916), who first attributed it to Jan Mostaert. Describing it as an Ecce Homo, he associated it with a *Christ before Pilate*[6] that he dates about 1510, placing the Linsky picture somewhat later. Friedländer (1933) correctly designates the picture as a Christ Shown to the People and groups it with the half-length *Christ Shown to the People* in the Museum of Fine Arts, Moscow, and its variants.

N. I. Romanov (1934) considers the Linsky picture in connection with the Moscow painting. He asserts that both are variants of the "Ecce Homo" seen by Karel van Mander but supposedly lost today. G. J. Hoogewerff (1937) also relates the Linsky and Moscow pictures. He, however, believes the latter to have been the one actually seen by van Mander (see Biography above).

The Linsky painting is closely related to a number of works attributed uncontestably to Jan Mostaert. Closer even than the *Christ before Pilate* mentioned by Friedländer is another *Christ before Pilate* in Saint Louis,[7] which is of the same date as Friedländer's comparative picture but was unknown to him in 1933. Particularly characteristic of the artist's work is the treatment of the cobblestone pavement in the Saint Louis and Linsky pictures, a point of recognition that is seen again in the *Christ Shown to the People* on the interior right wing of the Adrichem Triptych in Brussels, a key work in Mostaert's oeuvre that dates from the second decade of the sixteenth century. The Christ type in these three works is also homogeneous. The artist's penchant for including diminutive figure scenes in the background of his compositions is another feature the Adrichem Triptych shares with the present picture. In the background of the exterior left wing, *The Road to Calvary*, there is a group with the swooning Virgin very similar to the one in the Linsky picture. The same mushroomlike trees are also found in both panels. This tree form is seen again in the *Portrait of Jan Jansz. van der Meer*, in the Nationalmuseet, Copenhagen, a painting that can be dated before 1510. The contours of the head of the stout man at the right in the Linsky painting and, even more, the conception of the background space and the foreground figures' relation to it correspond precisely to the Copenhagen portrait. The Linsky *Christ Shown to the People* falls between the Saint Louis and Brussels pictures, and it is closer to the Copenhagen portrait than to the later triptych. It can be dated assuredly 1510–15.

NOTES:

1. For a detailed review of the facts arguing for a 1473 birth date see M. Dolleman, "Jan Jansz. Mostaert, schilder en beroemd Haarlemer," *Jaarboek van het Central Bureau voor Genealogie* XVII (1963), pp. 1–15.

2. An oeuvre, culled from works formerly attributed to Geertgen and Mostaert, has recently been assigned to Jacob Jansz. See A. Châtelet, *Early Dutch Painting*, New York, 1981, pp. 124–33.

3. A not likely exception is a *Virgin and Child* with a dubious monogram in the Palazzo Venezia, Rome. See M. Winner, "Eine Signatur Jan Mostaerts," *Oud Holland* LXXIV (1959), pp. 247–48.

4. No. 1466 cannot be the *Christ Shown to the People* attributed to the Master of Hoogstraten in M. Friedländer, *Early Netherlandish Painting*, VII (1971), p. 73 n. 114, pl. 87, and listed by Friedländer as in the Spencer-Churchill collection, Northwick Park, since he says it was acquired in 1913. This picture, whose present location is unknown, did not appear in the 1965 sale of the Spencer-Churchill collection.

5. This would not be the only instance of a picture, not purchased in 1859, reentering the Northwick Park collection at a later date. Neither the Guido Reni *Saint Jerome* (Cat. 1859, no. 539) nor the Guercino *Christ and the Woman of Samaria* (Cat. 1859, no. 1692) were bought by the 3rd Lord Northwick, yet both reappeared at Northwick Park, the former between 1864 and 1908, the latter in 1873. This seems to be the case also with the Linsky Gerard David from Northwick Park (see no. 17).

6. Present location unknown. See Friedländer (1973), p. 69, no. 10, pl. 10.

7. L. Silver, "Early Northern European Paintings," *Saint Louis Art Museum Bulletin* XVI (no. 3, 1982), pp. 16–17.

EX COLL.: Probably sale, Phillips', London, July 27, 1832, no. 4, as Cornelius Enghelbrechtsen, to Lord Northwick; probably John Rushout, 2nd Lord Northwick, Thirlestane House, Cheltenham (1832–59; sale, Phillips', London, Aug. 18, 1859, possibly no. 1466, as Quentin Matsys, to the Rev. Boyd); George Rushout Bowles, 3rd Lord Northwick, Northwick

Park, Blockley, Gloucestershire (by 1864–1887); his widow, Elizabeth Augusta Bowles, Lady Northwick, Northwick Park (1887–1912); her grandson, Capt. E. G. Spencer-Churchill, Northwick Park (1912–64; sale, Christie's, London, May 28, 1965, no. 59, as Jan Mostaert, to Linsky); Mr. and Mrs. Jack Linsky, New York (1965–80); The Jack and Belle Linsky Foundation, New York (1980–82).

EXHIBITED: Royal Academy of Arts, London, *Flemish and Belgian Art 1300–1600*, 1927, no. 117 (as Jan Mostaert, lent by Capt. E. G. Spencer-Churchill); Royal Academy of Arts, London, *Dutch Pictures 1450–1750*, Nov. 22, 1952–Mar. 1, 1953, no. 11 (as Jan Mostaert, lent by E. G. S. Churchill).

BIBLIOGRAPHY: *A Catalogue of the Pictures, Works of Art, &c. at Northwick Park*, 1864, p. 21, no. 163 (reprint with additions, 1908, p. 25) // M. Friedländer, *Von Eyck bis Bruegel*, Berlin, 1916, p. 148; *From van Eyck to Bruegel*, trans. M. Kay, New York, 1956, p. 116 // T. Borenius, comp. *Catalogue of the Collection of Pictures at Northwick Park*, London, 1921, p. 89, no. 203 // M. Friedländer, *Die Altniederländische Malerei*, Berlin, X (1933), p. 120, no. 12; *Early Netherlandish Painting*, New York, X (1973), p. 69, no. 12, pl. 11 // N. I. Romanov, "Jan Mostaert's Great 'Ecce Homo,'" *Art in America* 22 (1934), p. 47 // G. J. Hoogewerff, *De Noord-Nederlandsche Schilderkunst*, The Hague, 11 (1937), p. 493.

GCB

Attributed to
JAN CORNELISZ. VERMEYEN

Born 1500, Beverwijk; died 1559, Brussels

KAREL VAN MANDER'S report of Vermeyen's birth in 1500 in Beverwijk, a small town near Haarlem, is believed to be reliable. About 1525 he entered into the service of Margaret of Austria, regent of the Netherlands. After her death in 1530, he worked intermittently for her nephew Charles V. He accompanied Charles on the Tunis campaign of 1535, and the following year he was granted a privilege to publish engravings of it. During the years 1545–48 he was engaged by Mary of Hungary, Margaret's niece and her successor as regent, to design tapestry cartoons. In 1550 he was commissioned by Charles V to execute a copy of a *Pietà* by Titian.

Jan Vermeyen is an elusive artistic personality. His principal work, the Raising of Lazarus Triptych in the Musées Royaux des Beaux-Arts de Belgique, Brussels, is attributed to him largely on the grounds that some Roman ruins from Tunis may be in its background. A signed *Holy Family* in the Frans Halsmuseum, Haarlem, displays the marked influence of Jan Gossaert. The only other signed paintings are a *Tourney at Toledo*, dated 1534, in the Stopford-Sackville collection, Drayton House, Thrapstone, Northamptonshire, and a gouache, *The Pacification of Ghent*, dated 1540, in the Bibliothèque Royale Albert Ire, Brussels. Despite the recognition he must have enjoyed in his time, it is not surprising that the literature on Vermeyen today is sparse.

Documents indicate that Vermeyen was probably active primarily as a portrait painter. The stylistic basis for attribution of portraits to him is a portrait in the Rijksmuseum, Amsterdam, *Erard de la Marck*. An etching of the same subject made by Vermeyen corresponds with this picture, and the artist is documented as having twice painted de la Marck's portrait. Presumably the print is after one of these two paintings, but it is not so identified by the artist.

26. Queen Mary of Hungary

Oil on wood. 21½ × 18 in. (54.6 × 45.7 cm.)
1982.60.26

The picture is in poor condition and heavily restored. Although the face is moderately well preserved, there are large inpainted areas of paint loss elsewhere, particularly on the backs of both hands, and extensive repainting in the wimple. Nothing of the painting's original support can be detected. The picture appears to have been transferred from panel to canvas and then retransferred to its present cradled plywood support. It is apparent from a break in the paint surface that runs across the shoulders that the original panel was joined horizontally. It is also apparent that it had a shaped top: the upper corners were cut diagonally.

THE DOWAGER QUEEN is presented half-length against a blue ground, holding a pair of gloves. She is dressed in mourning: a black dress, a coat with fur lapels, and a white cloth wimple. She wears a wedding band set with sapphires on her left ring finger.

Mary of Hungary (1505–1558) was the fourth daughter and youngest child of Philip the Fair and Joanna the Mad, and the sister of Holy Roman Emperors Charles V and Ferdinand I. She was married, at the age of nine, to Louis II Jagellon, who became king of Bohemia and Hungary

the following year, 1516. Her husband was killed in 1526 in an equestrian accident fleeing a losing battle against the Turks. In 1531 she succeeded her aunt, Margaret of Austria, as regent of the Netherlands, remaining a widow until she died.

In 1530 Jan Vermeyen was sent by Margaret of Austria to Augsburg and Innsbruck to paint portraits of Charles V, Ferdinand I and his wife Anna of Hungary, and Mary of Hungary.[1] Gustav Glück (1933; 1934) believed the present picture to be identical with, or "at least a first-rate repetition of," the portrait of Mary painted by Vermeyen in 1530, and his suggestion is followed by Marianne Takács (1955).

W. R. Valentiner (1944) thought this portrait was mentioned in a 1524 inventory of the contents of Margaret's palace at Malines. He was, however, in error, since, as Glück had already noted, the inventoried picture is said to be painted on canvas and the present picture appears originally to have been painted on panel.

The present portrait surely relates to the portrait painted by Vermeyen in 1530 rather than to the one mentioned in 1524: not only does the sitter appear to be at least twenty-five years old as opposed to what her age must have been, nineteen at most, when the earlier portrait was painted but apparently she is depicted in mourning. However, because of the portrait's condition it is difficult to accept without reservation the notion that it is identical with the original. Max Friedländer (1934), in a cautiously worded certification, gives recognition to Glück's suggestion and then defers to his soon-to-be-published volume of *Die Altniederländische Malerei*, in which he treats Vermeyen's work. All he writes there concerning the portraits of Charles, Ferdinand, Anna, and Mary is the following: "These were probably copied in his workshop many times and copies of various degrees of merit have turned up. They all display Vermeyen's characteristic style."[2]

NOTES:
1. See A. Pinchart, "Tableaux et sculptures de Marie d'Autriche, reine douairère de Hongrie. (1558)," *Revue Universelle des Arts* III (1856), p. 137 n. 2.

2. M. Friedländer, *Early Netherlandish Painting*, New York, XII (1975), p. 89.

EX COLL.: ?The House of Orange; ?The House of Hohenzollern; ?Wilhelm II of Germany, Schloss Oranienburg, near Berlin (in 1907); [Hugo L. Moser, Berlin, by 1933–1957]; [Hugo Moser and Paul Drey Gallery, New York, 1957–59; sale, Christie's, London, June 26, 1959, no. 95 (as Jan Cornelisz. Vermeyen)]; Mr. and Mrs. Jack Linsky, New York (1959–80); The Jack and Belle Linsky Foundation, New York (1980–82).

EXHIBITED: ?Preussische Akademie der Künste, Berlin, *Exhibition of Paintings from the Collection of Emperor Wilhelm II*, 1907; Museum Boymans, Rotterdam, *Jeroen Bosch, Noord-Nederlandsche Primitieven*, July 10–Oct. 15, 1936, no. 125 (as Jan Cornelisz. Vermeyen, lent by H. Moser); The Detroit Institute of Arts, *Loan Exhibition of Early Dutch Paintings 1460–1540*, Feb. 1944, no. 27 (as Jan Vermeyen, lent by Hugo L. Moser); Art Association of Montreal, *Loan Exhibition of Great Paintings: Five Centuries of Dutch Art*, Mar. 9–Apr. 9, 1944, no. 21 (as Jan Vermeyen, lent by Hugo L. Moser).

BIBLIOGRAPHY: G. Glück, "Bildnisse aus dem Hause Habsburg. I. Kaiserin Isabella," *Jahrbuch der Kunsthistorischen Sammlungen in Wien* n.s. VII (1933), p. 196 // G. Glück, "Bildnisse aus dem Hause Habsburg. II. Königin Maria von Ungarn," *Jahrbuch der Kunsthistorischen Sammlungen in Wien* n.s. VIII (1934), pp. 178–80, fig. 92 // M. Friedländer, unpublished opinion, Dec. 11, 1934 // W. R. Valentiner, *Early Dutch Painting 1460–1540* (exhib. cat.), Detroit, 1944, pp. 7, 15 // M. Takács, "Un Nouveau Portrait de la reine Marie de Hongrie à la galerie des maîtres anciens," *Bulletin du Musée Hongrois des Beaux-Arts* VII (no. 7, 1955), pp. 38, 40, fig. 26.

GCB

27. Portrait of a Man with a Rosary

Oil on wood. 20 × 16¼ in. (50.8 × 41.3 cm.)
Dated (to left of sitter's head): 1545
Inscribed (to right of sitter's head): 63
1982.60.27

The picture is in fair condition. There are overall minor
inpainted losses and a repaired split in the oak support
that runs vertically to the right of the sitter's head.

THE SITTER, a sixty-three-year-old man whose identity
is unknown, is presented half-length behind a stone par-
apet and against a green ground on which are inscribed
the year and his age. He wears the black cap and gown of

a chancellor, and must have been an important official of
state. His garments consist of a full-sleeved red shirt be-
neath a tunic with a fur collar and wide fur lapels. In his
left hand he holds a pair of gloves, and in the right a
rosary with coral beads. He wears a gold ring set with a
blue stone on his right forefinger.

The summary handling of paint and the deft, schematic
underdrawing, visible to the naked eye because of the
thin paint surface, indicate an artist skilled as a portraitist.
Max Friedländer (1936) assigns this portrait along with a
number of others bearing dates from the same decade to
an anonymous artist he names the Master of the 1540s, an
artistic personality that has not been taken up subse-
quently by art historians.

W. R. Valentiner (1943) was the first to attribute the
painting to Jan Vermeyen. He calls attention to the simi-
larity of its treatment to that of three other portraits by
this artist: *Erard de la Marck*, in the Rijksmuseum, Am-
sterdam (inv. A4069);[1] *Jean Carondelet*, in the Brooklyn
Museum, New York;[2] and, in particular, the *Portrait of a
Man*, in the Akademie der Bildenden Künste, Vienna (inv.
1369).[3] These comparisons are sufficiently convincing to
warrant attribution of the present painting to Vermeyen.

The forceful presentation of the sitter is characteristic
of the mature Northern Renaissance portrait and is closely
related to those by the Antwerp artists Jan Gossaert and
Joos van Cleve. The evocative use of the sitter's hands to
express his character is a hallmark of Vermeyen's por-
traits.

NOTES:
1. See *All the Paintings of the Rijksmuseum in Amsterdam: A
Completely Illustrated Catalogue*, Amsterdam, 1976, p. 573.
2. See *The Brooklyn Museum Handbook*, New York, 1967, pp.
448–49.
3. There attributed to Joos van Cleve the Younger; see R.
Eigenberger, *Die Gemäldegalerie der Akademie der bildenden
Künste in Wien*, Vienna, 1927, pp. 75–76.

EX COLL.: [Rosenbaum, Amsterdam, in 1935]; Georges Blu-
menthal, Paris and New York (until 1941); Ernst Schwarz,
New York (by 1944–1959; sale, Christie's, London, June 26,
1959, no. 42, as Jan Cornelisz. Vermeyen); Mr. and Mrs. Jack
Linsky, New York (1959–80); The Jack and Belle Linsky
Foundation, New York (1980–82).

EXHIBITED: The Detroit Institute of Arts, *Loan Exhibition of
Early Dutch Paintings 1460–1540*, Feb. 1944, no. 26 (as Jan Ver-
meyen, lent by Ernest Schwarz); Art Association of Mon-
treal, *Loan Exhibition of Great Paintings: Five Centuries of Dutch
Art*, Mar. 9–Apr. 9, 1944, no. 20 (as Jan Vermeyen, lent by
Ernst Schwarz).

BIBLIOGRAPHY: M. Friedländer, *Die Altniederländische Malerei*, Leiden, XIII (1936), p. 163, no. 252; *Early Netherlandish Painting*, New York, XIII (1975), p. 94, no. 252, pl. 125 // W. R. Valentiner, unpublished opinion, Aug. 7, 1943.

GCB

DUTCH PAINTER, UNKNOWN

First half of 16th century

28. Portrait of a Man

Oil on wood. Overall, with arched top, 8¼ × 6½ in. (21 × 16.5 cm.); painted surface 8⅛ × 6⅛ in. (20.6 × 15.6 cm.)
1982.60.28

The picture is much abraded and overpainted. The barb of the painted surface survives all around, except at the bottom edge, where the panel appears to have been cut.

THE SITTER, whose identity is not known, is seen in three-quarter profile to the left against a green ground. He wears a black jacket with a slashed bodice over a white shirt, and a black hat with a badge. The badge is composed of a monogram conjoining letters that appear to be either *MR* or *HR*.

The painting's condition impedes identification of the artist. Its conservative compositional formula points to the generation of Lucas van Leyden and Jan van Scorel.

EX COLL.: Mr. and Mrs. Jack Linsky, New York (until 1980); The Jack and Belle Linsky Foundation, New York (1980–82).

GCB

DAVID BAILLY

Born 1584?, Leiden; died 1657, Leiden

ACCORDING TO Jan Orlers's *Description of the City of Leiden* published in 1643, which is virtually the only source for Bailly's biography, the artist was the son of Pieter Bailly, a calligrapher from Antwerp. The young Bailly reportedly was influenced by the important draftsman, engraver, and painter Jacob de Gheyn II; it is not known if Bailly was his pupil. Orlers names a self-taught painter, Adriaen Verburgh, as Bailly's instructor, but his formal studies evidently began after the Bailly family moved to Amsterdam about 1602. Another Flemish immigrant, the prominent portraitist Cornelis van der Voort, became Bailly's teacher, and under his tutelage Bailly copied some of the many Flemish history pictures, landscapes, and various kinds of still-life painting in his collection. In 1608, after a stay in Leiden, Bailly went to Hamburg; he remained there for about a year and then traveled through Frankfurt, Nuremberg, and other German cities to Venice, Rome, and elsewhere in Italy. Bailly is said to have spent five months in Venice in 1610, and to have traveled from there northward through Germany, where he supposedly worked for several noblemen, including the duke of Brunswick, Heinrich Julius. Returning to Leiden in 1613, Bailly apparently stayed there for the rest of his life, and became one of the town's leading artists. He married in 1642, at the age of fifty-eight, and in 1648 was one of the founders of the Guild of Saint Luke, where he served as dean in 1649. Bailly probably died shortly after making out his will in April 1657.

84

As a portraitist, Bailly received commissions from university professors, students, distinguished foreign visitors, and members of patrician families in Leiden and Amsterdam. He also painted *vanitas* still lifes, at least within portraits, and was the teacher of his two nephews, the *vanitas* still-life painters Harmen and Pieter van Steenwyck. Bailly was a very capable but conservative artist. He was aware of Rembrandt, Hals, and other younger painters in Amsterdam and Haarlem, but his style remained closer to that of Jacob de Gheyn II and to the South Holland tradition of portraiture represented by, for example, Michiel van Miereveld.

29. Portrait of a Man, Possibly a Botanist

Oil on wood. 33 × 24½ in. (83.8 × 62.2 cm.)
Inscribed (center right): *Ætatis 66 / ANº 1641*
1982.60.29

The picture is in good condition; the face, hands, and book are well preserved. The background is thin, and considerably retouched. There are also numerous retouches in the costume and along the vertical joins of the three boards that make up the panel.

THIS IMPRESSIVE portrait was ascribed to Ferdinand Bol, probably by Cornelis Hofstede de Groot, when it was sold in New York in 1925, but Sturla Gudlaugsson attributed the painting to David Bailly.[1] Establishing Bailly's authorship conclusively would require firsthand comparisons with his signed portraits of about the same date, but it appears very likely that he is indeed responsible for the present picture.

The composition and, generally considered, the style of execution are typical of South Holland, specifically the area of The Hague and Delft, where the principal portraitists of the period were Michiel van Miereveld, Willem van Vliet, and Jan van Ravesteyn. Van Miereveld and van Ravesteyn both enjoyed the patronage of the House of Orange and the emulation of other artists. Bailly's portraits may be broadly associated with those by van Ravesteyn and van Miereveld, particularly the latter.

The Museum's painting *Jacob van Dalen*, signed by van Miereveld and dated 1640, provides a very suitable example for comparison with the Linsky picture.[2] In van Miereveld's painting, the sitter's features are modeled strongly but smoothly, and the head gives the impression of a relief rather than a solid form in three-dimensional space. The hair is treated as a soft mass. (Van Ravesteyn's modeling is soft in general, giving a less sculptural impression than portraits by van Miereveld, and lacking the latter's broad distinctions in texture between skin, hair, and cloth.) Bailly, by contrast, emphatically models the sitter's head as a three-dimensional form, and employs a heavier application of paint to articulate the topography of the face and suggest the texture of the skin. The present sitter's beard, although more softly rendered than the skin, is more minutely described than similar passages in portraits by van Miereveld. On the whole, Bailly's sitters are observed much more incisively than sitters treated in the South Holland style, a generalization one is tempted to extend beyond physical traits to those of character as well. These qualities, found in the Linsky picture, give it the appearance of a work of the Leiden school, and of Bailly's portraiture at its best.

Gudlaugsson probably assigns the portrait to Bailly because of its similarity to one or two portraits by Bailly of older men in academic or clerical dress (it is often difficult to distinguish the two): the *Portrait of Anthony de Wale (Antonius Walaeus), Professor of Theology at the University of Leiden*, dated 1636, in the Rijksmuseum, Amsterdam, and the *Portrait of an Unknown Professor or Pastor*, signed and dated 1642, in the van Heeckeren van Wassanaer collection at Kasteel Twickel.[3] The latter picture, dating from one year later than the present panel, is a three-quarter-length portrait that includes a very similar chair and table and the motifs of eyeglasses held in the right hand and a book, the sitter's place marked by a finger, held in the left hand. In both paintings, the rendering of the furniture in perspective is slightly inaccurate.

The sitter in the Linsky portrait has not been identified. He may be a student of botany, but his very conservative costume, with its many buttons and unusually thin ruff, would be entirely appropriate for a university professor. The book he holds, open to two views of a narcissus, is probably the artist's invention; in any case, it cannot be considered a clue to his identity. Should the portrait prove to represent a Leiden professor or amateur of botany, this would be circumstantial evidence in favor of the attribution to Bailly.

NOTES:
1. Blankert (1982).
2. K. Baetjer, *European Paintings in The Metropolitan Museum of Art by Artists Born in or Before 1865: A Summary Catalogue*, New York, 1980, III, p. 397, no. 25.110.13, ill.

3. J. Bruyn, "David Bailly, 'fort bon peintre en pourtraicts et en vie coye'" (conclusion), *Oud Holland* LXVI (1951), pp. 213–15, figs. 9, 13. Bruyn, in a letter dated September 1, 1983, doubts that Bailly painted the Linsky picture, and also rejects Jacob Gerritsz. Cuyp, Jacob Willemsz. Delff II, and Hendrick (not Willem) van Vliet, "not to mention Bol." The stylistic qualities that suggest Bailly's authorship, however, are not nearly as evident in black-and-white photographs as they are in the painting itself; in reproductions, the portrait seems more similar than it is to routine products of the South Holland school.

EX COLL.: Achillito Chiesa, Milan (sale, American Art Association, New York, Nov. 27, 1925, no. 18, as Ferdinand Bol; the sale catalogue was compiled by Cornelis Hofstede de Groot, G. J. Hoogewerff, and Giacomo de Nicola); Roland L. Taylor, Philadelphia (sale, Parke-Bernet, New York, Apr. 5, 1944, no. 25, as Ferdinand Bol); Mr. and Mrs. Jack Linsky, New York (until 1980); The Jack and Belle Linsky Foundation, New York (1980–82).

BIBLIOGRAPHY: A. Blankert, *Ferdinand Bol (1616–1680): Rembrandt's Pupil*, Doornspijk, 1982, p. 180, no. R 168, titles the picture *Old Man Studying a Botanical Book*, and gives the artist as David Bailly, crediting the attribution to S. J. Gudlaugsson's undated note in the photographic files of the Rijksbureau voor Kunsthistorische Documentatie, The Hague.

WL

GERARD TER BORCH

Born 1617, Zwolle; died 1681, Deventer

GERARD TER BORCH first studied with his father, Gerard ter Borch the Elder, and then, in 1634, with Pieter de Molijn in Haarlem. According to Arnold Houbraken, in *De Groote Schouburgh der Nederlantsche Konstschilders en Schilderessen*, published in Amsterdam in 1718–21, ter Borch traveled in England (where he was recorded in July 1635), the Netherlands, France, Germany, Spain, and Italy; he was probably back in Holland before 1640. His genre paintings and portraits of the 1640s depend upon the works of Amsterdam and Haarlem artists, and in the mid-1640s he painted portraits of prominent Amsterdam citizens. Ter Borch was in Münster during the peace negotiations of 1646–48, and executed small portraits of Dutch and Spanish dignitaries, as well as the important group portrait *The Swearing of the Oath of Ratification of the Treaty of Münster, 15 May 1648*, in the National Gallery, London. The artist was recorded in Amsterdam in November 1648, and in April 1653 he witnessed a deposition in Delft along

with the young Jan Vermeer. In February 1654, ter Borch married in Deventer, where he became a citizen in 1655 and appears to have spent the rest of his life. Like ter Borch's native Zwolle, Deventer is in Overijssel, and rather far from the main centers of Dutch art.

Nonetheless, ter Borch was definitely not a provincial artist. His father had lived in Italy and encouraged ter Borch and his sister, Gesina (his model in a number of genre scenes), to study art and literature at an early age. Ter Borch's youthful training outside the provinces of Holland and Utrecht may partly explain his later independence from stylistic conventions. The small full-length portraits he painted from about 1640 onward, for example, are more similar to his early sketchbook studies from life than to most contemporary Dutch portraits, although examples by the older Amsterdam artist Thomas de Keyser may have impressed ter Borch. Similarly, his genre paintings dating from after 1650, although they are sophisticated in iconography and style, are remarkable for their naturalistic treatment of interior space, the portraitlike individuality of the figures, and the sensitivity with which the artist interprets human situations. Ter Borch seems to stand apart even from those painters who influenced him, such as Pieter Codde and Willem Duyster, and from those with similar interests, such as Gabriel Metsu. Houbraken reports that Caspar Netscher was ter Borch's pupil in Deventer.

30. The van Moerkerken Family

Oil on wood. 16¼ × 14 in. (41.3 × 35.6 cm.)
Inscribed (upper left, on ribbon of family crests):
V:MOERKERKEN NYKERKEN
1982.60.30

The painting is in very good condition.

THE MAN in this engaging family portrait is ter Borch's cousin Hartogh van Moerkerken (1622–1694), who was the representative of the Dutch government to the area of 's Hertogenbosch.[1] He and his first wife, Sibilla Nijkerken,[2] lived in the village of Monster near The Hague. The couple, identified by their family crests, are portrayed with their son Philippus.[3] Because the boy was born on January 8, 1652, the portrait is generally dated 1653–54. Ter Borch was recorded in Delft, which is very close to The Hague, in April 1653, and was probably in the area more frequently than is known from documen-

tary sources.[4] The style of the picture is entirely consistent with a date of about 1653–54, and the composition is very similar to that of *The de Liedekercke Family*, in the Frans Halsmuseum, Haarlem, which dates from about 1653–55. Anthonie Charles de Liedekercke was, like van Moerkerken, in service to the Estates General (as a captain of the fleet), and resided in Delft, or possibly Leiden, at the time ter Borch painted the de Liedekercke portrait.[5]

In both that painting and *The van Moerkerken Family*, a pocket watch is prominently displayed. The wife of de Liedekercke hands a closed watch to her son; the three figures look out at the viewer, which gives the action a ceremonial aspect. In the van Moerkerken portrait, the father shows an open watch to his wife, who looks directly at it. Watches in Dutch and Flemish portraits frequently served as *vanitas* symbols,[6] but in these two family portraits by ter Borch the watch must be an heirloom signifying that, in time, the son would become the head of the family. Both the young man in the de Liedekercke portrait and the child in the Linsky picture were evidently firstborn sons. This reading is supported by the repetition, in each of the paintings, of the paternal family crest. A poignant note is provided by historical hindsight: the van Moerkerken and de Liedekercke sons were both outlived by their fathers.

The composition of *The van Moerkerken Family* has been commented upon by several writers, one of whom, the eminent connoisseur Cornelis Hofstede de Groot, was not entirely pleased by it.[7] The panel survives intact; the rather low placement of the figures in the picture field serves to set them apart from the family crests, and to establish an impression of spatial depth with very limited means. A similar approach is found in genre pictures and in other group portraits painted by ter Borch about 1650–53, in comparison with which the van Moerkerken and de Liedekercke portraits are somewhat formally arranged.[8] In the Linsky picture the restraint of the composition not only is appropriate to the commemorative nature of the portrait but enhances the appeal of the handsome sitters and the charm of their expressions.

NOTES:

1. Gudlaugsson (1959–60), II, pp. 43, 46 (Family Table II), 113, no. 102. Two other painted portraits of Hartogh van Moerkerken are known: a panel signed by Crispyn van den Queboorn and dated 1645, in the Museum Boymans-van Beuningen, Rotterdam, and a panel by Herman ter Borch, Gerard's stepbrother, which is dated by Gudlaugsson, II, p. 287, no. 5, to the mid-1650s or slightly later, and which was sold, along with the

Linsky picture (see Ex coll.) and three other portraits of members of the Hartogh van Moerkerken family by Herman ter Borch, at the De Fremery sale in New York on December 16, 1942; see Gudlaugsson, II, p. 287, nos. 3, 4, 6.

2. Ibid., II, p. 113; on page 287, no. 6, Gudlaugsson records a portrait of Sibilla (or Sibille) Nijkerken by Herman ter Borch (see note 1 above), and another portrait of her (De Fremery sale, New York, Dec. 16, 1942, no. 11), "by another hand."

3. Ibid., II, pp. 43 n. 63 (citing M. E. Houck), 113. A painted Dutch inscription of uncertain date on the back of the Linsky panel identifies Philippus van Moerkerken and his parents as the sitters.

4. Ibid., I, p. 93; II, pp. 20–24 (documents of 1649–54).

5. Ibid., pp. 112–13, no. 101.

6. See de Jongh (1982).

7. Hofstede de Groot (1913), p. 85: "A good picture, though not very happily composed. The coloured shields spoil the effect." See also Hellens (1911), p. 99 ("belle sobriété de sa composition"); and Plietzsch (1944), p. 17.

8. See, for example, Gudlaugsson (1959–60), I, pls. 90, 91, 97.

EX COLL.: Hartogh van Moerkerken, Monster, The Netherlands; by descent from the van Moerkerken family to James de Fremery, 's Gravezande (on loan to the Mauritshuis, The Hague, from 1895 to 1904), and later (by 1913) Oakland, Calif.; R. de Fremery, San Francisco (sale, Waldorf-Astoria, New York, Dec. 16, 1942, no. 26); [D. M. Koetser, New York, evidently acting on behalf of Mr. and Mrs. Jack Linsky]; Mr. and Mrs. Jack Linsky, New York (until 1980); The Jack and Belle Linsky Foundation, New York (1980–82).

EXHIBITED: Utrecht, *Tentoonstelling van Oude Schilderkunst te Utrecht*, 1894, p. 101, no. 266 (lent by James de Fremery, 's Gravezande); Mauritshuis, The Hague, 1895–1904, no. 604 (lent by James de Fremery, 's Gravezande).

BIBLIOGRAPHY: E. W. Moes, *Iconographia Batava, Beredeneerde Lijst van Geschilderde en Gebeeldhouwde Portretten van Noord-Nederlanders in Vorige Eeuwen*, Amsterdam, II (1905), p. 108, nos. 5094, 5096, 151, no. 5477 // F. Hellens, *Gérard Terborch*, Brussels, 1911, pp. 99–100, ill. opp. p. 32, describes the composition // C. Hofstede de Groot, *A Catalogue Raisonné of the Works of the Most Eminent Dutch Painters of the Seventeenth Century*, London, V (1913), pp. 84–85, no. 248, p. 92, no. 282, p. 142, identifies the sitters, describes their costume, criticizes the composition, and dates the picture to 1653–54 // E. Plietzsch, *Gerard Ter Borch*, Vienna, 1944, pp. 16–17, 44–45, no. 45, pl. 45, dates it 1654–55 on the basis of the boy's apparent age, describes the composition, and compares it to other family portraits by ter Borch // A. Chapuis, *De Horologiis in Arte*, Lausanne, 1954, p. 72, fig. 99, calls the sitters the van Moerkenken (sic) family // S. J. Gudlaugsson, *Gerard Ter Borch*, The Hague, 1959–60, I, pp. 93, 261, pl. 102, 420; II, pp. 40, 43, 46, 112, no. 101, 113, no. 102, 287, identifies the sitters, dates the painting to about 1653–54, and compares it with *The de Liedekercke Family* in the Frans Halsmuseum, Haarlem // Museum Boymans-van Beuningen, *Catalogus schilderijen tot 1800*, Rotterdam, 1962, p. 108, no. 1697, a por-

trait of Hartogh van Moerkerken by Crispyn van den Queboorn // *Gerard Ter Borch: Zwolle 1617–Deventer 1681* (exhib. cat.), Münster, Westfälisches Landesmuseum für Kunst und Kulturgeschichte, 1974, p. 118, no. 29, *The de Liedekercke Family*, considers the two pictures to date from about the same time // W. H. Wilson, *Dutch Seventeenth Century Portraiture: The Golden Age* (exhib. cat.), Sarasota, The John and Mable Ringling Museum of Art, 1980–81, no. 9, a miniature portrait of a woman of the van Moerkerken family, suggests that the sitter may be a younger sister or in-law of the van Moerkerken family // E. de Jongh, *Still-Life in the Age of Rembrandt* (exhib. cat.), Auckland, New Zealand, Auckland City Art Gallery, 1982, p. 159, fig. 29a, considers the watch a symbol of transience. WL

JAN STEEN

Born Leiden, 1625/26; died Leiden, 1679

A NATIVE OF LEIDEN, Steen was said to be twenty years old when he enrolled at the University of Leiden in November 1646. He was a founding member of the artists' guild in Leiden in March 1648. According to Arnold Houbraken, in *De Groote Schouburgh der Nederlantsche Konstschilders en Schilderessen*, 1718–21, Steen was a pupil of Jan van Goyen, but that artist sold his house in Leiden in November 1631 and became a citizen of The Hague in March 1634. Steen married van Goyen's daughter Margaretha (Grietje) at The Hague in December 1649, and was still there in July 1654; he may have studied with van Goyen during the early 1650s, although at this stage of his career Steen would not have been a pupil in the usual sense. Steen's father leased a brewery for him in Delft between 1654 and 1657. From 1656 to 1660 the painter lived in Warmond, near Leiden, and in 1661 he entered the artists' guild in Haarlem. He is recorded there, although infrequently, until 1670, and his wife died there in 1669. The following year he inherited a house in Leiden. He obtained permission to run an inn there in 1672, and in that year and the next two years served as an officer of the Leiden artists' guild. He was buried in his home town on February 3, 1679.

Steen painted landscapes, portraits, and a fair number of history pictures, but by far the greater part of his large oeuvre consists of genre scenes. Most of these scenes are satirical, which sets Steen apart from other Dutch painters of everyday life, particularly those of his own generation. His humor, while distinctive, is drawn from sources in popular literature and the comic theater (it may also

represent a light side of Leiden academic life) and from pictorial examples, probably including prints after drawings by Pieter Brueghel the Elder and paintings by Adriaen Brouwer. The finely rendered details in some of Steen's work seem typical of the Leiden school, but his fluid technique, with which he achieved broad and occasionally brilliant effects (especially in passages of drapery and daylight), testifies to Steen's study of art from outside his native town, and lends support to Jacob Campo Weyerman's statement in *De Levensbeschryvingen der Nederlandsche Kunstschilders*, 1729, that the artist was influenced by Knüpfer, van Ostade, and van Goyen. Steen's figures are similar to those of the leading Flemish painter of the day, Jacob Jordaens, in that in the genre scenes stock types mingle successfully with figures modeled on real people. The comparison may be extended to portraits and religious pictures, in which Steen's figures, like those of Jordaens, are presented in a serious manner.

31. The Dissolute Household

Oil on canvas. 42½ × 35½ in. (108 × 92.2 cm.)
Signed (lower right): I. STEEN
1982.60.31

The picture is in excellent condition; some glazes are missing from the bodice of the figure in the foreground.

THIS LARGE canvas represents one of the most successful interpretations of a theme that Steen treated frequently in the 1660s.[1] The painting is remarkable also for its state of preservation and for its outstanding quality of execution. The artist's oeuvre is uneven, and strong and weak passages are found in individual works. Here, however, Steen maintains a very high standard throughout the composition, and in some places—for example, in the still-life details, in the skirt of the woman in the foreground, and in the figure of the boy in blue—demonstrates his exceptional abilities.

As in similar pictures by Steen, members of his immediate family served as models: the central figure is a self-portrait; the woman in the foreground is Steen's wife, Grietje van Goyen; the younger boy, to the far left, is probably the couple's second son, Cornelis.[2] Comparisons between this and similar compositions, and between the figures here and those based on the same models in other paintings, indicate that the Linsky canvas dates from about 1665. Steen's formal *Self-Portrait* in the Rijksmuseum, Amsterdam, dates from the middle of the 1660s

and supports this dating of the present picture. In 1665 Steen was thirty-nine and his son Cornelis was about nine years old.

The painting depicts an upper-middle-class family at home, in an advanced state of gastronomic gratification and, in the case of the master and the lady of the house, inebriation. Dinner is finally over, to judge from the disarray of the table, the neglected roast on the floor, the presence of a large bowl of fruit (this motif, and the roast on a pewter plate, appear to be derived from still lifes by Jan Davidsz. de Heem),[3] and the fact that the grandmother has fallen asleep. The man enjoys a pipe, his wife another glass of wine. Both of them are, in a sense, served by the maid, who joins hands with the man in a manner that is explicitly obscene (as if clarification were needed, the artist places the maid before a bed, with its curtain drawn up like a decorative flourish above the symbolic gesture).[4] To the left, a young boy tickles the sleeping woman with a straw, while his older brother, dressed like a soldier, draws his sword to drive away an old beggar at the door.

The composition is littered with signs and symbols, none of which is obscure enough to have escaped the understanding of contemporary viewers.[5] The lute and the backgammon board add to the general atmosphere of idle pleasure and at the same time suggest discord (the strings of the lute are broken) and impending ill fortune.[6] The lute may also refer to the character of the woman in the foreground: the word "lute" (*luit*) was an indelicate term for the female anatomy,[7] and the woman, who is immodestly dressed, is in a pose curiously paralleled by the position of the lute (this kind of formal correspondence was often employed by Dutch genre painters). The book on the floor may be assumed to be a Bible, and is trampled underfoot. The watch, which has presumably dropped off the edge of the table (the location familiar from still lifes by de Heem, Kalf, and other contemporaries of Steen), is a *vanitas* motif. The broken jug is possibly a similar reminder of a sudden end, but it could also intimate the loss of feminine innocence.[8]

In other contexts—for example, Nicolaes Maes's paintings of old women who have fallen asleep (in some cases, while reading a Bible)[9]—sleep may imply death, but here the old woman's behavior is merely an example of sloth. Negligence is suggested by the cat's stealing unguarded food, which would not likely happen in a well-tended household. In general, however, the impression of disorder is as much the effect of Steen's busy design as it is of

scattered motifs. An X in the composition formed by the lute and four of the figures lends some stability to the rich pattern of colors, lines, and details.

The fate of this family literally hangs over its heads, in the form of a basket filled with objects.[10] The sword and the switch are instruments of justice. The other objects indicate the depths to which dissolute living leads: the crutch and can were often carried by beggars; bundles of twigs (like matchbooks today) were sold for pennies in the street; wooden clappers (*Lazarusklep*) like the one hanging at the left side of the basket announced lepers or those with contagious diseases; the Jack of Spades perhaps suggests the life-style of cardsharps and no doubt is a sign of bad luck. The flag, certainly a military standard, might indicate a career in the army, which was a last resort of men fallen on hard times.[11] It seems more likely, however, that the standard, which in seventeenth-century Dutch portraits is displayed more appropriately and proudly than it is here, is one more sign of duty being neglected.

Some support is given to this reading of the flag, and a label, so to speak, is given to the whole composition by the animals painted on the windows that frame the man's head. To the left is a lion with a scepter or staff; the animal to the right, apparently a boar, marches along with a rifle over its shoulder. Animals taking on human roles, and taking over things in general, were commonly featured in popular broadsheets of the sixteenth and seventeenth centuries.[12] Many of these illustrate the theme of the World Upside Down, which is certainly the artist's meaning here.

Steen's paintings of dissolute households and similar subjects are among the most obvious examples of Dutch pictures that extol virtue by condemning vice,[13] in this case by means of lighthearted parody. In the Linsky canvas, the *vanitas* motifs and other symbols, and even the mistreated Bible, do not bear the weight they were ordinarily given by contemporary religious writers, popular moralists, and some painters of still lifes and genre scenes. Indeed, the most impressive didactic element is perhaps the one that is most subtly stated: the allusion to the parable of the rich man and Lazarus (Luke 16:19–31).[14] In the biblical story, a beggar is driven away from the sumptuously laid table of a wealthy man; later, his soul is saved but the rich man roasts in hell. Here the figure of the beggar also lends a note of irony, since—as the objects hanging overhead portend—poverty will overtake the merrymakers as well.

Three or four copies or versions of this composition are known; none appears to be by Steen himself.[15]

NOTES:

1. See Braun (1980) for pictures by Steen of this and closely related subjects.

2. See Braun (1980) for self-portraits in pictures by Steen, for paintings in which Steen's wife appears, and for some of the pictures in which Cornelis appears.

3. See I. Bergström, *Dutch Still-Life Painting in the Seventeenth Century*, trans. C. Hedström and G. Taylor, London, 1956, figs. 166, 168, 169.

4. A similar gesture is made by the figure to the right in Frans Hals's early *Merrymakers at Shrovetide* (*The Merry Company*), in the Metropolitan Museum (14.40.605).

5. Lyckle de Vries, in a letter, July 21, 1983, and Nanette Salomon, verbally, September 1983, made substantial contributions to the discussion of symbols and the general meaning of the Linsky picture.

6. *Tot Lering en Vermaak: Betekenissen van Hollandse genrevoorstellingen uit de zeventiende eeuw* (exhib. cat.), Amsterdam, Rijksmuseum, 1976, nos. 12, 14, 21, 54, on the meanings of stringed instruments; no. 22 on backgammon (or trictrac).

7. Ibid., no. 8.

8. On the broken jug, see G. Zick, "Der zerbrochene Krug als Bildmotiv des 18. Jahrhunderts," *Wallraf-Richartz-Jahrbuch* XXXI (1969), pp. 149–202, where earlier Northern examples are reviewed.

9. See W. R. Valentiner, *Nicolaes Maes*, Stuttgart, 1924, pls. 14, 33, 35; *Tot Lering en Vermaak* (see note 6 above), no. 32.

10. See Braun (1980), pp. 10, 110, no. 179, on the same motif in Steen's so-called *World Upside Down* in the Kunsthistorisches Museum, Vienna (Braun's title, *In weelde siet toe*—"in prosperity, watch out"—is better, at least in Dutch). A similar basket also appears in *The Consequences of Intemperance*, in the National Gallery, London, illustrated in Braun (1980), no. 250.

11. This reading was suggested by de Vries (see note 5 above).

12. D. Kunzle, "Bruegel's Proverb Painting and the World Upside Down," *Art Bulletin* LIX (1977), pp. 197–202; D. Kunzle, "World Upside Down: The Iconography of a European Broadsheet Type," in *The Reversible World: Symbolic Inversion in Art and Society*, ed. B. A. Babcock, Ithaca, N.Y., 1978, pp. 39–94 (with bibliography).

13. S. Schama, "The Unruly Realm: Appetite and Restraint in Seventeenth Century Holland," *Daedalus* CVIII (1979), pp. 113–14.

14. Steen depicted this parable at least twice; see B. D. Kirschenbaum, *The Religious and Historical Paintings of Jan Steen*, New York, 1977, pp. 135–37, nos. 58, 59, figs. 103, 57.

15. See Braun (1980), p. 121, no. 251; his list is not reliable.

EX COLL.: Jan Tak, Leiden (sale, Soeterwoude, the Netherlands, Sept. 5, 1781, no. 19, to Hoogeveen); van Eyl Stuyter (van Helsleuter?), Amsterdam (sale, Paris, Jan. 25, 1802, no. 164, to Simon); Cardinal Fesch, Lyons and Rome (sale, Rome, Mar. 17–18, 1845, no. 226, to Preston); Jules Porgès, Paris, in 1911 (see under Exhibited); [N. Beets Galleries, Amsterdam? (according to Hannema, see Bibliography)]; H. E. ten Cate, Almelo and De Lutte, the Netherlands (by 1926–until at least 1957; the picture was exhibited in 1936 and 1937 as lent by D.

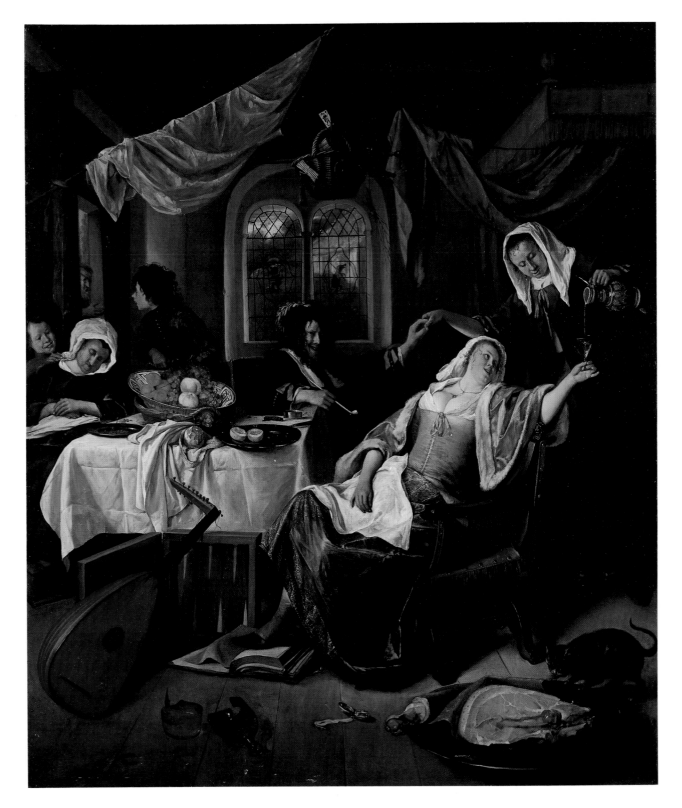

Katz, Dieren, and may have been consigned for sale to that dealer); Mrs. Myrtil Frank, New York (until 1964); Mr. and Mrs. Jack Linsky, New York (1964–80); The Jack and Belle Linsky Foundation, New York (1980–82).

EXHIBITED: Musée du Louvre, Galerie du Jeu de Paume, Paris, *Grands et petits maîtres hollandais*, 1911, no. 151 (lent by Jules Porgès); Rijksmuseum, Amsterdam, 1922; Stedelijk Museum "De Lakenhal," *Jan Steen*, Leiden, 1926, no. 73 (lent by H. E. ten Cate); Gemeente-Museum, Arnhem, *Tentoonstelling van Schilderijen van 17e eeuwsche Nederlandsche Meesters . . .*, 1934, no. 57; Commissie Waalbrug (in Huize "Belvoir"), Nijmegen, *Tentoonstelling van 16e en 17e eeuwsche Hollandsche, Vlaamsche en Italiaansche Schilderijen . . .*, 1936, no. 62; Firma D. Katz, Dieren, *Tentoonstelling van belangrijke 16e en 17e eeuwsche Hollandsche schilderijen . . .*, 1937, no. 88; Firma D. Katz, Dieren, *Exhibition of 17th Century Dutch Masterpieces*, 1939, Boymans Museum, Rotterdam, *Kunstschatten uit Nederlandse Verzamelingen*, 1955, no. 119 (lent by H. E. ten Cate); Dordrechts Museum, Dordrecht, *Mens en Muziek*, 1957, no. 76 (lent by H. E. ten Cate).

BIBLIOGRAPHY: J. Smith, *A Catalogue Raisonné of the Works of the Most Eminent Dutch, Flemish, and French Painters*, London, IV (1833), p. 12, no. 39, as "The Dessert," in the collection of J. Tak, Leiden, 1781 // *Le Cabinet de l'amateur et de l'antiquaire. Revue des tableaux . . .*, Paris, IV (1845–46), p. 282, no. 226, reports the picture's sale from the collection of Cardinal Fesch in Rome // T. van Westrheene, *Jan Steen*, The Hague, 1856, pp. 153, no. 291, 168, no. 471, records the sale of the picture from the Tak collection, Leiden, 1781, and its purchase at that sale by a Mr. Hoogeveen; records a second version in the Danser Nijman sale, 1797 // C. Hofstede de Groot, *A Catalogue Raisonné of the Works of the Most Eminent Dutch Painters of the Seventeenth Century*, London, I (1907), p. 41, no. 112, records the Tak and Fesch sales, and a Paris sale of 1802 (see Ex coll.) // F. Würtenberger, *Das holländische Gesellschaftsbild*, Schramberg, 1937, pp. 93, 94, pl. XXIII, discusses the picture's meaning // A. M. Frankfurter, "One Hundred Lowland Masterworks" (review of the exhibition at the Katz gallery in Dieren), *Art News* XXXV, no. 39 (1937), p. 26, compares eighteenth-century English conversation pieces // E. Trautscholdt, in *Allgemeines Lexikon . . .*, ed. U. Thieme and F. Becker, Leipzig, XXXI (1937), p. 511, lists the painting as at the Katz Gallery in Dieren // C. H. de Jonge, *Jan Steen*, Amsterdam, 1939, pp. 28–30, ill. p. 27, dates the picture to 1660, identifies Steen's self-portrait, describes the canvas as the first of a series representing the Dissolute Household, and discusses the symbolic motifs // D. Hannema, *Catalogue of the H. E. ten Cate Collection*, trans. G. Talma-Schilthuis and D. Fletcher, Rotterdam, 1955, I, p. 17, no. 13; II, pl. 4, describes the composition, records the support incorrectly as a panel, and lists the literature, exhibitions, and earlier collections // K. Braun, *Alle tot nu toe bekende schilderijen van Jan Steen*, Rotterdam, 1980, pp. 120–21, no. 251, ill. p. 121.

WL

GABRIEL METSU

Born Leiden, 1629; died Amsterdam, 1667

GABRIEL METSU was the son of a painter of Flemish origin, Jacques Metsue (this spelling, as well as Metzue and Metzu, was occasionally employed by Gabriel). At the age of fifteen, in 1644, Metsu was among the artists who petitioned for the establishment of a Guild of Saint Luke in Leiden, and he was one of its founding members in 1648. Metsu is recorded in 1650–51 as having left Leiden, but he paid his dues to the guild in 1649 and 1650, and is mentioned as a resident of Leiden in documents of 1652 and 1654. The artist moved to Amsterdam by July 1657, and was married there in 1658 to Isabella de Wolff, described by Houbraken as proficient in painting, perspective, and architecture. The couple made out their will in Amsterdam in 1664; Metsu was buried in the city's New Church on October 24, 1667, in his thirty-eighth year.

Metsu was a gifted but eclectic painter of genre scenes and, in much smaller numbers, of history pictures, portraits, and still lifes. There is no documentary evidence for the modern supposition that Metsu was a pupil of Leiden's leading painter, Gerard Dou, but the subjects and, to some extent, the style of Metsu's earliest pictures are indebted to that influential artist. Metsu's paintings of the 1650s reveal an interest in the work of his approximate contemporary in Leiden, Jan Steen, and in pictures by the Utrecht artists Nicolaus Knüpfer and Jan Baptist Weenix. At the same time, Metsu appears to have influenced the early efforts of Frans van Mieris. In Amsterdam, Metsu painted his best pictures, and became aware of some of the most important genre painters of the period: Nicolaes Maes, Pieter de Hooch, Jan Vermeer, and especially Gerard ter Borch and Gerard Dou were his principal points of reference. Metsu's scenes of upper-middle-class life are distinguished by their warmth and charm. The mature works of Metsu must have been among the most popular and reassuring images of domestic life during the decade of Holland's greatest prosperity.

32. Lady Seated at a Window

Oil on wood. 10⅞ × 8⅞ in. (27.6 × 22.5 cm.)
Signed (bottom center): *G. Metsu*
1982.60.32

The condition of the picture is generally very good, but the head of the woman is somewhat abraded, and retouched along the wood grain. The still-life details are in excellent condition.

THE PAINTING represents the mistress of the household, sitting in an interior before an arch-shaped stone window, about to peel some apples. Windows of this type were not an element of Dutch domestic architecture but an arbitrary illusionistic device introduced in Leiden by Gerard Dou and frequently employed by Leiden artists such as Metsu and Frans van Mieris the Elder. These painters usually rendered their signatures, as here, as if they were inscribed in the stone.

The suggestion, expressed quite tentatively by Franklin Robinson, that the present picture and *A Huntsman* (*Hunter in a Niche*), in the Mauritshuis, The Hague, were painted as pendants would appear to deserve stronger support.[1] The two panels are virtually identical in size, and are entirely complementary in composition. The style of execution is very much the same in both pictures and is consistent with the date, 1661, inscribed, along with the same form of signature, below the window ledge in the Mauritshuis painting. As Sturla Gudlaugsson notes with respect to *A Huntsman*, Metsu's manner is "relatively broad" in comparison with that of Leiden *fijnschilders* such as Dou and van Mieris, even in works that, like these two, come close to those artists in style.[2]

Metsu invented interesting variations upon conventional iconographic themes of Dutch genre painting, particularly those involving men and women in domestic settings.[3] The subject of a woman peeling apples is found in the works of other artists, especially Nicolaes Maes, during the 1650s and 1660s, and may be described as an homage to the good housewife. Spiritual purity, a concept intimately associated with that of domestic diligence in seventeenth-century Dutch literature, is suggested here by the fruit itself (the apple was a common symbol of the Virgin, the New Eve); by the book, which is probably a prayer book; by the bunch of grapes, particularly in view of their prominent stem (the latter is an obscure but once familiar symbol of marriage);[4] by the clinging vine, an ancient attribute of fidelity;[5] and by the butterflies—one on a twig at the lower left and another among the leaves above—a symbol of the soul.

The hunter in the Mauritshuis picture is surrounded, by contrast, with attributes appropriate to a man's world, which is presented as a somewhat less restricted environment. Grapes, for him, are the source of wine, which he gallantly offers—a male prerogative—to his virtuous companion. The open door in the background, the rifle to the right, and the hunting horns and dead bird on the window ledge indicate that the man has just returned home from a successful outing; he is a good provider, and has earned his rest and refreshment.

Whatever the more specific meanings of this pair of panels, they are simple—if exquisite—celebrations of the good life as it was enjoyed by upper-middle-class citizens of Amsterdam during the prosperous decades of the 1650s and 1660s.

NOTES:

1. Robinson (1974), pp. 28–29.
2. S. J. Gudlaugsson, "Kanttekeningen bij de ontwikkeling van Metsu," *Oud Holland* LXXXIII (1968), p. 31.
3. This point is made by Robinson (1974), p. 78 n. 49. The following remarks, however, are not based upon Robinson's discussion of the Mauritshuis and Linsky pictures (pp. 28–29; his reference to "erotic allusions" seems inappropriate here) so much as they do upon observations kindly made by Nanette Salomon in conversation (August 1983).
4. E. de Jongh, "Grape Symbolism in Paintings of the 16th and 17th Centuries," *Simiolus* 7 (1974), pp. 166–91.
5. E. de Jongh and P. J. Vinken, "Frans Hals als voortzetter van een emblematische traditie," *Oud Holland* LXXVI (1961), pp. 118–19, cited by Robinson (1974), p. 78 n. 49.

EX COLL.: According to Smith (1942), brought from Copenhagen to England by a Mr. Chaplin; Edmund Higginson, Saltmarsh Castle, Herefordshire (by 1842; sale, Christie's, London, June 4, 1846, no. 95); Mme Duval (sale, Hôtel Drouot, Paris, Nov. 28, 1904, no. 9); [F. Kleinberger, Paris, in 1904]; Marcus Kappel, Berlin (by 1906; sale, P. Cassirer and H. Helbing, Berlin, Nov. 25, 1930, no. 11); Mr. and Mrs. Jack Linsky, New York (until 1980); The Jack and Belle Linsky Foundation, New York (1980–82).

EXHIBITED: Kaiser Friedrich-Museum, Berlin, *Ausstellung von Werken Alter Kunst aus dem Privatbesitz der Mitglieder des Kaiser Friedrich Museums-Vereins*, 1906, no. 83 (lent by Marcus Kappel).

BIBLIOGRAPHY: J. Smith, *Catalogue Raisonné of the Works of the Most Eminent Dutch, Flemish, and French Painters*, London, IX (1842), p. 528, no. 41, describes the picture, states that it was "imported by Mr. Chaplin, from Copenhagen," and that it is in the collection of Edmund Higginson // C. Hofstede de Groot, *A Catalogue Raisonné of the Works of the Most Eminent Dutch Painters of the Seventeenth Century*, London, I (1907), p. 324, no. 213, adds to Smith's information notices of the sales of 1846 and 1904 (see Ex coll.) and the exhibition of 1906, and states that the painting is "now in the collection

Born Dordrecht, 1630; died Dordrecht, 1674

ACCORDING TO Arnold Houbraken, who may have had access to written records in Dordrecht, Cornelis Bisschop was born in that town on February 12, 1630. His father, Jacob Dionysz. Bisschop, was a tailor and the proprietor of a well-known inn in Dordrecht; his mother, Anneke van Beveren, was from Utrecht. Houbraken states that Cornelis was a pupil of Ferdinand Bol, who was also from Dordrecht but was living in Amsterdam by the late 1630s. Bisschop was presumably in Bol's studio in Amsterdam around the late 1640s. Geertruyt van Botlant of Dordrecht became Bisschop's bride on October 26, 1653, in the couple's home town; their first child, Anna, was born five months later. Houbraken reports that Bisschop was survived by his wife and eleven children when he died, at the age of forty-four, in 1674.

Although Bisschop's services were supposedly requested by Frederick III, the king of Denmark, shortly before the painter's death, his career does not appear to have prospered. A good part of his income evidently came from the sale of decorated furniture, cabinets, comb cases, "and other things of this sort," according to the French traveler Balthasar de Monconys, whose *Journal de Voyages de Monsieur de Monconys* was published in Lyons in 1665. Bisschop also painted dummy-board figures—that is, life-size or nearly life-size cut-out panels representing people; Houbraken describes some that held candles, including one that was offered a tip by unsuspecting houseguests. The artist is best known for his genre paintings, which depend mostly on those of Nicolaes Maes, and for his portraits and history pictures. The extent and chronology of Bisschop's oeuvre are far from clear, but most of his works appear influenced by paintings by either Bol or Maes that date from at least a few years earlier in each case. Bisschop's stylish *Self-Portrait* of 1668 is in the Dordrecht Museum.

of M. Kappel, Berlin" // W. von Bode, *Die Gemäldesammlung Marcus Kappel in Berlin*, Berlin, 1914, p. 16 and no. 16, describes the composition and the style of the picture, considers it to be from "his mature period," and compares similar motifs in works by ter Borch and Maes // F. W. Robinson, *Gabriel Metsu (1629–1667): A Study of his Place in Dutch Genre Painting of the Golden Age*, New York, 1974, pp. 28–29, 78 n. 48, fig. 30, discusses the subject and the symbolism of the picture, and tentatively suggests that it might be a pendant to the *Hunter in a Niche* (Robinson's title) in the Mauritshuis, The Hague.

WL

33. A Young Woman and a Cavalier

Oil on canvas. 38½ × 34¾ in. (97.8 × 88.3 cm.)
1982.60.33

The picture is in good condition, although there are many small retouches over the entire surface. The glazes have been abraded in the red bodice of the woman

especially, and to some extent in her face; the right contour of her head has been reinforced. The background is somewhat obscured by varnish.

THIS UNUSUALLY large genre picture was attributed to Gabriel Metsu by W. R. Valentiner,[1] but it bears no more than a superficial similarity to that artist's work. The subject recalls some of the paintings of amorous couples by Metsu; the style of execution and the picture's intimate mood, however, are much more reminiscent of genre scenes by Nicolaes Maes dating from about 1655–60.[2]

The canvas may be attributed with considerable confidence to Cornelis Bisschop, one of Maes's contemporaries in Dordrecht, on the basis of at least three arguments. First, the style of execution is very close to that of Bisschop in his few known works and would date from approximately the same period. These include the *Woman Sewing in an Interior* in the Minneapolis Institute of Arts;[3] *Joseph and Potiphar's Wife* of 1664, formerly private collection, Berlin;[4] and the *Self-Portrait* of 1668 in the Dordrechts Museum,[5] all of which are signed. In the Linsky picture, the warm palette (inspired by Maes), the use of a very dark background, the broad, soft modeling, and particularly the gradual transitions of light and shade (expressively employed in the faces) are entirely consistent with the most distinctive characteristics of Bisschop's mature style. This is, perhaps, less immediately evident because Bisschop's best-known painting, the *Woman Peeling Apples* of 1667 in the Rijksmuseum, Amsterdam, is much smaller in scale than the New York canvas, and represents a figure in an interior flooded by daylight.[6]

Second, Bisschop is one of the very few Dutch painters who, like Maes in his pictures of old women praying, composed scenes of domestic life on such a large scale as here.[7] Houbraken's account of Bisschop's dummy-board figures is brought to mind by the nearly life-size scale and silhouetted effect of the figures in the present painting.[8] The comparison, although admittedly unusual, cannot be lightly dismissed: Houbraken emphasizes the quality of Bisschop's freestanding figures (none by Bisschop is known, but some seventeenth- and eighteenth-century examples conform to a standard more to be expected in easel pictures), and he notes that those holding candles are painted "in the manner of night pieces."[9] The scale of the figures in the present picture is especially unexpected in view of the subject; almost all Dutch paintings of cavaliers and women in interiors are on a much smaller scale, and were clearly meant to be appreciated in close, lingering perusals.

Third, the man in the Linsky painting strongly resembles the artist as he appears in the *Self-Portrait* in Dordrecht, and the woman seems to be the same model Bisschop employed in a number of history and genre pictures dating from the 1660s.[10] Clotilde Brière-Misme, in her description of these paintings, concludes that the model is without doubt Bisschop's wife, Geertruyt.[11] The French traveler Balthasar de Monconys describes Bisschop's wife as "pretty,"[12] which, by the standards seen in seventeenth-century Dutch genre paintings, the woman in the Linsky picture certainly is. Bisschop's wife was four years younger than he. A date in the early 1660s, which is suggested by a comparison of the painting both with other pictures by Bisschop and with works by contemporary genre painters, is consistent with the apparent ages of the figures and with their appearance in other works. The most reliable comparison would of course be Bisschop's *Self-Portrait* of 1668, in the Dordrechts Museum, allowing for the difference in years.

If the Linsky picture represents the artist and his wife, this would help to explain its two most unconventional qualities: its scale, which is not unusual for a double portrait, and which recalls the larger scale of genre paintings in which the artist (e.g., Vermeer, in the Dresden *Procuress*), or the artist and his wife (Rembrandt and Saskia in the *Prodigal Son*, also in Dresden), is featured; and the entirely sympathetic treatment of the subject of sensual love. Most contemporary Dutch paintings of courting or otherwise amorous couples appear to contain some element that expresses a view critical of their behavior.[13] It is very difficult to discern such a meaning here. In other contexts, an extinguished or unlit candle and a wick trimmer (here, on the tray) could be interpreted as *vanitas* symbols, and a pitcher of water might be a reminder of purity.[14] Here, however, the jug is almost certainly meant to be understood as containing wine, which, like the candlestick, is apparently being taken from the table to a more private part of the house.[15] The young woman seems to respond to her companion's encouragement; the hat on his head, the sword belt over his shoulder, and the cloak hung up on the wall to the right indicate that he has just arrived. Wine was reputed to inflame love, and the flame of love might itself be suggested by an illuminated candle or similar source of light and heat.[16] One may assume that the candle in the present picture will soon be lit.

The candlestick appears distorted, as if its base were seen from above and its top from below. The artist prob-

95

96

ably wished to suggest a very close vantage point, which is also indicated, if less emphatically, by the view of the tabletop. The same kind of "distortion" is sometimes evident in contemporary paintings of church interiors (e.g., by Hendrick van Vliet), domestic interiors (Gerard Dou), still lifes (Abraham van Beyeren), and even small figures (Willem Duyster).[17] Samuel van Hoogstraten, writing in Dordrecht, criticized the effect and recommended that the artist assume a reasonable viewing distance.[18] The present canvas was certainly meant to be appreciated from a comparatively distant vantage point, at which the objects in the woman's hands, seen against the rather flat areas of her bodice and the tabletop, appear to project forward. The spatial effect of the picture would have been particularly impressive in the uneven illumination of an actual seventeenth-century Dutch interior.

NOTES:

1. W. R. Valentiner, letter of June 7, 1954, to Jack Linsky, citing Hofstede de Groot (1908).

2. See W. R. Valentiner, *Nicolaes Maes*, Stuttgart, 1924. William Robinson, a specialist on the works of Maes, saw the Linsky picture in 1982. He agreed that it is close to Maes in style, and tentatively supported an attribution to Bisschop.

3. C. Brière-Misme, "Un Petit Maître hollandais, Cornelis Bisschop (1630–1674)," *Oud Holland* LXV (1950), pp. 189–90, fig. 9.

4. Ibid., p. 147, fig. 4.

5. Ibid., pp. 104–5, fig. 1.

6. Ibid., pp. 231–34, fig. 5; P. J. J. van Thiel et al., *All the Paintings of the Rijksmuseum in Amsterdam*, 1976, p. 118, no. A 2110, and literature cited.

7. Brière-Misme (see note 3 above), p. 183, fig. 4; the similar picture in the Kunsthalle, Hamburg (illustrated in *Katalog der alten Meister der Hamburger Kunsthalle*, 5th ed., Hamburg, 1966, p. 32, no. 666); possibly the *Card Players*, said to be signed and dated 1657, published by Brière-Misme, "Notes complementaires sur Cornelis Bisschop, II," *Mededelingen van het Rijksbureau voor Kunsthistorische Documentatie* 8 (no. III), in *Oud Holland* LXVIII (1953), pp. 184–86.

8. See Bisschop's biography above, and A. Houbraken, *De Groote Schouburgh der Nederlantsche Konstschilders en Schilderessen*, Amsterdam, 1718–21, II, p. 220. On dummy-board figures, see P. MacQuoid and R. Edwards, *The Dictionary of English Furniture*, 2nd ed., rev. enl., London, 1954, II, pp. 229–32; J. W., "Les Personages factices," *Connaissance des Arts*, no. 62 (Apr. 1957), pp. 82–87. The latter article cites Houbraken's account of Bisschop's dummy-board figures, and, following Houbraken, considers Bisschop to have pioneered this form of illusionistic interior decoration. However, the article by MacQuoid and Edwards describes and illustrates examples dating from as early as about 1630.

9. Houbraken, II (see note 8 above), p. 220.

10. Brière-Misme (see note 3 above), p. 105, fig. 1; p. 141, fig.

1; p. 147, fig. 4; p. 232, fig. 5 (*Woman Peeling Apples*, Rijksmuseum, Amsterdam).

11. Ibid., p. 188, citing four pictures (adding fig. 8 on p. 187 to those cited in note 10 above).

12. Balthasar de Monconys, quoted in Brière-Misme (see note 3 above), p. 28.

13. See, for example, *Tot Lering en Vermaak: Betekenissen van Hollandse genrevoorstellingen uit zeventiende eeuw* (exhib. cat.), Amsterdam, Rijksmuseum, 1976, nos. 1, 8, 9, 11, 13.

14. Ibid., nos. 17, 48; and E. Snoep-Reitsma, "De Waterzuchtige Vrouw van Gerard Dou en de betekenis van de lampetkan," in *Album Amicorum J. G. van Gelder*, ed. J. Bruyn, The Hague, 1973, pp. 285–92.

15. Nanette Salomon first proposed this interpretation, in conversation, 1983.

16. See *Tot Lering en Vermaak* (see note 13 above), no. 28; *Die Sprache der Bilder: Realität und Bedeutung in der niederländischen Malerei des 17. Jahrhunderts* (exhib. cat.), Brunswick, Herzog Anton Ulrich-Museum, 1978, nos. 15, 32, 33.

17. For examples by these artists, see W. A. Liedtke, *Architectural Painting in Delft*, Doornspijk, 1982, pls. 43, 47–49, etc; W. Martin, *Gerard Dou, des Meisters Gemälde*, Stuttgart, 1913, pp. 71, 90, 99, and especially 95; *Katalog der alten Meister der Hamburger Kunsthalle* (see note 7 above), p. 55, no. 46, ill. (Willem Duyster); I. Bergström, *Dutch Still-Life Painting in the Seventeenth Century*, trans. C. Hedström and G. Taylor, London, 1956, fig. 203 (van Beyeren).

18. S. van Hoogstraten, *Inleyding tot de Hooge Schoole der Schilder-konst*, Rotterdam, 1678, p. 34 (book I, chapter 7, on the *Zichtkunst*): "for it is a frequent mistake that the pictures foreshorten the head toward the top and the feet toward the bottom; the tiled floors are broader than long, the columns round like an egg, and the squares become irregular; and even pyramids and other stones appear to slant." For the entire passage, translated into English, see W. A. Liedtke, "The New Church in Haarlem Series: Saenredam's Sketching Style in Relation to Perspective," *Simiolus* 8 (1975–76), p. 161.

EX COLL.: Mr. and Mrs. Jack Linsky, New York (?1954–80; a letter from W. R. Valentiner to Jack Linsky, dated June 7, 1954, would appear to suggest that Mr. Linsky had recently bought the picture in London or Paris); The Jack and Belle Linsky Foundation, New York (1980–82).

EXHIBITED: Possibly Leeds City Museum, *National Exhibition of Works of Art, at Leeds, 1868*, 1868, no. 573, as Gabriel Metsu, *A Woman Holding a Jug and a Man behind Her*, lent by the Baron de Ferrières.

BIBLIOGRAPHY: Possibly C. Hofstede de Groot, *A Catalogue Raisonné of the Works of the Most Eminent Dutch Painters of the Seventeenth Century*, London, 1 (1908), p. 308, no. 175f, as Gabriel Metsu; titled *A Woman Holding a Jug and Man behind Her*; no mention of support, dimensions, or signature; recorded as "Exhibited at Leeds, 1868, No. 573, [lent] by Baron de Ferrières."

WL

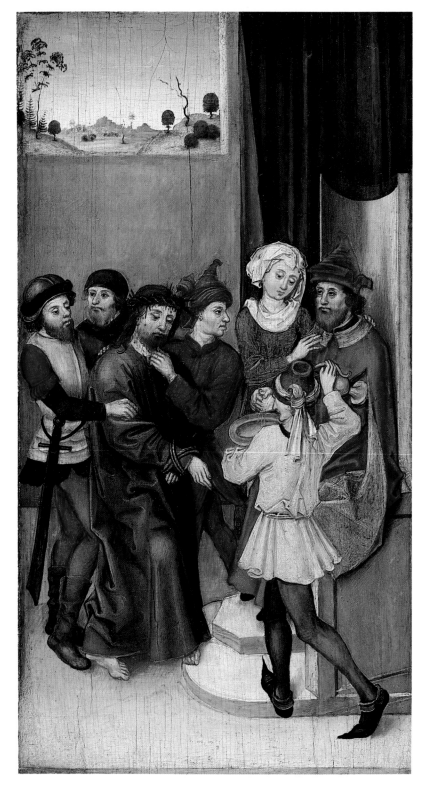

German Paintings

Attributed to
LUDWIG SCHONGAUER

Active by 1479, Ulm; died 1493 or before
January 18, 1494, Colmar

LUDWIG SCHONGAUER is thought to have been born
about 1440, the same time his father, Caspar, a goldsmith,
settled in Colmar. Ludwig was the brother of Martin
Schongauer, the renowned printmaker and painter, who
was probably the younger of the two. Three other broth-
ers, Caspar, Jörg, and Paul, were goldsmiths. Ludwig's
apprenticeship to the Colmar painter Caspar Isenmann is
presumed on stylistic and historical grounds.

The earliest documentary mention of the artist records
his purchase in 1479 of citizenship in Ulm, the leading
town after Augsburg in the duchy of Swabia. In 1486 he
became a citizen of Augsburg, and he remained there
until 1491. After the death of Martin Schongauer the same
year, he assumed control of his brother's workshop in
Colmar, where he is documented as active still in 1493.
He is recorded as deceased on January 18, 1494.

Ludwig Schongauer is thought to have been active in
Ulm as early as 1472, designing woodcut illustrations for
the 1473 edition of the works of Boccaccio published in
that city, and later contributing to a 1477 edition of Ae-
sop's fables, though his participation in these projects is
contested. Although the artist apparently was primarily a
painter, his more conspicuous activity as a printmaker has
attracted greater attention because the only works known
with certainty to be by him are four engravings signed
with his monogram. Attribution of a body of paintings
to this artist remains subject to a wide variety of opinion.

34. Christ before Pilate

Oil on wood. Overall 15⅛ × 8¼ in. (38.4 × 21 cm.);
 painted surface 14⅜ × 7¾ in. (36.5 × 19.7 cm.)
1982.60.34a

35. The Resurrection

Oil on wood. Overall 15⅛ × 8¼ in. (38.4 × 21 cm.);
 painted surface 14½ × 7¾ in. (36.8 × 19.7 cm.)
1982.60.34b

Except for the damages described below, the paint
surfaces of both pictures are in an excellent state of
preservation. They were painted on the recto and verso
of a fir panel that was subsequently cut in half. When
divided, the support was shaved so thin that the resultant
panels repeatedly split along the vertical grain. There are
minor paint losses and inpainting along these splits, the
worst of which are found about 1¼ inches from the right
edge of *Christ before Pilate* and about 1¼ inches from the
left edge of the *Resurrection*. The panel with the
Resurrection was sawed through the paint surface
horizontally across Christ's chest, between his raised arm
and the staff.

In *Christ before Pilate*, the wall below the window has
been painted over an underdrawn landscape with a large
rock formation that can be detected by infrared
reflectograph. The underdrawing also includes a dog,
visible at the lower left corner. There are pentiments at
both the top and the base of Pilate's throne, and along
the hem of Christ's robe, which was originally higher.

In the *Resurrection* there are inpainted losses on the
part of Christ's red cloak that covers his leg. In the
underdrawing a thin pennon attached to Christ's staff
wafts in the breeze to the left. In the painting it appears
to have been supplanted by the cruciform banner, for
which no underdrawing can been detected.

IN ONE PICTURE, Christ, with wrists bound, is brought
before Pilate. He wears a gray-purple robe and the crown
of thorns. A soldier in armor and two other captors pre-
sent him to Pilate, who is seated on a throne. Pilate's
wife, attempting to intercede in Christ's behalf, stands
behind her husband and places her hands on his shoul-
ders. A servant, seen from the back, pours water from a
ewer into a basin for Pilate, who washes his hands in an
expression of his attempt to abnegate responsibility for
Christ's eventual execution. This rendering of the subject
follows most directly the account in Matthew (27:1–29),
the only Gospel that mentions Pilate's wife and the wash-
ing of his hands. However, as is common for the period,
the artist has conflated different moments from the Pas-
sion; it was only after he was examined by Pilate that
Christ was garbed in purple and crowned with thorns.

In the other picture, the risen Christ, wearing a loin-
cloth and clad in a red shroud, steps from an open stone

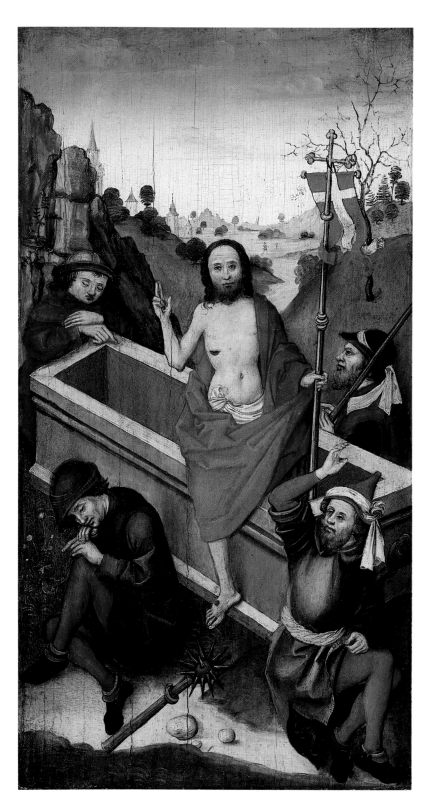

sarcophagus. He raises his right hand in a gesture of blessing, and holds in the left a cruciform staff from which a red banner with a white cross is suspended. Four watchmen, positioned at the four sides of the tomb, are represented in progressive states of consciousness, counterclockwise left to right. A mace lies in the foreground. The background landscape shows a Gothic city beyond green hills, partly visible behind a large rocky outcrop in the left middle ground. The barren tree in the otherwise verdant countryside, which figures prominently in the right middle ground, possibly alludes to the prophecy of Ezekiel (17:24), "I the Lord . . . have made the dry tree to flourish," a metaphorical prefiguration of the renewal of man's spirit through Christ.

These pictures originally constituted the recto and verso of a single panel that was sawed in half. Another panel from the same altarpiece with the *Flagellation of Christ* on one side and *Christ Carrying the Cross* on the other is reported by W. von Kalnein, in Bushart (1959), to be in the castle of Salem, a town about fifty-four miles southwest of Ulm. Presumably the panels formed the shutters of a small Passion triptych. The *Flagellation* and *Christ before Pilate* would have been seen when it was closed, and *Christ Carrying the Cross* and the *Resurrection* would have flanked a painted or carved Crucifixion when it was open.

These pictures display the style of an artist from the immediate circle of Martin Schongauer, the most influential German artist of the second half of the fifteenth century. They are assigned to an anonymous follower of Martin in the 1958–59 Stuttgart exhibition catalogue, where it is noted that E. Buchner had designated them as works by a late fifteenth-century Swabian artist, presumably from Ulm. The composition of the *Resurrection* depends in part from Martin's engraving of the same subject, and that of *Christ before Pilate* appears to be a combination of elements from his prints *Christ before Annas* and *Christ before Pilate*.[1]

The present pictures were first published by Bushart (1959), who amended the oeuvre proposed by Alfred Stange for Ludwig Schongauer.[2] Of Stange's attributions, he accepts only the *Circumcision* in the Musée d'Unterlinden, Colmar (transferred in 1967 from the Louvre, Paris). That picture formed part of an Infancy of Christ Altarpiece together with four other pictures: the *Visitation* and *Adoration of the Magi* in the Hessisches Landesmuseum, Darmstadt (there attributed to the Master of the Seligenstadt Altarpiece); the *Nativity* in the Philadelphia Museum of Art (there attributed to Bartholomaeus Zeitblom);

and the *Annunciation* from the F. Sarre collection, Philadelphia.[3] Bushart considers these pictures to form the core of Ludwig's painted oeuvre. He regards the present pictures as later in date—shortly after 1485—and of less distinction than the pictures from the Infancy of Christ Altarpiece, and leaves open to question whether they are by Ludwig himself or by a workshop collaborator.

The attribution to Ludwig Schongauer is given credence by comparison with three of his four initialed engravings (see Biography). The profile of the watchman at right center in the *Resurrection* and the servant's figure in *Christ before Pilate* compare favorably to the profile and figure of the man in *The Elephant with Its Master*.[4] The close-knit facial features and the compression of figures in a flattened space in both pictures are found again in *The Descent from the Cross*.[5] Most important, the dog in the underdrawing of *Christ before Pilate* has its reversed counterpart in Ludwig's print *Two Dogs*.[6]

NOTES:
1. For reproductions of the three engravings by Martin Schongauer see M. Lehrs, ed., *Martin Schongauer: Nachbildungen seiner Kupferstiche*, Berlin, 1914, pls. XIX, X, and XIII, respectively.
2. A. Stange, *Schwaben in der Zeit von 1450 bis 1500*, vol. VIII of *Deutsche Malerei der Gotik*, Munich, 1957, pp. 17–20, pls. 32–35. At least eleven drawings have been assigned to Ludwig; see T. Falk, *Katalog der Zeichnungen des 15. und 16. Jahrhunderts in Kupferstichkabinett Basel*, Basel, I (1979), nos. 38–48.
3. For the *Nativity* and the *Annunciation* see F. Winkler, "A Suabian Painter of about 1480," *Art Quarterly* XIX (1956), pp. 255–63.
4. Reproduced in M. Lehrs, *Geschichte und kritischer Katalog des deutschen, niederländischen und französischen Kupferstichs im XV. Jahrhundert*, Vienna, 1927, no. 399.
5. Reproduced in C. von Lützow, *Geschichte des deutschen Kupferstiches und Holzschnittes*, Berlin, [1891], p. 41, fig. 18.
6. M. Lehrs (see note 4 above), no. 400.

EX COLL.: Paul Ackermann, Stuttgart (by 1958–1965; sale, Sotheby's, London, Mar. 24, 1965, no. 113 [the pair], as Ludwig Schongauer, to Linsky); Mr. and Mrs. Jack Linsky, New York (1965–80); The Jack and Belle Linsky Foundation, New York (1980–82).

EXHIBITED: Staatsgalerie, Stuttgart, *Meisterwerke aus baden-württembergischem Privatbesitz*, Oct. 9, 1958–Jan. 10, 1959, nos. 182 and 183, respectively (as follower of Martin Schongauer).

BIBLIOGRAPHY: B. Bushart, "Studien zur altschwäbischen Malerei: Ergänzungen und Berichtigungen zu Alfred Stanges 'Deutsche Malerei der Gotik,' VIII. Band, 'Schwaben in der Zeit von 1450 bis 1500,'" *Zeitschrift für Kunstgeschichte* XXII (1959), pp. 140–41; ill. p. 142, figs. 10 and 11, respectively.

GCB

LUCAS CRANACH THE ELDER

Born 1472, Kronach; died 1553, Weimar

TO JUDGE BY his output and that of his prolific shop, Lucas Cranach the Elder was perhaps the most successful German artist of his time. He was born in 1472 in Kronach, a small town about fifty-five miles north of Nuremberg. His earliest known painting, the *Crucifixion* in the Kunsthistorisches Museum, Vienna, dates from about 1501, the same year he established himself in Vienna, where he remained for the next four years. In 1505 he moved to Wittenberg, entering into the service of Frederick the Wise, elector of Saxony (1486–1525). In 1508, he was granted a patent to bear a coat of arms incorporating a winged serpent—the source of the Cranach workshop emblem— and in the same year he traveled to Flanders, where he painted the Emperor Maximilian's portrait and that of his son, the future Charles V.

In Wittenberg, Cranach became an associate and intimate friend of Martin Luther, who, from 1508, was professor of theology at the university there. Cranach was an alderman of Wittenberg from 1519 until 1545, and in 1537 and 1540 he is recorded as burgomaster. In 1524 he was in Augsburg, where Dürer painted his portrait.

Cranach continued as court painter in Wittenberg through the rule of John the Steadfast (1525–32) and of John Frederick the Magnanimous (1532–47). He remained in John Frederick's service during the ex-elector's captivity in Augsburg by Charles V from 1500 until 1552. While in Augsburg, Cranach made a portrait of Titian, court painter to Charles V. He retired with his patron to Weimar in 1552, and died there the following year.

In his early years of activity, influenced by the woodcuts of Dürer and by the circle of humanists around Konrad Celtis in Vienna, Cranach achieved a new, emotive style that incorporated strikingly naturalistic landscapes. After he became a painter at court, his paintings became increasingly elegant and stylized. During the first part of his career, he also produced impressive woodcuts and engravings, and made designs for book illustrations.

Lucas Cranach the Elder headed up a large workshop in Wittenberg, where he was assisted by his older son, Hans (d. 1537), and by Lucas Cranach the Younger (1515–1586), an accomplished painter in his own right. The sons closely imitated their father's work, and it is often impossible to separate their contributions from his.

36. Christ and the Adulteress

Oil on wood. 6¼ × 8½ in. (15.9 × 21.6 cm.)
Inscribed (at top): WER UNTER EUCH ON SUNDE IST.
DER WERFFE DEN ERSTEN STEIN AUFF SIE. ~ JOH ~
VIII ~ [Winged serpent emblem]
1982.60.35

The picture is in an excellent state of preservation.

CHRIST TAKES the adulteress by her wrist in one hand and gestures toward her with the other as he looks benignly in the direction of a group of her tormentors at the left. Presumably he has just admonished them with the words inscribed in German along the upper edge of the panel: "He that is without sin among you, let him first cast a stone at her" (John 8:7). A lout in armor to the fore of this group, holding a hatful of stones in one arm and poised to throw the first one with the other, is presented as a counterpart to the accused woman dressed as a courtesan at the right, who has been seized by a brute in chain mail. Two of Christ's disciples among several included in the crowd of scribes and Pharisees can be distinguished: Peter at the right, and behind him Paul.

Christ and the Adulteress is treated together with *Christ Blessing the Children* in the next entry.

EX COLL.: Probably Ernst II, duke of Saxe-Coburg and Gotha, Herzogliches Museum, Gotha (by 1858–after 1890); M. D. Schevitch, Paris (until 1906; sale Galerie Georges Petit, Paris, Apr. 4, 1906, no. 3, as Cranach, to M. Drey); [probably A. S. Drey, Paris and Munich, from 1906]; Gustav von Gerhardt, Budapest (until 1911; sale Lepke's, Berlin, Nov. 10, 1911, no. 81, as Lucas Cranach d. Jüng., bought in); [R. Ederheimer, New York]; Henry Schniewind, New York (in 1936); Mrs. Arthur Corwin, Greenwich, Conn. (until 1955); [Newhouse Galleries, New York, 1955]; Mr. and Mrs. Jack Linsky, New York (1955–80); Mrs. Belle Linsky, New York (1980–82).

EXHIBITED: The Germanic Museum (now Busch-Reisinger), Cambridge, Mass., *German Paintings of the Fifteenth and Sixteenth Centuries*, June 5–Sept. 30, 1936, no. 8 (as Lucas Cranach the Elder, lent by Mr. Henry Schniewind); Duveen, New York, *Cranach Loan Exhibition*, May 1–31, 1960, no. 16 (as Lucas Cranach the Elder, lent by Mr. and Mrs. Jack Linsky).

BIBLIOGRAPHY: *Catalog der Herzoglichen Gemäldegallerie zu Gotha*, Gotha, 1858, p. 35, no. 364 // C. Aldenhoven, *Katalog der Herzoglichen Gemäldegalerie*, Herzogliches Museum zu Gotha, Gotha, 1890, p. 79, no. 103 // H. Michaelson, *Lukas Cranach der Ältere: Untersuchung über die stilistische Entwickelung seiner Kunst*, Leipzig, 1902, p. 107 // C. L. Kuhn, *A*

WER VNTER EVCH ONSVNDE IST DER WERFFE DEN ERSTEN STEIN AVFF SIE . IOH .. VIII ...

Catalogue of German Paintings of the Middle Ages and Renaissance in American Collections, Cambridge, Mass., 1936, p. 36, no. 82; C. O. Kibish, "Lucas Cranach's *Christ Blessing the Children*: A Problem of Lutheran Iconography," *Art Bulletin* XXXVII (1955), p. 198.

GCB

37. Christ Blessing the Children

Oil on wood. 6½ × 8¾ in. (16.5 × 22.2 cm.)
Inscribed (at top): LASSET DIE KINDLIN ZU MIR
 KOMEN. UND WERET INEN NICHT. DENN SOLCHER
 IST DAS REICH GOTTES. ~ MARCUS. X. ~ [Winged
 serpent emblem]
1982.60.36

The picture is in an excellent state of preservation.

CHRIST, in a gesture of blessing, places his left hand on an infant presented to him on a cushion. In his right arm he holds another child, presumably the son of the woman at the right who holds her hands in prayer. The other mothers who congregate around Christ hold one or more children; two of them nurse, and one in the left foreground turns to grab her unruly son, who rides a hobbyhorse. The boy is one of four older children in the foreground, another of whom is a girl carrying a doll, a playful restatement of the theme. Peter and Paul with two other disciples are recognizable at the right, marveling at Christ's pronouncement, inscribed in German along the upper edge: "Suffer the little children to come unto me, and forbid them not: for of such is the kingdom of God" (Mark 10:14).

The subject of Christ Blessing the Children is apparently not encountered in the history of panel painting before Lucas Cranach the Elder. Cranach and his shop treated the subject at least sixteen times.[1] Payments made in 1539, 1543, and 1550 for paintings of Christ Blessing the Children are recorded in the accounts of John Frederick the Magnanimous.[2] One reason for the sudden proliferation of this theme was Martin Luther's reading of the Gospel passage as divine authorization of infant baptism, as opposed to the doctrine of adult baptism espoused by the Anabaptists, a Protestant sect then considered heretical by Luther and the elector of Saxony.[3]

Christ and the Adulteress was also a popular subject in the Reformation. There are at least fifteen surviving versions of the subject by Cranach and his shop in addition

to the Linsky picture.[4] The didactic treatment of the theme exhorts the viewer to recognize his own sins, for which he is condemned under the Law, and to leave judgment to divine authority, as it is only through grace that absolution of his sins is possible.[5] The subject also illustrates a teaching from the Sermon on the Mount, a point of departure fundamental to Lutheran doctrine. It embodies the lesson "Judge not, that ye be not judged" (Matthew 7:1).

The present paintings, to judge by their agreement in style and format, must have been conceived together. Evidently they were in the Herzogliches Museum, Gotha, in the nineteenth century. Both the dimensions and the detailed descriptions of the pictures once in Gotha provided by Carl Aldenhoven (1890) leave little doubt about

their identification with the Linsky panels. Further research may establish that they were in the ducal collection in Gotha long before, a possibility that their exceptional state of preservation suggests.

In the Gotha museum catalogues, the pictures are assigned to the Cranach school. Hedwig Michaelson (1902) proposes that they are early works by Lucas Cranach the Younger. *Christ and the Adulteress* was catalogued as Cranach the Younger in the 1911 sale of the Gustav von Gerhardt collection. It is curious that that painting can be traced through the Schevitch and Gerhardt collections but not *Christ Blessing the Children*. If separated, the two were again united by 1936, when they were exhibited at the Germanic Museum of Harvard University as Lucas Cranach the Elder.

It is generally accepted that the Cranach workshop emblem was modified from a serpent with wings extended upward to a serpent with wings folded in 1537, the year of Hans Cranach's death. Charles L. Kuhn (1936) read the emblems on the present panels as of the extended-wing type; indeed, he considered the panels to date from about 1520. However, the emblems are very small and the one on *Christ and the Adulteress* is indistinct and difficult to decipher. The form of the emblem on *Christ Blessing the Children* has its closest parallels in emblems on paintings by both Cranach the Elder and Cranach the Younger dating from the 1540s onward.

The quality of painting in these small panels is very high, and their compositions, as is characteristic of the Cranach shop, are unique among the surviving variants. However, it is difficult to attribute them to Lucas Cranach the Elder without reservation because of the extensive collaboration between father and son. The sweetness of expression evident in these paintings, particularly in the faces of *Christ Blessing the Children*, indicates the probable participation of Lucas Cranach the Younger in their creation. A drawing of the same subject made about 1540 by Cranach the Younger in the Museum der Bildenden Künste, Leipzig (inv. NJ 16), is very similar in conception to the present picture.[6] His painting *John the Baptist Preaching*, dated 1549, in the Herzog Anton Ulrich-Museum, Brunswick, is very close stylistically to these panels.[7] The Linsky pictures must date from the mid-1540s, when it is often impossible, as is repeatedly noted, to distinguish between the contributions of father and son in paintings from their shop.

NOTES:

1. See M. J. Friedländer and J. Rosenberg, *The Paintings of Lucas Cranach*, rev. ed., Ithaca, 1978, nos. 217, 217A–C, 362, 362A–H, 363. Friedländer and Rosenberg appear not to have been aware of the present picture or its companion. They also overlook a version of about 1540 attributed to Lucas Cranach the Younger; see D. Koepplin and T. Falk, *Lukas Cranach: Gemälde, Zeichnungen, Druckgraphik* (exhib. cat.), Basel, Kunstmuseum Basel, II (1976), p. 518, no. 367.

2. C. Schuchardt, *Lucas Cranach des Ältern Leben und Werke, Nach urkundlichen Quellen bearbeitet*, Leipzig, I (1851), pp. 22, 161, 208.

3. As demonstrated by C. O. Kibish, "Lucas Cranach's *Christ Blessing the Children*: A Problem of Lutheran Iconography," *Art Bulletin* XXXVII (1955), pp. 196–203.

4. See M. J. Friedländer and J. Rosenberg, *The Paintings of Lucas Cranach* (see note 1 above), nos. 129, 129A–B, 216, 216A–B, 364, 364A–G.

5. For a recent discussion of Lutheran content in this subject and in Christ Blessing the Children, see C. Christensen, *Art and the Reformation in Germany*, Athens, Ohio, 1979, pp. 130–36.

6. Reproduced in W. Schade, *Die Malerfamilie Cranach*, 3rd ed., Dresden, 1974, pl. 208.

7. Ibid., pl. 212.

EX COLL.: Probably Ernst II, duke of Saxe-Coburg and Gotha, Herzogliches Museum, Gotha (by 1858–after 1890); [R. Ederheimer, New York]; Henry Schniewind, New York (in 1936); Mrs. Arthur Corwin, Greenwich, Conn. (until 1955); [Newhouse Galleries, New York, 1955]; Mr. and Mrs. Jack Linsky, New York (1955–80); Mrs. Belle Linsky, New York (1980–82).

EXHIBITED: The Germanic Museum (now Busch-Reisinger), Cambridge, Mass., *German Paintings of the Fifteenth and Sixteenth Centuries*, June 5–Sept. 30, 1936, no. 9 (as Lucas Cranach the Elder, lent by Mr. Henry Schniewind); Duveen, New York, *Cranach Loan Exhibition*, May 1–31, 1960, no. 8 (as Lucas Cranach the Elder, lent by Mr. and Mrs. Jack Linsky).

BIBLIOGRAPHY: *Catalog der Herzoglichen Gemäldegallerie zu Gotha*, Gotha, 1858, p. 35, no. 365 // C. Aldenhoven, *Katalog der Herzoglichen Gemäldegalerie*, Herzogliches Museum zu Gotha, Gotha, 1890, p. 79, no. 102 // H. Michaelson, *Lukas Cranach der Ältere: Untersuchung über die stilistische Entwickelung seiner Kunst*, Leipzig, 1902, p. 107 // C. L. Kuhn, *A Catalogue of German Paintings of the Middle Ages and Renaissance in American Collections*, Cambridge, Mass., 1936, p. 36, no. 83 // C. O. Kibish, "Lucas Cranach's *Christ Blessing the Children*: A Problem of Lutheran Iconography," *Art Bulletin* XXXVII (1955), p. 198.

GCB

CONRAD FABER VON CREUZNACH

Active by 1524, Frankfurt; died 1552/53, Frankfurt

THE NAME of Conrad Faber, painter from Creuznach, appears in the records of the city of Frankfurt at regular intervals throughout the second quarter of the sixteenth century. He won the right of citizenship in 1538. The only work that can be attributed to Faber with certainty is the lost design for a woodcut representing the siege of Frankfurt of 1552. It has, however, for some time been assumed that he also painted a number of portraits of prominent citizens of Frankfurt—some of them signed on the reverse with the monogram · Ɔ v C ·—which date from the second quarter of the century, and which were at first ascribed to the Master of the Holzhausen Portraits. Members of the Holzhausen family who sat to Faber included Hamman, Justinian, and Gilbrecht; their portraits descended in the Holzhausen family until 1923, when they were bequeathed, with several others by the same hand, to the Städelsches Kunstinstitut, Frankfurt. Faber's portraits generally show the sitters in half-length, the men facing to the right and the women to the left; all are elaborately garbed, and most are represented against a landscape background. In many cases inscriptions, dates, and coats of arms are painted on the reverse.

38. Portrait of a Member of the vom Rhein Family

Oil and gold on wood. Overall 21¾ × 15⅝ in. (55.2 × 39.7 cm.); painted surface 21½ × 15 in. (54.6 × 38.1 cm.)
1982.60.37

Although the surface is much abraded, particularly the face and the landscape, the painting still reads well; the sky, hands, and rosary are in better state. The artist used gold leaf for the cap, ring, and rosary bead. The panel is cradled, and the lipped edge is preserved all around.

THE SITTER is shown in half-length, facing toward the right. He wears a black hat with a broad brim over a gold cap trimmed with black. His chemise is white, his doublet black, and his gray cloak is lined with brown fur and has a broad fur collar of the same color. He wears a gold finger ring and holds a rosary.

A portrait of the same man in the Musées Royaux des Beaux-Arts, Brussels (54 × 37 cm., inv. 10), has long been identified as the first, autograph version of the picture.[1] In addition, there may be as many as three replicas of the Brussels work, or as few as one. Erna Auerbach (1937) published a panel in the collection of Viscount Lee of Fareham that, to judge from black-and-white photographs, differs from the painting in Brussels only in that the fore edge of the ledge is in shadow. The Lee picture, according to Auerbach, measures 53.6 × 37.4 cm. It did not go to the Courtauld Institute, as did many other paintings from Lord Lee's collection, and its present location is unknown. In 1950 a cradled panel 55.9 × 39.4 cm. that, from the reproduction in the catalogue, appears more or less identical, was sold by N. M. Friberg of Stockholm at Kende Galleries, New York.[2] The name of the buyer is not recorded. The present work—also cradled and of roughly the same size—has no previous history and is, once again, essentially identical.

Two figures on a bridge in the left background, the windows of farm buildings in the right middle distance, and an island in front of a causeway in the background at the right are clearly visible in the Brussels painting. These details are legible in old photographs of Lord Lee's picture; they are more difficult to discern in the reproduction of Mr. Friberg's; and they can be seen in the Linsky panel only with the aid of a microscope. In the Brussels painting the figure wears a patterned robe. The pattern is absent from the Linsky picture, and difficult if not impossible to make out in the other two images. The discrepancy in size among the three works is negligible, and the different degrees of legibility of the details may result from the intervention of one or more restorers. It therefore seems very likely that the Lee, Friberg, and Linsky paintings are one and the same: an autograph replica of the Brussels portrait.

The sitter has not been identified with certainty. A later variant, bequeathed to the Städelsches Kunstinstitut, Frankfurt (inv. 1769), by a member of the Holzhausen family in 1923, is inscribed on the reverse:

PHILIPP VOM RHEIN ZUM MOHREN. ANNO DOMINI. MCCCCLXXVII DIE S. ANGELI EPISCOPI. OBIT A? DN. M. D. XXXVIII DIE XXXI IANVARI.

M. D. XXXVI. die XIV Octobris

As Brücker (1963) points out, information about two different members of the family has been conflated. Heinrich vom Rhein zum Mohren was born in 1477 and died

in 1536. Faber painted his daughter, Margarethe, in 1533. Philipp vom Rhein zum Lindwurm was born in 1484 and married Margarethe von Holzhausen; he died, childless, in 1537. Brücker inclines to the opinion that the older brother, Heinrich, was the sitter. The work is datable to the late 1520s.

NOTES:
1. The Brussels picture is not signed or dated; nor is it painted on the reverse. See Brücker (1963).
2. The compiler of the Kende Galleries catalogue, *Important Oil Paintings From the Collection of N. M. Friberg, Stockholm, Sweden*, New York, 1950, p. 34, no. 23 (22 × 15½ in.), assumes that the Lee and Friberg paintings are two separate works, and Brücker (1963) is of the same opinion. The frame for the Linsky panel is faintly inscribed in chalk on the reverse with the number *23*, which coincides with the lot number in the Friberg sale.

EX COLL.: ? Viscount Lee of Fareham, White Lodge, Richmond, Surrey (1937); N. M. Friberg, Stockholm (sale, Kende Galleries, New York, May 18, 1950, no. 23), [John Mohnen, Del-Mar, California, from 1950]; Mr. and Mrs. Jack Linsky, New York (until 1980); The Jack and Belle Linsky Foundation, New York (1980–82).

BIBLIOGRAPHY: E. Auerbach, "Conrad Faber, or 'The Master of the Holzhausen Portraits,'" *Burlington Magazine* LXX (1937), pp. 15–19 nn. 1, 2, 23, pl.1B (the Lee version) // W. Brücker, *Conrad Faber von Creuznach*, vol. XI of *Schriften des Historischen Museums Frankfurt am Main*, Frankfurt am Main, 1963, pp. 23–25, 111–12 nn. 78–83, 146, 148, 150, 154–57, nos. 4, 4a–c, 226, pls. 6, 51, 52 // W. Brücker, in a letter, 1983, agrees that this picture may be identical with the Lee version, and that it is the one from the Friberg collection; he calls it a work of "good quality, . . . painted in the XVI. century," but does not "dare to attribute it to C. Faber himself."

KB

Attributed to
HANS BROSAMER

Active by 1536, Fulda; ? died 1552 or later, Erfurt

THE ONLY painting by the artist that is fully signed and dated is the portrait of Chancellor Johannes von Otthera of Fulda of 1536 (private collection, Switzerland). A printmaker called Hans Brosamer was living at Fulda in 1542, and an artist of the same name is reported to have died of the plague at Erfurt in 1552. Works ascribed to Brosamer,

most of which are initialed *HB*, have been tentatively grouped as follows: A number of panels with the monogram *HB* and a griffin's head show the influence of Lucas Cranach the Elder. The earliest of these is the *Mother and Child*, 1528 (Herzog Anton Ulrich-Museum, Brunswick), and *Christ Blessing the Children*, 1548 (formerly in Berlin; destroyed), is one of the latest. There is an undated book of woodcut designs for goldsmiths' work by a Hansen Brösamer Maler zu Fuld. Twelve of twenty-one woodcuts in a 1540 edition of Luther's Small Catechism, published at Magdeburg, are monogrammed *HB*, and one of these may also bear the griffin's head; furthermore, some woodcuts initialed *HB* in a Bible published at Magdeburg in 1536 have been attributed to the same hand. A dozen or more portraits from the 1520s may be subdivided into two groups, one of which includes three portraits of unidentified male sitters, all monogrammed and dated 1520 (Kunsthistorisches Museum, Vienna; Musée des Beaux-Arts, Strasbourg; Borromeo collection, Milan). Among the works in the other group is the portrait of Katharina Merian (see below). It seems unlikely that all the portraits are by the same hand. Those from the later 1520s may be by the artist who painted the 1536 portrait. However, as most of them have been for many years privately owned and thus unavailable for examination, the attribution must be regarded as provisional.

39. Katharina Merian

Oil and gold on wood. Overall 18¼ × 13⅛ in. (46.4 × 33.3 cm.); painted surface 17⅝ × 13⅛ in. (44.8 × 33.3 cm.)
1982.60.38

The painting, which is cradled, is in very good state except for the woman's left cheek, which is slightly abraded. Gold leaf has been used for the jewels. The sides of the panel have been cut, but only to the edges of the painted surface; the bottom and top edges are original.

THE SUBJECT is shown standing, her hands folded at her waist, in three-quarter view toward the left, against a green ground. Her braided hair is brown, and her eyes are gray. She wears a broad-brimmed black hat with gold points, a white chemise with a collar added, a black dress, and a black belt with a gold buckle and studs. Her finger rings are also of gold, as is the heavy necklace, from which

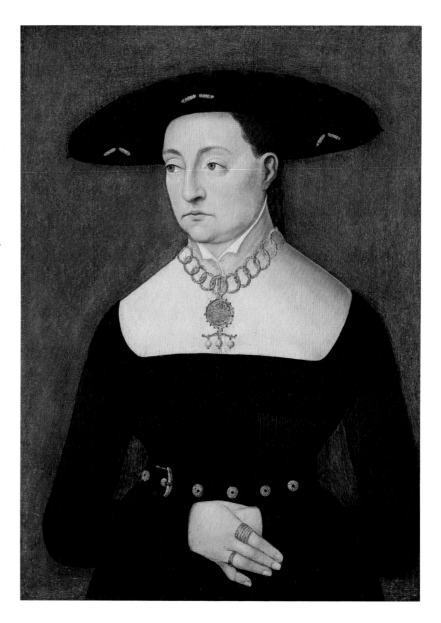

a pendant and three large pearls are suspended. The panel was thinned before it was cradled, and the monogram *HB*, the date 1524, and the inscription—first transcribed by F. A. von Lehner (1871) as KATHARINA MERIAN ÆT. 38—are no longer visible.

This picture is consistent in style with portraits of Wolf Fürleger, 1527 (formerly art market, Germany), S. Haller, 1528 (North Carolina Museum of Art, Raleigh),[1] and Christoph Haller, 1529 (formerly Pannwitz collection, Holland); the four families to which the sitters belong are all recorded in Nuremberg. Another related work is the portrait of Jochum Wirman, 1521 or 1524 (private collection). The portraits of men bear the artist's monogram, the date, and the sitters' ages and names in large capital letters at the top. The inscription that was once on the back of the Linsky picture cannot, however, have been cut from the front, as has been generally supposed, because the top edge of the panel is original. Irene Kunze (1941) believes that an undated portrait of a man in a black cap (private collection, Oberallmannshausen), monogrammed *HB*, and a portrait of Wolfgang Eisen (Staatliche Kunsthalle, Karlsruhe), which lacks the monogram but is inscribed and dated 1523, belong to this group. She is persuaded that the hand is that of Hans Brosamer, who painted the 1536 portrait of Johannes von Otthera (see Biography).

NOTE:

1. W. R. Valentiner, North Carolina Museum of Art, *Catalogue of Paintings*, Raleigh, 1956, p. 74, no. 163, pl. 163.

EX COLL.: The Princes of Hohenzollern-Sigmaringen, Meersburg and Sigmaringen; Prince Karl Anton of Hohenzollern, Sigmaringen (by 1871–1885; Cat. 1871, no. 54, as HB; Cat. 1883, no. 54, as HB); Prince Leopold of Hohenzollern, Sigmaringen (1885–1905); Prince Wilhelm of Hohenzollern, Sigmaringen (1905–27); Prince Friedrich of Hohenzollern, Sigmaringen (1927–28, or soon after; Cat. 1928, no. 13); Han Coray, Erlenbach (sale, Wertheim, Berlin, Oct. 1, 1930, no. 42, to Bottenwieser); [Paul Bottenwieser, Berlin, 1930–after 1931]; [P. Jackson Higgs, New York; sale, American Art Association-Anderson Galleries, New York, Dec. 7, 1932, no. 26]; Mrs. William Fox, New York (sale, Kende Galleries, New York, Dec. 1, 1942, no. 35); Mr. and Mrs. Jack Linsky, New York (until 1980); The Jack and Belle Linsky Foundation, New York (1980–82).

EXHIBITED: Städelsches Kunstinstitut, Frankfurt, *Sigmaringer Sammlungen*, 1928, no. 13.

BIBLIOGRAPHY: F. A. von Lehner, Fürstlich Hohenzollern'sches Museum zu Sigmaringen, *Verzeichniss der Gemälde*, Sigmaringen, 1871, p. 16, no. 54, inv. 2182, ascribes this portrait from Meersburg to a South German painter, noting that the reverse is monogrammed *HB*, dated 1524, and inscribed KATHARINA MERIAN ÆT. 38 // F. A. von Lehner, Fürstlich Hohenzollern'sches Museum zu Sigmaringen, *Verzeichniss der Gemälde*, 2nd ed., Sigmaringen, 1883, p. 18, no. 54, inv. 2182, suggests that the inscription, which he believes to be by a later hand, may originally have been on the front of the panel // [G.] Pauli, in *Allgemeines Lexikon . . .*, ed. U. Thieme and F. Becker, V (1911), p. 66, attributes it to Hans Brosamer, noting that the inscription, which is not by the artist, was probably cut off the front of the panel and applied to the back // F. Rieffel, "Das Fürstlich Hohenzollernsche Museum zu Sigmaringen: Gemälde und Bildwerke," *Städel-Jahrbuch* 3–4 (1924), p. 64, fig. 59, quotes, with reservations, Pauli's attribution to Brosamer // S. Schwabacher, "Erwerbung des Sigmaringer Museums für Frankfurt," *Der Cicerone* XX (1928), pp. 455–56, as Brosamer // O. Fischel, *Sammlung Han Coray*, Berlin, 1930, p. 9, no. 42, pl. 42, as Brosamer // C. L. Kuhn, *A Catalogue of German Paintings of the Middle Ages and Renaissance in American Collections*, Cambridge, Mass., 1936, p. 90, no. 410, as Brosamer // I. Kunze, "Der Meister HB mit dem Greifenkopf: Ein Beitrag zur Brosamer-Forschung," *Zeitschrift des Deutschen Vereins für Kunstwissenschaft* 8 (1941), pp. 233–35 n. 33, fig. 28, attributes it to Brosamer, associating it with dated portraits of 1527, 1528, and 1529; notes South German characteristics // I. Kühnel-Kunze, "Hans Brosamer und der Meister HB mit dem Greifenkopf: Ein weiterer Beitrag zur Brosamer-Forschung," *Zeitschrift für Kunstwissenschaft* XIV (1960), pp. 74, 77–78, attributes it to Brosamer // K. Löcher, "Nürnberger Bildnisse nach 1520," in *Kunstgeschichtliche Studien für Kurt Bauch zum 70. Geburtstag von seinen Schülern*, Munich, 1967, pp. 116–17, 120–21, fig. 5, notes that the portrait of Barbara Straub, 1525, by Hans Plattner was much influenced by this work // K. Löcher, "Ein Bildnis der Anna Dürer in der Sammlung Thyssen-Bornemisza," *Wallraf-Richartz-Jahrbuch* XXXIX (1977), p. 87, fig. 6, as Brosamer.

KB

Spanish Paintings

LUIS EGIDIO MELENDEZ

Born 1716, Naples; died 1780, Madrid

THE ARTIST'S full name was Luis Egidio Meléndez de Rivera Durazo y Santo Padre; he was also known as Menéndez. His parents were Spanish, and the year after he was born in Naples the family returned to Madrid, where Francisco Meléndez, the father, was employed as a miniaturist in the service of Philip V, king of Spain. Luis studied with his father, and later with Louis-Michel van Loo, who was appointed court painter in 1737. The elder Meléndez was instrumental in persuading the king to form an academy for the training of artists, but as a result of his disagreements with the organizing committee his son, who in 1745 had been judged the most talented of the first group of students accepted, was expelled from the provisional Real Academia in 1748. Luis pursued his studies in Rome and Naples, returning to Spain in 1753 to illuminate choir books for the royal chapel. He petitioned unsuccessfully for the post of court painter in 1760, and again in 1772. In June 1780 he signed a declaration of poverty, and he died a few weeks later.

A number of miniatures by Luis Meléndez are preserved in choir books in the chapel of the Palacio Real, Madrid, and the self-portrait of 1746 in the Louvre, Paris, testifies to his considerable skill in that genre; he is known, however, for his *bodegones*, a type of still life that is uniquely Spanish, and in which only food, tableware, and kitchen utensils are represented. He is widely regarded as the most distinguished painter of still life in eighteenth-century Spain.

40. Still Life: La Merienda (The Afternoon Meal)

Oil on canvas. 41½ × 60½ in. (105.4 × 153.7 cm.)
Inscribed (lower right): *2ss.M.de.R.* [inventory number, in white paint]
1982.60.39

The picture is in very good state, though the darks have sunk, disturbing somewhat the balance of the composition. The shapes of a number of fruits at the lower left, painted out by the artist, are now visible.

THREE PEARS, a plate of peaches, a melon from which slices have been cut, a bottle of red wine, a knife, and two loaves of bread are arranged along a rocky ledge. To the left are an earthenware bowl with an inverted plate resting on its rim, and a copper vessel; and to the right are a basket, which holds a white cloth and a number of small white dishes, and a wooden wine cooler containing another bottle of wine with a stopper and a cord twisted around the neck. Bunches of green and purple grapes, with leaves and tendrils, are piled up in a wicker basket at the center. The objects are confined to a shallow space by a screen of dark foliage except at the left, where, in a triangular space in the upper corner, a tree is silhouetted against a view of a mountain landscape.

This is one of the finest still lifes by the artist, who painted kitchen utensils, bread and fruit, and occasionally fish and fowl, but never meat, or flowers. The same objects, studio props, are used repeatedly in different combinations: the lidded copper pot is represented in a still life of 1772 in the Prado, Madrid (inv. 902);[1] the basket with a handle appears in paintings in the Museum of Fine Arts, Boston (inv. 39.41),[2] and in the Louvre, Paris (inv. R.F.3849);[3] and the bowl was frequently represented.[4] The format is the one Meléndez most often favored. The light falls, as usual, from the left, and the shallow space and foreground are carefully defined. Cubic volumes and textures—of copper and pottery, of the pitted flesh of pears, the rough skin of a melon, and the smooth, luminous skins of grapes—are meticulously rendered. Landscape is a component in only a half-dozen of the artist's still lifes. Of these, the four in the Prado (inv. 922, 923, 939, 940)[5]

109

are thought to have been intended as pairs, and the present picture may therefore originally have had a pendant, with a view of a landscape at the right. It is the more exceptional in that the composition is unusually elaborate, and the canvas is by far the largest of some eighty-five still lifes known today. There is no record of the early history of these works, but nearly half of them, thirty-nine, are in the Prado. Thirty-two are signed, twenty are dated—between 1760 and 1774—and all are thought to have come from the royal palace at Aranjuez, where forty-five Meléndez paintings of the type were hanging in the king's dining room at the time of the 1818 inventory. *Watermelons and Apples*, in the Prado (inv. 923), one of the still lifes with landscape backgrounds, was painted in 1773, and it is likely that *La Merienda* is also a late work. The inventory number at the lower right identifies the picture as having belonged to the Marqueses de Remisa.[6]

NOTES:

1. E. Tufts, "Luis Meléndez, Still-Life Painter *sans pareil*," *Gazette des Beaux-Arts* ser. 6, C (1982), p. 149, no. 1, ill.

2. Ibid., p. 157, no. 48, ill.

3. Ibid., p. 164, no. 84, ill.

4. See, for example, ibid., pp. 154, no. 32, ill., 156, no. 47, ill.

5. Ibid., pp. 152, nos. 21, 22, ill., 155, nos. 38, 39, ill.

6. Information kindly communicated by Jonathan Brown, in a letter, 1983.

EX COLL.: Marqueses de Remisa; Sra. Vda. de Moret, Madrid (1935); Sr. D. Salvador Moret, Madrid (1940); [Newhouse Galleries, New York, 1958]; Mr. and Mrs. Jack Linsky, New York (1958–80); Mrs. Belle Linsky, New York (1980–82).

EXHIBITED: Palacio de la Biblioteca Nacional, Madrid, *Floreros y bodegones en la pintura española*, 1935, no. 84 (as *Bodegón*, lent by Sra. Vda. de Moret); John Herron Museum of Art, Indianapolis, *El Greco to Goya*, 1963, no. 50 (lent by Mr. and Mrs. Jack Linsky); Museum of Art, Rhode Island School of Design, Providence, *El Greco to Goya*, 1963, no. 50 (lent by Mr. and Mrs. Jack Linsky); Wildenstein, New York, *The Object as Subject: Still Life Paintings from the Seventeenth to the Twentieth Century*, 1975, no. 45.

BIBLIOGRAPHY: The authorities cited below attribute this painting to Luis Meléndez. J. Cavestany and E. Lafuente [Ferrari], *Floreros y bodegones en la pintura española* (exhib. cat.), Madrid, Palacio de la Biblioteca Nacional, [1935], p. 68, no. 84, as from the collection of the Marqués de Remisa // E. Lafuente Ferrari, "La Peinture de bodegones en Espagne," *Gazette des Beaux-Arts* ser. 6, XIII (1935), pp. 181–82, fig. 9, as belonging to Mme de Moret y Remira // J. Cavestany, *Floreros y bodegones en la pintura española* (exhib. cat.), Madrid, Palacio de la Biblioteca Nacional, 1936 and 1940, pp. 53, 161, no. 84, pl. LXIV (in color), as in the collection of Sr. D. Salvador Moret // J. de Contreras, Marqués de Lozoya, *Historia del arte hispánico*, Barcelona, IV (1945), p. 518, pl. XLVI (in color) // C. G. Coley, "The Delectable Foothills of Spanish Painting," *Art News* 62 (Mar. 1963), p. 25, ill. // D. G. Carter, "El Greco to Goya: An Exhibition at Indianapolis and Providence," *Connoisseur* 153 (May 1963), pp. 55, fig. 4, 56 // E. M. Tufts, *A Stylistic Study of the Paintings of Luis Meléndez*, Ann Arbor, 1971, I, pp. 27, 30–31, 38 n. 68, 184–85, no. 62; II, fig. 56, suggests that the painting may have been one of a pair // E. Tufts, "Luis Meléndez, Still-Life Painter *sans pareil*," *Gazette des Beaux-Arts* ser. 6, C (1982), p. 163, no. 81, ill. // J. J. Luna, *Luis Meléndez: Bodegonista español del siglo XVIII* (exhib. cat.), Madrid, Prado, 1982, p. 40, ill.

KB

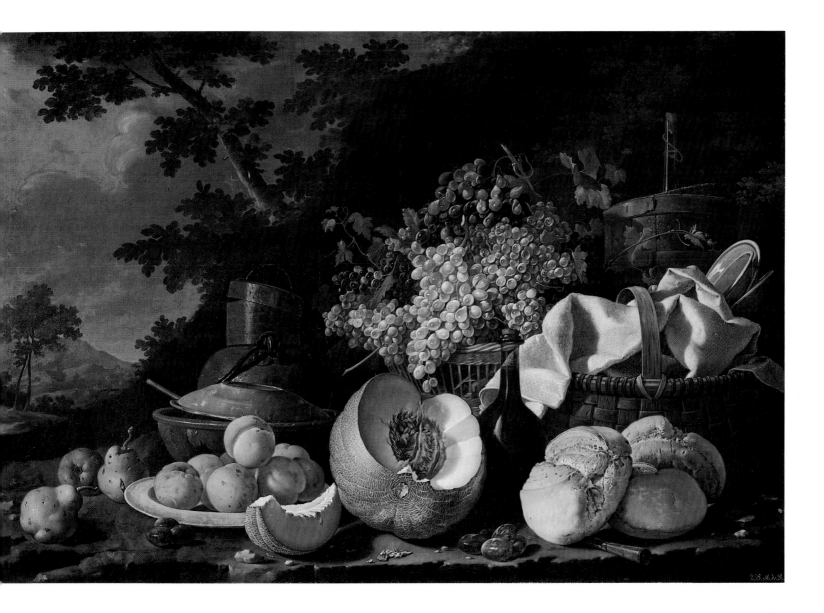

III

French Paintings

FRENCH OR GERMAN PAINTER, UNKNOWN

Late 15th century

41. The Resurrection

Tempera and/or oil and silver on wood, gold ground.
31 × 24⅞ in. (78.7 × 63.2 cm.)
1982.60.40

Most of this picture, the part that is original, is very well preserved. The panel probably had an attached frame, the upper inside edge of which was arched, perhaps scalloped, and followed very closely an arc circumscribing the tops of the trees and Christ's staff and halo. The gilding in the upper reaches of the ground and the blue, brocade-patterned field are entirely false. The banner of Christ's staff has been completely repainted since 1915 over faint traces of the original paint. The foliage of some of the trees appears to be retouched. The helmet of the soldier at the left and the armor of the soldiers at the right are silver leaf that has oxidized. These passages, dark brown today, originally would have had a shiny metallic appearance. Seven old square nails protrude from the back of the panel, where a horizontal brace once joined the three boards comprising it. The nails have caused raised knotholelike protuberances to appear on the painting's surface about twelve inches from the lower edge.

THE RISEN CHRIST, shrouded in a white cloak and with a tool-punched halo, steps from a stone sarcophagus. Surprisingly earthbound, he supports his weight on a cruciform staff to which is attached a white pennon with a red cross. Three soldiers in armor slumber around the tomb. The soldier at the far right, half-asleep, holds a mace and a shield with a pseudo-Kufic inscription. Shrublike leafy trees, some in coppices, are seen in the otherwise barren hilly background against a gold field.

This picture is difficult to place geographically. Its rough-hewn style indicates a provincial origin. The stylized tree forms are found in pictures of this period from eastern Germany; however, the closest analogies to its technique are paintings from eastern France. The striated modeling of shadows, particularly in the draperies, the sharply de-lineated faces, and a similar tool-punched halo are found, for example, in a picture attributed to the fifteenth-century school of Avignon, *Saint John Preaching in the Desert* (George Wildenstein collection, Paris);[1] the similarity

would be greater still if the present picture had retained its original attached frame. The Linsky panel is reported to have come out of France, and has been catalogued by Maurice Brockwell (1915) as "early French school."

NOTE:
1. Reproduced in L. Réau, *French Painting in the XIVth, XVth and XVIth Centuries*, trans. M. Chamot, London, 1939, pl. 15.

EX COLL.: Sir Frederick Lucas Cook, Doughty House, Richmond, Surrey (1901–20); his son Sir Herbert Frederick Cook, Doughty House (1920–39); his son Sir Francis F. M. Cook, Doughty House (from 1939); Mr. and Mrs. Jack Linsky, New York (until 1980); The Jack and Belle Linsky Foundation, New York (1980–82).

EXHIBITED: Southampton City Art Gallery and Museums, Southampton, England (on extended loan when owned by Sir Francis Cook).

BIBLIOGRAPHY: M. Brockwell, *English, French, Early Flemish, German and Spanish Schools*, vol. III of *A Catalogue of the Paintings at Doughty House Richmond & Elsewhere in the Collection of Sir Frederick Cook, Bt.*, ed. H. Cook, London, 1915, no. 423, ill. p. 40.

GCB

CORNEILLE DE LYON

Active by 1531, Lyons; died 1575, Lyons

CORNEILLE MUST have been born about 1500, presumably in Holland, since in all contemporary archival sources he is referred to as Corneille de la Haye (Cornelius from The Hague). He has been dubbed "de Lyon" because he was active in that town for over forty years and his family name is not known. Corneille was described in 1534 as *peintre de la reine* to Eleanor of Austria, and in 1541 as *peintre du dauphin* to the future Henry II. He became a naturalized French citizen in 1547 and was *peintre du roi* throughout the reigns of Henry II (1547–59) and Charles IX (1560–74). In 1551 he was named *peintre et valet de chambre du roi*, the most honored position then attainable by a French painter. He was buried November 8, 1575.

Corneille de Lyon is associated only with small, half-length portraits on panel, usually with green backgrounds, a format he seems to have introduced in France. These display the influence of Netherlandish portrait traditions. Most of the surviving portraits depict the nobility, though more portraits of a bourgeois clientele than hitherto supposed may have perished due to their less stable circumstances of preservation. To judge by the numerous—approximately two hundred—pictures that survive, often in several versions, Corneille was immensely successful and widely imitated. Their varied styles and degrees of quality indicate the participation of several workshop assistants, presumably including his son and daughter, both of whom were painters.

It is difficult to attribute works to Corneille with assurance, and even more to assign them a chronology. He seems never to have signed his portraits, nor are any dated by him. Only one, the *Portrait of Pierre Aymeric*, 1534, in the Louvre, Paris, is considered documented.[1] It is evident from the style of that painting that a number of works formerly attributed to an assistant called the Master of the Benson Portraits must now be regarded as paintings by Corneille. Still, the quality of any given picture remains the best criterion for determining which of the pictures grouped under the name Corneille are by the master himself, and which are by assistants.

42. Portrait of a Man

Tempera and oil on wood. Diameter 3¾ in. (9.5 cm.)
1982.60.41

The picture is in a very good state of preservation.

THE SITTER, a man apparently in his mid- to late twenties, is seen in three-quarter profile facing left against a green ground. He wears a black coat and hat, and engages the viewer's glance directly. The right and upper edge of the ground are shadowed as if by a frame.

A portrait attributed to Corneille in the Musée des Beaux-Arts, Dijon, clearly represents the same individual.[2] Oval in format and almost twice as large, it differs only in the sitter's glance, which is diverted to the left. The Dijon version appears to have been made after the present picture: the modeling is harder, the draftsmanship is less sensitive, and in general the effect is stiffer and less spontaneous. The Linsky roundel may well have served as its model, since Corneille is believed not to have made

preparatory studies but rather to have drawn directly from life on the panel.

The subject of the Dijon portrait is presumed, on the basis of a supposed similarity to a portrait by Corneille in the Louvre,[3] to be Jean de Bourbon-Vendôme, comte de Soissons et d'Eghien (1528–1557). A label in an eighteenth-century hand on the verso of the Louvre panel designates the subject as Jean, a fairly sure identification since the picture once belonged to Roger de Gaignières (1642–1715), a renowned connoisseur who collected more than a thousand sixteenth-century portraits of French nobles and who was especially interested in the identities of the subjects. However, the features of the man in the Dijon and Linsky portraits do not agree sufficiently with those of the Louvre subject to extend the identification convincingly.

The quality of the present picture warrants attribution to Corneille himself, rather than to an assistant. It appears to date from about 1545.

NOTES:
1. See S. Béguin and A. de Groër, "A Propos d'un nouveau Corneille: Le Portrait de Pierre Aymeric," *La Revue du Louvre* XXVIII (1978), pp. 28–42.
2. Musée des Beaux-Arts de Dijon, *Catalogue des peintures françaises*, Dijon, 1968, p. 16, no. 14, pl. XI.
3. C. Sterling and H. Adhémar, Musée National du Louvre, *Peintures: Ecole française XIVᵉ, XVᵉ et XVIᵉ siècles*, Paris, 1965, p. 29, no. 81, pl. 188.

EX COLL.: François Flameng, Paris (by 1912); Mrs. François Flameng (until 1919; sale, Galerie Georges Petit, Paris, May 26–27, 1919, no. 8, as François Clouet, to Gotti & Cie.); Glückstadt, Copenhagen; George Rasmussen, Clampenborg; Mrs. George Rasmussen (until 1938; sale, Christie's, London, Feb. 25, 1938, no. 58, as Corneille de Lyon, to Bacri); [Bacri Antiquaire, Paris, 1938–67]; Mr. and Mrs. Jack Linsky, New York (1967–80); The Jack and Belle Linsky Foundation, New York (1980–82).

EXHIBITED: Brussels, *Exposition de la Miniature*, Mar.–July 1912, no. 646 (as François Clouet, lent by François Flameng).

BIBLIOGRAPHY: C. Saunier, "Collection François Flameng," *Les Arts* XIV (no. 167, 1917–18), pp. 16–17, ill. p. 18 (attributed to Clouet).

GCB

JEAN-MARC NATTIER

Born 1685, Paris; died 1766, Paris

NATTIER'S FATHER, Marc, was a portraitist, and his mother, née Marie Courtois, a miniaturist. As a young man Jean-Marc was influenced by his godfather, Jean Jouvenet, and also by Hyacinthe Rigaud. He achieved his first success with the publication, in 1710, of engravings based in great part on his drawings after Rubens's cycle of the life of Marie de' Medici (Louvre, Paris). In 1717 he traveled to the Netherlands, where he accepted several commissions from Peter the Great, who was in residence there. Returning to Paris, Nattier was received into the Académie Royale on October 29, 1718, with *Perseus Turning Phineus to Stone* (Musée des Beaux-Arts, Tours). Although he may have aspired to the more elevated rank of a history painter, he suffered financial reverses, and was soon obliged to turn to the more lucrative practice of portraiture. He often represented his sitters—most of them were women, whom he flattered while still retaining a likeness—in mythological or allegorical guise. Nattier exhibited regularly at the Salon from 1737. He was popular at the court of Louix XV and attracted the notice of the queen, Maria Leszczyńska, whose portrait he painted in 1748. But he is perhaps best known for his likenesses of the royal daughters, who sat for him on numerous occasions. His style never changed, and eventually he fell from favor. He became ill, stopped painting, and died at the age of eighty-one in considerable poverty.

43. Portrait of a Lady, called the Marquise Perrin de Cypierre

Oil on canvas. 31½ × 25¼ in. (80 × 64.1 cm.)
Signed and dated (center left, on tree trunk): *[N]attier. p. x. / 1753*
1982.60.42

There is some damage in the area of the flower still life and the ledge in the foreground, but the painting, which was cleaned and relined at the Metropolitan Museum in 1982, is in good state. It was discovered that the edges of the canvas had been made up in the past, and the paint surface extended by roughly 1¼ in. (3.2 cm.) at the bottom, 1 in. (2.5 cm.) at the left, and ½ in. (1.3 cm.) at the right. When the canvas is framed for exhibition, these additions are not visible.

THE SITTER is shown in half-length, facing toward the left. Her hair, dressed in tight curls and powdered, and

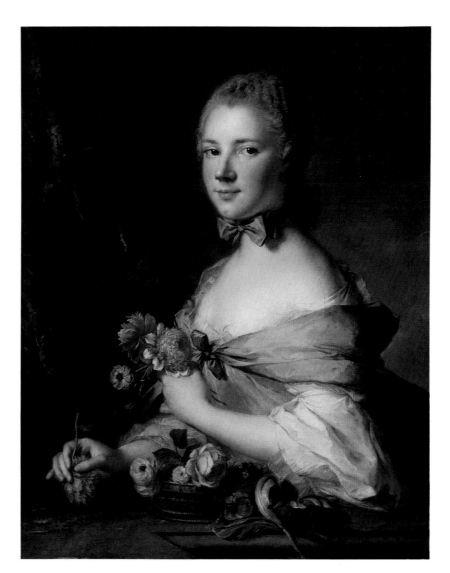

her costume, a white dress with a low neck and a blue shawl knotted at the breast, are typical of the artist, as are the foliage, the gray sky shaded to blue, and the tree trunk that defines the composition at the left. The lady's direct, determined expression gives her a certain individuality, and suggests that the portrait may be a good likeness. The flowers are represented in greater abundance and rather more naturalistically than is usually the case. The mauve, yellow, and white tulip appears also in Nattier's portrait of the Marquise de Baglion (Bayerisches Staatsgemälde-sammlungen, Munich), which was exhibited at the Salon of 1746.[1]

The lady in this exceptionally fine portrait was first identified as the Marquise Perrin de Cypierre in the 1905 catalogue of an exhibition at Thos. Agnew & Sons, London. According to the catalogue note she was the "daughter of the Duc de Vienne, wife of the Intendant of the King (Louis xv.) and Governor of Orleans."[2] A connection with the Cypierre family may be tentatively established, as the painting seems to have come from the estate sale of a M. de Cypierre in 1845. However, because it was then titled *Jeune Femme tenant des fleurs dans ses deux mains*, the identity of the sitter is not assured.[3]

NOTES:
1. *Die Münchner Pinakotheken: Meisterwerke aus den Bayerischen Staatsgemäldesammlungen*, ed. E. Steingräber, Munich, 1972, p. 32, pl. 59 (in color).
2. *Eleventh Annual Exhibition on Behalf of the Artists' General Benevolent Institution* (exhib. cat.), London, Thos. Agnew & Sons, 1905, p. 1, no. 1. Evelyn Joll kindly advises, in a letter, 1983, that Agnew's records the picture under this title, as coming from the family of the sitter. He presumes that the information was provided by Fairfax Murray. The picture is not in Pierre de Nolhac's monograph on the artist (*J.-M. Nattier*, Paris, 1905); no standard work has been published since that date.
3. *Catalogue de tableaux . . . composant la collection de feu M. de C[ypierre]*, Paris, 1845, p. 19, no. 91: "Elle est vue de trois quarts sur un fond de paysage. Robe blanche décolletée, léger châle de soie bleue, noué sur le sein." The dimensions are not supplied. The sitter is seen in three-quarter length, according to this catalogue; however, the coincidence of names supports the proposed identification.

EX COLL.: ? M. de Cypierre, Paris (sale, Paris, Mar. 10ff., 1845, no. 91, as *Jeune Femme tenant des fleurs dans ses deux mains*); ? Mrs. Isabella Maria Malton, London (sale, Christie's, London, Mar. 10, 1892, no. 167, as *Portrait of a Lady, with a Basket of Flowers*); Charles Fairfax Murray, London (until 1905); [Thos. Agnew & Sons, London, 1905–7]; Charles Fairfax Murray, London (1907–after 1909); J. P. Morgan, Wall Hall, Aldenham, Hertfordshire (until 1943; sale, Christie's, London, Mar. 31, 1944, no. 138, to Koetser); [Koetser, London,

1944]; Mr. and Mrs. Jack Linsky, New York (1944–80); The Jack and Belle Linsky Foundation, New York (1980–82).

EXHIBITED: Thos. Agnew & Sons, London, *Eleventh Annual Exhibition*, 1905, no. 1; Salle du Jeu de Paume, Paris, *Cent portraits de femmes*, 1909, no. 83 (as *Portrait de femme*, lent by M. Fairfax Murray).

KB

JEAN-BAPTISTE-JOSEPH PATER

Born 1695, Valenciennes; died 1736, Paris

JEAN-BAPTISTE PATER, the son of a sculptor, was apprenticed at an early age to a minor local painter, Jean-Baptiste Guidé. Like Antoine Watteau, he was a native of Valenciennes, and when he began to show some aptitude for painting he was sent to study with his compatriot in Paris. Watteau had a quarrelsome disposition, and he and his only pupil soon parted; they were, however, reconciled shortly before Watteau's death, and Pater was decisively influenced by him, imitating throughout his life the *fêtes galantes* and the military subjects that had been his stock-in-trade. Pater was received into the Académie Royale in 1728 with a *fête champêtre* titled *Soldiers Merrymaking* (Louvre, Paris). Although he was a painter of relatively modest talents, his work enjoyed enormous popularity in his own time: Frederick the Great of Prussia, for example, owned more than forty of his pictures. It is said that overwork, brought on by a miserly disposition, contributed to his premature death.

44. The Golden Age

Oil on wood. Overall, with added strips, 7½ × 9⅞ in. (19.1 × 25.1 cm.); original panel 6⅜ × 9 in. (16.2 × 22.9 cm.)
1982.60.43

The painting, which is very well preserved, was cleaned at the Metropolitan Museum in 1982. When the picture is framed for exhibition, the added strips on the four edges are not visible.

AT THE LEFT are several trees with soft, delicate foliage, and the trunk of another tree closes off the composition

at the right, while at the center seven children and a dog are playing. A little girl in a yellow dress, white apron, and cap gives her hand to a blond child in a rose-colored dress and green stockings who has fallen to the ground; a slightly older girl with brown hair, dressed in green and wearing pink stockings, gestures in their direction. Two of the children are holding hobbyhorses, and another little girl, her back turned and her head in profile, holds up a pinwheel to catch the breeze. A young boy in brown tumbles to the ground at the right, his feet in the air. Behind him, in the near distance, are a pool, a cottage shaded by a tree, and a gentle slope. Pater is at his best, as here, when painting figures on a very small scale. The composition is tightly knit, the children forming a shal-low triangle, contained by the trees at either edge. Children play a supporting role in many of Pater's paintings, but rarely, as in the present work, are they his principal subject. The picture was engraved under this title by La-live de Jully,[1] a wealthy courtier, to whose distinguished collection of contemporary French painting and sculp-ture it belonged. Lalive had another Pater, also called *L'Age d'or*, which seems to have been owned by Robert de Saint-Victor in the early nineteenth century.[2] If Flor-ence Ingersoll-Smouse (1928) was correct in stating that the second picture was slightly larger and on canvas, then it seems most unlikely that the two would have been pen-dants. The present whereabouts of the other painting is unknown.

NOTES:

1. For further information on Lalive de Jully as a collector see B. Scott, "La Live de Jully: Pioneer of Neo-Classicism," *Apollo* XCVII (1973), pp. 72–77.

2. *Catalogue d'une riche collection de tableaux . . . qui composaient le cabinet de feu M. Robert de Saint-Victor*, Paris, Galerie Le Brun, Nov. 26, 1822, and Jan. 7, 1823, no. 576. "Un joli petit tableau . . . offrant . . . un Groupe de jeunes enfans qui conduisent une petite fille dans une voiture en forme de berceau, attelée de deux chiens . . . B[ois]." The description matches quite closely Lalive de Jully's engraving, reproduced in Ingersoll-Smouse (1928), p. 203, fig. 206. It does not, however, seem likely that no. 575 in the Saint-Victor sale ("Cinq jeunes Enfans jouant dans un paysage, dont un déguisé en Pierrot. T[oile] ") is the Linsky picture. Ingersoll-Smouse (1928), p. 77, seems to have confused the supports for the two pictures.

EX COLL.: Ange-Laurent de Lalive de Jully, Paris (by 1758–1770; Cat. 1764; sale, Paris, 1770, no. 73); E. H. . . . (sale, Hôtel Drouot, Paris, Mar. 9, 1951, no. 53); Mr. and Mrs. Jack Linsky, New York (1951–80); The Jack and Belle Linsky Foundation, New York (1980–82).

BIBLIOGRAPHY: The authorities cited below attribute this painting to Jean-Baptiste-Joseph Pater. A.-L. de Lalive de Jully, *Catalogue historique du cabinet de peinture et sculpture françoise, de M. de Lalive . . .* , Paris, 1764, p. 36, lists it as one of two panels, each 6 × 8½ *pouces* (or roughly 6⅜ × 9 in.), representing childrens' games; he further notes that the two had been engraved by an *amateur* // Hébert, *Dictionnaire pittoresque et historique . . .* , Paris, 1766, I, p. 122, lists the two paintings on wood representing childrens' games in the collection of Lalive de Jully // L. Duvaux, *Livre-journal de Lazare Duvaux, marchand-bijoutier ordinaire du roy, 1748–1758*, Paris, 1873, I, p. CCLXXXIII, lists the two paintings on wood representing childrens' games in the collection of Lalive de Jully // F. Ingersoll-Smouse, *Pater*, Paris, 1928, pp. 77, no. 503, 203, fig. 205 (engraving, in reverse, by Lalive, titled *L'Age d'or*), catalogues the two paintings, noting that the other is slightly larger and on canvas, but calling them pendants nevertheless.

KB

FRANÇOIS BOUCHER

Born 1703, Paris; died 1770, Paris

THE YOUNG painter studied with his father, Nicolas Boucher, and then, briefly, with François Lemoyne. In 1723 he won first prize at the Académie Royale with *Evilmerodach Frees Jehoiachin from Prison* (Columbia Museum of Art, Columbia, South Carolina, Kress Collection, inv. K 2148). He was proficient as an engraver as well, collab-

orating with Jean de Julienne on a compilation of prints after works by Antoine Watteau. Boucher's travels in Italy and his stay in Rome, from 1727 to 1731, were undertaken independently, rather than as a *pensionnaire* of the French academy; little of his work from this early period has survived. Returning to Paris, he was received into the Académie upon presentation of *Rinaldo and Armida* (Louvre, Paris) in 1734, and in the same year he was first associated with the tapestry manufactory at Beauvais. In 1735 Boucher won his first important commission from the Direction des Bâtiments: he painted four allegories in grisaille for the apartments of the queen, Maria Leszczyńska, at Versailles. Throughout his career he enjoyed the benefits of royal patronage. He was the favorite painter and portraitist of the Marquise de Pompadour, who in 1745 was installed as *maîtresse en titre*, and subsequently, through her brother, the Marquis de Marigny, he received further commissions for decorations at Versailles, Marly-le-Roi, and Bellevue. Boucher was appointed *inspecteur* of the Gobelins tapestry manufactory in 1755. In 1765 he was named *premier peintre du roi*, the same year he succeeded to the post of director of the Académie Royale, to which he was unanimously elected. He died at the Louvre, where he had had lodgings since 1752, on May 30, 1770, the most acclaimed of all French painters of the eighteenth century.

45. A View of the Campo Vaccino

Oil on canvas. 25 × 31⅞ in. (63.5 × 81 cm.)
Signed and dated (lower left center): *boucher · 1734*
1982.60.44

The painting, which is in beautiful state, was cleaned at the Metropolitan Museum in 1982. The foliage of the tree at the center and a few of the architectural details are slightly rubbed and have been retouched. There is a pentiment behind and to the left of the standing cowherd.

THIS PICTURE is an imaginary evocation of the Roman Forum, which had fallen to ruins centuries before, and was known in Boucher's time as the Campo Vaccino from the cattle that grazed there. At the left center of the picture are two small buildings with red roofs joined by a masonry wall. The ruins of an ancient structure at the center are overgrown with trees and vines, and to the

right, behind a wooden fence and the gnarled trunk of a dead tree, is a hut with a thatched conical roof. Four cows drink from a shallow stream in the foreground. In the corner of the painting at the left are two young boys, one dressed in a red jacket and short blue trousers, carrying a covered basket over his right arm, and the other bare-legged, wearing a brown sleeveless jacket and a red cap, seated and holding a shepherd's staff.

The picture is perhaps the most idyllic of the landscapes that were the fruit of Boucher's travels in Italy and his stay in Rome from which he had returned three years earlier, in 1731. In 1735 Boucher published his *Livre d'études d'après les desseins originaux de Blomart*....[1] For this vol-

ume he etched, separately, the two figures in the Linsky picture: the standing figure is paired with a seated woman, and the seated shepherd is shown with a companion, another boy (or perhaps it is the same model), seated and seen from the back (Cabinet des Dessins, Louvre, Paris, inv. 18228LR and 18226LR).[2] For the second of these two groups there is also a preliminary red chalk drawing by Boucher, after Bloemaert (Musée des Beaux-Arts, Orléans, inv. 94668).[3] The shepherd in the drawing faces in the same direction as in the painting; in the respective etchings, as would be expected, the figures are both in reverse. A study in black chalk for the cow in the foreground at the left is in the Nationalmuseum, Stockholm

(inv. H 2955/1863).[4] The existence of additional black chalk drawings, a pair in the Louvre (Cabinet des Dessins, inv. 24797, 24800) that are related, respectively, to the Linsky picture and to the *Landscape at Tivoli with the Temple of Vesta* in Stockholm (Nationalmuseum, inv. 5035), led Regina Slatkin to suppose that the paintings were intended as pendants.[5] The two canvases are not, however, the same size, and the one in Stockholm, while of roughly the same date, is evidently somewhat inferior in quality. The drawings, uprights in which both compositions have been considerably modified, seem to have been made after the paintings rather than before. A black chalk drawing (Cabinet des Estampes, Bibliothèque Nationale, Paris) of a landscape very similar to the Linsky picture may, on the other hand, be earlier in date.[6] In this drawing there is a mound of earth in the foreground, with some scrubby bushes and trees, and a wall, while behind and to the right Boucher drew a small building rather than the thatched hut that he introduced into the painting.

NOTES:

1. See R. S. Slatkin, "Abraham Bloemaert and François Boucher: Affinity and Relationship," *Master Drawings* XIV (1976), pp. 247–60, for Boucher's etchings and the history of the related Bloemaert drawings upon which the etchings are based.

2. Ibid., pp. 252, fig. 8, etching no. 10, and 251, fig. 7, etching no. 8. Paintings by Bloemaert in which these figures appear include *Tobias and the Angel* (Gemäldegalerie, Staatliche Museen, Berlin-Dahlem, inv. 1995), and the *Preaching of Saint John* (Bayerische Staatsgemäldesammlungen, Schleissheim).

3. Ibid., pl. 2.

4. Ananoff (1976), I, p. 230, fig. 401.

5. R. S. Slatkin, "Two Early Drawings by François Boucher," *Master Drawings* IX (1971), pls. 41, 42, p. 401, fig. 4 (Stockholm painting). The author was misinformed about the size of the present picture.

6. Ananoff (1976), p. 229, fig. 396. Ananoff deals with additional related material.

EX COLL.: Private collection, France (until 1952); Mr. and Mrs. Jack Linsky, New York (1952–80); The Jack and Belle Linsky Foundation, New York (1980–82).

EXHIBITED: Rome, *Il Settecento a Roma*, 1959, no. 98 (as *Veduta del Palatino*, lent by the Weitzner collection, London); Finch College Museum of Art, New York, *French Masters of the Eighteenth Century*, 1963, no. 19 (as *View of the Palatine Hill*, lent by Mr. and Mrs. Jack Linsky); National Gallery, Washington, D.C., *François Boucher in North American Collections: 100 Drawings*, supplement 1973–74, (as *Landscape with Ruins*, lent anonymously).

BIBLIOGRAPHY: The authorities cited below attribute this painting to François Boucher. H. Voss, "François Boucher's Early Development," *Burlington Magazine* XCV (1953), pp. 80, fig. 34, 82, 85, publishes the picture for the first time, noting that it was "sold to America by a French private collector in 1952," and points out that it shows the influence of Abraham Bloemaert, from whom Boucher openly borrows the staffage figures // P. Jean-Richard, "Expositions, Musée du Louvre, Cabinet des Dessins: Boucher, gravures et dessins," *La Revue du Louvre* XXI (1971), p. 199, states that a drawing at the Louvre, *Paysage décoratif avec une villa en ruines*, is identical to the picture, the figures of the two shepherds having been copied from Bloemaert drawings that Boucher would have had in his studio at the time, as the related prints appeared as plates 8 and 10 of the *Livre d'étude*, which was announced in the *Mercure* of June 1735 // R. S. Slatkin, "Two Early Drawings by François Boucher," *Master Drawings* IX (1971), pp. 401, fig. 3, 403 n. 9, publishes the *Paysage décoratif* and the *Paysage inspiré de Tivoli*, also in the Louvre, as studio sketches, respectively, for the Linsky picture and the *Landscape at Tivoli with the Temple of Vesta* in Stockholm, suggesting that both the paintings and the drawings were intended as pendants, and dating the drawings 1732–34 // A. Ananoff, *François Boucher*, Lausanne, 1976, I, pp. 228–29, no. 101, fig. 394, catalogues the picture under the title *Vue de Campo Vaccino*, listing as related works the two prints, Boucher drawings at Stockholm, Orléans, and the Bibliothèque Nationale, Paris, and a Natoire drawing of the same site, Campo Vaccino, in 1766 // R. S. Slatkin, "Abraham Bloemaert and François Boucher: Affinity and Relationship," *Master Drawings* XIV (1976), pp. 248–49, 254, discusses the prints of the shepherd boys, seated and standing, as well as Boucher's only direct copy after Bloemaert, the red chalk drawing at Orléans, all of which are related to the present picture // A. Ananoff and D. Wildenstein, *L'Opera completa di Boucher*, Milan, 1980, pp. 92, no. 101, 93, ill. // P. Grate, in a letter, 1982, believes that in view of the discrepancy in size the Stockholm picture cannot be the pendant to this one, though it was painted about the same date, in France rather than in Italy // B. Schreiber, unpublished opinion, 1983, suggests that the pair of drawings at the Louvre were done after both this painting and the picture in Stockholm, which are not in her opinion a pair, but that the related figure and landscape drawings may date from the artist's Roman period.

KB

46. Jupiter in the Guise of Diana, and Callisto

Oil on canvas. Oval, 25½ × 21⅝ in. (64.8 × 54.3 cm.)
Signed (lower right): *f. Bouch(er)*
1982.60.45

The painting is in nearly perfect state. There is an old damage the size of a small coin at top center, and some small, scattered retouches near the nose of Diana and

on the neck and right shoulder of Callisto. The crackle pattern is pronounced throughout.

THE NYMPH Callisto is seated at the right, her left arm at her side and her left leg extended toward the center of the canvas. She wears a white chemise, but her shoulders and breasts and her knees and lower legs are bare. A blue ribbon is threaded through her blond, braided hair. Kneeling and leaning forward to embrace Callisto, Diana caresses the nymph's cheek with her left hand. The goddess is identified by the small crescent moon in her brown hair; she wears a blue cloak with a leopard-skin lining draped over her left shoulder. The presence of the eagle in the clouds at the upper left confirms that she is Jupiter in disguise. At the center, over Diana's head, are three winged putti, one brandishing flaming torches and another holding a spray of roses. Above the clouds to the right and at the top center are the trunk and leafy branches of a tree. Two quivers, attributes of the goddess and her followers, are at the left center and in the right foreground. Boucher has chosen as his subject a popular myth, recounted by Ovid in the *Metamorphoses*, according to which Jupiter transforms himself into Diana to seduce the nymph Callisto. "Straightway he put on the features and dress of Diana. . . . When she began to tell him in what woods her hunt had been, he broke in upon her story with an embrace, and by this outrage betrayed himself."[1] Callisto, powerless, finds herself with child and is expelled from Diana's virgin troupe. When she gives birth to a son, Arcas, Juno in jealous wrath transforms her into a she-bear, and Jupiter, to protect them both, transports them to the heavens, as neighboring stars.

There is good reason to believe that both this painting and *Angelica and Medoro* (no. 47), conceived as a pair, were exhibited together at the Salon of 1765. The two are close in size, and they are on matching stretchers bearing the same stamp, that of MOMPER A PARIS; the dimensions given in the Salon catalogue (each 2 *pieds* × 1½)[2] and in the Marin sale catalogue (each 24 × 20 *pouces*)[3] correspond closely enough; and the frames, a matching pair, may be the ones mentioned in the catalogue of the sale of Prousteau de Montlouis as "leurs bordures du temps."[4] Ananoff reproduces a drawing by Gabriel de Saint-Aubin (Cabinet des Dessins, Louvre, Paris, inv. 32749) in which, curiously, the artist twice represents the *Jupiter*, as installed at the Salon.[5] While there are evidently no canvases that might be confused with *Angelica and Medoro*, there are many others representing Jupiter in disguise

seducing Callisto. One painting, whose present whereabouts is unknown, was exhibited at the Salon of 1761.[6] Another, larger than the present work, is in the Wallace Collection, London;[7] it is signed and dated 1769, and is evidently the source for the Gobelins tapestry woven in 1776–78. A third painting of this subject, also of 1769, is recorded, and a fourth, which is usually dated in the 1760s, is in the North Carolina Museum of Art at Raleigh.[8] A grisaille, last exhibited at the Royal Academy, London, in 1968, may be a first sketch,[9] and others remain to be accounted for. All of these, except for the sketch, are in reverse, and none seems to have had a pendant. It is recorded that Boucher in 1765 was ill, and for this reason borrowed back from Bergeret de Grancourt canvases painted two years earlier.[10] Diderot, as might have been expected, did not admire them; otherwise these works, by the newly appointed *premier peintre du roi* and director of the Académie Royale, were greeted with enthusiasm.

NOTES:

1. Ovid, *Metamorphoses*, trans. F. J. Miller, Cambridge, Mass., 1946, I, pp. 90–91, ll. 425, 432–33.

2. D. Diderot, *Salons*, ed. J. Seznec and J. Adhémar, Oxford, II (1960), p. 19.

3. *Catalogue d'une très belle collection de tableaux . . . provenant du cabinet de feu M. Marin*, Paris, 1790, pp. 88–89, no. 335.

4. *Catalogue d'une collection de tableaux . . . dont la vente se fera pour cause du décès de M. Prousteau de Montlouis*, Paris, 1851, p. 5, no. 11.

5. Ananoff (1976), II, p. 229, fig. 1558.

6. See, for example, Diderot (see note 2 above), p. 20, and also the Saint-Aubin drawing reproduced in Ananoff (1976), I, p. 93, fig. 132.

7. *Wallace Collection Catalogues: Pictures and Drawings*, 16th ed., London, 1968, pp. 36–37, no. P446, ill.

8. For the 1769 painting see Wallace Collection, *Summary Illustrated Catalogue of Pictures*, London, 1979, p. 28. The information about the Raleigh painting was kindly communicated by Peggy Jo D. Kirby, in a letter, 1982.

9. D. Sutton, *France in the Eighteenth Century* (exhib. cat.), London, Royal Academy, 1968, p. 50, no. 65, fig. 128.

10. *Mercure de France*, Oct. 1765, p. 152, as quoted in Ananoff (1976), I, p. 111.

EX COLL.: M. Bergeret de Grancourt (1763–after 1765); Calonne Angelot (sale, May 11, 1789, no. 101); M. Marin (posthumous sale, Paris, Mar. 22, 1790, no. 335, *Jupiter sous la figure de Diane* . . . and *Les Amours de Bacchus & d'Ariane*, to Geoffrey); Geoffrey (1790); M. Prousteau de Montlouis (posthumous sale, Hôtel des Ventes, Paris, May 5, 1851, no. 11, *Diane et Calisto* and *Vénus et Adonis*); Sir Richard Wallace, Paris (by 1883–90); Amélie-Julie-Charlotte, Lady Wallace, Paris (1890–97); Sir John Arthur Murray Scott, Paris (1897–1912; inv., 1912–13); Victoria, Lady Sackville (1912/13–1913/14);

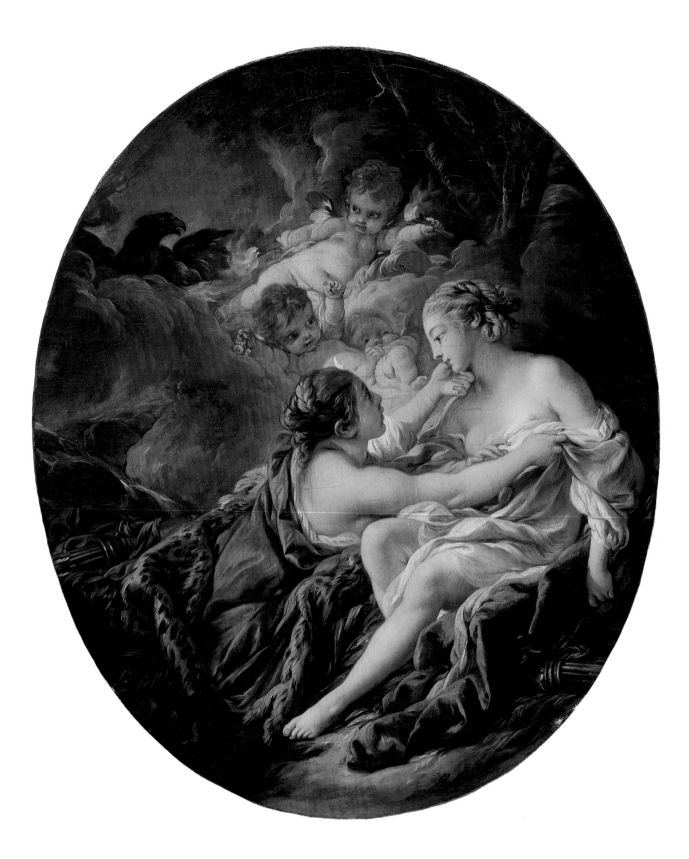

122 46. JUPITER IN THE GUISE OF DIANA, AND CALLISTO

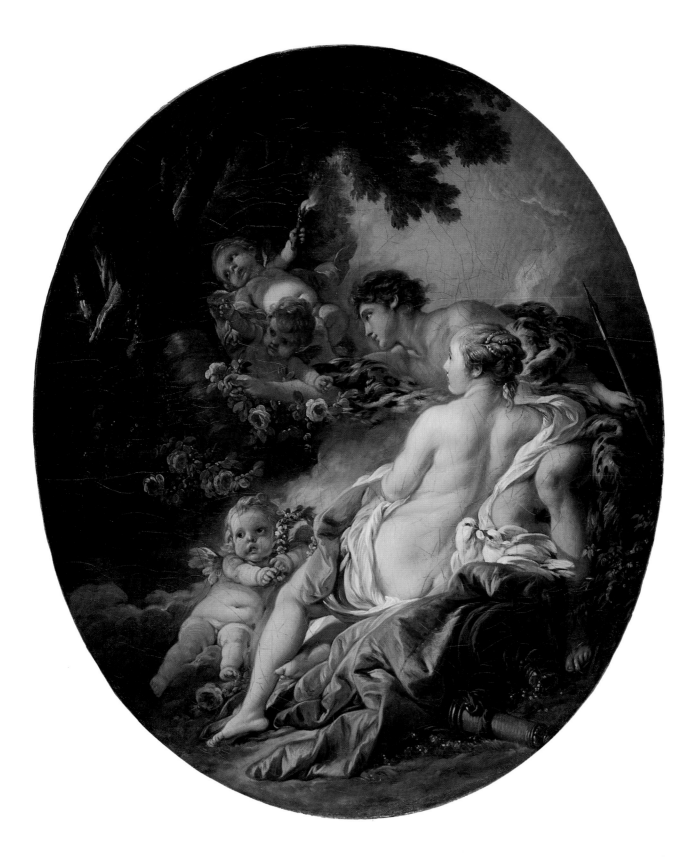

47. ANGELICA AND MEDORO

[Jacques Seligmann, Paris, 1913/14]; [M. Knoedler & Co., New York, 1914–17]; Mr. and Mrs. Morton F. Plant, Mrs. Plant, later Mrs. William Hayward, later Mrs. John E. Rovensky, New York (1917–57; sale, Parke-Bernet, New York, Jan. 16, 1957, nos. 457 and 458, *Jupiter and Calisto* and *Angelique and Medor*); Mr. and Mrs. Jack Linsky, New York (1957–80); Mrs. Belle Linsky, New York (1980–82).

EXHIBITED: Salon, Paris, 1765, nos. 8 and 9 (*Jupiter transformé en Diane pour surprendre Calisto* and *Angélique & Médor*, lent by M. Bergeret de Grancourt); Galerie Georges Petit, Paris, *L'Art au XVIII siècle*, 1883–84, nos. 5 and 6 (*Vénus et Adonis* and *Diane et Vénus*, lent by Sir Richard Wallace); Detroit Institute of Arts, *French Paintings of the Eighteenth Century*, 1926, nos. 8 and 9 (*Jupiter and Callisto* and *Angélique and Medor*, lent by Mrs. William Hayward); M. Knoedler & Co., New York, *24 Masterpieces*, 1946, nos. 17 and 18 (*Jupiter and Callisto* and *Angelic and Medor*, lent by Mrs. William Hayward); National Gallery, Washington, D.C., *François Boucher in North American Collections: 100 Drawings*, 1973–74, supplement (*Jupiter and Callisto* and *Angelique and Medor*, lent anonymously).

BIBLIOGRAPHY: The authorities cited below attribute these paintings to François Boucher. D. Diderot, *Salons*, ed. J. Seznec and J. Adhémar, Oxford, II (1960), pp. 77–78, 187–88, describes the pictures in detail, commenting on them in disparaging terms // P. Manz, *François Boucher, Lemoyne et Natoire*, Paris, [1880], pp. 151–53 // A. Michel, *F. Boucher*, vol. XXIV of *Les Artistes Célèbres*, [Paris],[1886], p. 122 // A. Michel, *François Boucher*, Paris, [1906], p. 125 // L. Soullié and C. Masson in A. Michel, *François Boucher*, Paris, [1906], pp. 7, no. 75, 13, nos. 182, 194, list the two pictures in the Bergeret de Grancourt collection, noting (probably in error) that the *Jupiter* belonged to M. Leroy in 1780; they list them also in the Marin sale, the *Angelica* under the title *Bacchus et Ariane* // P. de Nolhac, *François Boucher: Premier peintre du roi, 1703–1770*, Paris, 1907, p. 93 // G. Pannier in P. de Nolhac, *François Boucher: Premier peintre du roi, 1703–1770*, Paris, 1907, pp. III, 116–17, 125, catalogues the *Angelica* as *Bacchus et Ariane* and, separately, its pendant, in the Marin sale, no. 335, and lists them, one as *Jupiter* and the other as *Venus et Adonis*, in the Prousteau de Montlouis sale, no. II, sold for 3,250 fr. // H. Macfall, *Boucher: The Man, His Times, His Art, and His Significance, 1703–1770*, London, 1908, p. 71 // J. Seznec and J. Adhémar in D. Diderot, *Salons*, Oxford, II (1960), pp. 19–20, 77–78, 187–88, transcribe the Salon catalogue entries and Diderot's comments, identifying (incorrectly) the *Jupiter* with Soullié and Masson nos. 179 and/or 180, and the *Angelica* with Soullié and Masson no. 76 // D. Sutton, *France in the Eighteenth Century* (exhib. cat.), London, Royal Academy, 1968, p. 50 // *Wallace Collection Catalogues: Pictures and Drawings*, 16th ed., London, 1968, p. 37 // A. Ananoff, *François Boucher*, Lausanne-Paris, 1976, I, pp. 108–9, III, II, pp. 228–30, nos. 575–76, figs. 1553, 1557, quotes the *Lettres à Monsieur****, *A propos du Salon de 1765*, and *Mercure de France*, all of 1765, and catalogues the paintings, listing them (incorrectly) as in the Bethnal

Green Museum exhibition of 1872 // R. W. Lee, *Names on Trees: Ariosto into Art*, Princeton, 1977, pp. 57–58, fig. 38 (*Angelica*), 108 n. 124, discusses the subject of the *Angelica*, suggesting that it may represent a conflation of Ovid and Ariosto // J. Seznec in D. Diderot, *Salons*, 2nd ed., Oxford, II (1979), pp. 19–20, 77–78, 187–88, identifies the *Jupiter* (incorrectly) with no. 65 in the Royal Academy, London, exhibition of 1968 // A. Ananoff and D. Wildenstein, *L'Opera completa di Boucher*, Milan, 1980, p. 134, nos. 606–7, ill. // J. Ingamells, in a letter, 1983, confirms that the paintings belonged to Sir Richard Wallace, and notes that they were listed in the posthumous inventory of the French estate of Sir John Murray Scott, drawn up between February 16, 1912, and November 11, 1913, as "Boucher—deux pendants—scènes mythologiques—toiles de forme ovale (100,000 fr.)."

KB

47. Angelica and Medoro

Oil on canvas. Oval, 26¼ × 22⅛ in. (66.7 × 56.2 cm.)
Signed and dated (lower left): *f. Boucher / 1763*
1982.60.46

For a work of its date, the painting is in a nearly perfect state of preservation. The crackle pattern is pronounced throughout, and there are some very minor retouches on the chest of Medoro, near the profile of Angelica.

ANGELICA, FAIR skinned, her pale blond hair dressed with pearls, is seated, her back to the viewer, on a tasseled green cushion. Two doves perch behind her. Despite the pink, gray, and white drapery she is mostly nude. Her right elbow rests on Medoro's knees, and he reaches past her, his right arm extended, to wrap a garland of pink roses around the trunk of the tree, where, according to the story, their names are inscribed. Medoro's skin is by contrast darker, and his hair is brown; the leopard skin he wears leaves his shoulders and chest and his lower arms and legs bare. Three putti are grouped near the tree trunk at the left: one floats on his back, holding a small torch aloft; another hovers above the garland, his arms open wide; and the third, seated on a cloud in the foreground, clutches a smaller wreath of flowers. Foliage and the crossed trunks of trees fill the space to the left and at the top of the canvas.

The subject is drawn from Ludovico Ariosto's epic verse narrative *Orlando Furioso*. Angelica, the haughty daughter of the king of Cathay, abandons the hero, Orlando, for an unknown Moorish soldier called Medoro, whom Cupid, to spite her, has wounded with his dart. They stay

together in a herdsman's cottage until Medoro is healed, and they marry, remaining there for more than a month. Indoors and out, wherever they go, Angelica carves their names—on the walls, on rocks, and, as here, on the trunks of trees. These inscriptions, which Orlando eventually discovers, will drive him nearly mad with grief. Alexandre Ananoff (1976) reproduces a drawing from the sale of a Madame D . . . , April 27, 1932, no. 32, that is evidently related.

EX COLL.: See above.

EXHIBITED: See above.

BIBLIOGRAPHY: See above.

KB

MEDIEVAL AND RENAISSANCE OBJECTS

Catalogue entries by

WILLIAM D. WIXOM

CHARLES T. LITTLE

CARMEN GÓMEZ-MORENO

CLARE VINCENT

JESSIE McNAB

48. Corpus from a cross

Cast bronze, engraved and stippled, with traces
 of gilding. Height 6½ in. (16.5 cm.)
Mosan-Rhenish, 3rd quarter of 12th century
1982.60.395

WITH THE ARMS spread in a wide horizontal upward
curve, and the hands outstretched, the nearly rigid body
of the dead Christ seems even more erect without the
missing cross. Christ's head, bowed to the left, breaks the
frontality of the figure. The legs taper downward, and the
artist depicted the feet, which rest on an undecorated
wedge-shaped support known as the suppedaneum, as
splaying outward, but neglected to show the spikes through
them. The loincloth, or *perizonium*, pulled in tight folds
across the body, is texturally enhanced with a fine-punched
pattern. Tied in a projecting knot at Christ's right side,
the excess cloth is suspended in an angular cone of folds.
The upper torso is subdivided by a series of horizontal
incisions and planes that indicate the ribs and the chest
muscles. The muscles of the abdomen are suggested by
convex curves.

Rounded and blocky at the same time, the head is fur-
ther characterized by a broad nose, closed and swollen
eyes, a short incised beard, and long hair, the twisted and
curvilinear strands of which form a ridge over the fore-
head and fall in three pointed locks over the shoulders.
Hollowed out at the back, the figure was once attached
to a wood or metal cross by means of small spikes through
the holes in the palms and through the loop below the
suppedaneum.

Peter Bloch has shown that this corpus is one of a series
of at least twenty-eight examples ultimately deriving sty-
listically from a type that originated in the early twelfth
century in the Meuse Valley (in modern Belgium). The
creator of the type was Reiner of Huy. A corpus, of about
1110–20, by this gifted Mosan artist is in the Schnütgen-
Museum, Cologne.[1] Reiner is best known for the impres-
sive bronze baptismal font, of 1107–18, preserved in Saint-
Barthélemy, Liège.[2] His figures in both works are re-
markable for their subtle and smooth, yet firm, modeling,
and for their underlying classicism. The rounded folds of
drapery tend to emphasize the figural masses that they
cover. Undulating rolls of hair frame the faces.

This fluid, organic style is modified, even codified, in
such crucifix figures created after the middle of the twelfth
century as the Linsky corpus, or such smaller, related ex-

amples as those in the Kestner-Museum, Hanover, and in
the Cleveland Museum of Art.[3] The modifications in-
clude the taut displacement of the folds of the loincloths
and the more planar and linear simplifications of the tor-
sos. The treatment of the hair and the features is also
more linear. The character of the heads reflects that of the
heads of more monumental works. For example, the pro-
portions of the head of the Linsky corpus, the schematic
features, the broad aquiline nose, the bulging eye sockets,
and the wide mouth recall the similar characteristics of the
larger Mosan *Head Reliquary of Pope Alexander*, of 1145,
formerly belonging to Abbot Wibald's Abbey of Stavelot
and now in the Musées Royaux d'Art et d'Histoire, Brus-
sels.[4]

The exact localization of crucifix figures of the Linsky
type remains elusive. While the source of the style and
type is demonstrably Mosan, and ultimately that of Reiner
of Huy, the emanation of the type into the Rhineland and
northern Germany precludes a more precise geographical
attribution for this fine Romanesque corpus.

NOTES:
1. P. Bloch, "Bronzekruzifix in der Nachfolge des Reiner von
Huy," *Rhein und Maas, Kunst und Kultur 800–1400* 2, Cologne,
1973, p. 252, fig. 1.
2. D. Kötzsche, in *Rhein und Maas* (exhib. cat.) 1, Cologne,
1972, pp. 238–39, no. G 1, ill.
3. W. D. Wixom, "Twelve Additions to the Medieval Trea-
sury," *Bulletin of The Cleveland Museum of Art* LIX, 4 (Apr. 1972),
pp. 86–89, figs. 5–6 and 1–4, respectively.
4. D. Kötzsche, in *Rhein und Maas* 1, p. 250, no. G 11, ill.

EX COLL.: [Leopold Seligmann, Cologne].

EXHIBITED: The Cloisters, Metropolitan Museum of Art, New
York, *Medieval Art from Private Collections*, Oct. 30, 1968–Jan.
5, 1969, no. 92 (lent by Mr. and Mrs. Jack Linsky); Art Gal-
lery, University of Notre Dame, Notre Dame, Indiana,
Medieval Art, 1060–1550, Dorothy Miner Memorial, Mar. 16–Apr.
14, 1974, no. 37 (lent by Mr. and Mrs. Jack Linsky).

BIBLIOGRAPHY: E. Lüthgen, *Die abendländische Kunst des 15.
Jahrhunderts*, Bonn and Leipzig, 1920, pp. 27, 110, pl. 2, called
Rhenish or Saxon; E. Lüthgen, *Rheinische Kunst des Mittel-
alters aus Kölner Privatbesitz*, Bonn and Leipzig, 1921, p. 75,

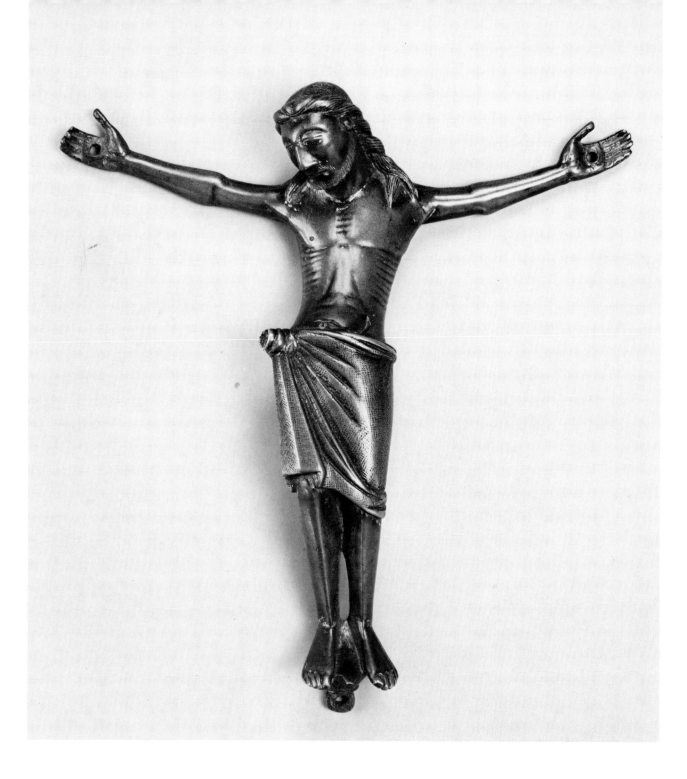

pl. 17, identified as Rhenish; *Die Sammlung Dr. Leopold Selig-mann, Köln*, Berlin [1930], no. 115, pl. xxx, called Mosan; C. Gómez-Moreno, *Medieval Art from Private Collections* (exhib. cat.), New York, Metropolitan Museum of Art, 1968, no. 92, ill., described as "Northwest German or Mosan, second half of the XII century"; P. Bloch, "Bronzekruzifix in der Nach-

folge des Reiner von Huy," *Rhein und Maas, Kunst und Kult-ur 800–1400* 2, Cologne, 1973, no. 14, pp. 254, 255, 260, identified as "Rhein-Maas-Gebeit, 2 H. 12 Jh."; *Medieval Art, 1060–1550, Dorothy Miner Memorial* (exhib. cat.), Notre Dame, Indiana, 1974, no. 37, ill.

WDW

49. Monk-scribe astride a dragon

Brass, cast and chiseled. Height 9⅜ in. (23.8 cm.),
width 7½ in. (19 cm.), depth 3⅝ in. (9.2 cm.)
Rhenish, Cologne ?, 3rd quarter of 12th century
1982.60.396

A YOUNG, beardless monk, tonsured and wearing a hooded tunic, sits backward on a dragon. The monk's face is long and oval. His wide-open eyes protrude beneath broad curved brows and above high cheekbones. His long nose continues in a straight line the profile of the sloping brow. A full-lipped yet small, somewhat puckered, mouth projects from the shallow hollow between the nose and the chin. The jaw and neck are firmly curved. A fringe of hair, with vertically engraved lines, forms an encircling band around the head and partly covers the small ears.

The monk's tunic is decorated by widely spaced punch marks and engraved cross-hatching in the borders. His lower legs and his feet are bare and smooth, in contrast to the textured imbrications of the dragon's wings. The monk's left leg is bent sharply, accentuating the point of the knee, whereas the right leg is less flexed, so that the foot is parallel to the dragon's body. With head bowed, the monk is intent on what he is inscribing with a pen in his right hand. A correcting knife, or scraper, is poised in his left hand.

The dragon is truly Romanesque, with richly feathered wings, crosshatched shoulders, furry legs, and vegetative extensions. His tail, resting on a third foot, is, in fact, a nubby stem supporting the lectern upon which the monk writes. His head and neck curl upward in an S curve and, with the crest, form a back support for the monk. The dragon's head, almost serpent-like, is alert, with the pointed ears raised and the long, nearly smiling mouth firmly closed. Augmenting the very effective contrast of textures in other areas are the patterns of punch points and engraved lines on both the head and the neck.

Examination of the dragon's feet reveals not only the ridges of the toes, but also their method of attachment. The front left foot is drilled horizontally, whereas the third foot is drilled perpendicularly downward. Hints of the original lugs are evident beneath the front feet, as well as beneath the lower edge of the chest. These clues, plus the pose of the monk, suggest that the group originally was intended to be mounted on a diagonal, with the dragon facing downward and the monk's back in an erect position, his knees hugging the body of the dragon as those of a jockey would that of a rearing horse. The support for the group must have been a much larger ensemble, probably assembled from multiple castings bolted together, using the holes and lugs provided for this purpose.

Carmen Gómez-Moreno, without correcting the angle of the Linsky group, suggested very plausibly that it could have come from a large Romanesque candlestick or lectern, or from the base of a cross, because the dragon resembles the dragon bases of several objects with such functions.[1] Also, the pose and the action of the monk—but not the style—seem to be heir to those of the Evangelist figures who act as scribes while riding dragons on a number of earlier Lower Saxon cross bases of the eleventh and twelfth centuries.[2]

It is more difficult to locate parallels for the monk and his distinctive style. The only example of a Romanesque hooded and tonsured monk in bronze or brass may be seen paired with a bishop on the large brass foot for a cross in the Victoria and Albert Museum, London.[3] The two churchmen simply hold books as they face outward across the ends of this Mosan-Rhenish work, dating to about 1150. Since the figure style is not the same as that of the monk, other objects, some in different mediums, must be sought for comparison. Gómez-Moreno stated that "Erich Meyer, who intended to publish this piece, believed it to have come from Lorraine." Finding the extant works from this region more elaborate and refined, Gómez-

Moreno proposed a northern German, Lower Saxon, locale as the source of the monk-scribe. This might be quite acceptable except for his animated pose and very distinctive facial style. The head of the monk recalls those found in the decoration of the much earlier polychromed wood doors, of about 1050, in Sankta Maria im Kapitol, Cologne, particularly the heads in the Annunciation to the Shepherds scene.[4] A comparison with examples of this Cologne physiognomy dating from the third quarter of the twelfth century—including the *Sitting Angel*, of painted poplar, in the Staatliche Museen, Berlin-Dahlem; the *Head of a Bishop*, of painted oak, in the Schnütgen-Museum, Cologne; and the tympanum of Sankta Caecilien (now the Schnütgen-Museum), Cologne[5]—tends to confirm a Cologne, or at least a Rhenish, origin.

The Linsky group has been subjected to extensive laboratory examination. Several interesting observations appear in the report dated July 29, 1983, by Richard E. Stone of the Department of Objects Conservation. The thick casting is hollowed out from below, obviating the need for the core holders usually found in medieval aquamanilia. Thermoluminescence dating revealed that the core was "last fired between 180 and 300 years ago, 250 most probable." The accidental or intentional reheating took place, therefore, between 1683 and 1803, with the most likely date occurring about 1733, well before the medieval revivals of the nineteenth century. Microbeam probe confirmed that the metal was "leaded brass, approximately 15 percent zinc, 5 percent lead, the balance being copper." While there are no repaired breaks, the work was cleaned with sulfuric acid at some undetermined date. The subsequent patina is a natural brown oxide.

The Metropolitan Museum of Art, including the Lehman Collection and The Cloisters, is extremely rich in medieval bronzes, especially aquamanilia, but the acquisition of the Linsky monk-scribe adds a previously unrepresented type and style to its holdings. Since this piece probably came from a larger work, possibly a base for a cross, it provides an important insight into the nature of monumental church furnishings of the Romanesque period.

NOTES:
1. She cited O. von Falke and E. Meyer, *Romanische Leuchter und Gefässe. Giessgefässe der Gotik*, Berlin, 1935, nos. 236, 237.
2. P. Springer, *Kreuzfüsse, Ikonographie und Typologie eines hochmittelalterlichen Gerätes*, Berlin, 1981, no. 3, pp. 67–75, bibl., figs. K 22–33, K 36–38; no. 17, pp. 112–16, bibl., figs. K 143–155; no. 36, p. 162, bibl., figs. K 227–229.

3. Ibid., no. 25, pp. 136–40, bibl., figs. K 197–202.
4. F. Souchal, *Art of the Early Middle Ages*, New York, 1968, p. 143, colorplate; R. Haussherr, "Die Skulptur des frühen und hohen Mittelalters an Rhein und Maas," *Rhein und Maas, Kunst und Kultur 800–1400* 2, Cologne, 1973, p. 394, fig. 6, colorplates 19 opp. p. 404, 20 opp. p. 412.
5. R. Haussherr, in *Rhein und Maas* (exhib. cat.) 1, Cologne, 1972, no. J 32, colorplate opp. p. 308, and no. J 35, ill.; *Das Schnütgen-Museum* (coll. cat.), Cologne, 1961, no. 44, ill.

EX COLL.: [Mr. and Mrs. John Hunt, Drumleck, Baily, Ireland].

EXHIBITED: Art Gallery, University of Notre Dame, Notre Dame, Indiana, *Medieval Art, 1060–1550, Dorothy Miner Memorial*, Mar. 16–Apr. 14, 1974, no. 38 (lent by Mr. and Mrs. Jack Linsky); The Cloisters, Metropolitan Museum of Art, New York, *Medieval Art from Private Collections*, Oct. 30, 1968–Jan. 5, 1969, no. 93 (lent by Mr. and Mrs. Jack Linsky).

BIBLIOGRAPHY: C. Gómez-Moreno, *Medieval Art from Private Collections* (exhib. cat.), New York, Metropolitan Museum of Art, 1968, no. 93, ill.

WDW

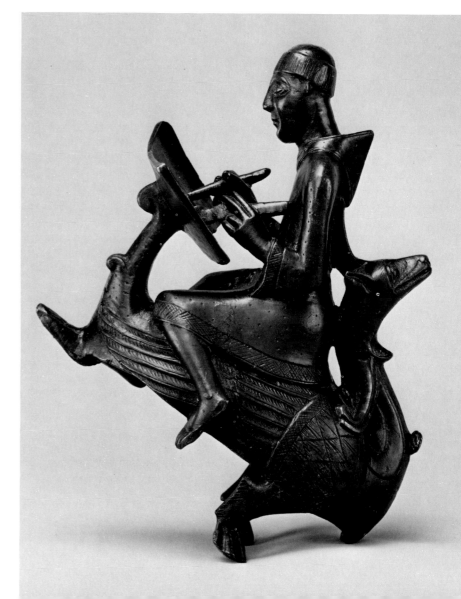

50. Passion booklet

Ivory, polychromy, and gold. Height 2⅞ in. (7.3 cm.),
width, closed, 1⁹⁄₁₆ in. (4 cm.), depth ⅞ in. (2.3 cm.)
Northern French, ca. 1300 (carving); Upper Rhenish,
ca. 1310–20 (painting)
1982.60.399

GOTHIC IVORY carving of the thirteenth and four-
teenth centuries is marked by a profusion of rich and
varied works, such as diptychs, triptychs, caskets, and
mirror backs. One of the most exceptional forms, how-
ever, is the ivory booklet. Secular examples were com-
mon, but tablets with religious subjects were extremely
rare and are known primarily from surviving inventories.

This diminutive booklet is unusual in that the exterior
covers are not the only carved components: Both the in-
terior of each cover as well as its outer vertical edge are
carved. The subjects of the upper and lower exterior cov-
ers are (from right to left, bottom to top): the Betrayal of
Christ, Judas's acceptance of the thirty pieces of silver, the
Flagellation, Pilate's washing his hands, the Way to Cal-
vary, and the Crucifixion of Christ surrounded by two
thieves and witnessed by the Virgin and John the Evan-
gelist. Figures and events secondary to the principal nar-
rative are continued on the outer vertical edges, so that
Judas committing suicide is adjacent to the Betrayal of
Christ (at the lower left), a man with a hammer (?) is part
of the Way to Calvary (at the upper left), Longinus with
his spear and sword is alongside the Crucifixion (at the
upper right), and a counselor (?) is next to the scene with
Pilate (at the lower right).

The interiors of both covers contain carvings: In the
front is a standing Virgin and Child beneath a trefoil arch
and between kneeling donors; in the back is a Coronation
of the Virgin also set beneath a trefoil arch. Two images
painted on the leaves facing the interior covers are clearly
additions, transforming the standard iconic subjects of
the carvings. Along with the kneeling donors, three Magi
under a trefoil arch create an unusual Adoration group,
while the corresponding scene added to the Coronation
includes a fair-haired female figure dressed in a golden
gown and with attendant angels—one has a viol—who
unquestionably are presenting her to the royal heavenly
couple. As there is no nimbus or attribute for this young
maiden, she would seem to be a purely secular concep-
tion, yet such an interpretation makes the reason for her
inclusion in the depiction of this event all the more mys-

tifying. The fact that donors inhabit the scene with the
Virgin and Child might suggest an association between
the female donor who wears a wimple and the figure with
angels, but, since the painting is an addition, might not
the female figure be a new donor? More likely, she sym-
bolizes the elect in the celestial court, as seen in a much
expanded form in the *Hours of Mahaut de Brabant*, dating
from before 1288.[1] Conversely, the praying figure might
correspond to the kneeling nuns that so frequently occur
in the margins of fourteenth-century Rhenish manu-
scripts illustrating the Coronation.[2] The donors actually
seem to represent idealized symbols of the faithful rather
than the patrons who commissioned this work.

In spite of the fact that the painted panels were added
to the carved scenes, creating a certain iconographic am-
biguity, from the beginning these spaces must have been
intended for some purpose. Except for the two painted
leaves, all have raised edges, which would have allowed
wax to have been placed on the surfaces for writing with
a stylus. The religious character of this booklet suggests

that it served as an accessory for private devotion. The wax tablets within could have contained prayers of intercession or the litanies of saints.

The Museum's booklet is related to a series of ivories that derive from a late-thirteenth-century diptych said to have come from the Abbey of Saint-Jean-des-Vignes in Soissons (and now in the Victoria and Albert Museum, London).[3] An *à jour* panel of the Passion, in the British Museum, retains many of the distinguishing features of this Soissons diptych group, especially the architectural system that isolates each episode, but the proportions of the figures are more compact, while the heads are larger. Almost identical figure types and compositions characterize the New York ivory booklet, but the visual effect is different because the architecture has been eliminated, and the narrative is more compressed. Also similar to the Linsky example are a small triptych of the Last Judgment and the Crucifixion in the Schnütgen-Museum, Cologne, and a miniature polyptych with scenes from the Infancy of Christ, in the Victoria and Albert Museum.[4] The predilection for selective polychromy and gilding on exceptionally small works is a characteristic of this group.

The chronological position of our ivory can better be established by examining the painted portions of the booklet. The artist either worked or trained in the vicinity of Lake Constance. His style is close to that of the illuminations in the *Manesse Codex* and in the *Weingarten Liederhandschrift*.[5] Several of the twenty-five miniatures in the *Liederhandschrift*, especially, present comparable figure types. The couple in the "Herr Rubin" illumination (fol. 131) recalls the angelic group: Each of the similar long-waisted figures has a doll-like face, wavy golden hair, and draperies characterized by simple breaking folds.[6] Dating just after the *Manesse Codex*, the *Liederhandschrift* was painted about 1310–20. Even if the paintings in the booklet are an addition, placed there shortly after the ivory was carved, they establish a *terminus ante quem* for the work in the second decade of the fourteenth century. Therefore, no more than a decade or two seems to have elapsed between the creation of the booklet, at the end of the thirteenth or the beginning of the fourteenth century, and the inclusion of the paintings.

If it can be demonstrated that they were probably made in the Bodensee area, might this also be the origin of the booklet, as a whole? With no trace of the influence of the carving style upon that of the paintings, it is unlikely that they were done in the same place. The dichotomy between carved and painted portions speaks strongly in favor of both the London and New York ivories being carved in one locale and painted in another. Works of art were frequently produced especially for trade and export. The formative influences in the workshops (especially those in Paris) of journeymen with foreign backgrounds, however, compound our problem today in determining the artistic origins of these works. Also, the possibility that carvers from a single atelier collaborated on a particular object must not be excluded. Whether these important works were produced in Paris, at another center in France, or even in the Rhine-Meuse Valley under Parisian influence is highly debatable. Clearly, the figure types and compositions of the carvings in the booklet are linked to the orbit of the Soissons diptych group, in spite of the absence of the characteristic architectural framework. This alliance is further reinforced by the formal pose and the rapport between the Virgin and Child, which are related to those of a Parisian, northern French type. The traditional view that the Soissons diptych group evolved from the same artistic milieu as the *Psalter of Saint Louis*[7] or the transept sculptures in Notre-Dame reinforces the notion that the work is of Parisian origin but was made for export. Although at present it may not be possible to isolate another specific geographic center for the New York booklet carvings, they nevertheless imitate Parisian models, while Cologne works of this period manifest a distinguishably different set of stylistic characteristics. It is unlikely that these relatives of the Soissons diptych group reflect either the permeation of Rhenish stylistic features in a northern French atelier or the transplanting of that style to the Rhine Valley. On the contrary, the ivory booklet from the Linsky collection becomes a significant point of reference toward ascertaining the complex formative influences within the context of the Soissons diptych tradition.

NOTES:

1. Cambrai, Bib. Mun., ms. 87, fol. 17v°. See P. Verdier, *Le Couronnement de la Vierge*, Montreal and Paris, 1980, pl. 71.

2. See, for instance, a leaf of a Gradual in *Medieval and Renaissance Miniatures from the National Gallery of Art* (exhib. cat.), Washington, D.C., 1975, no. 36, and C. Weigelt, "Rhenische Miniaturen," *Wallraf-Richartz-Jahrbuch* 1 (1924), figs. 4–5.

3. R. Koechlin, *Les Ivoires gothiques français*, Paris, 1924, no. 38; M. F. Longhurst, *Catalogue of Carvings in Ivory*, London, Victoria and Albert Museum, 1929, II, pp. 10 ff.; L. Grodecki, *Ivoires français*, Paris, 1944, pp. 88 ff.

4. *Das Schnütgen-Museum, Ein Auswahl* (coll. cat.), Cologne,

51. Corpus from a cross

Bronze, partly gilded. Height 8¾ in. (21.5 cm.)
Northern Italian, Venice, 2nd half of 14th century
1982.60.397

CONSIDERING its large size, this figure of the crucified Christ must come from a processional, rather than an altar, cross. Moreover, the length of the arms and the size of the upper part of the body are out of proportion in relation to the legs. This indicates that the figure was meant to be seen from below. Iconographically and stylistically, this corpus appears to date to the second half of the fourteenth century, the derivation of a type introduced into Tuscany by Giovanni Pisano at the turn of the century and inspired by French prototypes. The crown of thorns is rare in Italy in this period, but is found in Venice more frequently than in other regions of the country. In this instance, the crown is in the form of entwined reeds without any visible thorns. The serenity of the face, with its elongated eyes; the shape of the loincloth, which is shorter in the front than its northern European counterparts; and the absence of exceedingly dramatic overtones are typically Italian. The gilding has been rubbed off to a large extent, but what is left seems to be original. A very similar corpus, perhaps from the same mold, is in the Victoria and Albert Museum, London.

EX COLL.: [J. J. Klejman, New York].

EXHIBITED: The Cloisters, Metropolitan Museum of Art, New York, *Medieval Art from Private Collections*, Oct. 30, 1968–Jan. 5, 1969, no. 106 (lent by Mr. and Mrs. Jack Linsky); Art Gallery, University of Notre Dame, Notre Dame, Indiana, *Medieval Art, 1060–1550, Dorothy Miner Memorial*, Mar. 16–Apr. 14, 1974, no. 41 (lent by Mr. and Mrs. Jack Linsky).

BIBLIOGRAPHY: C. Gómez-Moreno, *Medieval Art from Private Collections* (exhib. cat.), New York, Metropolitan Museum of Art, 1968, no. 106, ill.; *Medieval Art, 1060–1550, Dorothy Miner Memorial* (exhib. cat.), Notre Dame, Indiana, 1974, no. 41, ill.

CG-M

1968, no. 8, fig. 81; Longhurst, II, p. 23, fig. 2.

5. Heidelberg, Universitätsbibliothek, Bibl. ms. pal. germ. 848; Stuttgart, Württembergische Landesbibliothek, ms. HB XIII 1.

6. W. Irtenkauf, K. H. Kalbach, and R. Kroos, *Die Weingarten Liederhandschrift*, text volume, Stuttgart, 1969, pp. 133 ff. See also G. Spahr, *Weingartener Liederhandschrift*, Weissenhorn, 1968.

7. Paris, Bibliothèque Nationale, ms. lat. 10525.

EX COLL.: Albert Freund, Vienna; [Blumka Gallery, New York].

CTL

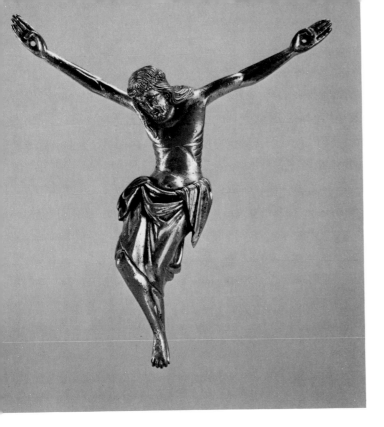

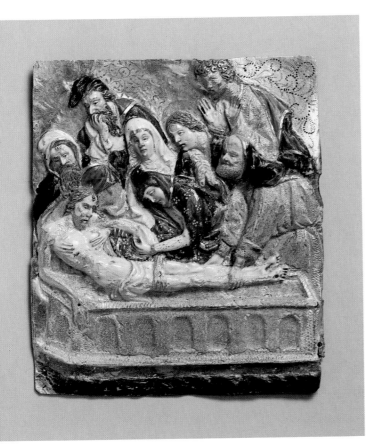

52. The Entombment of Christ

Opaque and translucent enamel on gold. Height
 3½ in. (8.9 cm.)
Franco-Burgundian, mid-15th century
1982.60.398

THIS PLAQUE is a rare and beautiful example of *émail-en-ronde-bosse*, a technique in which white opaque enamel is applied to a gold relief or figure in the round and covered, in part, by brilliantly colored translucent enamel. The technique flourished among artists at the Franco-Burgundian court about 1400, and the punched design on the background is characteristic of that school. The upper half of the present composition is marked by the turbulence of the attendant figures, clearly Burgundian in style, who are garbed in robes of brilliant colors accented by metallic highlights. This vibrant effect is arrested by the rigid horizontality of the figure of Christ, in pale opaque enamel, and by the solid structure of the sarcophagus. Despite its small size and jewel-like quality, this Entombment has the power and projected emotion of a large sculptural composition. There is nothing to indicate that this plaque was part of an ensemble. However, there is a plaque with the same subject matter and of similar style set into the reliquary of Pope Sixtus V in the Cathedral, Montalto delle Marche, Italy.[1]

NOTE:
 1. T. Müller and E. Steingräber, "Die französische Goldemailplastik um 1400," *Münchner Jahrbuch der bildenden Kunst* ser. 3, 5 (1954), p. 37, fig. 10.

EX COLL.: [Rosenberg & Stiebel, Inc., New York; sale, 1947].

EXHIBITED: The Cloisters, Metropolitan Museum of Art, New York, *Medieval Art from Private Collections*, Oct. 30, 1968–Jan. 5, 1969, no. 172 (lent by Mr. and Mrs. Jack Linsky).

BIBLIOGRAPHY: T. Müller and E. Steingräber, "Die französische Goldemailplastik um 1400," *Münchner Jahrbuch der bildenden Kunst* ser. 3, 5 (1954), pp. 29–79; C. Gómez-Moreno, *Medieval Art from Private Collections* (exhib. cat.), New York, Metropolitan Museum of Art, 1968, no. 172, ill.

CG-M

53. Enthroned Virgin and Child

Jet, with traces of gold. Height 6¾ in. (17.2 cm.)
Spanish, Santiago de Compostela, 16th century ?
1982.60.400

JET IS a deep-black lignite substance of organic origin found abundantly in northwestern Spain. It was used to make all kinds of objects related to Saint James the Greater, including statuettes and even amulets, which were purchased by the pilgrims who visited the tomb of the apostle. By the fifteenth century, the fraternity of jet carvers was extremely well organized, and their products were widely distributed as a result of the pilgrimages. Iconographically, this statuette of the Virgin and Child corresponds to a Romanesque type, but the style and, above all, the coat of arms and the angels carved on the throne indicate a date no earlier than the sixteeenth century. The jet industry became rather standardized from the fifteenth century on, and the carvers used models from earlier periods instead of creating new ones. This caused a decline in quality. Because of the extreme brittleness of jet, what has survived in that medium, from Compostela, is comparatively small and very scattered. The most comprehensive collection is in the museum in Pontevedra, also in the Galician region and not far from Compostela.

EXHIBITED: The Cloisters, Metropolitan Museum of Art, New York, *Medieval Art from Private Collections*, Oct. 30, 1968–Jan. 5, 1969, no. 220 (lent by Mr. and Mrs. Jack Linsky).

BIBLIOGRAPHY: C. Gómez-Moreno, *Medieval Art from Private Collections* (exhib. cat.), New York, Metropolitan Museum of Art, 1968, no. 220, ill.

CG-M

54. Triptych with the Nativity and the Annunciation

Enamel on copper. Central panel 8½ × 8 in. (21.6 × 20.3 cm.); left and right panels each 8½ × 3½ in. (21.6 × 8.9 cm.)
Attributed to the workshop of the Master of the Orléans Triptych
French, Limoges, probably ca. 1520
1982.60.131

THE THREE PANELS of this triptych are undoubtedly the work of the same enamel painter. The triptych is unsigned, but on stylistic grounds the painter has been variously identified as Nardon Pénicaud (about 1470–1541), a member of Nardon's workshop, or the anonymous Master of the Orléans Triptych (working late fifteenth–early sixteenth century), whose artistic identity was first recognized in an enameled triptych depicting the Annunciation, with David and Isaiah on the wings, in the collection of the Musée Historique et Archéologique de l'Orléanais, Orléans.[1] None of these attributions is convincing when our triptych is compared to the accepted works of either Nardon Pénicaud or the Master of the Orléans Triptych himself, but the Linsky triptych is, in fact, very close in style to an enameled plaquette depict-

ing the Annunciation in the collection of the Walters Art Gallery, Baltimore (inv. no. 44.172). Philip Verdier has attributed the Baltimore enamel to a member of the workshop of the Master of the Orléans Triptych and dated it around 1520.[2] The attribution seems a reasonable one, for comparison of both the Baltimore Annunciation and our triptych with the recognized work of the Master of the Orléans Triptych shows the same tendency of our enamel painter to repeat the Master's compositions, but with the kinds of generalized form and abbreviated detail that are usually associated with workshop production.

In subject, the origins of our triptych are more complicated, and the enamel admirably demonstrates the close connections between several of the Limoges workshops during the late fifteenth and early sixteenth centuries. The central panel illustrates a manger with the Christ Child lying on a corner of the Virgin's mantle and worshiped by the kneeling Virgin and Saint Joseph, who is shown holding a candle, and with the Annunciation to the Shepherds in the background. It is a close copy of an enameled plaquette in the British Museum, London.[3] To this composition our painter has added two kneeling angels and

an extra shepherd, and he has brought the style of the architectural elements of the manger somewhat more up to date. Marvin C. Ross found the model for the British Museum's plaquette in one of the miniatures of a manuscript Book of Hours in the collection of the Art Institute of Chicago (acc. no. 15.540), which, like the British Museum plaquette, he attributed to the Master of the Orléans Triptych.[4]

The same composition was used by another enamel painter believed to have been a member of the workshop of the Master of the Orléans Triptych, but whose style is quite different from that of the painter of our triptych.[5] Variants of the same composition also appear in a triptych attributed to the workshop of Nardon Pénicaud[6] and one attributed to an anonymous painter, who is thought to have begun by working for the Master of the Orléans Triptych, but who emerged as a painter with a separate and distinct style of his own, known as the Master of the Large Foreheads (working late fifteenth–early sixteenth century). The latter triptych is in the Metropolitan Museum's Benjamin Altman Collection (acc. no. 14.40.698).[7]

The two wings of our Linsky triptych consist of panels with the angel Gabriel kneeling and holding a staff and scroll with the words AVE [MARIA] GRAC[IA] PLENA (Hail Mary, Full of Grace) and the Virgin, seated and turning in surprise from the lectern where she has been reading. The origin of these two figures remains obscure, but they too were used repeatedly, both within late Gothic architectural settings and with Italianate paneling and Corinthian pilasters, by several workshops of Limoges enamelists. Verdier has listed five examples that he attributes to the anonymous Master of the Triptych of Louis XII (working late fifteenth-early sixteenth century). They are a triptych in the Walters Art Gallery (inv. no. 44.145), a triptych in the Victoria and Albert Museum illustrated by Marquet de Vasselot,[8] a plaquette in the Victoria and Albert Museum (inv. no. 474-1873), two wings from a triptych in the Victoria and Albert Museum (no. C. 494, 494A–1921), and two wings formerly in the A. Rütschi collection illustrated by Otto von Falke.[9] To this list Verdier added the two wings from our Linsky triptych, which are here attributed to the workshop of the Master of the Orléans Triptych.[10]

Verdier also noted the existence of a variant of the same Annunciation on a single plaquette in a triptych from the workshop of the Master of the Large Foreheads illustrated by Marquet de Vasselot[11] and another on a dish from the workshop of Jean I Pénicaud (working about

1480–after 1541) in the Victoria and Albert Museum (inv. no. 2052-1855). In addition, the wings of the Metropolitan Museum's Altman triptych with a Nativity by the Master of the Large Foreheads repeat the composition of the Annunciation, this time by an enamelist whose work appears closest in style to that of Nardon Pénicaud.

The top of the left panel of the Linksy triptych is painted with the words AVE MARIA: GRACIA (Hail Mary, [Full of] Grace) and the right one with O MATER DEI MEMENTO (Oh Mother of God, Remember [Us]). The angel of the Annunciation to the Shepherds has a scroll lettered GLORIA IN EXCELCIS (Glory in the Highest). The top right corner of the Nativity has been restored, and there are areas of overpainting on Saint Joseph's robe as well. There is also a small chip in the enamel at the top edge of the left wing. The gilt-metal frames are of nineteenth- or early twentieth-century origin.

NOTES:
1. J. J. Marquet de Vasselot, *Les Emaux limousins de fin du XV^e siècle et la première partie du XVI^e*, Paris, 1921, pp. 242–43, no. 51.
2. P. Verdier, in Walters Art Gallery, *Catalogue of the Painted Enamels of the Renaissance*, Baltimore, 1967, pp. 31–32, no. 19, p. 33, fig. 19.
3. M. C. Ross, "The Master of the Orléans Triptych: Enameller and Painter," *Journal of the Walters Art Gallery* IV (1941), p. 23, fig. 16.
4. Ibid., p. 22, fig. 15, p. 23.
5. Marquet de Vasselot, p. 254, no. 70, pl. XXV.
6. Ibid., pp. 269–70, no. 99.
7. Metropolitan Museum of Art, *Handbook of the Benjamin Altman Collection*, New York, 1914, pp. 82–83.
8. Marquet de Vasselot, pp. 294–96, no. 127, pl. XLIX.
9. O. von Falke, *Alte Goldschmiedewerke im Züricher Kunsthaus*, Zurich, 1928, no. 56, pl. 18.
10. Verdier, pp. 63–68, no. 33.
11. Marquet de Vasselot, p. 289, no. 121, pl. XLVII.

EX COLL.: Mortimer L. Schiff, New York (sale, Christie's, London, June 22–23, 1938, p. 37, lot 95); [J. Seligmann and Co., New York]; sale, Christie's, London, May 14, 1957, p. 18, lot 53.

EXHIBITED : Jacques Seligmann and Co., New York, *Loan Exhibition of Religious Art for the Benefit of the Basilique of the Sacré Coeur of Paris*, Mar. 17–Apr. 7, 1927, no. 35 (lent by Mortimer L. Schiff).

BIBLIOGRAPHY: P. Verdier, in Walters Art Gallery, *Catalogue of the Painted Enamels of the Renaissance*, Baltimore, 1967, p. 67.

CV

55. Standing cup

Grayish glass, enameled in white, yellow, blue, green, and
brick red, embellished with fired-on gold leaf. Height
11⅝ in. (29.5 cm.)
Italian, Venice, ca. 1530
1982.60.130

THE BODY of blown glass was manipulated to an ogee
profile with a separately blown pedestal, everted at the
foot with the edge turned up and over. The vertical ribs
on the bowl and pedestal were formed of trailed-on spines,
which, upon reheating, fused and subsided, merging with
the level of the supporting glass. Here in the very form of
the object we see the combination of a late Gothic shape
with vertical gadroons that evoke a common feature of
glass bowls of the Roman era. In the decoration, too,
there is a mixing of classical and contemporary motifs.
The bands of gold leaf around the lip and at the top of
the pedestal bear a scratched scale pattern, with a dentil
band added at the lower edge of the gilding around the
lip. These, and the enameled round and oval rings threaded
alternately on a string that encircles the foot, are classical
elements, while the beaded dots of enamel over the scale
pattern and the tied pairs of loosely curled lines that out-
line the ribs of the body, with their pendent beaded or-
nament, are of Levantine inspiration, though ultimately
of Chinese derivation. It is this last element that allows us
to place this cup latest in a group of enameled cups of
similar shape.

 The imposing size and the shape of the piece suggest
that it was made for the German market. It probably
originally had a cover, as it is a parallel in glass of the Ger-
man late Gothic silver and silver-gilt standing covered cups
made in great numbers in Nuremberg in the late fifteenth
and early sixteenth centuries. Even the jagged horizontal
ruff of glass jutting out from the base of the body is the
counterpart in glass of the wreath of leaves so often seen
in the metal examples. The gilding is worn, especially on
the pedestal, where the cup would have been held.

EX COLL.: Dukes of Devonshire, Chatsworth (sale, Christie's,
London, June 26, 1958, no. 108).

JMcN

SCULPTURE

Catalogue entries by

JAMES DAVID DRAPER

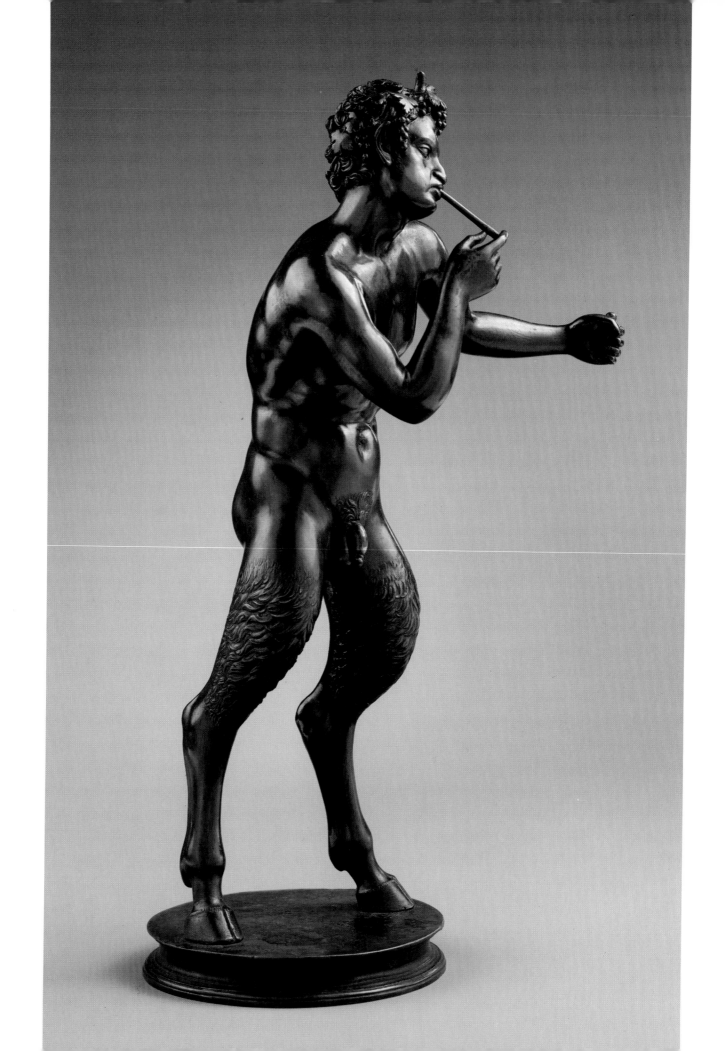

Italian Renaissance and Baroque Bronzes

ANTICO
(Pier Jacopo Alari-Bonacolsi)

Born ca. 1460, Mantua; died 1528, Gazzuolo

SCULPTOR, GOLDSMITH, and architect. His earliest datable works, two medals commemorating a Gonzaga marriage of 1479, are signed ANTI, an abbreviation of his nickname. Not only did Antico revive the manner of the ancients in his coolly neoclassical statuettes and busts, but he also was the restorer of ancient sculptures, including one of the Dioscuri on the Monte Cavallo, in Rome. Documents place him in Rome in 1495 and 1497; before and after, he seems to have worked almost exclusively for the Gonzaga in Mantua and at their estates, Bozzolo and Gazzuolo.

56. Satyr

Bronze, with remains of dark brown lacquer. Height 12 in. (30.5 cm.)
Italian, Mantua, ca. 1510–20
1982.60.91

THE PRIDE of the Linsky bronzes is this statuette, admirable both for its graceful rightward sway and for the delicate attention to chasing manifest throughout. The latter mark of excellence is only to be expected in bronzes by the goldsmith-sculptor Antico. The eyes are not silvered, as they are in many of Antico's bronzes; rather, he left them unlacquered, producing a fiery glint where the reddish exposed bronze contrasts with the surrounding dark lacquer.[1] The molded base is original, and, as in several of his best efforts, the statuette is mounted on it by means of tangs that have been flattened and finely chased with the rest of the base's interior.

The composition appears to be Antico's own invention, not a copy of an antique source, although he was familiar with, and copied, a figure of Pan from an ancient marble group known as *Pan and Apollo*. His reduction in bronze of the Pan, in the Kunsthistorisches Museum, Vienna, originally was paired with a nude female figure, as we know from a letter of 1499 to Antico from Bishop Lodovico Gonzaga.[2] The Pan was positioned so that he appeared to "caress" the girl, and Antico has retained the rightward motion of the arms, with the right elbow hooked across the chest, in the present bronze.

The attributes are rather perplexing, there being no immediate explanation for the thin rod that passes from the satyr's lips to his right hand, or for the short, rounded protuberance that rises at a different angle above his left hand. That they belonged to a musical instrument, such as a flute or panpipes, seems out of the question, since the figure's hands are not aligned on the same plane with the rod. The strong sideward movement suggests that the statuette had some relationship to another, as was often the case with Antico's bronzes. The 1496 inventory of the estate of Gianfrancesco Gonzaga, Count of Rodigo and Lord of Bozzolo and Sabbioneta, mentioned numerous bronzes generally supposed to be by Antico, among them "Due fauni cum due lumere."[3] The 1542 inventory of the effects of the lately deceased Marchesa Isabella d'Este similarly lists "duoi Satiri che servono per candeglieri," while the inventory prepared in the same year for Duke Federigo II Gonzaga names "Trei satiri di metale per candelieri."[4] It is just possible that the Linsky satyr was fancifully equipped with a candlestick whose remnants are the rod and knob in his hands. Such a lamp cannot have been very heavy, in view of the satyr's pull to the side, but it is not difficult to visualize him contrived so as to appear to be blowing a small flame through the "tube" inserted in his mouth. This would explain his puffed-out cheeks.

NOTES:
1. It has been observed by Anthony Radcliffe ("Antico and the Mantuan Bronze," in *Splendours of the Gonzaga* [exhib. cat.],

London, Victoria and Albert Museum, 1981, p. 49) that the absence of gilding and silvering are characteristic of statuettes, now in Vienna, cast by Antico for the *Grotta* of Isabella d'Este in 1519.

2. H. J. Hermann, "Pier Alari-Bonacolsi, gennant Antico," *Jahrbuch der Kunsthistorischen Sammlungen des Österreichischen Kaiserhauses* XXVIII (1910), pp. 208, 262–63.

3. Ibid., p. 214.

4. Ibid., pp. 216, 217.

EX COLL.: possibly the Gonzaga collections, Mantua; Antal Marczibányi, Budapest ?; Maurice Kann, Paris; Queen Marie of Rumania; Prince Nicolas of Rumania (sale, Galerie Jürg Stuker, Bern, May 21–30, 1964, no. 3389); [Cyril Humphris, London].

EXHIBITED: Cyril Humphris Ltd., London, *Renaissance Sculpture from the Collection of Prince Nicolas of Rumania and Faience of the 15th and 16th Centuries*, Apr. 6–30, 1965, no. 12.

RICCIO
(Andrea Briosco)

Born 1470, Padua; died 1532, Padua

SON OF A Paduan goldsmith, Riccio finished part of the Roccabonella monument by Bartolomeo Bellano in San Francesco in the late 1490s. His masterwork is the towering bronze Paschal candlestick in Sant'Antonio, begun in 1507 and installed in 1516. Statuettes of mythological creatures, such as satyrs, embellish the candlestick, and it is likely that independent statuettes of satyrs, for which Riccio is famous, were a sideline that developed from the main project. Although Riccio, like Antico, was undeniably an entrepreneur in this field, the numbers of extant statuettes that can actually be by him have been grossly exaggerated.

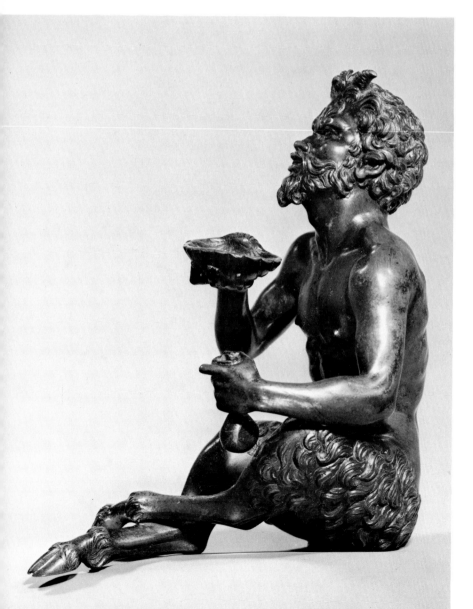

WORKSHOP OF RICCIO

57. Seated satyr, with a shell

Bronze, with dark brown lacquer patina. Height 8¼ in. (21 cm.)
Italian, Padua, ca. 1520–30
1982.60.114

THE OBJECT in the satyr's left hand, possibly a moneybag, is of later facture. Otherwise, the bronze is unusually crisply chased and an altogether superior product of the Riccio workshop. Its details, especially the hair, are more incisive than those of the seated satyr with inkwell, shell, and candlestick in the Frick Collection, New York, which bears the arms of the Paduan Capodivacca family, and much more so than related bronzes in Berlin-Dahlem and in the Louvre. A good variant was in the Chichester-Constable collection.[1] Although the alert poses greatly resemble each other, notably in the gracile crossing of the hooves, it is worth stressing that the composition of each member of this group was completely reworked, as was standard practice in the Riccio workshop.

NOTE:
1. Sale, Christie's, London, July 19, 1927, no. 33.

EX COLL.: Antal Marczibányi, Budapest; Matild Justh, Budapest; [Wendlinger, Vienna]; A. C. von Frey, Berlin and New York; [Paul Drey Gallery, New York].

BIBLIOGRAPHY: L. Planiscig, *Andrea Riccio*, Vienna, 1927, fig. 423, pp. 350, 484; G. Entz, "I bronzetti della collezione Marczibányi," *Acta Historiae Artium* II (1954/55), pp. 220, 231.

58. Seated satyr, with an inkwell and a candlestick

Bronze, with brown lacquer patina. Height 10 in. (25.4 cm.)
Northern Italian, ca. 1530–40
1982.60.92

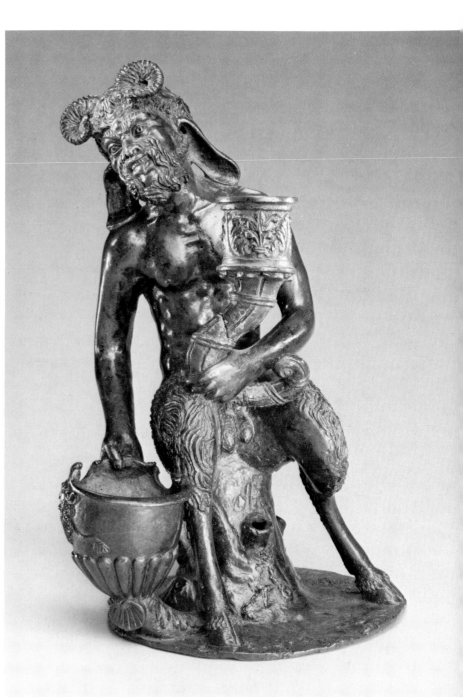

BRONZES IN the Louvre and in the Wallace Collection, London, are virtually identical to this one, except that the horns are differently fashioned in each, and the Linsky bronze bears a special feature—a small rodent—brusquely chased into the tree trunk alongside a bit of sprouting foliage. The candlestick, in the form of a cornucopia, has been broken and mended.

It is difficult to say where bronzes of this model were produced. Knowledge of the satyrs by Andrea Riccio is evident, but there is no equivalent in Riccio's oeuvre for the laxity of tooling, as in the ropy channels chased into this satyr's flanks. The workshop of Severo da Ravenna, the attribution proposed by Bertrand Jestaz[1] for bronzes of this group, does not offer strong enough analogies. Our artist was best at fashioning grotesque heads, as demonstrated by those of the satyrs themselves and by the masks on their inkwells. The opulent ornamental vocabulary in the fittings, and the passages of stippling beneath the inkwell of this satyr were usages widespread in bronzes originating in the Veneto.

NOTE:
1. B. Jestaz, "Un Bronze inédit de Riccio," *La Revue du Louvre et des Musées de France* 25, 3 (1975), p. 161.

EX COLL.: Prince Nicolas of Rumania (sale, Galerie Jürg Stuker, Bern, May 21–30, 1964, no. 3388); [Cyril Humphris, London].

EXHIBITED: Cyril Humphris Ltd., London, *Renaissance Sculpture from the Collection of Prince Nicolas of Rumania and Faience of the 15th and 16th Centuries*, Apr. 6–30, 1965, no. 6.

59. Oil lamp, in the form of a bearded acrobat

Bronze, with dark brown lacquer patina, partially gilded.
 Length 5¼ in. (13.3 cm.)
Italian, probably Padua, early 16th century
1982.60.93

INGENIOUSLY FASHIONED so that, when the lamp is lighted, the figure appears to blow flame from his behind, the model of this frequently encountered oil lamp is generally ascribed to Riccio. The Linsky example is distinguished by the gilding of hair and beard. The foliate stem on which the knees are balanced allowed for easy removal, probably from an elaborate base. After a couple of centuries, Ricciesque lamps came to be considered Greco-Roman antiquities; an engraving of this model was published by Bernard de Montfaucon,[1] with the observation that such lamps "show all of the bizarre and the extravagant which the workman or the one who commissioned the work could imagine, and have no need of further commentary."

NOTE:
 1. See B. de Montfaucon, *L'Antiquité expliquée et représentée en figures*, v, 2nd ed., Paris, 1722, pl. 152, 1, where it is described as belonging to Dom Emmanuel Marti, and p. 108.

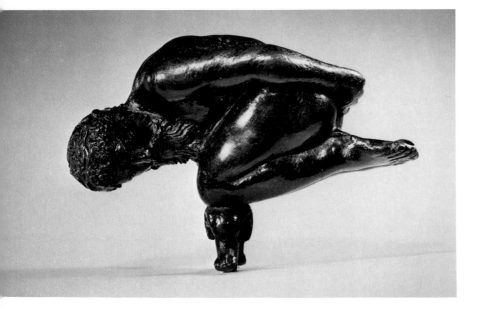

60. Door knocker

Bronze, with dark brown patina. Length 13 in. (33 cm.)
Northern Italian, ca. 1530–40
1982.60.112

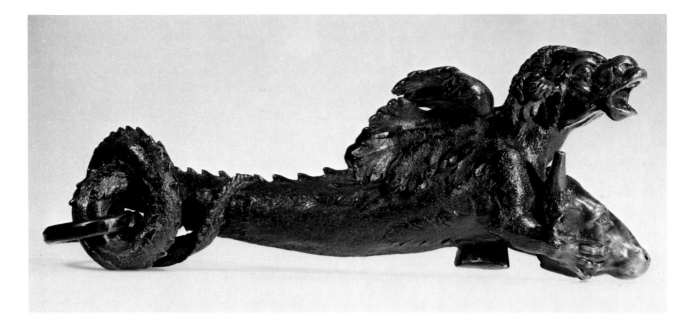

THE COLLECTIONS of the Rijksmuseum, Amsterdam, and of the Cleveland Museum of Art each contain related door knockers that present a leafy devil clutching the head of an ox. This apparently unique variant is in the form of a dog-headed monster with foliate wings, a more fish-like body, and a more sinuously curled tail. These door knockers are conventionally attributed to Riccio, but their opulent workmanship, especially impressive in the delineation of scales all over the body of the present example, could as easily be Venetian, and slightly later in date.

EX COLL.: Count Friedrich von Pourtalès, Berlin and Saint Petersburg.

EXHIBITED: Kunstgeschichtliche Gesellschaft, Berlin, *Ausstellung von Kunstwerken des Mittelalters und der Renaissance aus Berliner Privatbesitz*, May 20–July 3, 1898, no. 459.

BIBLIOGRAPHY: W. von Bode, *The Italian Bronze Statuettes of the Renaissance*, London, I (1908), pl. XXXVIII, 1; L. Planiscig, *Andrea Riccio*, Vienna, 1927, fig. 449, pp. 362–63, 489.

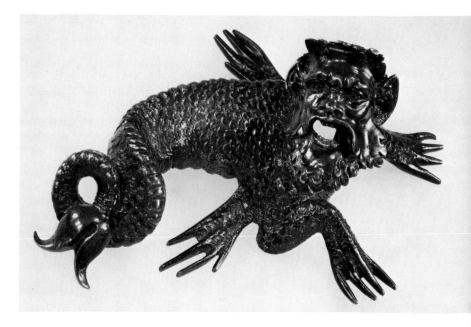

SEVERO CALZETTA DA RAVENNA

Born Ravenna?; died before 1543, Ravenna

BORN INTO a family of sculptors of Ferrarese origins, Severo was active in Ravenna in 1496, in Padua between 1500 and 1509, and afterward again in Ravenna. His principal documented work is a marble Saint John the Baptist, of 1500, in Sant'Antonio, Padua, and his signature appears on bronze statuettes of a sea monster (in the Blumka collection, New York) and of a kneeling satyr (also in a private collection). On the basis of these, Severo and his studio are credited with a large number of statuettes that are technically consistent, if varying radically in quality. The bulk of them may have been made in Ravenna rather than in Padua.

61. Sea monster

Bronze, with red-brown lacquer patina. Length 10 in. (25.4 cm.)
Italian, probably Padua, ca. 1500–1510
1982.60.95

THIS CREATURE from the depths derives from an image in Mantegna's engraving *The Battle of the Sea Gods*. The fame of the engraving made bronzes of this type extremely popular, as attested by their existence in many collections. These bronzes show various compositional changes. The example with a shell on its tail, in the Blumka collection, New York, was modeled with greater freedom than others of the type, and it is also signed.[1] Statuettes of more elaborate sea monsters, thrashing their necks and surmounted by figures of Neptune, are in the Frick Collection, New York, and in the National Gallery of Art, Washington, D.C. (Widener Collection). The pose of the Linsky bronze resembles that of a sea monster in a Neptune group in the Bargello, Florence. The Bargello group shows a decline in vigor when compared with those in the Frick Collection and the National Gallery. Severo's workshop probably cast the groups, as well as the sea monsters as independent objects, over at least a ten-year period—and perhaps even longer.

NOTE:
1. The signature has been the basis for wide-ranging efforts to reintegrate Severo's output. See most recently C. Avery and A. Radcliffe, "Severo Calzetta da Ravenna: New Discoveries," *Studien zum europäischen Kunsthandwerk. Festschrift Yvonne Hackenbroch*, Munich, 1983, pp. 107–22.

EX COLL.: probably the example sold at Sotheby's, London, Dec. 4, 1956, no. 117.

WORKSHOP OF SEVERO CALZETTA DA RAVENNA

62. Tobias

Bronze, with remains of brown lacquer. Height 7½ in.
(19.1 cm.)
Italian, probably Ravenna, ca. 1530–40
1982.60.94

THE ATTRIBUTION of this model—represented by an example on an inkstand in the Bargello, Florence—was made by Bertrand Jestaz.[1] The Severo workshop pro-duced two types of the Tobias: one, a small child, and the other, a slightly older and more elastic boy, as in this and the Bargello examples. The young voyager carries his bed-roll on a stick slung over his left shoulder. The object in his right hand is probably a stringer, from which sepa-rately cast fish would have been suspended. The identifi-cation of the subject is assured by the Bargello inkstand, which shows the boy with fish (integrally cast) as well as with his companion dog.

NOTE:
1. B. Jestaz, "Une Statuette de bronze: Le Saint Christophe de Severo da Ravenna," *La Revue du Louvre et des Musées de France* 22, 5 (1972), pp. 77–78.

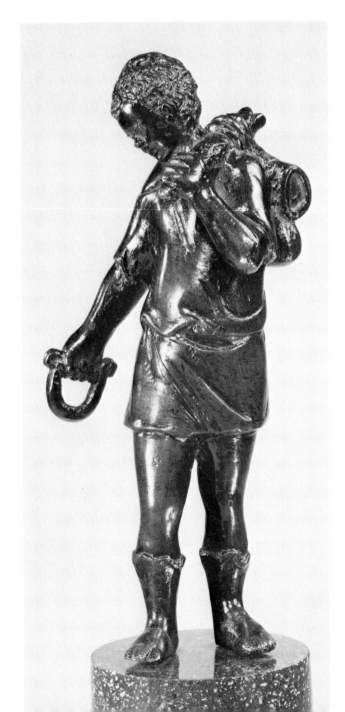

63. Incense burner

Bronze, with dark brown lacquer patina. Height 13¾ in.
(35 cm.)
Northern Italian, ca. 1530–40
1982.60.108

THIS IS an unusually complete example of a type of ves-sel whose tapering triangular form is an adaptation of that of Riccio's Paschal candlestick in Sant'Antonio, Padua; the candlestick was also the precedent for the bound satyrs on the incense burner's corners. In the zones filled here by masks, some incense burners from this workshop—such as one in the Rijksmuseum—contain reliefs. These reliefs derive from the plaquettes by a mysterious artist who signed himself Moderno, and it is worth raising the question whether Moderno himself, or his heirs, possibly located in Verona, were not responsible for the incense burners as a whole. The satyrs have a tightly knit linearity that is not incompatible with the plaquette designs. A recent trend links the name of Desiderio da Firenze with the incense burners, but the work by which Desiderio is best known, the voting urn fashioned, in 1532–33, for the Consiglio of the Comune of Padua, is incomparably freer in its plasticity.[1]

NOTE:
1. B. Jestaz, "Un Groupe en bronze érotique de Riccio," *Monuments et Mémoires* LXV (1983), p. 51, promises a forthcom-ing study on Desiderio.

EX COLL.: Dukes of Devonshire, Chatsworth (sale, Christie's, London, June 26, 1958, no. 106).

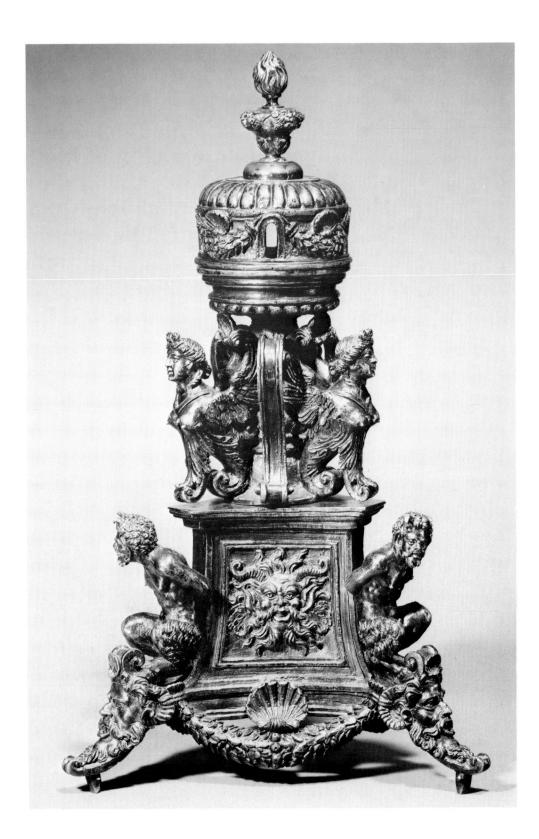

VINCENZO GRANDI

Active 1507–77/78

GIAN GEROLAMO GRANDI

Born 1508; died 1560

SCULPTOR-FOUNDERS active in Padua and Trent. Vincenzo was the uncle of Gian Gerolamo. Their most important collaboration was the Cantoria, of 1532–42, in Santa Maria Maggiore, Trent.

WORKSHOP OF THE GRANDI

64. Mortar

Bronze, with dark brown lacquer patina. Height 8⅜ in.
 (21.3 cm.)
Italian, Padua or Trent, ca. 1540–50
1982.60.111

MORTARS WERE produced in fair abundance throughout northern Italy. In the central zone of the Linsky mortar, classical swags of meandering ribbons and firmly modeled cornucopias enframe alternating griffins and stags. The ornamentation closely resembles that of mortars (such as one in the Kunstgewerbemuseum, Berlin) also attributable to the workshop of Vincenzo and Gian Gerolamo Grandi by analogy with the highly worked bronze utensils, including buckets and bells, which they produced in Trent for Bishop Bernardo da Cles between 1532 and 1539.[1] The relatively spacious design of the mortar may indicate that it was made at a slightly later date, when the Grandi were relocated in Padua—between 1542 and the death of Vincenzo in 1577/78.

NOTE:
 1. F. Cessi, *Vincenzo e Gian Gerolamo Grandi scultori*, Trent, 1967, pp. 58–73.

EX COLL.: Oscar Bondy, Vienna; [Blumka Gallery, New York].

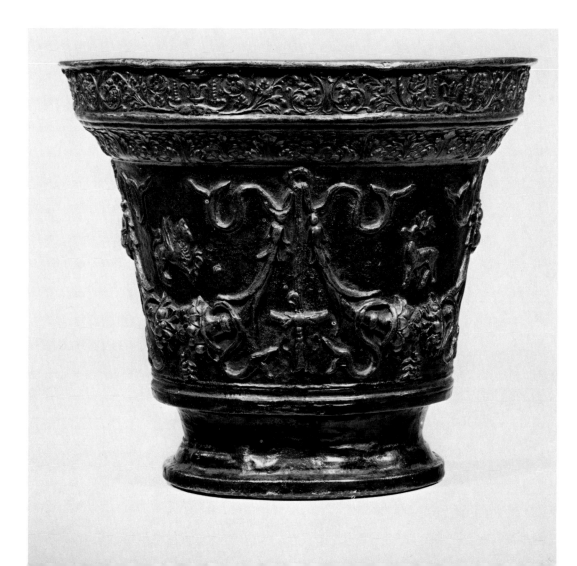

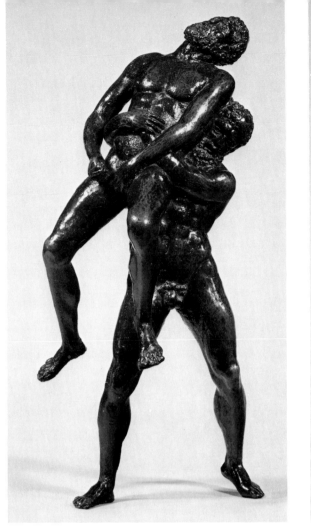
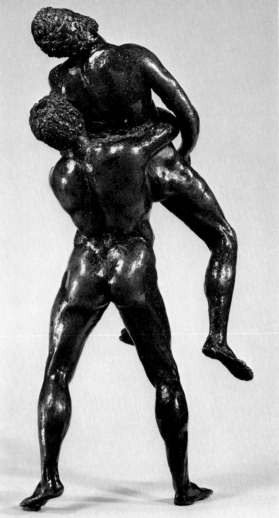

65. Hercules and Antaeus

Bronze, with red-brown natural patina, and remains of
dark brown lacquer. Height 11¼ in. (28.6 cm.)
Italian, probably Florence, early 16th century
1982.60.98

THIS IS a free copy of an ancient marble group that was
much admired during the Renaissance. The marble, now
in the Palazzo Pitti, Florence, was brought in fragmentary
form to the Vatican Belvedere by Julius II and apparently
reached the Medici collections as a gift of Pius IV in
1560.[1] Before then, the head and right arm of Antaeus and
the lower legs of both figures were still missing. Until the
restorations were carried out, artists accordingly had license
to complete the group following their own fancy.
Our sculptor chose to show Antaeus's head thrown back,
as did Antico in his two statuettes of the composition (in
Vienna and in the Victoria and Albert Museum).[2] A further
innovation in this bronze is the curious placement of
the hands of Antaeus.

The heavy, solid cast of reddish metal is worked all over
by hammer strokes. Sharp creases delineate the folds of
skin, but not all the metal has been chased cleanly away
from adjoining areas, such as that between the back of
Antaeus and the shoulder of Hercules. The technique involves
hardy and even rudimentary methods of casting
and chasing, which might be expected of Florentines in
the wake of Bertoldo di Giovanni (d. 1491). Little is known
of Florentine bronzes of the first half of the sixteenth
century, and exact parallels do not come readily to mind.
In any case, the attribution to the Venetian artist Camelio
(ca. 1460–1537), proposed in the 1962 Sotheby's catalogue
(see Ex coll.), is incorrect.

NOTES:
1. F. Haskell and N. Penny, *Taste and the Antique*, New Haven
and London, 1981, pp. 232–34.
2. See A. Radcliffe, in *Splendours of the Gonzaga* (exhib. cat.),
London, Victoria and Albert Museum, 1981, no. 55.

EX COLL.: Antal Marczibányi, Budapest ?; (sale, Sotheby's,
London, May 10, 1962, no. 139).

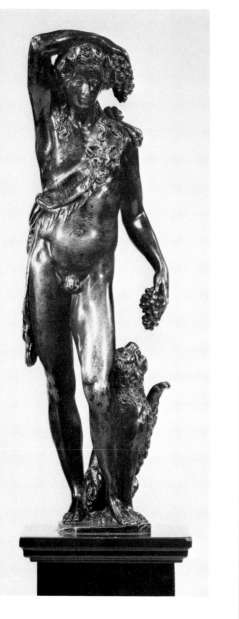

66. Bacchus and a panther

Bronze, with transparent brown lacquer patina. Height
8¾ in. (22.2 cm.)
Italian, possibly Florence, 16th or 17th century
1982.60.99

A LARGE NUMBER of statuettes of this model exist,
varying so much in their surface treatment that it is im-
probable that they were made at the same time and place.
Some examples, such as another in the Metropolitan Mu-
seum (32.100.190; formerly in the Pfungst, Morgan, and
Friedsam collections), are less articulate than the Linsky
Bacchus and have relatively matte surfaces, which might
indicate Venetian workmanship. Attributions have ranged
from the early-sixteenth-century Paduan goldsmith
Francesco da Sant'Agata, to a Florentine under the influ-
ence of Benvenuto Cellini.[1] There is undoubtedly a Man-
nerist element in the svelte figure, but this is due largely
to the ancient type that the artists were imitating. The
classical precedent may have been a bronze statuette, since
lost,[2] or a variation on a marble, such as one in Munich.[3]

NOTES:
1. See H. R. Weihrauch, *Die Bildwerke in Bronze und in an-
deren Metallen*, Munich, Bayerisches Nationalmuseum, 1956, no.
266.
2. For the type, see S. Reinach, *Répertoire de la statuaire grecque
et romaine*, II, Paris, 1908, pl. 122, nos. 1, 2.
3. A. Furtwängler, *Beschreibung der Glyptothek*, Munich, 1900,
no. 226; the much-restored sculpture, from the Braschi collec-
tion, was originally an Apollo of the type of the *Apollino* in the
Uffizi, Florence.

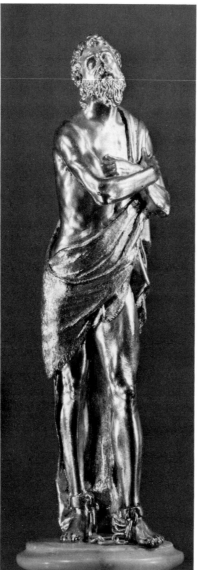

67. Saint John the Baptist in chains

Gilt bronze. Height 5 in. (12.7 cm.)
Italian, probably Rome, late 16th–early 17th century
1982.60.103

THE ELEGANT contrapposto, elongation, and refine-
ment of details are strongly suggestive of an artist in the
stylistic wake of Guglielmo della Porta (d. 1577), dean of
Roman Mannerist sculptors, whose influence was felt by
modelers and goldsmiths long after the close of the six-
teenth century. The statuette has been regilded.

GIOVANNI BOLOGNA

Born 1529, Douai; died 1608, Florence

BORN Jean Boulogne, the artist trained in Flanders. In about 1556, he settled in Florence, where his name was italianized and where he dominated the art of sculpture for the next half-century. Some of his most familiar works are the Fountain of Neptune, in Bologna, and in Florence the *Mercury* in the Bargello and the equestrian statue of Cosimo 1 de' Medici in the Piazza della Signoria. For work in bronze, his numerous assistants and followers included Antonio Susini and Pietro Tacca. Giovanni Bologna did more than any other Renaissance artist to popularize bronze statuettes: His eloquent compositions were replicated in great numbers, often with considerable variations and usually reduced to an accessible scale.

After a model by GIOVANNI BOLOGNA, cast by the WORKSHOP OF ANTONIO SUSINI (d. 1624)

68. The Crucified Christ

Bronze, with medium brown lacquer patina. Height 14 in. (35.6 cm.)
Italian, Florence, early 17th century
1982.60.101

GIOVANNI BOLOGNA invented two types of crucifixes that were widely disseminated through the reductions made by the Susini workshop: a *Cristo vivo*, and a *Cristo morto* that corresponds to this pose, the beautiful head sunk toward the chest. At least two examples of the *Cristo morto*, each about forty-six centimeters high, were produced by Giovanni Bologna in or about 1588: One was his gift to the convent of Santa Maria degli Angiolini, Florence; the other was made for the altar of the Salviati Chapel in San Marco, Florence.[1]

NOTE:
1. K. J. Watson, in *Giambologna, 1529–1608: Sculptor to the Medici* (exhib. cat.), A. Radcliffe and C. Avery, eds., London, Arts Council of Great Britain, 1978, nos. 105, 107.

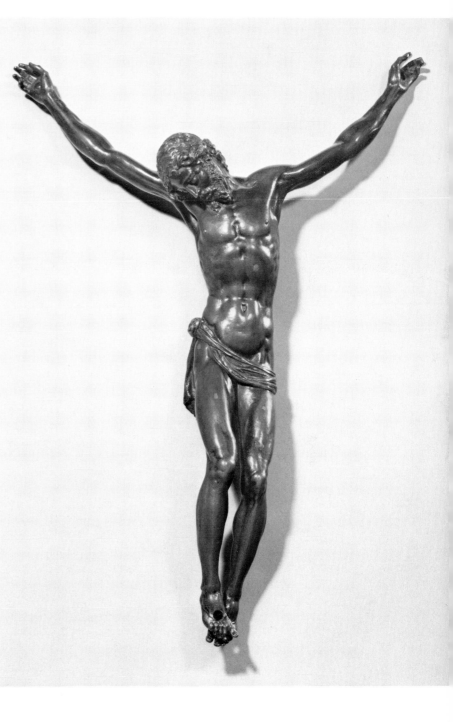

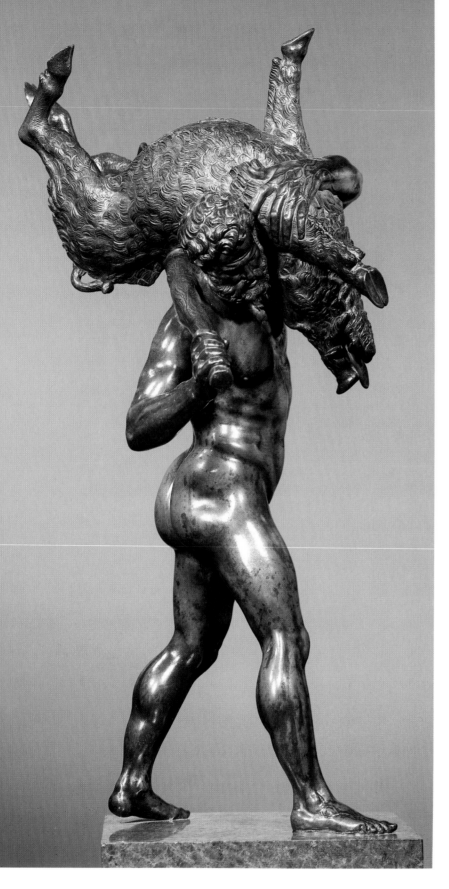

After a model by
GIOVANNI BOLOGNA

69. Hercules and the Erymanthian Boar

Bronze, with red-brown lacquer patina. Height 17½ in.
(44.4 cm.)
Italian, Florence, mid-17th century
1982.60.100

THE ORIGINAL composition dates from about 1587 to
1589. In the latter year, Jacopo Bylivelt cast a silver statuette of the subject, one of six Labors of Hercules after
Giovanni Bologna's models, which had been ordered by
Francesco I de' Medici for the Tribuna of the Uffizi. The
beautifully ponderated model proved highly successful,
and several bronzes of it exist. The one now in Vienna
was the earliest to be documented; it appears in the inventory of the collections of Emperor Rudolph II compiled between 1607 and 1611.[1] The present statuette
(apparently unpublished) is extremely light in weight, with
a dark but warm brown patina and richly variegated toolmarks, such as the punch marks that articulate the club.
These characteristics are typical of bronzes cast by
Ferdinando Tacca (1619–1686) well into the seventeenth
century.[2] Tacca was a sculptor of some independence, and
this bronze probably should not be attributed to him
personally. He was, apparently, the author of a clear-cut
variant, in the Louvre.[3]

NOTES:
1. See A. Radcliffe, in *Giambologna, 1529–1608: Sculptor to the
Medici* (exhib. cat.), A. Radcliffe and C. Avery, eds., London,
Arts Council of Great Britain, 1978, pp. 122–23, nos. 78, 79.
2. See A. Radcliffe, "Ferdinando Tacca, the Missing Link in
Florentine Baroque Bronzes," in *Kunst des Barock in der Toskana: Studien zur Kunst unter den letzten Medici*, Munich, 1976,
pp. 14–23.
3. A. Radcliffe, in *Giambologna*, no. 80, p. 127.

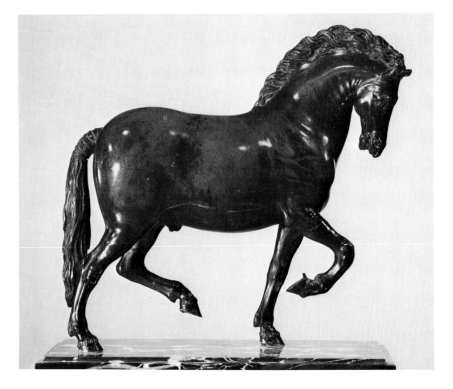

After a model by
GIOVANNI BOLOGNA

70. Pacing horse

> Bronze, with remains of red-brown lacquer. Height 9½
> in. (24.1 cm.)
> Italian, Florence, probably mid-17th century
> 1982.60.102

THE HORSE'S tail is separately cast below the fancy braiding. This is one of a number of reproductions of a preliminary model by Giovanni Bologna. About 1581, he first contemplated sculpting a colossal horse derived from the famous ancient equestrian statue of Marcus Aurelius on the Campidoglio, Rome, and this plan gradually resulted in the equestrian monument of Cosimo I de' Medici erected in 1594 in the Piazza della Signoria, Florence.[1]

NOTE:

1. See K. J. Watson, in *Giambologna, 1529–1608: Sculptor to the Medici* (exhib. cat.), A. Radcliffe and C. Avery, eds., London, Arts Council of Great Britain, 1978, no. 151, for a superior bronze of this type in the Victoria and Albert Museum and a list of further examples.

FERDINANDO TACCA

Born 1619, Florence; died 1686, Florence

FROM THE time of the death of his father, Pietro, in 1640, until his own death, Tacca was sculptor and architect to the grand dukes of Tuscany. In the numerous bronzes attributed to him Tacca basically perpetuated the style of Giovanni Bologna.

71. Christ bearing the Cross

> Bronze, with red-brown lacquer patina. Octangular
> relief, height 6⅝ in. (16.8 cm.)
> Italian, Florence, mid-17th century
> 1982.60.109

THIS MAY be the finest surviving example of the plaque. The elastic poses, the use of stippling to define details such as clouds and turf, and the ruddy translucent lacquer all justify Anthony Radcliffe's inclusion of the model among lesser works by Ferdinando Tacca.[1] Inferior examples are

155

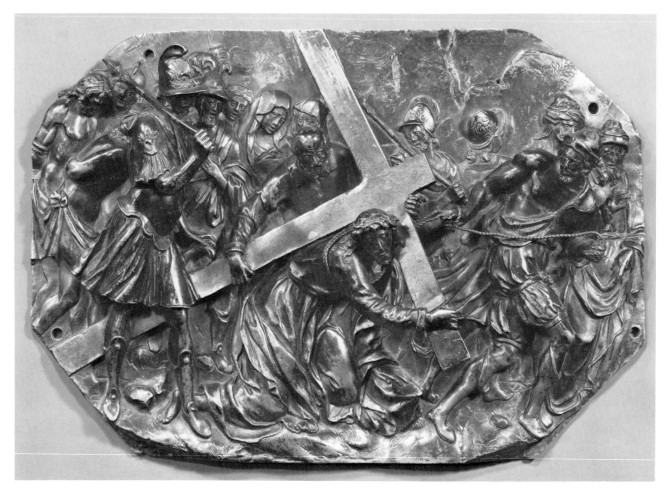

71. CHRIST BEARING THE CROSS

paired with equally unevenly cast representations of a scene from the Flight into Egypt in the Minneapolis Institute of Arts; the Spencer Museum of Art, University of Kansas, Lawrence; and the Wernher Collection at Luton Hoo.[2] Even at their best, as here, the plaques do not suggest the atmospheric breadth achieved in Tacca's masterpiece in relief, *The Martyrdom of Saint Stephen*, in Santo Stefano al Ponte, Florence,[3] and are probably to be dated somewhat earlier.

NOTES:

1. A. Radcliffe, "Ferdinando Tacca, the Missing Link in Florentine Baroque Bronzes," in *Kunst des Barock in der Toskana: Studien zur Kunst unter den letzten Medici*, Munich, 1976, p. 20.

2. Ibid., p. 23 n. 22, for bibliography and further details.

3. Ibid., figs. 1, 3–4, a work of 1656.

72. David and Goliath

Bronze, with dark brown lacquer patina. Height 17⅝ in. (44.8 cm.)
Possibly English, 18th century, probably after a 16th-century Florentine composition
1982.60.117

WILHELM VON BODE described an example of apparently comparable quality (then in the collection of Gustave de Rothschild, Paris) as Florentine, from about 1570.[1] Subsequent scholars have proposed that the statuettes reflect a lost Mannerist composition. W. R. Valentiner, illustrating the Linsky example, thought it a copy of a model by Baccio Bandinelli (1493–1560) that was men-

tioned by Vasari. John Pope-Hennessy cited this and one other example in the Pushkin Museum, Moscow, and suggested that the original was a work of Vincenzo de' Rossi (1525–1587), further noting that the composition exists in a much larger lead group in the garden at Seaton Delaval. The lead version, which lacks the rounded base with picturesque attributes found in the statuettes, is paired with a lead cast after Giovanni Bologna's marble *Samson Slaying a Philistine*.[2] The marble, in the Victoria and Albert Museum, was at Buckingham House and at Hovingham Hall, Yorkshire, during the eighteenth century.

The facture of the Linsky bronze is not consistent with sixteenth-century Florentine practice. The interior has been filled with dark wax, but it appears to be a thin, rough cast. The surface is only slightly reworked. It is conceivable that our David and Goliath is a bronze from a different time and place—possibly eighteenth-century England. John Cheere (1709–1787), an enterprising sculptor who carried on a lively trade in plaster and lead copies after antique statues and those by Italian masters, sold a lead copy of Giovanni Bologna's *Samson Slaying a Philistine*, along with ninety-seven other works in lead, to the Portuguese royal palace at Queluz in 1756. Another Samson group was acquired after Cheere's death by Samuel Whitbread and installed at Southill Park, Bedfordshire.[3] It is probable that Cheere's workshop produced the Samson and David groups at Seaton Delaval, and it is not out of the question that the shop was responsible for the bronze statuettes as well, although nothing is known of Cheere's activity in this field. The composition may have influenced John Flaxman's famous marble group, of 1822, *Satan Overcome by Saint Michael*, at Petworth House, Sussex.[4]

NOTES:

1. W. von Bode, *The Italian Bronze Statuettes of the Renaissance*, London, III (1912), pl. CCXX, 2. In the reprint edition, New York, 1980, p. 107, the Linsky example is wrongly assumed to be the same as the Rothschild one.

2. See C. Hussey, "Seaton Delaval, Northumberland," part ii, *Country Life* LIV (1923), figs. 14, 15, p. 867.

3. See T. Friedman and T. Clifford, *The Man at Hyde Park Corner. Sculpture by John Cheere 1709–1887* (exhib. cat.), Leeds, Temple Newsam, and Twickenham, Marble Hill House, 1974, p. 15 and no. 3.

4. M. Whinney, *Sculpture in Britain 1530 to 1830*, Harmondsworth, England, 1964, pl. 155 a.

BIBLIOGRAPHY: W. R. Valentiner, "Bandinelli, Rival of Michelangelo," *The Art Quarterly* XVIII (1955), pp. 256–59; J. Pope-Hennessy, "An Exhibition of Italian Bronze Statuettes," review reprinted in *Studies of Italian Sculpture*, London, 1968, pp. 191–92.

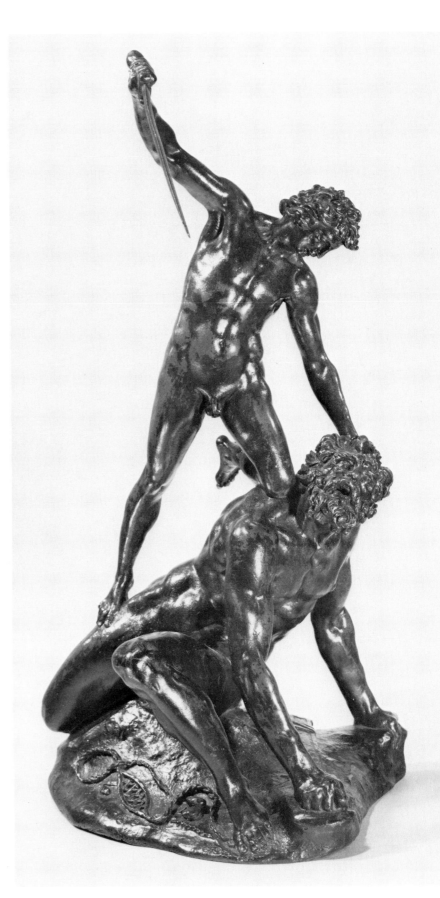

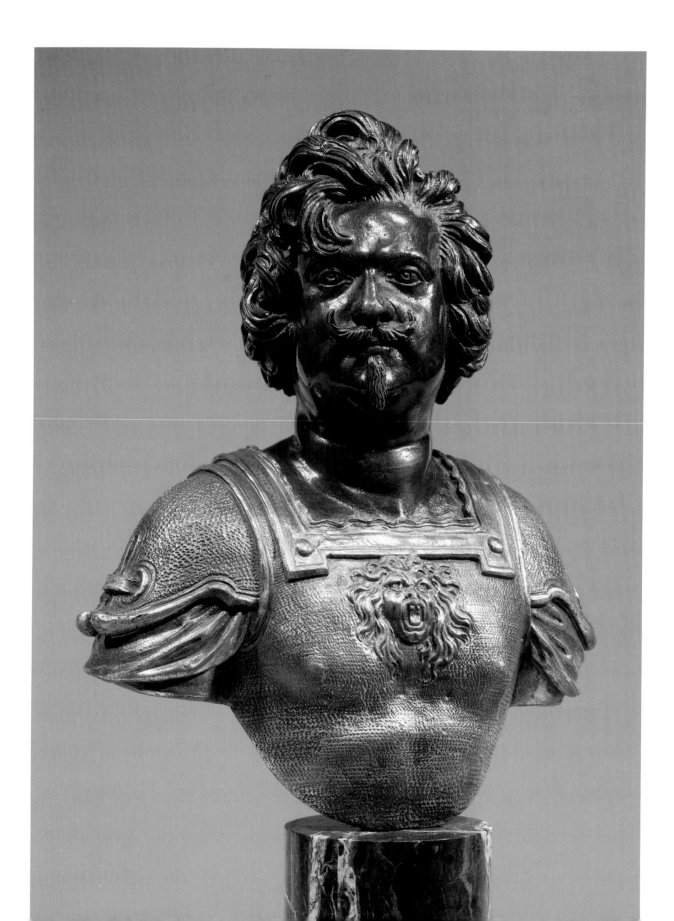

JOHANN JAKOB KORNMANN

Born Augsburg ?; died after 1672, Rome

THIS MEDALIST is probably to be identified with the goldsmith Johann Kornmann who married in Landsberg am Lech in 1620. He was briefly active in Venice and was afterward established in Rome as medalist at the papal mint. He evidently did not commit suicide in 1649, as reported by the biographer Joachim von Sandrart, because one of his medals, representing Flavio Orsini, is signed and dated 1672.

73. Bust of Paolo Giordano II Orsini, Duke of Bracciano

Bronze, with dark brown lacquer patina, and gilded and silvered details. Height 7¼ in. (18.4 cm.)
Italian, Rome, ca. 1625–35
1982.60.106

PAOLO GIORDANO ORSINI, born in 1591, was duke of Bracciano from 1615 until his death in 1656. He was a great friend to musicians, but in the visual arts his interest centered mainly on portraits of himself. Artists invariably seized upon his self-important but likable nature, manifested by his proud posture, pudgy features, and artfully flung-back hair. Such portraits are often described as verging on caricature, but they are probably quite faithful records of the duke, who paraded through life as an opulent sort of *miles gloriosus*.

Since its appearance on the art market in the 1960s, this miniature bust has been assumed to have been cast after a model by Gian Lorenzo Bernini, and it has been related to documents dating from 1623–24 in the Orsini archives in Rome, according to which the founder Sebastiano Sebastiani would receive twenty-five scudi for making wax replicas to test the piece mold taken from Bernini's model.[1] Two further examples of the bust have since emerged in England: One is in the collection of the Plymouth City Museum and Art Gallery and one was sold at Sotheby's in London on July 12, 1979, and afterward was lent to the Victoria and Albert Museum.[2] Although the heads are similar, there are distinct differences in the armor of each bust. The Linsky example is easily distinguished by the painstaking stippling of the corselet and by the touches of gilding and silvering that the others lack. It is also more forceful in its plasticity than the other two.

The bust in Plymouth rests on a fancy base incorporating lions. Hinged to the top of the base is a copper lid engraved with an inscription relating that it was a gift to Johann Anton Gugler, a Bavarian priest, from the Roman bronze founder Bernardino Danese in the Year of Jubilee, 1675. The inscription may apply only to the base, because the relationship of the bust's wood socle to the base is rather strange: They are separated by a wood-filled element bound in a thin octagonal band of copper.

Anthony Radcliffe supposes a sequence whereby Sebastiani cast the first model of the bust, which later became available to Danese, both men having been active as founders for Bernini projects. However, Gisela Rubsamen, in an as yet unpublished lecture,[3] demonstrated that the bronze bust on which Bernini and Sebastiani worked was life size, weighing about one hundred pounds, and that the chasing of the head was executed by Bernini himself. Rubsamen also discovered an engraving reproducing one of the miniature busts, apparently the Linsky example, and bearing an inscription identifying the sculptor as Johann Jakob Kornmann.

Kornmann (or Cormano, as he was known in Italy) produced several medals of Orsini, from 1621 to 1635.[4] There is no reason not to conclude that Kornmann was responsible for all three miniature busts, altering the details with each presentation to the duke, more or less as he modeled the medals with minor variations. The 1656 inventory of the possessions of the lately deceased Paolo Giordano, in his palace on the Monte Giordano in Rome, contained metal busts of the duke valued at twenty-five and fourteen scudi, which may well be identical with the busts of this type,[5] as well as a series of medals in lead, silver, and an unspecified material.

NOTES:
1. R. Wittkower, *Gian Lorenzo Bernini: The Sculptor of the Roman Baroque*, 2nd ed., London, 1966, no. 36, pp. 203–4, 3rd rev. ed., Oxford, 1981, no. 36, p. 275. The documents were first published by F. Haskell, *Patrons and Painters, A Study in the Relations Between Italian Art and Society in the Age of the Baroque*, London, 1963, 2nd rev. ed., New Haven and London, 1980, p. 388.
2. For these, see A. Radcliffe, "Two Bronzes from the Circle of Bernini," *Apollo* n.s. CVIII (1978), pp. 418–23; A. Radcliffe, in *An Exhibition of Old Master and English Drawings and European*

Bronzes . . . on loan from The City Museum and Art Gallery, Plymouth, London, Sotheby's, 1979, no. 1, pp. 31–32.

3. "Bernini and the Orsini Portrait Busts," in *Abstracts of Papers Delivered in Art History Sessions, Sixty-third Annual Meeting of the College Art Association of America*, Washington, D.C., Jan. 22–25, 1975.

4. Details of his activity in G. Pollard, "La medaglia con ritratto di epoca barocca in Italia," in *La medaglia d'arte. Atti del primo convegno internazionale di studio* (Udine, 1970), Udine, 1973, pp. 142–43, 159 n. 10.

5. G. Rubsamen, *The Orsini Inventories*, Malibu, Calif., 1980, pp. 11, 13.

EX COLL.: Paolo Giordano II Orsini, duke of Bracciano ?; [Cyril Humphris, London].

BIBLIOGRAPHY: R. Wittkower, *Gian Lorenzo Bernini: The Sculptor of the Roman Baroque*, 2nd ed., London, 1966, no. 36, pp. 203–4, 3rd rev. ed., Oxford, 1981, no. 36, p. 275; A. Radcliffe, "Two Bronzes from the Circle of Bernini," *Apollo* n.s. CVIII (1978), pp. 418–23; A. Radcliffe, in *An Exhibition of Old Master and English Drawings and European Bronzes . . . on loan from The City Museum and Art Gallery, Plymouth*, London, Sotheby's, 1979, no. 1, pp. 31–32; F. Haskell, *Patrons and Painters, A Study in the Relations Between Italian Art and Society in the Age of the Baroque*, London, 1963, 2nd rev. ed., New Haven and London, 1980, p. 401.

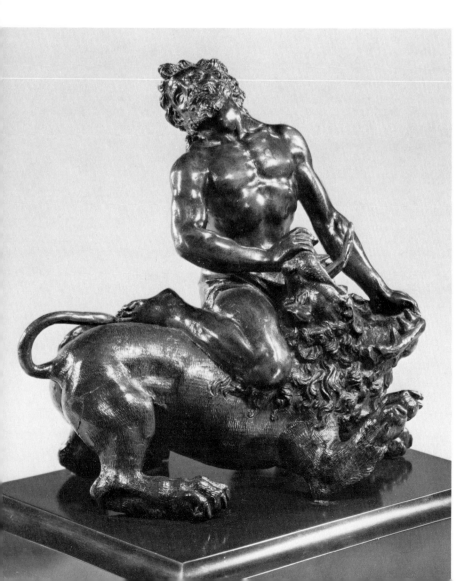

74. Samson and the Lion

Bronze, with red-brown natural patina, and remains of dark brown lacquer. Height 7½ in. (19.1 cm.)
Probably Italian, 17th century
1982.60.107

THIS IS a relatively crisply chased example of a composition in which the lion's gaping mouth serves as an inkwell. The model is frequently encountered in disappointing casts. Attributions in the past have run a wide gamut, from Pollaiuolo to Tiziano Aspetti. Anthony Radcliffe has ascribed the Samson statuettes to Bernardino Danese, the seventeenth-century Roman founder, noting a resemblance between the lion in a good example of the type in the Plymouth City Museum and Art Gallery and the two lions that adorn the pedestal of the bust of Paolo Giordano II Orsini in the same museum.[1] The Samson and the Orsini bust in Plymouth share the same early provenance.[2] When actually placed side by side, however, the lions in Plymouth are not so compellingly similar in modeling or in chasing. Those under the bust are conventional Baroque heraldic beasts tooled with relatively rigid parallel strokes. Bernardino Danese's main documented efforts—various bronze castings for Bernini's Cappella del Sacramento (of 1673–75) in Saint Peter's—are works of a much higher technical order than any of these small bronzes. Radcliffe may be right to trace the Samson's flowing design to the seventeenth century, but we are no closer than before to knowing the name of its author.

NOTES:

1. See A. Radcliffe, "Two Bronzes from the Circle of Bernini," *Apollo* n.s. CVIII (1978), pp. 418–22, with a full account of earlier literature; A. Radcliffe, in *An Exhibition of Old Master and English Drawings and European Bronzes . . . on loan from The City Museum and Art Gallery, Plymouth*, London, Sotheby's, 1979, no. 2, pp. 32–33, citing numerous other versions, among them three said to be in the Metropolitan Museum. In 1982, the two then in the Museum were deaccessioned once the superiority of the Linsky example was recognized.

2. The collection of the Marchese Leonori of Pesaro (sale, Christie's, London, Jan. 27–30, 1772, nos. 31, 86, both as by Alessandro Algardi).

FRANCESCO FANELLI

Born Florence ?; died 1665, Paris

SAID BY English chroniclers to have been Florentine, Fanelli is first recorded in Genoa in 1609–10. He designed a multifigured fountain for Charles I at Hampton Court, and his small bronzes brought the manner of Giovanni Bologna's followers to England. He apparently left England for Paris in 1642. The death date of 1665 is also a matter of supposition.

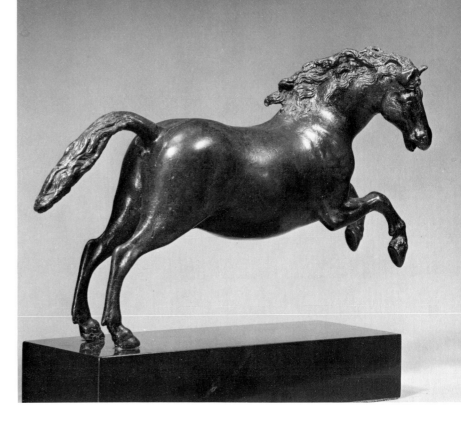

75. Galloping horse

Bronze, with remains of dark brown lacquer. Height
 5 in. (12.7 cm.)
Probably made in England, ca. 1630–40
1982.60.113

IF NOT terribly exacting technically, Fanelli bronzes such as this have dependably lively Baroque compositions.[1] About 1736, George Vertue compiled a short list of "so many of this little Statues as I have seen at Ld Oxfords";[2] the list includes several horse subjects, among them "a horse full gallop" that is very likely a bronze of this composition. Another of the type is in the Herzog Anton Ulrich-Museum, Brunswick.

NOTES:
 1. See J. Pope-Hennessy, "Some Bronze Statuettes by Francesco Fanelli," *Burlington Magazine* XCV (1953), pp. 157–62.
 2. Walpole Society, *Vertue Note Books: IV*, The Twenty-Fourth Volume of the Walpole Society, 1935–36, p. 110.

EX COLL.: probably the example sold at Sotheby's, London, Mar. 23, 1971, no. 81.

76, 77. Pair of double-headed monsters

Bronze, with black lacquer patina. Lengths 8¾ in. (22.3
 cm.), 10½ in. (26.7 cm.)
Italian, possibly Venice, late 17th century
1982.60.115,116

VENICE IS suggested only as a possible place of origin for these exceptionally vigorous Baroque creatures; Augsburg and even France would be equally plausible. It is no easier to reconstruct the purpose for which they were made. Their undersides are slightly flattened and pierced for attachment, so that they could have flanked a bust on an elaborate pedestal, or, perhaps more likely, they may have embellished a fountain.

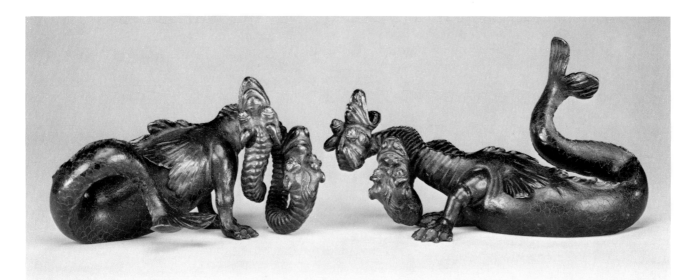

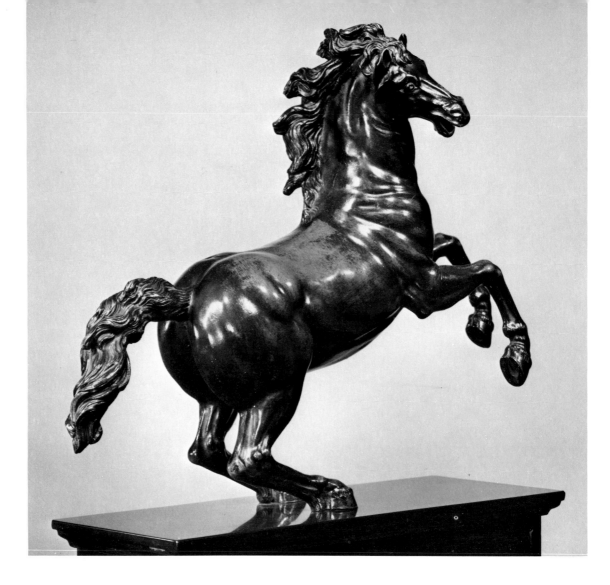

78. Rearing horse

Bronze, with pale brown natural patina, and remains of
dark brown lacquer. Height 13¾ in. (34.9 cm.)
Italian or French, late 17th century
1982.60.104

79. Hercules and the Nemean Lion

Bronze, with brown lacquer patina. Height 12¾ in.
(32.4 cm.)
Italian or German, late 17th century
1982.60.96

TWO REARING horses, related in pose and size but dif-
fering in their greenish patina—a later addition—were
part of the Untermyer gift to the Metropolitan Museum.
(They were deaccessioned because the present bronze is
of finer quality.) There has been no satisfactory solution
to the question of the facture of these horses. A debt to
the equestrian monuments and models of Giovanni
Bologna's seventeenth-century Florentine followers, such
as Pietro Tacca, is manifest, but a French adaptation from
the time of Louis XIV is equally possible.

THE COMPOSITION recurs in a bronze in the Badisches
Landesmuseum, Karlsruhe, and in another bronze on the
art market in London (sale, Sotheby's, New York, May
29, 1981, no. 162). Wilhelm von Bode discussed the pres-
ent statuette as an early-sixteenth-century Venetian work
from the circle of Camelio. However, the violent side-
ward torsion and the decorous penetrations of space along
the right flank are fully Baroque. Convincing compari-
sons with Italian sculpture are wanting. The richly fac-
eted surface suggests an original model in limewood. The

anatomy is expressive but scientifically inexact, as can be appreciated especially in Hercules' muscular back, where the forms are knotted together around a high, pinched-in waist. These qualities recall German Baroque carving—large-scale sculptures by the Bendl, Brokoff, and Braun families of Bohemia come to mind—but next to nothing is known about German bronze statuettes of the late seventeenth century.

EX COLL.: [A. S. Drey, Munich]; Samuel Untermyer, New York and Yonkers (sale, Parke-Bernet, New York, May 10–11, 1940, no. 161); Alvin Untermyer, New York and Greenwich, Conn. (sale, Parke-Bernet, New York, Oct. 2–3, 1964, no. 285); [Arthur Erlanger].

BIBLIOGRAPHY: W. von Bode, *Die italienischen Bronzestatuetten der Renaissance*, Berlin, 1922, p. 55, pl. 35, 2.

Northern European Renaissance and Baroque Sculptures in Bronze, Brass, Wood, and Ivory

80. Venus

Bronze, with yellow-brown natural patina. Height 11½ in. (29.2 cm.)
South German, early 16th century
1982.60.120

THE SCULPTOR'S simplified volumetric approach is remarkable even among German bronzes, in which simplicity and geometry were prized qualities. Exact parallels for the bejeweled goddess have not been found, but the planar treatment of the forms, the reinforced engraving of details such as nipples and navel, the gouging of facial features, and the grooved waves of hair are encountered in various works that originated in Innsbruck, as well as in Nuremberg and Augsburg.[1] The necklace alone does not establish the identity of the goddess. She formerly held an object in her raised right hand and possibly steadied something with her lowered left hand, whose thumb has broken. It is not out of the question that the statuette—which was attached to another object by means of the hole in the middle of the base—formed part of a fountain.

NOTE:
1. E. F. Bange, *Die deutschen Bronzestatuetten des 16. Jahrhunderts*, Berlin, 1949, pls. 80, 93, 140.

81. Wild Man

Brass. Height 6¾ in. (17.1 cm.)
Flemish, 16th century
1982.60.124

THIS STATUETTE was included, *hors catalogue*, in the 1980 exhibition at The Cloisters, "The Wild Man: Medieval Myth and Symbolism."[1] The hirsute species survived well into the sixteenth century, notably in the imagery of Albrecht Dürer, but in an increasingly heraldic role. Our example no doubt brandished a club in his raised right hand and with his lowered left (where there are remains of a pin) steadied a shield, as did the Wild Men that

functioned as supporting figures or finials on various earlier utensils.[2] He might have served as either a support or a finial for an object such as a large tankard; wide holes in his seat and in the top of his head indicate that the place of attachment could have been at either end. The Linsky Wild Man illustrates the fundamental conservatism of dinanderie as it survived into the sixteenth century, the only novelty being the diamond-shaped gouges that characterize his hairy hide.

NOTES:

1. The exhibition catalogue by Timothy Husband (which bears the same title) presents the background for the development of the Wild Man in medieval art and literature.

2. See nos. 50–52 in The Cloisters catalogue.

EX COLL.: [Cyril Humphris, London].

82, 83. Two landsknechts

Bronze, with natural brown patina, and remains of black lacquer. Heights 8⅜ in. (21.3 cm.), 9⅜ in. (23.8 cm.)
German, probably Nuremberg, mid-16th century
1982.60.118, 119

THE TWO landsknechts, varying slightly in height and in costume, originally served as candle holders; candles were inserted in the holes in their raised hands. Bronze projections from the insteps of the taller soldier indicate that the figures belong to a common sixteenth-century type, of brass as well as of bronze, in which the feet often stood on flared stems rising from circular bases.[1] The folkloric designs were popular again in the nineteenth century; a thinly cast copy of one of our landsknechts appears on a candlestick in the reserves of the Louvre, paired with a variant model.[2]

NOTES:

1. V. Baur, *Kerzenleuchter aus Metall*, Munich, 1977, pls. 58–61; E. Turner, *An Introduction to Brass*, London, 1982, pl. 13.

2. G. Migeon, *Catalogue des bronzes et cuivres du Moyen Age, de la Renaissance et des temps modernes*, Paris, Musée National du Louvre, 1904, no. 119.

84. Neptune and Caenis

Bronze, with dark brown lacquer patina. Height 12½
in. (31.8 cm.)
Probably Netherlandish, late 16th–early 17th century
1982.60.127

OVID (*Metamorphoses*, XII, 195–209) relates Neptune's rape of the maiden Caenis while she walked along the Thessalian shore. The god, sated, promised to grant her any favor in return. Anxious to avoid further attacks of the sort, Caenis asked to become a man. Duly transformed, Caenis took on the masculine name Caeneus. Representations of the subject are rare, but, much like the story of Hercules and Omphale, Ovid's tale of androgyny was certain to be relished by the Late Mannerists: It challenged them to capture the moment of transformation, for, even as she named her wish, says Ovid, Caenis's voice took on

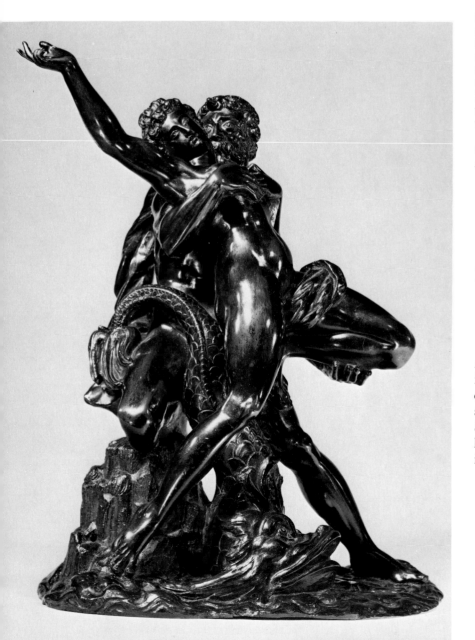

deeper male tones. In the bronze there is, accordingly, a certain masculinization of the female form.

The composition is derived from an engraving, dated 1580, by Johann Sadeler the Elder, based in turn on a drawing by Bartholomaeus Spranger in the Museum Plantin-Moretus, Antwerp.[1] The crisscrossing forms realized in the bronze were a quintessential feature of Spranger's brand of Mannerism. Born in Antwerp in 1546, Spranger traveled widely in Italy and worked for Maximilian II and Rudolph II in Vienna and in Prague, where he died in 1611. A later cast of this bronze, in which the figure of Caenis is more modestly draped and the rhythms of the waves are more repetitious,[2] has been attributed to Hans Mont, a sculptor from Ghent who is known to have collaborated with both Giovanni Bologna and Spranger, but Mont's actual style is an unknown quantity.

NOTES:

1. For the engraving, see F. W. H. Hollstein, *Dutch and Flemish Etchings, Engravings and Woodcuts . . .*, Amsterdam, XXI (1980), no. 479, which excerpts the principal figures from Spranger's drawing. See A. J. J. Delen, Cabinet des Estampes de la Ville d'Anvers (Musée Plantin-Moretus), *Catalogue des dessins anciens. Ecoles Flamande et Hollandaise*, Brussels, 1938, no. 116, pl. XXVII. Spranger's painting of the scene is listed in a Prague inventory of 1621 (K. Oberhuber, "Die stilistische Entwicklung im Werk Bartholomäus Sprangers," Ph.D. diss., University of Vienna, 1958, p. 245, no. 5).

2. *Faces and Figures of the Baroque* (exhib. cat.), London, Heim Gallery, 1971, no. 49, identifying the work as Neptune and Amphitrite.

HUBERT GERHARD

Born ca. 1540–50, apparently in Amsterdam; died 1620, apparently in Munich

AFTER STUDYING in Italy, Gerhard was active, from 1581, in Munich, Kirchheim, and Augsburg, as well as at the court of Archduke Maximilian III in Innsbruck. His large-scale bronze masterworks include the contemporaneous Saint Michael (of 1588–92) on the façade of the Michaelskirche, Munich, and the Augustus Fountain (of 1589–94) in Augsburg.

After a composition by
HUBERT GERHARD

85. Tarquin and Lucretia

Bronze, with red-brown lacquer patina. Height 22¼ in.
 (56.5 cm.), including original bronze base
Possibly French, late 17th century
1982.60.122

THE DESIGN is a compositional outgrowth of Hubert Gerhard's *Mars, Venus, and Cupid*. His large bronze group with that subject, cast in 1584–85 as the centerpiece for a fountain at the Fugger castle, Kirchheim, is now in the Bayerisches Nationalmuseum, Munich, and a fine reduction, with modifications, is in the Kunsthistorisches Museum, Vienna. The Tarquin and Lucretia is a further variant in which the movements of both figures are directed more

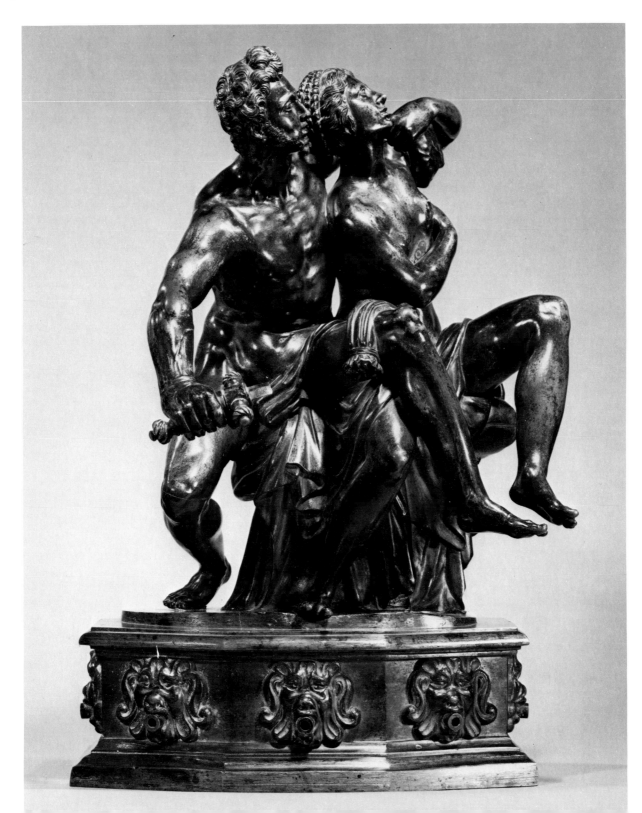

violently to the right. Several examples exist—in museums in Amsterdam, Baden-Baden, Baltimore, and Cleveland, among others. The strongest may be one in the Metropolitan Museum (50.201; from the Thyssen collection, Schloss Rohoncz).[1] It preserves something of the vigorous approach to the metal that might be expected of Gerhard and his school. The present bronze is sleeker, and of a yellowish metal covered with the ruddy lacquer patina that is typical of bronzes of the Louis XIV period.

The masks on the self-base are equipped with spouts that suggest a table fountain. The masks also appear on the group with which this bronze was formerly paired: a Rape of Deianira, based on a composition by Giovanni Bologna, which is now in the Statens Museum for Kunst, Copenhagen. That museum's catalogue notes the earliest owner of both bronzes as Baron Vittinghoff-Riesch. Later they belonged to Gorm Rasmussen of Sølyst. In the Rasmussen auction catalogue the two bronzes are illustrated surmounting commodes.

NOTE:
1. For a list of the several casts, see W. D. Wixom (see Bibliography below).

EX COLL.: Baron Vittinghoff-Riesch, Neschwitz, Saxony; [A. S. Drey, Munich]; [Jacques Seligmann, Paris]; Gorm Rasmussen, Sølyst (sale, V. Winkel and Magnussens, Copenhagen, June 28–29, 1946, nos. 41, 42); [French & Company, New York].

BIBLIOGRAPHY: A. E. Brinckmann, *Süddeutsche Bronzebildhauer des Frühbarocks*, Munich, 1923, pl. 31; W. D. Wixom, *Renaissance Bronzes From Ohio Collections* (exhib. cat.), The Cleveland Museum of Art, 1975, no. 213; H. Olsen, *Aeldre Udenlandsk Skulptur*, I, Copenhagen, Statens Museum for Kunst, 1980, p. 28.

86. Male nude supporting a wreath on his head

Bronze, with remains of dark brown lacquer. Height 9⅟₁₆ in. (23 cm.)
Probably French, late 16th–early 17th century
1982.60.97

THE MODEL was possibly intended as a furniture mount, serving, for example, in the manner of a telamon between two zones of a cabinet. The rather labored contrapposto suggests a late School of Fontainebleau origin. A variant with a bit of drapery falling over the figure's shoulder was

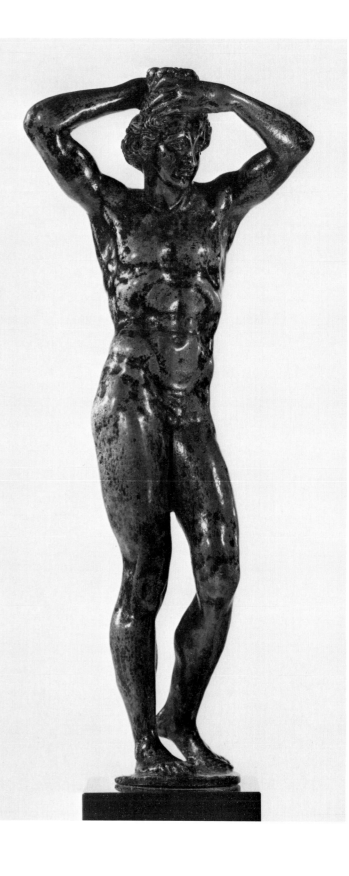

in the collection of Sir Ivor C. Proctor-Beauchamp.[1] The number 212 engraved on the back of the right leg of our bronze corresponds to the entry in the inventory of the French royal collections ordered by the National Assembly: "Un homme ayant les deux mains sur la tête, haut de huit pouces et demi, moderne, estimé cent vingt livres."[2]

NOTES:

1. Sale, Sotheby's, London, June 10, 1969, no. 71.

2. J. M. Bion, C. G. F. Christin, and F. P. Delattre, *Inventaire des diamans de la Couronne . . . perles, pierreries, tableaux, pierres gravées, et autres monumens des arts et des sciences existans au Garde-Meuble, imprimé par ordre de l'Assemblée Nationale*, II, Paris, 1791, p. 262, no. 212.

EX COLL.: French royal collections.

87. Hercules and the Nemean Lion

Bronze, with etched golden-brown surface, oxidized
 dark brown where rubbed. Height 9⅝ in. (24.5 cm.)
Possibly French, early 17th century
1982.60.105

THE LATE Mannerist composition, derived only generically from the Hercules groups of Giovanni Bologna, displays networks of interlocking triangular shapes, resulting from Hercules' legs being stretched crosswise behind the lion. The base, a segmental arc, is especially curious. The chasing is closely controlled, almost like medalic engraving. The head seems to reflect the features of the *Farnese Hercules* and those of Henri IV, but a French

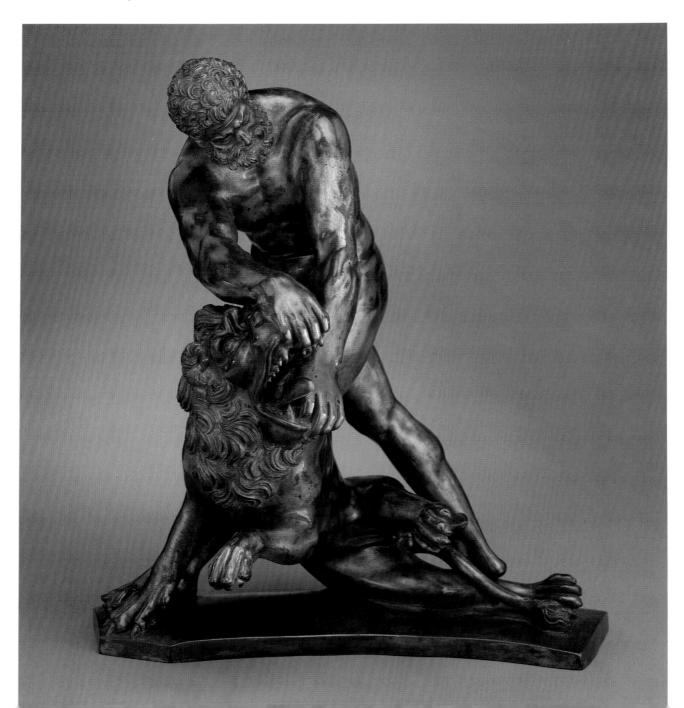

facture is offered here only provisionally. Another cast cited by Bode as belonging to the Victoria and Albert Museum is not, in fact, there.[1]

NOTE:

1. W. von Bode, *The Italian Bronze Statuettes of the Renaissance*, London, III (1912), pl. CXCVIII, 2.

EX COLL.: Mortimer L. Schiff, New York (sale, Christie's, London, June 23, 1938, no. 123); [Paul Drey Gallery, New York].

88. Girl braiding her hair

Bronze, with red-brown lacquer patina. Height 7 in. (17.8 cm.)
Netherlandish or French, early 17th century
1982.60.126

THIS IS a fine example of a frequently encountered composition, from a workshop that emulated the production of small bronzes by Giovanni Bologna and his associates. Scholars' impressions concerning the workshop vary fairly widely. Wilhelm von Bode first grouped an example of this model (then in the Morgan collection; now in the Huntington Library, San Marino) with other models of seated female nudes, and with a paired lady and gentleman in what appears to be Dutch bourgeois costume, calling them late-sixteenth-century Italo-Netherlandish.[1] Not all members of Bode's grouping have the same taut composition and finish. Robert Wark added to our knowledge of the workshop's output by including male nudes formerly thought to be the work of the Florentine Domenico Poggini,[2] as did Yvonne Hackenbroch, who contributed appreciably to our awareness of the shop's creation of genre subjects.[3] Hans R. Weihrauch attempted to establish a Dutch "Meister der Genrefiguren" as the artist responsible for these bronzes,[4] but a growing trend among scholars has been to assign the production to a French atelier (or ateliers).[5] These authors base their conclusions, in part, on the appearance of bronzes clearly belonging to the group in the inventory of the collection of André Le Nostre, taken in 1700 after his death.[6] Male and female nudes from the core group occur in both French and Netherlandish still lifes. Charles Avery states that the bronzes "may in fact be the work of Barthélemy Prieur, the Parisian court sculptor."[7] The statuettes, often rather finicky in their finish, are a bit hard to square with the rangy style of Prieur, as known from his larger works.

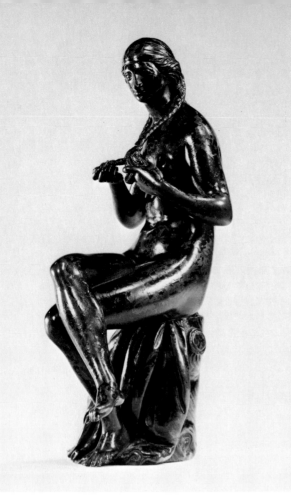

NOTES:

1. W. von Bode, *The Italian Bronze Statuettes of the Renaissance*, London, III (1912), pls. CCXV–CCXVIII.

2. R. Wark, *Sculpture in the Huntington Collection*, Los Angeles, 1959, pls. XII–XIV, pp. 65–66.

3. Y. Hackenbroch, "A Group of Italo-Dutch Bronzes," *Connoisseur* 154 (1963), pp. 16–21.

4. H. R. Weihrauch, *Europäische Bronzestatuetten, 15.–18. Jahrhundert*, Brunswick, 1967, pp. 364–67.

5. See B. Jestaz, "Travaux récents sur les bronzes II: Renaissance septentrionale et Baroque," *Revue de l'Art* 9 (1970), pp. 78–79; B. Jestaz, "L'Influence flamande en France à la fin du XVIᵉ siècle," in *Actes du Colloque International sur l'art de Fontainebleau* (Fontainebleau and Paris, Oct. 18–20, 1972), Paris, 1975, pp. 78–83; A. Radcliffe, in *An Exhibition of Old Master and English Drawings and European Bronzes . . . on loan from The City Museum and Art Gallery, Plymouth*, London, Sotheby's, 1979, no. 3, pp. 33–34.

6. J. Guiffrey, "Testament et inventaire après décès de André Le Nostre," *Bulletin de la Société de l'Histoire de l'Art Français* (1911), p. 257, no. 353, refers to a specimen of this model as "Femme assize quy trais ses cheveux."

7. C. Avery, "Giambologna's 'Bathsheba': An Early Marble Statue Rediscovered," *Burlington Magazine* CXXV (1983), p. 349 n. 44, adds that the attribution depends on unpublished research by himself, Regina Seelig-Teuwen, and Anthony Radcliffe.

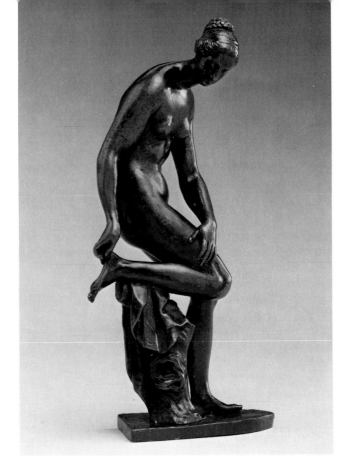

90. Lucretia

Pearwood. Height 10½ in. (26.7 cm.)
German, possibly 17th century
1982.60.128

THIS IS one of a number of hardwood statuettes of nudes that traditionally were associated with Conrad Meit of Worms (ca. 1475–1550/51) until Jörg Rasmussen related them instead to the work of Daniel Mauch (1477–ca. 1541), differentiating Mauch's voluptuous manner from Meit's more tightly knit style.[1] Rasmussen's Mauch group includes a boxwood Lucretia in the Metropolitan Museum.[2]

Both of the Linsky figure's arms have been finely restored, in a manner too meticulous to be original to the free-flowing design. In all other respects, the statuette has the same composition as one in Vienna that entered the literature later, after being acquired by the Kunsthistorisches Museum in 1923.[3] The base of the Vienna figure bears a Dürer-like monogram that appears to be a *G* within an *A*. Her left hand and her dagger are restorations, so that it is not completely certain that she was meant to be

89. Bather

Bronze, with medium brown patina, and remains of
dark brown lacquer. Height 7¾ in. (19.7 cm.)
Possibly French, early 17th century
1982.60.125

THIS COMPOSITION has been discussed in the literature in the same terms as the girl braiding her hair (no. 88). Its looser rhythms give this figure a different kind of elegance, especially admirable from her right side, which might better qualify the work as French. Two variants of the model, on the other hand, correspond more closely to the core group in certain of their features, such as the spiraled tooling on their tree trunks. The two were in the Oppenheim collection, Berlin,[1] and in the Baron Hatvany collection, London.[2] The relatively recent shield-shaped brass base of the Linsky example is stamped on the underside with an unrecorded mark: an N surmounted by a quatrefoil.

NOTES:
1. W. von Bode, *The Italian Bronze Statuettes of the Renaissance*, London, III (1912), pl. CCXI, 1, describes it as "Italo-Flemish, about 1580."
2. Sale, Christie's, London, June 25, 1980, no. 41, as "perhaps by Barthélemy Prieur."

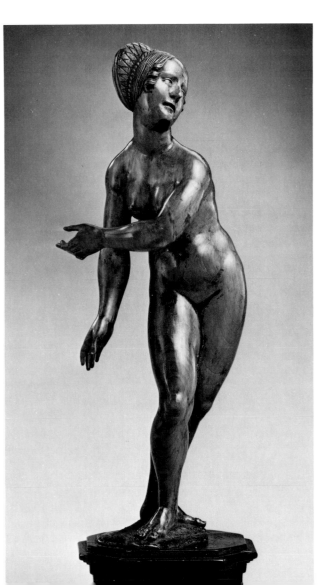

Lucretia, and yet the pained expressions and sideward turns of the Linsky and Vienna statuettes make this probable The hands of the Linsky heroine, in any case, easily can be imagined as having been similarly positioned, about to plunge a dagger into her breast.

The Linsky and Vienna carvings are apparently by the same artist—the Vienna figure offering slightly more detail—as a goddess with outspread arms, in the Victoria and Albert Museum.[4] The last was previously in the Spitzer and Schoeller collections with the Linsky Lucretia, but the two were not a pair or group, the Linsky figure being taller. Linking the three figures are the stylization of their coiffures—with flatly carved bands of hair and curls—and their peculiarly unanatomical backs and shoulders. A date for these works is hard to establish. Perhaps they should be considered as part of the "Dürer revival" of the seventeenth century.

NOTES:

1. "Eine Gruppe kleinplastischer Bildwerke aus dem Stilkreis des Conrat Meit," *Städel-Jahrbuch* n.s. 4 (1973), pp. 121–44.

2. Morgan collection, 17.90.582. Ibid., p. 134, fig. 19.

3. Ibid., p. 134, fig. 20.

4. M. Baxandall, *German Wood Statuettes 1500–1800*, London, Victoria and Albert Museum, 1967, no. 3; Rasmussen, "Eine Gruppe kleinplastischer Bildwerke . . . ," p. 121, figs. 1, 2, pp. 123–24. In a private communication, Rasmussen has indicated that he would no longer associate the Vienna, Linsky, and Victoria and Albert statuettes with the style of Daniel Mauch.

EX COLL.: Frederick Spitzer, Paris; Paul Ritter von Schoeller, Vienna; Hinrichssen, Bad Aussee.

BIBLIOGRAPHY: A. Pabst, *La Collection Spitzer*, III, Paris, 1891, p. 286, no. 181; A. Schestag, "Die Neuaufstellung der Sammlung der Kleinplastik im Österreichischen Museum," *Kunst und Kunsthandwerk* XXII (1919), pp. 112–14; F. Winkler, "Konrad Meits Tätigkeit in Deutschland," *Jahrbuch der preuszischen Kunstsammlungen* XLV (1924), p. 46; G. Troescher, *Conrat Meit von Worms: ein Rheinischer Bildhauer der Renaissance*, Freiburg im Breisgau, 1927, p. 50; E. F. Bange, *Die Kleinplastik der deutschen Renaissance in Holz und Stein*, Florence and Munich, 1928, p. 66, pl. 67; *Aufgang der Neuzeit: Deutsche Kunst und Kultur von Dürers Tod bis zum Dreissigjährigen Krieg, 1530 bis 1650* (exhib. cat.), Nuremberg, Germanisches Nationalmuseum, 1952, no. C 54; J. Rasmussen, "Eine Gruppe kleinplastischer Bildwerke aus dem Stilkreis des Conrat Meit," *Städel-Jahrbuch* n.s. 4 (1973), pp. 139, 143 nn. 55, 56.

LEONHARD KERN

Born 1588, Forchtenberg; died 1662, Schwäbisch-Hall

KERN, born in the Hohenlohe territories, was the son of a stonemason. From 1609 to 1614, he lived in Italy. In his travels he even reached North Africa. He worked in Forchtenberg, in Heidelberg, and, from 1620 until his death, in Schwäbisch-Hall, as a sculptor of ivory, wood, and stone, as well as bronze.

After a composition by
LEONHARD KERN

91. Nude women wrestling

Bronze, with medium brown natural patina, and traces of dark brown lacquer. Height 8¼ in. (21 cm.)
German, mid-17th century
1982.60.121

AN IVORY of this composition, in Vienna, has been convincingly assigned to the prolific Leonhard Kern.[1] The ivory is smaller (17.2 centimeters) and its self-base naturalistically carved with shells and a dog. Among other bronzes of this composition, equivalent in quality to ours, are those in the Wallace Collection, London, and in the Nationalmuseum, Stockholm. They are conventionally called Italo-Flemish, and are dated to the late sixteenth or early seventeenth century, because of their supposed resemblance to bronzes of the type of nos. 88 and 89.[2]

It is generally assumed that one of the bronzes was the model for the ivory, but the case is more likely to have been the reverse. While omitting the elaborate base of the ivory, the maker of the bronzes retained some, if not all, of the simple volumetric masses that typify Kern's carving style. This maker may best be defined as either a workshop associate or an early imitator.

The iconography remains unexplained. Diana discovering the pregnancy of Callisto and a scene from Tasso's *Gerusalemme liberata* (XV, 18) have been proposed as subjects.[3]

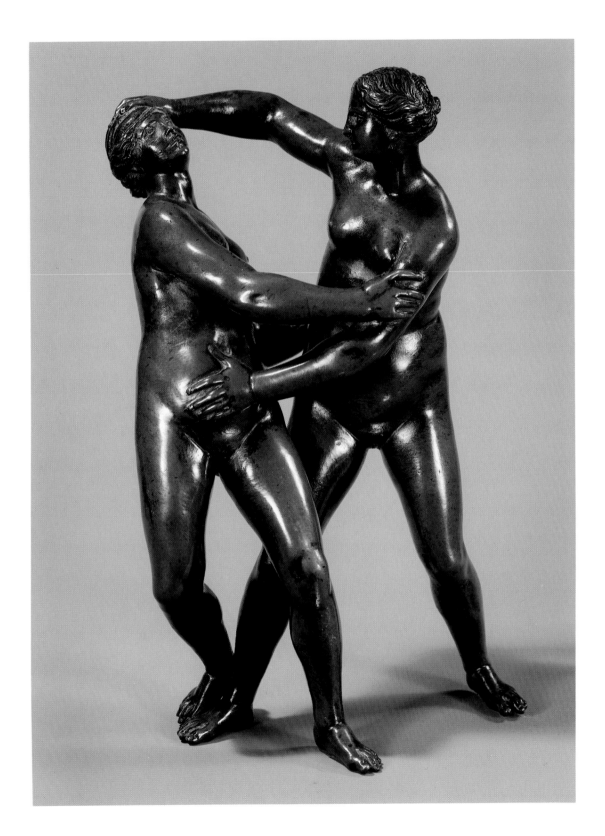

NOTES:

1. E. Grünenwald, *Leonhard Kern: ein Bildhauer des Barock*, Schwäbisch-Hall, 1969, no. 121, dated ca. 1635.

2. H. R. Weihrauch, *Europäische Bronzestatuetten, 15.–18. Jahrhundert*, Brunswick, 1967, p. 366, links them with his "Meister der Genrefiguren."

3. J. G. Mann, *Wallace Collection Catalogues. Sculpture*, 2nd ed. with supplement, London, 1981, no. 130.

EX COLL.: Michael Jaffé, London (sale, Sotheby's, London, May 18, 1967, no. 44).

BIBLIOGRAPHY: J. G. Mann, *Wallace Collection Catalogues. Sculpture*, 2nd ed. with supplement, London, 1981, no. 130.

CASPAR GRAS

Born ca. 1584, Constance or Mergentheim; died 1674, Schwaz

SCULPTOR-FOUNDER at the court in Innsbruck. His chief works in that city are the tomb of Archduke Maximilian III (of 1615–19) in Sankt Jakob, and the fountain (of 1623–29) with the equestrian figure of Archduke Leopold V.

92. Owl on a frog

Bronze, with brown lacquer patina. Height 6¾ in. (17.1 cm.)
Innsbruck, ca. 1620
1982.60.123

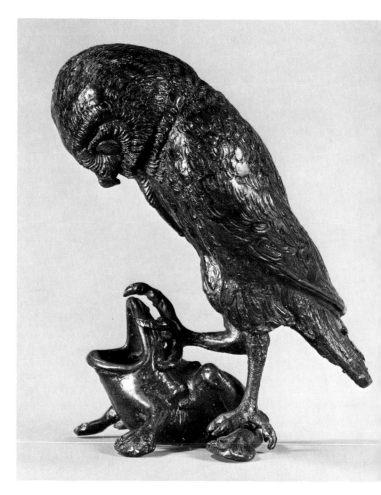

THE TASTE for naturalistic bronze animals such as frogs and crabs, often cast from life, seems to have begun in Padua and then spread northward. In the case of Caspar Gras, such objects were probably an outgrowth—and an easily marketable one—of his work on the bronze columns for the tomb of Archduke Maximilian III in the Jakobskirche, where the spiraling bands are inhabited by birds and insects.[1] The slightly granular surfaces of the columns are directly comparable to those of our owl, which was certainly modeled and not cast from life. The frog's open mouth serves as an inkwell. Another cast of the ensemble was in the Isaac Falcke collection.[2] The owl alone exists in casts in the Herzog Anton Ulrich-Museum, Brunswick, and in the Kunsthistorisches Museum, Vienna.[3] Like those of the Vienna example, the Linsky owl's eyes are emphasized by having been patinated a slightly more golden hue than the rest of the bronze.

NOTES:

1. E. Egg, "Caspar Gras und der Tiroler Bronzeguss des 17. Jahrhunderts," *Veröffentlichungen des Museum Ferdinandeum* XL (1960), fig. 10.

2. Sale, Christie's, London, Apr. 19, 1910, no. 65.

3. L. Planiscig, *Die Bronzeplastiken: Statuetten, Reliefs, Geräte und Plaketten*, Vienna, Kunsthistorisches Museum, 1924, no. 272, describes it as Manner of Giovanni Bologna. Planiscig's nos. 369–373 are birds attributed to Gras on the strength of their resemblance to those on the columns. They share with the owl a provenance from Schloss Ambras, Innsbruck.

174

93. Hercules and Antaeus

Ivory. Height 11 in. (28 cm.)
Probably Austrian, mid-17th century
1982.60.129

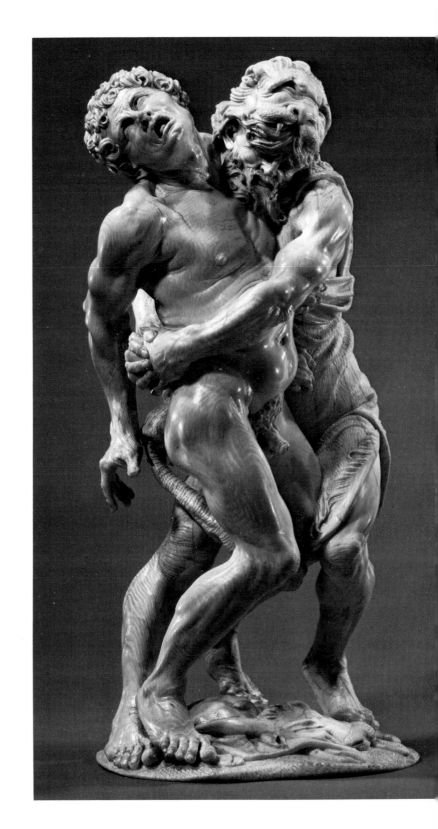

IN THIS ebullient Baroque carving, the coarse grain of the ivory is used to great advantage to underscore the fierce tension of the figures' muscles and veins. Graphically literal anatomy is the most salient characteristic of the carving, along with its virtuoso undercutting. When in the Anselm von Rothschild collection, the group sat atop a pedestal bearing an ivory relief said to represent Apollo and Marsyas,[1] although an old photograph[2] shows a pedestal—which looks to be the original—with the more appropriate subject of Hercules and the Cretan Bull.

The British Museum owns a virtually identically composed boxwood group (Waddesdon Bequest),[3] which came from the same collection, that of Anselm von Rothschild. The boxwood's details are marginally less incisive, and it may well be a later copy of our ivory. The animal's head on the base of the boxwood is similarly flattened, but the base itself is rounder: The original thickness of the wood before carving allowed the artist to effect a somewhat freer movement in the region of the lower limbs, whereas the ivory carver had to stay within the narrower bounds of the tusk. Additions to the tusk were necessary for Antaeus's left heel and Hercules' back (the latter addition is now missing).

The British Museum draws a parallel between the boxwood and the style of a relief of the Martyrdom of Saint Sebastian, dated 1655, in the Kunsthistorisches Museum, Vienna.[4] The anatomy of the figures in the relief is vigorously detailed with the same hyperrealism found in our ivory group, their features equally deeply cut and their hair drawn out in sinuous strands. A seminude figure wrestling with a snake, now in the Liechtenstein collections, Vaduz,[5] is by the same hand as the Vienna relief and the Linsky group.

NOTES:
1. F. Schestag, *Katalog der Kunstsammlung Freiherr Anselm von Rothschild*, II, Vienna, 1872, p. 16, no. 104.
2. The photograph was made available by Christian Theuerkauff, who is preparing an article on the origins of the works discussed here.
3. Height 29.8 cm. I am grateful to Hugh Tait for details concerning the boxwood, which also formerly had a pedestal inlaid with ivory.

4. E. von Philippovich, "Hauptwerke des Elfenbeinkünstlers Johann Caspar Schenck," *Kunst im Hessen und am Mittelrhein der Hessischen Museen* XIII (1973), pl. 1, pp. 47–50. Comparisons with the work of the Viennese carver Schenck (died 1674) are not entirely convincing.

5. From the Ernest Brummer collection, New York (sale, Galerie Koller, Zurich, Oct. 16, 1979, no. 99, as a figure of Laocoön).

EX COLL.: Anselm von Rothschild, Vienna.

BIBLIOGRAPHY: F. Schestag, *Katalog der Kunstsammlung Freiherr Anselm von Rothschild*, II, Vienna, 1872, p. 16, no. 104.

GOLDSMITHS' WORK AND JEWELRY

Catalogue entries by

CLARE VINCENT
CLARE LE CORBEILLER

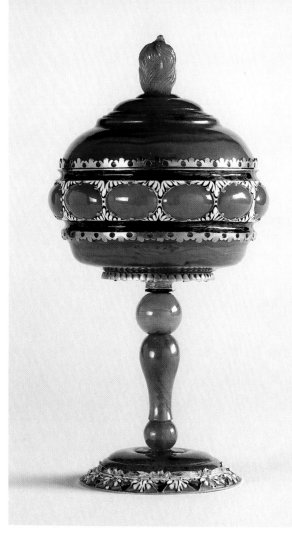

94. Cup and cover

Carnelian with enameled gold mounts. Height 4⅞ in.
 (12.4 cm.)
Mark engraved on rim of cover: *446*
French, ca. 1650–60
1982.60.134

THE FLAME finial and band of cabochon-cut gems of
carnelian, a reddish variety of chalcedony, set in bands of
black and white and translucent green-enameled gold,
identify this exquisite object as one of the French royal
treasures listed in an inventory made during the reign of
King Louis XIV (1643–1715). Daniel Alcouffe has recog-
nized that the majority of the objects made of polished
hardstone formerly in the collection of King Louis XIV
and now in the Louvre, Paris, were, in fact, purchased by
the king from the estate of his first minister, Cardinal
Mazarin, at the time of the cardinal's death in 1661.[1] The
published inventory of the cardinal's possessions, made

in 1653 and describing in detail his extraordinary collec-
tion of painting and sculpture, as well as household fur-
niture, plate, and goldsmiths' work, makes no mention,
however, of this object. While it is not possible at present
to be certain whether or not the cup was a later addition
to the cardinal's collection, the close resemblance of the
enameled gold mounts to the mounts of a group of ob-
jects shown to have been in the collection and illustrated
by Alcouffe strengthens the supposition that it was.[2]

The similarity of the leaf-motif ornament of the cup's
mounts to the ornament that adorns the mounts of many
of the objects in Alcouffe's group also permits their attri-
bution to a seventeenth-century French goldsmith. It is
an attribution based on the internal evidence provided by
the group. The sensuous beauty of colored hardstone has
been highly prized in a great many civilizations, and the
cardinal's collection contained finely cut and polished
hardstone objects of widely different origin and date. A
number of such pieces belonging to the group, mounted
with similar enameled-gold ornament, can thus be rec-
ognized as having been embellished about the middle of
the seventeenth century, when the cardinal was collecting
them, and, in all probability, by local goldsmiths.

Not only the mounts but also the hardstone compo-
nents of the Linsky cup and cover seem likely to have
been the products of a lapidary workshop that was both
local and contemporary. The separate pieces of translu-
cent reddish-brown carnelian that were used for the foot,
baluster stem, bowl, and cover, as well as the twelve ca-
bochon gems, are of similar hue and finish, and they
display a unity of style, both with one another and with
their mounts, that is seldom found in objects assembled
from components of widely divergent origins.

NOTES:
 1. D. Alcouffe, "The Collection of Cardinal Mazarin's Gems,"
Burlington Magazine CXVI (1974), pp. 514–26.
 2. Ibid., fig. 19, opp. p. 517.

EX COLL.: Louis XIV, king of France, Louis XV, king of France,
Louis XVI, king of France.

BIBLIOGRAPHY: J. M. Bion, C. G. F. Christin, and F. P. De-
lattre, *Inventaire des diamans de la couronne, perles, pierreries,
tableaux, pierre gravées, et autres monumens des arts & des sci-
ences existans au garde-meuble, imprimé par ordre de l'Assemblée
Nationale*, Paris, 1791, II, pp. 108–9, no. 446; J. Guiffrey, *In-
ventaire général du mobilier de la couronne sous Louis XIV (1663–
1715)*, Paris, I (1885), p. 203, no. 226.

95. Ewer

Smoky crystal with enameled gold mounts set with
diamonds. Height 9⅞ in. (25 cm.)
Attributed to the workshop of Ferdinand Eusebio
Miseroni (working 1656–84)
Bohemian, Prague, about 1680; probably mounted in
London ca. 1810–19
1982.60.138

THE NAPOLEONIC WARS resulted in an enormous displacement of art of all kinds, and, after the defeat of Napoleon in 1810, English collectors rushed to take advantage of the continental markets from which they had long been excluded. Among them was the eccentric millionaire William Beckford, who had commissioned the celebrated neo-Gothic Fonthill Abbey from the architect James Wyatt in 1796 and filled it with paintings, rare books and manuscripts, antique furniture, porcelains, and objects of art of all descriptions. One such treasure was this ewer, which appeared in an engraving titled "Groupe of the Rarest Articles of Virtu" in John Rutter's 1823 publication *An Illustrated History and Description of Fonthill Abbey.*

Beckford had purchased the ewer from the London antiques dealer Edward Baldock in 1819 with the understanding that it was a marriage present for Catherine Carnaro and the king of Cyprus made by the Italian Mannerist goldsmith Benvenuto Cellini, two claims that were, in fact, mutually exclusive, since Cellini was not born until some twenty-five years after the marriage. In a letter dated October 29, 1819, quoted by Boyd Alexander, Beckford says that he has been reading Cellini's autobiography in the hope of finding the ewer described, "though it matters little whether or not I find the answer—the object in itself deserves the most wholehearted eulogy."[1] Three years later, financial reverses forced Beckford to sell Fonthill and its contents, and the ewer appeared in Christie's auction catalogue, where it was described as "formed of the LARGEST KNOWN BLOCK of HUNGARIAN TOPAZ, hollowed out with vast labour, and externally sculptured, mounted with a Dragon Handle of gold enamelled set with Diamonds, and supported on a Tripod Stand, formed of Three small Dragons of green and blue Enamel. . . . The whole of the UNDOUBTED EXECUTION OF BENVENUTO CELLINI. . . . "

Modern connoisseurship permits the attribution of the ewer, made of a variety of crystalized quartz sometimes, and incorrectly, called smoky topaz, to the Prague workshop of Ferdinand Miseroni, and by comparison with examples made for Emperor Leopold I, it can be dated about 1680.[2] The mounts of rock-crystal vessels made in Prague during this period are usually quite modest. The dragon mounts of this ewer are designed in a kind of Renaissance style that cannot be identified with known works from any of the great centers of Renaissance goldsmiths' work, and, in any case, they would have been long out of fashion by the middle of the seventeenth century.

By reason of the technology employed in the working of the gold, the setting of the diamonds, and the assembling of the parts, these mounts cannot, in fact, have been made very long before Baldock sold the ewer to Beckford. They are in all probability the product of a still unidentified London goldsmith whose neo-Renaissance design must have drawn heavily on the same sources that inspired the chinoiseries of the Royal Pavilion at Brighton, especially those of the Banqueting Room, designed by John Nash and Robert Jones.[3]

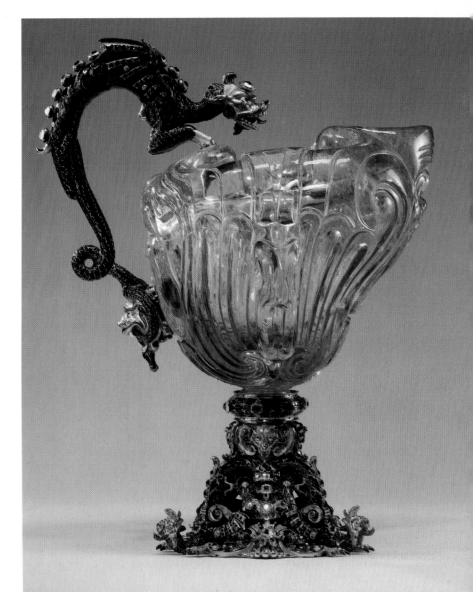

NOTES:
1. B. Alexander, *Life at Fonthill, 1807–1822, with Interludes in Paris and London, from the Correspondence of William Beckford*, London, 1957, p. 324.
2. See R. Distelberger, "Beobachtungen zu den Steinschneidewerkstätten der Miseroni in Mailand und Prag," *Jahrbuch der Kunsthistorisches Sammlungen in Wien* 74 (1978), pp. 126–52.
3. See H. D. Roberts, *A History of the Royal Pavilion, Brighton*, London, 1939, pp. 146–47.

EX COLL.: William Beckford, Fonthill Abbey, Wiltshire; Baron Nathaniel Rothschild, Tring, Hertfordshire.

BIBLIOGRAPHY: Christie's, London, *Magnificent Effects at Fonthill Abbey, Wilts.*, Oct. 1–10, 1822, pp. 42–43, Oct. 5, lot 50; J. Rutter, *An Illustrated History and Description of Fonthill Abbey*, Shaftsbury, 1823, p. 7; B. Alexander, *Life at Fonthill, 1807–1822, with Interludes in Paris and London, from the Correspondence of William Beckford*, London, 1957, pl. opp. p. 323, p. 190 n. 2, p. 323 n. 3, and pp. 323–324; B. Alexander, "Fonthill, Wiltshire III: William Beckford as Collector," *Country Life* CXL (Dec. 8, 1966), p. 1575, fig. 10, and p. 1576; J. Lees-Milne, *William Beckford*, Tilbury, England, 1976, p. 90.

CV

96. Pendant in the form of a cross

Enameled gold. Height 4¼ in. (10.8 cm.)
European, probably late 16th century
1982.60.379

WHILE PRECISE identification of this cross is difficult, the maker must have been familiar with more sophisticated goldsmiths' work made in the second half of the sixteenth century. The schematic form of the crucified Christ, the inexpert use of basse-taille enameling techniques, resulting in the loss of most of the enamel that once covered the front of the cross; and the rather awkward chasing of some of the symbols of the Passion, overlaid with translucent enamels on the back, indicate that the cross was not made in one of the major centers of European goldsmithing. The sides are inscribed ·ECCE·/ ·VT·/IMI/TERIS· and VT CONREGNES/COMPATERE [Behold. Suffer with Him in order that you may imitate Him and reign with Him (in Heaven)]. The cross is now a great deal more somber than its maker intended it to be, for, in addition to the loss of the dark blue enamel that once covered the front, only traces remain of the red, green, and white enamels that enlivened the foliate decorations on the ends of the arms.

BIBLIOGRAPHY: Y. Hackenbroch, *Renaissance Jewellery*, London, 1979, pl. XXXVIII, figs. 879A, B, p. 330, figs. 879A, B.

CV

97. Pendant with Charity and Her Children

Gold, partly enameled and set with diamonds, rubies, and an emerald and with pendent pearls. Height 5¹/₁₆ in. (12.9 cm.)
Probably German, Augsburg, late 16th or early 17th century
1982.60.375

from the series of the Virtues were copied with minor revisions by Johann Israël and Johann Théodore de Bry.[1] The goldsmith who made this jewel has modified the Mignot designs considerably, but he must have had extensive knowledge of them, for he adopted decorative details from several engravings in different series.

At some time in its history, this jewel was broken in two, and there is evidence of at least two attempts to refurbish it. The back was soldered together, and the small figures of Hope and Faith were added to strengthen the repair. The six cross-shaped jewel settings, each holding a ruby in the center and diamonds in the arms of the cross, were either repaired or, more likely, newly made. Still another, less skillful, goldsmith replaced or reenameled the base on which Charity stands and reset the jewels.

NOTE:
1. See A. Hämmerle, "Daniel Mignot," *Das Schwäbische Museum: Zeitschrift für Kultur, Kunst und Geschichte Schwabens*, Augsburg, 1930, p. 73, figs. 101–3.

EX COLL.: Karl von Rothschild, Frankfurt am Main.

BIBLIOGRAPHY: F. Luthmer, ed., *Der Schatz des Freiherrn Karl von Rothschild: Meisterwerke Alter Goldschmiedekunst aus dem 14–18. Jahrhundert*, Frankfurt am Main, II (1885), pl. 35; Y. Hackenbroch, *Renaissance Jewellery*, London, 1979, pl. xx, figs. 482A, B, p. 176, figs. 482A, B, pp. 178, 180.

CV

98. Pendant in the form of a seated cat

Baroque pearl with enameled gold mounts and with pendent pearls. Height 2¹⁄₁₆ in. (5.3 cm.)
Probably Spanish, late 16th or early 17th century
1982.60.391

YVONNE HACKENBROCH attributed this jewel to an Augsburg goldsmith working in the style of Daniel Mignot, a French Huguenot ornamental engraver, who was in Augsburg in the early 1590s and published a large number of engraved designs for jewels. A few of these are in the style associated with the Augsburg enamel work of David Altenstetter of around 1600, but many more have the airy, open, scrolled backs, decorated with swags and grotesques like those found on the reverse side of this pendant. One series of designs, dated 1593, illustrates pendants decorated with the Cardinal Virtues, including Charity clad only in a loose, open robe. Mignot's designs must have circulated widely, for at least three of them

THE TINY ANIMAL of this pendant has the expectant look of an impatient house cat awaiting its bowl of cream. A design for a comparable jewel with a seated but somewhat more placid cat appears in a drawing by Grabiell Gomar, dated 1603, from the *Llibres de Passanties*, a set of volumes in the Barcelona Archivo Histórico de la Ciudad, containing the master drawings of applicants for admission to the Barcelona goldsmiths' guild. The drawing was illustrated by Priscilla E. Muller, who noted that similar jewels had previously been considered to be German.[1] From the evidence provided by the design, however, Yvonne Hackenbroch has attributed this jewel to a Spanish goldsmith working about 1580 to 1590.

The Spanish design shows the cat seated on a cushion-like base decorated with ornamental scrolling. The base of this jewel consists of an oval plinth with openwork guilloche-patterned sides. The underside, possibly a later replacement, is decorated with enameled birds and foliage that owe their inspiration to the enamels associated with such northern centers as Augsburg and Prague.

NOTE:

1. P. E. Muller, *Jewels in Spain, 1500–1800*, New York, 1972, p. 94, fig. 149.

EX COLL.: Karl von Rothschild, Frankfurt am Main.

BIBLIOGRAPHY: F. Luthmer, ed., *Der Schatz des Freiherrn Karl von Rothschild: Meisterwerke Alter Goldschmiedekunst aus dem 14–18. Jahrhundert*, Frankfurt am Main, II (1885), pl. 31; Y. Hackenbroch, *Renaissance Jewellery*, London, 1979, pl. XXXX, fig. 904B, p. 338, fig. 904B.

CV

99. Pendant in the form of a parrot

Baroque pearls with enameled gold mounts and with pendent pearls. Height 2⅞ in. (7.3 cm.)
Probably Spanish, late 16th or early 17th century
1982.60.390

A COMPARABLE pendant from an inventory preserved in the Archivo del Real Monasterio in Guadalupe, Spain, is illustrated by Priscilla E. Muller, who noted that parrots were preferred subjects for Spanish Renaissance jewels and that another Spanish inventory of 1559 described one of "green-enameled gold" with "a pearl as its body, two suspended from its wings, a third atop the jewel."[1] Some of the feathers of the Linsky parrot jewel show evidence that they have been reenameled in blue and red over the translucent green with which they were originally enameled. A piece of mother-of-pearl fitted to the back of the bird may have been added when the jewel was reenameled.

NOTE:

1. P. E. Muller, *Jewels in Spain, 1500–1800*, New York, 1972, pl. IV, pp. 76–77.

CV

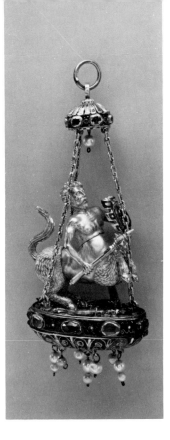

100. Pendant in the form of a centaur

Baroque pearl with enameled gold mounts set with sapphires and rubies and with pendent pearls. Height 3½ in. (8.9 cm.)
Possibly Spanish, late 16th or early 17th century
1982.60.381

BAROQUE PEARLS provided a special challenge to the imagination of the Renaissance goldsmith. The rather difficult shape of this irregular pearl has been used in an ingenious way to suggest the hybrid form of the centaur, the half-human, half-equine creature of classical myth. The base of the jewel incorporates an earlier piece of gold filigree work in a lobed pattern associated with Hispano-Moresque design. In addition, although reenameled, it displays traces of the dull enameled colors used by Hispano-Moresque goldsmiths. The jewel-decorated band on the side of the base, the chains, and the canopy from which the chains are suspended are later additions.

BIBLIOGRAPHY: Y. Hackenbroch, *Renaissance Jewellery*, London, 1979, pl. XXXXIII, fig. 899A, p. 336, fig. 899A.

CV

101. Pendant with a Pelican in Her Piety

Rock crystal and enameled gold set with a ruby and with pendent pearls. Height 3⁵⁄₁₆ in. (8.4 cm.)
Probably Spanish, first quarter of 17th century
1982.60.387

THE PELICAN sustaining her young by means of her own blood, here represented by the ruby mounted on the breast of the bird, is the Christian symbol for loving sacrifice and hence for Christ the Redeemer. From the Middle Ages onward jewels have been presented as votive offerings to religious shrines or cult figures, and the religious nature of this jewel suggests that it may have had some such provenance. Charles Oman has noted the existence in Spain of several richly endowed shrines as well as many lesser ones before the Napoleonic invasions of 1808.[1] The widespread destruction and looting by the French armies was followed by further depredations of religious treasure by both radical and impecunious governments throughout the century, but the last of the great treasuries was not dispersed until its sale in 1870 by the canons of the Cathedral of the Virgin of the Pillar in Saragossa.

The frame of this jewel, made of rock crystal and enameled gold, is similar both in media and in style to those of

several originally from the treasury of the cathedral in Saragossa now in the Victoria and Albert Museum, London.[2] While there is some evidence that at least one of these might be Italian in origin, there exists, on the other hand, a design for a pendant with a similar frame by a Spanish goldsmith, Honoffrio Fornes, who signed and dated his drawing April 5, 1589. The drawing was published by Baron Charles Davillier in the late nineteenth century.[3] (Baron Davillier did not give the location of the design, but it is probable that the *Llibres de Passanties* in the Barcelona Archivo Histórico de la Ciudad was his source.) It seems likely, therefore, that this jewel is Spanish.

NOTES:
1. C. Oman, "The Jewels of Our Lady of the Pillar of Saragossa," *Apollo* n.s. 5 (June 1967), pp. 400–406.
2. *Princely Magnificence: Court Jewels of the Renaissance, 1500–1630* (exhib. cat.), London, Victoria and Albert Museum, 1980, p. 81, figs. 96, 99, 108, pp. 80, 81, 83, nos. 96, 99, 108.

3. C. Davillier, *Recherches sur l'orfèvrerie en Espagne au moyen age et à la renaissance*, Paris, 1879, pl. XV opp. p. 242.

CV

102. Pendant with the Virgin and Child

Enameled gold set with diamonds and a ruby. Height 2½ in. (6.4 cm.)
Spanish, probably first half of 17th century
1982.60.383

THE STIFF, hieratic images of the Virgin and Child can be compared to those of several jewels known to have come from the treasury of the Cathedral of the Virgin of the Pillar in Saragossa, Spain.[1] The Saragossa Virgins stand on distinctive pillar supports, however; this Virgin also differs from them in that she wears a red robe rather than a blue one and has a large red ruby embedded in the back of her star-covered mantle. These distinctive features originally may have served to identify her with another Spanish shrine.

It is probable, however, that this jewel was made for quite a different purpose, for the crescent moon on which this Virgin stands identifies her as the Madonna of the Immaculate Conception. Priscilla E. Muller has called attention to the proliferation in sixteenth-century Spain of confraternities formed to promote acceptance of the Im-

maculate Virgin as dogma.[2] These confraternities reached their greatest influence in the second decade of the seventeenth century, when gold images of the Virgin were worn as emblems by confraternity members.

NOTES:
1. *Princely Magnificence: Court Jewels of the Renaissance, 1500–1630* (exhib. cat.), London, Victoria and Albert Museum, 1980, p. 80, figs. 104, 107, pp. 82–83, nos. 104, 107.
2. P. E. Muller, *Jewels in Spain, 1500–1800*, New York, 1972, pp. 120–23.

BIBLIOGRAPHY: Y. Hackenbroch, *Renaissance Jewellery*, London, 1979, pl. XXXXIV, fig. 912, p. 339, fig. 911.

CV

103. Pendant in the form of a hand

Rock crystal with enameled gold mount set with emeralds. Height 2⅝ in. (6.7 cm.)
Possibly Spanish, first half of 17th century
1982.60.394

JEWELS HAVE been worn as amulets from time immemorial. The earliest known lapidary, or mineralogical treatise, written by the Greek Theophrastus in the fourth century B.C., attributed both medicinal and magical

properties to gems. Late Medieval and Renaissance European lapidaries not only listed the physical properties of minerals and precious stones, but also drew upon Greek sources among others in attributing intrinsic virtues or magical powers to gems. As late as the first half of the seventeenth century, a lapidary of this type, written by Anselm Boëtius de Boodt, *Gemmarum et Lapidum Historia*, went through at least four editions, the first published in Hanover in 1609. A French translation appeared in 1644, and another edition of 1647 included the treatise of Theophrastus. Joan Evans has discussed de Boodt's work in detail and noted that he highly recommended the protective influence of the emerald.[1] Worn around the neck or on the finger, emeralds would, among other things,

prevent epilepsy, avert panic fear, and ward off demons. Their use on the mount of this jewel is not likely to have been merely decorative, for the mount is a sleeve that secures a rock-crystal hand, or, more specifically, a fist, with the thumb projecting between the first and second fingers, a gesture believed to ward off the baleful effects of the evil eye.

The purpose of this pendant would thus seem to support a southern European attribution. Such amulets were known in Spain as *higas*, and a similar one in the Museo de la Fundación Lázaro Galdiano in Madrid is illustrated

by Priscilla E. Muller.[2] It is by no means certain, however, that all of them were made in Spain. A fist-shaped amulet of rock crystal referred to as a *Feige* is illustrated by Liselotte Hansmann and Lenz Kriss-Rettenbeck; the authors identify it as probably German and compare it to a detail showing a fist or *Feige* from a sheet of sketches by Albrecht Dürer in the Albertina in Vienna (45.420).[3]

Stylistically, the enameled floral and scroll designs on the mount of this pendant most closely recall those of the hardstone and rock-crystal objects mounted in France during the first half of the seventeenth century. During the same period, however, there was extensive mining of Colombian emerald deposits by the Spanish. The exclusive use of emeralds on the mount of this pendant may stem from the belief in their magical properties, but it also strengthens the likelihood that the pendant was, in fact, made in Spain, or in the Spanish possessions in Italy and the Mediterranean islands.

NOTES:
1. J. Evans, *Magical Jewels of the Middle Ages and the Renaissance, Particularly in England*, Oxford, 1922, pp. 152–54.
2. P. E. Muller, *Jewels in Spain, 1500–1800*, New York, 1972, p. 69, no. 94.
3. L. Hansmann and L. Kriss-Rettenbeck, *Amulett und Talisman: Erscheinungform und Geschichte*, Munich, 1966, p. 199, fig. 640.

CV

104. Pendant in the form of Neptune and a sea monster

Baroque pearl with enameled gold mounts set with rubies, diamonds, and pearls. Height 4⅜ in. (11.1 cm.)
Probably Netherlandish, early 17th century
1982.60.378

THE SIMILARITY of this sea monster to designs by Hans Collaert the Elder (about 1530–1581) has been commented upon by Yvonne Hackenbroch, who noted that the designs are known from the engravings of them by Hans Collaert the Younger, published in 1582 by Philip Galle in Antwerp.[1] On the basis of these engravings Hackenbroch attributed this jewel to a goldsmith of Netherlandish origin, working about 1580–90. This monster, especially on the reverse side of the large baroque pearl that forms its belly, is quite realistic looking, however, and it may per-

185

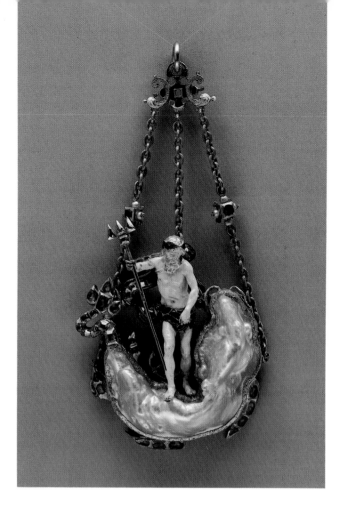

NOTES:
1. Y. Hackenbroch, *Renaissance Jewellery*, London, 1979, pp. 234–38.
2. See F. W. H. Hollstein, *Dutch and Flemish Etchings, Engravings and Woodcuts*, Amsterdam, [1949–80], IV, p. 207, nos. 648–702.

BIBLIOGRAPHY: Y. Hackenbroch, *Renaissance Jewellery*, London, 1979, pl. XXVII, figs. 653A, B, p. 242, figs. 653A, B, p. 243.

CV

105. Pendant with a head of the Virgin

Bloodstone with enameled gold mount. Height 3⅜ in. (8.6 cm.)
Probably Bohemian, Prague, early 17th century
1982.60.393

THE SUBJECT of this jewel was probably derived from a bronze medal attributed by Leo Planiscig to Antonio Abondio the Younger (1538–1591).[1] Abondio was born in Milan, but he spent a great deal of the later part of his life at the courts of the Hapsburg emperors Maximilian II and Rudolph II in Vienna and Prague. In addition to the medal depicting the Virgin, there is another attributed to Abondio with the head of Christ. Variants of these two images appear on several jewels mounted as pairs now in the Kunsthistorisches Museum, Vienna. These were attributed by Fritz Eichler and Ernst Kris to an Italian working in the early seventeenth century,[2] and, in fact, there is another jewel with a head of the Virgin belonging to this group in the collection of the Museo degli Argenti in Florence, as well as a fifth head of the Virgin, now mounted in a ring, in the Milton Weil Collection in the Metropolitan Museum (acc. no. 39.22.6). All the jewels belonging to this group are of carved and polished bloodstone or heliotrope, a variety of dark green chalcedony with reddish spots, an appropriate medium, since the spots were traditionally regarded as symbolic of the blood of Christ.

Three other jewels are related by their subject to this group. One, carved with a variant of the Abondio head of the Virgin, has been identified as the work of Ottavio Miseroni (recorded 1588–died 1624) on the basis of its stylistic similarities to a jewel signed by that artist.[3] The other two are a pair depicting the Virgin and Christ, also attributed to Miseroni, in the collection of the Reiche

haps owe as much, if not more, to the engraved fishes by another Antwerp artist, Adriaen Collaert (about 1560–1618), also published by Philip Galle in a series of 1588.[2] While they are still subject to embellishment, the engravings of the latter Collaert are based, by and large, on the observation of nature, and they differ quite markedly from those of the fanciful sea creatures of Hans Collaert the Elder.

The engravings of both Collaerts were widely circulated and could thus have been put to use by a goldsmith working in any of the European courts or other major centers where patronage for such luxury items was to be found. The figure of Neptune, the sea god, who calmly bestrides the thrashing fish, also suggests a Netherlandish connection, but one of slightly later date, for it is closest in style to some of the early seventeenth-century sculpture and metalwork made by Dutch-born late Mannerists such as Adrien de Vries and Paulus van Vianen.

Certain peculiarities in the way the chains are joined to the body of the fish and an empty hole at the bottom suggest that the jewel was not always suspended in the present fashion. Both the fish and Neptune's cloak have been reenameled.

186

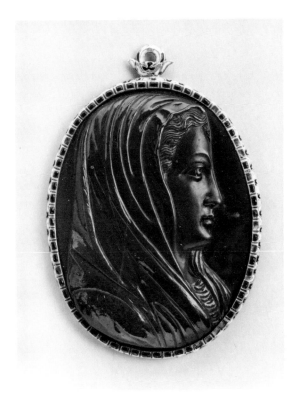

3. Ibid., p. 144, no. 305, pl. 42, no. 305.

4. E. Kris, *Meister und Meisterwerke der Steinschneidekunst in der italienischen Renaissance*, Vienna, 1929, I, p. 189, nos. 604, 605; II, p. 181, nos. 604, 605.

CV

106. Locket

Gold, partly enameled, and rock crystal. Height 1⁹⁄₁₆ in. (3.9 cm.)
Probably French, ca. 1620–40
1982.60.388

THE BACK of this locket is a fine and rather rare example of a type of ornament called "peapod," although the individual elements often look more like leaves than peapods. Peapod ornament was popularized by French engravers, and an engraved design for a jewel of the type by Gédéon l'Egaré (1615–1676) was published by Désiré Guilmard in the late nineteenth century.[1] Guilmard identified l'Egaré as one of several artists who provided designs for similar ornamental engravings that he dates to the third and fourth decades of the seventeenth century.

The peapod ornament on this locket was executed in the champlevé enamel technique, by which the gold ground was cut away to form the design and to receive the colored enamels. The object was then fired and the hardened enamel polished down to the level of the metal. The enamels used were translucent blue, green, and golden brown, accented with black, white, and pale blue opaque enamels. The cover, made of polished rock crystal set in an enameled gold bezel and hinged to the back of the case, may originally have protected a painted miniature.

NOTE:

1. D. Guilmard, *Les Maîtres ornemanistes*, Paris, 1881, II, pl. 20.

CV

Kapelle in Munich.[4] All three jewels are carved from various colored hardstones. Like Abondio, Ottavio Miseroni was of Milanese origin. He was a member of a family that, with Jacopo da Trezzo the Elder, Leoni Leoni, Annibale Fontana, and the Sarachi, made Milan famous for its lapidary work in the second half of the sixteenth century. About 1600 Ottavio Miseroni was employed by Rudolph II in Prague, and he set up a workshop there for the carving and polishing of hardstones and rock crystal.

The carved hardstone jewels that can be firmly attributed to Ottavio Miseroni are somewhat different from the group made of bloodstone. While the latter group cannot be connected to the Miseroni workshop with any certainty, the presence of so many of them in former Hapsburg imperial collections would seem to indicate that they may indeed have originated in Prague.

NOTES:

1. L. Planiscig, comp., *Die Estensische Kunstsammlung I: Skulpturen und Plastiken des Mittelalters und der Renaissance*, Vienna, 1919, p. 195, no. 426, pl. 30, no. 426.

2. F. Eichler and E. Kris, comps., *Die Kameen im Kunsthistorischen Museum*, Vienna, 1927, pp. 177–78, nos. 416–19, pl. 59, nos. 416, 417, pl. 61, nos. 418, 419.

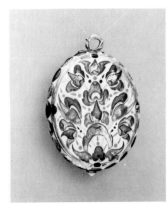

107. Rosette

Gold, partly enameled and set with diamonds,
 emeralds, spinels, and pearls. Diameter 3¹/₁₆ in. (7.8
 cm.)
Probably Hungarian, second quarter of 17th century
1982.60.385

JEWELED ROSETTES of this kind have had functions as
various as fastenings for ecclesiastical vestments, as fastenings for a type of coat worn by Hungarian men, as
brooches for women, and even as horse trappings. Six
gold loops, four on the back of this rosette and two on
the circumference, are the only surviving evidence of its
original form of attachment, ruling out the probability of
its use as a morse, since morses are usually equipped with
some form of hook to hold the two sides of a cope together.

Somewhat comparable in form to this rosette are several ornaments that are parts of clasps or chains for securing the Hungarian *mente*, or short coat, illustrated by
Angéla Héjj-Détári, who also illustrated a Hungarian
brooch of comparable form made in the late seventeenth

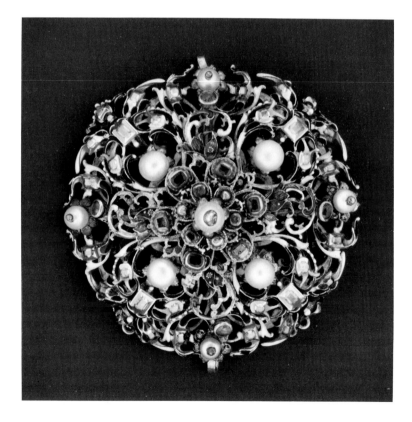

or early eighteenth century.[1] Several portraits of the first
half of the seventeenth century showing women wearing
large, circular brooches or pendants are illustrated by Erna
von Watzdorf, and she also illustrates the jeweled rosettes
used as decorations for the harness of a horse that belonged to the elector of Saxony, Johann Georg IV (ruled
1691–94).[2] Our rosette could have been made for any of
these purposes.

Watzdorf also published several surviving and comparable rosettes, which are in the collection of the Historisches Museum in Dresden and thought to be seventeenth-century German, as well as still another example now in
the Victoria and Albert Museum in London.[3] The jeweled scrollwork of the Victoria and Albert Museum's rosette is closest in style to the foliate scrolls of the outer
circles of the Linsky rosette, and in the most recent publication of the Victoria and Albert Museum's jewels, Shirley Bury has attributed their rosette to a Hungarian
goldsmith working about 1630.[4]

Our rosette has undergone several modifications in the
course of its history. The central jeweled ornament is a
replacement, perhaps of the late seventeenth or early
eighteenth century, and it somewhat resembles Hungarian work of that time. The four outer pearls and their
settings may also date from the same period. The four
pearls nearest the central boss and at least two of the six
gold loops on the outer circumference of the rosette are
modern additions.

NOTES:
1. A. Héjj-Détári, *Old Hungarian Jewelry*, trans. L. Halápy,
Budapest, 1965, pl. 28, p. 61, no. 28, pl. 35, p. 63, no. 35, pl. 38,
p. 63, no. 38.
2. E. von Watzdorf, "Der Dresdner Goldschmied Abraham
Schwedler und sein Kreis," *Zeitschrift für Kunstwissenschaft* XVI
(1962), p. III, fig. 23, p. 115, figs. 26, 27, p. 116, fig. 28, p. 112,
fig. 24.
3. Ibid., p. 113, fig. 25, p. 121, fig. 33, and p. 123, fig. 35.
4. S. Bury, in Victoria and Albert Museum, *Jewellery Gallery
Summary Catalogue*, London, 1982, p. 73, no. 3.

CV

HARDSTONES—which were found in abundant supply and variety in the mines of Saxony and Silesia—are the focal element in much German goldsmiths' work and *galanterien* of the eighteenth century. The carving of stones into naturalistic and zoomorphic forms has been traditionally associated with Dresden, where the court jeweler Johann Melchior Dinglinger (1664–1731) produced ornamental figures of great skill and inventiveness composed of jewels, hardstones, and gold; such pieces are invariably unmarked, however, and their origin cannot be considered certain. In addition to this piece only one other comparable model is known, an agate bull supporting a watch in the Metropolitan Museum (acc. no. 48.185.1), evidently

108. Cameo with the head of a satyr

Sardonyx with gold mount. Height 2⅛ in. (5.4 cm.)
Probably Italian, late 18th or early 19th century
1982.60.392

THE TRADITION of representing satyrs on intaglios and cameos is an ancient one, stretching back at least as far as sixth-century Greece. This cameo, with its forced perspective and strong, unidealized image, belongs to a rather late stage in the evolution of the representation of the sylvan deity. It was probably made in Italy, the chief center of cameo production in the late eighteenth and the nineteenth century, as it is today.

CV

109. Miniature clock in the form of an elephant supporting a watch case and standing on a base with a hinged (snuffbox?) compartment

Agate, heliotrope, gold, and diamonds. Height 7⁵⁄₁₆
 in. (18.5 cm.)
Unmarked
German, Dresden (?), ca. 1750; watch dial a later 18th-
 century replacement
1982.60.140

from the same workshop. The bull clock is about fifteen years earlier in date and somewhat less finished in several details of carving and goldsmithing, but it shares with this piece, in addition to the basic design, such devices as the leaf-strewn base and hinged compartment.

Although made for this piece, the watch does not appear to be original to it; the unusual placement of the numbers on the dial and the pastel enameling indicate a date of about 1770.

<div align="right">CLC</div>

110. Nécessaire

Mother-of-pearl and gold, fitted inside with sewing and writing implements and a watch signed *Roth/a Paris*. Width 5 in. (12.7 cm.)
Unmarked
German, 1745–50
1982.60.135

SOME HALF-DOZEN boxes of this type are known and have been variously attributed as English, French, and German. All are unmarked, which precludes any possibility of their being French. This example, by far the most sophisticated and refined of the group, is also the most unmistakably German, the swooping bird, the trees, and in particular the flamelike scrolls all echoing the work of the Munich designer François Cuvilliés (1695–1768). Grandjean illustrates a simpler box with similar but less dramatic scrollwork that he considers to be probably German on the grounds of affinity with ornamental designs of the Augsburg school.[1] This piece, the Waddesdon box, and a third example exhibited in New York in 1968[2] all depict exotic figures (Indians or Turks) on the cover and appear to comprise a group to themselves, of which this box is quite the most accomplished.

The signature on the watch cannot be identified, as no watchmaker named Roth is recorded as working in Paris in the eighteenth century. An André Roth died in Strasbourg in 1754.[3]

NOTES:
1. S. Grandjean, *The James A. de Rothschild Collection at Waddesdon Manor: Gold Boxes and Miniatures of the Eighteenth Century*, Fribourg, Switzerland, 1975, no. 45.
2. A La Vieille Russie, *The Art of the Goldsmith and the Jeweler* (exhib. cat.), New York, 1968, no. 143.
3. Tardy, *Dictionnaire des horlogers français*, Paris, 1971–72, p. 572.

<div align="right">CLC</div>

III. Automaton in the form of a chariot pushed by a Chinese attendant and set with a clock

Gold, brilliants, and paste jewels. Height 10 in. (25.4 cm.)
Signed on dial plate: *J^a Cox/London*
Maker: James Cox (working ca. 1749–83; d. 1791)
English, London, 1766
1982.60.137

BIBLIOGRAPHY: [W. Meyrick], *A Short Account of the Remarkable Clock Made by James Cox, in the Year 1766, by Order of the Hon. East India Company for the Emperor of China: Illustrated*, London, 1868; C. Davis, comp., *A Description of the Works of Art Forming the Collection of Alfred de Rothschild*, London, 1884, II, no. 141; E. Wenham "Time-tellers—Ingenious and Quaint," *Antique Collector* 24 (1953), fig. 12, p. 212; C. Le Corbeiller, "James Cox: A Biographical Review," *Burlington Magazine* CXII (1970), p. 351, fig. 4.

CLC

THE AUTOMATON is set in motion by levers that activate the whirligig held in the woman's left hand and the wings of the bird perched above the dial of the clock. A bell hidden beneath the lower tier of the parasol sounds the hours, and the entire mechanism is propelled by a spring and fusee device housed above the two central wheels.

This is the surviving half of a pair of automata commissioned from Cox by the English East India Company for presentation to the Ch'ien Lung emperor in 1766.[1] Almost nothing is known of Cox before this date, but it is clear that he must have acquired a reputation for this genre, with which his name is regularly associated. From 1766 until 1772 Cox was preeminent in the vigorous but short-lived industry manufacturing clocks and automata for the Chinese market. In the latter year financial considerations led him to exhibit his inventions—with a view to selling them by lottery—in his "museum" in Spring Gardens, Charing Cross, London. His activity diminished after a second exhibition in 1773, but he continued to supply the Chinese market at least until 1783.

According to an account published in 1868, this piece had recently been acquired by a Bond Street dealer in Paris with the story that it had been brought from Peking by a French sailor, evidently as spoils of the looting of the Summer Palace by the English and French in 1860. The London dealer then sold it to an anonymous collector, who was presumably Alfred de Rothschild, in the catalogue of whose collection the automaton appeared in 1884.

NOTE:
1. *The Gentleman's Magazine* XXXVI (Dec. 1766), p. 586.

EX COLL.: Alfred de Rothschild, London.

EXHIBITED: A La Vieille Russie, New York, *Antique Automatons*, Nov. 3–Dec. 5, 1950, no. 13, fig. 1 (lent by Mr. and Mrs. Jack Linsky).

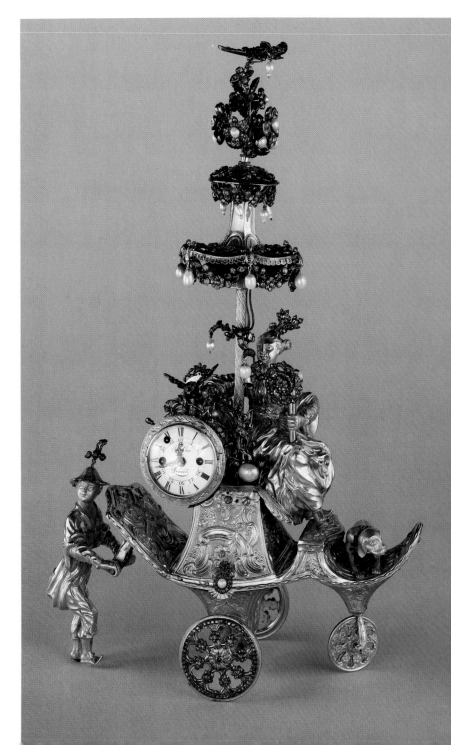

112. Automaton in the form of a triumphal chariot drawn by four horses

Gilt bronze and brilliants. Length 14⅝ in. (37.1 cm.)
Unmarked
English, 1760–70
1982.60.136

A SPRING-DRIVEN device above the right front wheel activates that wheel and two shafts beneath the horses, propelling the chariot forward and causing each pair of horses to bob back and forth. As the shafts are jointed, the chariot can be steered by turning the lead horses to the right or left.

Automata of this type are in character with those made by James Cox, and, while the workmanship of this piece is from a different hand, its accomplished style is quite compatible with that of Cox's automaton of 1766 (no. 111). A variant model of this automaton was formerly in the Foy collection[1] and included, in place of the military trophy resting on the seat of the chariot, a watch signed by the London watchmaker James Upjohn (working 1760–about 1779). Two somewhat similar carriage automata—one driven by horses, the other pulled by flying doves—are at Waddesdon Manor;[2] the latter is surmounted by a watch signed by the unrecorded watchmaker William Crouch. The designers and casters of the gilt-bronze elements of these pieces are so far almost entirely anonymous, and it is possible at this time only to note the existence of differences in the styles and degrees of refinement in their production.

NOTES:
1. Thelma Chrysler Foy collection, New York (sale, Parke-Bernet, New York, May 22–23, 1959, lot. no. 645).
2. G. de Bellaigue, *The James A. de Rothschild Collection at Waddesdon Manor: Furniture, Clocks and Gilt Bronzes*, Fribourg, Switzerland, 1974, I, nos. 25, 26.

CLC

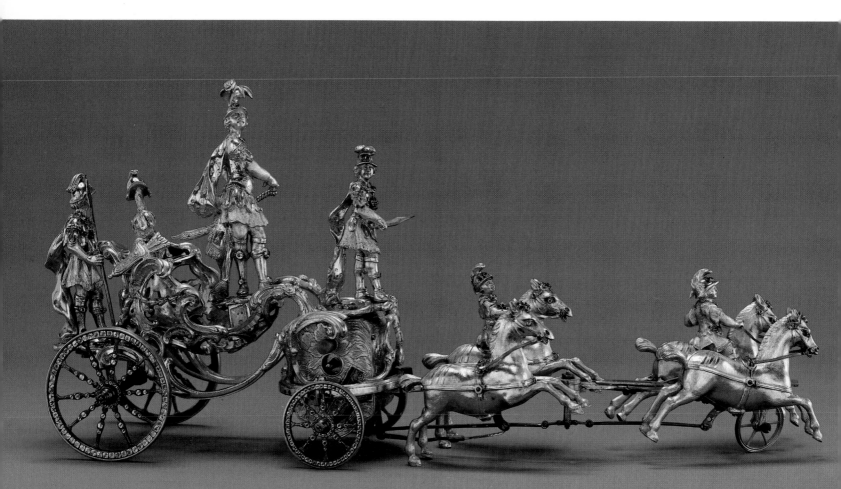

113. Miniature cabinet or house altar

Ebonized fruitwood and enameled gold. Height 14½
in. (36.8 cm.)
Designed by Reinhold Vasters (1827–1909)
Probably French, ca. 1876–95
1982.60.133

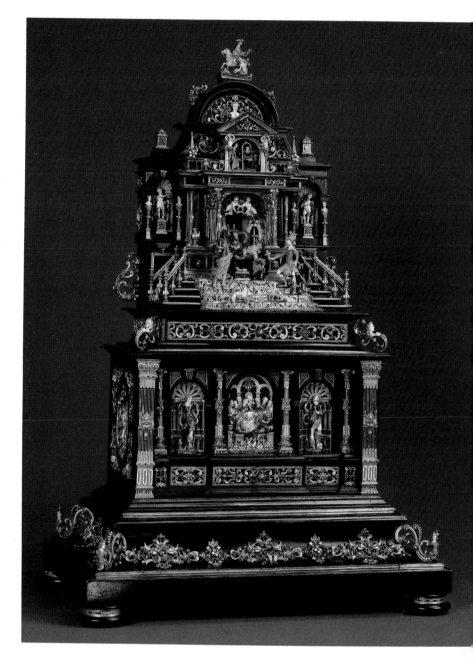

REINHOLD VASTERS is listed in the standard work on German goldsmiths, *Der Goldschmiede Merkzeichen*, as a goldsmith who worked in Aachen between 1853 and 1890.[1] Only one piece, a cross in the cathedral of Aachen marked R. VASTERS, was known to the author, Marc Rosenberg, but since his publication, a great deal more has been learned about Vasters, and much of it will appear in a forthcoming article by Yvonne Hackenbroch.[2]

Our present understanding of Vasters's activities rests to a great extent on his surviving designs for goldsmiths' work. More than a thousand of them, chiefly but not exclusively in medieval and Renaissance style, were assembled after Vasters's death in 1909 and given to the Victoria and Albert Museum, London. It was not until quite recently, however, that the significance of the drawings was recognized. In an article in *Connoisseur*, Charles Truman, a curator at the Victoria and Albert Museum, began to match the designs with objects in various museums and private collections.[3] Most had long been thought to be the work of sixteenth- and early seventeenth-century goldsmiths, and among the objects mentioned was this cabinet or house altar, so named because it was thought to have been made as a small private altar. The top, an elaborate architectural setting for a miniature Nativity, seems to support this supposition, but the lower portion, though decorated with scenes from the Passion of Christ, is fitted with drawers and secret compartments that have more in common with Renaissance jewel cabinets than with portable altars.

Truman noted that a large number of drawings for the object exist and that, unlike the rest of the surviving drawings, the accompanying instructions for their execution are written in French. The object is, in fact, believed to have a French Rothschild provenance, and it seems likely that it was actually made in France from the detailed drawings for both the cabinetry and goldsmiths' work provided by Vasters. The cabinet had previously been accepted as the product of a late-Renaissance or Mannerist goldsmith of south German origin and had even been attributed to the workshop of Abraham Lotter the Elder.[4] Lotter was an Augsburg goldsmith who, with the cabinetmaker Hans Krieger, is recorded as having worked for the Bavarian court in the 1570s, and the two have been identified by Ulla Krempel as the makers of the house altar of Duke Albrecht v now in the Schatzkammer in Munich,[5] as well as another house altar also in the Munich Schatzkammer.[6]

It is not known whether Reinhold Vasters actually saw

these house altars, but detailed lithographs of the two, as well as a third known as the "altar of the Three Kings," also in the Munich Schatzkammer, are to be found in a Munich publication of 1876.[7] The last of the three was undoubtedly Vasters's source of inspiration for the top of the Linsky cabinet, and it contains a similar architectural setting with a steep flight of steps upon which the Magi approach the crib of the Christ Child. The figures of the Magi and the Saint Joseph of the Nativity, the angel Gabriel and the Virgin of the Annunciation scene above, as well as some of the decorative scrolls, terms, and the two figures flanking the relief of the Last Supper on the lower part of the Linsky cabinet have all been adopted quite literally from the Munich altar of the Three Kings. The remainder of the decoration of the present cabinet is a skillful evocation of the style of the Munich altar.

NOTES:

1. M. Rosenberg, *Der Goldschmiede Merkzeichen*, Frankfurt am Main, I (1922), p. 12.

2. Y. Hackenbroch, "Reinhold Vasters," *Metropolitan Museum Journal*, forthcoming.

3. C. Truman, "Reinhold Vasters: 'The Last of the Goldsmiths'?," *Connoisseur* 200 (Mar. 1979), pp. 154–61.

4. See U. Krempel, "Augsburger und Münchner Emailarbeiten des Manierismus aus dem Besitz der Bayerischen Herzöge Albrecht V, Wilhelm V, und Maximilian I," *Münchner Jahrbuch der Bildenden Kunst* XVIII (1967), p. 152, fig. 51, p. 156.

5. Ibid., pp. 137–45, p. 136, fig. 29, p. 137, fig. 30, p. 138, fig. 31, p. 176, no. 17.

6. Ibid., p. 140, fig. 32, p. 141, fig. 33, pp. 177–78, no. 19.

7. L. Enzler, F. X. Zettler, and J. Stockbauer, *Ausgewählte Kunstwerke aus dem Schatz der Reichen Capelle in der Königlichen Residenz zur München*, Munich, 1876, pls. I, IX, XXI.

EX COLL.: Arturo Lopez-Willshaw, Paris (sale, Sotheby's, London, Oct. 13, 1970, pp. 38–41, lot 20).

BIBLIOGRAPHY: U. Krempel, "Augsburger und Münchner Emailarbeiten des Manierismus aus dem Besitz der Bayerischen Herzöge Albrecht V, Wilhelm V, und Maximilian I," *Münchner Jahrbuch der Bildenden Kunst* XVIII (1967), p. 152, fig. 51, and p. 156; J. F. Hayward, *Virtuoso Goldsmiths and the Triumph of Mannerism, 1540–1620*, London, 1976, p. 380, no. 453, fig. 453; C. Truman, "Reinhold Vasters: 'The Last of the Goldsmiths'?," *Connoisseur* 200 (Mar. 1979) p. 158.

CV

114. Pendant with a Triton riding a unicorn-like sea creature

Baroque pearl mounted with enameled gold set with pearls, emeralds, and rubies and with pendent pearls. Height 4½ in. (11.5 cm.)
Designed by Reinhold Vasters (1827–1909)
Probably German or French, ca. 1870–95
1982.60.382

WITH THE EXCEPTION of the links of the chain, an additional molding separating the two bands of decoration on the base, and the unicorn's horn, this jewel is identical to one in a design in the Victoria and Albert Museum, London (inv. no. E 2818-1919), by Reinhold Vasters of Aachen. The design was included among the nineteenth-century Renaissance-style jewels and jewelry designs in that museum's exhibition *Princely Magnificence: Court Jewels of the Renaissance, 1500–1630*. It is illustrated in the exhibition catalogue,[1] where it was noted that the base of a jewel in the same exhibition lent by Lord Astor of Hever was made from the design for the lower part of the base of the jewel in the drawing.[2] The same jewel was illustrated in the catalogue of the collec-

tion of Frederick Spitzer, where it was identified as an Italian work of the sixteenth century.[3]

The variation in quality and variety of media found in objects known to have been made from Vasters's designs indicate that a number of craftsmen were employed in carrying them out. Although many of the designs are accompanied by directions for their execution, and nearly all the directions are written in German, many of the objects made from them were sold by Frederick Spitzer in Paris. Some of them, at least, may have been executed there. It seems possible on the evidence provided by this jewel to question whether all the designs were in fact executed under Vasters's supervision. The creature in the drawing for this jewel is without a horn. Vasters probably intended it to be a hippocampus, but the identity of the finished figure is confused by the addition of the horn to its forehead, and one wonders whether the resulting seagoing unicorn might have been the whim of the goldsmith who executed the design.

NOTES:

1. *Princely Magnificence: Court Jewels of the Renaissance, 1500–1630* (exhib. cat.), London, Victoria and Albert Museum, 1980, p. 140, fig. HG4, pp. 139–40, no. HG4.

2. Ibid., p. 138, fig. H20.

3. F. Spitzer, *La Collection Spitzer: Antiquité, moyen-âge, renaissance*, Paris, III (1891), p. 152, no. 56.

BIBLIOGRAPHY: Y. Hackenbroch, *Renaissance Jewellery*, London, 1979, pl. XXXX, fig. 908, p. 338, fig. 908.

CV

Pierpont Morgan Collection in The Metropolitan Museum of Art (acc. no. 17.190.882).[2]

While it is possible that the frame may have been designed for existing pieces of *verre églomisé*, or reverse-painted glass, close examination of the paintings suggests that they, too, are the products of a nineteenth-century craftsman. There are four *verre églomisé* paintings, all apparently by the same hand. Those on one side of the jewel illustrate the Nativity and Annunciation to the Shepherds and, in the center, a separate piece shows a hermit saint kneeling before a crucifix; on the other side are the Adoration of the Magi and, in the center, a female saint seated in front of a crucifix. Leaving aside the question of whether or not it is probable that four complementary sixteenth-century pieces are likely to have been available for mounting in the nineteenth century, the vagueness of the iconographic scheme and the inferior quality of the painting indicate that the entire jewel is probably a nineteenth-century fabrication.

NOTES:

1. See E. Steingräber, *Antique Jewelry*, New York, 1957, p. 125, fig. 209.

2. F. Dennis, *Renaissance Jewelry: A Picture Book*, New York, 1943, fig. 4.

BIBLIOGRAPHY: Y. Hackenbroch, *Renaissance Jewellery*, London, 1979, pl. XXXIX, fig. 885, p. 331, fig. 885.

CV

115. Pendant with scenes from the Life of Christ and Two Saints

Verre églomisé with enameled gold mounts and with a pendent pearl. Height 5¼ in. (13.3 cm.)
Designed by Reinhold Vasters (1827–1909)
German or French, ca. 1870–95
1982.60.380

THE FRAME of this pendant was made from an unpublished design by Reinhold Vasters in the collection of the Victoria and Albert Museum, London (inv. no. E 3569-1919). The pendant is based on a sixteenth-century type believed to have been made in northern Italy or perhaps Spain.[1] Faith Dennis published an example from the J.

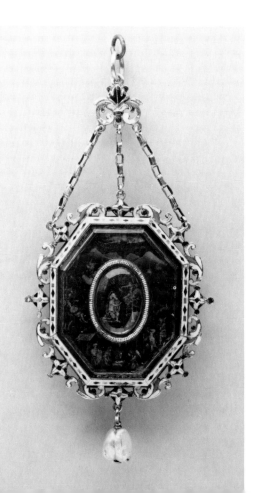

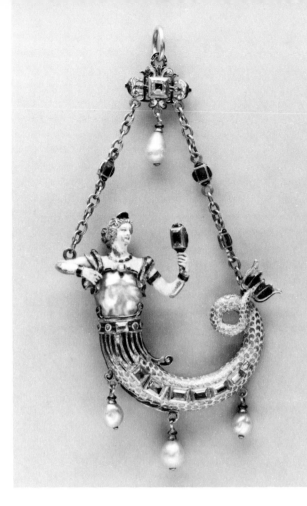

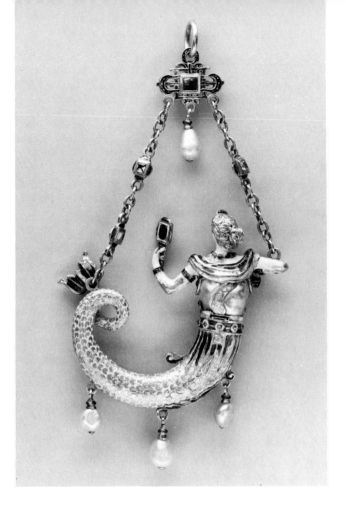

116. Pendant in the form of a mermaid

Baroque pearl with enameled gold mounts set with
diamonds and with pendent pearls. Height 4⅞ in.
(12.4 cm.)
Probably based on a design by Reinhold Vasters
German or French, ca. 1870–95
1982.60.377

A NUMBER OF details of the design of this jewel—including the long, attenuated fish tail, the wispy, feather-like skirt, the stole draped from the shoulders, and the hair styled in a low chignon worn with a tiara—are present in two unpublished designs for a mermaid jewel by the Aachen goldsmith Reinhold Vasters that are now in the Victoria and Albert Museum, London. The techniques employed in finishing the enameled gold tail indicate that the goldsmith who executed the jewel misunderstood certain Renaissance practices in preparing gold to receive enamel and in smoothing and polishing

the surface once the enamel had been fired, misunderstandings that may have arisen, at least in part, from looking at worn or damaged sixteenth-century jewels.

BIBLIOGRAPHY: Y. Hackenbroch, *Renaissance Jewellery*, London, 1979, pl. XXVIII, fig. 648, p. 241, fig. 648.

CV

117. Pendant in the form of a siren

Baroque pearl with enameled gold mounts set with
rubies. Height 4³⁄₁₆ in. (10.7 cm.)
European, probably ca. 1860
1982.60.376

WHEN THIS jewel was lent by Joseph Duveen to an exhibition at the Fogg Museum, Cambridge, Massachusetts, in 1937 it was said to be the work of Benvenuto Cellini. The jewel is indeed splendid, for the exquisite craftsmanship lavished upon the enameled gold upper body and long, sinuous tail more than matches the sensuous beauty of the enormous baroque pearl that forms the torso of the siren. Considering the prodigious number of

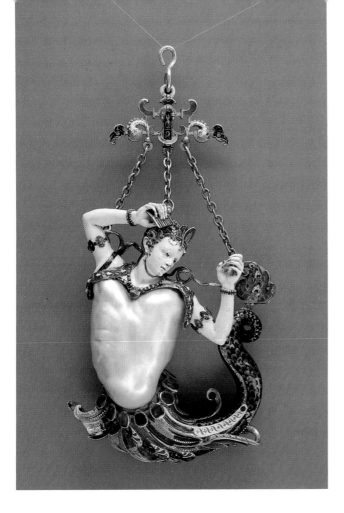 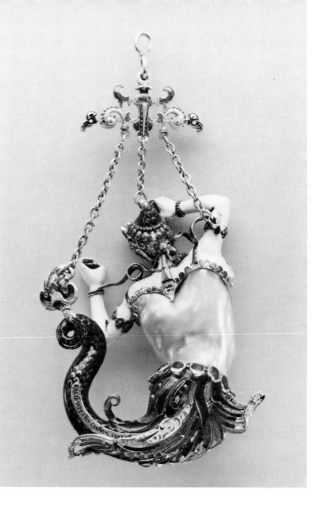

objects of widely diverse origin that had been attributed to the famed Italian Mannerist goldsmith during the course of the nineteenth and early twentieth centuries, the Fogg Museum's catalogue entry was not unreasonable, and, in fact, the siren jewel is closely related to another object that was once also attributed to Cellini, the Metropolitan Museum's Rospigliosi cup (acc. no. 14.40.667).[1] Comparative study of the two objects has revealed that the work of the goldsmith who made the siren jewel displays all of the observed idiosyncrasies of the maker of the Rospigliosi cup. The choice of enamel colors, the love of small, fussy patterns such as the stylized green scales on the tail of the siren, the ornament of the siren's feathery skirt (probably derived from textile patterns), and, above all, the painstaking realism of the most minute details of face, hands, coiffure, comb, and jewelry worn by the siren are typical as well of the fantastic creatures of the Rospigliosi cup.

The identity of the goldsmith is not certain, but in a forthcoming article for the *Metropolitan Museum Journal*, Yvonne Hackenbroch will show that the Rospigliosi cup is another of the nineteenth-century Renaissance-style objects made from designs by the Aachen goldsmith Reinhold Vasters (1827–1909).[2] While there are several pendent mermaids among Vasters's designs preserved in the Victoria and Albert Museum, London, none particularly resembles this jewel. The design may have been based, however, on another jewel, such as one illustrated when it was in the collection of King George V[3] or even one worn by a member of the Hapsburg family in a sixteenth-century portrait.[4]

Much has been written about the provenance of the jewel, but its history remains somewhat obscure. An engraving showing the front and back, accompanied by a description of it in French, can be found in the Rijksmuseum, Amsterdam,[5] but the engraving is neither signed nor dated. According to one tradition, the jewel once belonged to the Mogul emperors of India.[6] It was believed to have been found along with a pendent Triton or merman, now known as the Canning jewel, in the treasury of the king of Oudh and to have been purchased by Lord Canning while he was governor general and viceroy of India. Whether the siren jewel ever really belonged to Lord Canning has not been established, but, as we have seen, it could not have been made very long before Lord Canning's return from India and subsequent death in 1862.

The first firm record of its existence is in a catalogue entry for an exhibition held in London in 1862, where the jewel is described as a sixteenth-century Italian work brought from India and lent by a Colonel Guthrie. Evidence for its subsequent ownership is conflicting, and the provenance supplied by Duveen at the time of the Fogg Museum exhibition does not agree with those given by Peter Stone and Yvonne Hackenbroch.

The enameled inscription on the reverse side of the siren's tail FALIT · ASPECTVS · CANTVSQ · SYRENÆ (Deceitful is the appearance of the siren and deceitful her song) is an apt one, indeed. The meaning of the letters D · L · VD · R on one of the feathers of her skirt has never been successfully explained. A jeweled mirror, made at some time between the 1862 and 1937 exhibitions, has been removed from the left hand of the figure.

NOTES:
1. See Metropolitan Museum of Art, *Handbook of the Benjamin Altman Collection*, New York, 1914, pp. 77–78.
2. Y. Hackenbroch, "Reinhold Vasters," *Metropolitan Museum Journal*, forthcoming.
3. See A. B. Tonnochy, "Jewels and Engraved Gems at Windsor Castle," *Connoisseur* 95 (May 1935), p. 279.
4. Y. Hackenbroch, *Renaissance Jewellery*, London, 1979, p. 241, fig. 645.
5. Ibid., p. 240, fig. 643.
6. P. Stone, "Baroque Pearls: II," *Apollo* 69 (Feb. 1959), p. 33.

EX COLL.: Col. Guthrie; Robert Philips, London; Lord Duveen, Millbank, New York; [Duveen Brothers, New York]; Arturo Lopez-Willshaw, Paris (sale, Sotheby's, London, Oct. 13, 1970, pp. 18–21, lot 9).

EXHIBITED: South Kensington Museum, London, *Catalogue of the Special Exhibition of Works of Art of the Medieval, Renaissance, and More Recent Periods on Loan at the South Kensington Museum, June 1862*, 1862, p. 636, no. 7,271 (lent by Col. Guthrie); L. Gonse, *L'Art ancien à l'exposition de 1878*, Paris, 1879, pp. 253–54 (lent by Robert Philips, London); Fogg Art Museum, Cambridge, Mass., *The Art of the Renaissance Craftsman: An Exhibition of Fifteenth, Sixteenth and Seventeenth Century Workmanship*, 1937, pp. 21–22 (lent by Lord Duveen); W. M. Milliken, "Exhibition of Gold," *Bulletin of the Cleveland Museum of Art* XXXIV (Nov. 1947), pl. following p. 216 (lent by Duveen Brothers, Inc.).

BIBLIOGRAPHY: P. Stone, "Baroque Pearls: II," *Apollo* 69 (Feb. 1959), pp. 33–34, figs. II, III; G. S. Salmann, "A Great Art Lover, The Late Arturo Lopez-Willshaw," *Connoisseur* 151 (Oct. 1962), pp. 77–79, figs. 12a, b; G. Bott, *Ullstein Juwelenbuch*, Frankfurt am Main, 1972, pp. 111, 113; Y. Hackenbroch, *Renaissance Jewellery*, London, 1979, p. 239, figs. 640A, B, p. 240, p. 368 n. 21.

CV

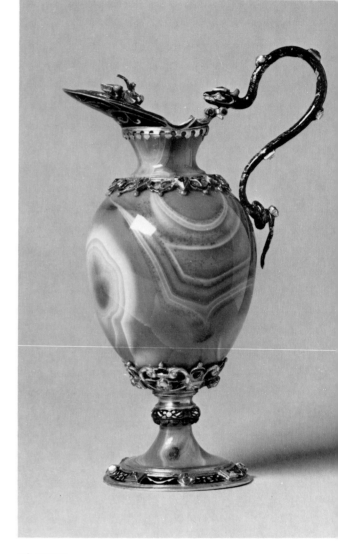

118. EWER

118. Ewer

Sardonyx with enameled gold mounts set with
 diamonds. Height 4¾ in. (12.1 cm.)
European, second half of 19th century
1982.60.141

THE MODEL for this ewer was probably a cruet of agate
with an enameled gold handle in the form of a serpent,
made for Cardinal Mazarin, probably about the middle
of the seventeenth century and now in the Louvre.[1] Late-
Renaissance-style ornament has been substituted for the
more naturalistic leaf designs characteristic of seventeenth-
century French goldsmiths' work.

 Among the drawings for goldsmiths' work by Rein-
hold Vasters (1827–1909) in the Victoria and Albert Mu-
seum, London, is one for a somewhat similarly attenuated
serpent with a knotted tail. The drawing was apparently
intended for a handle, and, although there is not enough
evidence to be certain of any attribution, this ewer may
have been the work of either Vasters or the nineteenth-
century craftsmen who executed his designs.

NOTE:
1. D. Alcouffe, "The Collection of Cardinal Mazarin's Gems,"
Burlington Magazine CXVI (Sept. 1974), p. 516, fig. 397.

<div align="right">CV</div>

119. Pendant with the Sacrifice of Isaac

Enameled gold set with emeralds, rubies, and pearls
 and with pendent pearls. Height 7⅛ in. (18.1 cm.)
European, probably second half of 19th century
1982.60.384

THE SIZE and shape of this pendant suggest that its model
was not a Renaissance jewel, but perhaps instead an or-
namental cartouche from the rim of a Mannerist silver
basin, a plaquette of gold, silver, or rock crystal from a
jewel casket, or a book cover. The ornament on the frame
and the back of the pendant is a mixture of decorative
motifs that were in vogue at several different periods dur-
ing the sixteenth and early seventeenth centuries. The
central pattern on the back, ultimately derived from
sixteenth-century Moresque ornament, is comparable to
one of Reinhold Vasters's designs for a pendant in the
Victoria and Albert Museum, London, but the identity
of the maker of this pendant remains uncertain.

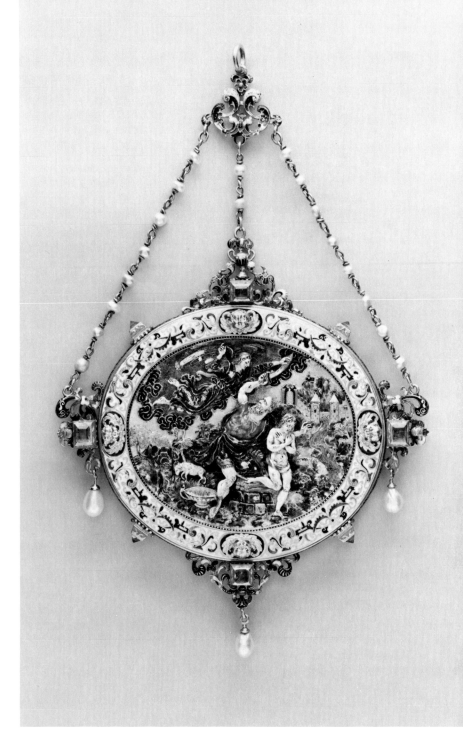

EX COLL.: Arturo Lopez-Willshaw, Paris (sale, Sotheby's,
London, Oct. 13, 1970, pp. 45–46, lot 22).

BIBLIOGRAPHY: G. Bott, *Ullstein Juwelenbuch*, Frankfurt am
Main, 1972, pp. 96, 97, 108, 113.

<div align="right">CV</div>

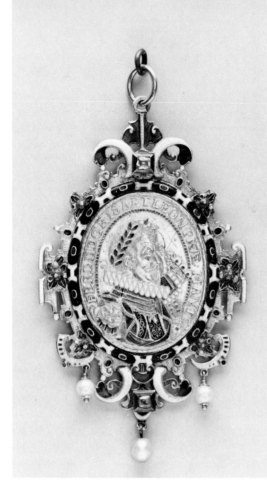

The ornament of the frame of the medal draws upon a decorative vocabulary in use during the latter part of the sixteenth century, and it would have been quite out of fashion by the third decade of the seventeenth century, when the bronze portrait medal was made. In addition, some of the enamel colors, the finishing of the gold, and the extreme flatness of the scrolled ornament mark this pendant as the work of a nineteenth-century craftsman.

NOTES:
1. For examples made in the last quarter of the sixteenth and the early seventeenth centuries, see E. Steingräber, *Antique Jewelry*, New York, 1957, p. 131, fig. 233, or *Princely Magnificence: Court Jewels of the Renaissance, 1500–1630* (exhib. cat.), London, Victoria and Albert Museum, 1980, p. 76, figs. 80, 81.
2. K. Domanig, *Porträtmedaillen des Erzhauses Österreich von Kaiser Friedrich III. bis Kaiser Franz II. aus der Medaillensammlung des Allerhochsten Kaiserhaus*, Vienna, 1896, pl. XXIV, fig. 177, p. 16, no. 177.

CV

121. Pendant with a head of Jupiter

Agate cameo with an enameled gold mount set with
 diamonds. Height 4⅝ in. (11.8 cm.)
European, 19th century
1982.60.372

120. Pendant with Emperor Ferdinand II and Empress Eleanor Gonzaga

Enameled gold set with diamonds and with pendent
 pearls. Height 4⅛ in. (10.5 cm.)
European, second half of 19th century
1982.60.389

THIS JEWEL is a nineteenth-century version of a type of German pendant that incorporated a gold coin or medal within an ornamental frame.[1] The central medallion of enameled gold, with portrait busts of the Holy Roman Emperor Ferdinand II (1578–1637) and his second wife, Eleanor Gonzaga of Mantua (1598–1655), whom he married in 1622, is a copy of a seventeenth-century bronze medal. An example of the medal is illustrated by Karl Domanig.[2] Both the bronze medal and the gold copy identify the subjects with a raised inscription: FERD · II · D : G · R · I · S · A · ET · LEON · PR · Æ · MANT. The reverse sides of both display the Hapsburg imperial arms, the date 1626, and initials of the medalist, HR.

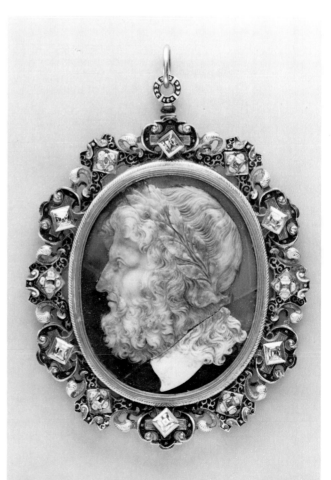

THIS CAMEO is unsigned, but it can be compared in subject and style to one signed by the Italian lapidary Giovanni Dies (1776–1849) in the Kunsthistorisches Museum in Vienna.[1] The cameo by Dies was acquired in 1822. Still closer in style is a nineteenth-century Italian cameo head of Menelaus in the Hermitage in Leningrad depicting a bearded warrior in profile, his helmet pushed back on his head.[2] Like the head of Jupiter, that cameo is unsigned, but both in the formal design and in the impressionistic rendering of the hair and beard there are similarities between the two. The head of Jupiter cameo has been broken in three places. The lower right portion, carved with the neck and long, curly hair, is a replacement made of ivory or horn. It may have been made at the time that the late-Renaissance-style gold frame was added, probably in the second half of the nineteenth century.

NOTES:
1. F. Eichler and E. Kris, comps., *Die Kameen im Kunsthistorischen Museum*, Vienna, 1927, pl. 76, no. 620, p. 218, no. 620.
2. J. Kagan, *Western European Cameos in the Hermitage Collection*, Leningrad, 1973, fig. 101, p. 96, no. 101.

BIBLIOGRAPHY: Y. Hackenbroch, *Renaissance Jewellery*, London, 1979, pl. IV, fig. 78, pp. 40–41, fig. 78.

CV

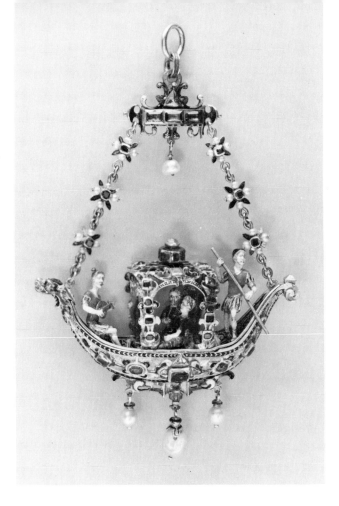

122. Pendant in the form of a gondola

Enameled gold set with diamonds, emeralds, rubies, and pearls and with pendent pearls. Height 4⅞ in. (12.4 cm.)
European, probably second half of 19th century
1982.60.373

THE GONDOLA, a memento of the delights of Venice, was among the forms employed by Renaissance goldsmiths for jeweled pendants. Yvonne Hackenbroch has noted the existence of a gondola-shaped jewel in a Hapsburg collection inventoried in 1590,[1] and there is a sixteenth-century pendant gondola from the collection of Anna Maria Luisa de' Medici (1667–1743) in the Museo degli Argenti in Florence.[2] It is the jewel in the Museo degli Argenti that probably provided the inspiration for our gondola pendant. The two jewels differ widely, however, in the form of the gondolas and in the figure style and dress of the tiny gondoliers and their passengers. The shape of the vessel of our pendant more nearly approaches that of a true gondola, but the gondolier and musician wear short-skirted tunics that resemble the costume of a Roman legionnaire. The lady has hiked her skirt above the knee. The interior of the hull and the back of the jeweled cartouche from which the gondola is suspended are covered with small, busy patterns of enameled ornament that seem closer in their origin to nineteenth-century textile designs than to Renaissance goldsmiths' work.

Certain characteristics of the enameling and finishing of the gold also indicate that our pendant is of nineteenth-century origin. Where enamel is used, it is thickly applied, and in places it has been permitted to spill over the edges of the intended design. Large areas of the exterior of the hull of the gondola have been left unenameled and the exposed metal chased with linear patterns. In a Renaissance jewel these would almost certainly have been made to prepare the surface of the metal for enameling. Here they are employed solely as decoration.

201

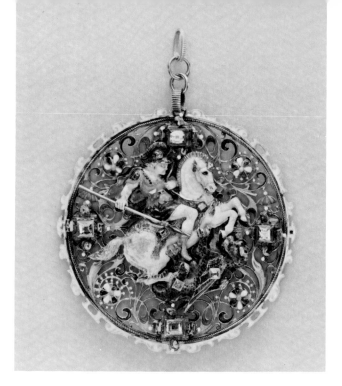

NOTES:
1. Y. Hackenbroch, *Renaissance Jewellery*, London, 1979, pp. 146, 361 n. 69.
2. K. Aschengreen Piacenti, *Il museo degli argenti a Firenze*, Milan, [1968], pl. 62, p. 212, no. 1971.

BIBLIOGRAPHY: Y. Hackenbroch, *Renaissance Jewellery*, London, 1979, pl. XII, fig. 379, p. 146, p. 147, fig. 379.

CV

123. Pendant with a youth playing a lyre and riding an elephant

Enameled gold set with diamonds and rubies and with pendent pearls. Height 4⅞ in. (12.4 cm.)
European, probably second half of 19th century
1982.60.386

THE ICONOGRAPHY of this jewel is apparently the original creation of the designer. It may perhaps have resulted from combining a figure of Apollo or Orpheus, the two most widely represented harp players from classical mythology, with the small gold elephant worn by recipients of the Danish Order of the Elephant. The scrolled backplate of the pendant and some rather perfunctory floral ornament are cast in a single piece from a three-dimensional model. Visible on the back are the clumsy attempts to disguise the joints of the setting of the four large diamonds. Two bent gold pins secure the elephant.

CV

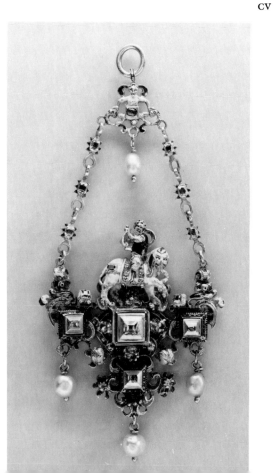

202

124. Pendant with Saint George and the Dragon

Enameled gold set with diamonds. Diameter 2¾ in. (7 cm.)
Possibly French, ca. 1890–1910
1982.60.374

THE CENTRAL motif of this romantic evocation of a Renaissance jewel was probably inspired by a sixteenth-century pendant such as the Saint George in the collection of the Grünes Gewölbe in Dresden.[1] This Renaissance-style motif is attached to an openwork roundel, and it is repeated as though seen from the back on the reverse side of the roundel, but in a flat, linear style that seems to have no parallel in a sixteenth-century jewel. While the technique of enameling is not the same, the effect achieved resembles French *plique-à-jour* enamels of about 1900; but the jewel is perhaps closest in style to turn-of-the-century graphic art—for example, the book illustrations by Arthur Rackham for Grimm's fairy tales or the Wagnerian legends.

NOTE:
1. J. Menzhausen, *Das Grüne Gewölbe*, Leipzig, 1968, p. 90, no. 66, pl. 66.

BIBLIOGRAPHY: Y. Hackenbroch, *Renaissance Jewellery*, London, 1979, pl. XVII, figs. 448A, B, p. 166, figs. 448A, B, pp. 166–67.

CV

125. Cup

Gold, partly enameled and set with diamonds,
 emeralds, rubies, pearls, sardonyx, and glass. Height
 12⅛ in. (30.8 cm.)
European, second half of 19th century
1982.60.139

THE MAKING of decorative showpieces was greatly en-
couraged by the nineteenth-century institution of the in-
ternational exhibition, where objects that were tours de
force of contemporary craftsmanship could be displayed.
By the middle of the century, the catalogue for the Crystal
Palace Exhibition included a number of examples of
goldsmiths' work that approximated medieval, Renais-
sance, Mannerist, and Baroque styles.[1] Many of them made
lavish use of precious materials and were, in fact, eclectic
in their inspiration. This cup, although probably not made
for such an exhibition, as its lack of a maker's mark and

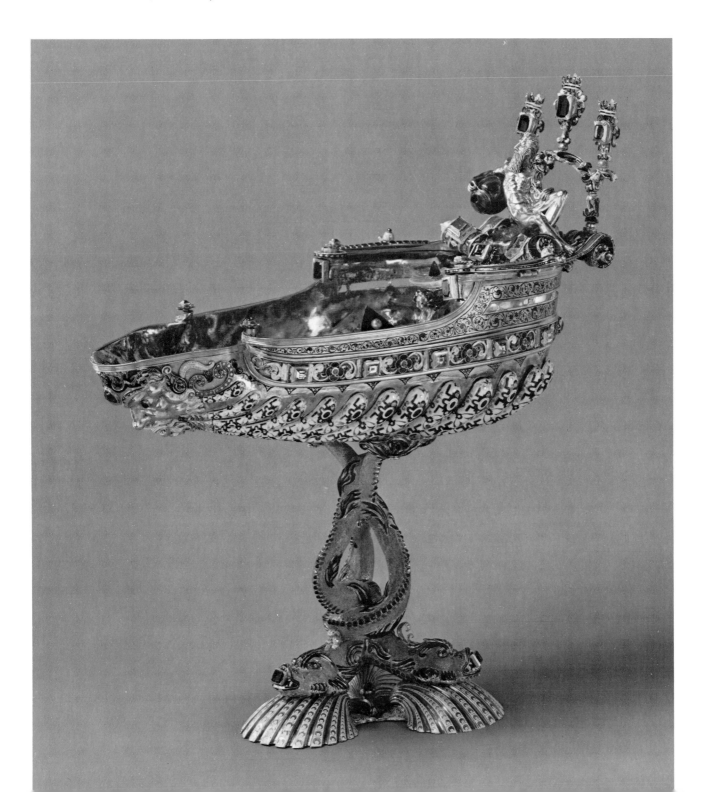

its fanciful inscription would indicate, can best be understood in terms of the nineteenth-century exhibition piece. It is a remarkable combination of borrowed forms and decorative styles.

Lacking a Mannerist model in gold, the designer apparently turned to objects made of rock crystal for his prototypes. The result is a cup with a long stem and foot in the form of entwined dolphins—probably borrowed from a rock crystal cup by Gaspero Miseroni (active 1550–75) in the Kunsthistorisches Museum, Vienna[2]—supporting a nef or vessel in the form of a ship. Although late-Renaissance nefs of silver gilt do exist, the closest model here would seem to have been a late sixteenth-century rock crystal ship on wheels from the collection of Louis de France, the Grand Dauphin (1661–1711), in the Prado, Madrid.[3] To this the maker added a satyr's mask on the prow; a Roman river god perched uneasily at the stern below a superstructure composed of three intaglio-carved seals; and, in the hold, a Mannerist hybrid sea creature supporting a shell and framed by a spray of water leaves. The decorative motifs on the sides of the vessel consist of airy arabesques of a kind that appear in ornamental engravings circulated throughout Europe about the middle of the sixteenth century, and angular patterns that are difficult to describe, but are loosely derived from the enameled decoration associated with Prague workshops of about 1600.

The cup is completed by an inscription on the foot recording its purported commission in 1595 by an imaginary king of Sicily: PHILIPPI · II · HISPAN · ET · SICIL · R · SICIL · R · N · M · Q · D · FABRITIVS · REGVLOR · SICVLOR · PRIMVS · PRINCEPS · BVTERAE · IV · PETRAPERTIAE · III · MARCHIO · LICODIAE · V · MILITELLI · II · BARRAFRAN-CAF · III · COMES · MAZARENI · V / AQVILAE · LACVSQ · LEONTIN · DN · CVM · HERES · FAMILIAR · BARRESIAE · AC · SANTAPAV · TATAM · AMPLITVDINEM · SVO · GENERI · BRANCIFORTIO · TRADIDISSET · AD · HAR · TRIVM · FA-MILIAR · CONIVNCTIONIS · MEMORIAM / SVAEQ · SPLEN-DOREM · PROGENIEI · POCVLVM · EX · AVRO · TRIPES · GEMMIS · ATQ · SIGNIS · BENE · DISTINCTVM · FIERI · FECIT · ANNO · A · CHRISTO · NATO · CIƆ · IƆ · XCV ·

While no expense was spared in the choice of media, the execution of the work is remarkably crude, for instance in the joining of the various elements by means of visible and ugly pins or screws or the careless and perfunctory scoring of the gold settings for some of the jewels and of the heads of the gold pins that hold the curious, gadroon-like ribs of the vessels in place. The ribs themselves are none too exactly fitted to the sides of the vessel. The designer and maker of this cup have not been identified as yet, but it is clear that neither had the sophistication or technical skill of Reinhold Vasters or the nineteenth-century craftsmen who carried out his designs.

NOTES:
1. *The Art Journal Illustrated Catalogue: The Industry of All Nations*, London, 1851.
2. R. Distelberger, "Beobachtungen zu den Steinschneidewerkstätten der Miseroni in Mailand und Prag," *Jahrbuch der Kunsthistorischen Sammlung in Wien* 74 (1978), p. 80, fig. 48.
3. E. Steingräber, ed., *Royal Treasures*, trans. S. de Haan, New York, 1968, p. 35, fig. 3.

CV

FURNITURE AND CARPETS

Catalogue entries by

WILLIAM RIEDER

ALICE ZREBIEC

ANDRE-CHARLES BOULLE

French, 1642–1732

ANDRE-CHARLES BOULLE was born in Paris in 1642 and trained under his father, a carpenter. He also became adept in other fields (in contemporary documents he is described as painter, architect, mosaicist, engraver, bronze worker, and designer of monograms) and was elected to the Parisian Académie de Saint-Luc as a painter. From 1664 he was attached to the Collège de Reims in Paris as both painter and maker of marquetry. After his appointment in 1672 as *ébéniste du roi*, he supplied extensive furniture and decoration for the royal palaces, especially Versailles, as well as for members of the court, wealthy financiers, and foreign royalty. He became the most celebrated cabinetmaker of Louis XIV's reign, executing lavish furniture adorned with marquetry of brass and tortoiseshell, a type of marquetry that has subsequently borne his name. He directed his large workshop in the Louvre until his death in 1732.

126. Commode

Ca. 1710–32
Veneered on walnut with ebony and marquetry of engraved brass inlaid on a tortoiseshell ground; gilt-bronze mounts; verd antique marble top. Height 34½ in. (87.6 cm.), width 50½ in. (128.3 cm.), depth 24¾ in. (62.9 cm.)
Mark painted on the underside in eighteenth-century script: *3*
1982.60.82

IN 1708 André-Charles Boulle executed two "bureaux" for the bedroom of Louis XIV at the Palais de Trianon (known today as the Grand Trianon), for which he was paid in September 1708 and April 1709 the sum of three thousand livres. The duc d'Antin, *directeur des bâtiments*, wrote to the king on July 3, 1708: "J'ai été à Trianon pour voir le second bureau de Boulle; il est aussi beau que l'autre et sied à merveille à cette chambre." They remained at the Trianon through most of the eighteenth century, although by 1729 they were described in an inventory as "commodes" rather than "bureaux." In 1790 they were removed to the Garde-Meuble in Paris, thus escaping the Revolutionary sales of furniture at Versailles. Several years later they were sent to the Bibliothèque Mazarine in the former Collège des Quatre-Nations (now the Palais de

l'Institut) and were referred to in nineteenth-century publications on French decorative art as the "Commodes Mazarines." In 1933 they were moved to the Château de Versailles, where they remain.

A new invention in the history of furniture, the Trianon "bureaux" were a combination of the table and the newly emerging commode, with two drawers fitted under the top in a shape influenced by the Roman sarcophagus and by Jean Berain's engraved designs for bureaus. The drawers in Boulle's model required four extra tapered scroll legs for support. The result, however much criticized by later historians, was a spectacular and opulent design, which became one of the most frequently repeated pieces of French eighteenth-century furniture; repetitions were made by Boulle himself[1] and by other cabinetmakers in the eighteenth century, with many copies produced in the nineteenth and twentieth centuries.

The present commode is similar in construction, in the quality of the bronze mounts, and in the engraved ornament on the inlaid brass to the Trianon prototypes, and it appears to be an early version made in Boulle's workshop. It bears an unidentified number *3* on the underside in eighteenth-century script.

Other eighteenth-century versions are the example at Petworth House (formerly in the collection of the duke of Hamilton at Hamilton Palace and said to have been acquired by him from William Beckford at Fonthill);[2] a pair at Vaux-le-Vicomte stamped by Etienne Levasseur (1721–1798), who specialized in making and restoring furniture in the Boulle technique;[3] and a single commode said to be eighteenth century, formerly in the Jean Lombard collection.[4] In the second half of the eighteenth century, several commodes of this model were sold: from the collections of Marcellin-François Zachorie de Selle,[5] Randon de Boisset,[6] the marquis de Marigny,[7] and the comte de Merle;[8] some of these may be repetitions, and none has been identified with an extant version. Sir William Chambers recorded a commode of this model in a drawing of 1774 inscribed "Various decorations in the Hotel de Voyer, Ecole Militaire &c," leaving its location unclear.[9]

In the nineteenth century the Trianon commodes were widely copied. Among the best-known examples are the pair in the Frick Collection by the London firm of Blake[10]

and three made in the second half of the nineteenth century by the Paris firm of Fourdinois (a pair in the Musée des Beaux-Arts, Rouen, and a single commode in the Palacio Real, Madrid).[11]

NOTES:

1. J.-P. Samoyault, *André-Charles Boulle et sa famille*, Geneva, 1979, pp. 68, 84–85 n. 19.

2. See G. Jackson-Stops and W. Rieder, "French Furniture," in *Treasures of the National Trust*, ed. H. R. Fedden, London, 1976, p. 120.

3. C. Mauricheau-Baupré, "Musée de Versailles, le mobilier: deux commodes de Boulle de la chambre du roi," *Bulletin des Musées de France* 6 (1934), ill. p. 51.

4. *Les Deux Grands Siècles de Versailles* (exhib. cat.), Geneva, Musée d'Art et d'Histoire, 1953, no. 8.

5. Sale, Paris, Feb. 19–28, 1761, lot 143.

6. Sale, Paris, Feb. 27, 1777, lot 779, to the comte d'Artois.

7. Sale, Paris, Mar. 18, 1782, lot 584.

8. Sale, Paris, Mar. 1, 1784, lot 206, to Lenoir de Breuil.

9. J. Harris, "Sir William Chambers and His Parisian Album," *Architectural History* VI (1963), pp. 64, 85–86, fig. 7.

10. G. Brière, *French Furniture of the Eighteenth Century*. Vol. IX of *An Illustrated Catalogue of the Works of Art in the Collection of Henry Clay Frick*, New York, 1949–55, pp. 19–21, nos. 2, 3, pl. II.

11. L. Feduchi, "Two Centuries of Furniture," *Apollo* n.s. 87 (May 1968), p. 360, fig. 18.

EX COLL.: Winston Guest (sale, Parke-Bernet, New York, Dec. 2, 1967, lot 136).

BIBLIOGRAPHY: P. Verlet, *Le Mobilier royal français*, Paris, 1945, pp. 3–4, fig. 1; *Louis XIV, faste et décors* (exhib. cat.), Paris, Musée des Arts Décoratifs, 1960, nos. 84, 85, with bibliography of Trianon commodes; J.-P. Samoyault, *André-Charles Boulle et sa famille*, Geneva, 1979, pp. 4, 68, 84–85, fig. 18b; R. Freyberger, "The Randon de Boisset Sale, 1777: Decorative Arts," *Apollo* n.s. III (1980), pp. 300–301, fig. 7.

WR

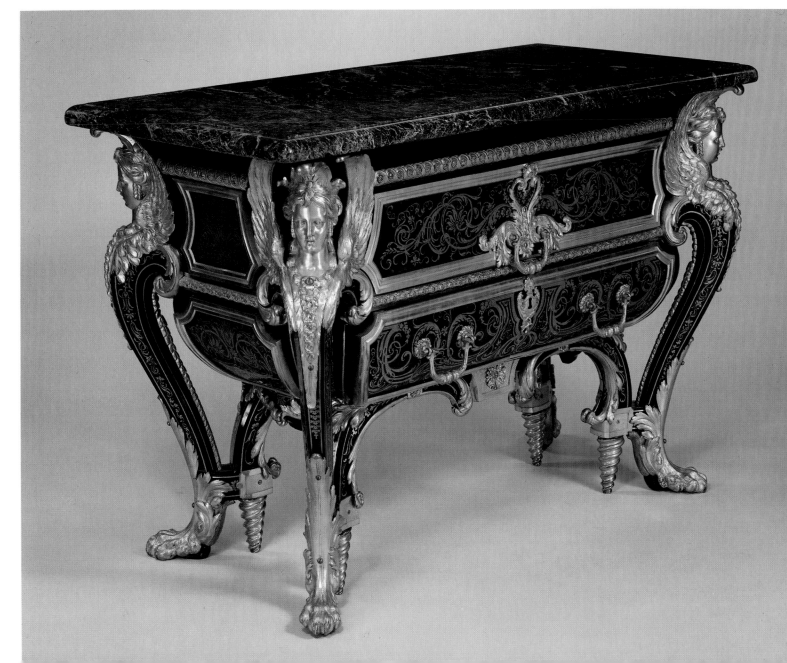

CHARLES CRESSENT

French, 1685–1768

CRESSENT was unusual in the world of French eighteenth-century furniture making: he trained both as a sculptor and an *ébéniste*. With considerable skill in both disciplines, he created a body of furniture of high quality and of a distinctively sculptural character. He designed and made the models for his mounts, which, contrary to guild regulations, were often cast and chased on his own premises, leading to repeated disputes with the guilds of *fondeurs-ciseleurs* and *ciseleurs-doreurs*. In 1714 he was elected to the Académie de Saint-Luc as sculptor, and before 1719 he was appointed *sculpteur du roi*. In 1719 he was also appointed *ébéniste* of Philippe, duc d'Orléans. He organized three sales of his own furniture and works of art (1749, 1757, and 1765), the catalogues of which he wrote himself. Cressent's furniture was highly regarded and earned him distinguished patronage, including the regent, his son Louis, duc d'Orléans, and his grandson Louis-Philippe, duc d'Orléans. Among others who acquired his furniture in Paris were the duc de Richelieu and the marquis de Marigny; his foreign clients included John v of Portugal and Charles Albert, elector of Bavaria.

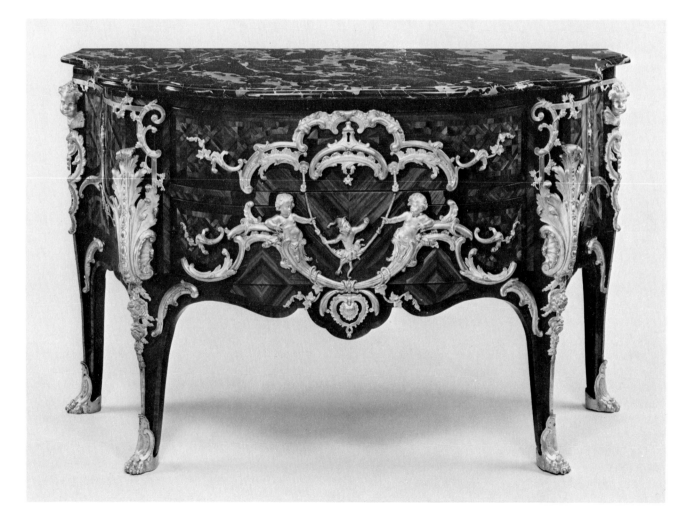

127. Commode

Ca. 1745–49

Veneered on pine and oak with purplewood,
mahogany, and satinwood; gilt-bronze mounts;
portor marble top. Height 34½ in. (87 cm.), width 55
in. (140 cm.), depth 22¾ in. (58 cm.)

Mounts stamped in numerous places with the crowned
C mark (period 1745–49)

Pasted to the top beneath the marble is the trade card
of the dealer Rousselot: "Au Chasteau de
Vincennes, Rue de la Monoye, vis à vis la Porte des
Balanciers de la Monoye. Rousselot, Marchand
Mercier-Joyalier, Vend Glaces de toute grandeurs
pour les Appartements & Carrosses, Miroirs,
Trumeaux & Cheminées de Glace de toutes facons;
Bureaux, Commodes, Secretaires, Tables, Coffres,
Cabarets, Toilettes & autre Ouvrages de Marqueterie
& Ebenisterie de toutes sortes, Bois & Vernis,
enrichis de Bronze dorée d'or moulu, ou en couleur;
Tables de Marbre sans pieds & avec pieds, & autres
Emmeublements de Bois sculptez & dorez; Bras,
Feux, Flambeaux & autres Ouvrages de Cuivre
dorez d'or moulu . . . ; Porcelain de la Chine & du
Japon, garnies ou non garnies . . ." (This dealer of
furniture, porcelain, and jewelry remains untraced,
and no other example of his trade card is known.)

1982.60.56

THIS COMMODE belongs to a group of six, several of
which have been attributed to Charles Cressent on the
basis of descriptions of pieces in his three sales. Two are
in the Gulbenkian Museum, Lisbon;[1] two are at Waddes-
don Manor;[2] and one is in the Louvre.[3] With minor vari-
ations, they all have similar mounts and marquetry; the
Louvre commode is the exception, having plain veneers
of tulipwood and kingwood rather than the mahogany
trellis-pattern marquetry of the others. The distinctive
feature of these commodes is the central motif of a mon-
key on a swing flanked by two boys emerging from acan-
thus foliage. In each of Cressent's three sales there were
commodes whose descriptions match the objects in this
group. In the first, held on March 19, 1749, lot 7 com-
prised "deux commodes d'un contour extraordinaire à
toutes celles qui se sont faites jusqu'à présent, avec deux

portes par les côtés, enrichies d'ornemens de bronzes. Il y
a sur le devant deux enfans qui balancent un singe, le tout
parfaitement sizelé; doré d'or moulu, le marbre de Verret
du plus beau; elles portent quatre pieds six pouces; les
deux tiroirs sont de hauteur." In the 1757 sale four com-
modes were similarly catalogued with tops of brocatelle
and serracolin marble, and in the 1765 sale was a single
example. Cressent may well have made more than seven
commodes of this model, or fewer (some may have been
withdrawn and offered later with different tops). None of
the existing commodes has been identified with a specific
entry. Only the Linsky commode and one of those in
Lisbon (no. 240B) have mounts stamped with the crowned
C mark; although this suggests that they were made by
1749, they are not a pair, and each could have been in any
of the three sales. In short, there are five eighteenth-century
commodes of this model known, and Cressent described
seven. The 1749 entry is also significant in presenting the
shape of the commode as an innovation. In both the elab-
orate bombé plan—a bowed front with rounded forecor-
ners and splayed shaped ends—and the massive acanthus
scroll mounts on the forecorners, these commodes are
indeed extraordinary. The marquetry and many of the
mounts (including the zephyr's head at each rear corner)
were used by Cressent with variations on a number of
objects executed at this time.

NOTES:

1. Museu Calouste Gulbenkian, *Catalogue*, Lisbon, 1982,
no. 671.

2. G. de Bellaigue, *The James A. de Rothschild Collection at
Waddesdon Manor: Furniture, Clocks and Gilt Bronzes*, Fribourg,
Switzerland, 1974, I, pp. 207–17, nos. 45, 46. Bellaigue notes
that one commode (46) is a nineteenth-century copy with the
eighteenth-century mounts interchanged.

3. D. Alcouffe, *Charles Cressent* (exhib. cat.), Paris, Louvre,
1974, no. 4.

EX COLL.: Sale, Galerie Charpentier, Paris, Mar. 27, 1952,
lot 92.

EXHIBITED: Parke-Bernet Galleries, New York, *Art Treasures
Exhibition*, June 1955, no. 286.

WR

JEAN-FRANÇOIS OEBEN

French (born Germany), 1721–1763

BORN IN Heinsberg near Aachen in 1721, Oeben is thought to have arrived in Paris about 1740. He worked as a journeyman from 1751 to 1754 for Charles-Joseph Boulle (son of André-Charles Boulle). After Boulle's death in 1754, Oeben was made *menuisier-ébéniste du roi* and given lodgings in the Manufacture Royale des Gobelins. He moved his workshop in 1756 to the Arsenal, where he resided and worked until his early death in 1763. The business was continued by his widow, who married Jean-Henri Riesener in 1767. Oeben was extensively patronized by Madame de Pompadour. His most famous piece of furniture, the *bureau du roi*, was commissioned by Louis XV in 1760 and completed by Riesener in 1769. Oeben was related by blood and marriage to several prominent cabinetmakers. His brother was Simon-François Oeben, and his sister, Marie Catherine, married the cabinetmaker Martin Carlin in 1759. In 1749 Oeben married Françoise-Marguérite Vandercruse, the daughter of the cabinetmaker François Vandercruse (called Lacroix) and sister of Roger Vandercruse (also called Lacroix).

128. Writing table

Ca. 1761–63
Veneered on oak with mahogany, kingwood, and tulipwood with marquetry of mahogany, rosewood, holly, and various other woods; gilt-bronze mounts.
Height 27½ in. (69.8 cm.), width 32¼ in. (81.9 cm.), depth 18⅜ in. (46.7 cm.)
Stamped under the rear rail: J F OEBEN; stamped under the left rail: R.V.L.(C), for Roger Vandercruse (called Lacroix), with JME, the monogram of the guild
1982.60.61

THIS TABLE has long been recognized as one of Jean-François Oeben's masterpieces. It was made for his most important client, Madame de Pompadour. The main charge of her coat of arms, a tower, appears at the top of the gilt-bronze mount at each corner, and on the vase at the center of the marquetry top is the ducal coronet (in 1752 she was given the title duchesse-marquise de Pompadour).

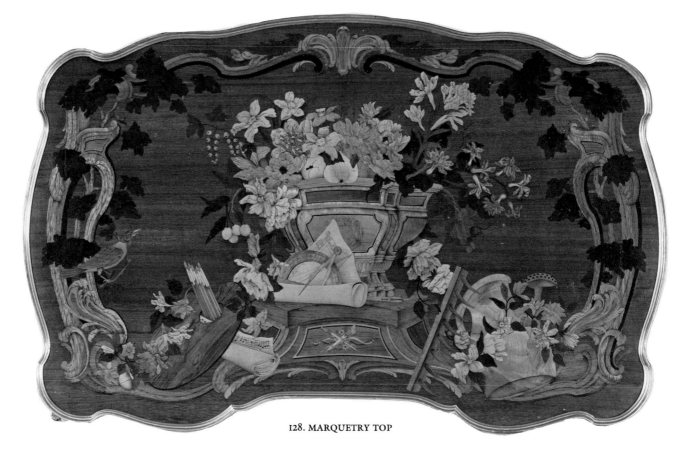

128. MARQUETRY TOP

The top was designed to reflect her interest in the arts. At the center the vase of flowers rises above an architectural trophy with compass, protractor, and a scroll of paper revealing the plan of a building, flanked by allegorical trophies representing Music and Painting on the left and Gardening on the right. These major groups are contained within a scrolling, foliate border with birds and vines executed in etched, stained, and natural woods on a mahogany ground in a technique raised to a new level of art by Oeben. Combining an extraordinary design with marquetry of remarkable sophistication, the top is one of the finest panels in all of his furniture.

Oeben's skills not only as an *ébéniste* but as a *mécanicien* are apparent in the elaborate mechanism that allows the top to slide back as the large drawer below moves forward, thereby doubling the surface area. With the drawer open, the table could be used for either reading or writing. A central arched panel, hinged at the front, rises by

means of a hidden ratchet support and contains a rectangular panel, which can be rotated and fixed in position so that either side faces forward. One side of this panel is lined with blue moiré silk; the other is decorated with pseudo-Japanese lacquer. Flanking this are two flaps, which are inlaid with large tulips overlapping bound-ribbon borders and which cover two shaped compartments veneered with tulipwood. A secret button releases a shallow drawer below the reading-and-writing panel. One of the most unusual features of this table are the legs, which are pierced with three openings, each framed with a gilt-bronze rim—a detail that is unique in Oeben's work.

It is not known when Oeben began this table. He had developed the model early in his career. In a portrait by François Guérin of Madame de Pompadour and her daughter Alexandrine, painted about 1754, is an open table of similar type, showing on the side a mosaic-pattern marquetry similar to that on the side of the drawer of the

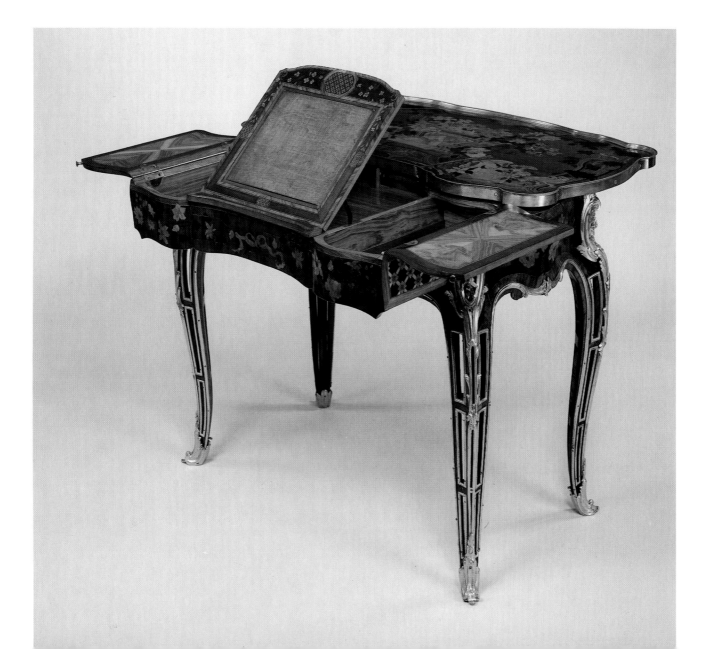

present table rather than the floral marquetry on the exterior side.[1] The present table is perhaps more likely to have been commissioned later (Madame de Pompadour ordered a number of pieces from Oeben in 1761), left unfinished on his death in 1763, and completed by his brother-in-law, Roger Vandercruse (called Lacroix), whose stamp (R.V.L.C.) along with Oeben's is found on the underside. It cannot be identified in the inventory prepared after Oeben's death either in the list of ten items awaiting delivery to Madame de Pompadour or in his large stock of completed and partly completed furniture.[2] However, the brevity of the entries makes identification difficult. The inventory mentions several tables "courantes" or "à coulisse" but with only a few generalized details, which could describe any one of a number of existing tables. Madame de Pompadour died in April 1764, and the lengthy inventory of her possessions presents the same problem.[3] Whether she ever took possession of this table cannot be determined from her inventory.

For such a well-known piece of furniture, this table has a surprisingly vague history until the early twentieth century. Freyberger speculates that it may have belonged to Madame de Pompadour's brother and principal heir, the marquis de Marigny,[4] although there is no evidence to suggest it. In the catalogue of the 1928 sale of Judge Elbert H. Gary's collection, a series of previous owners was listed (the marquis of Tullibardine; Mrs. Mary Gavin Baillie-Hamilton; Lady Harvey, London; [Lewis and Simmons, Paris]), but in none of these collections has it been documented.[5] In the present century it has sold twice at public auction, both times fetching record prices for a piece of French furniture: at the Gary sale it was acquired by the dealer Joseph Duveen, and at the sale of the Martha Baird Rockefeller collection in 1971, it was acquired by Jack and Belle Linsky.[6]

Oeben made a number of similar tables with sliding tops and drawers, sometimes fitted as combination writing and toilet tables. In 1757–58 the dealer Lazare Duvaux, for whom Oeben is known to have worked, provided four tables of the same model with sliding tops, described as "une table à écrire dont le dessus à coulisse, le tiroir garni de quarts de rond, baguettes, pieds, chûtes & ornemens dorés d'ormolu, le placage en bois de rose à fleurs." The related tables by Oeben are in the Louvre;[7] the J. Paul Getty Museum, Malibu;[8] the Huntington Art Gallery, San Marino;[9] the National Gallery of Art, Washington;[10] the Rijksmuseum, Amsterdam;[11] the Residenzmuseum, Munich;[12] the Victoria and Albert Museum, London;[13] the Bowes Museum, Barnard Castle;[14] and the Gulbenkian Museum, Lisbon.[15]

NOTES:

1. The painting was formerly in the Edouard de Rothschild collection (C. Stryienski, "François Guérin," Gazette des Beaux-Arts ser. 3, XXVIII [1902], p. 308).

2. J. J. Guiffrey, "Inventaire de Jean-François Oeben," Nouvelles Archives de l'Art Français ser. 3, XV (1899), pp. 289–367.

3. J. Cordey, Inventaire des biens de Madame de Pompadour redigé après son décès, Paris, 1939.

4. R. Freyberger, "The Judge Elbert H. Gary Sale," Auction II (June 1969), pp. 12–13.

5. Judge Elbert H. Gary, New York (sale, American Art Association, New York, Apr. 21, 1928, lot 271).

6. Martha Baird Rockefeller, New York (sale, Sotheby's, New York, Oct. 23, 1971, lot 711).

7. Formerly in the collection of the duchesse de Richelieu, (D. Alcouffe, Louis XV: Un Moment de perfection de l'art français [exhib. cat.], Paris, Hôtel de la Monnaie, 1974, no. 423).

8. G. Wilson, Decorative Arts in the J. Paul Getty Museum, Malibu, 1977, nos. 68, 69.

9. R. Wark, French Decorative Art in the Huntington Collection, San Marino, 1979, fig. 77.

10. A. Boutemy, "Une Table mécanique de la National Gallery of Art de Washington," Analyses stylistique et essais d'attribution de meubles français anonymes du XVIIIe siècle, Brussels, 1973, pp. 218–21.

11. Rijksmuseum, Catalogus von Meubelen en Betimmeringen, 's-Gravenhage, 1952, no. 492, fig. 74a–b.

12. P. Verlet, Les Ebénistes du XVIII siècle français, Paris, 1963, p. 149, fig. 3.

13. P. Thornton, "John Jones, Collector of French Furniture," Apollo n.s. 95 (Mar. 1972), p. 171, fig. 7.

14. A. Boutemy, "Les Tables-coiffeuses de Jean-François Oeben," Bulletin de la Societé de l'Histoire de l'Art Français 1962, p. 112, fig. 9.

15. Museu Calouste Gulbenkian, Catalogue, Lisbon, 1982, no. 685.

EX COLL.: (traditionally said to have belonged to Madame de Pompadour; the marquis of Tullibardine; Mrs. Mary Gavin Baillie-Hamilton; Lady Harvey, London; [Lewis and Simmons, Paris]); Judge Elbert H. Gary, New York (sale, American Art Association, New York, Apr. 21, 1928, lot 271); Martha Baird Rockefeller (sale, Sotheby's, New York, Oct. 23, 1971, lot 711).

BIBLIOGRAPHY: A. Boutemy, "Les Tables-coiffeuses de Jean-François Oeben," Bulletin de la Societé de l'Histoire de l'Art Français 1962, p. 106; A. Boutemy, "Jean-François Oeben méconnu," Gazette des Beaux-Arts ser. 6, LXIII (1964), p. 215, fig. 21; R. Freyberger, "The Judge Elbert H. Gary Sale," Auction II (June 1969), pp. 12–13.

WR

RENE DUBOIS

French, d. 1792

RELATIVELY little is known about this cabinetmaker who stamped his works R DUBOIS. He was probably a cousin of the well-known René Dubois (1737–1798; see no. 132). He was elected *maître ébéniste* in 1757 and worked as both a cabinetmaker and a dealer on the rue Saint-Honoré, where he specialized in the sale of toys and mechanical pieces of furniture.

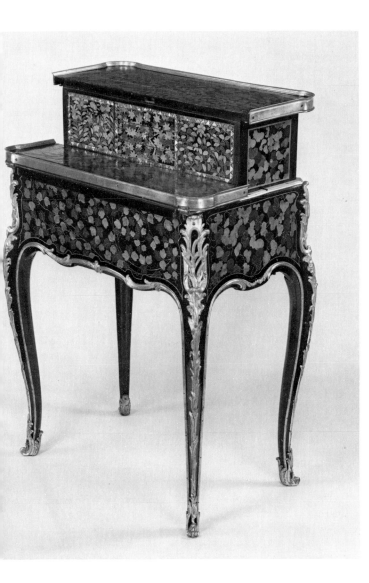

129. Mechanical table
(*table à la Bourgogne*)

Ca. 1760
Veneered on oak with black, yellow, and red European lacquer; interior fittings and drawer linings of rosewood; gilt-bronze mounts. Height 29¼ in. (74.3 cm.), width 24 in. (61 cm.), depth 15½ in. (39.4 cm.)
Stamped twice (underneath the front and rear rails):
 R DUBOIS
1982.60.60

THE FRONT HALF of the top folds over to form a writing surface covered with the original brown leather. The rear part of this surface folds forward to reveal three compartments of rosewood. The rear section of the table forms a nest of drawers; a spring mechanism, controlled by two catches, allows this nest to rise out of the body. The nest contains seven drawers, four of which are released by buttons concealed beneath the top. With the rear section raised, all the main visible surfaces, including the sides and rear of the nest, are lacquered with an overall pattern of red and yellow leaves on a black ground.

This table is twice stamped R DUBOIS for René Dubois. As few pieces of furniture are known by this cabinetmaker, it cannot be related to other examples of his work. The corner mounts with bulrushes and foliage are found on two mechanical tables that have been attributed to Jean-François Oeben.[1] The attribution is, however, questionable.[2] The two tables are veneered with elaborate pictorial and floral marquetry in a style not typical of Oeben and are of a more complex bombé shape than the present rectangular example. The corner mounts were probably available from a Parisian bronze maker and could be purchased by any *ébéniste*; the repetition of these mounts is therefore not sufficient reason to attribute the two marquetry tables to René Dubois.

Mechanical tables of varying degrees of complexity were popular in the mid-eighteenth century and were made by several *ébénistes*. In addition to Oeben, the most prominent were Jean-Pierre Latz,[3] Roger Lacroix,[4] and Christophe Wolff.[5]

NOTES:
1. One formerly in the Wildenstein and Ojjeh collections (sale, Sotheby's, Monte Carlo, June 25–26, 1979, lot 191); the second, nearly identical, table sold at Sotheby's, New York, Nov. 6, 1982, lot 187.
2. The attribution to Oeben is made by C. Packer, *Paris Furniture by Master Ebénistes*, Newport, England, 1956, fig. 61, and

repeated by A. Boutemy, "Jean-François Oeben méconnu," *Gazette des Beaux-Arts* ser. 6, LXIII (1964), p. 220, figs. 37–39, and again by S. de Plas, *Les Meubles à transformations et à secret*, Paris, 1975, p. 32.

 3. G. de Bellaigue, *The James A. de Rothschild Collection at Waddesdon Manor: Furniture, Clocks and Gilt Bronzes*, Fribourg, Switzerland, 1974, I, no. 82.

 4. *Musée Nissim de Camondo* (coll. cat.), Paris, 1973, no. 345.

 5. Louvre, *Catalogue sommaire du mobilier et des objets d'art du XVIIe et du XVIIIe siècle*, comp. Carle Dreyfus, 2nd ed., Paris, 1922, no. 45; Bellaigue, I, no. 83, attributed to Wolff.

WR

ROGER VANDERCRUSE
(called Lacroix)

French, 1728–1799

ROGER VANDERCRUSE was born in Paris in 1728, son of the cabinetmaker François Vandercruse. He became a *maître-ébéniste* in 1755 and took over his father's workshop on the rue du Faubourg Saint-Antoine. In the early part of his career, he was strongly influenced by his brother-in-law Jean-François Oeben, whom his eldest sister had married in 1749. He appears to have worked primarily for the *marchand-merciers*, particularly for Simon-Philippe Poirier from about 1760 onward. It was through Poirier that he supplied furniture for Madame du Barry at Louveciennes. He was also employed by the crown and the duc d'Orléans. Lacroix was a *juré* of his guild from 1768 to 1770 and later held other high administrative positions in the Corporation des Menuisiers-Ebénistes. Some of his early work is in the Louis XV and transitional styles, but the great majority of his furniture is in the Louis XVI style. He used two different stamps: R LACROIX and R.V.L.C.

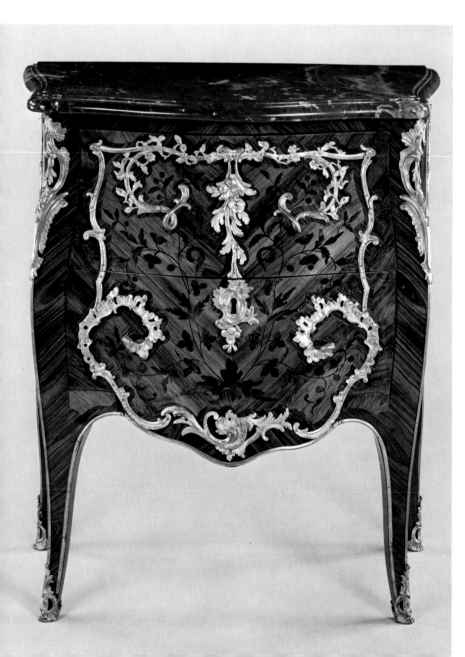

130. Commode

Ca. 1755–60
Veneered on oak with tulipwood, rosewood, and endcut kingwood; gilt-bronze mounts; top of *rouge griotte* marble. Height 32¼ in. (81.9 cm.), width 28¼ in. (71.8 cm.), depth 16¾ in. (42.6 cm.)
Stamped beneath the right side: R.V.L.C., with JME, the monogram of the guild
1982.60.59

THIS SMALL two-drawer commode, made about 1755–60, appears to be an early work of Roger Vandercruse Lacroix. The two drawers are treated as a single decorative unit with continuous floral marquetry of endcut kingwood framed by scrolled and foliated mounts. Few pieces of furniture by Lacroix in the Louis XV style are known, and the present example belongs to no established group of his furniture. The mounts were used in varying combinations on commodes by a number of contemporary cabinetmakers—e.g., Charles Chevallier *le jeune* (*maître* before 1738–1771), Pierre Macret (1727–1796), Nicolas Petit (1732–1791), Adrien Faizelot Delorme (*maître*

1748, retired 1783), and Matthieu Criaerd (1689–1776)—and were probably commercially available in Paris in the 1750s.

WR

131. Writing table

Ca. 1760–70
Veneered on oak with rosewood, endcut kingwood, and banding of holly; gilt-bronze mounts. Height 28¾ in. (73 cm.), width 18¼ in. (46.4 cm.), depth 13½ in. (34.3 cm.)
Stamped on the underside of the back rail:
R LACROIX, with JME, the monogram of the guild
Pasted inside the bottom drawer is a printed label ("Museum für Kunsthandwerk, Frankfurt am Main") with an ink inscription ("G. R. 956").
1982.60.62

THE WRITING DRAWER contains a slide covered with modern tooled green leather and fitted with three gilt-metal containers for pens, sand, and an inkwell. The two lower drawers are treated as though they were a single panel, veneered with continuous floral marquetry and framed by a gilt-bronze molding of entwined-rope design chased with beading. The overall shape of this table and the style of floral marquetry with endcut kingwood suggests a date early in Lacroix's career when he was still working under the influence of Oeben. The marquetry and cabriole legs in combination with fully neoclassical mounts denote a transitional table. The mounts and marquetry are found on other pieces by Lacroix, particularly the central ornamental motif of the foliated wheel inlaid on both top and lower shelf, a motif that he often repeated. It was used on small transitional tables;[1] on a group of neoclassical bonheurs du jour;[2] and on a group of neoclassical upright secretaires where the motif is combined with cornflower marquetry in diamond reserves.[3] Lacroix also made this shape of table as a combined toilet and writing table; an example that repeats some of the same mounts, although veneered with a more naturalistic floral marquetry, was in the René Fribourg collection.[4]

NOTES:
1. Examples are in the Musée Cognacq-Jay, Paris (E. Jonas, comp., *Collections leguées à la ville de Paris par Ernest Cognacq*, Paris, 1930, p. 88, no. 401) and a table formerly in the Heywood-Lonsdale collection (sale, Christie's, London, June 6, 1957, lot 155).

2. One in the collection of Mr. and Mrs. Charles Wrightsman, New York (F. J. B. Watson, *The Wrightsman Collection*, New York, 1966, I, pp. 180–81, no. 103); another formerly in the collection of Mrs. Derek Fitzgerald (sale, Sotheby's, London, Nov. 22, 1963, lot 134); and two formerly at Kraemer & Cie, Paris (P. Verlet, *Les Ebénistes du XVIIIe siècle français*, Paris, 1963, p. 169, fig. 2; *Connaissance des Arts* no. 285 [Nov. 1975], p. 37 [advertisement]).

3. One is published in G. Janneau, *Le Meuble léger en France*, Paris, 1952, p. 353, figs. 194,195; two were formerly in the collection of Mrs. Alexander Hamilton Rice, New York (sale, Sotheby's, New York, Oct. 3, 1970, lots 146, 147); at Dalva Brothers, Inc., New York, 1983.

4. Verlet, p. 167, figs. 2, 3.

EX COLL.: Goldschmidt-Rothschild collection; Museum für Kunsthandwerk, Frankfurt am Main; Schuster collection.

WR

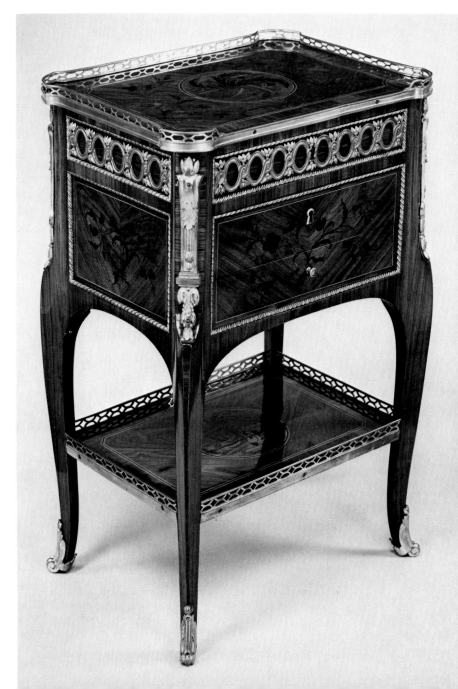

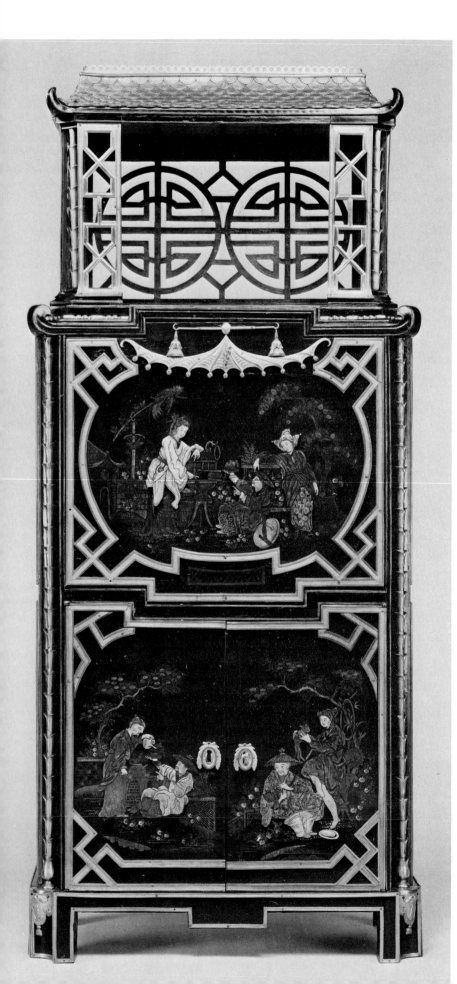

RENE DUBOIS

French, 1737–1798

SON OF THE cabinetmaker Jacques Dubois (1693–1763), René Dubois became a *maître-ébéniste* in 1755 but continued to work for his father until the latter's death. In 1763 his mother took over the direction of the family firm on the rue Charenton, and René worked with her until her retirement in 1772, when he acquired the stock and full control of the business. He ceased cabinetmaking in about 1779 to become a furniture dealer and retired shortly before the Revolution. His furniture is chiefly in the transitional and Louis XVI styles, but, because he continued to use his father's stamp (I. DUBOIS), there has been some confusion in distinguishing the works of father and son. He was employed by members of the nobility and by the French crown. Marie-Antoinette especially favored his furniture, and in 1779 he was recognized as an *ébéniste de la reine*.

132. Drop-front secretaire

Ca. 1770–75
Veneered on oak with panels of European lacquer; the interior veneered with mahogany and purplewood; gilt-bronze mounts. Height 60 in. (152.5 cm.), width 26¾ in. (68 cm.), depth 13⅜ in. (34 cm.)
Stamped on the back on the upper right side:
I DUBOIS, with JME, the monogram of the guild
1982.60.57

THE FALL FRONT opens to reveal a leather writing surface, four small drawers, and shelves; the cupboard doors on the lower part enclose a single shelf. The black European lacquer panels, decorated in colors with Chinese figures in gardens and landscapes, are overlaid with fretted gilt-bronze mounts of pseudo-oriental character. Watson sees this secretaire as "a striking instance of the combination of classical and oriental motives often favored by René Dubois" and notes that the unusual open-fret Chinese pagoda at the top anticipates some of Thomas Sheraton's designs.[1] Dubois made a number of secretaires and may have considered this type of furniture something of a specialty. When he acquired the firm's stock from his mother in 1772, secretaires constituted the largest single category (twenty-eight, three of which were described as drop-front). Several secretaires identically stamped and of similar form to the Linsky example are known, of which

the closest, also veneered with black European lacquer and with an identical pagoda top, was sold at auction in 1971.[2] Three related drop-front secretaires with canted corners and vitrines (rather than pagodas) on top are the marquetry example in the J. Paul Getty Museum, Malibu,[3] an example decorated with vernis Martin,[4] and another with painted panels.[5] All are firmly neoclassical in style and must date from the late 1760s or 1770s.

NOTES:
1. F. J. B. Watson, *Louis XVI Furniture*, London, 1960, p. 122.
2. Sale, Sotheby's, New York, Oct. 9, 1971, lot 232.
3. G. Wilson, *Decorative Arts in the J. Paul Getty Museum*, Malibu, 1977, no. 101.
4. Formerly in the collection of Alice, countess of Strafford (sale, Christie's, London, June 29, 1967, lot 77).
5. Formerly in the collection of Sir Anthony de Rothschild, Bart. (sale, Christie's, London, June 13, 1923, lot 54).

EX COLL.: Mrs. Charles Holland Warne (sale, Christie's, London, July 21, 1949, lot 88); H. M. Lee.

BIBLIOGRAPHY: F. J. B. Watson, *Louis XVI Furniture*, London, 1960, p. 122, fig. 90.

WR

MARTIN CARLIN

French (born Germany), ca. 1730–1785

CARLIN was born about 1730 in Freiburg im Breisgau, in southwest Germany, and settled in Paris in the 1750s. He probably trained under Jean-François Oeben, whose sister he married in 1759. In the early 1760s he was working as an *artisan libre* in the grande rue du Faubourg Saint-Antoine and was elected *maître-ébéniste* in 1766. He became one of the great masters of the Louis XVI style and produced an extensive body of furniture, ranging from small, portable, and highly refined desks and tables, in which he seems to have specialized, to larger case furniture, such as commodes and secretaires. Many of his pieces were mounted with plaques of Sèvres porcelain or panels of oriental lacquer. He worked principally for dealers, particularly for Simon-Philippe Poirier (1720–1785) and his successor Dominique Daguerre (d. 1796) and for Charles Darnault; it has been suggested that most of his furniture was executed following designs provided by them. Considerable quantities of his furniture were sold to the French crown, especially to Louis XVI's aunts (Mesdames Tantes) for Bellevue.

133. Small desk (bonheur du jour)

Ca. 1769
Carcase and drawer of the lower stage of oak; the three drawers of the upper stage of mahogany; veneered with tulipwood; marquetry of sycamore, ebony, boxwood, harewood, and mahogany; gilt-metal fittings; gilt-bronze mounts; seventeen plaques of Sèvres soft-paste porcelain. Height 32¼ in. (81.9 cm.), width 26¼ in. (66.7 cm.), depth 15¾ in. (40 cm.)
The desk is not stamped.
Affixed to the underside is a nineteenth-century paper label with ink inscription: *Earl Spencer*
1982.60.54

THIS TYPE of small desk with a raised section at the back was described in the eighteenth century as a *table à gradins* or bonheur du jour, the latter a term whose derivation is unknown. The desk has three drawers in the upper section; the single drawer in the lower section, its keyhole concealed behind the hinged circular wreath and patera pull, is a writing drawer. It contains, on the right, a loose container for materials with the original gilt-metal inkwell, pounce pot, and trough for a sponge and, on the left, the main compartment with a writing panel inset with modern gold-tooled red leather, which is hinged at the back to the top of the drawer. The underside of the panel is veneered with twelve squares of tulipwood in a checkered pattern within a white fillet banded with tulipwood; the compartment within is lined with tulipwood veneer.

This and the accompanying desk (no. 134), although very similar in most details, do not appear to have been made as a pair. The construction—the way in which the upper section fits onto the lower—is different in each desk. More importantly, the Sèvres plaques, which are the desks' chief decorative feature, form two distinct series, painted by different artists in different years. The plaques on the present desk display a deeper green color than those on the accompanying desk, and the painters involved were considerably more skilled in their art.

Ten desks by Martin Carlin of this design are known, with Sèvres plaques dating from 1766 to 1774. Two are in the Samuel H. Kress Collection in the Metropolitan Museum;[1] two are in the Huntington Art Gallery, San Marino;[2] two are at Waddesdon Manor;[3] one is in the collection of the duke of Buccleuch, Boughton House, Northamptonshire;[4] and one is in the Musée Nissim de Camondo, Paris.[5] The most complete accounts of this group are given

by Bellaigue and Parker. Although only seven of the desks are stamped by Carlin, they were clearly all made in his workshop. They were probably designed and commissioned by the dealer Simon-Philippe Poirier, who purchased from the Sèvres factory large numbers of plaques, which he then had mounted on furniture made by Carlin and other *ébénistes*. These ten bonheurs du jour vary little in ornamentation. This and the accompanying desk each have on the back three panels of stylized floral trails in marquetry of the same pattern, a design that is repeated on several others.

Three of the desks were bought by important patrons in the eighteenth century (Madame du Barry, the comtesse d'Artois, and the prince de Soubise), but the early history of the two under discussion is not known. By 1862 they were in Spencer House, London, and were lent that year by the fifth earl Spencer to the exhibition at the South Kensington Museum, where they were predictably described as a pair: "Nos. 830 & 831. Pair of small pier tables, with drawers, inlaid with plaques of Sèvres porcelain with green margins, and painted with bouquets of flowers. Period of Louis XVI." It is not known when they entered the Spencer collection. They are believed to have been sold in the late nineteenth century and were acquired by William Astor for Cliveden in Buckinghamshire, where they remained until 1967, when, following the death of the third viscount Astor, they were sold at Christie's and bought by Mr. and Mrs. Linsky.

The seventeen porcelain plaques have a green ground and are painted with bunches of flowers in reserves set in a triple border of tooled gold.

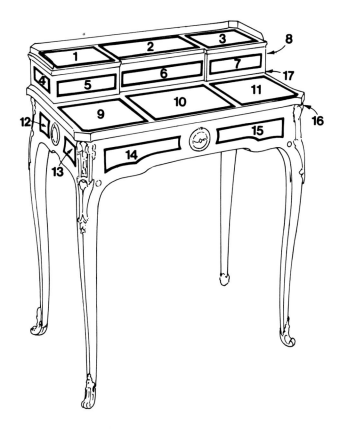

NUMBER	DATE	PAINTER	OTHER MARKS
I	1769	Pierre *jeune*	
2	1769	Noël	D
3	1769	Pierre *jeune*	
4	1769	unidentified	D
5	1769		D
6	1769	unidentified	D
7	1769	unidentified	D
8	1769	unidentified	D
9	1769	Noël	
10	1769	Pierre *jeune*	D
11	1769	Noël	
12	1769	Levé	D
13	1769	Levé	D
14	1769	Levé	D
15	1769	Levé	D
16			C
17	1769	Levé	D

Sixteen of the plaques are painted on the reverse in blue with the date-letter *q* for 1769 within crossed *LL*'s. Fifteen plaques are painted on the reverse with the marks of one of four flower painters:

1. Jean-Jacques Pierre: nos. 1, 3, 10 (Pierre *jeune*, born before 1752, working 1763–1800).[6]
2. Guillaume Noël: nos. 2, 9, 11 (1735–1804, working 1755–1804).[7]
3. Denis Levé: nos. 12–15, 17 (born ca. 1731, working 1754–93, 1795–1805).[8]
4. Unidentified flower painter: nos. 4, 6–8. The same mark occurs on a cabinet and similar desk in the Kress Collection in the Metropolitan Museum, where it is associated by Dauterman[9] with Pierre *jeune*. This, however, is not accepted by Eriksen[10] and remains questionable in view of Pierre's recorded mark.

Twelve of the plaques are marked on the reverse with a roman capital *D* in blue enamel; this mark does not occur

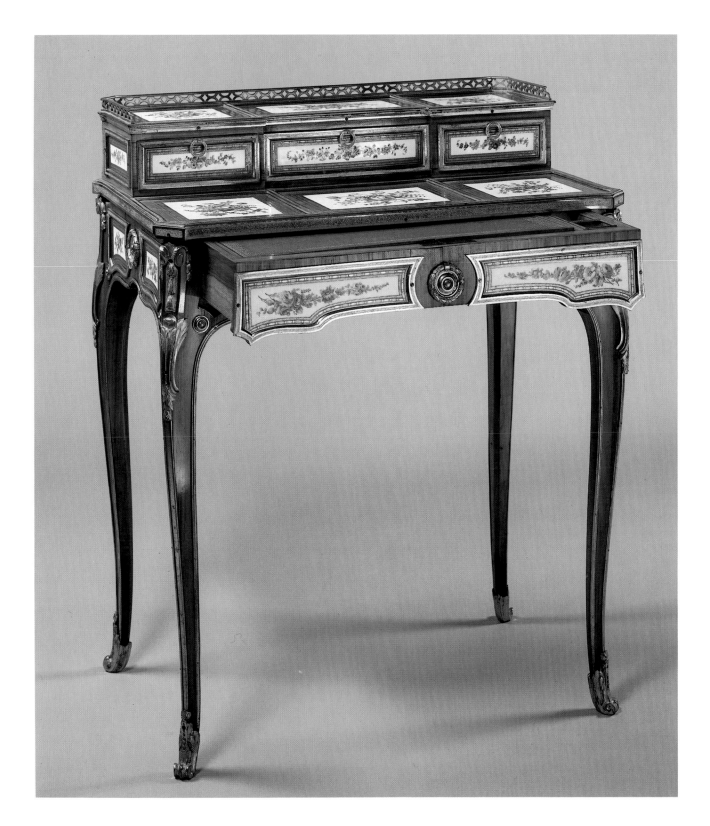

on other Sèvres plaques in this series of desks, and its significance is unknown. There are no incised marks on any of the plaques.

One plaque (no. 16) is painted on both sides with a bouquet of flowers and bears a roman capital *C* in blue on the reverse but no date-letter or crossed *LL*'s. This appears to be unique among all the known plaques made at Sèvres. The bouquet on the reverse is too large to have allowed for the addition of a border. The most likely explanation is that the unknown painter simply made a mistake and turned the plaque over to paint a bouquet of the correct size.

NOTES:

1. C. C. Dauterman, J. Parker, and E. A. Standen, *Decorative Art from the Samuel H. Kress Collection at the Metropolitan Museum of Art*, London, 1964, pp. 134–38, nos. 22, 23.

2. G. Wilson, "New Information on French Furniture at the Henry E. Huntington Library and Art Gallery," *J. Paul Getty Museum Journal* 4 (1977), pp. 39–40.

3. G. de Bellaigue, *The James A. de Rothschild Collection at Waddesdon Manor: Furniture, Clocks and Gilt Bronzes*, Fribourg, Switzerland, 1974, II, pp. 472–83, nos. 96, 97.

4. F. J. B. Watson, *Louis XVI Furniture*, London, 1960, p. 124, fig. 98.

5. *Musée Nissim de Camondo* (coll. cat.), Paris, 1973, p. 27, no. 126; S. Eriksen, *Early Neo-classicism in France*, London, 1974, p. 318, pl. III.

6. For biography, see Dauterman, Parker, and Standen, pp. 189–90; S. Eriksen, *The James A. de Rothschild Collection at Waddesdon Manor: Sèvres Porcelain*, Fribourg, Switzerland, 1968, no. 83.

7. See Dauterman, Parker, and Standen, p. 187; Eriksen, *The James A. de Rothschild Collection*, no. 47.

8. See Dauterman, Parker, and Standen, p. 187; Eriksen, *The James A. de Rothschild Collection*, no. 89.

9. Dauterman, Parker, and Standen, pp. 135, 190.

10. Eriksen, *The James A. de Rothschild Collection*, no. 83.

EX COLL.: the fifth earl Spencer, Spencer House, London; the third viscount Astor, Cliveden, Buckinghamshire (sale, Christie's, London, June 29, 1967, lot 95).

EXHIBITED: lent by the fifth earl Spencer to the 1862 exhibition at the South Kensington Museum, May 5, 1862, no. 830 or 831.

BIBLIOGRAPHY: C. C. Dauterman, J. Parker, and E. A. Standen, *Decorative Art from the Samuel H. Kress Collection at the Metropolitan Museum of Art*, London, 1964, pp. 136–37; G. de Bellaigue, *The James A. de Rothschild Collection at Waddesdon Manor: Furniture, Clocks and Gilt Bronzes*, Fribourg, Switzerland, 1974, II, pp. 478, 480, 482.

WR

134. Small desk (bonheur du jour)

Ca. 1770

For description, dimensions, label, history, exhibition, and bibliography, see no. 133.

Stamped twice (once beneath the left apron and again on the back rail of the top beneath the raised section): M CARLIN, with JME, the monogram of the guild; inscribed in black ink on the underside of the container fitted with gilt-metal inkwell, pounce pot, and sponge trough: *1 piece en soudurre forte*

1982.60.55

THE PRESENCE of the maker's stamp, dealer's inscription, and porcelain plaques constituting a separate series are the three features that significantly distinguish this from the preceding desk. Inscriptions on furniture ordered by Simon-Philippe Poirier are not uncommon, although this is the only desk in the group with this type of inscription. As Bellaigue has noted, the inscription presumably gives instructions to the silversmith or supplier of writing materials to whom the empty container was sent to be fitted with metal accessories.[1] Poirier's name occurs on the carcase of one desk and on a plaque on another in this series (both in the Huntington Art Gallery, San Marino).[2]

The seventeen porcelain plaques have an apple-green ground and are painted with bunches of flowers in reserves set in a triple border of tooled gold.

NUMBER	DATE	PAINTER	LOCATION MARK
1	1770	unidentified	
2	1770	Bertrand	
3	illegible	unidentified	
4	1770	Nicquet(?)	
5	1770	Nicquet(?)	
6	1770	Nicquet(?)	
7	1770	Nicquet(?)	
8	1770	Nicquet(?)	
9	1770		*haut*
10	1770	Bertrand	
11	1770	Bertrand	*h*
12	1770	Cornailles	*h*
13	1770	Cornailles	*h*
14	1770	Cornailles	*haut*
15	1770	Cornailles	*haut*
16	1770	Cornailles	*h*
17	1770	Cornailles	*h*

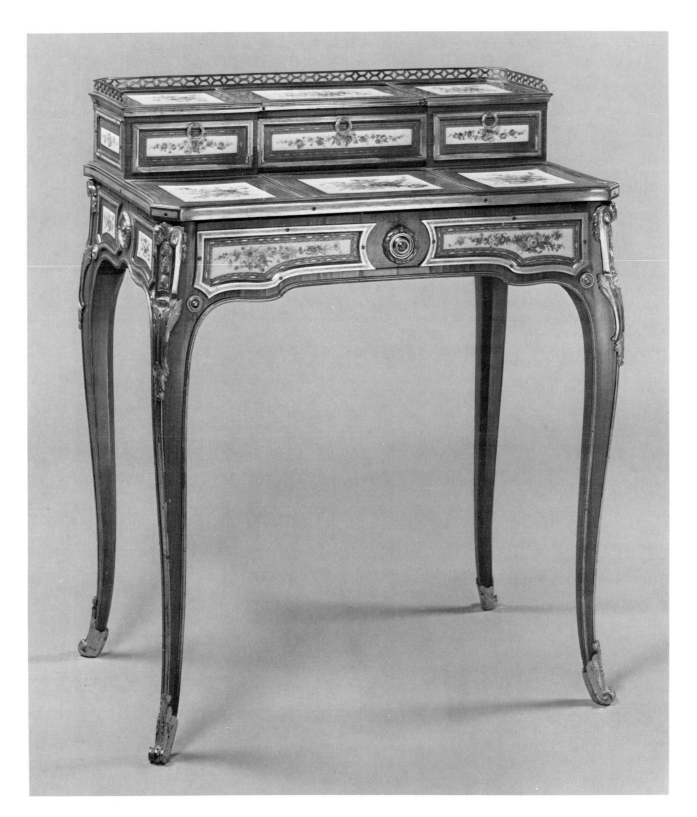

221

Sixteen of the plaques are painted on the reverse in blue with the date-letter *r* for 1770 within crossed *LL*'s; the date-letter on one plaque (no. 3) is illegible. Sixteen of the plaques are painted on the reverse with the marks of one of four flower painters:

1. Bertrand: nos. 2, 10, 11 (no first name known, working 1757–75, d. 1775).[3] Eriksen describes Bertrand's mark as the figure 6; Clare Le Corbeiller and Geoffrey de Bellaigue propose that this mark be read as the letter *B*.
2. Antoine-Toussaint Cornailles: nos. 12–17 (working 1755–92, 1794–1800).[4]
3. Five plaques (nos. 4–8) are painted on the reverse with a mark which is possibly that of the painter Nicquet (no first name known, working 1764–92).[5]
4. Unidentified flower painter: nos. 1, 3.

Eight of the plaques are painted on the reverse with marks indicating the top—on nos. 9, 14, and 15, the word "haut," and on nos. 11–13 and 16–17, the letter *h*.

NOTES:
1. G. de Bellaigue, *The James A. de Rothschild Collection at Waddesdon Manor: Furniture, Clocks and Gilt Bronzes*, Fribourg, Switzerland, 1974, II, p. 482.
2. G. Wilson, "New Information on French Furniture at the Henry E. Huntington Library and Art Gallery," *J. Paul Getty Museum Journal* 4 (1977), pp. 39–40.
3. S. Eriksen, *The James A. de Rothschild Collection at Waddesdon Manor: Sèvres Porcelain*, Fribourg, Switzerland, 1968, p. 315.
4. C. C. Dauterman, J. Parker, and E. A. Standen, *Decorative Art from the Samuel H. Kress Collection at the Metropolitan Museum of Art*, London, 1964, p. 183.
5. The mark is illustrated in M. Brunet, *Les Marques de Sèvres*, Paris, 1953, p. 33.

WR

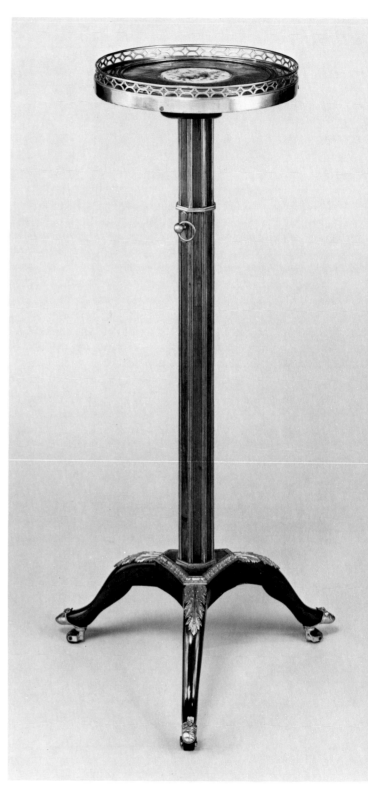

DAVID ROENTGEN

German, 1743–1807

135. Candlestand

Ca. 1780
Veneered with tulipwood, the legs of solid mahogany;
 gilt-bronze mounts; plaque of Sèvres soft-paste
 porcelain. Height 31 in. (78.7 cm.)
1982.60.63

THIS ADJUSTABLE candlestand was intended to support a freestanding candlestick or candelabrum. The ring on the side of the pillar controls a spring-operated lever, which engages in a steel ratchet and allows the top to be set at any height up to 45¼ inches (114.8 cm.). Inset in the top is a circular plaque of Sèvres soft-paste porcelain. The plaque is painted with a broad apple-green border around a white reserve, which is framed by a gold band with branches and leaves; a composition of flowers and grapes is painted on the white reserve. The plaque is unmarked but can be dated about 1780 on stylistic grounds. The legs are a distinctive feature of this candlestand: each is a stylized human leg and terminates with a gilt-bronze mount in the form of a shoe tied with a ribbon.

Martin Carlin made a number of candlestands with Sèvres plaques, often with the addition of a second marquetried tray below the top and a pair of gilt-bronze candle arms on a steel shaft above the top (examples are at Waddesdon Manor, in the collection of Mr. and Mrs. Charles Wrightsman, New York, and in the Philadelphia Museum of Art). The refinement of the present candlestand and the high quality of chasing on the mounts recall Carlin's candlestands, but the legs and details of decoration are not so closely related to his signed work as to allow a strong attribution. Candlestands fitted with a ratchet system were also made by other cabinetmakers of this period, including Pierre Denizot (ca. 1715–1782) and Joseph Gengenbach, called Canabas (*maître* 1766–97).

WR

SON OF THE cabinetmaker Abraham Roentgen, David Roentgen was born in Herrenhaag, Upper Hesse. He studied under his father and succeeded him in 1772 in the workshop at Neuwied on the Rhine, near Coblenz. Under his direction the business flourished and soon employed more than a hundred workmen. After a visit to Paris in 1772, Roentgen began to attract French customers, including Marie-Antoinette, and in 1779 he was made *ébéniste-mécanicien du roi et de la reine*. With the sales of his furniture in Paris increasing, the French cabinetmakers' guild insisted upon his admission as *maître* in 1780. He traveled widely—to the Low Countries; to Russia, where he supplied large quantities of furniture for Catherine the Great; and to Vienna and Naples, where he established shops, as he had in Paris. The pictorial marquetry, often after designs of François Boucher, Jean Pillement, and Januarius Zick, was of extraordinary quality, and the intricate mechanical devices, such as elaborate locks and concealed buttons to open doors and drawers, appealed to collectors who could afford his high prices. Roentgen became the most successful cabinetmaker of the eighteenth century; his career was effectively ended, however, by the Revolution, during which his Neuwied workshop was destroyed. He died in Wiesbaden in 1807.

136. Commode

Ca. 1780
Veneered on oak and pine with tulipwood, sycamore,
 boxwood, purplewood, pearwood, harewood, and
 other woods; drawer linings of mahogany; gilt-
 bronze mounts; red brocatelle marble top. Height
 35¼ in. (89.5 cm.), width 53½ in. (135.9 cm.), depth
 27¼ in. (69.2 cm.)
Branded twice on the uprights of the back: double *V*
 beneath a crown (the château mark of Versailles)
1982.60.81

THE THREE marquetry panels on the front depict a Palladian stage with a tessellated floor, divided into three sections and seen in perspective through drawn curtains. The flanking areas are empty; the central one is occupied by three figures from the Italian Comedy: Pantaloon, his daughter Isabella, and Harlequin. Dividing the panels are

stiles mounted with elongated *S*-shaped scrolls of berried laurel swags tied with ribbons below a frieze divided by triglyphs and guttae adapted from the classical Doric order. A single drawer, occupying the entire width of the frieze, has three simulated drawer fronts with gilt-bronze mounts of marguerites, foliage, and scrollwork forming handles. An elaborate mechanism within the drawer locks it and also opens the three doors below, which are on spring-operated hinges. The center door conceals a cupboard with shelves; each of the slightly curved side doors conceals a nest of three mahogany drawers; the top drawer on each side is covered with a sliding tambour top and opens sideways on a hinge in the center, thereby dividing into two parts and revealing two small tulipwood draw-

ers and a secret drawer. Further releases and locks are concealed and worked by knobs on either side of the center door. Roentgen was fond of this type of complexity and often used it in commodes, tables, and secretaires. The mechanisms that operate the locks and doors were probably made by Peter Kinzing (1745–1816), a clockmaker who worked with Roentgen from about 1770 and who became clockmaker to Marie-Antoinette in 1785.

A large marquetry panel on each side of the commode depicts a genre scene. On the right side, in a paneled room with tall casement windows and with a pair of hunting horns suspended from the wall, a violinist and cellist in contemporary costume play from sheets of music inscribed "allegro." In the corresponding room on the

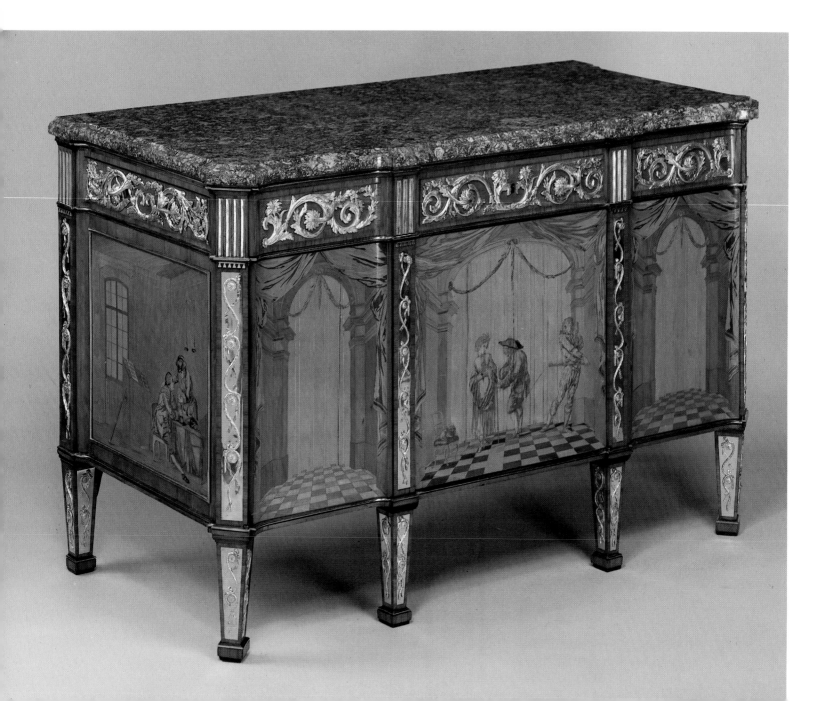

left side, they are at a table, holding carafes of wine; against the music stand rests a bassoon, and hanging from the wall are two woodwind instruments. The marquetry panels on this commode were most likely executed after drawings by Januarius Zick (1732–1797), court painter to the elector of Trier, who often furnished Roentgen with designs for marquetry. These panels, the gilt-bronze mounts, the mechanisms, and the interior fittings all show Roentgen working at his highest level.

Exactly when this commode entered Versailles is not yet known. It is branded twice on the back with the château mark of Versailles (double *V* beneath a crown), but it has no inventory number to provide more specific information. In 1792 it was in the private apartments of the king, in a small room called the *pièce du caffé*, adjacent to the passage leading to the *cour des cerfs*. In the *Inventaire général des meubles de la famille royale, Versailles*, of 1792, it is described as follows: "Une commode plaquée à tableau de bois fond satiné et ombré sur les 3 faces avec medallions à figures en bois à rapport à 3 vantaux. le dedans à mechanique orné de bronze à dessus de marbre bleu turquin de 4 pds 2 p° de large. 3,600 [livres]."[1] *Commode à vantaux* was a contemporary term for a commode with doors concealing the drawers in the front. The description of the marble top as *bleu turquin* (a blue-gray marble with markings of white and lighter blue) shows that the present red brocatelle marble top is not original. The commode was no doubt sold in the Revolutionary sales of furniture from Versailles, held between August 1793 and August 1794.

In the nineteenth century it was acquired by the earl of Rosebery and is first recorded at Mentmore in 1884 in one of the rooms off the gallery on the second floor. In the Mentmore catalogue of that year, it was described as "by David de Luneville [as David Roentgen was then known] and Gouthière." The Parisian bronze maker and gilder Pierre Gouthière (1732–1813/14) is not known to have worked with Roentgen, and the mounts cannot be attributed to him.

Roentgen repeated the three principal figural marquetry panels with variations on two other pieces of furniture. The two genre scenes flank the Italian Comedy vignette to form the top of a table mounted with Sèvres plaques on a later (nineteenth century?) base, published by Hans Huth as formerly in the collection of E. M. Hodgkins;[2] its present location is unknown. The scenes appear on a commode in the Victoria and Albert Museum, London, where they occupy the same positions as on the Linsky commode.[3] In place of the two flanking stages on the front of the Linsky commode are two oval panels depicting people in theater boxes viewing the Italian Comedy scene. The frieze of the Victoria and Albert commode is mounted with gilt-bronze rectangular plates with indented corners and handles in the form of looped swags of laurel. Behind the frieze mounts of the present piece are holes and outlines that correspond exactly with the Victoria and Albert mounts. This commode therefore either originally had frieze mounts of the thinner, more neoclassical, and idiomatic Roentgen type, or it was intended to have them, and either Roentgen or the unknown patron opted for the present finely chased foliate scroll mounts, which are entirely French in character and were probably made in Paris rather than Neuwied. The Linsky commode presents a more harmonious and sophisticated design in both marquetry and mounts than its London cousin, although it has less elaborate fittings. It is tempting to see it as a more evolved and thus later conception, but many factors were involved in a commode of this importance, not least the taste of the patron.

NOTES:
1. *Inventaire général des meubles de la famille royale, Versailles*, 1792, Archives National, Paris, o¹3354, p. 52.
2. H. Huth, *Abraham und David Roentgen und ihre Neuwieder Möbelwerkstatt*, Berlin, 1928, figs. 54, 90.
3. J. M. Greber, *Abraham und David Roentgen: Möbel für Europa*, Stainberg, 1980, II, figs. 543–47.

EX COLL.: Louis XVI, Château de Versailles; the earl of Rosebery, Mentmore, Buckinghamshire (sale, Sotheby's, London, Apr. 17, 1964, lot 54).

EXHIBITED: 25 Park Lane, London, *Three French Reigns*, 1933, no. 120.

BIBLIOGRAPHY: *Mentmore*, Edinburgh (privately printed), 1884, II, p. [187], fig. 10; F. J. B. Watson, *Louis XVI Furniture*, London, 1960, p. 99, fig. 2; H. Huth, *Roentgen Furniture, Abraham and David Roentgen*, New York, 1974, pp. 46, 78, pl. III, figs. 176, 177, 179; J. M. Greber, *Abraham und David Roentgen: Möbel für Europa*, Stainberg, 1980, I, pp. 215–17; II, figs. 537–542.

WR

CLAUDE-CHARLES SAUNIER

French, 1735–1807

SAUNIER was the son and grandson of cabinetmakers. He was received into the family atelier in 1752 and worked for his father, whom he succeeded as head of the workshop in 1765. He soon advanced from the Louis XV style to the Louis XVI. He often used oriental lacquer and veneers of contrasting colors, adding gilt-bronze mounts of high quality. Saunier executed a number of rolltop desks and *consoles-dessertes*, types that may have been something of a specialty. He produced some of his furniture for the *marchand-mercier* Dominique Daguerre (d. 1796).

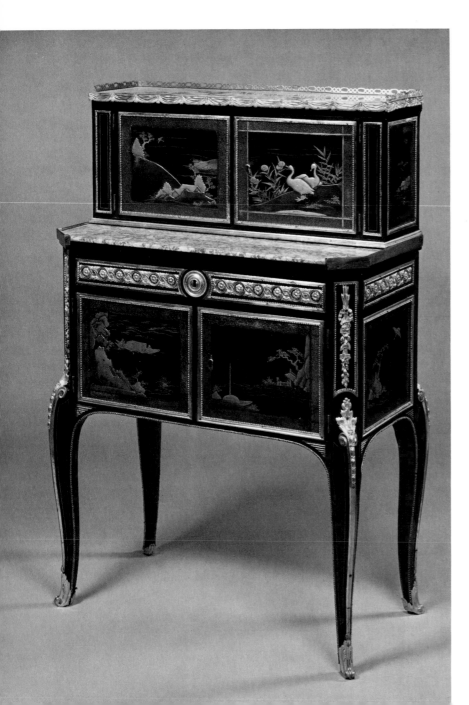

137. Small desk (bonheur du jour)

Ca. 1765–75
Veneered on oak with ebony and panels of black and
 gold Japanese lacquer; gilt-bronze mounts; two
 breccholito marble slabs. Height 39 in. (99.1 cm.),
 width 25¼ in. (64.1 cm.), depth 14½ in. (36.8 cm.)
Stamped on the underside of the back at the center:
 C. C. SAUNIER
1982.60.58

THE PRESENCE of cabriole legs on a bonheur du jour of rectilinear design with neoclassical mounts indicates that the piece is transitional between the Louis XV and Louis XVI styles. This bonheur du jour can thus be dated early in Saunier's career. The black and gold Japanese lacquer panels with *nashiji* borders depict geese and waterfowl, boats and buildings in river landscapes with flowering trees. The upper and lower sections each contain a single compartment enclosed by doors. The writing drawer has a writing slide with kingwood borders, inset with modern green leather, and the original gilt-metal pen tray and wells for ink and sand. Saunier repeated some of the mounts on later bonheurs du jour and other pieces in a purely Louis XVI style (e.g., the corner mounts with pendent berried husks and floral festoons suspended from riband ties, which appear on a bonheur du jour formerly in the Ojjeh collection[1] and a pair of console tables formerly at Mentmore[2]).

NOTES:
 1. Sale, Sotheby's, Monte Carlo, June 25, 1979, lot 16.
 2. Sale, Sotheby's, London, Apr. 17, 1964, lot 38.

EX COLL.: Ernest Rechnitzer (sale, Christie's, London, May 19, 1955, lot 84).

BIBLIOGRAPHY: "Un Meuble nommé bonheur du jour," *Connaissance des Arts* no. 67 (Sept. 1957), p. 59.

WR

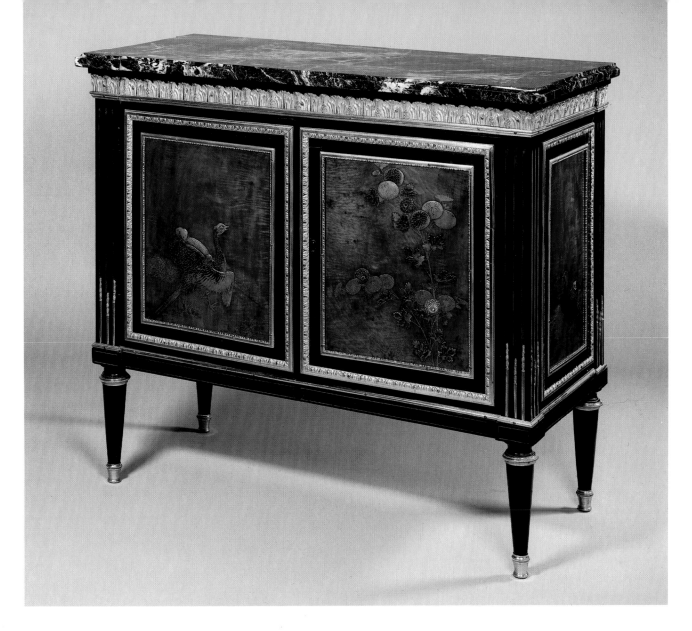

138. Commode

Ca. 1780–90

Veneered on oak with ebony, mahogany, and rosewood and with four red and gold Japanese lacquer panels; gilt-bronze mounts; *rosso levanto* marble top. Height 36¼ in. (92.1 cm.), width 41¾ in. (106 cm.), depth 19¼ in. (48.9 cm.)

Stamped below the marble on the left front corner:

C. C. SAUNIER, with JME, the monogram of the guild
1982.60.53

THIS COMMODE features four red and gold Japanese lacquer panels. Set into the doors and sides and framed by *nashiji* lacquer and gilt-bronze mounts, they are incorporated into a restrained and sophisticated neoclassical design. The flutes at the corners, which evoke the classical pilaster, are filled at the base with gilt-bronze *chandelles* (fillets in the form of candles). Some of the mounts are found on other lacquer pieces by Saunier of contemporary date (e.g., the acanthus-leaf frieze mount that is repeated on a commode and two corner cabinets supplied in 1791 by Dominique Daguerre to Lord Spencer for Spencer House[1]). The two doors conceal four drawers whose fronts are veneered with mahogany and rosewood.

NOTE:
1. P. Thornton and J. Hardy, "The Spencer Furniture at Althorp," *Apollo* n.s. 88 (Oct. 1968), p. 276, figs. 16–18.

WR

227

JEAN-HENRI RIESENER

French (born Germany), 1734–1806

RIESENER, who was born in 1734 at Gladbeck near Essen, came to Paris and entered the workshop of Jean-François Oeben soon after 1754. Following Oeben's death in 1763, Riesener took over the direction of the business and four years later married his widow. The following year (1768) he became a *maître* in the cabinetmakers' guild. During this period he completed a number of pieces begun by Oeben, most notably the *bureau du roi* (now in Versailles), commissioned from Oeben by Louis XV in 1760 and completed by Riesener in 1769. He succeeded Gilles Joubert as the royal cabinetmaker (*ébéniste ordinaire du roi*) in 1774 and held this position until 1784. Between 1775 and 1784 his commissions from the crown totaled nearly 900,000 livres; during this period the pictorial marquetry of his early Louis XV phase was often replaced by plain mahogany veneers or oriental lacquer, and his gilt-bronze mounts became less elaborate. Work fell off sharply after 1784, and after the Revolution Riesener bought back much of his own furniture. He has been consistently regarded as the greatest cabinetmaker of the Louis XVI period.

139. Commode

Ca. 1780–90
Veneered on oak with mahogany; gilt-bronze mounts; white marble top. Height 34 in. (86.3 cm.), width 36½ in. (92.7 cm.), depth 17¾ in. (45 cm.)
Stamped on the left side of the back: J. H. RIESENER
1982.60.51

THE FRONT is formed by a single wide drawer across the top above two doors, which open to reveal a cupboard divided by a shelf. The breakfront design is treated so as to give the illusion that the central section is superimposed over the front. The projecting central section on the doors is framed as a single panel with a gilt-bronze molding chased with water leaves, indented at the corners to accommodate four rosettes (modern replacements); the same framing on the flanking areas ends at the edges of the projecting panel as though it continued behind it. The drawer is similarly designed. Riesener employed the breakfront throughout his career and repeated this particular treatment of it with variations on a number of commodes, corner cupboards, and secretaires from about 1780 to 1790 (examples are in the Louvre, Versailles, Waddesdon Manor, the Wallace Collection, London, the Metropolitan Museum, the Philadelphia Museum of Art, the Detroit Institute of Arts, and the J. Paul Getty Museum, Malibu). The escutcheon mounts in the form of a female head framed by wreaths and bows, the apron mount with acanthus leaves and an acorn, the corner mounts of flowers modeled in high relief and tied by bows, and the mounts on the tapered legs with overlapping foliage are found on a number of other pieces by Riesener dating from the same decade. The use of a concave frieze is unusual in his work.

EX COLL.: J. V. B. Saumerez (sale, Sotheby's, London, May 31, 1957, lot 133).

BIBLIOGRAPHY: "Cours des meubles," *Connaissance des Arts* no. 69 (Nov. 1957), p. 58.

WR

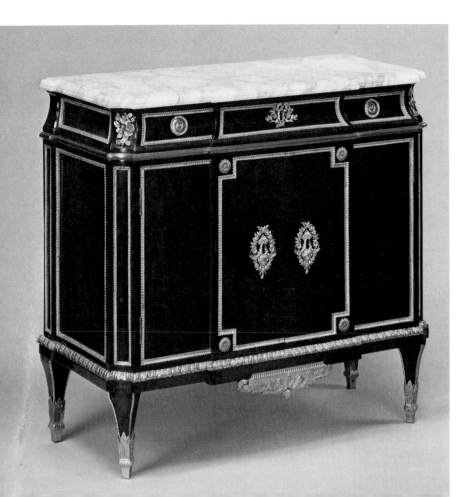

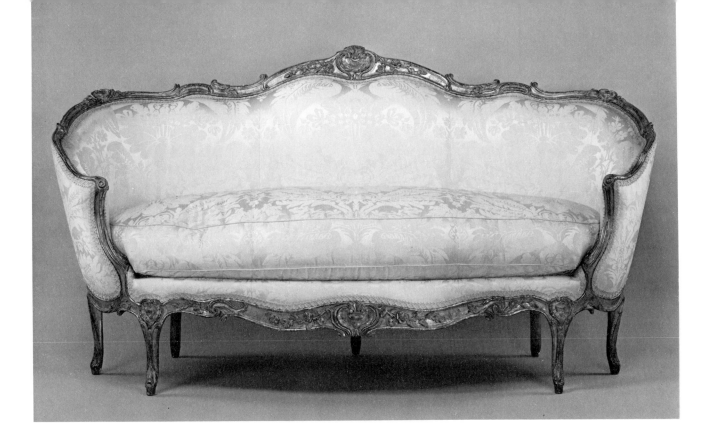

JEAN-BAPTISTE I TILLIARD

French, 1685–1766, or

JEAN-BAPTISTE II TILLIARD

French, *maître* 1752–97

JEAN-BAPTISTE I TILLIARD worked from about 1730 for the Garde-Meuble as a *menuisier-ordinaire*, making chairs, tables, and consoles for the crown, the prince de Soubise, and other patrons. He was influential in bringing the Louis XV style in chairs and other carved furniture into fashion. He collaborated with the carver Roumier and the gilder Bardou. His son, Jean-Baptiste II Tilliard, became a *maître* in 1752 and worked with him in a shop on the rue de Cléry until 1764, when the elder Tilliard retired and the younger registered his *maîtrise* and continued the business. He too worked for the court as well as for private clients, and he often employed the carver Chaillon and the gilder Mathon. Most of the younger Tilliard's furniture was in the Louis XVI style.

140. Sofa (*ottomane*)

Ca. 1750–60
Carved and gilded beechwood. Height 40¼ in. (102.2 cm.), length 78½ in. (199.4 cm.), depth 30 in. (76.2 cm.)
Stamped inside the back rail to the right of the center leg: TILLIARD
1982.60.72

BOTH FATHER and son used the stamp TILLIARD, and it is particularly difficult to distinguish the work of one from that of the other between 1752 and 1764, when they collaborated in the family workshop. The heart-shaped cartouche, a decorative motif often used by both, is a prominent feature on this sofa; it appears in the center of the front rail, at the top of the front legs, and at the rear corners of the top rail. The carving of the cartouche, the rococo scrolls, and the flowering vines is closely related to that on a daybed stamped by Tilliard, now in the Victoria and Albert Museum, London.[1]

NOTE:
1. M. Jarry, *Le Siège français*, Fribourg, Switzerland, 1973, fig. 105.

WR

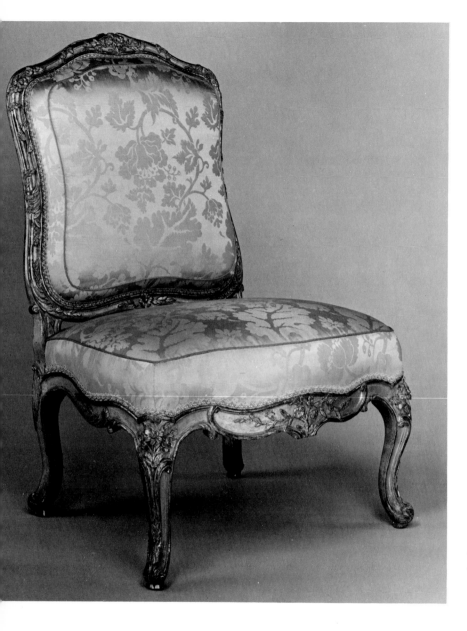

MICHEL GOURDIN
(known as Gourdin *le Jeune*)

French, *maître* 1752–died after 1777

MICHEL GOURDIN became a *maître* in 1752 and worked with his brother Jean-Baptiste Gourdin (*maître* 1748–died after 1776) in a shop on the rue de Cléry, close to their father's workshop on the rue Saint-Philippe. Both brothers made furniture in the Louis xv, transitional, and Louis xvi styles and were among the most highly skilled chairmakers of the period. In 1777 Michel became a supplier to the Garde-Meuble. He used the stamp M GOURDIN.

141. Pair of chairs
(*chaises à la reine*)

Ca. 1752–60
Carved and gilded beechwood. Height 36¼ in. (92.1 cm.), width 24½ in. (62.2 cm.), depth 26 in. (66 cm.)
Stamped inside the rear seat rail: M GOURDIN
1982.60.77,78

THE TOP RAIL of the back and front rail of the seat are carved with three flowers flanked by branches of flowers and leaves. Both Michel and Jean-Baptiste Gourdin used the motif of a flower at each front corner above a split stem running down the fore edge of the front leg with an acanthus leaf on the foot. Other chairs by Michel Gourdin are in the Louvre; the Bouvier Collection in the Musée Carnavalet, Paris; the Wallace Collection, London; Windsor Castle; and the collection of Mr. and Mrs. Charles Wrightsman, New York.

WR

142. Four armchairs (*fauteuils en cabriolet*)

French, ca. 1750–60
Carved and gilded beechwood. Height 34¼ in. (87 cm.), width 25½ in. (64.8 cm.), depth 26 in. (66 cm.)
1982.60.73–76

AN OPEN ARMCHAIR of this type with a slightly curved back was called a *fauteuil en cabriolet*. Although it has been said that the design was introduced in order to accommodate the human back more comfortably, it was probably more a matter of style, as the chair's back continues the curvilinear lines of the legs, rails, and arms. The type remained popular well into the 1770s. The four chairs that make up this suite, which may originally have been larger, are not identical. The carved sprays of flowers at the top of the back and at the center of the front rail vary from chair to chair. The carving of flowers, leaves, and scrolls on the rear side of the back indicates that these were *sièges courants*, which could be moved about and placed informally in the center of the room, as opposed to *sièges meublants*, which remained formally arranged against the walls. Although the carving is of high quality and the design of considerable elegance, the chairs are not stamped, and the maker remains unknown.

WR

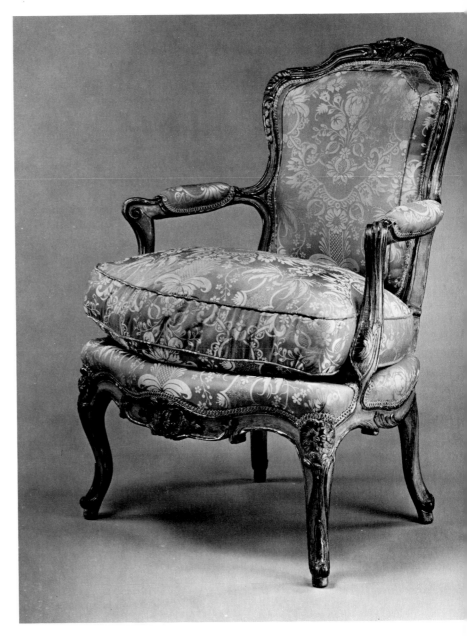

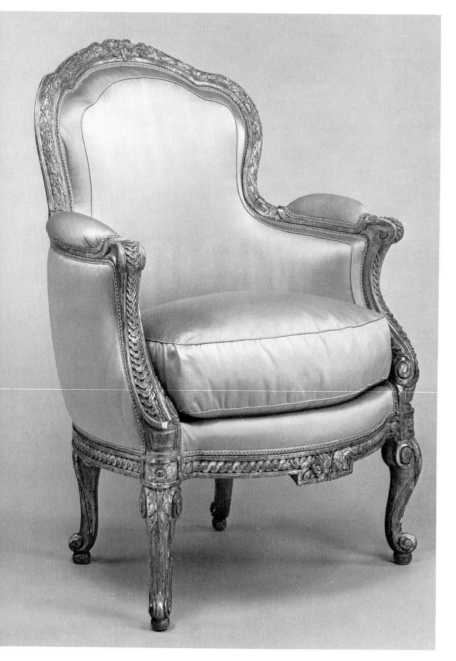

CLAUDE-LOUIS BURGAT

French, 1717–before 1782

CLAUDE-LOUIS BURGAT was born in 1717 and became a *maître* in 1744. He worked first on the rue de Cléry and then on the rue Feydeau, where he designed and carved all of his own furniture. Most of his work is in the Louis XV style. Although his name is not well known, his surviving furniture is well carved and of harmonious design. He used the stamp C L BURGAT.

143. Pair of armchairs (*bergères en cabriolet*)

Ca. 1760–70
Carved and gilded beechwood. Height 34½ in. (87.6 cm.), width 23 in. (58.4 cm.), depth 22 in. (55.9 cm.)
Stamped below the rear seat rail: C L BURGAT
1982.60.89,90

THESE CHAIRS show several features of the transitional style, combining the curvilinear design of the Louis XV style with several motifs more widely used in later neoclassical furniture: the laurel leaves and berries bound with crossing ribbons along the top rail, the scale pattern of overlapping medallions on the fronts of the arms, and the band of guilloche design on the front and side rails. A spray of two roses forms the central motif at the center of the top and front rails. The chairs were probably made by Burgat about 1760–70 and are more elaborately carved than many of those that bear his stamp.[1] Other chairs by Burgat are in the Mobilier National, Paris, and the Slottsmuseum, Stockholm.

NOTE:

1. Compare the examples in J. Nicolay, *L'Art et la manière des maîtres ébénistes français au XVIIIe siècle*, Paris, I, 1956, p. 84, figs. A–E.

WR

CLAUDE I SENE

French, 1724–1792

SON OF THE *menuisier* Jean Sené, Claude I Sené was born in 1724 and became a *maître* in his father's workshop in 1743. He established a business with his brother-in-law, Jean-Etienne Saint-Georges, on the rue de Cléry, where he worked until 1780 when he retired to live with his son Jean-Baptiste-Claude Sené, who became one of the most successful makers of seat furniture in the Louis XVI period. Claude I Sené worked in both the Louis XV and Louis XVI styles, with the major part of his furniture executed in the earlier period. He used the stamp G SENE, with the initial *C* resembling a *G* and the *N* reversed.

144. Sofa (*canapé à confidents*)

Ca. 1775–80
Carved and gilded beechwood. Height 34 in. (86.4 cm.), length 90 in. (228.6 cm.), depth 24½ in. (62.2 cm.)
Stamped inside the back rail to the right of the center leg: G SENE
1982.60.71

A SOFA of this type, with a wide central section and a single outward-facing seat at each end, was called a *canapé à confidents*, although a design less likely to encourage the exchange of confidences would be hard to imagine. Examples were made primarily in the Louis XV and Louis XVI periods, and only a small number survive. However impractical, the form was highly decorative, and it appears in designs for neoclassical wall elevations where the shape and carving are conceived in harmony with the wall paneling.[1] On the present piece, the carving on the wreaths of roses and olive branches tied by a ribbon at the top of each end is particularly skillful. This canapé has been described by both the comte de Salverte and Guillaume Janneau as Sené's finest known piece of furniture in the Louis XVI style.

NOTE:
1. An example by Richard de Lalonde in the Musée des Arts Décoratifs, Paris, is illustrated in *World Furniture*, ed. H. Hayward, New York, 1965, p. 124, fig. 453.

EX COLL.: Edouard Smith (sale, Hôtel Drouot, Paris, Feb. 26–Mar. 1, 1890, lot 276); Samy Chalom.

EXHIBITED: Musée des Arts Décoratifs, Paris, *Grands Ebénistes et Menuisiers Parisiens du XVIIIe Siècle*, 1955–56, no. 293.

BIBLIOGRAPHY: F. de Salverte, *Les Ebénistes du XVIIIe siècle*, 5th ed., rev, Paris, 1962, p. 306, fig. LXVI.

WR

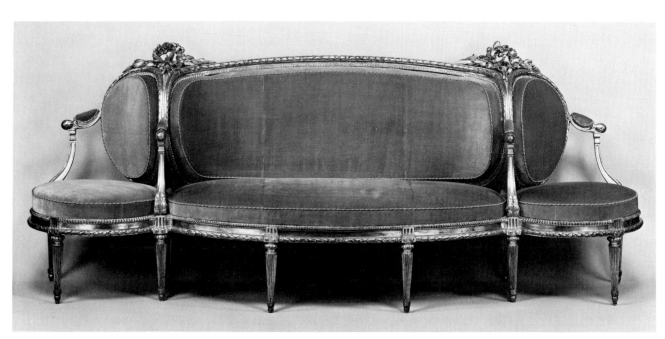

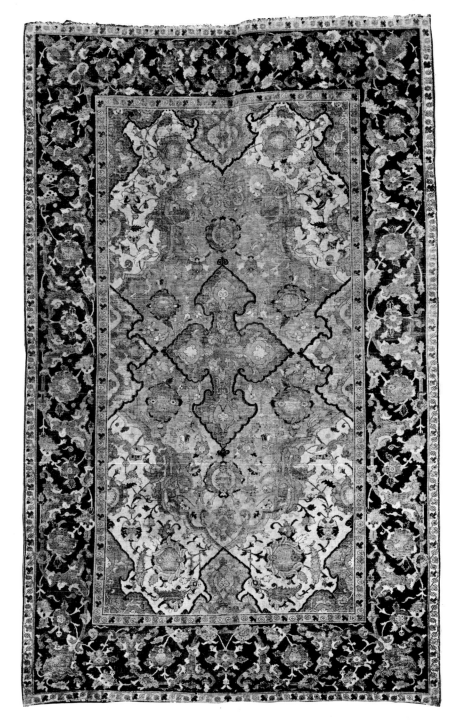

145. Polonaise rug

Persian, possibly Isfahan, first half of 17th century
Warp of cotton; weft of cotton and metallic thread;
silk pile; Sehna knot. Length 91 in. (231.1 cm.),
width 57¼ in. (145.4 cm.)
1982.60.79

THERE IS a large group of seventeenth-century Persian carpets with silk pile and often with brocading in metal thread that are commonly, though incorrectly, described as "polonaise" or "Polish." The mistake dates from the Paris exhibition of 1878, where five heraldic shields on a carpet of this type were thought to be those of the Czartoryski, and it was concluded that this and similar carpets were made in Poland.[1] Although it was soon realized that they were of Persian manufacture, the term "polonaise" has remained as a useful label for classification purposes. The rugs were exported to Europe during the seventeenth century and were highly prized as furnishings for the great houses of the Baroque period. The present piece is an excellent example of the small polonaise rug and was probably originally used as a table carpet. The field is patterned with a central four-lobed medallion set against a pale blue ground filled with curling vines, stylized flowers, and sickle leaves, which continue into the beige spandrel areas. Portions of medallions complete the field decoration. The main blue-ground border with two interlaced undulating rinceaux is framed by yellow guard stripes with small stylized floral motifs.

NOTE:
1. The carpet exhibited in Paris was formerly in the collection of Prince Czartoryski; it was later given to the Metropolitan Museum by John D. Rockefeller, Jr. (45.106). See K. Erdmann, *Seven Hundred Years of Oriental Carpets*, ed. H. Erdmann, trans. M. H. Beattie and H. Herzog, Berkeley, 1970, fig. 260.

WR

146. Carpet

French, Paris, Savonnerie Manufactory, ca. 1650
Wool, Ghiordes knot. Length 118 in. (295 cm.), width
92½ in. (235 cm.)
1982.60.80

THE NAME "Savonnerie" has become a general term to refer to pile carpets made in France. In actuality, during the seventeenth century there were two sites of production. The first atelier, under the direction of headweaver

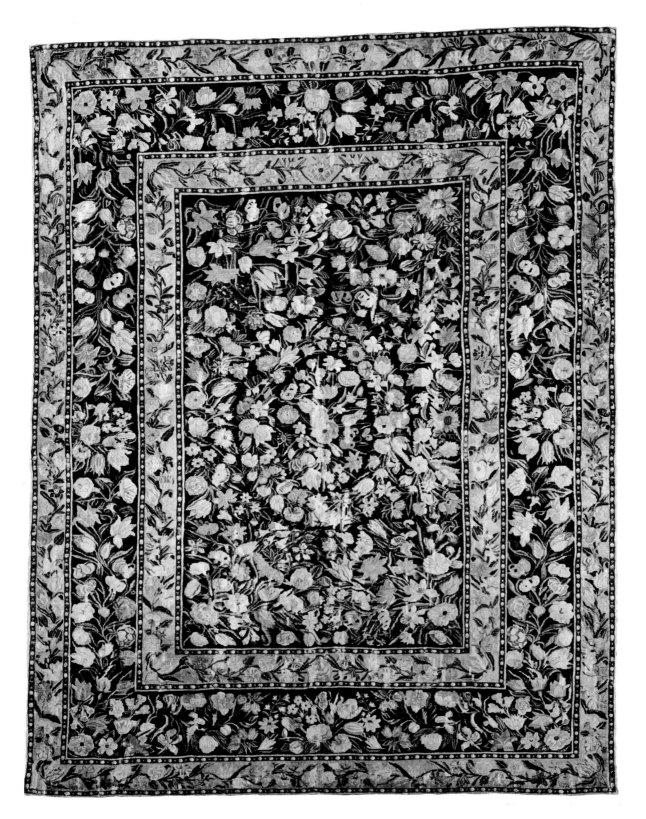

Pierre Dupont (1577–1640), was established by Henri IV at the Palais du Louvre in an attempt to encourage French production of these luxury goods, which were then being purchased abroad. This was followed by another atelier, that of Simon Lourdet (ca. 1595–1666), situated on the outskirts of Paris at Chaillot in an abandoned soap factory (*savonnerie*). It is not always possible to determine at which site a carpet was made, particularly during the first half of the seventeenth century, although it is thought that the finer and larger pieces were made at the Louvre atelier and the smaller, less complicated rugs at Chaillot.

This carpet is a rare survivor of a type called "Louis XIII," although certain examples may date to the reign of the Sun King. Characteristic of this group is the black field and profusion of floral motifs to the extent that these carpets are often referred to as "millefleurs," comparing them to late medieval tapestries of that name. In the field and main border of this example, naturalistic flowers are shown against a black ground. The central floral wreath, however, makes the composition more formal and elegant. The yellow-ground secondary borders contain a continuous undulating stem from which different flowers issue. Tiny yellow and light blue geometric shapes pattern the blue guard stripes.

EX COLL.: Thelma Chrysler Foy, New York (sale, Parke-Bernet, New York, May 22–23, 1959, lot 770).

AZ

CLOCKS, GILT BRONZES, AND MOUNTED PORCELAINS

Catalogue entries by
WILLIAM RIEDER

ETIENNE LE NOIR

French, 1660–1739

ETIENNE LE NOIR was active as a clockmaker in Paris during the first four decades of the eighteenth century. Although he is best known for elaborate decorative clocks, especially those incorporating porcelain, he also made clocks with cases of marquetry and of bronze and watches in gold, silver, and enamel.

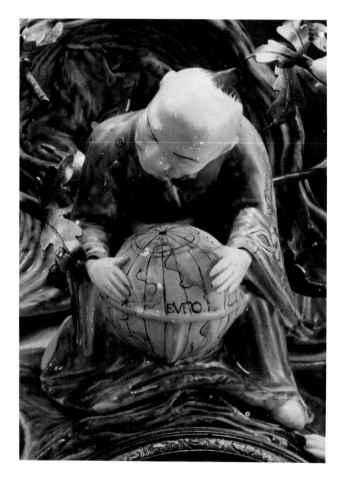

147. Cartel clock

Ca. 1735–40
Case of Chantilly porcelain; white enamel dial with
 blue numerals. Height 19 in. (48.2 cm.)
Movement and dial signed by Etienne Le Noir
1982.60.84

PORCELAIN cartel clocks were extremely rare in the eighteenth century. Two of the finest and most elaborate examples that have survived from the Chantilly factory are the present clock in the chinoiserie style with three oriental figures and movement by Etienne Le Noir, and the larger and somewhat later (about 1745) clock with a dragon, monkey, and goose and movement by Charles Voisin (J. Paul Getty Museum, Malibu).

The Chinese figures on the present clock are closely related to a number of single figures and groups made at Chantilly in the 1730s. The man seated before a terrestrial globe, seen here at the top, recalls a pair of Chantilly figures formerly in the Sydney H. Lamon collection.[1]

This clock has only one winding-square and does not strike the hours, which indicates that it was originally intended for a bedroom. It has lost many of the porcelain flowers that initially gave a more luxuriant effect.

NOTE:
 1. Sale, Christie's, London, Nov. 29, 1973, lot 49.

EX COLL.: Lady Margaret Fortescue, Castle Hill, Devon (sale, Christie's, London, Mar. 28, 1966, lot 145).

EXHIBITED: The Frick Collection, New York, *French Clocks in North American Collections*, 1982, no. 45.

BIBLIOGRAPHY: *Christie's Bicentenary Review of the Year*, London, 1965–66, p. 205; Tardy, *French Clocks the World Over*, 5th ed., Paris 1981, p. 197, pl. XXXVI; G. Wilson, "Acquisitions made by the Department of Decorative Arts, 1981," *J. Paul Getty Museum Journal* 10 (1982), pp. 67–68; W. Edey, *French Clocks in North American Collections*, New York, 1982, no. 45.

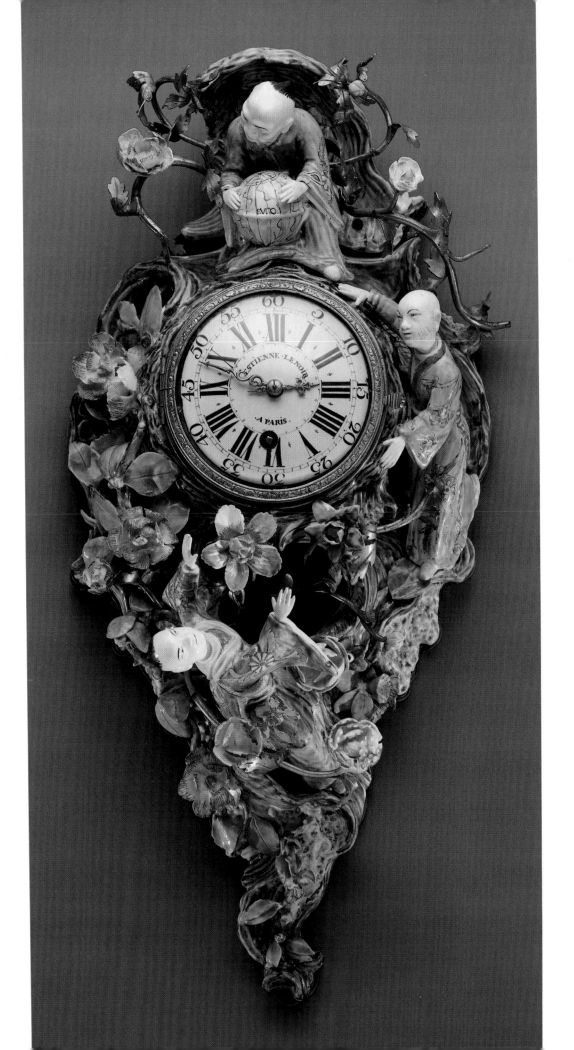

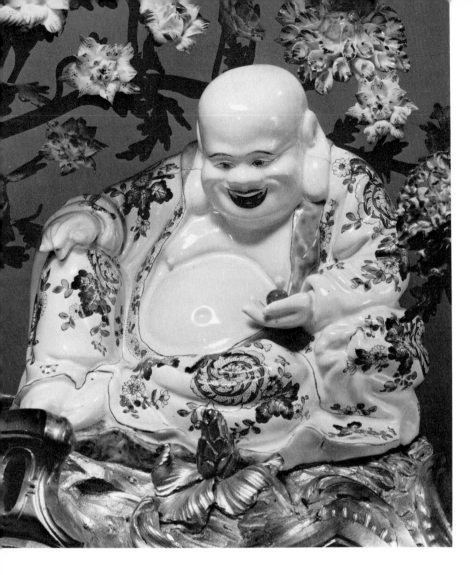

148. Mantel clock

Ca. 1745–49
Chantilly porcelain mounted on gilt bronze; flowers of
 soft- and hard-paste porcelain; clock face of white
 enameled metal. Height 21½ in. (54.6 cm.)
Signed on the dial: JULIEN LE ROY
The gilt-bronze mounts are stamped in numerous
 places with the crowned C mark (period 1745–49)
1982.60.68

THE FIGURE of Pu-tai Ho-shang, a Chinese apostle of
the Buddha, is a literal copy made at Chantilly in the
1740s of a blanc de chine model that originated at Tê-hua
in the Fukien province of China and was exported to the
West in the first half of the eighteenth century. Augustus
the Strong owned a number of examples, presumably
those described in the 1721 inventory of the Japanese Pal-
ace in Dresden as sitting pagods.[1] This Chantilly version
may be compared to a blanc de chine figure, mounted,
like this, in French gilt bronze of about 1745–49 in the
Walters Art Gallery, Baltimore.[2] Thirteen of the flowers
are original and are of soft-paste porcelain made at Chan-
tilly; the remainder are replacements in hard-paste por-
celain. The clock has a rack-and-snail quarter-striking
movement; the movement and hands are original; the
pendulum suspension has been replaced with a nineteenth-
century Brocot suspension, and the pendulum is missing.

NOTES:
 1. P. J. Donnelly, *Blanc de Chine*, New York, 1969, p. 160.
 2. F. J. B. Watson, *Chinese Porcelains in European Mounts* (ex-
hib. cat.), New York, China House Gallery, 1980, no. 5.

EXHIBITED: Parke-Bernet Galleries, New York, *Art Treasures
 Exhibition*, June 1955, no. 272.

BIBLIOGRAPHY: E. Tilmans, *Porcelaines de France*, Paris, 1953,
 p. 89.

JULIEN LE ROY

French, 1686–1759

JULIEN LE ROY was the most highly esteemed clock-
maker in France during the Louis XV period. Elected a
maître-horloger in 1713, he was appointed *horloger du roi* in
1739 and granted the workshop in the Louvre that accom-
panied that position. He published a number of treatises
on horology and was responsible for several important
inventions and improvements during his long and distin-
guished career.

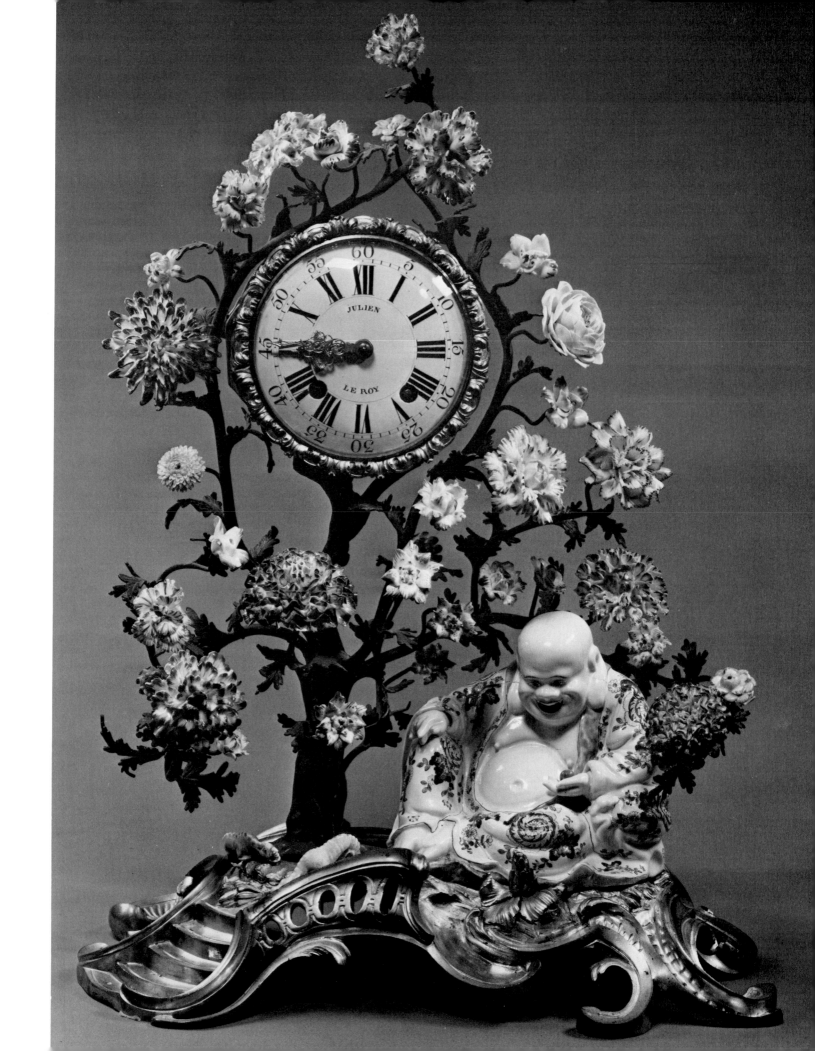

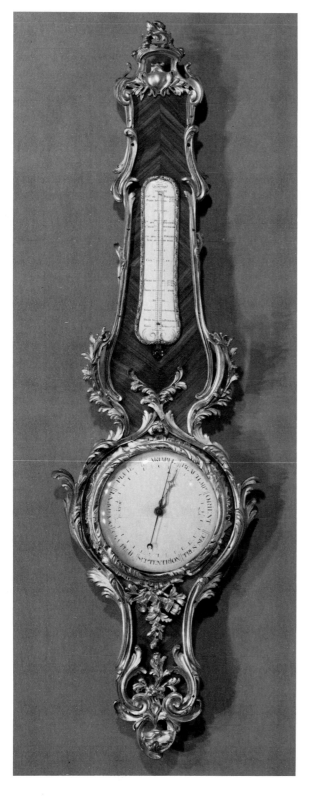

LANGE DE BOURBON

French, active third quarter of 18th century

149. Wall barometer-thermometer

Ca. 1760
Veneered on oak with rosewood; gilt-bronze mounts;
barometer and thermometer dials of white
enameled metal. Height 45¾ in. (116.2 cm.)
Signed at the top of the thermometer dial: *Lange de
Bourbon*
1982.60.52

THE DIAL of the thermometer is signed by the barome-
ter maker Lange de Bourbon, about whom little is known.
He signed other barometers of the period, including one
of about 1770 in the Metropolitan Museum, where the
dial reads: LANGE DE BOURBON, FAISEUR DE BARO-
METRE DU ROY.[1]

The thermometer is on the Réaumur scale (where water
freezes at 0° and boils at 80°), which prevailed in France
in the second half of the eighteenth century. The dates on
the dial record several extremes of temperature in Paris,
from a high of 32° Re in 1753 to a low of −15° Re in 1709.
Three other cities are included for their low tempera-
tures: Astrakhan, "Petersbour" (Leningrad), and "Ke-
bec" (Quebec), which reached −33° Re in 1743. The latest
date on the dial is 1754. Among other inscriptions are
"Ch[aleur] d'un Malade" and "Ch[aleur] des Versasoies"
(indicating the temperature at which silkworms were
raised). The barometer records the standard range of
weather indications.

A number of wall barometer-thermometers or clock-
thermometers of this design are known, with movements
by various makers or unsigned. With small variations these
objects are all mounted identically, and the group as a
whole shows that this model was available in Paris in the
1760s and could be adapted to suit the individual clock-
or barometer-maker. These works are (1) barometer-
thermometer, private collection, Paris, the case stamped
by the *ébéniste* Joseph de Saint-Germain (*maître* 1750);[2]
(2) barometer-thermometer, Drottningholm, Stock-
holm;[3] (3) barometer-thermometer, formerly in the col-
lection of Ernest Rechnitzer;[4] (4) clock-thermometer with
movement by Jean-André Lepaute (1720–1787) and
matching barometer-thermometer, both formerly in the
collection of the comte Greffulhe;[5] (5) clock-thermometer,
the clock signed "Giles Lainé à Paris" (active about 1760–

90), the thermometer signed "par Ronquetti Rue St. An-toine," Huntington Art Gallery, San Marino;[6] (6) barom-eter-thermometer and clock, the barometer and clock signed by David Frédéric Dubois, Victoria and Albert Museum, London; and (7) barometer-thermometer and clock, the barometer and clock signed by Ferdinand Ber-thoud (1727–1807), Alexander & Berendt Ltd., London, 1983.

NOTES:
1. C. C. Dauterman, J. Parker, and E. A. Standen, *Decorative Art from the Samuel H. Kress Collection at the Metropolitan Museum of Art*, London, 1964, no. 66, fig. 230.
2. A. Gonzalez-Palacios, "Le vendite Demidoff e Ruspoli Tal-leyrand," *Arte Illustra* no. 17–18 (1969), p. 125, fig. 18.
3. J. Böttiger, *Fran de Kungliga Slotten*, Stockholm, 1925, fig. 64.
4. Sale, Christie's, London, May 19, 1955, lot 46.
5. Sale, Sotheby's, London, July 23, 1937, lot 45.
6. R. Wark, *French Decorative Art in the Huntington Collection*, San Marino, 1979, p. 64, fig. 86.

EX COLL.: Erich von Goldschmidt-Rothschild (sale, Hermann Ball & Paul Graupe, Berlin, *Die Sammlung Erich von Goldschmidt-Rothschild*, Mar. 23–25, 1931, lot 180).

FERDINAND BERTHOUD
French, 1727–1807

BALTHAZAR LIEUTAUD
French, *maître* 1749–1780

FERDINAND BERTHOUD was born in Switzerland and apprenticed in Paris to Julien Le Roy, becoming a master in 1754. He became one of the leading Parisian watch- and clock-makers and wrote extensively on horology. Be-tween 1753 and 1807 he published ten books and an article in the *Encyclopédie*. He was elected *horloger du roi* in 1768 and was a member of the Institut and a fellow of the Royal Society in England.

Balthazar Lieutaud was an *ébéniste* specializing in fine clockcases, which he made in both the rococo and neo-classical styles. He was made *maître ébéniste* in 1749 and worked until his death in 1780 on the Ile de la Cité in Paris. Among the several bronze workers who provided mounts for his furniture were Philippe Caffiéri, Charles Grimpelle, and Edmé Roye.

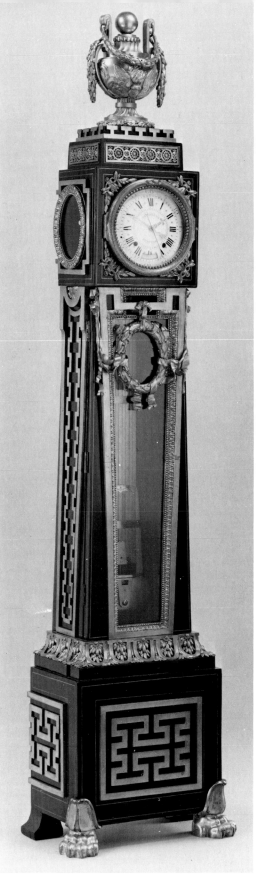

150. LONGCASE REGULATOR

243

150. Longcase regulator

Ca. 1768–70
Veneered on oak with ebony; gilt-bronze mounts;
 enameled dial. Height 90½ in. (230 cm.)
Movement and dial signed by Ferdinand Berthoud
Case stamped on the lower part of the base at the
 back: B. LIEUTAUD
1982.60.50

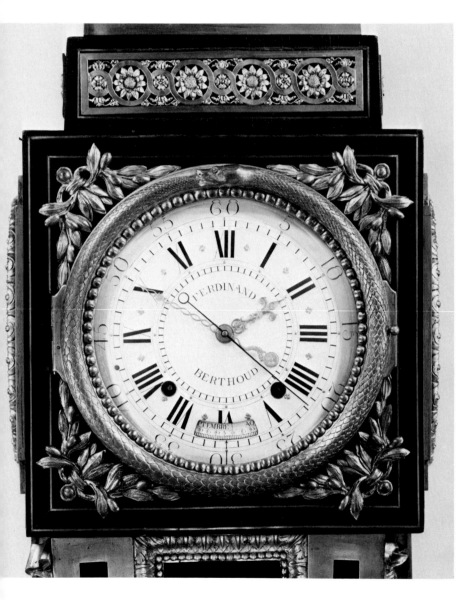

150. DETAIL

THE CLOCK has three hands, indicating hours, minutes, and seconds, and at the numeral VI an aperture through which the calendar ring reveals the month and date. The weight-driven movement runs for one month on a winding; the escapement is a Graham-type deadbeat. The pendulum is thermostatically compensated with alternating strips of brass and steel; above the bob is a thermometer.

A number of very similar regulator clocks with movements by Berthoud and cases by Lieutaud are known (Frick Collection, New York; Versailles; the Wallace Collection, London; the Jones Collection in the Victoria and Albert Museum, London; the Hillwood Museum, Washington; the Palacio Real, Madrid; and others). The bronzes on the Frick regulator are signed by the sculptor and bronze founder Philippe Caffiéri (b. 1714, *maître* 1743, *sculpteur-ciseleur ordinaire du roi* 1755, d. 1774) and dated 1767. It has been proposed by Winthrop Edey that Caffiéri was also responsible for the design and that the model was repeated by Lieutaud with many variations, with or without Caffiéri's collaboration.[1] The present example, which for horological reasons can be dated about 1768–70, shortly after the Frick regulator, repeats many of the same mounts, which are therefore best described as cast from models by Caffiéri. The serpent with its tail in its mouth around the dial, emblematic of Eternity, and the swagged urn on top with a winged and flaming altar do not occur on the Frick and Versailles examples but are present on a number of other clocks in this series. Two prominent features of the sophisticated design are the pedestal shape of the trunk, balanced by the inverted tapered opening before the pendulum, and the combination of a Chinese fret motif on the base and sides in conjunction with French neoclassical mounts.

NOTE:
 1. W. Edey, *French Clocks in North American Collections*, New York, 1982, no. 65.

EX COLL.: Mme Jacques Balsan, New York; Thelma Chrysler Foy, New York (sale, Parke-Bernet, New York, May 13, 1959, lot 352).

EXHIBITED: Parke-Bernet Galleries, New York, *Art Treasures Exhibition*, June 1955, no. 290.

151. Pair of firedogs

French, ca. 1760–70
Gilt bronze. Height 16½ in. (41.9 cm.)
1982.60.69,70

FIREDOGS with paired figures of a Chinese man and woman enjoyed a certain popularity in the mid-eighteenth century. The present pair, with each figure seated before a curved palm branch on a twisted S-shaped scroll supported by a truncated fluted column beside a finial, is the later of two models that incorporate these particular figures. On the earlier, fully rococo version, they sit before a curved balustrade atop a boldly asymmetrical C-shaped scroll. One example of the earlier model is signed by the goldsmith and bronze worker François-Thomas Germain (1726–1791), and others are thought to derive from it.[1] Another example of the present model is in the Musée des Arts Décoratifs, Lyons. Daniel Alcouffe has proposed that its combination of rococo (the Chinese figures, scrolls, and palms) and neoclassical motifs (column and finial) indicates a date of about 1760–70.[2] Eriksen has suggested a slightly narrower period: about 1760–65.[3] On a similar pair of firedogs in the collection of Mr. and Mrs. Charles Wrightsman, New York, the figures are reversed.

The Chinese female figure also appears with small variations in both gilt and patinated forms on several mid-eighteenth-century clocks with works by various clockmakers.[4]

NOTES:
1. C. Briganti, *Curioso itinerario delle collezioni ducali parmensi*, Parma, 1969, p. 58.
2. D. Alcouffe, *Louis XV: Un Moment de perfection de l'art français* (exhib. cat.), Paris, Hôtel de la Monnaie, 1974, no. 439.
3. S. Eriksen, *Early Neo-classicism in France*, London, 1974, p. 357, pl. 221.
4. An example with a patinated figure was in the Wildenstein and Ojjeh collections (sale, Sotheby's, Monte Carlo, June 25, 1979, lot 58).

BIBLIOGRAPHY: F. J. B. Watson, *The Wrightsman Collection*, New York, 1966, II, no. 196 A, B; D. Alcouffe, *Louis XV: Un Moment de perfection de l'art français* (exhib. cat.), Paris, Hôtel de la Monnaie, 1974, no. 439; S. Eriksen, *Early Neo-classicism in France*, London, 1974, p. 357, pl. 221.

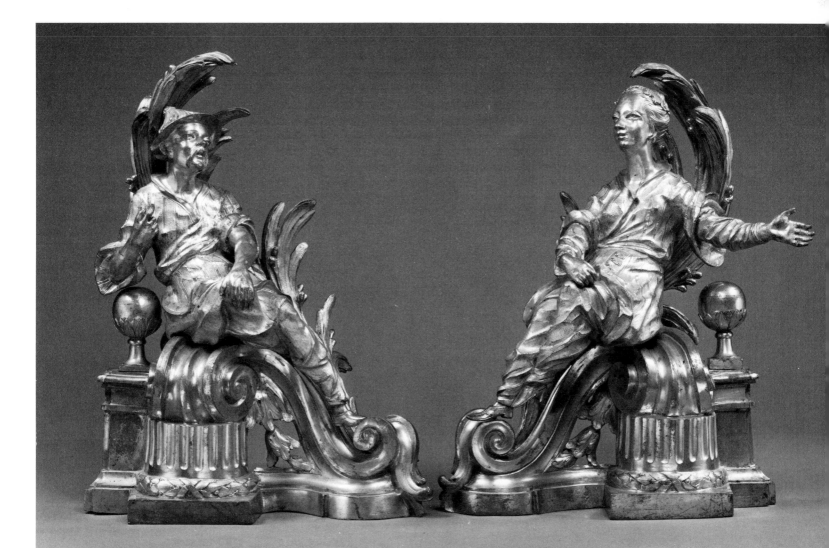

152. Pair of candlesticks

French, ca. 1770–80
Lacquer; gilt-bronze mounts. Height 9¼ in. (23.5 cm.)
1982.60.66, 67

THESE CHAMBER candlesticks were designed to be suspended from a hook, hung over a standing screen, or placed on a table. Both are formed of two lacquer dishes—one of black and gold, the other of red and gold—elaborately mounted with gilt bronze. The cup-shaped receptacles on the vertical handles originally contained candle extinguishers. The neoclassical design, combining pendent husks, rosettes, overlapping piasters, and draped festoons of berried laurel leaves, is closely related to the style of Jean-Charles Delafosse (1734–1791), a Parisian architect and ornamental artist who executed numerous sets of designs for furniture, metalwork, vases, trophies, and cartouches.

EX COLL.: Ernest Rechnitzer (sale, Christie's, London, May 19, 1955, lot 20).

153. Pair of candelabra

German, ca. 1740–50
The figures of lacquered wood or composition; the candle arms and bases of gilt bronze; Meissen hardpaste porcelain flowers. Height 6¾ in. (17.2 cm.)
1982.60.87, 88

IN THE mid-eighteenth century lacquered figures of Chinese men were popular as supports for candelabra and clocks. The present figures of lacquered wood or composition are of European origin and were mounted in Germany about 1740–50. The candleholders are chased with animals and sprays of flowers. The naturalistically colored porcelain flowers were made at Meissen. A related pair of candelabra is in the Musée Carnavalet, Paris.[1]

NOTE:

1. Musée Carnavalet, *La Demeure Parisienne aux dix-huitième siècle: Collection Henriette Bouvier léguée au Musée Carnavalet*, Paris, 1968, fig. 123.

EX COLL.: René Fribourg (sale, Sotheby's, London, June 28, 1963, lot 155).

RIGHT: 153. ONE OF A PAIR OF CANDELABRA

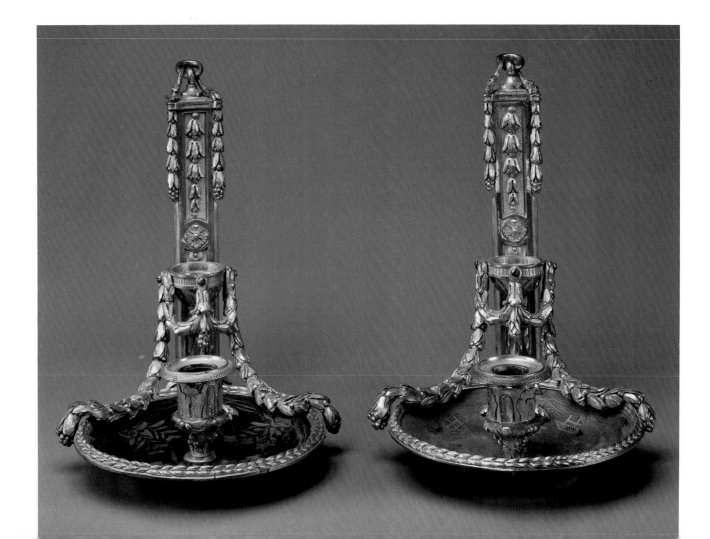

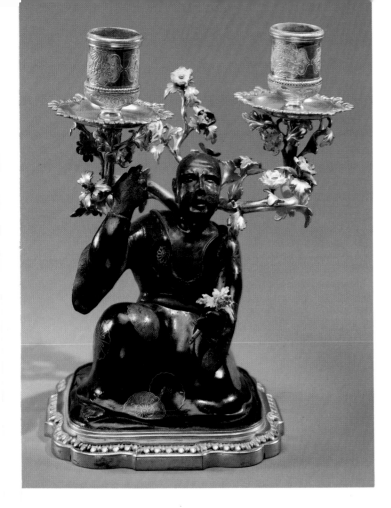

154. Pair of wall lights

French, ca. 1750
Statuettes of parrots of glazed biscuit Chinese
 porcelain, K'ang Hsi period (1662–1722);
 flowerheads of Vincennes soft-paste porcelain, ca.
 1750, and nineteenth-century hard-paste porcelain;
 mounted on gilt bronze. Height 23 in. (58.4 cm.)
1982.60.64,65

THE PARROTS on pierced rockwork bases are of Chinese porcelain from the K'ang Hsi period (1662–1722), mounted as wall lights in Paris in the mid-eighteenth century. They are a standard export model of which a number of examples are known. Similar pairs of parrots were mounted in Paris at various periods as candelabra: a pair mounted about 1720 as two-branch candelabra is in the Lesley and Emma Sheafer Collection at the Metropolitan Museum; a pair mounted about 1750 as three-branch candelabra with soft-paste flowers is in the Historisches Museum, Basel;[1] a pair mounted about 1770–80 as two-branch candelabra is in the Musée Nissim de Camondo, Paris;[2] and another pair mounted in the nineteenth century as two-branch candelabra is in the Victoria and Albert Museum, London.[3]

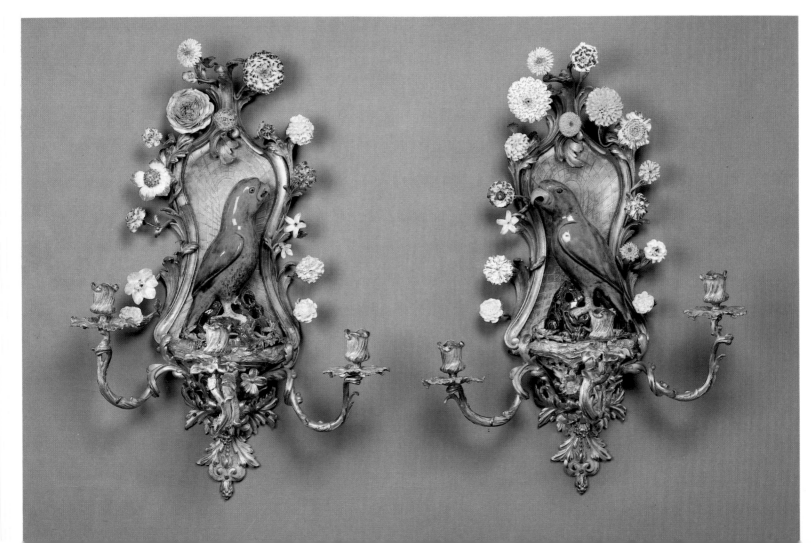

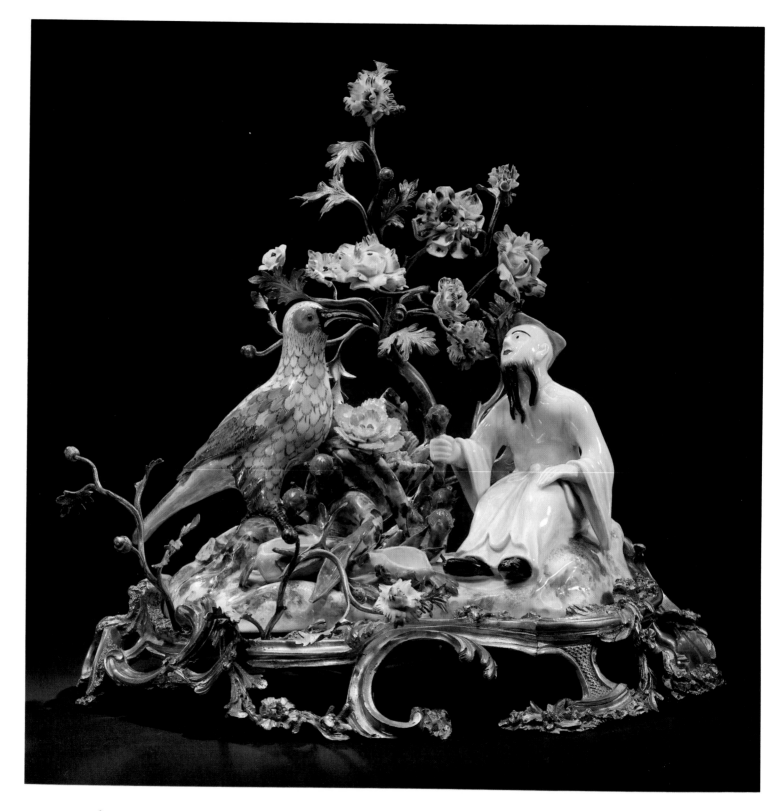

165. Chinaman with bird

Hard paste set in gilt-bronze mounts with soft-paste
 Vincennes flowers. Height 12 in. (30.4 cm.)
Mark on back of base in underglaze blue: crossed
 swords
Model attributed to Georg Fritzsche (1698–1756;
 working at Meissen from 1711)
German, Meissen, ca. 1727; mounts French, ca. 1750
1982.60.256

IN A LIST of workmen drawn up in 1719, Fritzsche is
cited as a maker of molds, and his name is associated
about 1727 with the production of molds for a clock case
and a basin, the latter having been designed by J. G.
Kirchner. That Fritzsche was also a modeler is clear from
an entry in the factory's records in 1727, stating that in
that year he originated a number of animal and other
figures that he made "free-hand, without having any
drawing or models." None of these figures has been iden-
tified. This group has traditionally been attributed to
Fritzsche, although it has recently been suggested that
the model is Kändler's work of about 1735.[1] The attribu-
tion to Fritzsche is supported here on the grounds that
the slight stiffness and primitive charm of the model are
consonant both with the naïveté of early eighteenth-century
chinoiserie and with the undeveloped state of porcelain
sculpture at Meissen prior to Kändler's arrival at the fac-
tory in 1731 and his introduction of a more dynamic and
sophisticated style.

NOTE:
 1. *Highlights of the Untermyer Collection* (exhib. cat.), New
York, Metropolitan Museum of Art, 1977, cat. no. 202.

EX COLL.: Emma Budge, Hamburg (sale, Paul Graupe, Berlin,
 Sept. 27–29, 1937, lot 730); H. E. Bondy, Vienna; Otto and
 Magdalena Blohm, Hamburg.

EXHIBITED: Stoner and Evans, Inc., New York, *Exhibition of
 the Collection of 18th Century European Porcelains Assembled by
 the Late Mr. Otto Blohm*, Jan. 1948; Metropolitan Museum of
 Art, New York, *Masterpieces of European Porcelain*, Mar. 18–
 May 15, 1949, cat. no. 289 (lent by Mr. and Mrs. Jack Linsky).

BIBLIOGRAPHY: R. Schmidt, *Early European Porcelain as Col-
 lected by Otto Blohm*, Munich, 1953, no. 12.

166, 167. Chinese couple as incense containers

Hard paste. Heights 6⅝ in. (16.9 cm.), 6³⁄₁₆ (15.8 cm.)
Mark inside base of each in underglaze blue: crossed
 swords
Models by Johann Friedrich Eberlein (1696–1749;
 working 1735–49)
German, Meissen, 1745–50, after models of 1735
1982.60.321,322

THE HOLLOW figures are pierced in several places to
release the smoke from incense.

 According to the factory records, the models were
completed by Eberlein in December 1735. A later date for
these examples is indicated by the fabric pattern of flow-
ering tendrils, found on models of the late 1740s.[1]

NOTE:
 1. R. Rückert, *Meissener Porzellan, 1710–1810* (exhib. cat.), Mu-
nich, Bayerisches Nationalmuseum, 1966, no. 987 (Malabar, ca.
1749), no. 1008 (Dancing Girl, ca. 1750).

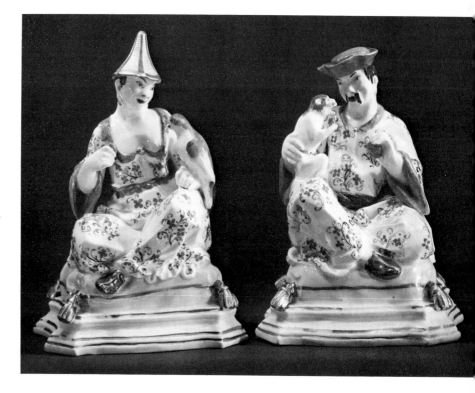

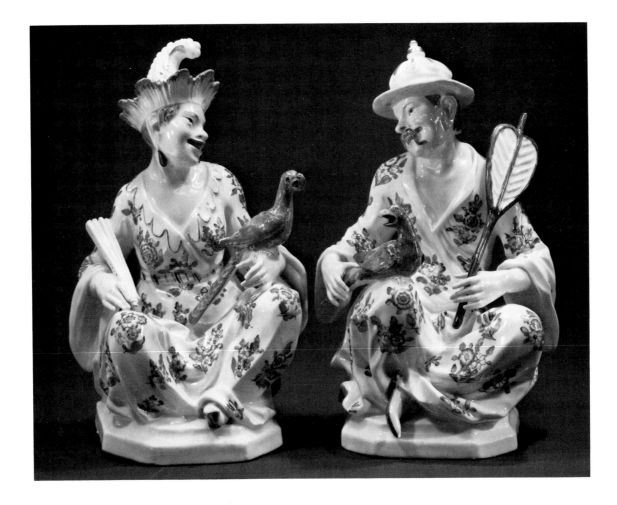

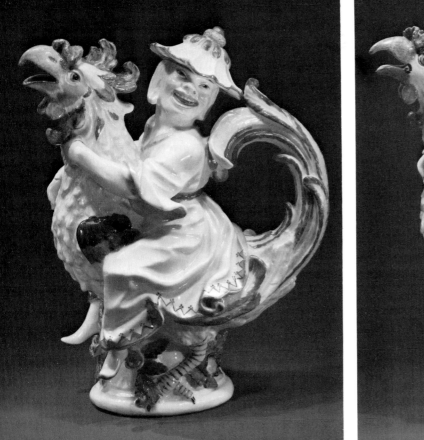 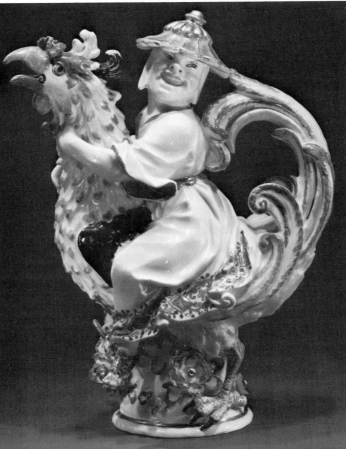

168, 169. Chinese couple

Hard paste. Height, each 7¹⁄₁₆ in. (17.9 cm.)
Mark on underside of unglazed base of man:
 crossed swords
Models by Johann Joachim Kändler (1706–
 1775; working at Meissen from 1731)
German, Meissen, ca. 1737
1982.60.319,320

EX COLL.: R. W. M. Walker, London (sale, Christie's, London, July 25, 1945, lot 10); [J. Rochelle Thomas, London]; [James A. Lewis, New York].

EXHIBITED: Metropolitan Museum of Art, New York, *Masterpieces of European Porcelain*, Mar. 18–May 15, 1949, cat. no. 275 (lent by Mr. and Mrs. Jack Linsky).

BIBLIOGRAPHY: (woman) W. B. Honey, *Dresden China*, London, 1934, pl. XXXIXd.

170. Oil or vinegar cruet

Hard paste. Height 6⅞ in. (17.5 cm.)
Mark on underside of unglazed base: crossed swords
Model by Johann Joachim Kändler
German, Meissen, ca. 1737
1982.60.328ab

171. Oil or vinegar cruet

Hard paste. Height 8³⁄₁₆ in. (20.8 cm.)
Mark on underside of unglazed base: crossed swords
Model by Johann Joachim Kändler
German, Meissen, ca. 1737
1982.60.329ab

THE MODEL was created by Kändler in 1737 for a table centerpiece, or *plat de ménage*, commissioned by Count Heinrich von Brühl, at that time director of the Meissen factory. Two cruets of this model were included in the centerpiece and are described by Kändler in September/October 1737 as "an oil and vinegar cruet [modeled as] an Indian hen on which rides a Pagod, the base decorated with flowers and leaves." The complete ensemble comprised a plateau on which stood an uncovered tureen-shaped vessel in the center with a sugar caster at each end and, in the center of each side, a double shell-shaped spice box. On the table surrounding the plateau were two cruets of this model, two mustard pots, and, at the ends, two spice boxes. With the exception of the shell boxes, all the pieces incorporated oriental figures variously described as

Indian, Japanese, or *Bajotten* (a Saxon dialectal word for pagod).

The first of the figural tablewares produced at Meissen, the models were widely repeated.

EX COLL.: Max Strauss, Vienna (sale, Glückselig and Wärndorfer, Vienna, Jan. 16–19, 1922, lot 217).

EXHIBITED: Metropolitan Museum of Art, New York, *Masterpieces of European Porcelain*, Mar. 18–May 15, 1949, cat. no. 324 (lent by Mr. and Mrs. Jack Linsky).

172. Nodding pagod

Hard paste. Height 8½ in. (21.6 cm.)
Mark inside base in underglaze blue: crossed swords
German, Meissen, ca. 1760
1982.60.325

OTTO WALCHA notes a revived interest in chinoiserie at Meissen about 1760, citing an order by Frederick II of Prussia for ten figures of this type.[1]

NOTE:
 1. O. Walcha, *Meissen Porcelain*, New York, 1981, p. 470.

EX COLL.: Franz Oppenheimer.

EXHIBITED: Parke-Bernet Galleries, New York, *Art Treasures Exhibition*, June 16–30, 1955, cat. no. 260 (lent by Mr. and Mrs. Jack Linsky).

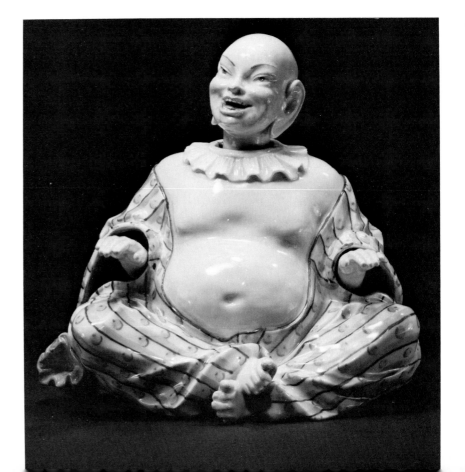

173. Peasant dancers

Hard paste. Height 6 in. (15.2 cm.)
Mark on underside of unglazed base: crossed swords
Model by Johann Friedrich Eberlein, ca. 1735
German, Meissen, ca. 1735
1982.60.314

EXHIBITED: Metropolitan Museum of Art, New York, *Masterpieces of European Porcelain*, Mar. 18–May 15, 1949, cat. no. 310 (lent by Mr. and Mrs. Jack Linsky).

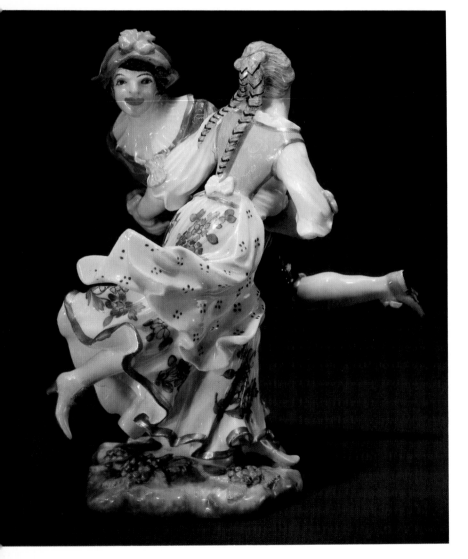

Italian Comedy Figures

A FEW Italian Comedy models were produced at Meissen prior to the appointment of Johann Joachim Kändler as chief modeler in 1733. The full repertoire of figures and groups, however, is due to Kändler and originated in 1736 with his *Harlequin with Goat as Bagpipes* (no. 178) and his first version of *Columbine and Pantaloon* (no. 183). Although Kändler continued to work with the subject until about 1750, the majority of his models had been created by 1743. Some are dated specifically in the factory records; others are recorded without date by Kändler in his *Taxa*, his résumé of work produced between 1740 and 1748.

174. Harlequin with jug

Hard paste. Height 6½ in. (16.5 cm.)
Unmarked
Model ca. 1738
1982.60.309

THE MODEL is dated in accordance with several examples—of which one is in the state collection, Dresden—inscribed *1738* on the jug.

EX COLL.: Sir Ernest Cassel, London (sale, Puttick and Simpson, London, May 26, 1932, lot 625); Armand Esders (sale, Hôtel Drouot, Paris, June 19–20, 1941, lot 184).

175. Harlequin with pince-nez

Hard paste. Height 7¼ in. (18.4 cm.)
Mark on underside of unglazed base: crossed swords
Model 1740–46
1982.60.307

176. Harlequin with pug as hurdy-gurdy

Hard paste. Height 7 in. (17.8 cm.)
Unmarked
Model ca. 1740
1982.60.306

177. Frightened Harlequin

Hard paste. Height 6⅝ in. (16.8 cm.)
Unmarked
Model ca. 1740
1982.60.308

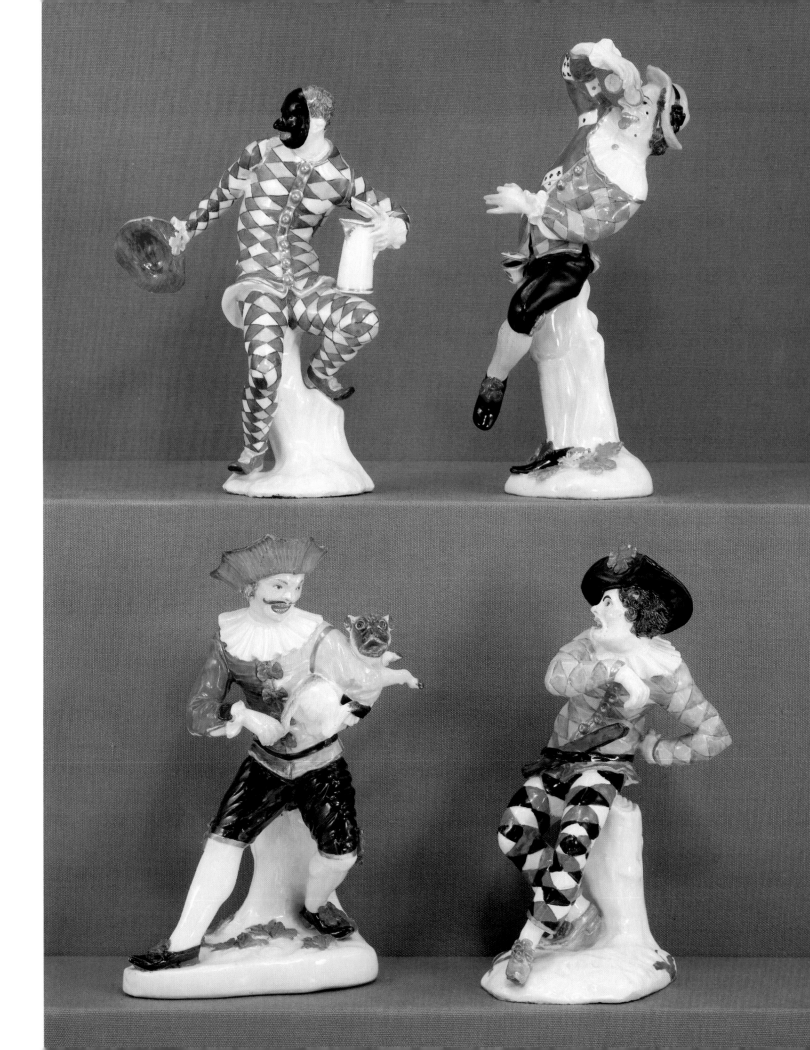

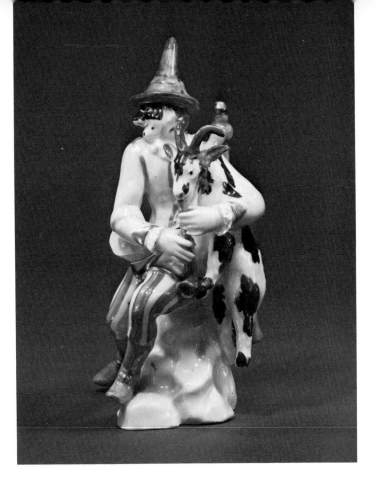

178

178. Harlequin with Goat as Bagpipes

Hard paste. Height 5⁹/₁₆ in. (14.1 cm.)
Unmarked
Model 1736
1982.60.316

179. Harlequin family

Hard paste. Height 7⅛ in. (18.1 cm.)
Unmarked
Model ca. 1740
1982.60.297

THIS IS one of three recorded versions of the model, which Rückert dates shortly before 1740.[1] In a second version the gestures of Columbine and the infant Harlequin are varied; in the third the child is absent.

See no. 309 for a Mennecy version of this group.

NOTE:
1. R. Rückert, *Meissener Porzellan, 1710–1810* (exhib. cat.), Munich, Bayerisches Nationalmuseum, 1966, cat. nos. 861, 862.

EXHIBITED: Metropolitan Museum of Art, New York, *Masterpieces of European Porcelain*, Mar. 18–May 15, 1949, cat. no. 293.

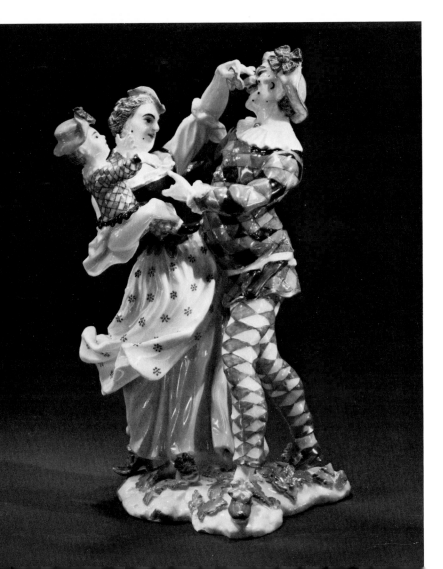

180. The Deceived Weakling

Hard paste. Height 7⁵/₁₆ in. (18.6 cm.)
Mark on underside of unglazed base: crossed swords
Model ca. 1740
1982.60.313

GENERALLY KNOWN as the "Mockery of Age," the subject is the cuckolding of the old man by the standing Harlequin, who holds a feather (now missing) over his head. In another version of the model that same Harlequin figure is suppressed.[1]

NOTE:
1. H. Jedding, *Meissener Porzellan des 18. Jahrhunderts in Hamburger Privatbesitz* (exhib. cat.), Hamburg, Museum für Kunst und Gewerbe, 1982, cat. no. 210.

EXHIBITED: Metropolitan Museum of Art, New York, *Masterpieces of European Porcelain*, Mar. 18–May 15, 1949, cat. no. 305 (lent by Mr. and Mrs. Jack Linsky).

179

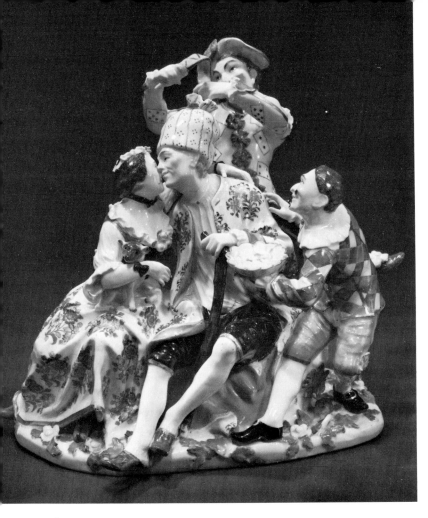

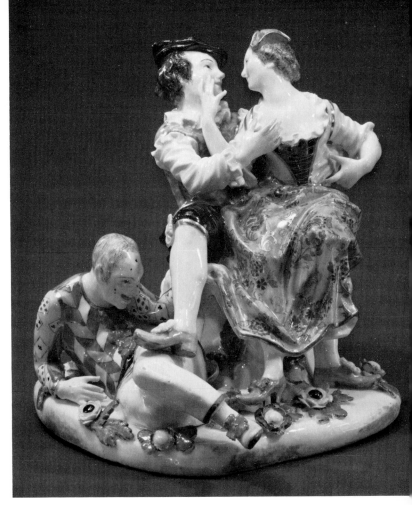

181. Indiscreet Harlequin

Hard paste. Height 6½ in. (16.5 cm.)
Unmarked
Model ca. 1740
1982.60.303

EX COLL.: Emma Budge, Hamburg (sale, Paul Graupe, Berlin, Sept. 27–29, 1937, lot 882); H. E. Bondy, Vienna.

182. Hanswurst and Columbine

Hard paste. Height 6 in. (15.2 cm.)
Unmarked
Model 1743
1982.60.302

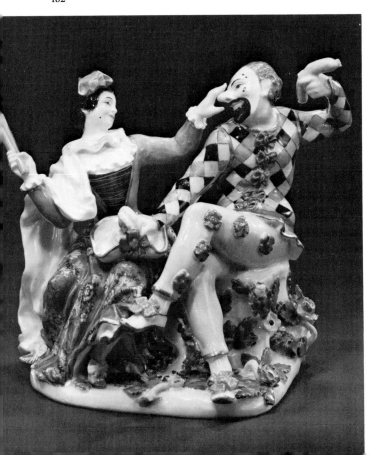

HANSWURST WAS the name given by German and Austrian troupes to a variant of the Pulcinella character. Like Harlequin, he is a comic servant, and, like Pulcinella, he frequently appears in Meissen porcelain dressed in Harlequin's traditional costume.

263

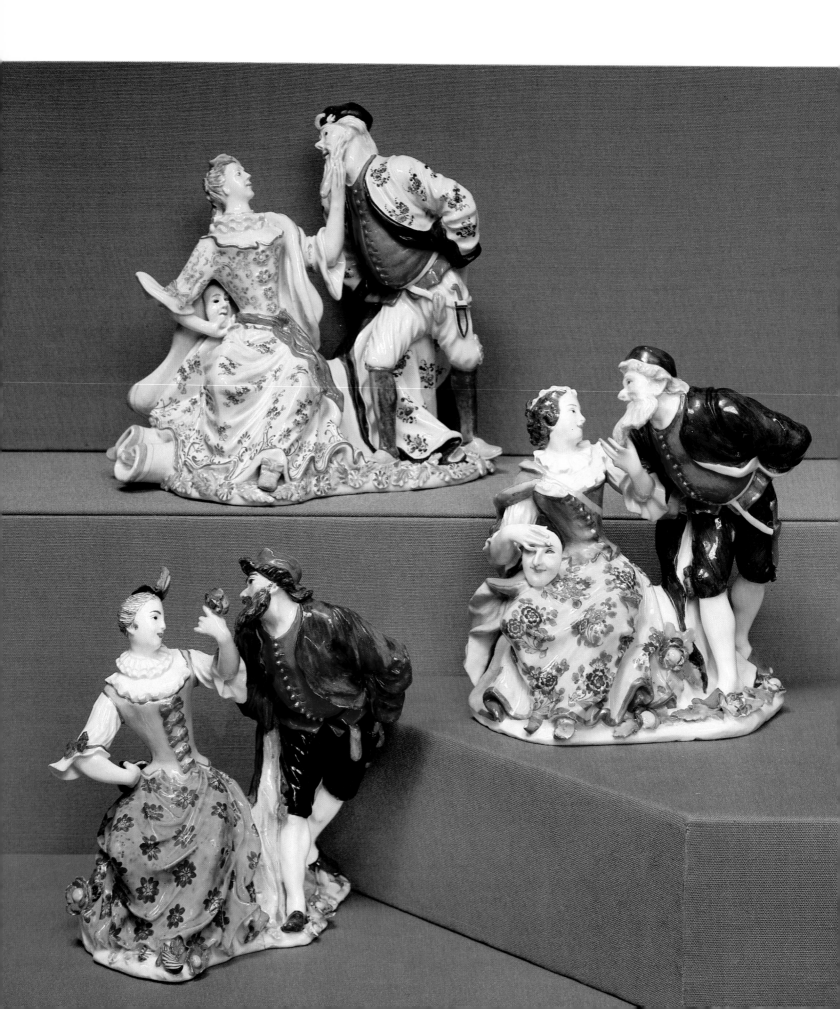

183. Columbine and Pantaloon

Hard paste. Height 6¼ in. (15.9 cm.)
Mark on underside of unglazed base: crossed swords
Model 1736
1982.60.300

THIS IS the earlier of two models of this subject. For a version of the second model of 1741, see no. 184.

EXHIBITED: Metropolitan Museum of Art, New York, *Masterpieces of European Porcelain*, Mar. 18–May 15, 1949, cat. no. 290 (lent by Mr. and Mrs. Jack Linsky).

184. Columbine and Pantaloon

Hard paste. Height 6⁵⁄₁₆ in. (16 cm.)
Mark on underside of unglazed base: crossed swords
Model ca. 1741
1982.60.301

KÄNDLER PRODUCED two distinct models of this composition, the first—in which Columbine holds a rose in her left hand—in 1736 (no. 183). In July and August 1741 Kändler noted his complete reworking of the earlier group. Although he described only one new model, it is evident that at least two were made. In one, of which a version is in the Untermyer Collection at the Metropolitan Museum (64.101.93), the figure of Pantaloon and the asymmetrical composition with its exaggeratedly indented base have been repeated, while the figure of Columbine is entirely new.

This model differs in all respects from those just mentioned. The composition is simpler and more frontal, the base more regular, and the figures modeled more broadly and simply. Its relationship to the others is therefore somewhat conjectural; it is perhaps a slightly later version of the 1741 model as represented by the Untermyer example.

185. Lawyer

Hard paste. Height 6³⁄₁₆ in. (15.7 cm.)
Mark on underside of unglazed base: crossed swords
Model ca. 1748
1982.60.296

LEFT, FROM THE TOP: 195, 184, 183

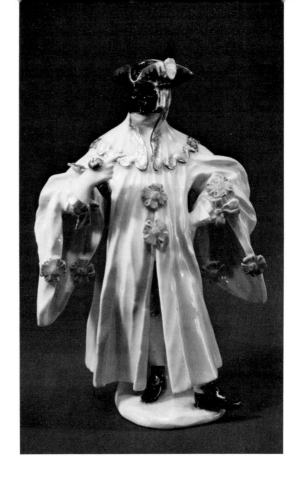

185

186. Harlequin with bird and cat

Hard paste. Height 5½ in. (14 cm.)
Mark on underside of unglazed base: crossed swords
Model by Johann Friedrich Eberlein, 1743
1982.60.304

THE MODEL exists in three distinct versions, the other two lacking either the cat or the birdcage.

186

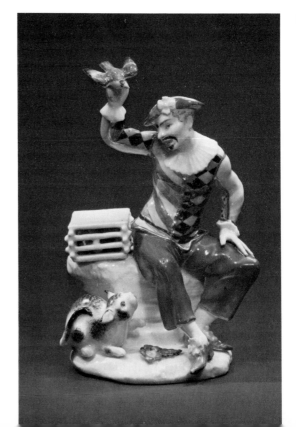

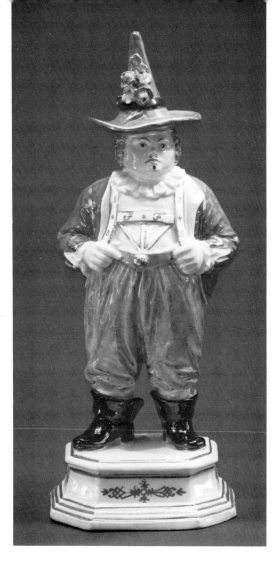

a model was already in hand in 1736 is made clear by Kändler's description in September of that year of "a figure of Joseph in clay, redone and improved so as to be modeled anew." The passage is presumed to refer to this model, of which four examples dated 1736 are known. The model continued to be produced at least until 1752.[2]

NOTES:
1. R. Rückert, "Der Hofnarr Joseph Fröhlich, Porträts und Lebenslauf eines Dresdener Spassmachers (Teil 1)," *Kunst & Antiquitäten* no. 5 (1980), pp. 45–46.
2. Sale, Sotheby's, London, Mar. 25, 1958, lot 167.

188. Lovers with birdcage

Hard paste. Height 4⅞ in. (12.4 cm.)
Mark on glazed portion of underside of base in underglaze blue: crossed swords
Model by Johann Joachim Kändler, Dec. 1736
German, Meissen, ca. 1736
1982.60.299

189. The trinket seller

Hard paste. Height 9³⁄₁₆ in. (23.3 cm.)
Mark on front of base in underglaze blue: crossed swords
Model by Johann Joachim Kändler
German, Meissen, 1745–50, after a model of ca. 1738
1982.60.298

THE MODEL exists in another, possibly earlier, version in which the figure of the serving boy is absent. Here he wears a cap inscribed with the monogram FA, presumably that of (Frederick) Augustus III of Saxony and Poland, who succeeded in 1733. This has led to the suggestion that the male figure represents Augustus himself,[1] but such an identification cannot be substantiated.

The suggested dating for this group is based in part on the inconsistent combination of oriental and naturalistic floral patterns of the woman's dress and also on an inscription on the trinket seller's case, unique to this example of the model. Although incompletely legible, it reads "acheptez pourque . . . Chez Ramponneau." *Tabatières à la Ramponeau* are mentioned as a novelty in 1760;[2] they are described as barrel-shaped boxes of tortoiseshell. No explanation of the name Ramponeau is given, and it

187. Joseph Fröhlich

Hard paste. Height 9¾ in. (24.8 cm.)
Unmarked
German, Meissen, dated 1739
1982.60.305

THIS PORTRAIT of Augustus the Strong's court jester is copied from an engraving by Christian Friedrich Boetius published in Dresden in 1729. In the engraving Fröhlich's suspenders are inscribed with his initials and the date 1728—the year of his arrival in Dresden—and most examples of this model likewise bear the date of their completion. Although the large number of recorded examples date only from 1736, it is possible that the model originated as early as 1733. An example so dated was recorded by Berling in 1900, but, as it seems to have disappeared and has never figured in subsequent discussions of Meissen, a question has been raised as to its authenticity.[1] That

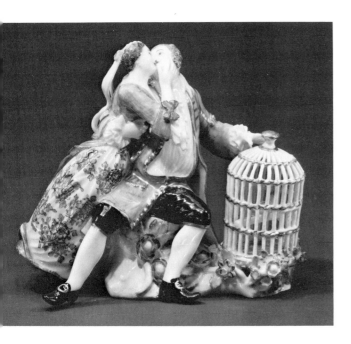

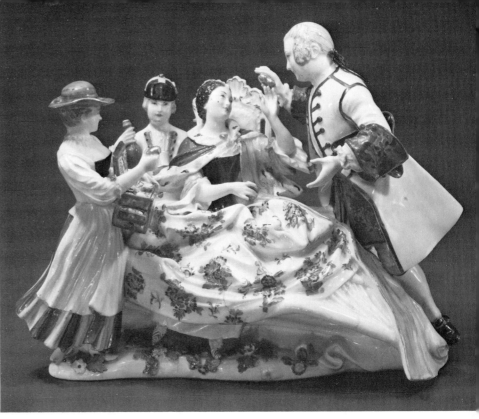

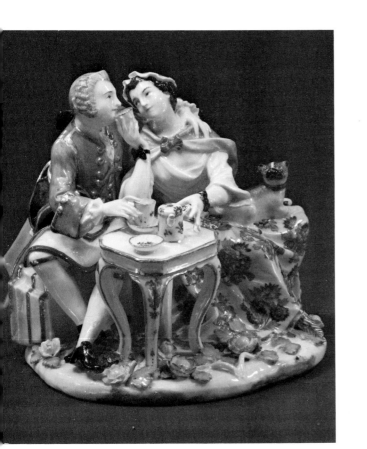

is expressly stated that the boxes were for sale in the shops of a number of retailers in Paris. The inscription on the trinket seller's box of this group, however, clearly implies the existence of a M. Ramponneau, who was both a *marchand* and the inventor of a particular style of snuffbox.

NOTES:
1. Y. Hackenbroch, *Meissen and Other Continental Porcelain in the Untermyer Collection*, New York, 1956, p. 46.
2. *L'Avant Coureur*, May 5, 1760, p. 288.

EX COLL.: Emma Budge, Hamburg (sale, Paul Graupe, Berlin, Sept. 27–29, 1937, lot 784).

190. Couple drinking chocolate

Hard paste. Height 5½ in. (13.9 cm.)
Unmarked
Model by Johann Joachim Kändler
German, Meissen, ca. 1744
1982.60.326

THE MODEL was described by Kändler in his *Taxa* as a Freemasonry group, the man wearing his Masonic apron and the woman seated with a pug on her lap, indicating her position as a member of the Mops order. This was

something of a rival Masonic organization, imitating the Freemasons in a number of its statutes and ceremonies, established in Germany after the excommunication of the Freemasons by Pope Clement XII in 1736. Its membership was exclusively Roman Catholic, and, unlike the Freemasons, it admitted women. According to a contemporary account of the Mops order, a dog was chosen as its emblem to signify fidelity and loyalty, and a pug in particular, as it was the favorite breed of one of the originators of the society.[1]

Kändler recorded two versions of the model, the second in November 1744, but without specifying their differences. A variant model omits the table altogether, and the woman holds a ewer in her left hand.[2]

NOTES:
 1. [G. L. C. Perau], *L'Ordre des francs-maçons trahi et le secret des mopses revelé*, Amsterdam, 1745, pp. 202–4.
 2. Sale, Sotheby's, London, June 15, 1965, lot 149.

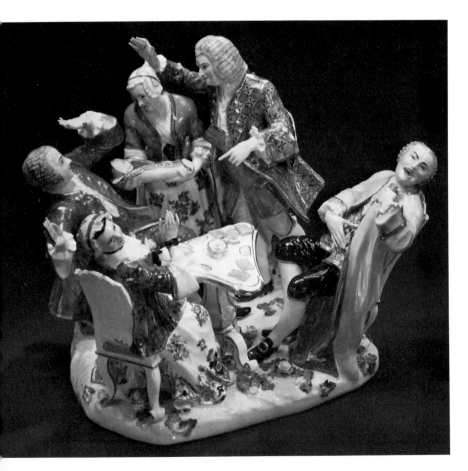

268

191. Satirical group

Hard paste. Height 9¼ in. (23.5 cm.)
Unmarked
Model by Johann Joachim Kändler
German, Meissen, ca. 1742
1982.60.317

A SURPRISED cardplayer is confronted with his paternity of a newborn baby by the mother and her lawyer. The model combines two of Kändler's groups described by him in his *Taxa*. In one, the woman carrying the baby, and the lawyer, approach a young man seated on the ground. The second is a couple seated at a table playing cards, and Kändler noted that "they can be combined with [the] group described previously, as if they were laughing at the man to whom the baby had been brought." The resulting model was referred to by Kändler in 1742 as a "difficult group" of six figures.[1]

NOTE:
 1. O. Walcha, *Meissen Porcelain*, New York, 1981, p. 446 n. 56.

EXHIBITED: Metropolitan Museum of Art, New York, *Masterpieces of European Porcelain*, Mar. 18–May 15, 1949, cat. no. 300 (lent by Mr. and Mrs. Jack Linsky).

BIBLIOGRAPHY: D. Rosenfeld, *Porcelain Figures of the Eighteenth Century in Europe*, New York, 1949, p. 39 (collection: Jack Linsky).

192. Dancing woman

Hard paste with gilt-bronze mounts. Height 11¾ in. (29.8 cm.)
Mark on underside of unglazed base: crossed swords
Model possibly by Johann Joachim Kändler and
 Friedrich Elias Meyer (working 1748–61)
German, Meissen, ca. 1748
1982.60.295

THE FIGURE is extremely similar in pose and proportions to one of a shepherdess in the Bayerisches Nationalmuseum, Munich, a model considered by Rückert to be possibly the joint work of Kändler and Meyer.[1] The shepherdess stands on the molded scrollwork base that superseded the standard flower-strewn pad base of this model about 1750. If Meyer is to be considered as having had some responsibility for this model, it must date al-

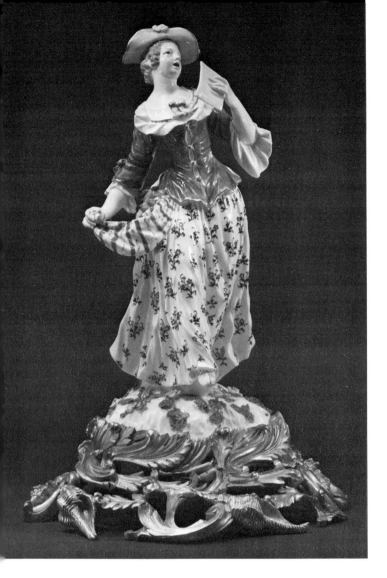

most immediately after his arrival at the factory in 1748. The gilt-bronze base dates from the nineteenth century.

NOTE:
1. R. Rückert, *Meissener Porzellan, 1710–1810* (exhib. cat.), Munich, Bayerisches Nationalmuseum, 1966, cat. no. 1004.

EXHIBITED: Metropolitan Museum of Art, New York, *Masterpieces of European Porcelain*, Mar. 18–May 15, 1949, cat. no. 254 (lent by Mr. and Mrs. Jack Linsky).

193. Sauceboat

Hard paste. Length 9⅜ in. (23.8 cm.)
Mark on underside of unglazed base: crossed swords
Model attributed to Johann Friederich Eberlein
German, Meissen, ca. 1738
1982.60.323

THE MODEL was created for the Swan Service, the dinner service of over two thousand pieces commissioned by Count Heinrich von Brühl in 1737 and completed in 1741. The scheme of decoration was established by J. J. Kändler, the execution of the models being shared by Kändler and Eberlein. According to the factory's records, each modeler produced a swan-form vessel with a putto in 1738. In Kändler's version, for oil or vinegar, the putto is astride the swan. This model, in which a putto winds a garland around the swan's neck, is presumably "the new clay model" of a sauceboat formed as a swan with a child described by Eberlein in August 1738. Both may derive from a sketch by Kändler considered to have been made the previous year.[1]

NOTE:
1. O. Walcha, "Ein Skizzenblatt Kaendlers," *Keramos* no. 21 (1963), p. 22, fig. 1.

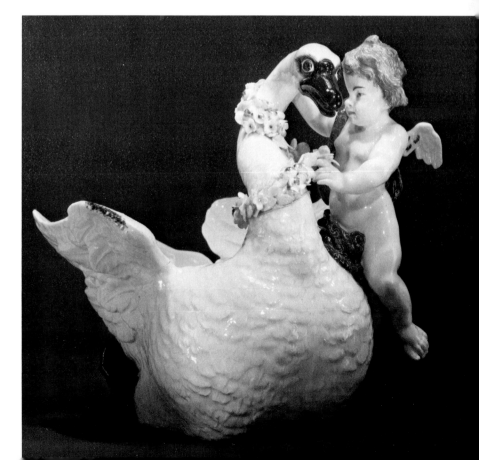

194. Monkey

Hard paste. Height 9½ in. (24.1 cm.)
Unmarked
Model attributed to Johann Joachim Kändler
German, Meissen, ca. 1740, after a model of ca. 1732
1982.60.310

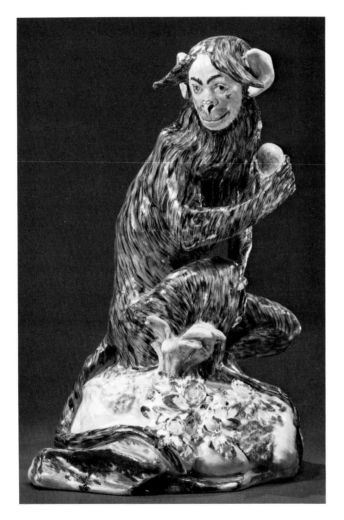

MUCH OF THE naturalism of Meissen figures of animals and birds is due to the availability of models from Augustus the Strong's collection of stuffed and live specimens, many of the latter brought back to Dresden in 1733 from an African expedition. This figure of a monkey, however, is essentially fictitious, displaying features characteristic of several mutually exclusive species. The model is probably based on an illustration from a bestiary, and at least in pose corresponds fairly closely to a woodcut of a Pras-yan ape in Edward Topsell's *History of Four-Footed Beasts*, first published in 1605.[1]

The figure was cited by Karl Albiker as a model of 1726 by J. G. Kirchner,[2] an attribution followed by Rückert, with an amended dating of 1733.[3] Most recently, the late archivist of the Meissen factory, Otto Walcha, has assigned the model to Kändler, about 1732.[4] A dating of about 1740 is suggested for this example on the evidence of the applied flowers on the base, a convention associated with Kändler's figure models after 1736.

NOTES:
1. Facsimile edition, New York, 1967, I, p. 7.
2. K. Albiker, *Die Meissner Porzellantiere im 18. Jahrhundert*, Berlin, 1935, p. 107.
3. *Meissener Porzellan, 1710–1810* (exhib. cat.), Munich, Bayerisches Nationalmuseum, 1966, cat. no. 1048.
4. O. Walcha, *Meissen Porcelain*, New York, 1981, pl. 86.

EX COLL.: [J. Rochelle Thomas, London].

EXHIBITED: Metropolitan Museum of Art, New York, *Masterpieces of European Porcelain*, Mar. 18–May 15, 1949, cat. no. 261 (lent by Mr. and Mrs. Jack Linsky).

Vienna

THE VIENNA factory was founded in 1718 by Claudius Innocentius Du Paquier (d. 1751), who retained his proprietorship until 1744. During this period the factory produced chiefly tablewares and ornamental pieces of exceptionally original design, quite uninfluenced by Meissen. Relatively little sculpture was produced. Toward the end of the period the models were occasionally derivative (nos. 195, 196), but they are no less idiosyncratic in the combination of awkwardness and authority that informs Du Paquier's porcelain. From the range of figures and certain stylistic differences among them, it is evident that several modelers were employed by Du Paquier, but none has been identified. In 1744 Du Paquier sold the factory to the Austrian state. It remained in operation until 1864.

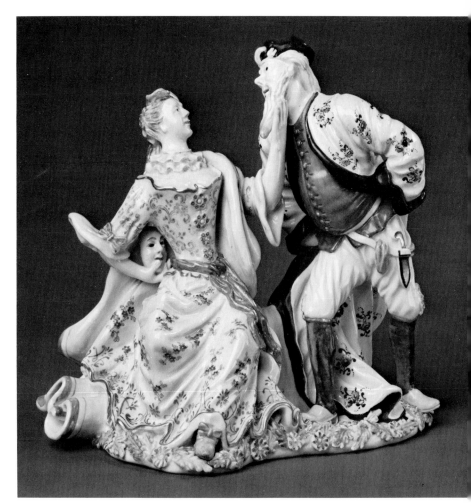

195. Columbine and Pantaloon

Hard paste. Height 7¼ in. (18.4 cm.)
Unmarked
Austrian, Vienna (Du Paquier period, 1718–44), 1741–44
1982.60.234

OF THE FEW figures made during Du Paquier's directorship at Vienna, the majority date from the last years of his tenure and are either interpretations or direct casts of Meissen models. This group corresponds to one reworked by Kändler in 1741 from an earlier composition. A variant of Kändler's 1741 model, also made at Meissen, is no. 184.

EX COLL.: Otto and Magdalena Blohm, Hamburg.

EXHIBITED: Stoner and Evans, Inc., New York, *Exhibition of the Collection of 18th Century European Porcelains Assembled by the Late Mr. Otto Blohm*, Jan. 1948.

BIBLIOGRAPHY: R. Schmidt, *Early European Porcelain as Collected by Otto Blohm*, Munich, 1953, no. 97, pl. 29.

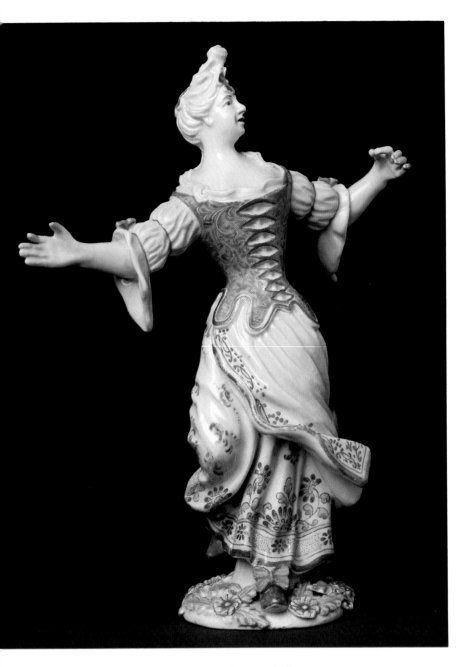

THE FIGURE is a variation on a Meissen model attributed to J. J. Kändler. In the only known surviving example of the Meissen figure in the Untermyer Collection at the Metropolitan Museum (64.101.105), the girl holds an empty birdcage under her left arm, while a bird is perched on her right wrist. The date of the Meissen model is not known, but it may be presumed to have been current at the time Du Paquier began to produce sculpture after Meissen originals in the last years of his directorship.

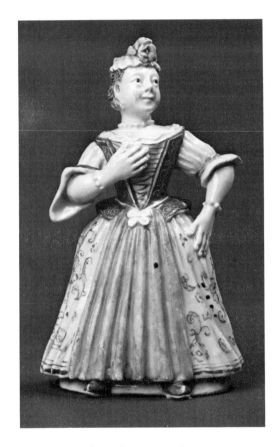

196. Dancing girl

Hard paste. Height 7⁷⁄₁₆ in. (18.9 cm.)
Unmarked
Austrian, Vienna (Du Paquier period, 1718–44), ca.
 1740–44
1982.60.233

197. Bell in the form of
a standing girl

Hard paste. Height 4⁹⁄₁₆ in. (11.6 cm.)
Unmarked
Austrian, Vienna (Du Paquier period, 1718–44), ca.
 1740
1982.60.237

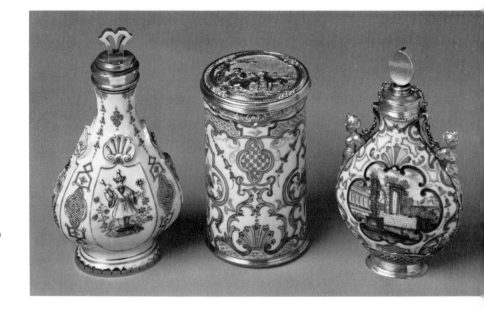

198. Scent flask

Hard paste with gold mounts. Height 3⅜ in. (8.6 cm.)
Unmarked
Austrian, Vienna (Du Paquier period, 1718–44),
 1725– 30
1982.60.235

THE MOUNTS are not contemporaneous with the porcelain. An identical flask is in the Österreichisches Museum für Angewandte Kunst, Vienna.[1]

NOTE:
1. W. Mrazek and W. Neuwirth, *Wiener Porzellan, 1718–1864* (exhib. cat.), Vienna, Österreichisches Museum für Angewandte Kunst, [1970], cat. no. 157.

EX COLL.: Heinrich Rothberger, Vienna; [H. E. Backer, London].

EXHIBITED: Metropolitan Museum of Art, New York, *Masterpieces of European Porcelain*, Mar. 18–May 15, 1949, cat. no. 17 (lent by Mr. and Mrs. Jack Linsky).

BIBLIOGRAPHY: J. F. Hayward, *Viennese Porcelain of the Du Paquier Period*, London, 1952, pl. 49b (property of H. Backer [sic]).

199. Counter box

Hard paste with contemporaneous gold mounts.
 Height 2½ in. (6.3 cm.)
Unmarked
Austrian, Vienna (Du Paquier period, 1718–44),
 1730– 40
1982.60.252

200. Scent flask

Hard paste with contemporaneous gold mounts.
 Height 3³⁄₁₆ in. (8.1 cm.)
Unmarked
Austrian, Vienna (Du Paquier period, 1718–44),
 1730–40
1982.60.236

THE PIERCED and figural mounts are possibly by the goldsmith responsible for those on a Du Paquier tray with two cups of the same date in the Metropolitan Museum (68.141.282–4).

EX COLL.: Berta Floderer-Herzfelder, Vienna; Anton Redlich, Vienna/New York (sale, Kende Galleries, New York, Apr. 5–6, 1940, lot 42).

EXHIBITED: Belvedere, Vienna, *Prinz-Eugen-Ausstellung*, May–Oct. 1933, p. 117, cat. no. 23 (collection Floderer-Redlich); Musée du Jeu de Paume, Paris, *Exposition de l'art autrichien*, May–June 1937, cat. no. 163 (lent by Anton Redlich); Metropolitan Museum of Art, New York, *Masterpieces of European Porcelain*, Mar. 18–May 15, 1949, cat. no. 18 (lent by Mr. and Mrs. Jack Linsky).

BIBLIOGRAPHY: L. Ruprecht, "Porzellansammlung Berta Floderer-Herzfelder, Wien: I," *Belvedere* n.s. 12 (Mar. 1928), fig. 8.

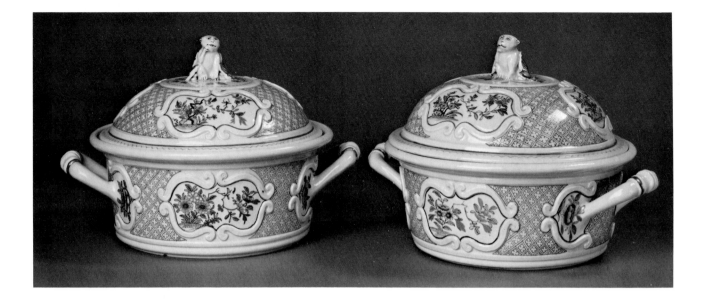

201, 202. Two covered tureens

Hard paste. Height, each 6 in. (15.3 cm.)
Unmarked
Austrian, Vienna (Du Paquier period, 1718–44), 1725–
30
1982.60.246ab, 247ab

TUREENS OF this model exist in several sizes and are traditionally said to have formed part of a table service made for a Prince de Rohan. As no factory archives from the Du Paquier period have survived, this has not proved verifiable. No objects other than tureens are associated with the service.

The cover of one of these must originally have been made for the next-larger size of tureen in the service.

EX COLL.: Oscar Bondy, Hamburg.

203. Standing woman

Hard paste. Height 5⅝ in. (14.3 cm.)
Unmarked
Austrian, Vienna, ca. 1750–60
1982.60.241

EX COLL.: Heinrich Rothberger, Vienna (?).

The German Factories

Between 1710 and 1750 no hard-paste factories came into existence in Germany. A factory organized at Höchst in 1746 did not begin to manufacture porcelain until four years later, surviving until 1796. The Nymphenburg and Fürstenberg factories (both still in operation) were established in 1747, to be followed by Frankenthal in 1755 (closed 1799), and Ludwigsburg in 1758, although production at the latter place does not appear to have begun until 1760. It closed in 1824. The last of the major German factories, Fulda, was founded in 1764 and closed in 1789.

This quick succession was prompted by a number of circumstances: the demand for porcelain generated by the international success of Meissen, the easy availability of kaolin from Passau (the chief, but not the exclusive, source of the material), and the constant movement of technicians and artists. Except for Fürstenberg, all the factories mentioned above depended for their initial technical expertise on information provided by the arcanist Joseph Jakob Ringler (d. 1802), who began working in Vienna and left in 1747, taking details of paste and kiln construction to Höchst (1751–52), Nymphenburg (1753–57), and Ludwigsburg (1758–1802). Ringler did not himself work at Frankenthal, but supplied its founder, Paul Hannong, with the same assistance. In like manner, modelers and decorators moved back and forth as opportunity arose. To cite only a few of many such cases, Karl Gottlieb Lück, at Meissen from 1744 until 1757, also worked at Höchst (1758) and Frankenthal (1760–75; no. 229). Simon Feilner's career began at Höchst (1751–53; nos. 204–208), continued at Fürstenberg (1753–68; nos. 209, 210), and concluded at Frankenthal (1770–97). Nor was this itinerancy confined within Germany: we see Joseph Nees at Ludwigsburg and Zurich (nos. 233–235, 247) and A. C. Luplau at Fürstenberg and Copenhagen (nos. 217, 335).

The effect of this movement on the style and production of an individual factory is difficult to evaluate. Whether a model that occurs in two factories is to be accounted for by the accessibility of a popular engraving or the presence in both places of a single modeler (nos. 217, 335), and whether a modeler can be said to have a definitive style, is not easily determined. Joseph Nees is one of the few modelers with elements of a personal style recognizable in his work at Ludwigsburg and Zurich, and the models of Franz Anton Bustelli at Nymphenburg are on the whole consistent and unmistakable. But it must be pointed out that some models attributed to both artists do not display their usual characteristics, while those assigned to Wenzel Neu (nos. 239, 246) differ considerably in their manner. There can be little doubt that the identifying characteristics of modelers and decorators, whether they moved about or stayed in a single factory, must often have been submerged into a prevailing "house" style.

That the simultaneous development of these German factories did not result in either destructive competition or more than a token uniformity of repertoire is largely due to the physical division of Germany into independent political and cultural territories and the essentially local orientation of the factories (even those that had retail markets elsewhere on the Continent, as did Ludwigsburg), which existed at the pleasure of a founding duke or elector whose tastes they served. What the German factories did share was the influence of Kändler's work, visible in the occasional borrowing of Meissen models (no. 221) but, more importantly, in the emphasis given to sculpture in the first place, and the

wide circulation of engravings that established a more or less common iconography. It is likely that by far the majority of figure models derive from engravings, either original or engraved after well-known paintings. The practice of reengraving (no. 230) and the informal alteration of engravings with—one supposes—the introduction of original compositional elements, greatly complicates the task of identifying such sources accurately.

Seven Italian Comedy Figures

TWO SETS OF Italian Comedy figures, one made at Höchst, the other at Fürstenberg, are connected by a common source and, possibly, the same modeler. The source was discovered by Arthur Lane among a collection of engravings in the Victoria and Albert Museum, London, that remain unidentified, as they have been cut out from their backgrounds and pasted on blank sheets.

The modeler of the Fürstenberg set of figures is Simon Feilner (1726–1798), who came to the factory in 1753 from Höchst, where he had been working since 1750. He is recorded at Höchst not as a modeler, but (in 1752) as a flower painter. That he worked as a modeler at Fürstenberg is confirmed by that factory's records, and his authorship of these particular figures is presumed on his having been the only modeler there in 1754 when a set of Comedy figures was listed in the factory's records.

The repetition of the figures within four or five years at the two factories where Feilner is known to have been employed has led to the conclusion that he was responsible for both series, and such a possibility cannot be dismissed. But engravings of popular subjects were in common circulation and are known to have inspired artists working at different factories. There are, in addition, differences in the characterization and modeling of the two sets of figures—demonstrable here in the two versions of Harlequin—that cannot easily be laid to a simple progression of style in so short a time. It has recently been suggested that the earlier series may possibly be the work of Johann Gottfried Becker, who was working at Höchst from 1746 to 1756 and again in 1759–60, having come from Meissen, where he had been a pupil of J.J. Kändler.[1]

1. P. W. Meister and H. Reber, *European Porcelain of the 18th Century*, Ithaca, 1980, p. 186.

204. Columbine

Hard paste. Height 8½ in. (21.6 cm.)
Mark incised on underside of unglazed base: IGE
Model by Simon Feilner (?)
German, Höchst, ca. 1750–53
1982.60.224

205. Captain

Hard paste. Height 8½ in. (21.6 cm.)
Marks on underside of unglazed base: a wheel over the letters PGS in red; PI incised
Model by Simon Feilner (?)
German, Höchst, ca. 1750–53
1982.60.225

FROM ONE of at least three versions of the Höchst series, differentiated by size, palette, and/or design of the base.

EX COLL.: Otto and Magdalena Blohm, Hamburg (sale, Sotheby's, London, Apr. 24–25, 1961, lot 392).

EXHIBITED: Metropolitan Museum of Art, New York, *Masterpieces of European Porcelain*, Mar. 18–May 15, 1949, cat. no. 201 (lent by Mr. and Mrs. Jack Linsky).

BIBLIOGRAPHY: R. Schmidt, *Early European Porcelain as Collected by Otto and Magdalena Blohm*, Munich, 1953, no. 166.

206. Bagolin

Hard paste. Height 8¼ in. (20.9 cm.)
Mark incised on underside of unglazed base: PI
Model by Simon Feilner (?)
German, Höchst, ca. 1750–53
1982.60.223

276

RIGHT, TOP: 204, 205. BOTTOM: 206, 207, 208

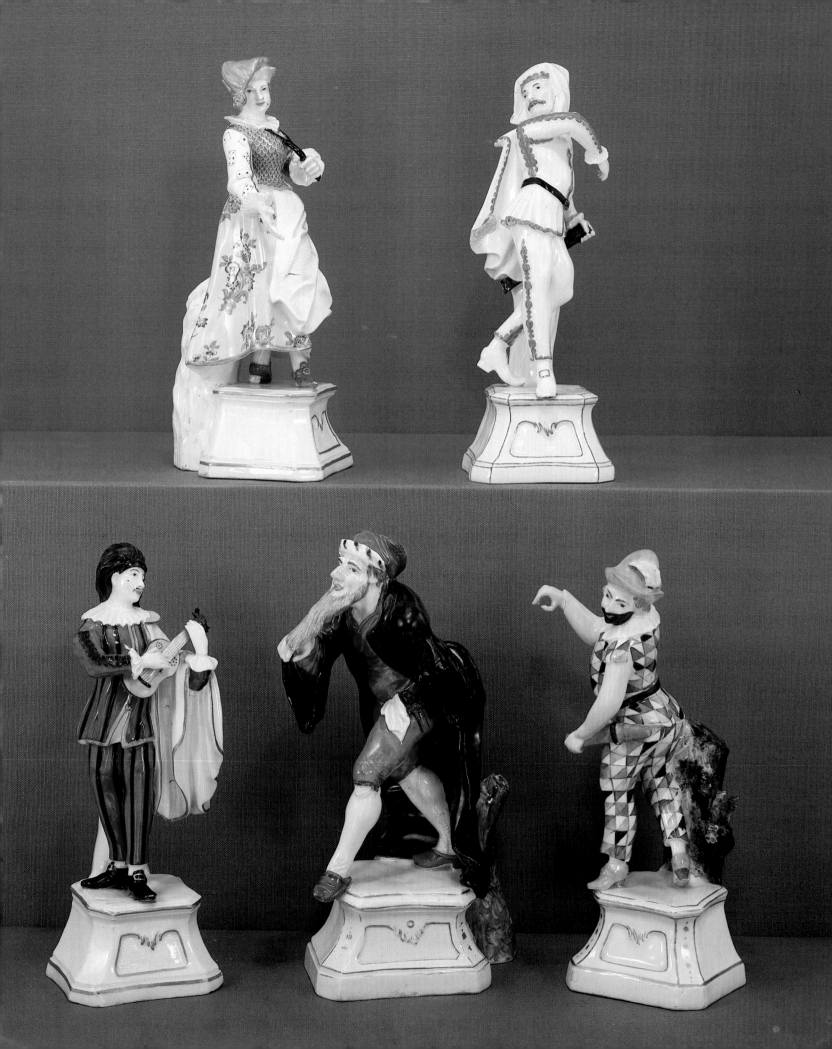

207. Pantaloon

Hard paste. Height 9 in. (22.9 cm.)
Mark on underside of unglazed base: a wheel in iron
 red
Model by Simon Feilner (?)
German, Höchst, ca. 1750–53
1982.60.226

208. Harlequin

Hard paste. Height 8³⁄₁₆ in. (20.8 cm.)
Mark on underside of unglazed base: a wheel in iron
 red
Model by Simon Feilner (?)
German, Höchst, ca. 1750–53
1982.60.222

209. Harlequin

Hard paste. Height 7¾ in. (19.7 cm.)
Dated *1764* on the back of the tunic
Model by Simon Feilner
German, Fürstenberg, 1764, after a model of ca. 1754
1982.60.204

EX COLL.: Erich Wolff.

BIBLIOGRAPHY: D. Rosenfeld, *Porcelain Figures of the Eigh-
teenth Century in Europe*, New York, 1949, p. 66 (collection:
Jack Linsky); S. Ducret, *Fürstenberger Porzellan*, 1965, III, fig.
32 (formerly Erich Wolff collection).

210. Ragonda

Hard paste. Height 7¹¹⁄₁₆ in. (19.5 cm.)
Unmarked
Model by Simon Feilner
German, Fürstenberg, ca. 1754
1982.60.203

THE SECONDARY characters in the Italian Comedy were
assigned different names by different troupes. Robert
Schmidt identifies Ragonda as the mother of Isabella's
(one of the lovers) suitor.[1]

NOTE:
 1. R. Schmidt, *Early European Porcelain as Collected by Otto
and Magdalena Blohm*, Munich, 1953, p. 118.

BIBLIOGRAPHY: D. Rosenfeld, *Porcelain Figures of the Eigh-
teenth Century in Europe*, New York, 1949, p. 66 (collection:
Jack Linsky).

209

210

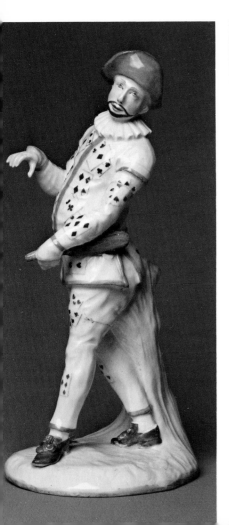

213. Hunters with blackamoor

Hard paste with gilt-bronze mounts. Height 9 in. (22.8 cm.)

Mark on underside of base in puce: a six-spoked wheel

German, Höchst, ca. 1760

1982.60.230

THE MOUNTS are eighteenth century, but not original to the group.

EX COLL.: Hedwig Ullmann, Frankfurt am Main; René Fribourg, New York (sale, Sotheby's, London, June 25, 1963, lot 1).

EXHIBITED: Mainz, Jahrtausand-Ausstellung, *Höchster Porzellan*, 1925, cat. no. 168 (lent by Frau Hedwig Ullmann).

ALTHOUGH THE specific compositions of these three groups have not proved traceable, they are almost certainly based on engravings by Johann Elias Ridinger (1698–1767), of which ten series of hunting scenes, comprising some 275 plates, were published between 1722 and about 1738.[1]

NOTE:

1. J. F. Hayward, "The Jagd-Service Du Paquier," *Keramik-Freunde der Schweiz Mitteilungsblatt* no. 45 (1959), p. 24.

211, 212. Hunters with hounds

Hard paste. Lengths 9⅞ in. (24.3 cm.), 8⅝ in. (22 cm.)

Mark on underside of base of each in red: a six-spoked wheel

German, Höchst, ca. 1760

1982.60.228,229

EX COLL.: [J. Rochelle Thomas, London]; [James A. Lewis, New York].

EXHIBITED: Metropolitan Museum of Art, New York, *Masterpieces of European Porcelain*, Mar. 18–May 15, 1949, cat. no. 210 (lent by Mr. and Mrs. Jack Linsky).

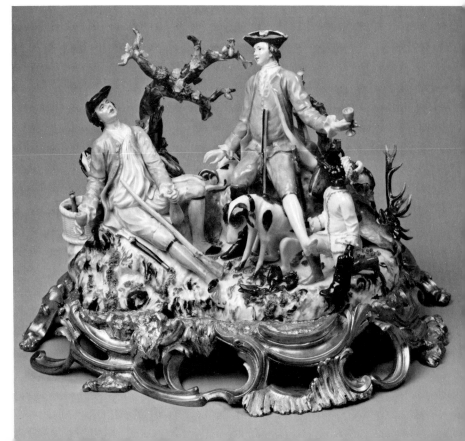

214

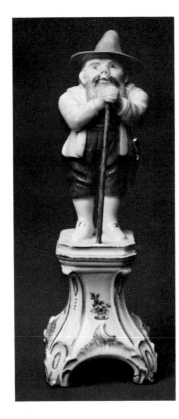

214. Dwarf

Hard paste. Height 6¼ in. (15.8 cm.)
Marks inside base: a six-spoked wheel in puce; I
 incised
German, Höchst, 1750–55
1982.60.244

EX COLL.: Baron Max von Goldschmidt-Rothschild, Frankfurt am Main.

EXHIBITED: Mainz, Jahrtausand-Ausstellung, *Höchster Porzellan*, 1925, cat. no. 65 (lent by M. v. Goldschmidt-Rothschild).

215. Kuan Yin

Hard paste. Height 5½ in. (14 cm.)
Marks inside base: six-spoked wheel in underglaze
 blue; N200/M9/LE incised
German, Höchst, ca. 1770, after a model of 1750–55
1982.60.243

THE MODEL is unrecorded, and no other example is known.

215, 216

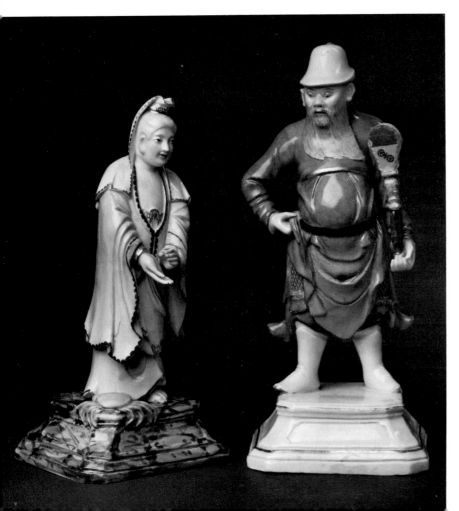

216. Oriental

Hard paste. Height 6⅜ in. (16.2 cm.)
Marks inside base: a six-spoked wheel in puce; I
 incised
German, Höchst, 1750–55
1982.60.242

EX COLL.: Baron Max von Goldschmidt-Rothschild, Frankfurt am Main (sale, Parke-Bernet, New York, Mar. 11, 1950, lot 225); [Rosenberg and Stiebel, New York].

EXHIBITED: Mainz, Jahrtausend-Ausstellung, *Höchster Porzellan*, 1925, cat. no. 195 (lent by M. v. Goldschmidt-Rothschild).

217. Sultan and Moor

Hard paste. Height 9⅝ in. (24.4 cm.)
Marks on underside of unglazed base: F, once in blue
 enamel and once incised
Model by Anton Carl Luplau (d. 1795; working at
 Fürstenberg 1765–76), 1773/74
German, Fürstenberg, ca. 1773
1982.60.293

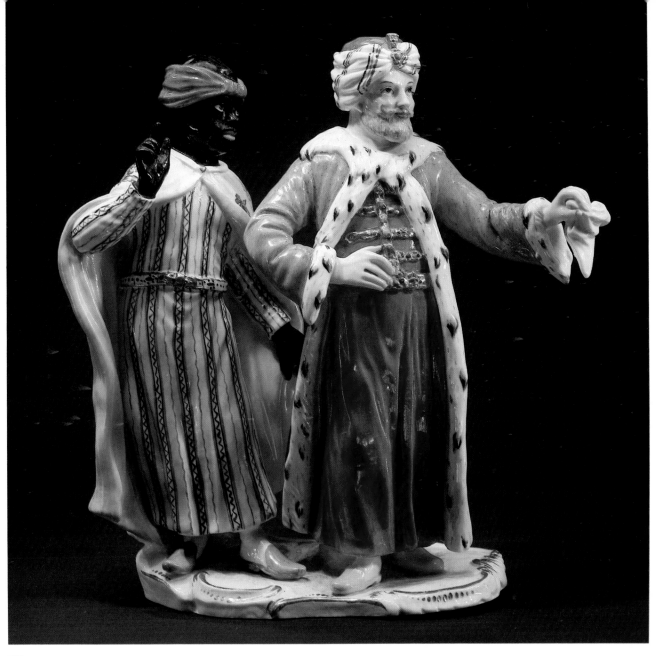

217

THE COMPOSITION is copied from plate 2 of the German edition, published in Nuremberg in 1719, of the *Recueil de cent estampes représentant differentes nations du Levant*. First published in Paris in 1714, this was a collection of engravings of paintings commissioned by Charles Ferriol, comte de Ferriol, while he was Louis XIV's ambassador to Constantinople, 1699–1709. The sultan is identified as Achmet III (1673–1736), sultan of Turkey 1703–30, at the age of forty-five. The engravings of the Nuremberg edition are by Johann Christoph Weigel (about 1654–1726).

According to Ducret, Luplau's models for this group and its companion of a sultana and attendant (of which an example is in the Pflueger collection) are numbered *119* and *120* and are datable to 1773/74. Luplau left Fürstenberg for Copenhagen, where he became chief modeler in 1776. For versions of this model and its companion made at Copenhagen during Luplau's tenure, see nos. 334, 335.

EX COLL.: Herman Isaacson; [Frank Partridge & Sons, London]; [J. J. Klejman, New York]; Felix Kramarsky, New York (sale, Parke-Bernet, New York, Jan. 10, 1959, lot 699).

BIBLIOGRAPHY: S. Ducret, *German Porcelain and Faience*, trans. D. Imber, New York, 1962, pl. 78.

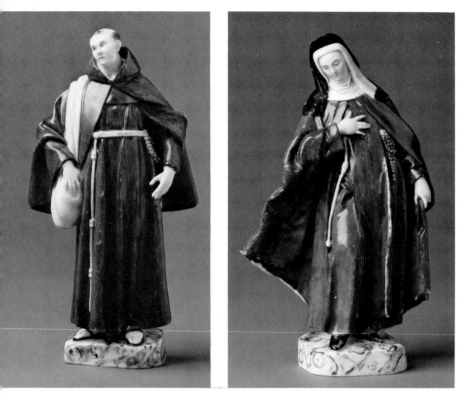

218, 219. Mendicant Capuchin friar and Franciscan nun

Hard paste. Heights 4¾ in. (12 cm.), 5 in. (12.7 cm.)
Marks on underside of unglazed base of friar: a six-
 spoked wheel in red; script *IN* incised; mark on
 underside of unglazed base of nun: a six-spoked
 wheel in red
German, Höchst, ca. 1765
1982.60.238, 239

THESE ARE two of at least six models in a series appar-
ently portraying members of the Dominican and Francis-
can orders. Another model of a Capuchin friar is, like
these, marked in red;[1] three others bear the wheel mark
in underglaze blue that began to supersede the red mark
after about 1765.[2]

NOTES:
 1. Sale, Sotheby's, London, July 2, 1974, lot 237.
 2. Darmstaedter collection (sale, Lepke, Berlin, Mar. 24–26,
1925, lots 283, 284); British Museum, London (1923, 3=14, 112).

BIBLIOGRAPHY: D. Rosenfeld, *Porcelain Figures of the Eigh-
teenth Century in Europe*, New York, 1949, p. 52 (collection:
Jack Linsky).

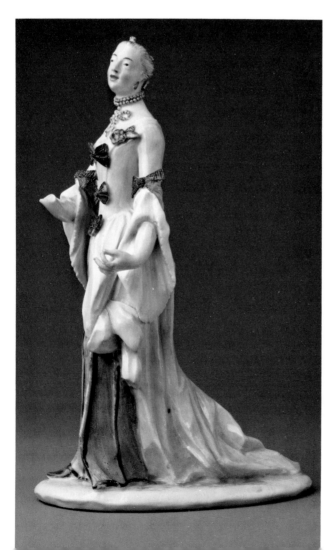

220. Standing woman

Hard paste. Height 7¹/₁₆ in. (17.9 cm.)
Mark impressed on top of base: a shield
German, Nymphenburg, 1750–55
1982.60.194

THE FIGURE is designed to accompany one of a man
and is one of a few repeated and varied models of well-
dressed ladies and gentlemen, all by the same modeler.
F. H. Hofmann attributed some to Johann Paul Härtl
and others to Franz Anton Bustelli.[1] Härtl was manager,
as well as modeler, by 1754, the year Bustelli came to
Nymphenburg. The stiffness of pose and modeling sug-
gests a date prior to Bustelli's arrival, but more relaxed
and graceful versions of the models might be clues to
Bustelli's development as a modeler.[2] The evidence of the
costumes is inconclusive. The dress and jewelry worn here
are a pastiche of earlier styles of about 1715–30; in another
model, in the Metropolitan Museum (64.101.297), it is
correctly fashionable for about 1750, while in a third, also
in the Metropolitan (1974.356.523), it is in the style of the
1760s.

NOTES:
 1. F. H. Hofmann, *Geschichte der bayerischen Porzellanmanu-factur Nymphenburg*, Leipzig, 1921–23, I, frontispiece, fig. 28; III, fig. 311.
 2. Hofmann, I, pl. 2; R. Rückert, *Franz Anton Bustelli*, Munich, 1963, fig. 1.

221, 222. Pair of Moors with sugar boxes

Hard paste. Height, each 5⁵/₁₆ in. (13.5 cm.)
Mark impressed on underside of each base: a shield,
 with .B. incised below
Models by Franz Anton Bustelli (1723[?]–1763;
 working from 1754)
German, Nymphenburg, ca. 1760
1982.60.197ab, 198ab

PROTOTYPES FOR these figures exist in a number of variant models produced both at Vienna and at Meissen between about 1744 and 1750. The covered bowls are borrowed directly from Meissen, but the seated Moors, while reminiscent of the earlier figures, are original models of Bustelli's. As a pair of similar boxes with seated Turks was also produced at Meissen,[1] it may be that the models originated as elements of a table centerpiece symbolizing the Four Continents.

The models are listed among Bustelli's work in 1760 as "1 Mohren und 1 Mohrin, jede mit einer geflochtenen Zuckerdusen." The decoration of these examples is later.

NOTE:
 1. K. Butler, *Meissner Porzellanplastik des 18. Jahrhunderts die Sammlung der Ermitage; Katalog*, Leningrad, 1977, no. 101.

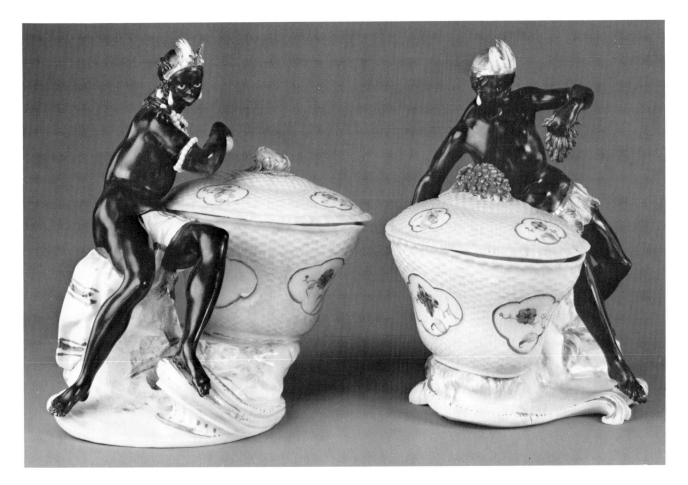

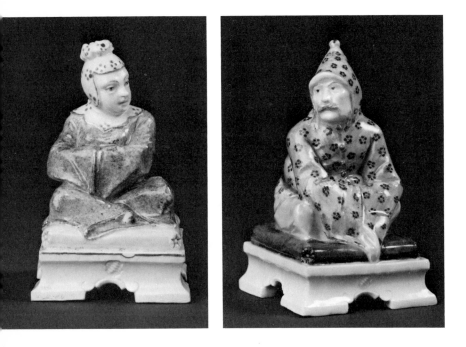

225. Asia

Hard paste. Height 7¼ in. (18.4 cm.)
Mark incised inside base: B
Model by Dominikus Auliczek (1734–1804; working
 at Nymphenburg 1763–97)
German, Nymphenburg, ca. 1763–65
1982.60.195

FROM A SET symbolizing the Four Continents, modeled
between Auliczek's arrival at Nymphenburg, in 1763, and
1765, when the figures are first mentioned in the factory
records.

223, 224. Pair of seated Chinese

Hard paste. Heights 3⅞ in. (9.9 cm.), 4⅛ in. (10.5
 cm.)
Mark impressed on front of each base: a shield; mark
 impressed under foot rim of man: 2
Models by Franz Anton Bustelli
German, Nymphenburg, ca. 1760
1982.60.199,200

THE FIGURES are hollow and the top of each headdress
pierced. The models are recorded by Hofmann[1] as light
extinguishers and are perhaps to be equated with the "two
squatting pagods" among Bustelli's models for 1756.

NOTE:
 1. F. H. Hofmann, *Geschichte der bayerischen Porzellanmanu-
faktur Nymphenburg*, Leipzig, 1921–23, III, p. 423.

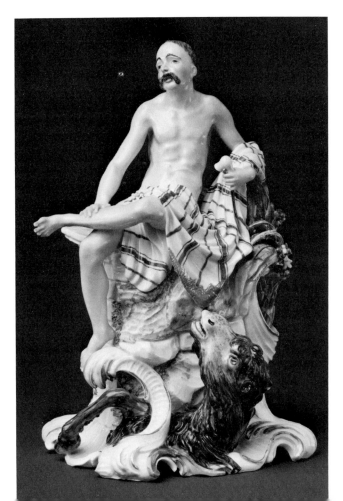

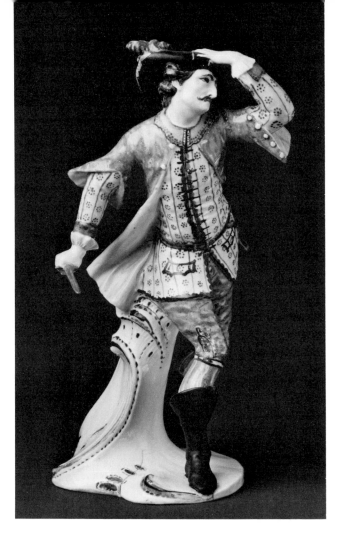

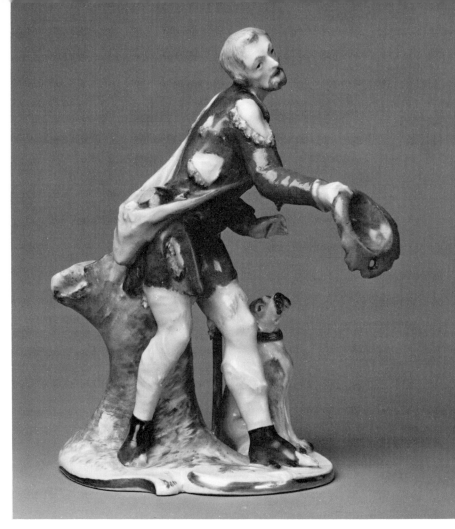

226. Captain Spavento, from the Italian Comedy

Hard paste. Height 7¼ in. (18.4 cm.)
Marks: impressed shield on base support; so-called
 alchemical symbols along edge of base in
 underglaze blue; incised annulet on unglazed
 underside of base
Model by Franz Anton Bustelli
German, Nymphenburg, ca. 1760
1982.60.196

NYMPHENBURG models were often left in the white at
the time they were made and were decorated, as was this
example, in the nineteenth century.

EX COLL.: Otto and Magdalena Blohm, Hamburg.

BIBLIOGRAPHY: M. Sauerlandt, *Deutsche Porzellanfiguren des
XVIII. Jahrhunderts*, Cologne, 1923, fig. 56; R. Schmidt, *Early
European Porcelain as Collected by Otto Blohm*, Munich, 1953,
no. 277, pl. 74.

227. Beggar

Hard paste. Height 6¾ in. (17.1 cm.)
Unmarked
Model by Franz Anton Bustelli
German, Nymphenburg, ca. 1760
1982.60.227

THE FIGURE is one element of a three-part composition
described in the factory records in 1760 as "one beggar-
woman with two children, 1 beggar with one dog, one
messenger [*Läufer*] accompanying a young lady who gives
alms to the beggarwoman." The couple is in the center,
the girl facing the beggar mother on the left, while the
man turns to face this figure of a beggar on the right.

Figures were frequently paired or grouped for the-
matic purposes, but Bustelli's device of creating a narra-
tive composition with three groups appears to be unique.

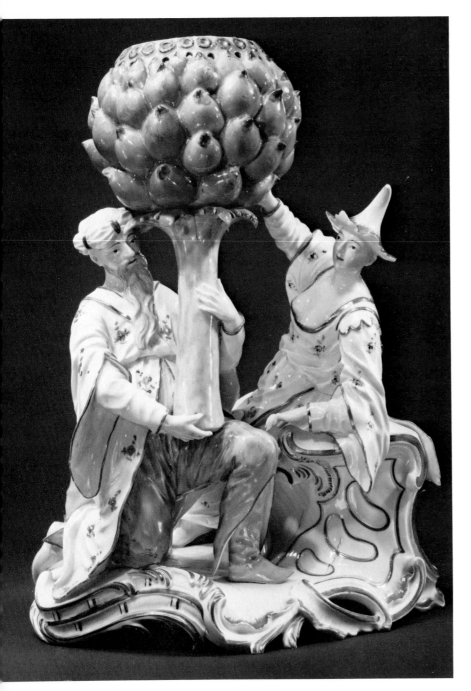

228. Orientals with artichoke as perfume burner

Hard paste. Height 11 in. (28 cm.)
Marks on base in underglaze blue: crowned
 monogram CT above AB conjoined and 6; H2 incised
Model by Johann Friedrich Lück (working 1757–64)
German, Frankenthal, ca. 1766
1982.60.292ab

THE MODEL must have originated before 1764, when Lück returned to Meissen, where he had worked from 1741 to 1757. On the evidence of an example marked with a lion rampant, it can be dated between 1757 and about 1759.[1] It was still being produced as late as 1785.[2]

The initials *AB* are those of Adam Bergdoll, director of the factory between 1762 and 1770, and the numeral *6* is presumably a year letter, although the practice of including the last two digits of a year in the factory mark did not become common at Frankenthal until after 1770.

The cover, not shown, is not original. Pierced, of low domed shape, it matches the design of the cover of at least two other examples of the model, but seems insufficient in scale.

On another two examples, the cover takes the form of a tiered crown of leaves. It is not certain which, if any, of these is original.

NOTES:
 1. Victoria and Albert Museum, London (C. 217–1913).
 2. Sale, Sotheby's, New York, Oct. 13, 1983, lot 61.

229. Chinese pavilion

Hard paste. Height 10 in. (25.4 cm.)
Unmarked
Model by Karl Gottlieb Lück (working 1760–75)
German, Frankenthal, ca. 1770
1982.60.294

THIS IS ONE of at least seven variant models. The cupola with its dragon finial is not original to this example, which evidently once had four small columns of square section set around the edge of the pavilion roof, a device used elsewhere by Lück.[1]

NOTE:
 1. F. H. Hofmann, *Frankenthaler Porzellan*, Munich, 1911, II, pl. 115.

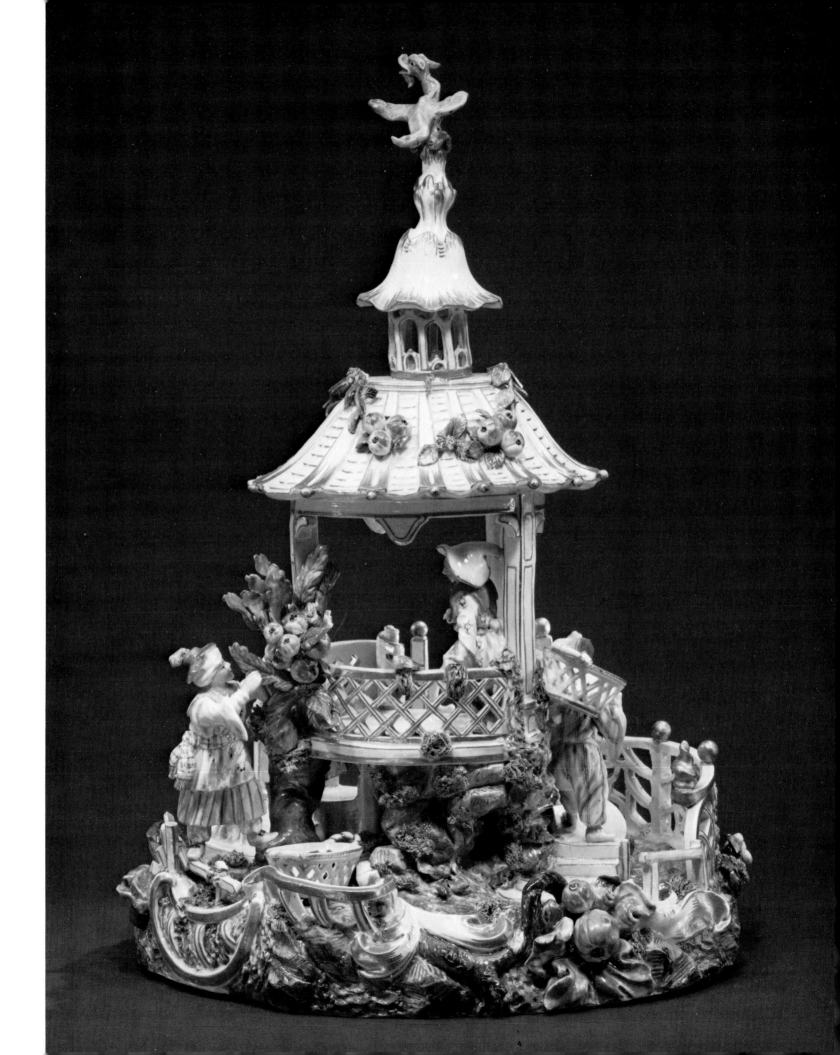

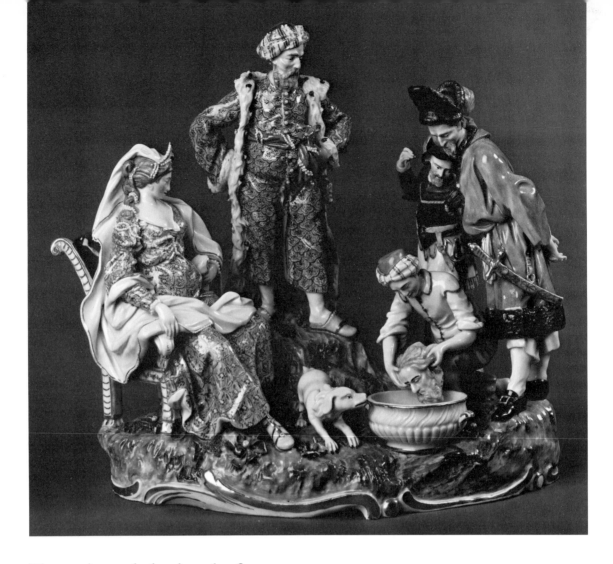

230. Tomyris and the head of Cyrus

Hard paste. Height 10¼ in. (26 cm.)
Unmarked
Model attributed to Karl Gottlieb Lück
German, Frankenthal, ca. 1773
1982.60.205

THE SCENE is that described by Herodotus in Book I of his *History*, in which Tomyris, queen of the Massagetae, dips the head of her vanquished enemy, the Persian king Cyrus, in a skin filled with blood to avenge his role in the suicide of her son. The composition of this group derives from two paintings of the subject by Rubens, dating about 1623, one in the Museum of Fine Arts, Boston, the other in the Louvre. The figures of the boy with the head, the dog, and the standing man on the right are borrowed from the Boston version, as is the turbaned figure, although he appears here in the opposite sense from the painting. Tomyris herself is taken from the Louvre ver-

sion, the figure again being reversed from the original. While eight engravings of the Boston Tomyris are recorded, there are none for the Louvre version, but the repetition and reversal of Rubens's figures in this recomposition indicate the availability to the modeler of engravings of both paintings.

Two dated examples of the model are known, one of 1773,[1] the other of 1779,[2] and the model is cited in the factory records in 1777 at a cost of thirty-five gulden.

NOTES:
1. P. W. Meister, ed., *Sammlung Pauls, Porzellan des 18. Jahrhunderts*, Frankfurt am Main, 1967, II, pp. 178–79.
2. F. H. Hofmann, *Frankenthaler Porzellan*, Munich, 1911, II, pl. 138.

BIBLIOGRAPHY: W. B. Honey, *German Porcelain*, London, 1947, pl. 57; D. Rosenfeld, *Porcelain Figures of the Eighteenth Century in Europe*, New York, 1949, p. 72 (collection: Jack Linsky).

231, 232. Chinese couple with attendants

Hard paste. Heights 11½ in. (29.2 cm.), 11¼ in. (28.6 cm.)

Marks inside base of each in underglaze blue: interlaced C's; inside base of woman, incised: M

Models attributed to Joseph Weinmüller (working 1765–67)

German, Ludwigsburg, 1765–67

1982.60.206,207

THE MODELS are two of a series of at least six single figures and groups tentatively attributed by the first historians of the factory to Domenico Ferretti (working 1762–67).[1] More recently, the entire group has been reattributed by Mechthild Landenberger to Weinmüller, primarily on the basis of a comparison of these models with stone sculptures of Omphale and a priestess executed by Weinmüller for the gardens of the Schönbrunn Palace and repeated in porcelain at the Ludwigsburg factory.[2] As a group, the figures—some of whom are playing musical instruments—may be taken to represent actors and dancers.

NOTES:
1. H. Christ, *Ludwigsburger Porzellanfiguren*, Stuttgart, 1921, fig. 61; W. B. Honey, *German Porcelain*, London, 1947, pl. 62.
2. *Austellung Alt-Ludwigsburger Porzellan, Schloss Ludwigsburg* (exhib. cat.), Stuttgart, Württembergisches Landesmuseum, 1959, cat. nos. 421–33.

EX COLL.: (man) [James A. Lewis, New York].

BIBLIOGRAPHY: D. Rosenfeld, *Porcelain Figures of the Eighteenth Century in Europe*, New York, 1949, p. 80 (collection: Jack Linksy).

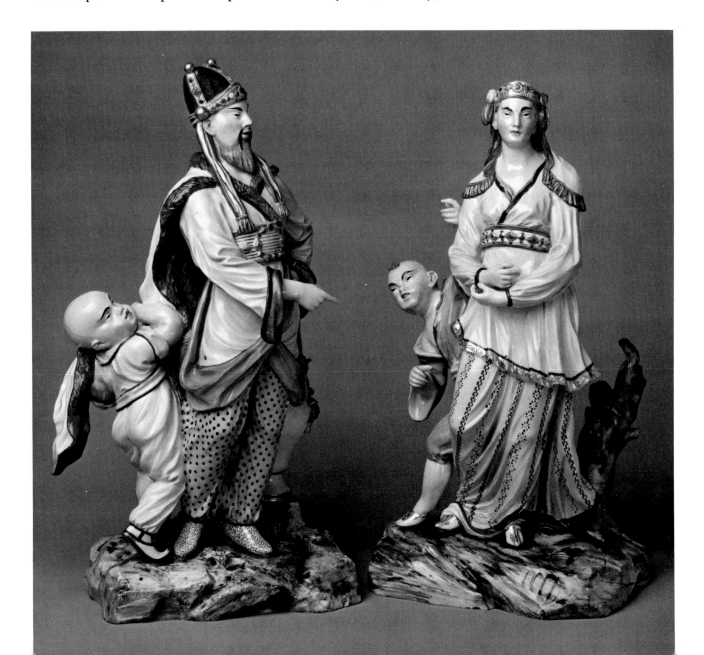

233. Pair of dancers

Hard paste. Height 5¹⁵⁄₁₆ in. (15.1 cm.)
Marks on underside of base: crowned interlaced c's
 in underglaze blue; s in red-brown; UM.M./NO 2.
 incised
Model by Joseph Nees
German, Ludwigsburg, ca. 1760–63
1982.60.191

EX COLL.: Lt.-Col. the Hon. Henry Hope, Kent (sale, Christie's, London, June 20, 1955, lot 23).

234. Pair of dancers

Hard paste. Height 5⅞ in. (14.9 cm.)
Marks on underside of base: interlaced c's in
 underglaze blue; .UM.N.²/MN3. incised
Model by Joseph Nees (working 1759–68)
German, Ludwigsburg, ca. 1760–63
1982.60.192

EX COLL.: Lt.-Col. the Hon. Henry Hope, Kent (Christie's, London, June 20, 1955, lot 24).

235. Pas de trois

Hard paste. Height 6¼ in. (15.9 cm.)
Marks on underside of base: crowned interlaced c's in
 underglaze blue; N° 2. incised
Model by Joseph Nees (active ca. 1754–73; working at
 Ludwigsburg 1759–68)
German, Ludwigsburg, ca. 1763
1982.60.193

EX COLL.: Lempertz, Cologne, May 22, 1957, lot 103.

DUKE KARL EUGEN of Württemberg, the founder of the Ludwigsburg factory, was also the effectual founder of what is now the Stuttgart Ballet. Having modernized his theater with the most elaborate stage machinery, in 1760 he engaged as ballet master the French choreographer Jean-Georges Noverre, who, in turn, attracted such artists as the dancers Gaetano Vestris and his brother, Angiolo, and Louis-René Boquet, a designer of scenery and costumes for court entertainments at Versailles and Fontainebleau.

Noverre stayed at Stuttgart until the end of 1766, during which time he produced at least nine ballets, chiefly for the annual festivities attending Karl Eugen's birthday. Boquet supplied the costumes for several of them, and his style is seen here in the two pairs of dancers. The costume of the men, each wearing a short wide skirt, or *tonnelet*, and beribboned crossbands and puffed sleeves, recurs throughout volume seven of Noverre's own treatise on dancing, *Théorie et pratique de la danse*, published in 1766—particularly in a costume designed for Gaetano Vestris, probably for his role in the ballet *Psyché*, first performed in 1762 (Bibliothèque et Musée de l'Opéra, Paris, D 216 04, fol. 43).

The very different dress of the third group reflects changes advocated by Noverre, who urged the abandonment of the stiff and cumbersome classical costume in favor of a more natural one.[1] Each costume was intended to identify and enhance the character of the dancer's role. Boquet was evidently resistant to this philosophy, and the costumes of the pas de trois may be considered to represent the style of another, more sympathetic, designer.

The three groups undoubtedly refer to specific ballets, and it is tempting to identify the pas de trois with the ballet *Pastorale—Le Triomphe d'amour*, performed in 1763 on the seventh of fourteen days of celebration of Karl Eugen's birthday. Involving two girls and two shepherds, it included a pas de trois featuring Mlle Toscani.

The groups are three of a number of models of dancers that have recently been accepted as the work of Joseph Nees.[2] Something of an itinerant modeler, Nees moved from Ellwangen to Ludwigsburg in 1759, leaving in 1768 for Zurich, where he remained until his death in 1773. A repetition of Ludwigsburg models at Zurich and a consistency of style have made it possible to identify his work at both factories: these figures may be compared with his group of musicians (no. 247), which are similarly characterized by gracefulness of pose and by long thin bodies, especially the legs and feet.

NOTES:
1. J.-G. Noverre, *Théorie et pratique de la danse*, Paris, 1766, I, pp. 225–26, 241–43.
2. *Ausstellung Alt-Ludwigsburger Porzellan, Schloss Ludwigsburg* (exhib. cat.), Stuttgart, Württembergisches Landesmuseum, 1959, cat. no. 57; P. W. Meister, ed., *Sammlung Pauls, Porzellan des 18. Jahrhunderts*, Frankfurt am Main, 1967, II, p. 202.

RIGHT, TOP: 235. BOTTOM: 233, 234

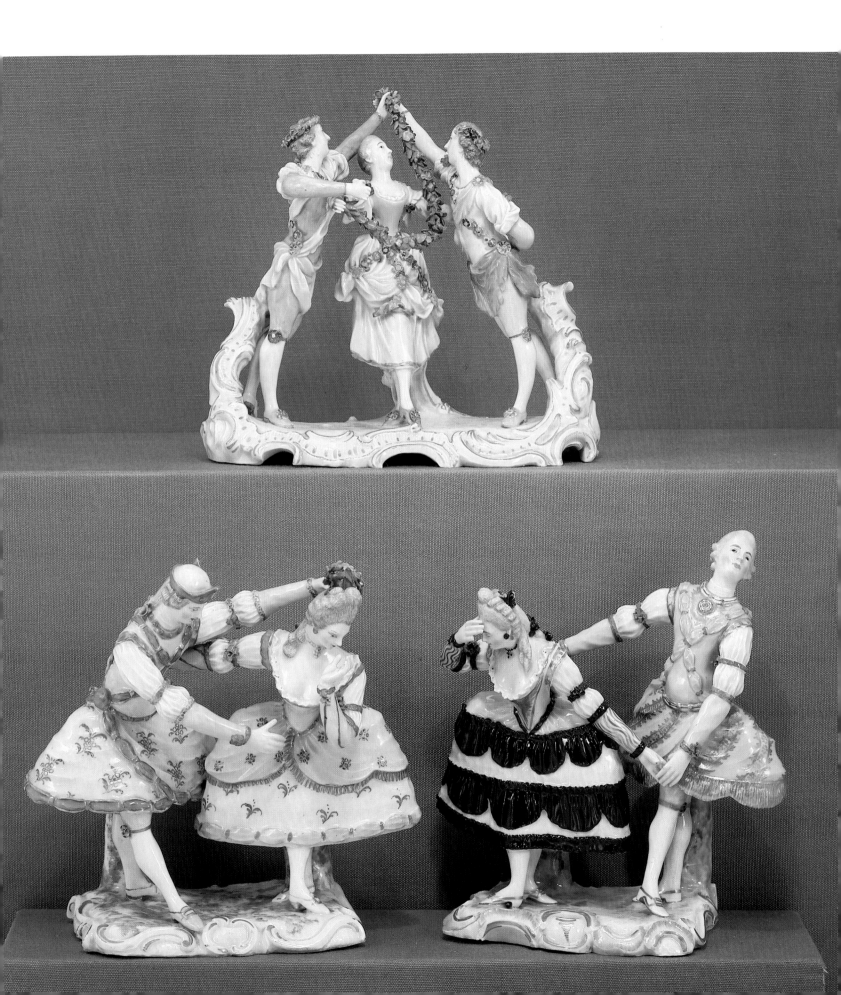

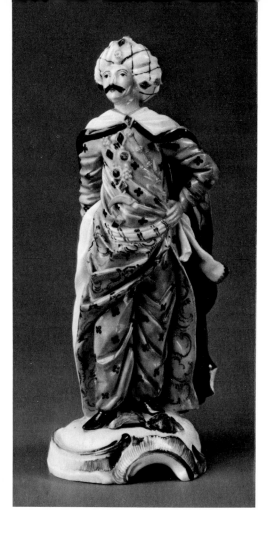

236. Sultan

Hard paste. Height 5⅞ in. (14.9 cm.)
Mark on underside of base in underglaze blue: a cross
German, Fulda, ca. 1770
1982.60.188

THE FIGURE is based—with slight variations in the pose—on plate 40 of the 1719 Nuremberg edition of the *Recueil de cent estampes représentant différentes nations du Levant* with engravings by Johann Christoph Weigel.

237, 238. Pair of sphinxes

Hard paste. Lengths 7⅞ in. (20 cm.), 7⅝ in. (19.3 cm.)
Mark inside base of each in blue: a cross
Probably German, Fulda (?), 18th century (?)
1982.60.183,184

AN IDENTICAL pair of sphinxes, attributed to Fulda and differing only in the palette of the decoration, was formerly in the Osterman collection.[1] Both are marked with a form of the cross used at Fulda between 1764 and 1781, but attribution of both pairs to that factory must be considered doubtful. The prominence of pearled ornament, the flower sprigs, and a generous use of gilding are all reminiscent of Fulda work, but the manner of painting lacks the degree of high refinement characteristic of Fulda. Absent, too, is the peculiar warm brilliance of a Fulda glaze. The rendering of the mark in enamel rather than underglaze blue further contributes to uncertainty.

NOTE:
1. Sale, Cassirer and Helbing, Berlin, Oct. 30–Nov. 2, 1928, lot 1791.

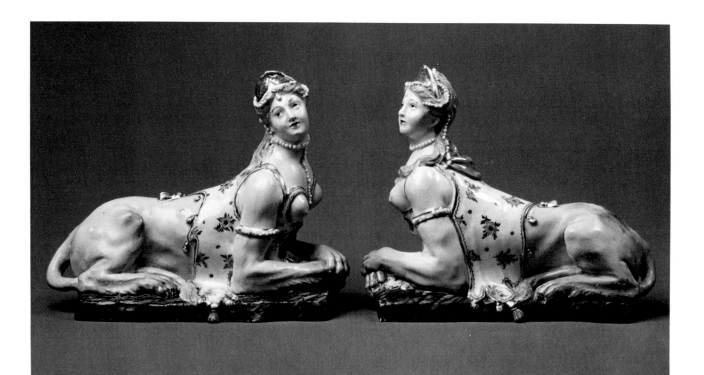

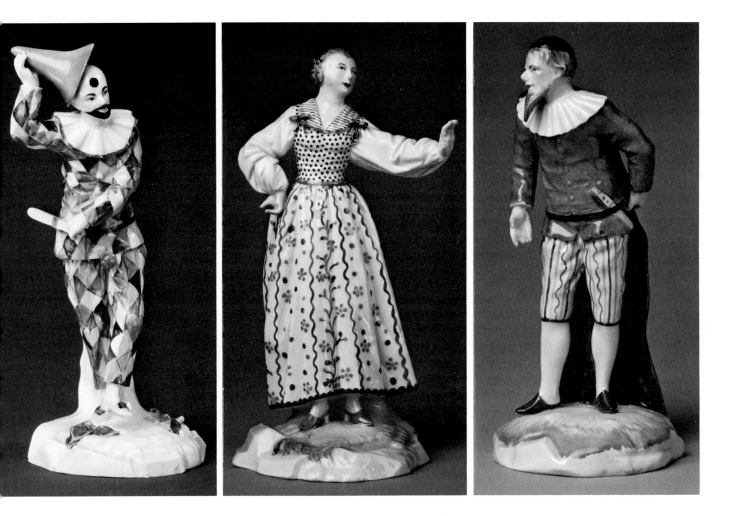

239–241. Harlequin, Columbine, and Pantaloon

Hard paste. Heights 5⁹⁄₁₆ in. (14.1 cm.), 5⅜ in. (13.6 cm.), 5¼ in. (13.3 cm.)

Mark on underside of base of each in underglaze blue: a cross

Models attributed to Wenzel Neu (1708–1774)

German, Fulda, ca. 1770

1982.60.187,186,185

THE MODELS are related in subject and treatment both to a series of Italian Comedy figures made at Kloster Veilsdorf in about 1764–65 and to two models of characters, copied from Jacques Callot's *Balli di Sfessania*, made at Fulda in about 1769–70. All the figures have been attributed to Wenzel Neu, most of whose career was spent at Fulda—first at the faience manufactory (founded 1740) and later as chief modeler when the porcelain manufactory was established in 1765. He is known, however, to have worked elsewhere, including Kloster Veilsdorf, from 1762 to 1767, after which he returned to Fulda. The Kloster Veilsdorf Italian Comedy figures are based on engravings by J. B. Probst after J. J. Schübler, published in Augsburg in 1729. While these Fulda models do not appear among the Probst-Schübler illustrations, the figures of Harlequin and Pantaloon appear to be adaptations of Neu's Kloster Veilsdorf models based on the Augsburg engravings.

EX COLL.: (Columbine) Felix Kramarsky, New York (sale, Parke-Bernet, New York, Jan. 10, 1959, lot 675).

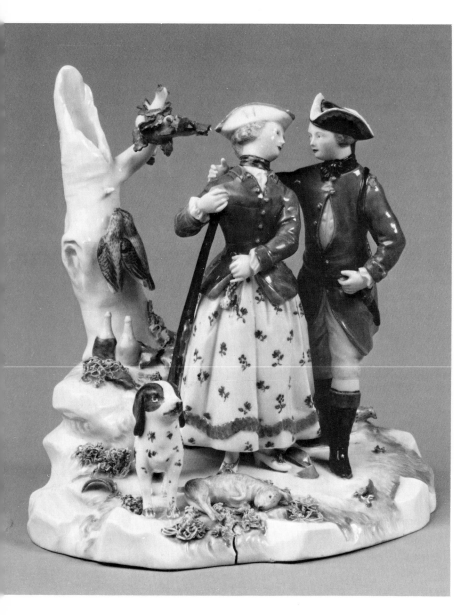

242. Hunting couple

Hard paste. Height 5⅞ in. (14.9 cm.)
Mark on underside of base in underglaze blue: a cross
German, Fulda, ca. 1775
1982.60.190

THE COMPOSITION is based on an undated engraving, *Autumn*, by the Augsburg illustrator Johann Esaias Nilson (1721–1788).

EX COLL.: Sir Bernard Eckstein, Sussex (sale, Sotheby's, London, May 30–31, 1949, lot 48, pl. x); [H. E. Backer, London].

BIBLIOGRAPHY: E. Kramer, "Kupferstiche von Johann Esaias Nilson für den Fuldaer Fürstbischof," *Keramos* no. 35 (1967), fig. 5; S. Ducret, *Keramik und Graphik des 18. Jahrhunderts*, Brunswick, 1973, fig. 121.

243. The sleeping shepherdess

Hard paste. Height 5⅛ in. (13 cm.)
Unmarked
Model attributed to Georg Ludwig Bartholome
 (working 1770–88)
German, Fulda, ca. 1775
1982.60.189

THE COMPOSITION is based on François Boucher's *La Bergère endormie* (1743) in the Louvre. It was engraved, together with three other related pastoral subjects, by Claude Duflos le jeune (1700–1786), the four being published collectively as *Les Amours pastorales*. Duflos's engraving was in turn copied in Germany by I. F. Schmidt, Martin Engelbrecht, and J. E. Ridinger. In a departure from the original composition, the position of the young man has been reversed.

The group is a companion model to one of a sleeping youth, both being cited in the factory records in 1775.[1] It may also be associated with a third group by the same modeler, after Boucher's *Le Panier mystérieux*, of which a marked example is in the Metropolitan Museum (50.211.255, R. Thornton Wilson Collection). Kramer attributes the first two models to Bartholome, who came to Fulda from Ansbach in 1770.[2]

NOTES:
1. E. Kramer, *Fuldaer Porzellan in hessischen Sammlungen*, Kassel, 1978, fig. 5.
2. Ibid.

EX COLL.: Marie Rosenfeld-Goldschmidt (sale, Frederik Muller, Amsterdam, May 9–12, 1916, lot 856).

EXHIBITED: Kgl. Kunstgewerbemuseums, Berlin, *Europäisches Porzellan des XVIII. Jahrhunderts*, Feb. 15–Apr. 30, 1904, cat. no. 813 (lent by M. Rosenfeld-Goldschmidt).

244, 245. Two children

Hard paste. Heights 5⁹⁄₁₆ in. (14.2 cm.), 5⁷⁄₁₆ in. (13.9 cm.)
Mark on underside of base of each in underglaze blue: crowned double *f*
German, Fulda, ca. 1781
1982.60.201,202

THE FIGURES are two of a group of Fulda models representing children fashionably dressed as adults. The girl recalls a Meissen model of a gardener child[1] and may, with the other figures, have been inspired by one of the several series of children and putti as adults produced at Meissen about 1750–60.

NOTE:
1. E. Kramer, *Fuldaer Porzellan in hessischen Sammlungen*, Kassel, 1979, fig. 11.

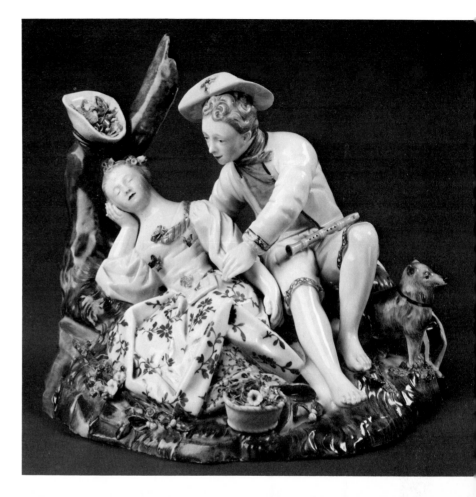

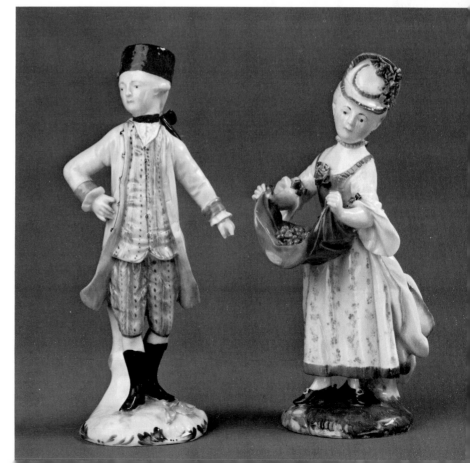

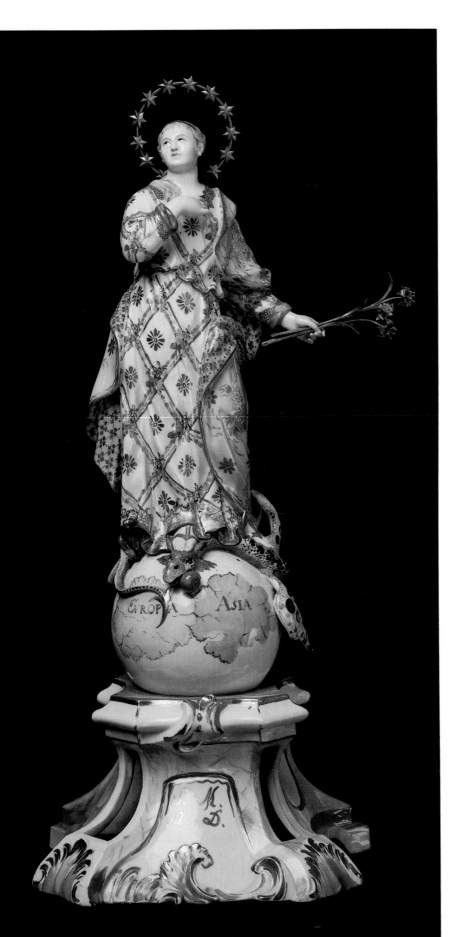

246. Virgin of the Immaculate Conception

Hard paste. Height 14⁵⁄₁₆ in. (36.3 cm.)
Mark inside pedestal in underglaze blue: a cross
Inscribed on the pedestal: s[ANCTA] m[ARIA]
 m[ATER] d[EI]
Model by Wenzel Neu
German, Fulda, ca. 1781
1982.60.182

THE MODEL is attributed to Neu by Ernst Kramer and considered by him to have originated about 1770;[1] it is mentioned in the factory records in 1786. Of the fourteen examples of the model that have been noted, three—this one and two others in the Cooper-Hewitt Museum, New York, and the Schloss Fasanerie, Fulda[2]—share a marked similarity in details of decoration and palette, and in all three the globe on which the Virgin stands depicts the Four Continents. The pedestal of the Schloss Fasanerie version bears the same letters, and the figure, like this one, is marked with a cross. The Cooper-Hewitt example is marked with a crowned double *f*, the mark that replaced the cross at Fulda in 1781, thus implying a date of about 1781 for all three.

The halo of twelve stars and the lily branch are not original, but may be considered as substitutions rather than additions. The backs of this figure and of another from the Untermyer Collection in the Metropolitan Museum (64.101.331ab) are pierced vertically in three places with circular holes into which glaze and decoration have spilled; they were apparently intended to accommodate the more usual mandorla of the Immaculate Conception, of which one appears on a version of the figure in the Museum für Kunst und Gewerbe, Hamburg.

NOTES:
1. E. Kramer, *Fuldaer Porzellan in hessischen Sammlungen*, Kassel, 1978, fig. 1.
2. Ibid.

Switzerland

247. Four carnival musicians

Soft paste. Height 7⅞ in. (20 cm.)
Mark inside base: three impressed circles arranged
 triangularly
Model by Joseph Nees
Swiss, Zurich, about 1770
1982.60.277

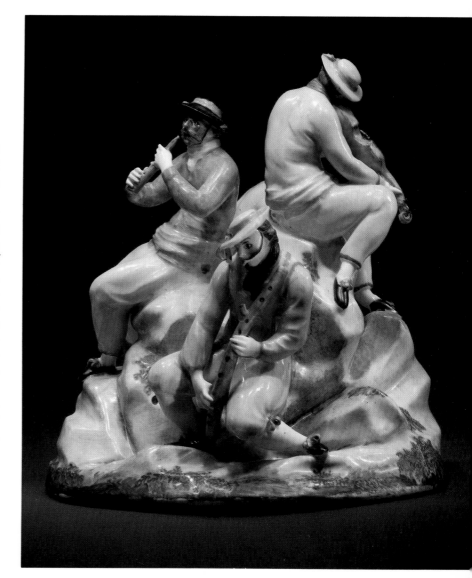

THREE EXAMPLES of this model have been recorded. In
addition to this one, a second is also in the Metropolitan
Museum (1982.450.16); the third is in the Museo Stibbert,
Florence.

In its subject matter, pastel coloring, and mild pensive-
ness of mood the group closely resembles Capodimonte
work and has always been attributed to that factory; more
recently an attribution to the later Neapolitan factory of
Ferdinand IV has been proposed.[1] The figure modeling,
however, is incompatible with the style of either factory.
Both the modeling and the presence of a hitherto unno-
ticed mark on this example permit a reattribution of the
group to Zurich. A single masked figure in the Metropol-
itan Museum's collection (50.211.285) is identical with re-
spect to the shape and character of the masked face, the
coloring, the dancelike ease of pose, and the narrow feet.
Further, it is marked on the base with three impressed
circles in a row. The official mark of the Zurich factory
was the letter Z, but it is frequently found accompanied
by one, two, or three circles either painted or impressed.

The original mold for our single figure has survived in
Zurich and has been recorded by the historian of that
factory, Siegfried Ducret. Although not specifically at-
tributed by Ducret, the model can be considered the work
of Joseph Nees, a modeler who came to Zurich in 1768
from Ludwigsburg, where he had been employed for the
previous ten years. His consistency of style is apparent
from his group of three dancers modeled at Ludwigsburg
(no. 235), which demonstrates the same treatment of the
figures. Although more than one modeler is known to
have worked at both Ludwigsburg and Zurich, only Nees
was active in the early years of the Zurich factory, a period
characterized by the use of the exceptionally creamy soft-
paste material of which this group is made.

NOTE:
 1. A.C.Perrotti, *La Porcellana della real fabbrica ferdinandea*,
Naples, 1978, pl. XVII.

EX COLL.: Renato Bacchi, Milan.

BIBLIOGRAPHY: G. Morazzoni and S. Levy, *Le porcellane ital-
 iane*, Milan, 1960, II, pls. 322, 323 (Bacchi collection).

Snuffboxes

248. Snuffbox

Hard paste with gold rims (not original). Diameter
2¼ in. (5.5 cm.)
Marks on gold rim of cover: ram's head (Paris
restricted warranty mark for gold, 1819–38);
mastiff's head (Paris census mark for small gold and
silver, 1838 to date)
Decoration in the style of Adam Friedrich von
Löwenfinck (1714–1754; working at Meissen 1727–
36)
German, Meissen, 1730–35
1982.60.359

249. Snuffbox

Hard paste with gold rims (not original). Diameter
2³⁄₁₆ in. (5.4 cm.)
Unmarked
Decoration in the style of Adam Friedrich von
Löwenfinck
German, Meissen, 1730–35
1982.60.360

EX COLL.: R. W. M. Walker, London (sale, Christie's, Lon-
don, July 25, 1945, lot 26).

BIBLIOGRAPHY: W. B. Honey, *Dresden China*, London, 1934,
pl. xxxb.

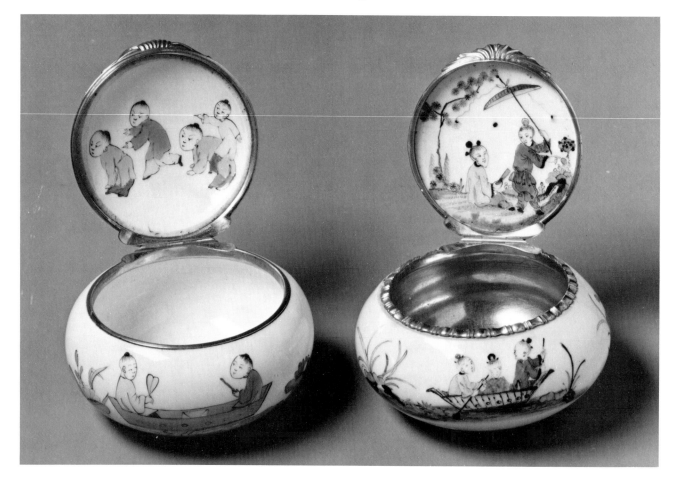

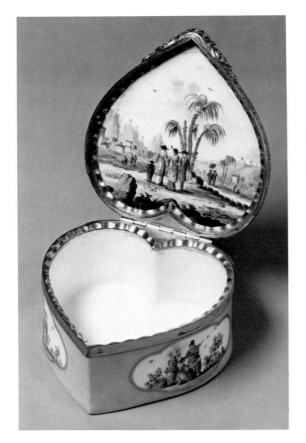

250. Snuffbox

Hard paste with gilt-metal mounts (not original).
 Width 3³⁄₁₆ in. (8.1 cm.)
Unmarked
German, Meissen, 1725–30 (?)
1982.60.334

251. Snuffbox

Hard paste with contemporaneous silver rims. Height
 2½ in. (6.2 cm.)
Unmarked
German, Meissen, ca. 1740
1982.60.339

252. Double snuffbox

Hard paste, gold, mother-of-pearl. Height 2⅝ in. (6.6
 cm.)
Unmarked
Decoration attributed to Johann Martin Heinrici
 (1711–1786; working 1741–57, 1763–86)
German, Meissen, 1745–50
1982.60.341

HEINRICI WAS primarily a portrait painter and color
chemist, but his name was associated with this imitation
piqué technique (the materials being affixed to, rather than
embedded in, the surface) by July 1745, when he was
granted a fixed salary at Meissen "because of his skill in
making works with gold and silver applied, as well as
with mother-of-pearl on porcelain."[1]

NOTE:
 1. O. Walcha, *Meissen Porcelain*, New York, 1981, p. 448 n. 74.

253. Snuffbox

Hard paste with contemporaneous gold mounts.
 Length 2⅞ in. (7.3 cm.)
Mark impressed inside base: a shield
Portrait attributed to Domenikus Auliczek
German, Nymphenburg, ca. 1765
1982.60.333

THE PORTRAIT in biscuit porcelain, which recurs on three other boxes of identical decoration, is unidentified. It does not represent, as has been stated, the elector Maximilian III Joseph, the patron of the Nymphenburg factory, whose portrait by Auliczek appears on snuffboxes of different design.[1] In Hofmann's opinion it is perhaps the portrait of an official of the factory.[2]

The interior of the cover is painted with a scene of somewhat involved iconography that may be interpreted as a woman, having conquered worldly temptations, being directed by religion to divine truth.

NOTES:
 1. F. H. Hofmann, *Geschichte der bayerischen porzellanmanufaktur Nymphenburg*, Leipzig, 1921–23, III, fig. 367.
 2. Ibid., p. 595.

254. Snuffbox

Hard paste with gold mounts. Height 2⅜ in. (6 cm.)
Marks on gold rim of cover: duck's head (Paris
 countermark, 1750–56); sprig of laurel (Paris
 countermark, 1756–62)
German, Meissen (porcelain); French, Paris (mounts),
 ca. 1750
1982.60.340

255. Snuffbox

Hard paste with gilt-metal mounts. Length 3½ in.
 (3.9 cm.)
Unmarked
German, Fürstenberg, ca. 1770
1982.60.344

THE COVER is set with a biscuit portrait medallion of Archduchess Maria Anna of Austria (1738–1789). Its source is possibly an unrecorded medal by Anton Franz Widemann (1724–1792), who executed numerous portraits of Empress Maria Theresa and her family. The text and disposition of the legend (M ANNA. AUSTRIACA.) are re-peated on the only known portrait of Maria Anna by Widemann, a medal of 1766 in which she looks rather younger than here, while the same pearl-threaded coiffure also appears in Widemann's 1769 medal of Maria Anna's sister, Maria Amalia.[1]

Although unmarked, the box may be attributed on the strength of one other, similarly decorated as to palette and scheme of decoration.[2] It too is unmarked, but the interior of the lid is painted with a pastoral subject consistent in execution with a signed and dated (1767) plaque of the same subject by the Fürstenberg painter Georg Heinrich Holtzmann.[3] The flower painting inside the lid corresponds in style and composition to signed Fürstenberg plaques dated 1767 and 1768.

NOTES:
 1. K. Domanig, *Porträtmedaillen des Erzhauses Österreich*, Vienna, 1896, nos. 295, 299.
 2. S. Ducret, *Fürstenberger Porzellan*, Brunswick, 1965, I, pl. 8; II, fig. 301.
 3. Ibid., II, fig. 56.

256. Snuffbox

Hard paste with gold rims (not original). Height 2⅛
 in. (5.3 cm.)
Unmarked
Decoration in the style of Christian Friedrich Herold
 (1700–1779; working at Meissen 1725–78)
German, Meissen, 1730–35
1982.60.346

RIGHT, TOP: 198, 199, 200
MIDDLE: 253, 254
BOTTOM: 255, 256

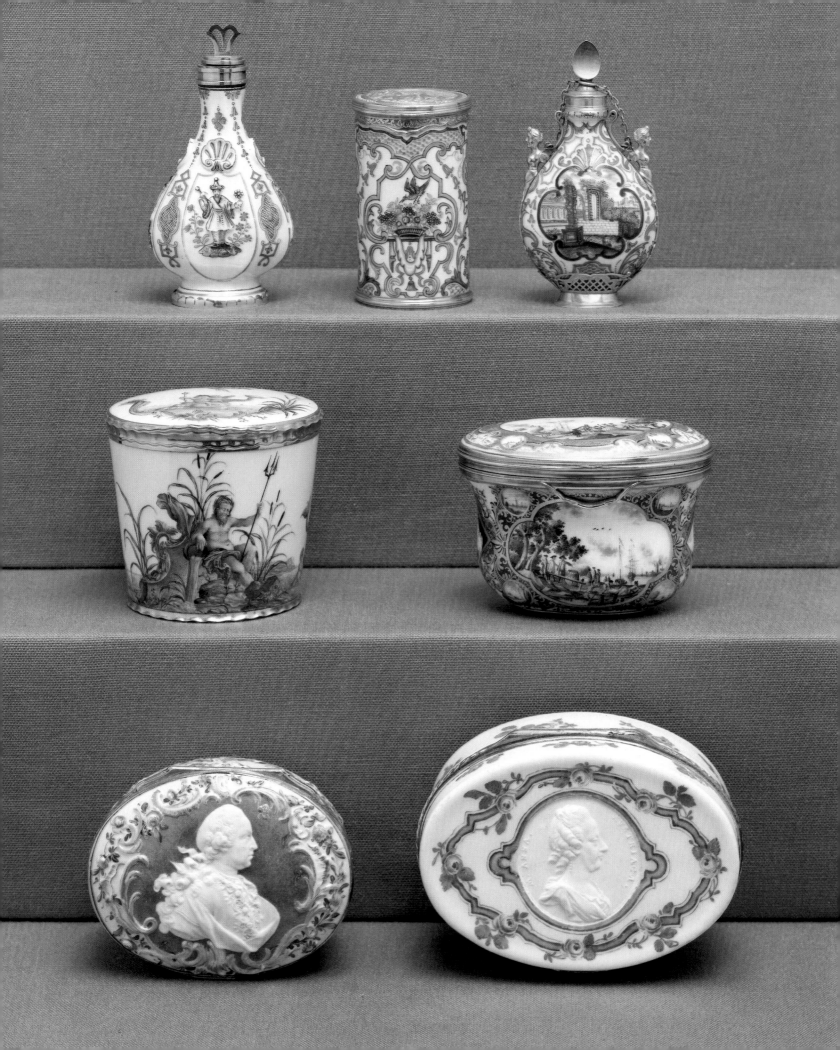

258. Snuffbox

Hard paste with gold rims, and rubies set in silver gilt.
 Height 1⅝ in. (4 cm.)
Unmarked; box rim engraved *No = 5*
German, Meissen, ca. 1755
1982.60.345

EX COLL.: Hermitage, Leningrad (sale, Rudolph Lepke, Berlin, Nov. 6, 1928, lot 248).

BELOW: 258

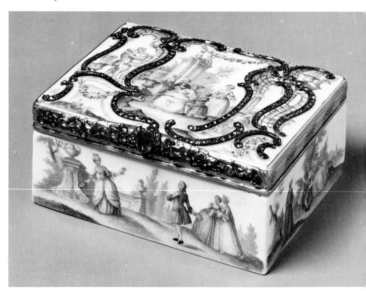

ABOVE: 257

257. Snuffbox

Hard paste with contemporaneous gold rims. Height
 1½ in.(3.7 cm.)
Unmarked
German, Meissen, ca. 1755
1982.60.335

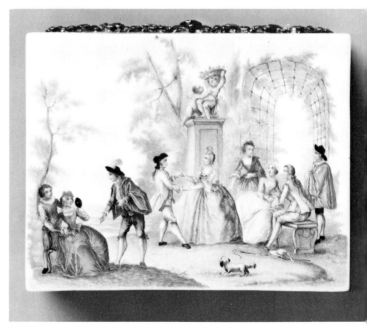

259. Box (possibly a thimble case)

Hard paste with gold mounts. Width 1⁵⁄₁₆ in. (3.3 cm.)
Mark twice on gold rim of body: weevil in an oval
(French mark for gold and silver imported from
countries with customs conventions, 1864–93)
German, Meissen, ca. 1760
1982.60.351

260. Snuffbox

Hard paste with gold mounts. Length 3³⁄₁₆ in. (8.1
cm.)
Unmarked
German, Meissen , ca. 1760
1982.60.356

THE INTERIOR of the cover is painted with the half-
length figure of a woman.

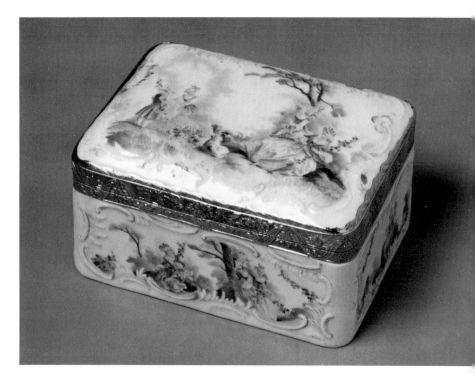

261. Snuffbox

Hard paste with silver mounts. Length 3⁵⁄₁₆ in.
(8.4 cm.)
Mark on base in underglaze blue: pseudo-crossed
swords; marks on thumbpiece: illegible 19th-century
French silversmith's mark; boar's head (Paris
restricted warranty mark, 1838 to date)
French, Paris, Samson and Company, 19th century
1982.60.337

THE INTERIOR of the cover is painted with a theatrical
scene.

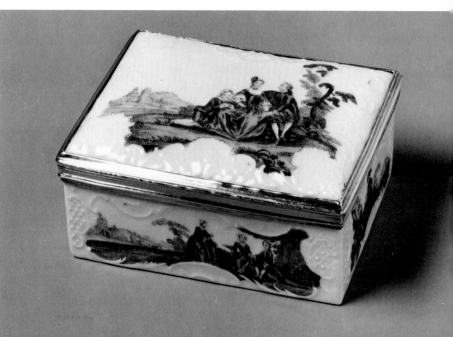

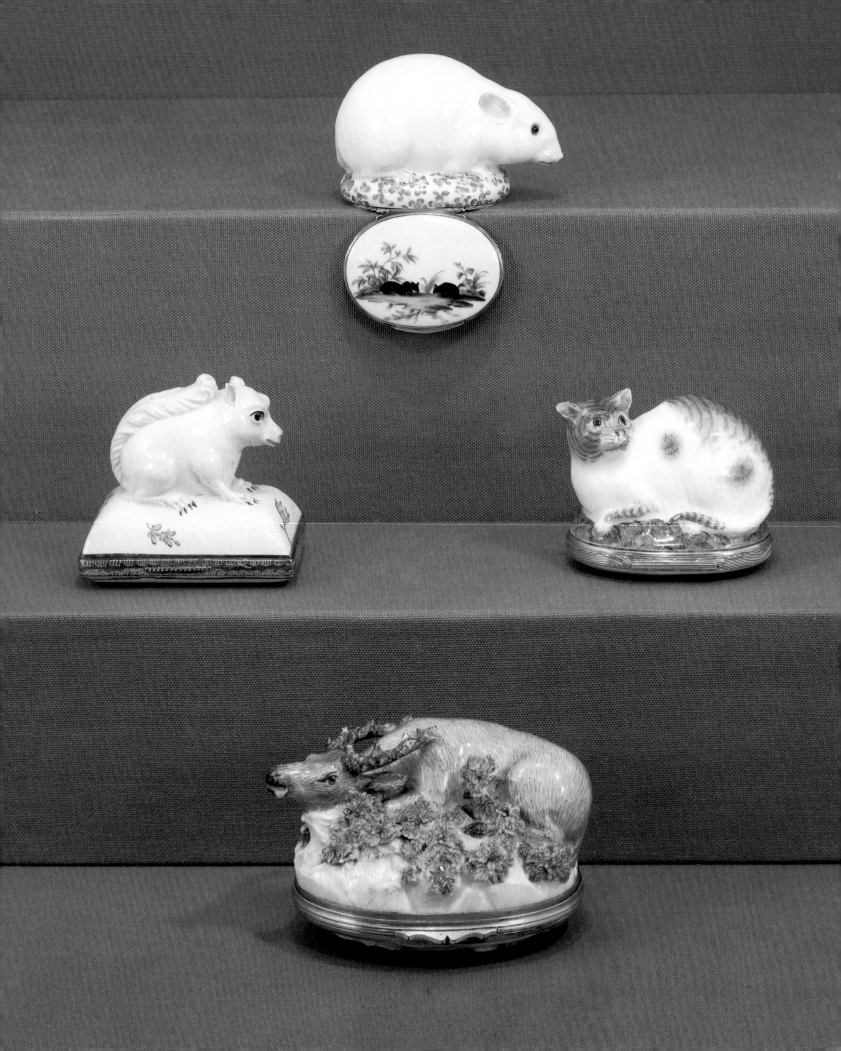

262. Snuffbox in the form of a rat

Hard paste with contemporaneous gold mounts.
 Length 2¹⁵⁄₁₆ in. (7.5 cm.)
Unmarked
German, Meissen, ca. 1745
1982.60.357

THE COVER is painted on the outside with three mice in a field and on the inside with a cat carrying mousetraps.

EX COLL.: Baron Henri de Rothschild; [James A. Lewis, New York].

263. Snuffbox in the form of a squirrel

Hard paste with gilt-metal mounts. Length 2¾ in.
 (7 cm.)
Unmarked
German, unidentified—probably Thuringian—factory,
 ca. 1770
1982.60.348

THE INTERIOR of the lid is painted in puce monochrome with buildings in a landscape.

264. Snuffbox in the form of a cat

Hard paste with gold mounts (not original). Length
 2⅝ in. (6.7 cm.)
Unmarked
German, Meissen, ca. 1745
1982.60.342

A CAT seated in an architectural interior is painted inside the cover.

265. Snuffbox in the form of a stag

Hard paste with gold mounts (not original). Length
 3⅞ in. (9.8 cm.)
Unmarked
German, Ludwigsburg, ca. 1760
1982.60.364

THE INTERIOR of the lid is painted with a scene of huntsmen in a landscape.

EXHIBITED: Metropolitan Museum of Art, New York, *Masterpieces of European Porcelain*, Mar. 18–May 15, 1949, cat. no. 335 (lent by Mr. and Mrs. Jack Linsky).

266. Double snuffbox

Hard paste with gilt-metal mounts. Height 3½ in.
 (9 cm.)
Unmarked
German, Nymphenburg, 1755–60
1982.60.349

ONE COVER is a replacement.

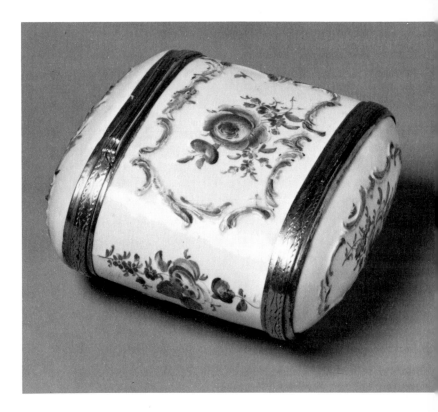

LEFT, TOP: 262
MIDDLE: 263, 264
BOTTOM: 265

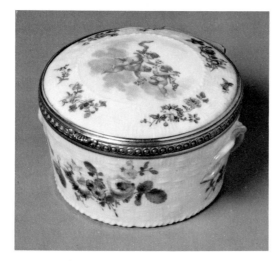

267. Snuffbox

Hard paste with gilt-metal mounts. Diameter 2⅜ in.
 (6 cm.)
Unmarked
Possibly Danish, Copenhagen, ca. 1775
1982.60.350

268. Snuffbox

Hard paste with gold mounts. Diameter 2⁵⁄₁₆ in.
 (5.9 cm.)
Mark on underside of base in underglaze blue: a
 shield
Austrian, Vienna, 1765–70
1982.60.347

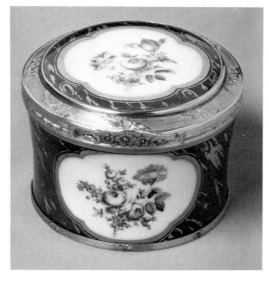

269. Snuffbox

Hard paste with silver-gilt mounts (not original).
 Diameter 3¾ in. (9.5 cm.)
Mark impressed inside base: a two-headed eagle
Russian, Saint Petersburg, Imperial Porcelain
 Manufactory, ca. 1760
1982.60.179

BOTH SIDES of the cover, the walls, and the base are
painted with views of châteaus and of an extensive river-
scape.

270. Snuffbox

Soft paste with silver mounts. Width 3¾ in. (9.5 cm.)
Marks on silver rim of box: crowned I (Paris warden's
 mark, 1749–50); salmon's head (Paris discharge
 mark for gold and small silver work, 1744–50)
French, Saint-Cloud, ca. 1749–50
1982.60.355

EX COLL.: Karrick Riggs, New York (sale, Parke-Bernet, New
York, Feb. 7–8, 1947, lot 254).

271. Snuffbox in the form of a slipper

Soft paste with gold rims (not original). Length 3⁹⁄₁₆
 in. (8.8 cm.)
Indecipherable mark on gold rim of slipper
French, Mennecy, ca. 1750
1982.60.363

272. Snuffbox

Soft paste with silver mounts. Height 2⅛ in. (5.4 cm.)
Mark on silver rim of box: crowned fleur-de-lis, two
 grains de remède, AD, device a miter (mark of
 Antoine Daroux, working 1735–89); ox head (Paris
 charge mark for gold and small silver work, 1750–
 56); crowned L (Paris warden's mark for silver, 1751–
 52); hen's head (Paris discharge mark for gold and
 small silver work, 1750–56)
French, Mennecy, ca. 1751–52
1982.60.353

EX COLL.: J. Pierpont Morgan, New York (sale, Parke-Bernet,
New York, Jan. 8, 1944, lot 465).

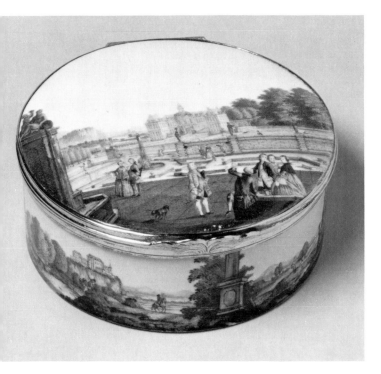

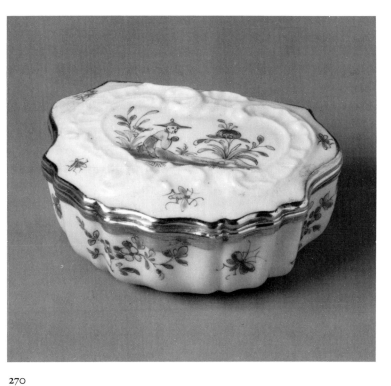

269 270

271 272

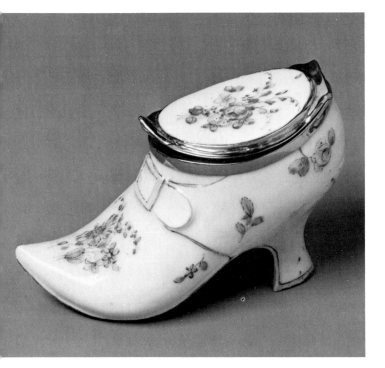

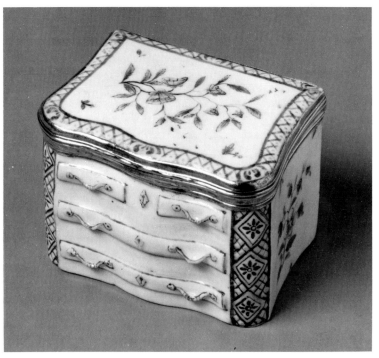

307

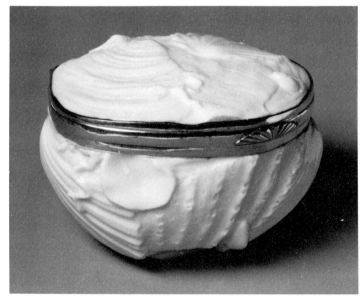

274

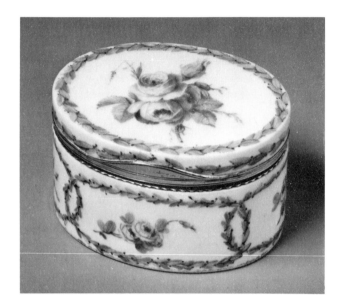

273. Snuffbox

Soft paste with silver rims (not original). Width 2¹³/₁₆
in. (7 cm.)
Unmarked
French, Sèvres, 1765–70
1982.60.361

274

308

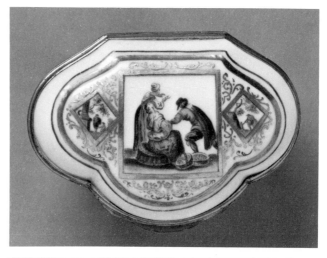

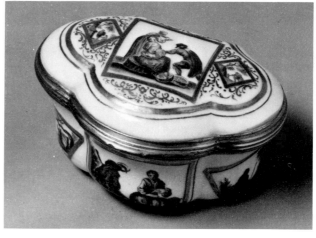

274. Snuffbox

Soft paste with gold mounts. Width 3³/₁₆ in. (8.1 cm.)
Unmarked
Model by Giuseppe Gricci (ca. 1700–1770)
Italian, Naples, Capodimonte, 1745–50
1982.60.338

THE INTERIOR of the cover is painted with a domestic scene. The model is first referred to in the factory records in December 1743 and was among snuffboxes of various models being sold in 1745.[1]

NOTE:
1. F. Stazzi, *Capodimonte*, Milan, 1972, p. 177.

EX COLL.: R. W. M. Walker, London (sale, Christie's, London, July 25, 1945, lot 25).

BIBLIOGRAPHY: A. Lane, *Italian Porcelain*, London, 1954, pl. 75B.

275. Snuffbox painted with peasant and pastoral scenes

Hard paste with gilt-metal mounts. Width 2⅞ in. (7.3 cm.)
Unmarked
Italian, Doccia, 1750–55
1982.60.365

276. Snuffbox

Hard paste with gilt-metal mounts. Width 3⁵/₁₆ in. (8.4 cm.)
Unmarked
Italian, Doccia, ca. 1760
1982.60.332

ON THE OUTSIDE of the cover, in relief, is a scene of the Judgment of Paris. The base and the interior of the lid are painted with landscapes.

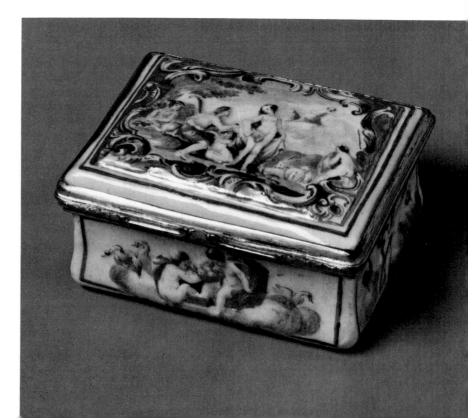

Chelsea Toys

SNUFFBOXES, smelling bottles, and etuis were among the "toys" first advertised for sale in London by Nicholas Sprimont in 1754. Although Sprimont was the proprietor of the Chelsea factory, the stock was not of his own manufacture, but was acquired by him from the "Girl-in-a-Swing" factory, a small, just-closed enterprise founded by a group of potters who had withdrawn from Chelsea. Sprimont took up the production of these "toys," which will have had as their inspiration models in both Meissen and French porcelain. It has been noted that the covers of these "toys" were always of some material other than porcelain.[1]

1. F. S. Mackenna, *Chelsea Porcelain: The Gold Anchor Wares*, Leigh-on-Sea, 1952, p. 25.

277. Snuffbox or patch box

Soft paste with agate cover and gold mounts. Height 2 in. (5 cm.)
Unmarked
English, "Girl-in-a-Swing" factory, 1751–54
1982.60.352

THE BOX is modeled as Venus reclining with Cupid in her lap, each figure holding a dove. On an enameled band on the gold rim is the inscription VOTRE S'AMITIE FAIT MON BONHEUR.

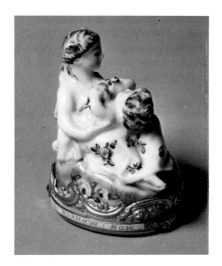

278. Snuffbox

Soft paste with hardstone cover and gilt-metal mounts. Height 2⅞ in. (7.3 cm.)
Unmarked.
English, Chelsea, 1755–60
1982.60.358

A GIRL reclines on a grassy mound with two goats and winds a garland around the horns of one. The same composition—which may perhaps be read as a simplified version of Boucher's *Autumn* of 1744[1]—occurs in a model attributed to Mennecy.[2]

NOTES:
1. A. Ananoff, *François Boucher*, Lausanne, 1976, I, no. 277.
2. Mrs. Alan L. Corey collection (sale, Sotheby's, New York, Dec. 5–7, 1974, lot 84).

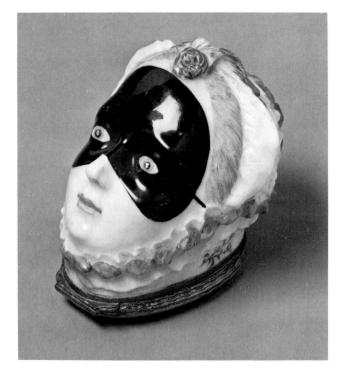

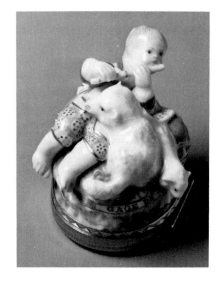

279. Snuffbox

Soft paste with enamel cover and gilt-metal mounts.
 Length 3 in. (7.6 cm.)
Unmarked
English, Chelsea, ca. 1760
1982.60.343

THE SAME model exists in a variant form without the mask.[1] This is the only recorded example of this version.

NOTE:
 1. Y. Hackenbroch, *Chelsea and other English Porcelain, Pottery, and Enamel in the Irwin Untermyer Collection*, Cambridge, Mass., 1957, pl. 69, fig. 214.

EX COLL.: R. W. M. Walker, London (sale, Christie's, London, July 18, 1945, lot 131).

BIBLIOGRAPHY: W. King, *Chelsea Porcelain*, London, 1922, pl. 46, no. 1.

280. Snuffbox or patch box

Soft paste with agate cover and gold mounts. Height
 1¹³⁄₁₆ in. (4.6 cm.)
Unmarked
English, Chelsea, ca. 1765
1982.60.354

THE BOX is modeled as a boy playing the flute, reclining on a grassy mound with a sheep and a lamb. A banderole on the mound is inscribed GAGE DE MON AMOUR.

Dwarfs

THE FOLLOWING nine figures are copied either from Jacques Callot's *Varie figure gobbi*, believed to have been published about 1622 in Nancy, or from a later collection of engravings entitled *Il Callotto resuscitato*, which included adaptations of a few of Callot's figures among otherwise original satirical characters. The authorship of *Il Callotto resuscitato* has been variously—and inconclusively—attributed; and the number and chronology of editions and their relationship to each other are unclear. What is evidently the earliest, with illustrations by J. A. Pfeffel the Elder (1674–1748), appeared in 1706, followed in and about 1716 by editions published in Augsburg and Amsterdam,[1] and in 1720 by another Amsterdam edition with additional illustrations. The names of the engravers Elias Baeck (1679–1747) and Martin Engelbrecht (1684–1756) have both been connected with the unsigned and undated Augsburg edition.[2] The Augsburg and Amsterdam editions differ with respect to ornamental borders and legends, and in one of the Amsterdam editions, dated 1716, some of the figures appear in reverse. Both editions seem to have been used as sources by porcelain modelers.

1. W. Neuwirth, *Wiener Porzellan: Original, Kopie, Verfälschung, Fälschung*, Vienna, 1979, pp. 438–40, in part summarizing unpublished information from Ernst Kramer.
2. S. Ducret, *Keramik und Graphik des 18. Jahrhunderts*, Brunswick, 1973, p. 33; R. Schmidt, *Early European Porcelain as Collected by Otto Blohm*, Munich, 1953, p. 196.

281. Dwarf

Soft paste. Height 6 in. (15.2 cm.)
Unmarked
French, Mennecy, 1740–45
1982.60.267

BASED ON an engraving in *Varie figure gobbi*,[1] but lacking the huge potbelly of Callot's figure.

NOTE:
1. J. Lieure, *Jacques Callot*, Paris, 1924–29, no. 415.

EX COLL.: J. H. Fitzhenry, Paris (sale, Hôtel Drouot, Paris, Dec. 13–16, 1909, lot 108); Karrick Riggs, New York (sale, Parke-Bernet, New York, Feb. 7–8, 1947, lot 34).

BIBLIOGRAPHY: E. Tilmans, *Porcelaines de France*, Paris, 1953, p. 73 (Linsky Collection).

282. Bagpiper

Soft paste. Height 5½ in. (14 cm.)
Mark inside base in black enamel: .D.V.
French, Mennecy, ca. 1740
1982.60.265

COPIED WITH slight variations from an engraving in *Varie figure gobbi*.[1]

NOTE:
1. J. Lieure, *Jacques Callot*, Paris, 1924–29, no. 424.

BIBLIOGRAPHY: E. Tilmans, *Porcelaines de France*, Paris, 1953, p. 96.

283, 284. Pair of hunchbacks

Soft paste. Height, each 4½ in. (11.4 cm.)
Marks: .D.V. in red inside base of 283; [.?]D.V. in blue inside base of 284
French, Mennecy, ca. 1740
1982.60.275,276

EACH FIGURE originally held a staff, now broken off, in his right hand. Both models are based on engravings in *Varie figure gobbi*.[1] While 283 is an almost literal copy, 284 is a freer version of one depicted by Callot as playing a kind of cooking grill as a violin. A figure in the same pose and with a staff in his right hand appears as plate 28 in *Il*

RIGHT, TOP: 281, 282. BOTTOM: 283, 284, 285

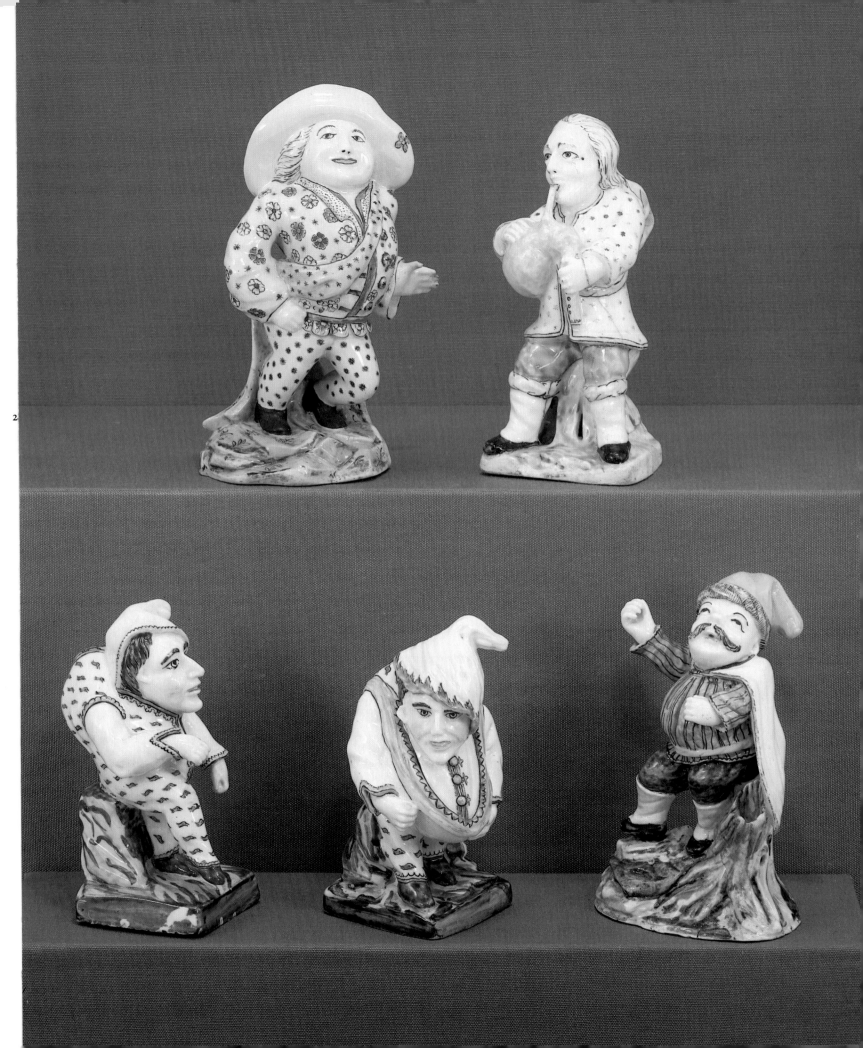

4. Sale, Sotheby's, London, May 21, 1968, lot 109.

EX COLL.: Wilhelm Gumprecht, Berlin (sale, Cassirer and Helbing, Berlin, Mar. 21, 1918, lot 384); Otto and Magdalena Blohm, Hamburg.

EXHIBITED: Metropolitan Museum of Art, New York, *Masterpieces of European Porcelain*, Mar. 18–May 15, 1949, cat. no. 124 (lent by Mr. and Mrs. Jack Linsky).

BIBLIOGRAPHY: R. Schmidt, *Early European Porcelain as Collected by Otto Blohm*, Munich, 1953, cat. no. 133; E. Tilmans, *Porcelaines de France*, Paris, 1953, p. 98.

289. Alchemist and his assistant

Hard paste. Length 7 in. (17.8 cm.)
Unmarked
Probably Italian, ca. 1770
1982.60.278

THIS IS a problematical group previously attributed to the Buen Retiro, Capodimonte, Cozzi, and Vienna factories. The figure of the alchemist originates in reverse as plate 36 of the Augsburg edition of *Il Callotto resuscitato*; this composition of the two figures together is said to occur in the engraved work of Anna Folkema (1695–1768), herself a contributor to an Amsterdam edition of *Il Callotto resuscitato*.[1] Four examples of the model, all unmarked, are recorded. The second (Metropolitan Museum, 64.101.345) and the third[2] are polychrome; the fourth is an all-white version in soft paste, attributed to Capodimonte.[3] Lane also reports the existence of a version in painted white earthenware.[4] Dissatisfaction with a Viennese origin for the group, suggested by Y. Hackenbroch,[5]

is based in part on consideration of the brownish-white paste with its matte surface; the palette of sharp purple, yellow, and lime green; and the somewhat heavy-handed style of painting, none of which is consistent with Viennese porcelain of the early State Period (1744–49), when such caricature figures were being produced.

A further indication that points away from Vienna is found in a companion group of two black-robed lawyers arguing, a composition also attributed to Anna Folkema and of which one figure derives from plate 13 of *Il Callotto resuscitato*. Only one, unmarked, example of the model is known (Metropolitan Museum, 64.101.344), but the figures occur singly in the Museo Teatrale alla Scala, Milan. In the catalogue of that collection they are identified as caricatures of two Italians, the Marchese Bernardo Tanucci (1698–1783), advisor to Ferdinand IV, and the Neapolitan Abbe Ferdinando Galiani (1728–1787).[6] In view of the engraved source of one of the two, this identification is suspect, but it may be noted that in the Milan version "Galiani" holds a scroll inscribed in idiomatic Italian, and that on the scroll in the Metropolitan Museum's example a few Italian words are legible. The caricature of "Tanucci" is not unlike another one also said to represent the marchese and considered by Stazzi to be Capodimonte.[7] The models of the single figures, which are unmarked, have been tentatively attributed to Andrea Corsini, who came from Doccia in 1773 to the Royal Factory in Naples, where he is described as executing grotesque figures. Callot-inspired dwarfs are among the repertoire of figures that were being made about 1770 at both Doccia and Cozzi, and the figures in this group invoke the Cozzi mannerism of heavy, outsize heads and contorted features, albeit on a larger scale. On balance, an attribution of this and the companion group to an Italian factory seems plausible.

NOTES:
1. *Highlights of the Untermyer Collection* (exhib. cat.), New York, Metropolitan Museum of Art, 1977, cat. no. 232.
2. Lane, *Italian Porcelain*, London, 1954, pl. 24B.
3. Sotheby's, London, May 21, 1968, lot 109.
4. Lane, p. 19.
5. *Highlights of the Untermyer Collection*, cat. no. 232.
6. Museo Teatrale alla Scala, *Museo Teatrale alla Scala*, Milan, 1975, II, nos. 601, 602.
7. F. Stazzi, *Capodimonte*, Milan, 1972, fig. 14.

EX COLL.: Otto and Magdalena Blohm, Hamburg.

BIBLIOGRAPHY: R. Schmidt, *Early European Porcelain as Collected by Otto Blohm*, Munich, 1953, no. 140.

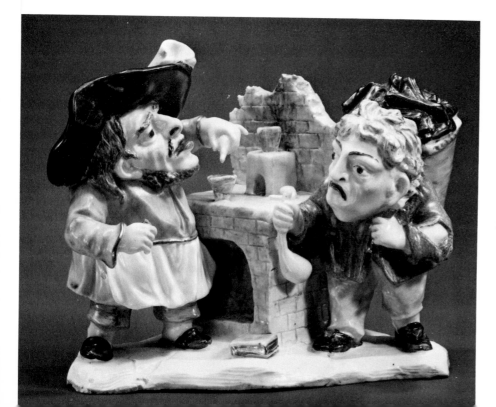

The French Factories

THE PRINCIPAL French factories were located in either Paris or its environs. Of these, Saint-Cloud, although not the first in priority of manufacture, was the first to succeed and may be counted as the first modern European porcelain manufactory. Its patent dates from 1702, but experiments in the manufacture of soft-paste porcelain had been instigated in the 1670s by its proprietor, Pierre Chicaneau (d. 1678). According to the patent, manufacturing techniques had been perfected before 1693, and the factory was in full operation by 1698, when it was described by an English visitor, Dr. Martin Lister. A branch of the factory was in existence by 1710 in Paris, on the rue de la Ville l'Evêque, but the distinction between the porcelains produced at the two sites is not clear. The Paris premises are believed to have closed, along with the parent factory, in 1766.

In 1725 Louis-Henry Auguste, seventh prince de Condé, founded a factory at Chantilly under the direction of Ciquaire Cirou, to whom he granted letters patent in 1735. After Cirou's death in 1751, the factory continued under a succession of proprietors, finally closing in 1800.

What we refer to as the Mennecy factory began not in the town of that name, but in Paris on the rue de Charonne. It was founded in 1734 by François Barbin. In 1748 Barbin was granted permission to relocate his factory at Mennecy, under the protection of Louis-François de Neuville, duc de Villeroy, and in 1773 it was again transferred (under new direction), to Bourg-la-Reine, where it remained until it closed in 1806. From the evidence of parish registers, it appears that Barbin enjoyed the duke's patronage from the beginning: in 1737 he was described as "fabricant de fayence et de porcelaine de cette paroisse" and as "m[aîtr]e de la manufacture de Villeroy."[1] He would thus seem to have run two simultaneous operations, at Mennecy—within the park of the château de Villeroy itself—and in Paris. Although the duc de Villeroy's name does not appear in connection with the rue de Charonne, his patronage is assumed on the evidence of Barbin's association with him between 1734 and 1748 at Mennecy, of Barbin's removal there in 1748, and of the porcelains marked D.V. [duc de Villeroy], which must be dated before 1748 on stylistic grounds.

A tradition of porcelain manufacture in France, however short, prior to the founding of Meissen in 1710, and the different capabilities of the soft-paste material, may be considered as factors contributing to a pronounced independence from German influence of the French factories, notably with respect to sculpture, in which Meissen played such a dominating role. Very few French figures owe their inspiration to Meissen, and in the instance of the large group of models of Orientals there is no debt at all.

Some of these models were copied from Chinese exemplars known to have been exported to the West (no. 148), and the presence of others in French collections must be presumed from the close correspondence between the oriental and French versions (nos. 292, 293). The authenticity of details such as costume may also be attributed to familiarity with oriental models, either directly or indirectly. In this context, the collection of the prince de Condé was clearly influential. Something of the nature of its composition can be gleaned from *Les Desseins chinois* by Jean-Antoine Fraisse, published in 1735.

This was a volume of sixty-two engravings of decorative patterns and genre subjects extrapolated from objects in the collection, which, according to Fraisse, included not only Chinese and Japanese porcelains but Indian textiles, Persian paintings, and lacquer "of all those countries where this art has been brought to its greatest perfection." The emphasis of the prince de Condé's collection was on Japanese porcelain, which he intended Chantilly to imitate. Little of this appears among Fraisse's illustrations, however, which instead provide numerous flower patterns and compositions of Chinese figures apparently copied from panels of lacquer screens (the originals are not specified). To these are added several plates of textile designs of the type of Indian chintz exported to Europe from the Coromandel coast in the first half of the eighteenth century.[2] The impact of Fraisse's volume on factories other than Chantilly is implicit in the authenticity of the patterned robes decorating the oriental figures produced at both Saint-Cloud and Mennecy about this time (nos. 294, 301).

Combined with the realism of several of the models is an air of playacting (nos. 298, 299, 304), whose origin lies elsewhere. The spirit of these figures is that of the romanticized chinoiserie of the French Rococo, initiated by Watteau in his designs for the Château de la Muette (about 1707) and reinforced by Boucher in his set of paintings depicting Chinese life exhibited in 1742. While elements of costume and composition were borrowed from travel books and, probably, illustrated accounts of Chinese life by French Jesuits resident in Peking,[3] scarcely any attempt is made to orientalize the features, and in theatricality of gesture and pose the figures are essentially Europeans acting or dancing on a stage.

1. A. Darblay, "Villeroy: Son Passé, sa fabrique," *Société Historique et Archéologique de Corbeil d'Etampes et de Hurepoix, Mémoires et Documents* no. 3 (1901), p. 73.
2. J. Irwin and K. B. Brett, *Origins of Chintz, with a Catalogue of Indo-European Cotton-paintings in the Victoria and Albert Museum, London, and the Royal Ontario Museum, Toronto*, London, 1970, pls. 10–12.
3. A. Ananoff, *François Boucher*, Lausanne, 1976, I, p. 338.

290. Oriental with potpourri jar

Tin-glazed soft paste. Height 6⅝ in. (16.8 cm.)
Unmarked
French, Chantilly, ca. 1735
1982.60.270ab

THE FIGURE is a variant of the Chinese blanc de chine model of the bodhisattva Pu-tai (see no. 148).

Several examples of this model are recorded; of them only one, formerly in the Dunlap collection, retains its original pierced cover, which is fluted to conform to the shape of the jar.[1] The cover of this example is too large, and the insetting rim has been partially ground away to make it fit.

NOTE:
1. Sale, Sotheby's, New York, Dec. 2, 1975, lot 242.

BIBLIOGRAPHY: E. Tilmans, *Porcelaines de France*, Paris, 1953, p. 74 (Linsky collection).

291. Oriental with potpourri jar (cover missing)

Tin-glazed soft paste. Length 9⁵⁄₁₆ in. (23.6 cm.)
Unmarked
French, Chantilly, 1735–40
1982.60.271

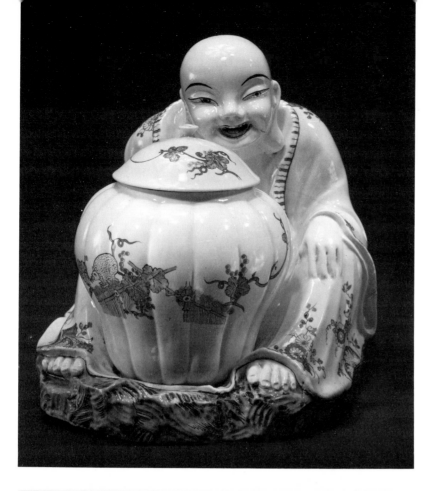

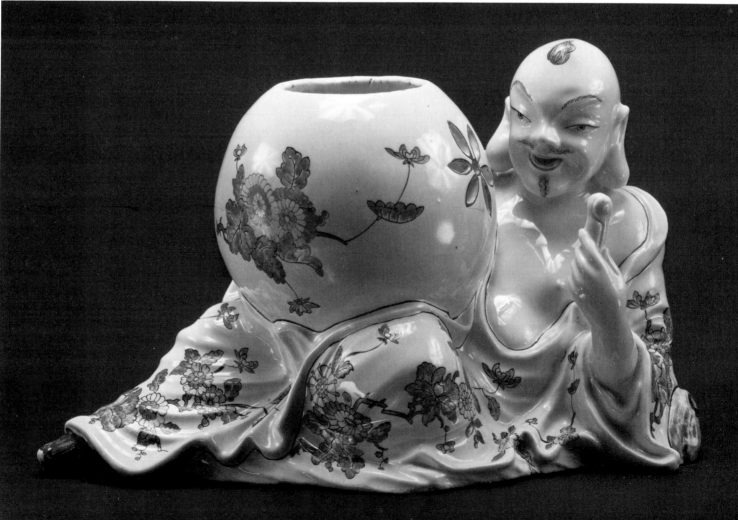

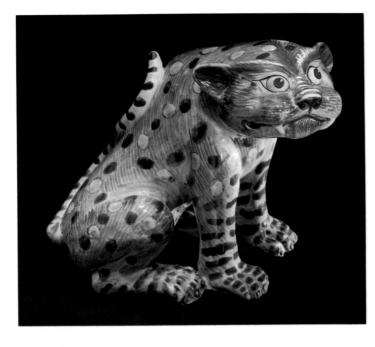

292. Leopard

Soft paste. Height 5¼ in. (14.6 cm.)
Unmarked
French, Chantilly, 1735–40
1982.60.369

THE MODEL is adapted from a late seventeenth-century Japanese figure of a tiger seated on a tall pedestal painted in the Kakiemon palette. Two pairs of the Japanese model are known, one, in the Chinese palace at Drottningholm, perhaps acquired in the eighteenth century by Queen Hedvig Eleonora (d. 1715) or Queen Ulrica Eleonora (d. 1741); the other is privately owned.[1] This figure is the only recorded European version of the model. Although unmarked, it is attributable to Chantilly on the circumstantial evidence of the soft-paste body and the particular impetus given to the Chantilly factory by the collection of Chinese and Japanese porcelains owned by its patron, the prince de Condé.

NOTE:
1. Sale, Christie's, London, Feb. 18, 1975, lot. 78.

EXHIBITED: Metropolitan Museum of Art, New York, *Masterpieces of European Porcelain*, Mar. 18–May 15, 1949, cat. no. 114 (lent by Mr. and Mrs. Jack Linsky); Parke-Bernet Galleries, New York, *Art Treasures Exhibition*, June 16–30, 1955, cat. no. 273 (lent by Mr. and Mrs. Jack Linsky).

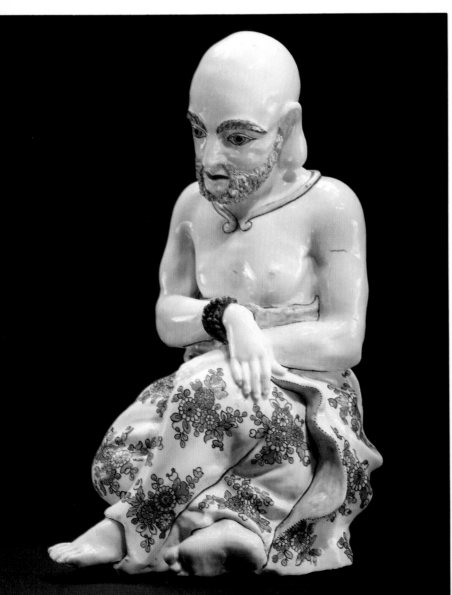

293. Seated Chinese

Tin-glazed soft paste. Height 10⅝ in. (27 cm.)
Unmarked
French, Chantilly, ca. 1735
1982.60.261

THE POSE of the figure is traceable to a Chinese model from the K'ang Hsi period (1662–1722) representing a Buddhist ascetic, or lohan, in meditation.[1] Here, however, a new character has been imposed on the figure by the introduction of cords that bind his hands, transforming him into a captive.

NOTE:
1. J. P. van Goidsenhoven, *La Céramique sous les Ts'ing, 1644–1851*, Brussels, 1936, pl. VII.

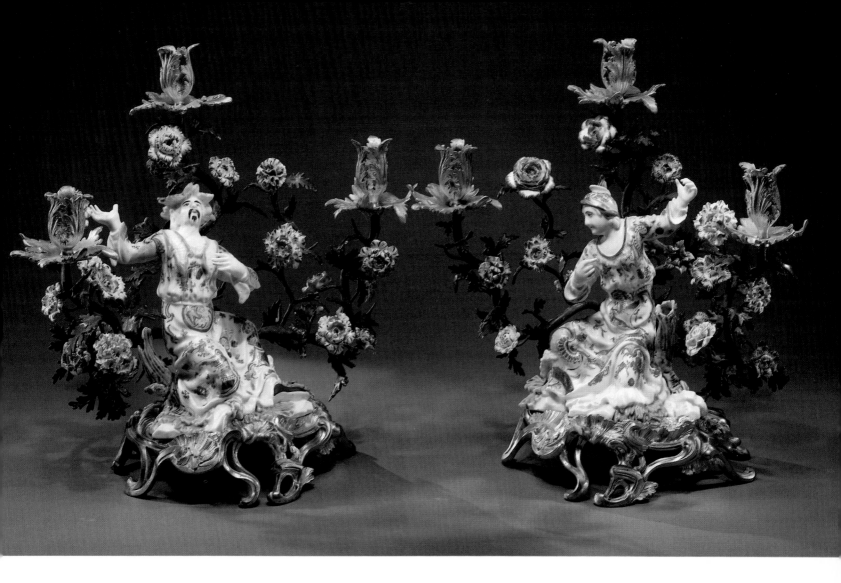

294, 295. Pair of Orientals mounted as candelabra

Soft paste with gilt-bronze mounts. Height, each 14½
 in. (36.8 cm.)
No visible marks
French, Saint-Cloud, ca. 1735; mounts French, ca.
 1740
1982.60.253,254

EX COLL.: Mlle Jane Demarsy, Paris (sale, Galerie Charpentier,
 Paris, Dec. 17, 1937, lot 48).

296. Standing Chinese

Soft paste. Height 7 in. (17.8 cm.)
Unmarked
French, Saint-Cloud, 1730–35
1982.60.259

297. Seated Chinese

Soft paste. Height 8½ in. (21.6 cm.)
Unmarked
French, Saint-Cloud, 1730–35
1982.60.257

EXHIBITED: Metropolitan Museum of Art, New York, *Master-pieces of European Porcelain*, Mar. 18–May 15, 1949, cat. no. 145 (lent by Mr. and Mrs. Jack Linsky).

298, 299. Dancers as Orientals

Soft paste. Heights 6¾ in. (17.2 cm.), 6⅝ in. (16.9 cm.)
Mark inside base of man in red: .D.V.
French, Mennecy, ca. 1740
1982.60.288,289

296

297

322

300. Standing Chinese

Soft paste. Height 6¹⁄₁₆ in. (15.4 cm.)
Mark inside base in faded black: .D.V.
French, Mennecy, ca. 1740
1982.60.273

THE MODEL is closely related to no. 301 and is thus possibly intended to represent a Buddhist deity. It recurs, in a more purely chinoiserie version, in French gilt bronze in a model of about 1750, paired with one of a woman, scarcely oriental in either feature or costume, for which there seems to be no porcelain prototype.[1]

NOTE:

1. René Fribourg, New York (sale, Sotheby's, London, Oct. 17–18, 1963, lot 739, as candelabra); Musée Nissim de Camondo, Paris, as single figures holding candle sockets.

EX COLL.: Comte X. de Chavagnac, Paris (sale, Hôtel Drouot, Paris, June 19–21, 1911, lot 167); Karrick Riggs, New York (sale, Parke-Bernet, New York, Feb. 7–8, 1947, lot 32).

EXHIBITED: Paris, *Exposition universelle internationale de 1900*, p. 70 (Chavagnac collection); Metropolitan Museum of Art, New York, *Masterpieces of European Porcelain*, Mar. 18–May 15, 1949, cat. no. 127 (lent by Mr. and Mrs. Jack Linsky).

298, 299

300

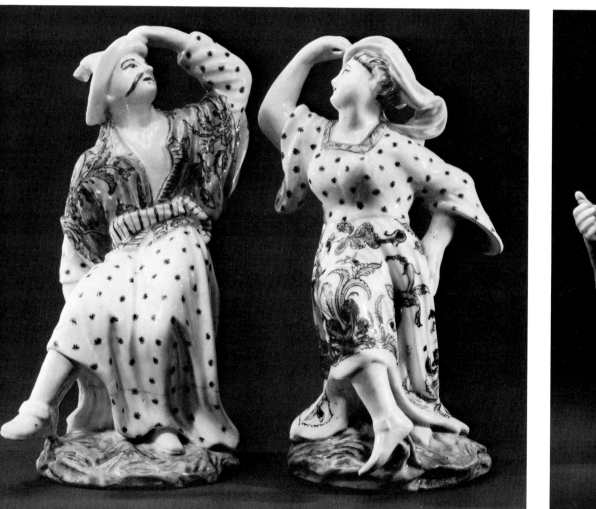

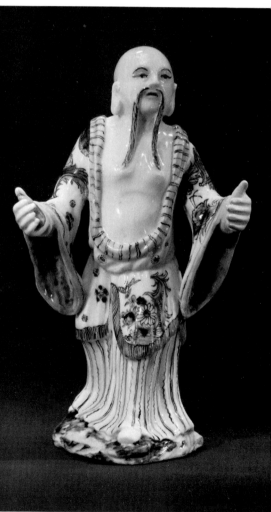

301. Buddhist ascetic, or lohan

> Soft paste with gilt-bronze mounts. Height 7 in. (17.8 cm.)
> Mark inside base in black (almost effaced): .D.V.
> French, Mennecy, porcelain and mounts ca. 1740
> 1982.60.260

UNDER HIS left arm the figure holds a sack from which emerges the head of a mythical creature. This is presumably an allusion to one of the sixteen lohans, who kept a dragon in a bottle and periodically let it out.

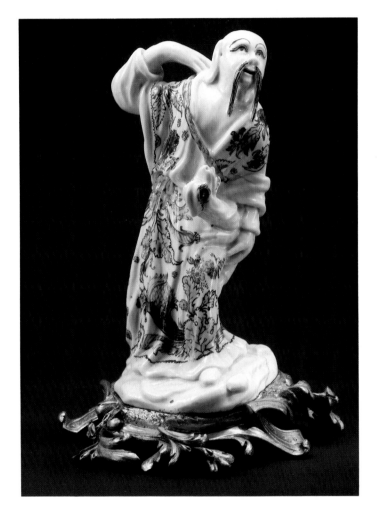

302. Seated Chinese

> Soft paste. Height 10³⁄₁₆ in. (25.9 cm.)
> Unmarked
> French, Mennecy, 1750–55
> 1982.60.272

EXHIBITED: Metropolitan Museum of Art, New York, *Masterpieces of European Porcelain*, Mar. 18–May 15, 1949, cat. no. 126 (lent by Mr. and Mrs. Jack Linsky); Parke-Bernet Galleries, New York, *Art Treasures Exhibition*, June 16–30, 1955, cat. no. 266 (lent by Mr. and Mrs. Jack Linsky).

303. Seated Chinese

> Soft paste with gilt-bronze mounts. Height 7⁵⁄₁₆ in. (18.6 cm.)
> Unmarked; mounts stamped twice with a crowned C
> French, Mennecy, 1750–55; mounts French, 1745–49
> 1982.60.264

THE FIGURE and its stand are so closely matched as to appear original to each other, indicating a date for the porcelain corresponding to that of the mount, which bears the French tax mark for gilt bronze in use from 1745 to 1749. There is an uneasy fit, however, between the two: the edges of both have been cut away, leaving the figure with an uncharacteristically ragged base rim, and gaps have been awkwardly filled. In addition, the plump, sketchy sprigs scattered over the robe are consistent with those on the Persians (nos. 305, 306) and the girl with a potpourri (no. 312), both datable about 1750–60. It is suggested that the figure is indeed of later date than the gilt bronze, but that the basic compatibility between the two is such that it must have been modeled to conform to the existing mount.

304. Kneeling Chinese

> Soft paste. Height 7⁵⁄₁₆ in. (18.6 cm.)
> Unmarked
> French, Mennecy, 1750–55
> 1982.60.258

EX COLL.: J. H. Fitzhenry, Paris (sale, Hôtel Drouot, Dec. 13–16, 1909, lot 76); Mme Helen Dupuy, Paris/New York (sale, Parke-Bernet, New York, Apr. 2–3, 1948, lot 363).

EXHIBITED: Metropolitan Museum of Art, New York, *Masterpieces of European Porcelain*, Mar. 18–May 15, 1949, cat. no. 125 (lent by Mr. and Mrs. Jack Linsky).

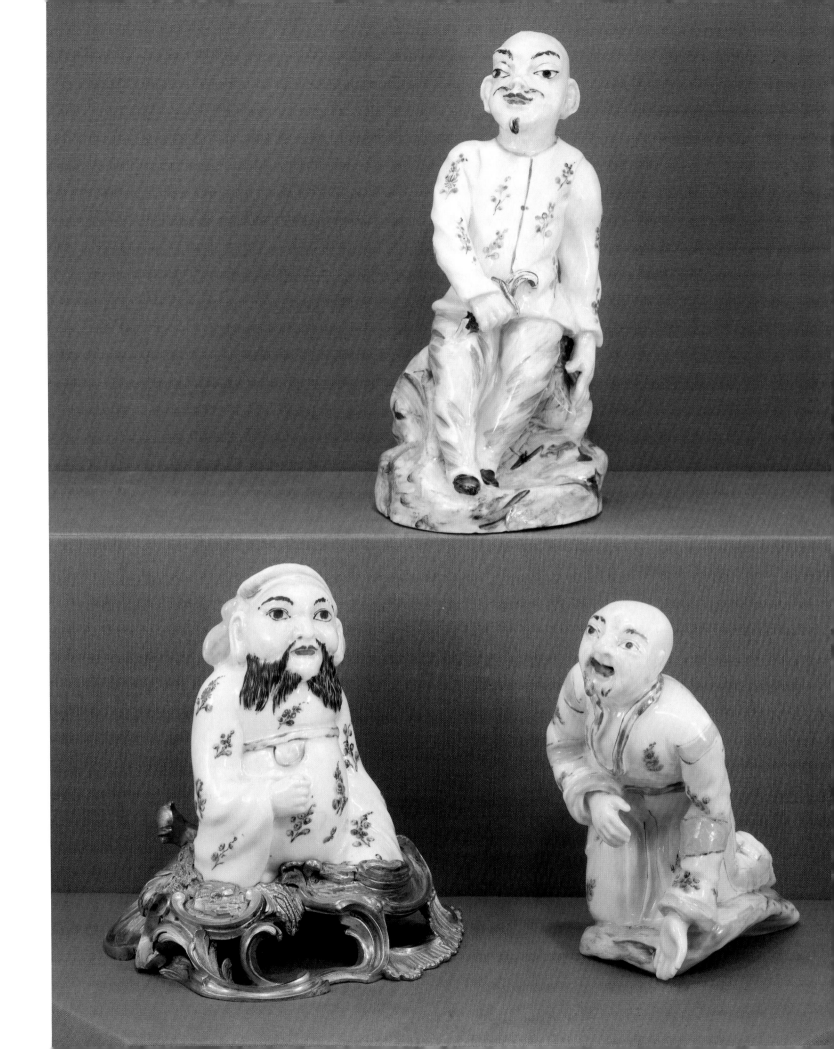

305, 306. Couple dressed as Persians

Soft paste. Heights 10½ in. (26.7 cm.), 9⅝ in. (24.4 cm.)
Mark incised on underside of base of each: D.V; mark incised on underside of base of girl: *Mathieu*
French, Mennecy, ca. 1760
1982.60.366,367

TWO VARIANT models of the figure of the girl, neither in oriental costume, have been recorded.[1]

The inscribed name of Mathieu Simon may be the same specimen noted by Chavagnac and Grollier on a "grande statuette" then in a Swiss collection, of which the last two letters, as here, were scarcely legible.[2] No other example of the signature has been noted. Simon was the son of Charles Simon of Mennecy, a winegrower who in 1753 was employed as a worker at the porcelain factory. Mathieu and his brother Charles were also subsequently hired by the factory, in 1756 and 1760, respectively, but only Charles is known to have qualified as a sculptor, in 1765; he later reverted to his position as "ouvrier."[3]

NOTES:
1. Félix Doistau collection (sale, Galérie Georges Petit, Paris, June 19, 1928, lot 31); Karrick Riggs collection (sale, Parke-Bernet, New York, Feb. 7–8, 1947, lot 322).
2. X. R. M. de Chavagnac and G. A. de Grollier, *Histoire des manufactures françaises de porcelaine*, Paris, 1906, p. 110.
3. Geneviève Le Duc, personal communication.

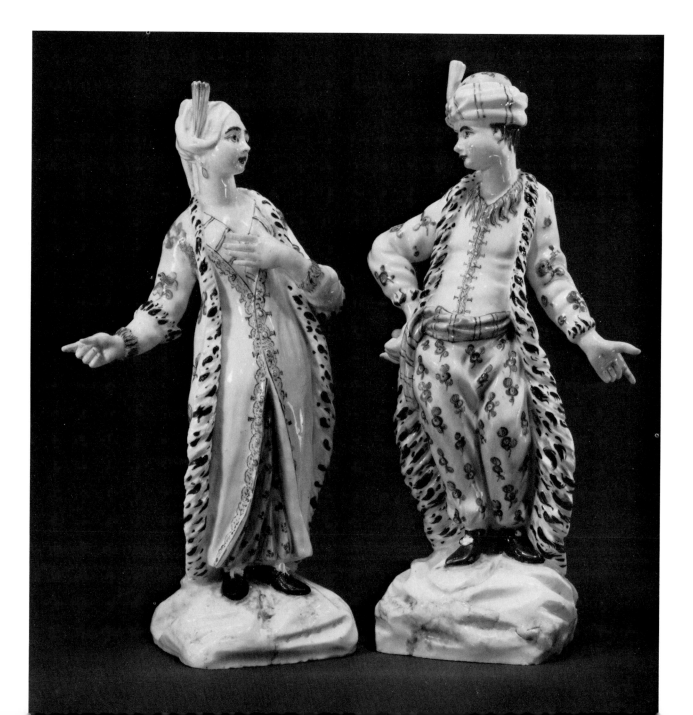

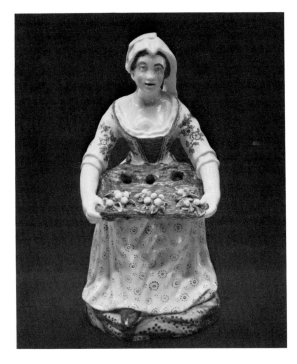

307. Flower seller

Tin-glazed soft paste. Height 8 in. (20.3 cm.)
Unmarked
Possibly French, Chantilly, ca. 1745(?)
1982.60.269

IF THE MODEL is to be read as a free version of one by
Kändler, about 1745,[1] it can be included among a small
number of Chantilly figures of this date based on Meissen
exemplars. In its modeling and with its flat unglazed
base it appears to be consistent with a pair of standing
gardeners, also after Kändler,[2] but the decoration of this
figure has little of the clarity of Chantilly painting, while
the treatment of the base, in streaks of brown laid over
green, is associated with such marked Mennecy figures as
nos. 283 and 284, while lacking the fluency of that facto-
ry's style.

NOTES:
1. R. Rückert, *Meissener Porzellan, 1710–1810* (exhib. cat.), Mu-
nich, Bayerisches Nationalmuseum, 1966, cat. no. 900.
2. Victoria and Albert Museum, London (C.392, 393–1909).

EX COLL.: Karrick Riggs, New York (sale, Parke-Bernet, New
York, Feb. 7–8, 1947, lot 280).

308. Satyr

Soft paste. Height 7⅟₁₆ in. (18 cm.)
Mark inside base in blue enamel: D.V.
French, Mennecy, ca. 1740
1982.60.290

THIS IS the only known example of this model, al-
though a variant (present whereabouts unknown) was
formerly in the Chavagnac collection. Apparently un-
marked, it was attributed in the catalogue of that collection[1]
to a small Parisian factory on the rue de la Ville l'Evêque,
an offshoot of the Saint-Cloud factory. If the attribution
was correct, the Chavagnac model might be associated
with the "figures Grotesques & Troncs d'Arbres" adver-
tised among Saint-Cloud productions in 1731, and this
example might by extension imply a link between the
Saint-Cloud and Mennecy factories, which share a num-
ber of unexplained similarities with respect to material
and style.

NOTE:
1. Sale, Hôtel Drouot, Paris, June 19–21, 1911, lot 83.

EX COLL.: [Gilbert Lévy]; Karrick Riggs, New York (sale, Parke-
Bernet, New York, Feb. 7–8, 1947, lot 84); René Fribourg,
New York (sale, Sotheby's, London, June 25, 1963,
lot 40).

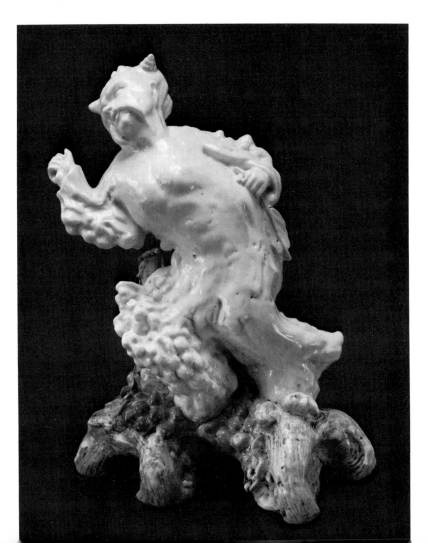

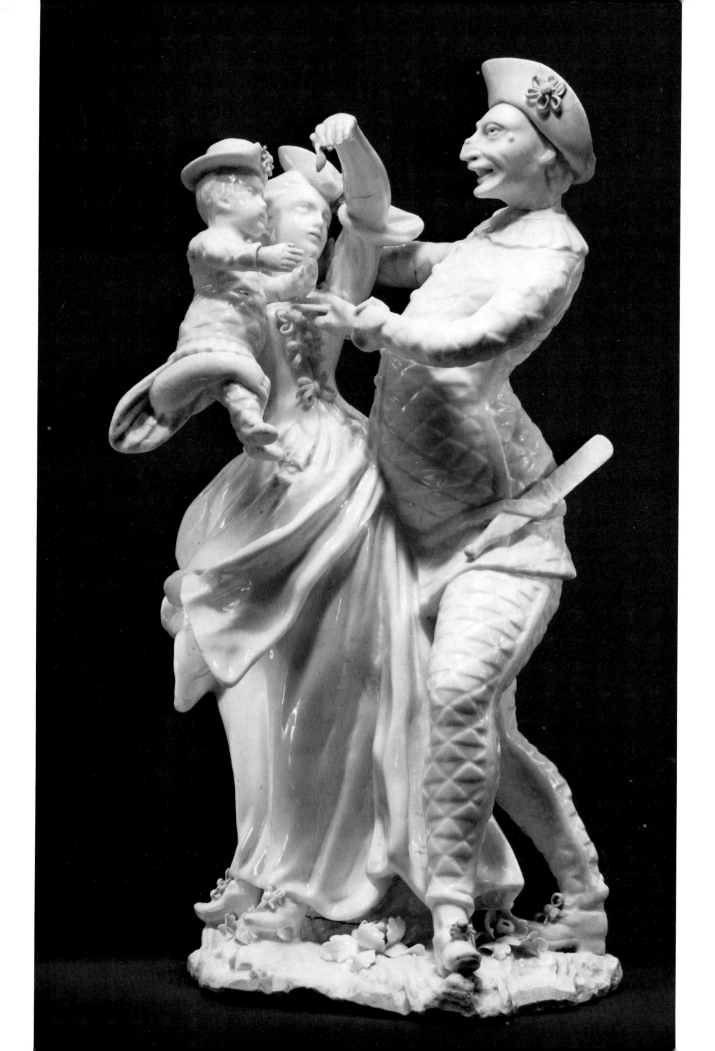

309. Harlequin family

Soft paste. Height 14⅜ in. (36.5 cm.)
Mark inside base in black enamel: .D.V.
French, Mennecy, 1740–45
1982.60.255

ORIGINATING AS a small playful Italian Comedy group at Meissen about 1740 (no. 179), this greatly enlarged version is a strange and dramatic departure both from Kändler's model and from the tenor of Mennecy work. The model is entirely uncharacteristic in its scale and indebtedness to a Meissen source. Less unexpected is the modification of the coquettishness of Kändler's composition to achieve a quieter, more brooding mood. The extensive firecracks and discolorations are witness to the experimental nature of the model.

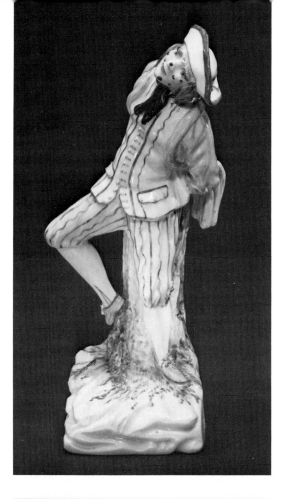

310. Lawyer from the Italian Comedy

Soft paste. Height 8⅜ in. (21.3 cm.)
Mark incised inside base: D.V.
French, Mennecy, 1755–60
1982.60.268

EX COLL.: J. H. Fitzhenry, Paris (sale, Hôtel Drouot, Paris, Dec. 14, 1909, lot 118).

311. Peasant woman carrying a child on her back

Soft paste. Height 7³⁄₁₆ in. (18.3 cm.)
Unmarked
French, Mennecy, 1750–60
1982.60.262

EX COLL.: Mme Helen Dupuy, Paris/New York (sale, Parke-Bernet, New York, Apr. 2–3, 1948, lot 302).

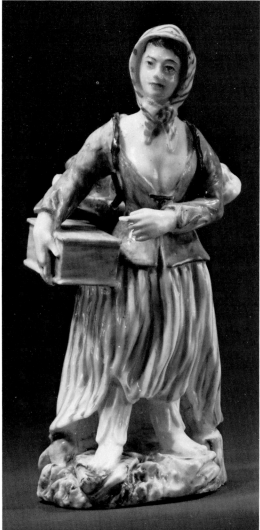

312. Potpourri vase with girl and dog

Soft paste. Height 9 in. (22.8 cm.)
Mark incised under glaze on underside of base of vase:
 DV, with a crescent under each letter
French, Mennecy, 1750–60
1982.60.263

THE PIERCED cover, although intended for a potpourri and contemporaneous with this group, is not original, being too small in diameter. It has been accommodated by the interposition of gilt-bronze foliage, to which eighteenth-century flowers have been attached.

This form of the factory mark has been recorded only on a cream pot with polychrome flower decoration.[1]

NOTE:
1. X. R. M. de Chavagnac and G. A. de Grollier, *Histoire des manufactures françaises de porcelaine*, Paris, 1906, p. 110.

BIBLIOGRAPHY: E. Tilmans, *Porcelaines de France*, Paris, 1953, p. 104 (Linsky collection).

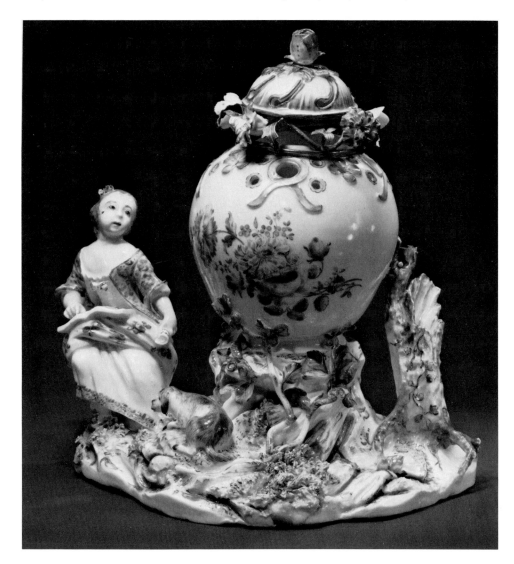

The Italian and Spanish Factories

FOUNDED IN 1743 under the patronage of Charles IV, king of Naples, Capodimonte was active until 1759, when Charles succeeded to the Spanish throne as Charles III and took forty-one workers and several thousand pounds of clay with him to Madrid, reestablishing the factory at the Buen Retiro palace, where it remained until its closing in 1808.

The chief modeler at Capodimonte and, later, Buen Retiro, was Giuseppe Gricci (about 1700–1770), whose only known signed work is a figure of the mourning Virgin in the Metropolitan Museum (1971.92.1). A large number of Capodimonte models have been attributed to Gricci, but verification is made difficult by the disappearance of many of the factory's records dating after 1750. The considerable variation in the modeling and painting of Capodimonte figures and the fact that six modelers are recorded as working under Gricci in 1755 indicate that some models were the work of still-unidentified artists.

Because of the continuity provided by the transfer of the factory from Naples to Madrid, the origin of some models is uncertain; the attribution of no. 320 to Buen Retiro is based on the markedly larger scale of modeling as well as on the painting, which makes use of a palette not encountered at Capodimonte.

The removal of Capodimonte left Naples without a factory until 1771, when Ferdinand IV started a new one, the Royal Factory, which remained in operation until 1806.

313. The washerwoman

Soft paste. Height 7³⁄₁₆ in. (18.3 cm.)
Mark on underside of base in blue enamel: a fleur-de-lis
Italian, Naples, Capodimonte, 1750–55
1982.60.279

THE SUBJECT is based on a painting by J. B. S. Chardin, of which one version, then in the collection of the chevalier Antoine de la Roque, was engraved in 1739 by Charles-Nicolas Cochin.

EX COLL.: Admiral A. Walker-Heneage-Vivian and Vivian Graham Loyd (sale, Sotheby's, London, Dec. 2, 1952, lot 51).

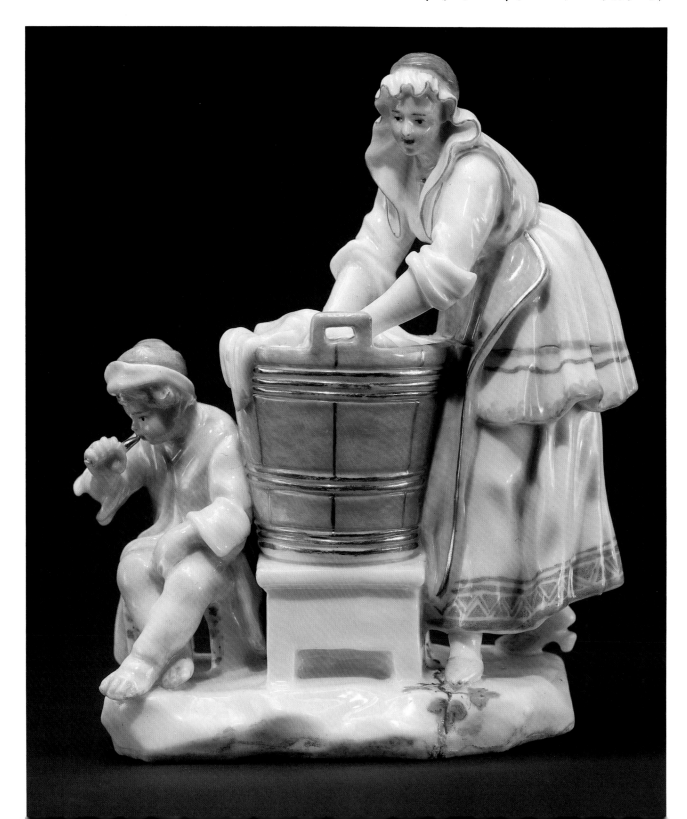

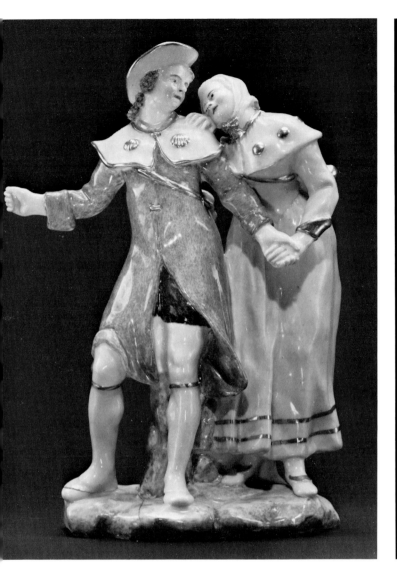

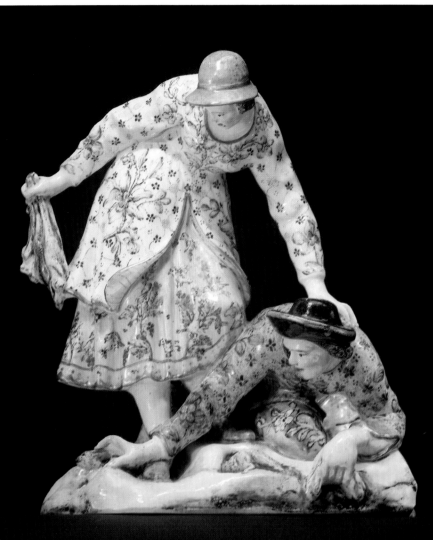

314. Pilgrim couple

Soft paste. Height 8⅜ in. (21.3 cm.)
Unmarked
Italian, Naples, Capodimonte, 1755–59
1982.60.291

315. Rabbit catchers

Soft paste. Height 6⁷⁄₁₆ in. (16.4 cm.)
Unmarked
Italian, Naples, Capodimonte, 1755–59
1982.60.286

EX COLL.: Otto and Magdalena Blohm, Hamburg (sale,
Sotheby's, London, Apr. 24–25, 1961, lot 458).

BIBLIOGRAPHY: R. Schmidt, *Early European Porcelain as Col-
lected by Otto Blohm*, Munich, 1953, no. 398.

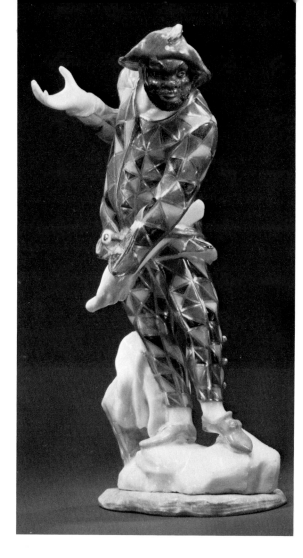

317. Guitarist

Soft paste. Height 7³/₁₆ in. (18.3 cm.)
Mark on underside of unglazed base in black: a fleur-
 de-lis
Italian, Naples, Capodimonte, 1755–59
1982.60.282

THE MODEL is unrecorded.

318. Boy with monkey

Soft paste. Height 3⁷/₁₆ in. (8.7 cm.)
Unmarked
Italian, Naples, Capodimonte, 1755–59
1982.60.284

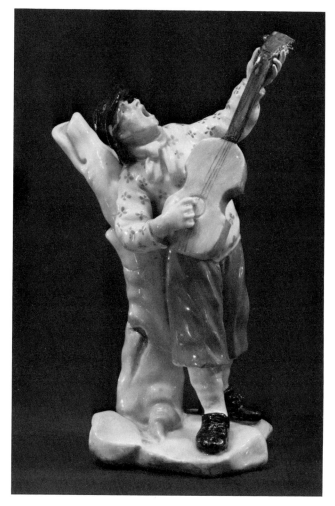

316. Harlequin

Soft paste. Height 8⁷/₈ in. (22.5 cm.)
Unmarked
Italian, Naples, Capodimonte, 1755–59
1982.60.283

THE MODEL is derived from a design by Watteau for
one panel of a six-panel screen known only through an
engraving by Louis Crépy (b. 1680).

EX COLL.: Otto and Magdalena Blohm, Hamburg.

EXHIBITED: Stoner and Evans, Inc., New York, *Eighteenth-
Century European Porcelains Assembled by the Late Mr. Otto
Blohm*, Jan. 1948; Metropolitan Museum of Art, New York,
Masterpieces of European Porcelain, Mar. 18–May 15, 1949, cat.
no. 379 (lent by Mr. and Mrs. Jack Linsky).

BIBLIOGRAPHY: R. Schmidt, *Early European Porcelain as Col-
lected by Otto Blohm*, Munich, 1953, no. 413, pl. III.

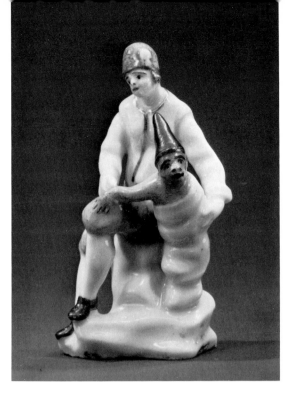

318

THE MODEL is unrecorded, but may be associated with a group of miniature figures of men and women with animals such as a girl leading a monkey by the hand, and another seated with a cat.[1]

NOTE:
1. A. Mottola Molfino, *L'arte della porcellana in Italia*, Milan, 1977, II, fig. 221.

319. Scaramouche with children

> Soft paste. Height 6½ in. (16.5 cm.)
> Mark on underside of unglazed base in black: a fleur-
> de-lis
> Italian, Naples, Capodimonte, 1755–59
> 1982.60.287

THE MODEL is unrecorded.

320. Couple with child

> Soft paste. Height 8⅝ in. (21.9 cm.)
> Mark on underside of base in underglaze blue: a fleur-
> de-lis
> Spanish, Buen Retiro, 1760–70
> 1982.60.285

EXHIBITED: Metropolitan Museum of Art, New York, *Masterpieces of European Porcelain*, Mar. 18–May 15, 1949, cat. no. 382 (lent by Mr. and Mrs. Jack Linsky).

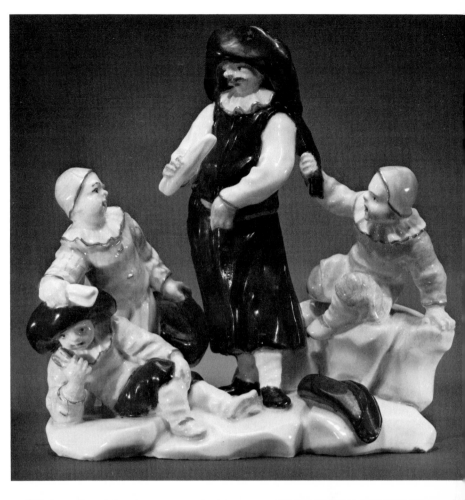

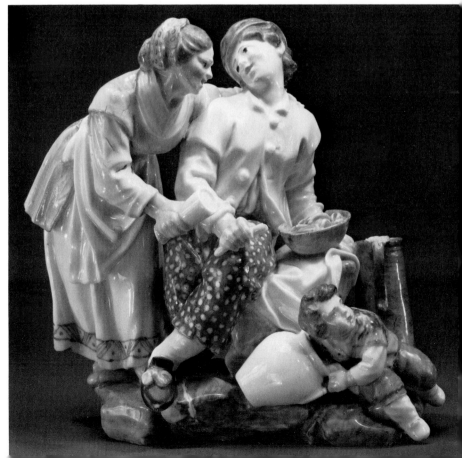

321. Woman

Hard paste. Height 9⁷⁄₁₆ in. (24 cm.)
Unmarked
Italian, Naples, Royal Factory, 1785–95
1982.60.281

322. Pastoral group

Hard paste. Height 6¹⁵⁄₁₆ in. (17.6 cm.)
Unmarked
Italian, Le Nove (Parolin period, 1781–1802), ca. 1781–
90
1982.60.280

FROM 1781 to 1802 Francesco Parolin was director of the Le Nove factory near Bassano, which he had leased from its owner, Pasquale Antonibon.

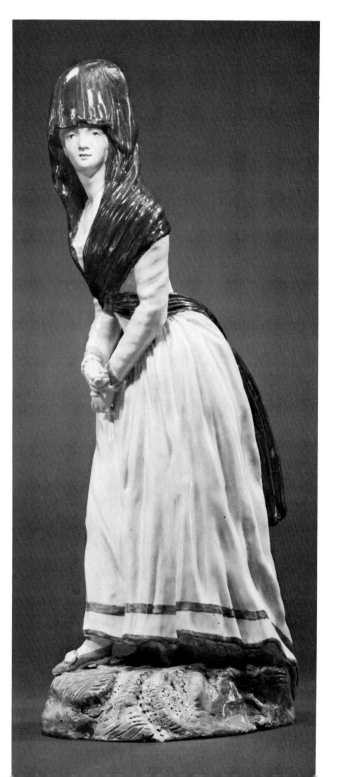

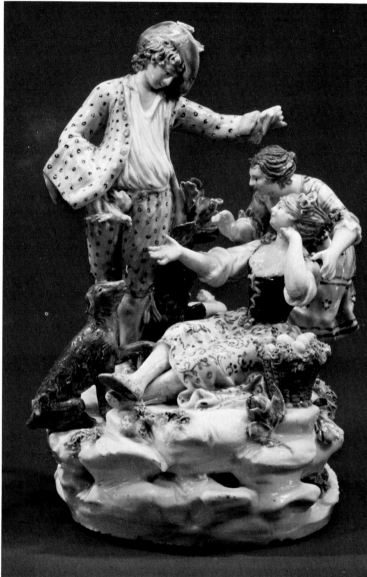

Copenhagen

DANISH PORCELAIN manufacture was centered in Copenhagen, where experiments with a soft-paste formula were begun about 1759 by Louis Fournier, who had until then been a modeler at Chantilly. After Fournier's return to France in 1765, a new factory, producing hard-paste porcelain, was set up by Frantz Heinrich Müller. With the financial backing of the royal family, the factory was formally established in 1775 as the Royal Copenhagen Manufactory and continues in operation today.

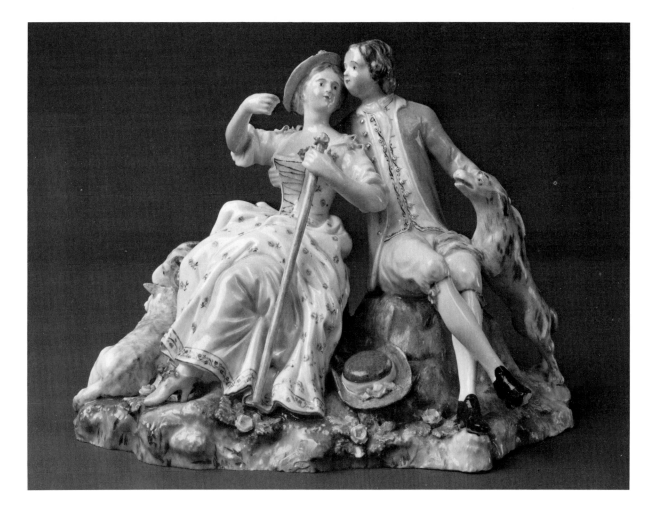

323. Shepherd couple

Hard paste. Height 6 in. (15.3 cm.)
Mark on back of base in underglaze blue: three waves
 arranged vertically
Danish, Copenhagen, Royal Porcelain Manufactory,
 1775–80
1982.60.216

324, 325. Pair of gardeners

Hard paste. Heights 8 in. (20.3 cm.), 7½ in. (19 cm.)
Mark on back of each base in underglaze blue: three
 waves arranged vertically; mark incised on
 underside of unglazed base of 324: AH; mark incised
 on underside of unglazed base of 325: S
Danish, Copenhagen, Royal Porcelain Manufactory,
 ca. 1786
1982.60.218,219

AS THE TWO figures are clearly the work of a single
modeler, the presence of the initials of both Andreas Hald
(working 1781–97) and J. J. Smidt (working 1778–1807)
implies that at least one of them was working in this
context as a repairer.

EX COLL.: Sale, Christie's, London, Mar. 22, 1965, lot 87.

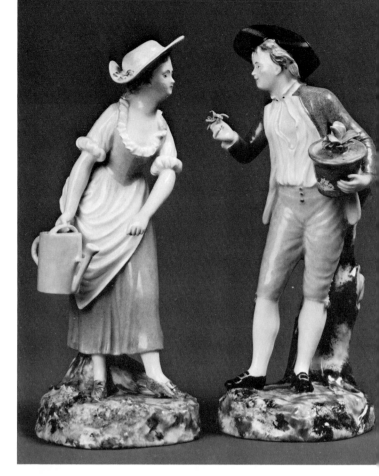

326. Lovers with cupids

Hard paste. Height 9¼ in. (23.5 cm.)
Mark incised on underside of unglazed base: AH
Model attributed to Andreas Hald (working 1781–97)
Danish, Copenhagen, Royal Porcelain Manufactory,
 ca. 1795
1982.60.217

WHILE HALD'S initials appear on dissimilar groups,
confusing his roles as modeler and repairer, something of
his personal style can be determined by the single piece
known to bear his signature, a group of lovers dated 1797.[1]
It shares with this group a slight stiffness of composition
and modeling and a base of the same design, and on these
grounds it is considered attributable to Hald.

This and a companion group are probably the "Groups
of Lovers" mentioned in the factory records for 1795.

NOTE:
1. A. Hayden, *Royal Copenhagen Porcelain*, London, 1911, p.
188.

EX COLL.: [James A. Lewis, New York].

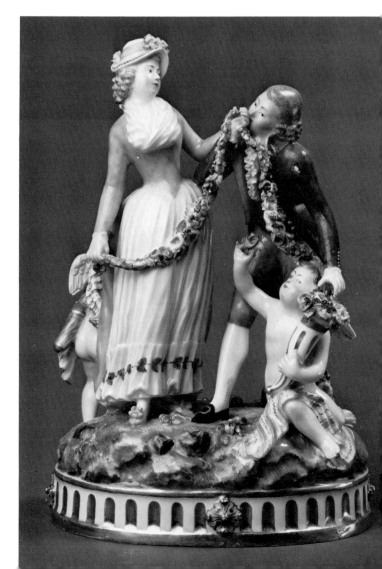

327, 328. Goose seller (two examples)

> Hard paste. Heights 6¹⁵⁄₁₆ in. (17.6 cm.), 7 in. (17.8 cm.)
> Marks: three waves inside base of each in underglaze blue; OM, a dot within the O, incised on underside of 327
> Danish, Copenhagen, Royal Porcelain Manufactory, ca. 1780
> 1982.60.208, 209

No. 328 is the crisper and more sharply detailed of the two examples; the painting of no. 327 appears to be by the same hand as that on no. 332.

329, 330. Two Norwegian peasants

> Hard paste. Heights 10⅜ in. (26.4 cm.), 10⅛ in. (25.7 cm.)
> Marks: on underside of man's robe in underglaze blue: three waves; on top of base of woman in black enamel: 23
> Danish, Copenhagen, Royal Porcelain Manufactory, ca. 1780
> 1982.60.212, 213

THE FIGURES depict a bridegroom from Fanøe and a woman from Tromsø and are two of at least fifty-six models representing Norwegian peasants. They are copied from engravings of ninety-six life-size sandstone statues executed by the Danish court sculptor Johann Gottfried Grund (1733–1796). Grund's figures were commissioned in 1764 by Frederick V of Denmark and Norway as part of the mise-en-scène of the Normandsdal, or Valley of the Norwegians, in the park surrounding Fredensborg Castle. The illustrations of Grund's statues were published in 1773 in *Afbildning af Normandsdalen*; the porcelain models are first mentioned in factory records in 1780, with fifty-six noted as completed in 1782. Andreas Hald and A. C. Luplau were among the several modelers who contributed to the series, but their individual work has not been distinguishable.

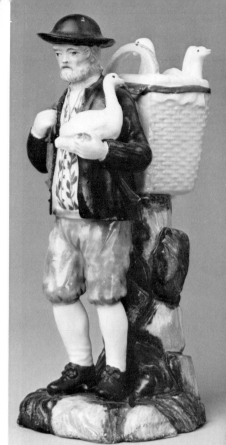
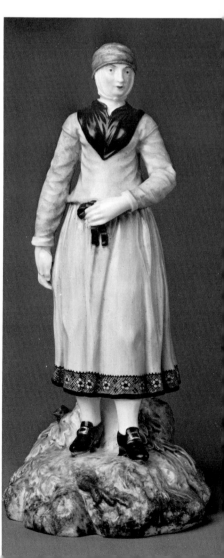
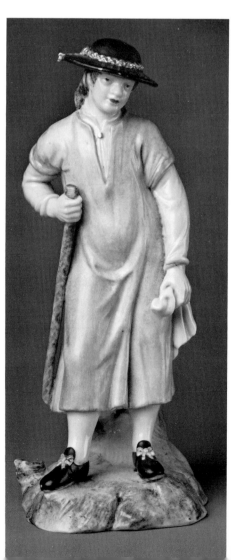
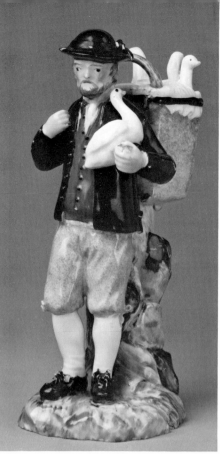

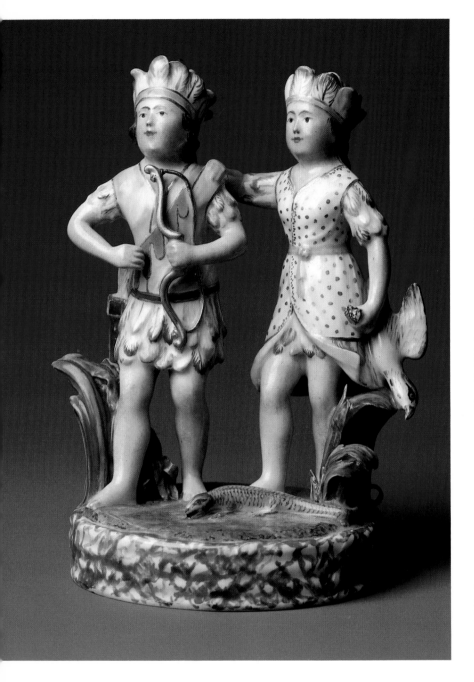

331. America

Hard paste. Height 6 in. (15.2 cm.)
Unmarked
Danish, Copenhagen, Royal Porcelain Manufactory, ca.
 1780–81
1982.60.210

FROM THE second of four series of the Continents.

EX COLL.: Sale, Christie's, London, Mar. 22, 1965, lot 91.

332. Orientals

Hard paste. Height 6⅛ in. (15.6 cm.)
Mark on back of base in underglaze blue: three waves
 arranged vertically
Danish, Copenhagen, Royal Porcelain Manufactory,
 ca. 1783
1982.60.211

DESPITE THEIR ambiguous costumes and the scimitar
held by the woman, the figures are described in the fac-
tory records as Chinese.

EX COLL.: Sale, Christie's, London, Mar. 22, 1965, lot 95.

333. Miner

Hard paste. Height 6¹⁄₁₆ in. (15.4 cm.)
Unmarked
Danish, Copenhagen, Royal Porcelain Manufactory,
 ca. 1787
1982.60.221

ONE OF A series of single figures and groups of miners
cited in the factory records between 1783 and 1811, this
figure is perhaps the "rock cavern" mentioned in 1787.
Five of the models were copied directly, or with only
slight variations, from Fürstenberg models of 1757–58
executed by Johann Georg Leimberger from drawings by
Simon Feilner, and at least one of these was repeated at
Fürstenberg by A. C. Luplau in 1772–73, four years be-
fore he left for Copenhagen. Given Luplau's association
with the two factories and the repetition of several of the
Fürstenberg models at Copenhagen, it must be assumed
that he brought them with him, but there is insufficient
evidence to attribute the full set of Copenhagen figures
to him.

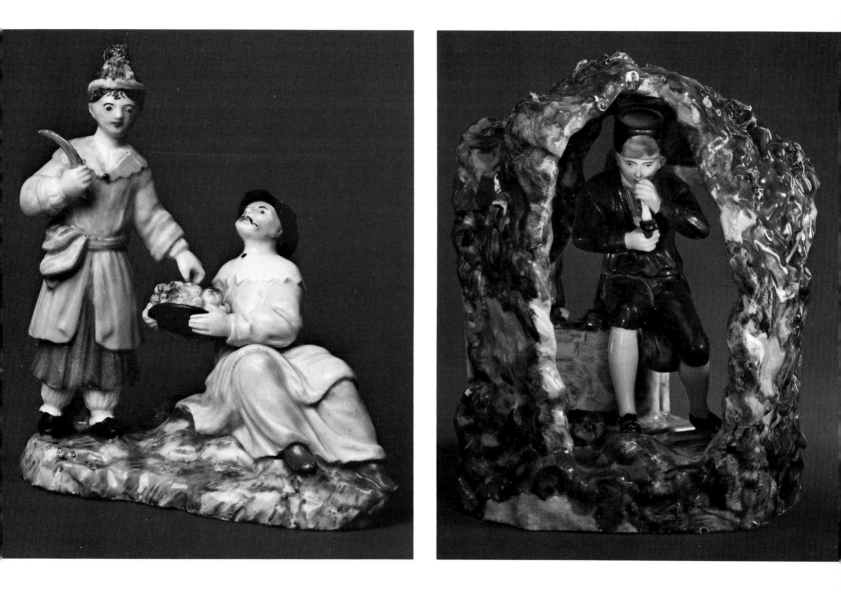

341

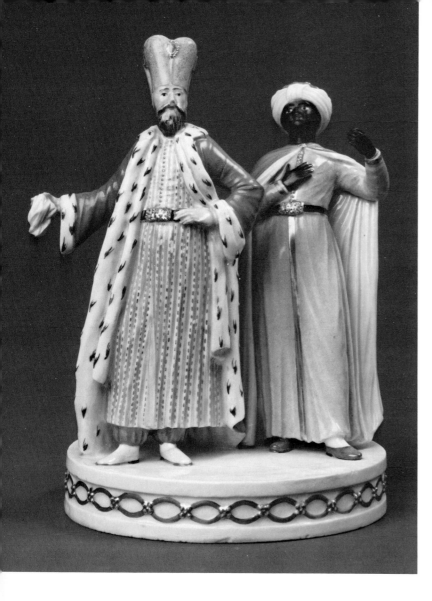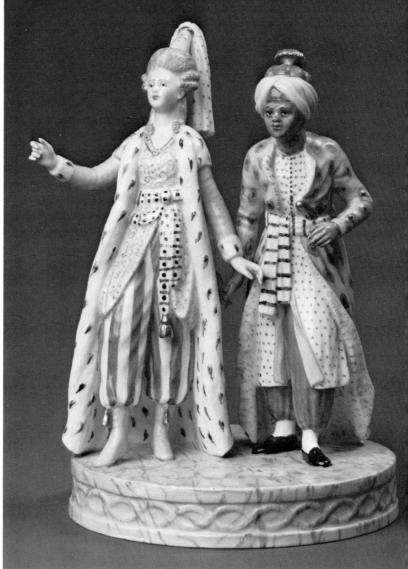

334. Sultan and blackamoor

Hard paste. Height 7⅛ in. (18.1 cm.)
Mark on back of base in underglaze blue: three waves
 arranged vertically; mark incised on unglazed
 bottom: AH
Model possibly by Andreas Hald
Danish, Royal Porcelain Manufactory, ca. 1787
1982.60.214

335. Sultana and eunuch

Hard paste. Height 7¼ in. (18.4 cm.)
Mark on underside of unglazed base in blue enamel:
 three waves
Danish, Copenhagen, Royal Porcelain Manufactory,
 ca. 1787
1982.60.215

THE SUBJECTS of these groups are based on engravings
by Philippe Simonneau (1685–after 1728) first published
in 1714 in *Recueil de cent estampes représentant différentes
nations du Levant*, a collection of engravings after paint-
ings commissioned by Charles, comte de Ferriol. The
group depicting Sultan Achmet III and his attendant is a
compilation of plates 1 and 2, the position of the figures
being copied from the second, while the sultan's head-
dress is borrowed from the first. The companion group is
based on plate 3, but varies considerably in details of pos-
ture and dress.

The same subjects were modeled at Fürstenberg about
1773–74 (see no. 217) by Anton Carl Luplau, who moved
to Copenhagen in 1776, working there as chief modeler
until his death in 1795. These groups are first mentioned

in the Copenhagen factory records in 1787. That Luplau was the modeler of both versions is unlikely in view of the considerable differences between them. As the Fürstenberg figures appear in reverse, it is evident that Luplau used the second, German, edition of Ferriol (Nuremberg, 1719) with the illustrations reengraved by Johann Christoph Weigel. And while this version of the sultana appears to be something of an invention, Luplau's Fürstenberg model is a literal copy of the Weigel engraving. Stylistically, too, the two pairs of groups are inconsonant, these being much smaller and more simplistically modeled than the German examples. Luplau's authorship of these must therefore be considered doubtful, although he very likely introduced the subject into the factory's repertoire.

Both models have been attributed to Andreas Hald on the basis of their affinity to other figures executed in the same style and set on bases of the same design, of which some—like no. 334—are marked with Hald's initials.[1] Against this must be considered Emil Hannover's point that as examples of a given model are found with different signatures, it is apparent that the Copenhagen modelers worked as repairers as well.[2]

NOTES:
1. S. B. Fredstrup, *Figurer og andre plastiske arbejder*, Copenhagen, 1939, summary, p. 5.
2. E. Hannover, *Pottery and Porcelain*, London, 1925, III, p. 450.

BIBLIOGRAPHY: (Sultana and eunuch) D. Rosenfeld, *Porcelain Figures of the Eighteenth Century in Europe*, New York, 1949, p. 119 (collection: Jack Linsky).

336. The Right of Nationality

Hard paste. Height 8⁹⁄₁₆ in. (21.8 cm.)
Marks incised on underside of unglazed base: three waves; s
Danish, Copenhagen, Royal Porcelain Manufactory, ca. 1780
1982.60.220

THE PERSONAE of this group have been traditionally identified as Piety receiving Denmark, Norway, and the duchies of Schleswig and Holstein (both represented by one of the three children) into the rights of citizenship.[1] The composition is copied from a silver medal by Daniel Jansen Adzer (d. 1808), dated 1776, said by Fredstrup to be based on a design by the sculptor Johannes Wiedewelt

(1731–1802).[2] Wiedewelt in turn borrowed his iconography from a classical source, specifically a bronze coin of the reign of Marcus Aurelius. The Roman legend *Pietas Aug* is expanded on Adzer's medal to *Pietas Augusta*, signifying, in accordance with classical usage, the exercise of humanitarian duty toward one's country (family). Since the issue commemorated by Adzer's medal was the granting of the rights of citizenship to those countries lately acquired by Denmark, it seems more reasonable to identify the characters as Denmark herself receiving Norway, Schleswig, and Holstein into the fold.

The mark is that of J. J. Smidt, but the model has not been attributed to him, and, in accordance with factory custom, he may simply have worked on this example as repairer.

NOTES:
1. E. Hannover, *Pottery and Porcelain*, London, 1925, III, fig. 711; S. B. Fredstrup, *Figurer og andre plastiske arbejder*, Copenhagen, 1938, ill. 12.
2. Fredstrup, summary, p. 5.

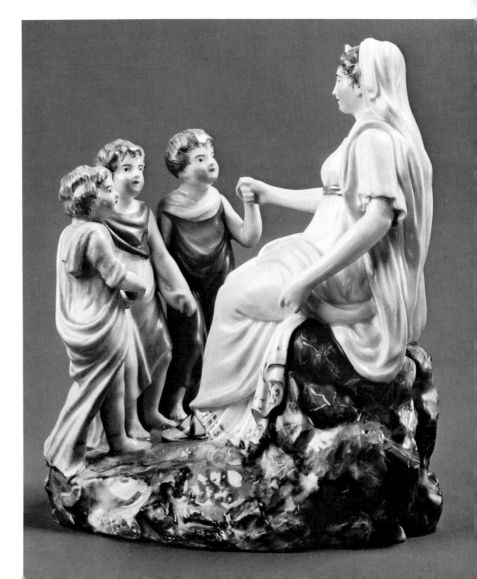

The Russian Factories

ONLY TWO factories were in operation in Russia during the eighteenth century, the Imperial Porcelain Manufactory in Saint Petersburg and the Gardner factory at Verbilki, outside Moscow. The former had its origin in experiments (1744–48) by the itinerant German arcanist C. C. Hunger, but manufacture began only with his successor, Dmitri Vinogradov (d. 1758). The factory continues in existence today, having been renamed the Lomonosov Porcelain Factory in 1925. In 1766 an Englishman, Francis Gardner, received permission to establish a porcelain factory, which he did the following year in the town of Verbilki, where it remained, being sold to M. S. Kuznetsov in 1892.

A considerable number of private factories sprang up during the nineteenth century, one of which was that founded in 1806 by a German, Karl Melli, and sold almost immediately thereafter to Aleksei Gavrilovich Popov. Situated at Gorbunovo, about thirty miles from the Gardner factory, it closed in 1875.

Peoples of Russia

Russian, Saint Petersburg, Imperial Porcelain
Manufactory, 1780–1800

A SERIES OF figures depicting Russian national types was initiated at the Imperial factory about 1780. The iconography for the models was provided, for the most part, by engravings in the *Description of All the Peoples Inhabiting the Russian State*, by Johann Gottlieb Georghi. The date of the first edition is generally given as 1776, but an earlier, unrecorded, edition is dated 1774 (copy in private possession). Subsequent editions are those of 1776, 1779, and 1799 (the last is referred to here).

Not all the models in the series—which is of undetermined size—were by Georghi, some (e.g., no. 338) being based on engravings of similar purpose by J. B. Le Prince (1734–1781), whose travels in Russia from 1758 to 1762 resulted in the publication of his *Divers Ajustements et usages de Russie dediés à M. Boucher* (included in his *Oeuvres*, 1782). The sources of still others remain unidentified.

The production of the series, which is believed to have continued until the end of the century, is said by Baron Wolf[1] and Lïudmila Nikiforova[2] to have been the work of Jean-Dominique Rachette (1744–1809), who, born in Copenhagen of French parents, emigrated to Russia and was appointed chief modeler at the Imperial factory in 1779. How far Rachette was responsible for all the models in the Peoples of Russia series is not clear. Aleksandr Saltykov[3] has suggested that his role was essentially supervisory, while the figures themselves were the work of such factory modelers as Kirsanov and Kozlov.

1. N. B. von Wolf, *Imperatorski farforovyĭ zavod 1744–1904*, Saint Petersburg, 1906, p. 87.
2. L. Nikiforova, *Russian Porcelain in the Hermitage Collection*, Leningrad, 1973, p. 119.
3. A. B. Saltykov, "Farfor," in Akademiïa khudozhestv SSSR, *Russkoe dekorativnoe iskusstvo*, ed. A. I. Leonov, Moscow, 1962–65, II, p. 563.

RIGHT, TOP: 337, 341. BOTTOM: 339, 338, 340

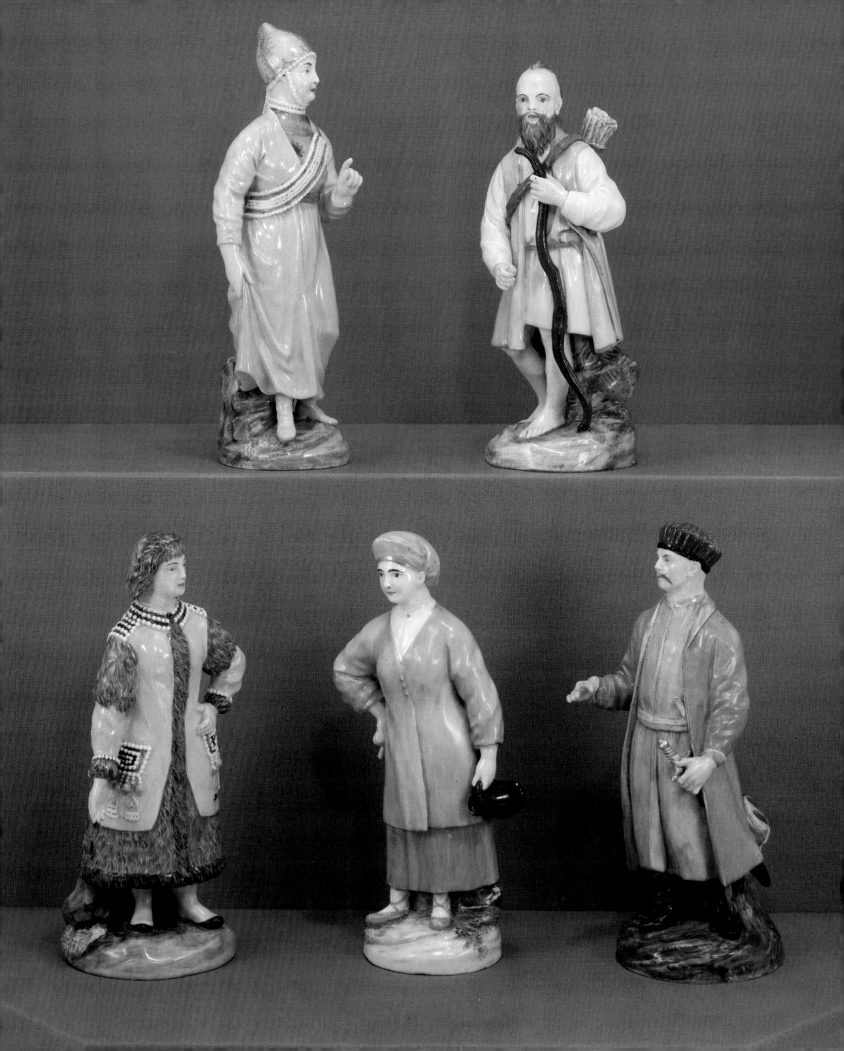

337. Kazan Tartar woman

Hard paste. Height 9 in. (22.9 cm.)
Marks inside base: E[KATERINA] II in underglaze blue
 in Cyrillic; P incised
1982.60.146

FRONT AND back views from Georghi, plates 27 and 28.
An example of the same model in the Hermitage is
inexplicably identified in a lettered inscription on the base
as a Kirghiz woman.[1]

NOTE:
 1. L. Nikiforova, *Russian Porcelain in the Hermitage Collection*, Leningrad, 1973, fig. 31.

338. Peasant woman from Ingria (Ingermanland)

Hard paste. Height 8¼ in. (21 cm.)
Mark inside base in underglaze blue in Cyrillic:
 E[KATERINA] II
1982.60.152

THE FIGURE does not appear in Georghi, but corresponds, with minor variations, to plate 6 in Le Prince's
Divers Ajustements . . . , entitled "Femme de la Province
Dingrie, du coté de la Finlande."

339. Yakut woman

Hard paste. Height 8⅜ in. (21.3 cm.)
Mark incised inside base in Cyrillic: PS
Inscribed on back of base in black enamel: YAKUTKA
1982.60.163

FROM GEORGHI, plate 52, where she is shown wearing
a two-horned headdress of which only the base remains
in this example.

340. Karbadian man

Hard paste. Height 8½ in. (21.5 cm.)
Unmarked; inscribed on back of base in raised Cyrillic
 letters: KABARDÍNITZ
1982.60.164

FROM GEORGHI, plate 31.

341. Kurile man

Hard paste. Height 8³⁄₁₆ in. (20.8 cm.)
Mark incised inside base in Cyrillic: S T
1982.60.168

THE FIGURE does not occur in Georghi, and its source
remains untraced. It is identified as a Kurile by Baron
Wolf.[1]

NOTE:
 1. N. B. von Wolf, *Imperatorski farforovyĭ zavod 1744–1904*, Saint
Petersburg, 1906, pl. III, no. 25.

342, 343. Tartar woman (two examples)

Hard paste. Heights 8¼ in. (21 cm.), 8⅜ in. (21.3 cm.)
Unmarked; inscribed on the back of each in raised
 Cyrillic letters: BABA:TATARSKAYA
1982.60.143,154

FROM GEORGHI, part 2, opposite page 158. The vaguer
painting and different treatment of the base indicate that
no. 339 is from a different, possibly later, edition of the
figures.

344. Kirghiz man

Hard paste. Height 8¼ in. (21 cm.)
Mark incised inside base in Cyrillic: L(?); inscribed on
 back of base in raised Cyrillic letters: KIRGHIZETZ
1982.60.153

ALTHOUGH THIS figure does not occur in Georghi, another, of a man on horseback, wearing an identical hat
(plate 38), is identified as a Kirghiz.

345. Lapplander

Hard paste. Height 8¹¹⁄₁₆ in. (22.1 cm.)
Unmarked; inscribed on back of base in raised Cyrillic
 letters: LOPAR'
1982.60.161

FROM GEORGHI, plate I.

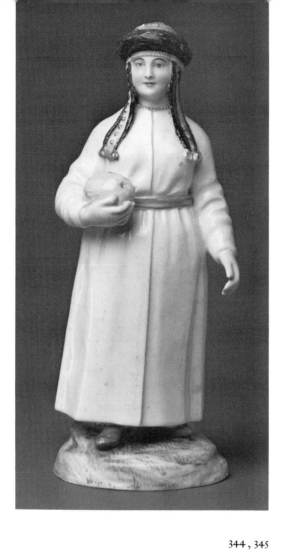

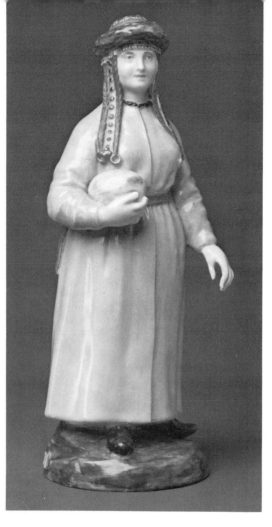

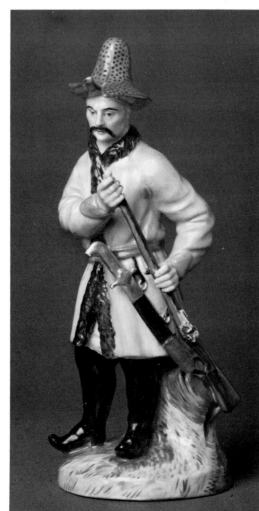

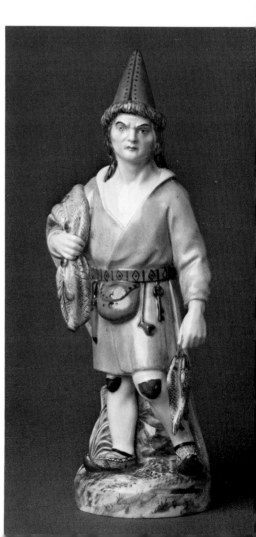

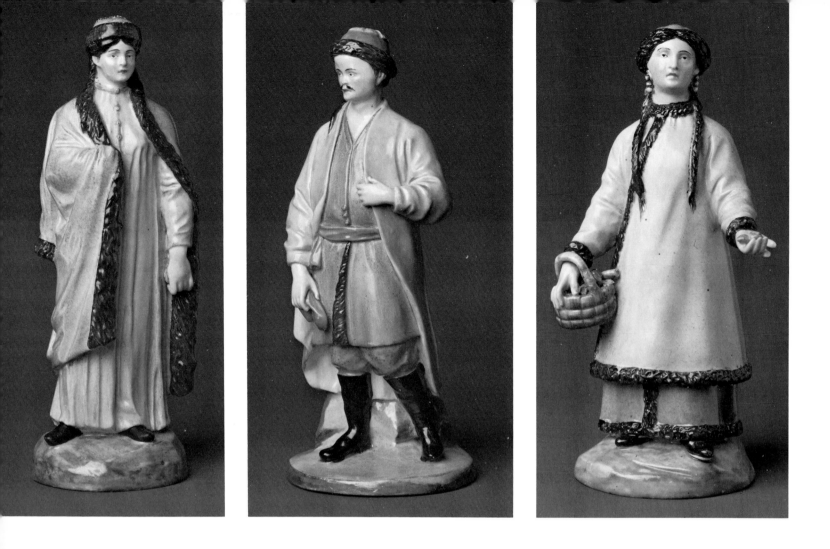

346, 347. Kalmuk man and woman

Hard paste. Heights 8½ in. (21.6 cm.), 8¹³⁄₁₆ in.
(22.4 cm.)
Mark incised on underside of base of man in script:
N.9.
1982.60.151,149

FROM GEORGHI, plate 76. With its flat, low base, the
figure of the man may be from a later series.

348. Tartar woman

Hard paste. Height 8³⁄₁₆ in. (20.8 cm.)
Unmarked
1982.60.162

THE SOURCE of the figure, which does not appear in
Georghi, is untraced. The model is identified as a Tartar
woman by Baron Wolf.[1]

NOTE:
1. N. B. von Wolf, *Imperatorski farforovyĭ zavod 1744–1904*, Saint
Petersburg, 1906, pl. III, no. 8.

349. Man from Kamchatka

Hard paste. Height 8⁹⁄₁₆ in. (21.8 cm.)
Indecipherable mark incised and filled in in brown
enamel inside base
1982.60.167

ALTHOUGH THE model is not found in the 1799 edition
of Georghi, it is said by Lĭudmila Nikiforova to be trace-
able to that source, and the Hermitage example of the
model is identified on the back of the base.[1]

NOTE:
1. L. Nikiforova, *Russian Porcelain in the Hermitage Collec-
tion*, Leningrad, 1973, fig. 32.

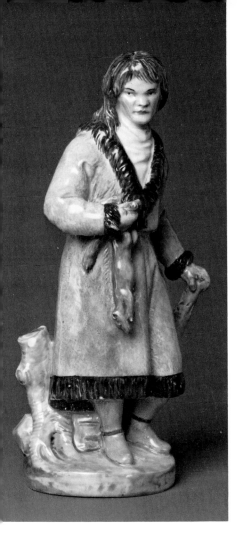

350, 351. Samoyed man and woman

Hard paste. Heights 8½ in. (21.6 cm.), 8¼ in. (21 cm.)
Inscribed on each base in black: on front of man, in
Cyrillic, SAMOYET; on back, *Samoede*; on front of
woman, in Cyrillic, SAMOYETKA; on back, *Femme de
Samoede*

1982.60.166,165

FROM GEORGHI, plates 56 and 57. The illustrations in
the 1774 and 1779 editions of Georghi are captioned in
three languages—Russian, German, and French—so that
the presence of multilingual identifications need not seem
peculiar. However, the spelling here does not correspond
to that in the 1799 edition of Georghi, and, as so few of
these figures are so inscribed, it may be questioned whether
these examples were made later for export to the West.

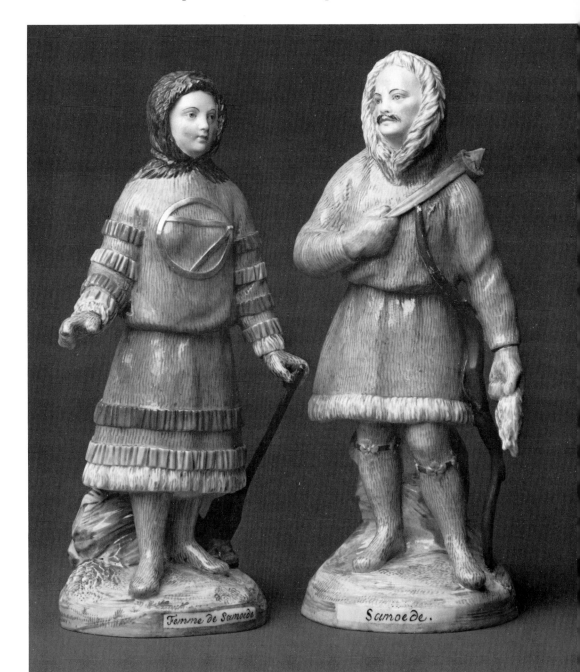

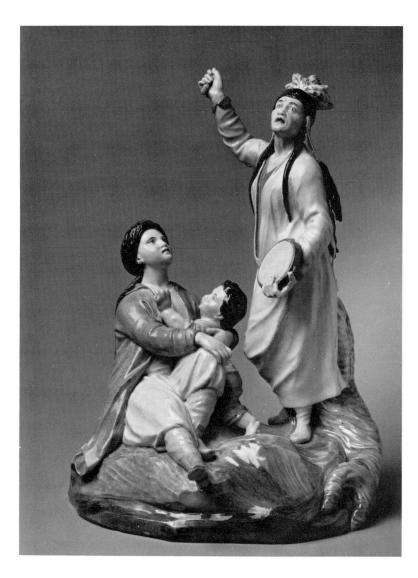

352. Female shaman

Hard paste. Height 10¼ in. (26.1 cm.)
Unmarked
1982.60.175

THE COMPOSITION, in which a *shamanka* chants her spells over a child and its mother, does not occur in Georghi, although the figure of the *shamanka* herself corresponds, in both front and back views, to illustrations in Georghi (plates 44, 45).

Craftsmen and Tradesmen

Russian, Saint Petersburg, Imperial Porcelain Manufactory, 1780–1800

HISTORIANS OF Russian porcelain have grouped under this designation a series of figures produced at the Imperial factory shortly after those depicting Russian national types. The sources of the models have not been identified, but it is likely that some were derived from Le Prince's engravings in his *Divers Ajustements* . . . , as there are similarities of both subject and pose between some illustrations and figures.

353, 354. Ice cream seller (two examples)

Hard paste. Heights 7⅞ in. (20 cm.), 8 in. (23 cm.)
Unmarked
1982.60.142,150

THE MODEL is so identified by Baron Wolf in *Imperatorski farforovyĭ zavod 1744–1904*, Saint Petersburg, 1906, fig. 83.

355. Poultry seller

Hard paste. Height 7¹⁵⁄₁₆ in. (20.2 cm.)
Mark incised inside base in Cyrillic: VM II
1982.60.160

THE MODEL is so identified by Lïudmila Nikiforova in *Russian Porcelain in the Hermitage Collection*, Leningrad, 1973, fig. 30.

356. Okhta milkmaid

Hard paste. Height 8 in. (20.3 cm.)
Mark incised inside base in Cyrillic: VM II
1982.60.147

NIKIFOROVA so identifies the model in *Russian Porcelain in the Hermitage Collection*, Leningrad, 1973, fig. 29.

357. Fisherman

Hard paste. Height 8¹⁵⁄₁₆ in. (22.7 cm.)
Mark inside base in underglaze blue in Cyrillic:
 E[KATERINA] II
1982.60.174

353

355

354

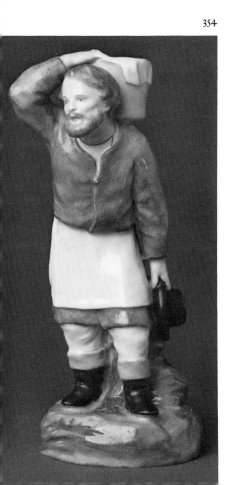

356

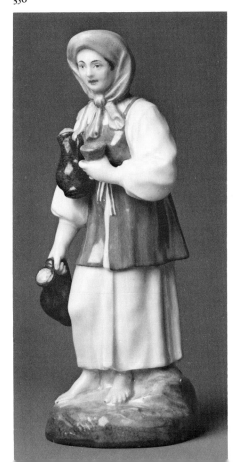

357, TWO VIEWS

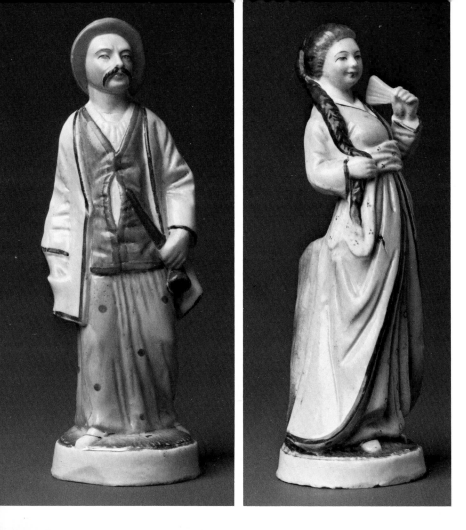

358, 359. Oriental couple

Hard paste. Heights 6¹⁵/₁₆ in. (17.6 cm.), 6¾ in. (17.2 cm.)
Unmarked
Russian, possibly Saint Petersburg, Imperial Porcelain Manufactory, first half of 19th century
1982.60.155,156

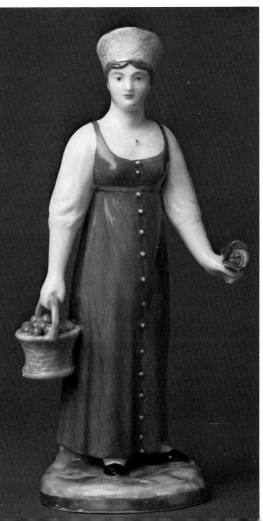

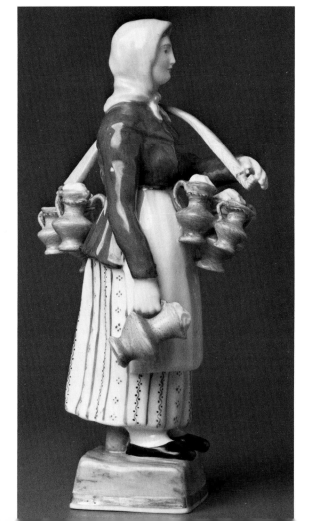

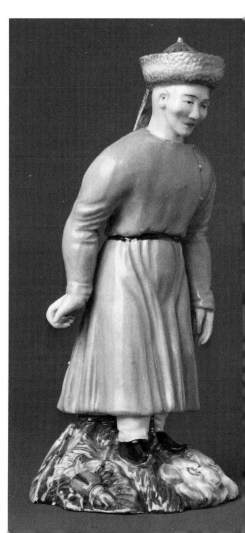

360. Woman with fruit basket

Hard paste. Height 6⁹⁄₁₆ in. (16.7 cm.)
Mark on underside of base in underglaze blue: G
Russian, Verbilki, Gardner factory, ca. 1820
1982.60.144

ACCORDING TO A. K. Lansere, the model may have originated as one of a set of figures made to supplement a table service made in 1809 at the Imperial factory for D. A. Guriev, Alexander I's privy councillor and minister of finance;[1] additions to the service were made over a number of years.

NOTE:
1. A. K. Lansere, *Russkiĭ farfor*, Leningrad, 1968, p. 20.

361. Milkmaid

Hard paste. Height 7 in. (17.8 cm.)
Marks on underside of base: G in underglaze blue; script G incised
Russian, Verbilki, Gardner factory, ca. 1820
1982.60.145

THE MODEL is based on the left-hand figure in plate 2 of *The Magic Lantern, or a Spectacle of St. Petersburg*, a monthly publication begun in late 1817 or early 1818 with illustrations of the "Common Vendors, Artisans, and other Common People." The engravings have been attributed to both A. G. Venetsianov and K. A. Zelentsov.[1] The figures are shown in couples "conversing with one another corresponding to each character and state," the milkmaid being paired with a laundress. As the Gardner factory issued models of both figures of at least one other illustration in *The Magic Lantern*,[2] it is likely that this model was originally accompanied by a companion model of the laundress.

NOTES:
1. A. V. Morozov, *Figury Gardnera po grarvīuram "volsheb-nogo Fonaria,"* Moscow, 1929, p. 9.
2. N. V. Chernyĭ, *Farfor Verbilok*, Moscow, [1970], figs. 56, 57.

362. Oriental man

Hard paste. Height 7⅛ in. (18.1 cm.)
Marks inside base in Cyrillic letters: AP conjoined in underglaze blue; v incised
Russian, Gorbunovo, Popov factory, ca. 1840
1982.60.148

363, 364. Covered cup and saucer

Hard paste. Height of cup 3⅞ in. (9.8 cm.); diameter of saucer 5⁵⁄₁₆ in. (13.5 cm.)
Marks on underside of each: double-headed eagle in black; astrological symbol for Mars incised
Russian, Saint Petersburg, Imperial Porcelain Manufactory, ca. 1760
1982.60.172ab,173

THE PIECES are part of a tea service said by Lansere to have been made for the empress Elizabeth.[1] They are dated here in accordance with the statement that the mark of the eagle was introduced in 1759.[2] The impressed mark is recorded by Lukomski as designating a gray clay from Gjelsk,[3] and, indeed, the very dingy color of the paste may have determined the decoration of this set, which is gilded throughout. In transliteration, an inventory mark in red Cyrillic letters on each piece reads *G. Ch.*, presumably indicating the imperial summer palace at Gatchina.

NOTES:
1. A. K. Lansere, *Russkiĭ farfor*, Leningrad, 1968, p. 10.
2. A. Popoff, "Russian Imperial Porcelain," *Connoisseur* 95 (1935), p. 324.
3. G. Lukomski, *Russisches Porzellan*, Berlin, 1924, p. 13.

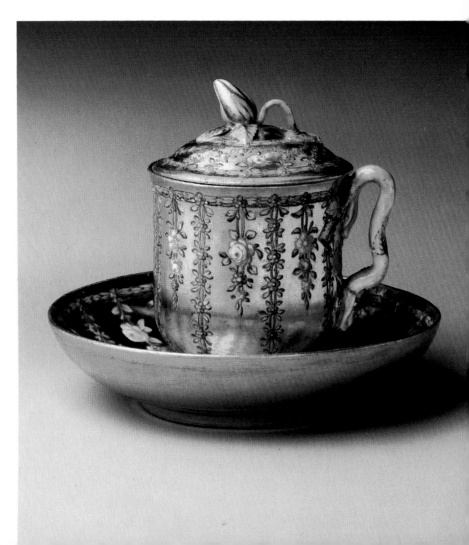

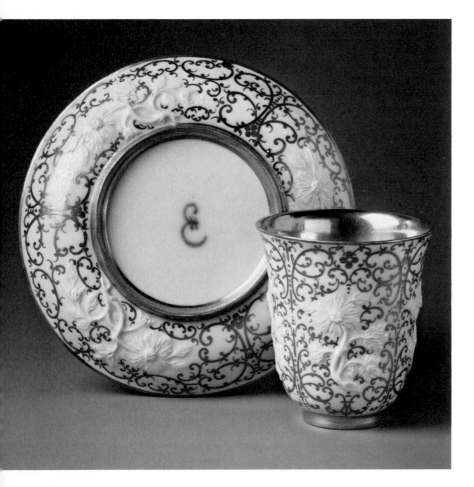

365, 366. Beaker and saucer

Hard paste. Height of beaker 3³⁄₁₆ in. (8.1 cm.);
diameter of saucer 5¹¹⁄₁₆ in. (14.4 cm.)

Mark on underside of each in underglaze blue in
Cyrillic: E[KATERINA] II

Russian, Saint Petersburg, Imperial Porcelain
Manufactory, ca. 1765

1982.60.177,178

THE COMBINATION of molded flowering branches on
a field of gilded lacework is at least borrowed, and per-
haps copied exactly, from Meissen work of the Böttger
period. The style is associated with Johann Georg Funcke
(working 1713–late 1730s), an independent Dresden gilder
and enameler; his son; and an associate, Johann Jakob
Gäbel. Independent styles of the three have not been dis-
tinguished, but the mark of a gold *F*, attributed to the
senior Funcke, has been recorded on a cup and saucer
decorated in a manner very similar to these pieces.[1]

NOTE:

1. R. Rückert, *Meissener Porzellan, 1710–1810* (exhib. cat.), Mu-
nich, Bayerisches Nationalmuseum, 1966, cat. no. 36, pl. 14.

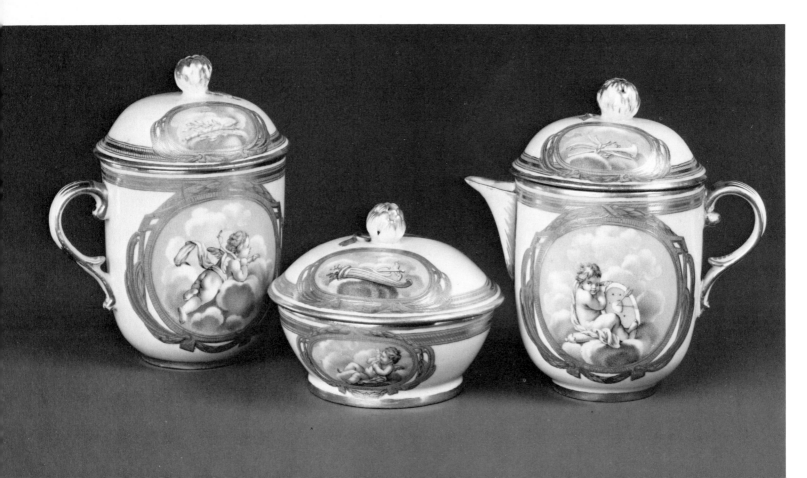

367–369. Covered cup, milk jug, and sugar bowl from a tea service

Hard paste. Heights of cup and milk jug 4⅛ in. (10.5 cm.); height of sugar bowl 2½ in. (6.3 cm.)
Mark impressed on underside and inside cover of each piece: a dot within an annulet
Russian, Saint Petersburg, Imperial Porcelain Manufactory, ca. 1775
1982.60.169ab–171ab

THE DECORATION of cloud-borne cherubs and trophies of love recalls similar vignettes on late Vincennes and early Sèvres porcelains, but the manner of painting them in grisaille against a pink ground within finely tooled gold borders is closer to the techniques of the makers of gold boxes. The style appeared in Paris by 1763/64 (an example by Louis Charonnat in the Metropolitan Museum, 1976.155.9) and in Saint Petersburg about 1775 (a box by Jean Pierre Ador).[1]

The shapes of these pieces have not been noted in European porcelain and are perhaps indigenous forms.

According to G. Lukomski,[2] the mark distinguishes porcelains made with Orenburg clay from those made with a grayer clay from Gjelsk (nos. 363, 364).

NOTES:
1. A. K. Snowman, *Eighteenth-Century Gold Boxes of Europe*, London, 1966, fig. 630.
2. G. Lukomski, *Russisches Porzellan*, Berlin, 1924, p. 13.

370. Tankard

Hard paste. Height 10 in. (25.4 cm.)
Mark on underside in underglaze blue in Cyrillic:
E[KATERINA] II
Russian, Saint Petersburg, Imperial Porcelain Manufactory, ca. 1780
1982.60.176ab

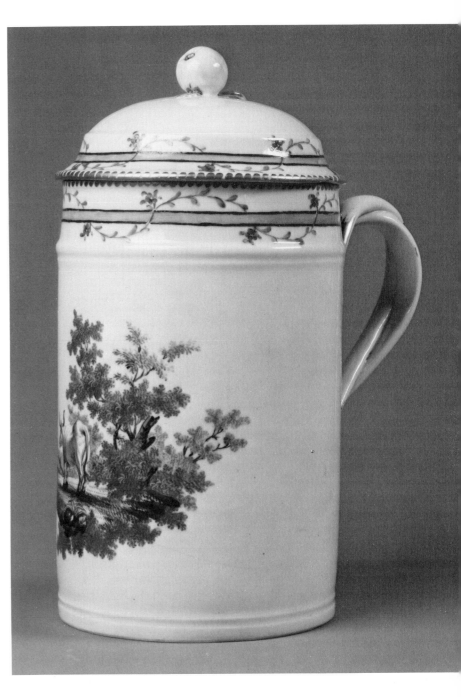

LEFT: 367–369. COVERED CUP, MILK JUG, AND SUGAR BOWL

371, 372. Harlequin, and Harlequin dressed as Columbine

Hard paste. Heights 6⅜ in. (16.2 cm.), 6½ in. (16.5 cm.)
Unmarked
Russian, Verbilki, Gardner factory, 1770–80
1982.60.157,158

ANOTHER PAIR of these figures, each with the usual Gardner factory mark of a *G* in underglaze blue, is in the Musée Céramique Nationale de Sèvres.

373. Monkey group

Hard paste. Height 6⁵⁄₁₆ in. (16 cm.)
Mark on top of base in underglaze blue: two pairs of crossed swords, overlapping
Russian, Verbilki, Gardner factory, ca. 1770
1982.60.159

EVIDENCE FOR a Russian origin of this group is chiefly circumstantial. The mark, which resembles interlaced crossed swords in imitation of the Meissen mark, was recorded in 1926 for the Gardner factory,[1] but possibly only on the basis of this example. Since then, two models of similar type have been noted. Both are composed of

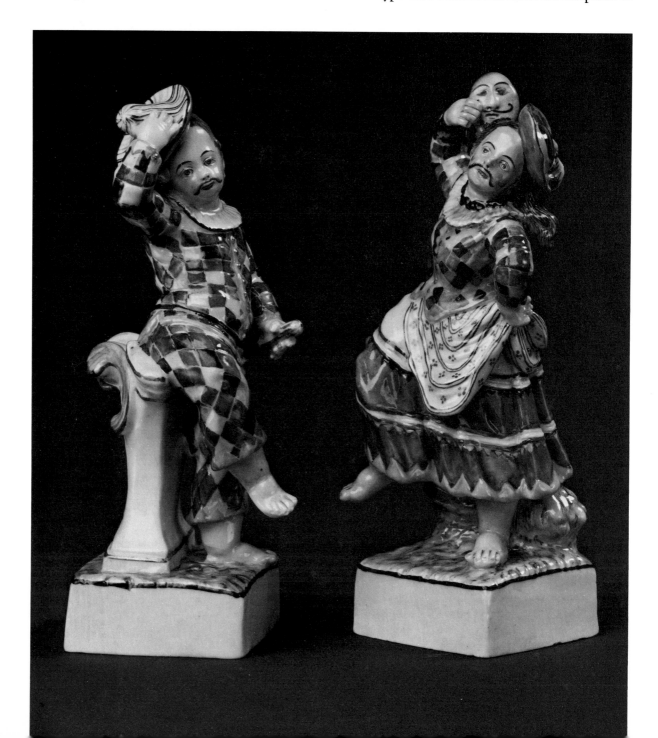

the same gray paste covered with a sticky glaze; they bear the same mark and share the same stylistic device of a high scrolled support and a rolled molding along the top of the base. One, in the British Museum, has no known provenance.[2] The other, in the Hermitage, by implication entered that museum in the 1920s from a private Russian collection.[3]

The three models are in every respect unlike porcelains bearing the more usual Gardner factory mark of a *G*, although the device of the scrolled pedestal recurs in the Gardner Italian Comedy figures (nos. 371, 372). This stylistic connection, and the Russian provenance of two of the three may thus be called on to justify the attribution.

NOTES:
1. A. Rozembergh, *Les Marques de la porcelaine russe*, Paris, [1926], pl. xxxix.
2. W. King, "Continental Porcelain Group," *British Museum Quarterly* II (1927), pp. 26–27, pl. xv.
3. L. Nikiforova, *Russian Porcelain in the Hermitage Collection*, Leningrad, 1973, fig. 44.

EX COLL.: M. and Mme Alexandre Popov, Paris.

EXHIBITED: Musée Céramique de Sèvres, *Catalogue de l'exposition de céramiques russes anciennes*, Apr.–Oct. 1929, cat. no. 270 (lent by M. and Mme Popov); London (1 Belgrave Square), *Exhibition of Russian Art*, June 4–July 13, 1935, cat. no. CI, p. 42 (lent by M. and Mme Popov [?]).

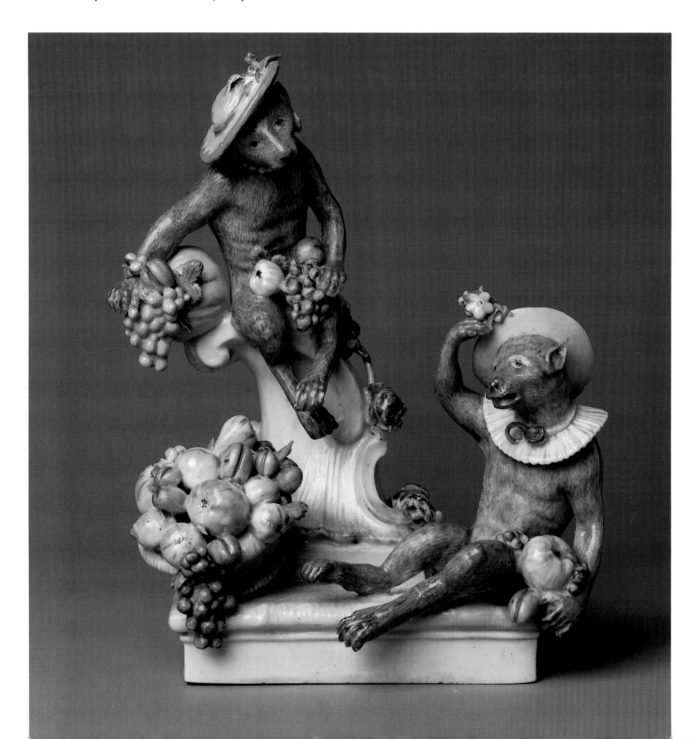

Acknowledgments

THE ADVICE of our colleagues is recorded in the individual entries for the European paintings in the Linsky Collection; we thank them for their assistance. Readers will have noted that a number of the pictures have been cleaned in the Museum's Paintings Conservation Department, which is under the supervision of John Brealey. All have been examined, and condition reports prepared in collaboration with the writers. Guy Bauman, Keith Christiansen, and Walter Liedtke therefore join me in gratefully acknowledging the work of John Brealey and his staff and the help they have given us in the preparation of our part of the catalogue.

Katharine Baetjer

FOR THE OVERALL design of the Linsky Galleries we are endebted to Henri Samuel of Paris and his associate in New York, Harold Eberhard. At the Metropolitan the architectural work was overseen by Arthur Rosenblatt, Vice President for Architecture and Planning, and Paul Chaitin, Supervisor for Construction. Robert Kupiec served as consulting architect in charge of the construction. Joseph De Paul and Sons was the general contractor, and William L. Riegel of the Metropolitan was the designer for lighting.

I wish to express as well my thanks, globally, to those Museum curators whose contributions of time and expertise account for the quality of this catalogue, especially to Olga Raggio, Chairman, Clare Le Corbeiller, Associate Curator, James Draper, Curator, and Clare Vincent, Associate Curator, of the Department of European Sculpture and Decorative Arts; to John Pope-Hennessy, Consultative Chairman, and Keith Christiansen, Associate Curator, of the Department of European Paintings. Special thanks go to William Rieder, formerly Associate Curator in the Department of European Sculpture and Decorative Arts, who played a key role in the initial planning of the galleries, and to Clare Le Corbeiller, who assumed those responsibilities when Bill Rieder left the Museum for a position at the J. Paul Getty Museum, Malibu.

Philippe de Montebello

I WOULD LIKE to thank the following people for their considerable help: Manfred Leithe-Jasper and Helmut Trnek of the Kunsthistorisches Museum, Vienna; Anthony Radcliffe of the Victoria and Albert Museum; Hugh Tait of the British Museum; M. V. Attrill of the City Museum and Art Gallery, Plymouth; and Christian Theuerkauff of the Staatliche Museen, Berlin-Dahlem. Also Charles Avery, Ruth Blumka, Elisabeth Drey, Cyril Humphris, and David Wille; Priscilla Grace, Mary Howard, and Catherine Leslie Parker; Richard E. Stone.

James David Draper

I HAVE BENEFITED from the generously given knowledge and assistance of a great many people. I should particularly like to thank Ingelore Menzhausen, Porzellansammlung, Dresden; Geneviève Le Duc, Musée National de Céramique, Sèvres; Gérard Mabille, Musée des Arts Décoratifs, Paris; Bredo Grandjean; T. H. Clarke; Horst Reber, Mittelrheinisches Landesmuseum, Mainz; Jessie McNab; Paul Schaffer, A La Vieille Russie; Hugh Tait, the British Museum; Katrina V. H. Taylor, Hillwood; Armin B. Allen; Letitia Roberts, Sotheby's; Marie Lawrence, American Museum of Natural History; Jacqueline von Saldern; Adrian Sassoon, J. Paul Getty Museum; and Toni Buld.

Clare Le Corbeiller

I WOULD LIKE to thank Daniel Alcouffe, Reinier Baarsen, Geoffrey de Bellaigue, Charles Beyer, Theodore Dell, Winthrop Edey, John Hardy, Clare Le Corbeiller, Daniel Meyer, Thierry Millerand, Jeffrey Munger, James Parker, and Gillian Wilson for their advice and help in preparing the entries on French furniture.

William Rieder

I AM DEEPLY GRATEFUL to James T. Frantz and Richard E. Stone of the Metropolitan Museum's Department of Objects Conservation, especially for the technical study

of the Beckford ewer. I am also particularly indebted to Priscilla E. Muller of the Hispanic Society of America, New York; Kirsten Aschengreen Piacenti of the Museo degli Argenti, Florence; Anna Somers Cocks and Charles Truman of the Victoria and Albert Museum; and Hugh Tait of the British Museum for their invaluable advice and assistance. R. A. Crighton of the Fitzwilliam Museum, Cambridge; Rudolf Distelberger of the Kunsthistorisches Museum, Vienna; Joachim Menzhausen of the Grünes Gewölbe in Dresden; and Gertie Van Berge of the Rijksmuseum, Amsterdam, were also most generous with their help. It is truly appreciated.

Clare Vincent

Appendix

The following works of art in the Jack and Belle Linsky Collection are not presently on exhibition.

JOOS VAN CLEVE
Active by 1511, Antwerp; died 1540/41, Antwerp
Madonna and Child. Oil on wood. 28⅜ × 21⅜ in. (72.1 × 54.3 cm.)
1982.60.47

LUCAS CRANACH THE ELDER
Born 1472, Kronach; died 1553, Wittenberg
Venus and Cupid. Oil on wood. Diameter 4½ in. (11.4 cm.)
1982.60.48

NICHOLAS ANTOINE TAUNAY
Born 1755, Paris; died 1830, Paris
The Billiard Room. Oil on wood. 6⅜ × 8⅝ in. (16.2 × 21.9 cm.)
1982.60.49

Vessel with three infants and a coat of arms
Bronze. Venetian, by Francesco Bertos, mid-18th century
1982.60.110

Table (table en carrosse)
Walnut. French, ca. 1720
1982.60.83

The Muse Thalia
Hard-paste porcelain. Model by J. J. Kändler. German, Meissen, ca. 1735
1982.60.331

The Thrown Kiss
Hard-paste porcelain. Model by J. J. Kändler. German, Meissen, ca. 1736
1982.60.311, 312

Beaker with imperial Russian arms
Hard-paste porcelain. Austrian, Vienna (Du Paquier period), ca. 1730–35
1982.60.240

Covered tureen with imperial Russian arms
Hard-paste porcelain. Austrian, Vienna (Du Paquier period), ca. 1730–35
1982.60.330ab

Pair of candlesticks
Hard-paste porcelain. Austrian, Vienna (Du Paquier period), ca. 1735
1982.60.231, 232

Snuffbox
Hard-paste porcelain. Probably German (Nymphenburg?), ca. 1770
1982.60.336

Snuffbox
Soft-paste porcelain. English, Chelsea, ca. 1760
1982.60.362

Figure of an Oriental
Tin-glazed soft-paste porcelain with gilt-bronze mounts. French, the porcelain Chantilly, ca. 1730, the mounts ca. 1775
1982.60.371

Covered bowl and tray
Soft-paste porcelain. French, Sèvres, 1764
1982.60.180ab, 181